*Art and Architecture
in Medieval France*

Frontispiece: Reims Cathedral. Choir and nave

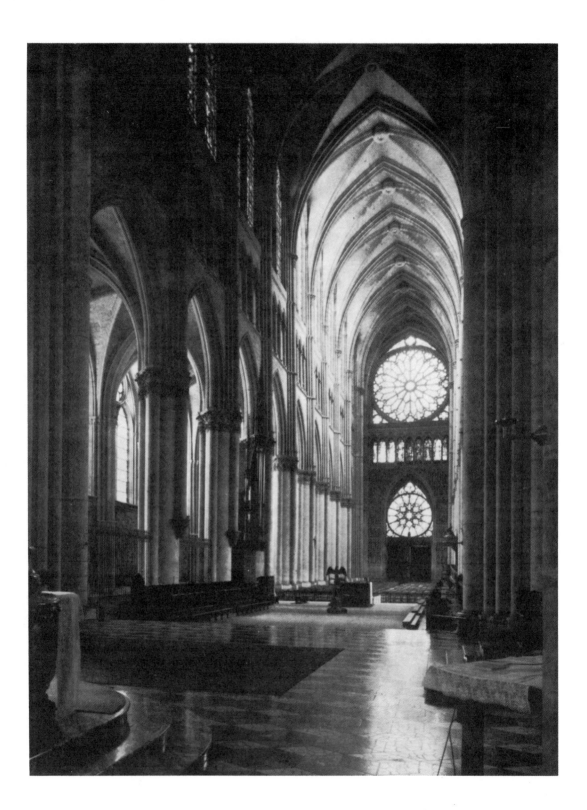

Art and Architecture in Medieval France

MEDIEVAL ARCHITECTURE, SCULPTURE,

STAINED GLASS, MANUSCRIPTS,

THE ART OF THE CHURCH TREASURIES

BY WHITNEY S. STODDARD

ICON EDITIONS

Harper & Row, Publishers, New York
Grand Rapids, Philadelphia, St. Louis, San Francisco
London, Singapore, Sydney, Tokyo, Toronto

To my wife Jean

Originally published under the title *Monastery and Cathedral in France,* Wesleyan University Press.

First ICON edition published 1972

Grateful acknowledgment is made to the following for permission to reprint passages from works under their control:

To the Bollingen Foundation for permission to quote from *The Gothic Cathedral: Origins of Gothic Architecture and the Medieval Concept of Order,* by Otto von Simson (Bollingen Series XLVIII; Pantheon Books, 1956). Copyright © 1956 by the Bollingen Foundation.

To Houghton Mifflin Company for permission to quote from *Europe in Transition,* by Wallace K. Ferguson. Copyright © 1962 by Wallace K. Ferguson.

To The Regents of the University of Wisconsin for permission to quote from *Twelfth-Century Europe and the Foundations of Modern Society,* edited by Marshall Clagett, Gaines Post, and Robert Reynolds (University of Wisconsin Press, 1961).

To the University of Chicago Press for permission to quote from *Monuments of Romanesque Art,* by H. Swarzenski (University of Chicago Press, 1954).

STANDARD BOOK NUMBER: 06-430022-6

93 94 95 30 29 28 27 26 25 24 23 22 21 20 19 18 17

Contents

v

Illustrations

Aʟʟ ᴘʜᴏᴛᴏɢʀᴀᴘʜs are by the author unless otherwise indicated. The author wishes to thank the following for permission to reproduce photographs: Professor Robert Branner; Professor Kenneth J. Conant; Professor Sumner McK. Crosby; Brooks W. Stoddard; Professor Clarence Ward; The Walters Art Gallery, Baltimore; The Museum of Fine Arts, Boston; The Cleveland Museum of Art; The Metropolitan Museum of Art; The Pierpont Morgan Library; Bibliothèque Nationale, Paris; National Gallery of Art, Washington; Sterling and Francine Clark Art Institute, Williamstown; Alinari, Florence; Archives Photographiques, Paris; Foto-Marburg; Photographie Giraudon, Paris. The majority of the photographs taken by the author and his son are available in colored slides at Sandak Incorporated, New York.

Preface

THIS book deals with five centuries of French
art, from the eleventh to the sixteenth century.
After the year 1000 in France, or more precisely
in the area which is modern France, a new style
of architecture, sculpture, and painting, called
Romanesque, came into being. Romanesque art
was derived in part from the arts of the Carolin-
gian and Ottonian Empires with their amalgam
of Roman, Early Christian, and northern barbar-
ian forms in a new synthesis with influences from
the Mediterranean, Roman, and Byzantine tradi-
tions. The Romanesque style underwent many
transformations as it spread across Western Eu-
rope. In the twelfth century in the Île-de-France
around Paris, a new Gothic style replaced Ro-
manesque, and the great cathedral age was born.
By the late 1190's and early decades of the thir-
teenth century, the experimental and probing
styles of Early Gothic were resolved in the con-
struction of Chartres and Bourges Cathedrals.
These High Gothic cathedrals served in turn as
models for Soissons, Reims, Amiens, and Beau-
vais. Again, this French creation became inter-
national in its influence. From the 1240's to the
early sixteenth century, the dynamic evolution of
artistic forms reveals no diminution of the urge
to refine and change.

The intention of this book is to treat the art
of Medieval France as a totality. This approach
attempts a unified discussion of architecture,
sculpture, mural painting and stained glass win-
dows, manuscripts, and liturgical objects within
the changing historical ambient. Architecture is
clearly the dominant art of Medieval France;
sculpture and painting function monumentally
and iconographically within the architectural con-
text. Many historical studies concentrate singly
on architecture or sculpture or stained glass, or
inclusively on Romanesque art or Gothic art in
Medieval Europe as a whole. Some but by no
means all of the great monasteries and cathedrals
have been studied in detailed monographs. This
book confines itself to Medieval France and at-
tempts to view all the arts as dynamically inter-
related. The text is written not from a point of
view first determined by theory and then illus-
trated by example, but from one derived from
the illustrations of major French monuments
themselves. No monument is analyzed which is
not illustrated in detail.

Part I discusses Romanesque France (c. 1000–
c. 1140), the monastic site, the monastic plan, the
church, its sculpture, mural painting, and the
evolution and variety of architectural and sculp-
tural forms. No attempt is made to delineate all
the regional Romanesque styles. Rather, key
monuments in all the arts are stressed, and the
homogeneity of Romanesque is emphasized by
comparisons of selected sculpture, murals, manu-
scripts, and enamels.

Part II contains an analysis of Early Gothic
monuments in the Île-de-France set within the
changing historical context. Individual chapters
are devoted to the Abbey of Saint-Denis and the
cathedrals of Sens, Noyon, Laon, and Paris, as
well as to Early Gothic portals and stained glass
windows. An attempt is made to explain why
a new style replaced Romanesque initially in a
small area around Paris.

Part III includes chapters on the great High

Gothic cathedrals (Chartres, Bourges, Soissons, Reims, Amiens, and Beauvais), with reference to lesser monuments in the interest of illustrating the development of the spacial, structural, sculptural, and pictorial vocabularies of this period. Smaller statues (reliquaries of goldsmith work or statuettes) are compared with monumental sculptures. A comparative study of a series of Madonnas, from Romanesque to Late Gothic times, concludes this section.

Part IV treats the late Middle Ages in all the arts: religious and domestic architecture, sculpture, stained glass, and tapestry. A special chapter is devoted to manuscripts in order to recapitulate the dramatic evolution of Medieval art from the Carolingian renaissance to the Renaissance.

Part V concentrates on the art of the church treasuries to point up the homogeneity of Medieval art at any given time in history and to review the evolution of that art in its entirety. Whenever possible, Medieval objects in museums and libraries in the United States are included to underline the extraordinary richness of American collections.

The majority of the 433 photographs of interiors, exteriors, details, portals, and stained glass used for illustrations I took expressly for this book. Many were made in 1955 on an Advanced Research Fulbright, studying Provençal Romanesque sculpture; others were photographed in colored negative in 1961–1962. For the careful enlargement of the first group I am indebted to Ernest LeClair, and to Victor H. and Harold J. Sandak for the second group. My son, Brooks W. Stoddard, of the Bowdoin College Art Department, took several of the photographs used in this book. John Churchill, Williams College 1966, very kindly located several photographs for me in Paris. Sumner McK. Crosby of Yale University loaned me an engraving of the façade of Saint-Denis, his reconstruction of the exterior, and his plan of Saint-Denis. Robert Branner of Columbia University allowed me to publish two of his photographs and one reconstruction of the choir of Beauvais.

Plans and sections of monuments, from publications, were photographed by Ernest LeClair, and drawn freehand by my colleague, H. Lee Hirsche. The only exceptions to this procedure are the plans, reconstructions, and sections of Cluny III, which were made by Kenneth J. Conant, who graciously allowed me to publish them. In all instances, an effort was made to have the plans and sections represent the building as originally designed and constructed and to remove the additions and restorations of subsequent centuries.

I wish to express my appreciation for the help and advice of the following members of the staffs of museums and libraries in the United States and France: Richard H. Randall Jr., Dorothy E. Miner, and Theodore L. Low of The Walters Art Gallery, Baltimore; Hanns Swarzenski of The Boston Museum of Fine Arts; James R. Johnson and William O. Wixom of the Cleveland Museum of Art; John Plummer of the Pierpont Morgan Library, New York; the late James J. Rorimer, Director, and William H. Forsyth of The Metropolitan Museum of Art, New York; Margaret B. Freeman and Thomas P. F. Hoving, formerly Associate Directors of The Cloisters Collection, The Metropolitan Museum of Art; Francis Salet, Director of the Musée de Cluny in Paris; and Jean Porcher of the Bibliothèque Nationale in Paris.

Scholars and teachers who stimulated my interest in Medieval art when I was a student and later teacher are Karl E. Weston, Wilhelm H. Koehler, C. Frederick Deknatel, and S. Lane Faison Jr. I also wish to thank three historians whose courses on Medieval history at Williams College I have attended and with whom I have collaborated: Donald Rohr, Professor at Brown University; and Dudley W. R. Bahlman and Francis C. Oakley, both of Williams College. Finally, I wish to thank the Williams College students who read the galleys of this book in the spring of 1966 and made helpful suggestions and corrections. Brooks W. Stoddard also discovered mistakes in the manuscript and omissions in the bibliography.

In spite of the help from all these sources, I must take the blame for all errors and omissions.

I wish to express my gratitude to the President and Trustees of Williams College for grants from the 1900 Fund which helped defray photographic costs and travel in the United States. During various stages in preparation of this book several individuals contributed much time and patience. Kay Hall deciphered tapes and confusing copy and typed the manuscript. Mary Richmond advised me about the format of the index. Most important, my colleague Don Gifford helped me immeasurably in the final preparation of the text. Finally, I owe a particular debt to my wife Jean, assistant photographer, cataloguer, and critic, for her sustaining patience and understanding. To her I dedicate this book.

W. S. S.

Williamstown, Massachusetts
June 1966

PART I

Romanesque France

Historical Background

THE ENTHUSIASM for Romanesque art shared by contemporary architects, historians, and sensitive travelers is a relatively recent phenomenon. In 1818, the archaeologist de Gerville, describing Norman buildings, wrote of an "opus romanum dénaturé ou successivement dégradé par nos rudes ancêtres." This characterization of Norman structures as the crude derivations of Roman art is understandable in the context of the Neo-Classic movement. As the eighteenth century deridingly labeled the seventeenth century as the "Baroque" and the Renaissance dismissed "Gothic" as the malformations of the barbarian Goths, the early nineteenth-century critics saw only negative connections between Norman and Roman. De Gerville's observations, however, led eventually to the use of the word "Romanesque" to designate Medieval art between the decline of the Carolingian empire in the ninth and tenth centuries and the beginnings of the Gothic period in the middle of the twelfth century.

Archaeological disclosures and scholarly research in the eighteenth and nineteenth centuries resulted in the discovery and definition of many architectural styles. These new perspectives in terms of which the past was re-evaluated and re-organized coincided with the nineteenth-century assumption that the architectural forms of the past were ideals which could be imitated, but scarcely improved. Architectural practice in the nineteenth century thus became eclectic and decorative; architects treated the past as an enormous architectural copybook from which forms could be plucked at random. But some few architects, in particular Henry Hobson Richardson, reinter-

preted creatively the power and vigor of the monuments of the past. Richardson's buildings in Boston, Chicago, and Pittsburgh, constructed in the 1870's and 1880's, give ample evidence of his extraordinarily sensitive transformation of Romanesque structures within the limitations of the broad revivalist movement. Richardson designed Henry Adams' house in Washington and in the process converted Adams to an interest in French Romanesque.

Henry Adams' famous book *Mont-Saint-Michel and Chartres,* privately printed in 1904, published in 1913, has served as the key to the understanding and appreciation of Romanesque art in the twentieth century. His penetrating descriptions of the militant, mural strength of the fortified island and its monastery gave new meaning to hundreds of structures which dot the western European landscape. By the marked contrast of the rugged Mount, the Archangel's fortress, and the soaring verticality of the Cathedral of Chartres — the Virgin's palace on earth — Henry Adams established a clear distinction between Romanesque and Gothic architecture and between the historical eras out of which these two periods of the Middle Ages grew.

Currently, the Romanesque is comprehended as a unique period of history — a period not "dark," but possessing tremendous vitality. Modern architects react to the mural massiveness, the spatial conquests of barrel and groin vaults, and the excitement of the bold massing; and their reactions are related in turn to new achievements in reinforced concrete. Modern painters and sculptors are excited by the discovery of the visual

sensitivity inherent in the interlacing forms of Romanesque sculpture and murals. Somewhat belatedly, historians are joining art historians in setting off the Romanesque as an historical period distinct from the confused century following the collapse of the Carolingian empire and at the same time distinct from the Early Gothic period of the twelfth century.

To place Romanesque art in its proper historical ambient, it is necessary to explore briefly some of the forces and factors of the early Middle Ages. In the broadest terms, the Middle Ages was a fusion, in varying degrees of importance, of three phenomena: (1) the persistence of the notion of empire, looking back to the golden past of ancient Rome; (2) Christianity and the Universal Church, with all mankind unified under one God; (3) the barbarians, with their Germanic codes and lack of political unity. All through the Middle Ages these three phenomena were in some kind of conflict. The revived Roman way of life, with its secular, worldly emphasis, was opposed by the spiritual otherworldliness of the Universal Church, while the successive waves of barbarian invasions forced marked changes in the political structure of society as Germanic institutions were grafted upon the Roman way of life.

During the second and third centuries, the Roman empire had suffered from civil wars, economic decay, and pressure from the barbarians on its northern borders along the Danube. With the Edict of Milan in 313, the Emperor Constantine set the stage for the final acceptance of Christianity as the sole religion of the empire in the late fourth century. At the same time, the Visigoths, reaching the interior frontiers, defeated the Romans at Adrianople in 378, continued into Italy and sacked Rome in 410, and finally occupied much of southwestern France and Spain. In the early fifth century, the Vandals migrated across northern Gaul, through Spain, and into North Africa. They captured Carthage in 439, became formidable pirates, ravaged many Mediterranean ports and islands, and sacked Rome in 455. The Huns, under Attila, invaded the west in 449. Repulsed by Romans and Visigoths at

Châlons-sur-Marne, the Huns overran most of northern Italy. Pope Leo I advanced to meet the oncoming Huns and was successful in his pleas to spare Rome (452). From 476 until 800 there was no Roman emperor in the west, while at Constantinople the Byzantine emperors carried on much of the spirit of the late Roman empire.

In the west, the Merovingian Frankish kingdom was formed by Clovis, who came to power in 481. At his death in 511, the Merovingians loosely controlled all Gaul and much of the area along the Rhine. Clovis and the Merovingians were converted to Christianity in the late fifth century by Irish and Anglo-Irish monks. As champion of the church, Clovis set the pattern of close ties between church and state, which was to continue through the Middle Ages. Clovis left his kingdom to his sons, who expanded it; yet subsequent quarrels between the different rulers resulted in its disintegration in the late sixth century.

The rise of Islam under Mahomet (c. 570–632) and its subsequent expansion to the Near East and across North Africa hindered travel and commerce by sea between west and east, though it did not stop them. In 711 Visigothic Spain was invaded by the Moslems (Saracens or Moors), and their penetration into France was stopped by Charles Martel in 732 or 733 at the Battle of Tours (Poitiers). The partial control of the shores of the Mediterranean by the Saracens lasted until the eleventh century, when the Normans conquered them in Sicily and South Italy. This Norman victory freed the Mediterranean for commerce and made possible an intensification of contacts between Europe and the Near East and Orient. The great contribution of the Moslems to Western culture was the preservation of the writings of Greek philosophers and scientists. The translations of these manuscripts into Latin and their availability to Western scholars profoundly influenced the Scholastics and theologians of the twelfth and thirteenth centuries.

The anarchy of western Europe in the eighth century was brought to an end by Charlemagne, the grandson of Charles Martel. After assuming power in 768, Charlemagne and his Frankish

army defeated the Lombards in the 770's, attacked the Moors in Spain in the late 770's, extended Carolingian control into Bavaria, and subdued and converted by force the Saxons in 803. In 800 he had himself crowned emperor by the pope. In his dual role as major champion and self-proclaimed head of the Christian church and as Emperor of the West, Charlemagne united church and state. In his capital in Aachen, he constructed an elaborate palace and chapel and attempted to revive Roman law and learning. This Carolingian "renaissance" involved the importation of scholars such as Alcuin of York and the establishment of a curriculum in the palace school which included the trivium (grammar, rhetoric, and dialectic) and the quadrivium (arithmetic, geometry, astronomy, and music). In spite of this conscious attempt to revive the glories of ancient Rome, Charlemagne's system of government followed Germanic traditions. He succeeded, however, in giving Europe a breathing space from invasion and at the same time established a new axis between the north and the Mediterranean world.

Charlemagne's empire gradually disintegrated following his death in 814. The early Medieval practice of dividing land equally among heirs had splintered his domain into three sections by 843, and six by the 880's. The final death blow to the empire was administered by new waves of plundering barbarians from northwest and northeast. First, the Vikings, or Norsemen (Normans), ravished western Europe. From the 840's on, France felt the fury of their devastating raids. Bands of Normans sacked towns and monasteries in land attacks or in amphibious operations up the Loire and other rivers. By 911, Rollo, the Norman, was granted Normandy as a fief and was baptized the following year. Thus, the ever-present threat from the sea was lessened and the tremendous energies of the Normans were localized in Normandy, only to break loose again with William the Conqueror's invasion of England in 1066.

The Magyars, or Hungarians, were the second new barbaric horde to descend on western Europe. Sporadic raids occurred in the 880's, inflicting much damage on monastic establishments in Burgundy. The German Kingdom under Henry the Fowler and Otto the Great turned back two large Hungarian armies in 934 and 955. After these two defeats, the Magyars remained in Hungary and were gradually converted to Christianity.

By the Romanesque period, the three-pronged attack of Normans, Magyars, and Saracens had been contained, and there followed a period of extraordinary building activity. The Burgundian monk Raoul Glaber wrote: "About three years after the year 1000, the earth was covered with a white robe of churches." What are the factors which help explain this building activity, extending from the late tenth to the mid-twelfth century? Certainly the relative political stability following the cessation of the barbarian raids must have been a contributing factor. Further, it has been argued that the fact that the world did not end in the year 1000 with the appearance of the Anti-Christ and the Final Day of Judgement unleashed an optimistic energy that manifested itself in the arts. There is no documentation directly before and after the year 1000 to substantiate this theory. Writings of the third quarter of the tenth century reveal a concern for the approaching end of the world; yet the calendar was so varied that no consensus existed concerning when the year 1000 would arrive. Famines in 1033 caused some to argue that the end of the world was 1000 years after the Passion of Christ. More important than speculation about the year 1000 are other factors: feudalism, the manorial system, the rise of the Capetians, the commercial revival, monasticism and the emergence of the monks as patrons, and the reformed papacy. All these, taken together, help explain the flowering of Romanesque art.

A new social system was needed to bring inner stability to Medieval life. Feudalism, in spite of its negative connotations, arose as a remarkably ingenious system to regularize authority. Following the natural order, or God's order, a gigantic, hierarchical pyramid was evolved which spread downward from king to tenants-in-chief to subtenants and finally to the knight's fief. This proc-

ess of subinfeudation resulted in a relatively ordered society. With the granting of a fief, the knight took an oath of fealty and homage, but gained legal and monetary rights. In spite of the complexities of this interlocking, pyramidal system, the king was able to function as a feudal overlord. Since bishops and abbots often held positions of tenants and subtenants, the church became deeply involved in the feudal contract and often served as arbiter in times of conflict.

In the absence of effective central government, the feudal system provided the means of collecting an army and defending an area. As Lynn White states in his book *Medieval Technology and Social Change:* "While semi-feudal relationships and institutions had long been scattered thickly over the civilized world, it was the Franks alone — presumably led by Charles Martel's genius — who fully grasped the possibilities inherent in the stirrup and created in terms of it a new type of warfare supported by a novel structure of society which we call feudalism." Further, White writes: "The Man on Horseback, as we have known him during the past millennium, was made possible by the stirrup, which joined man and steed into a fighting organism. Antiquity imagined the Centaur; the early Middle Ages made him the master of Europe."

Only about 5 per cent of the population was involved in the feudal hierarchy. The rest of the people were tied to the land and to agriculture as part of the manorial system. The origins of the manor go back either to Germanic traditions of tribal meetings in small villages, to transformed Roman estates, or to some combination of the two. The manorial system solved problems of the soil and improved nutrition by evolving the open field and the three-field, crop-rotating technique. The practice of New England towns in the seventeenth century resembled this co-operative use of equipment and communal use of land. The Medieval villages were tied to feudalism through acceptance of protection from the lord in times of strife. Either the serfs were attached to the land, or they emerged as free tenants. The manor became a self-contained economic unit, but was also

closely associated with the revival of trade and commerce.

The barbarian waves slowed down commerce, which had continued through the declining years of the Roman empire. With the relative stability of feudalism, markets were needed for surpluses created by technological change. The substitution of the share plow for the scratch plow brought heavy or wet soil under cultivation. This technological development, combined with the use of horseshoes and the invention of the shoulder harness, witnessed the replacement of oxen by horses during the twelfth century. A more balanced diet and food surpluses brought about a population increase, which in turn caused the rise of towns with a merchant class to buy and sell goods. Towns became both economic centers and places for defense. Within their walls, the serf could gain freedom. Many towns surmounted foundations of Roman camps, while others grew around the manor or monastery. These stable, growing town populations, together with the new prosperity, obviously affected the tempo of secular and religious building.

The process of the gradual transformation of feudal monarchies into national states was not completed until after the Middle Ages. The localized administrations of the barons and the perambulating court of the king mitigated against the development of a centralized royal bureaucracy in France. Armies raised by feudal levy sometimes opposed the mercenaries maintained by the king. Irregular payments from vassals and income from royal land existed side by side with the beginnings of a national treasury derived from direct taxation. Justice was divided among baronial, church, and royal courts. The papacy and kings fought for the control of the church.

In France, the king remained a feudal overlord, higher than the barons, but not an idealized or deified national figure until Saint Louis' reign in the thirteenth century. The Capetian line was founded by Hugh Capet, a great feudal duke who was elected and crowned in 987. As King of France, he was overlord of the small Île-de-France around Paris, of areas around Orléans and

Senlis, and of a small coastal strip. The rest of present-day France was divided into great independent duchies such as Normandy, Brittany, Maine, Poitou, Anjou, and Champagne. Some of the dukedoms owed vague allegiance to Hugh Capet, while Hugh owed his crown to those nobles who had elected him.

[Hugh Capet inaugurated the policy of electing and crowning his eldest son during his own lifetime. After his death, the formal election of his son as heir to the throne and anointment with holy oil took place.] This procedure, plus the ability of the Capetians to produce male heirs, resulted in the increase of the moral prestige of the monarchy, and uninterrupted Capetian rule lasted 327 years.

LOUIS VI (the Fat, 1108–1137) enlarged the royal domain by strategic marriages and by playing one vassal against another. Aligning the monarchy with the church, Louis controlled monasteries and church lands inside many of his vassals' territories. Rich farm lands astride the Seine and Loire rivers, plus the increasing prosperity of the towns, played into Louis' hands as the dukedom of the monarchy expanded its boundaries. In spite of the increasing size of the royal domain, the strength and relative independence of the Counts of Toulouse, Aquitaine, Auvergne, and other duchies gave the majority of Romanesque monuments and works of art a local, regional flavor.

There were in the course of the Romanesque period a reform and a revival of monasticism, and the greatest Romanesque builders were the abbots and priors of the great monasteries. Aided by large donations from the royalty, monasteries covered the land, literally a "white blanket." Since 540, when Saint Benedict wrote the Rules at Monte Cassino, monks had transported the Christian story to the corners of the world. Monasticism involved the uncompromising negation of the world; yet the negation was directed toward transforming the world spiritually, theologically, and artistically. The absolute acceptance of poverty, chastity, and obedience and the drive toward spiritual perfection resulted in the struggle of

spirit over flesh, reason over senses, and the supernatural over the natural. [The monasteries became the active vanguard of the church and educated within their walls many great abbots, bishops, theologians, and nobles. Monasteries evolved as centers of conversion and of learning.] During the Carolingian period, learning appeared in the court of Charlemagne at Aachen. Heretofore, knowledge of the past had been confined to the monastic communities. In spite of the short-lived nature of the Carolingian renaissance, it established a pattern of frequent reinterpretations of the classical past which occurred at many stages in the Middle Ages.

Monasticism declined drastically during the barbarian invasion of the ninth and tenth centuries. The papacy under the thumb of the Franks became corrupt, and monastic discipline broke down. The early tenth century marked the low ebb of Medieval learning — a truly Dark Age. The Cluniac reform reversed the deterioration of monasticism and set the stage for the founding of a vast empire of priories dependent on the Mother Abbey at Cluny. In 910, Berno, the Abbot of Baume, was approached by William, Duke of Aquitaine, who found himself without heirs and felt remorseful for having killed a man. William gave Berno land at Cluny, in Burgundy, for the establishment of a new monastery and further guaranteed to let Berno govern it free from outside interference. In the charter, which he signed at Bourges on September 11, 910, he stated:

> To those who consider things sanely it is evident that Divine Providence counsels the rich to use well those goods that they possess in transitory fashion, if they wish for eternal recompense. . . . Wherefore I, William, by the grace of God count and duke, having pondered these things and wishing while there is yet time to make provision for my salvation, have found it right, yea necessary, to dispose for the good of my soul of some of the temporal possessions which have been bestowed upon me. . . . That this benefaction may endure not only for time, but may last for ever, I will provide at my expense for men living together under monastic vows, with this faith and hope that if I cannot myself despise all the things of

this world, at least by sustaining those who despise the world, those whom I believe to be righteous in the eyes of God, I may myself receive the reward of the righteous.)

To all those who live in the unity of faith and who implore the mercy of Christ, to all those who shall succeed them and shall be living so long as the world endures, I make known that for the love of God and of our Saviour Christ Jesus I give and deliver to the Apostles Peter and Paul the village of Cluny, on the River Grosne,...

I give on condition that a Regular Monastery be established at Cluny in honour of the apostles Peter and Paul; that monks shall form a congregation there living under the rule of Saint Benedict; that they shall forever possess, hold and order the property given in such wise that this honourable house shall be unceasingly full of vows and prayers, that men shall seek there with a lively desire and an inner fervour the sweetness of converse with Heaven, and that prayers and supplications shall be addressed thence without ceasing to God, both for me and for those persons commemorated above. (See Joan Evans, *Monastic Life at Cluny*, pp. 4–5.)

With a few monks, Berno built a small structure and dedicated it to the strict interpretation of the rules of Saint Benedict. By 955, a whole new monastic complex was begun to serve some two-hundred monks and clerics. As Cluny expanded, so did the hundreds of dependencies which came under the jurisdiction of the Abbot of Cluny. By the 1080's the second church at Cluny was too small, and the enormous Cluny III was begun. A monastic empire was established for some two-thousand dependencies and with power which vied with the authority of the pope. The Cluniac Order became one of the main forces behind the quantity and quality of Romanesque art of the eleventh and early twelfth centuries.

As the Order of Cluny grew, the stage was set for the reform of the papacy. During most of the tenth and eleventh centuries, the papacy had been dominated by the German emperors, the Ottonians, to the extent that the emperors had been able to appoint popes, when they chose to exercise that power. In 1059 a papal decree stated that the popes would henceforth be elected by the cardinals. Pope Gregory VII, during his reign (1073–1085), reformed the church from within. He opposed simony, forbade the clergy to marry or to keep mistresses, and attempted to discourage kings from appointing bishops and archbishops. Gregory's fight with Henry IV of Germany resulted in the latter's capture of Rome in 1084 and Gregory's exile. Gregory's ideas, however, lived on in the French pope, Urban II (1088–1099). In 1092 Urban entered Rome and drove out the Anti-Pope, but he was still at odds with the kings of Germany, France, and England. It was largely to divert attention from this chaotic state of affairs that he urged the launching of the First Crusade. The Gregorian Reform, plus the rise of the Order of Cluny, tended to free the church from lay authority. The state in all its facets continued to be the great patron of the church; yet papal independence from the whims of kings and dukes meant an extraordinary increase in the power of the church. The implications of these changes are manifested in the artistic achievements of both the Romanesque and Gothic periods.

The fragmented political character of western Europe in the Romanesque period is reflected in the regionalism of architecture, sculpture, and painting. Two phenomena — the Crusades and the annual pilgrimage from all over western Europe to Santiago de Compostela — tended sporadically to break down this localism. By the 1070's the Turks had overrun the Holy Land and the eastern sections of the Byzantine empire. The Byzantine emperor appealed for help from the west in 1095. Pope Urban called a large convocation of the clergy at Vézelay, in Burgundy. The actual meeting took place at Clermont-Ferrand, in the Auvergne, in November 1095, and the First Crusade was launched. The pope's motives were threefold: to wrest the Holy Land from the infidel, to draw attention away from quarrels with French and German rulers, and to place the papacy at the head of a popular movement. Religious idealism and emotional enthusiasm captured the imagination of clergy and laity alike.

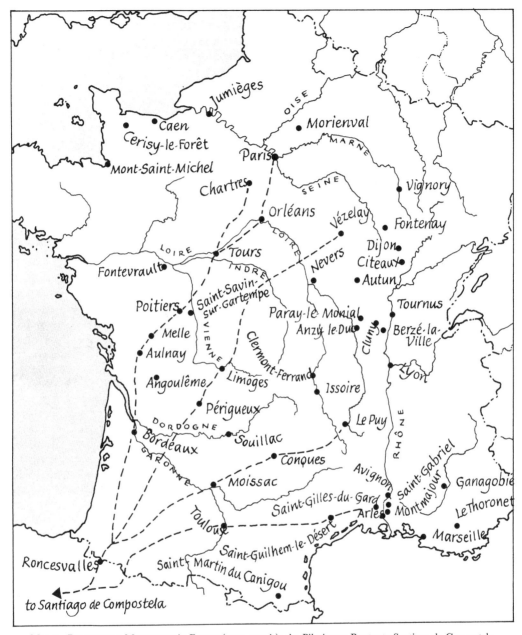

Map 1. Romanesque Monuments in France (1000–1130's); the Pilgrimage Routes to Santiago de Compostela

Waves of soldiers crossed Europe to attack the Turks. Each individual gained full indulgence from sins by embarking on the crusade, and at the same time he could seize property and bring home booty. Unfortunately, Pope Urban died in 1099, just before the capture of Jerusalem. The ill-fated Second Crusade of 1147–1149 will be discussed later.

The impact of the Crusades was manifold. The crusaders, as individuals, were fascinated by the wealth of the Near East and at the same time were dedicated spiritually and physically to the task of rescuing the holy places from Turkish hands. Trade with eastern Mediterranean ports increased markedly. Near Eastern objects, especially textiles, supplied motifs for sculptors and illuminators. Finally, the interlude of isolation which had followed the defense of western Europe against the barbaric invasions was broken.

A second popular and more influential pilgrimage was the journey to the grave of the Apostle Saint James Major in northwestern Spain. In his youth, Saint James had preached in that country. Later he became Bishop of Jerusalem. In 44 A.D. he was decapitated by order of Herod. According to legend his body, accompanied by two disciples, came by boat without sails to the coast of northwestern Spain, and there he was buried. Charlemagne attempted the first pilgrimage in the late 770's. According to the Callistine Codex, reportedly written by Pope Callixtus but actually assembled in the twelfth century by a Cluniac monk from Poitiers, Saint James appeared to Charlemagne and said: "You who have freed all other lands, why have you not freed my land and my route?" Charlemagne's campaign against the Moors was unsuccessful, and his chief lieutenant, Roland, was killed at the battle of Roncevaux while fighting a rear-guard action in the Pyrenees. The allegedly heroic superdeeds of Roland became the subject and the model of much Medieval literature. Henry Adams saw in the *Chansons de Roland* a literary experience akin to the architectural experience of Mont-Saint-Michel.

The Callistine Codex describes the miraculous discovery of the apostle's grave in northwestern Spain and the miracles performed at the sacred site. Further, the Codex became a guidebook for the thousands of pilgrims who walked from the corners of western Europe to Santiago, much as the modern pilgrim drives to Lourdes or Chartres. This contemporary guidebook was promulgated by the Cluniac Order to promote the pilgrimage. Since the church of Santiago de Compostela was under the control of Cluny, and since Alfonso, King of Aragon, was one of the largest contributors to the construction of Santiago, begun in 1078, and the great abbey of Cluny III, begun in 1088, both the king and the Order of Cluny profited by the pilgrimage. The Codex lists the monasteries where pilgrims could worship, eat, and sleep, including notes on sacred relics, the kinds of wine and food, and the characteristics of the people.

Finally, the Codex describes in detail the four major routes to Santiago, as well as some of the alternate or secondary routes: (1) Paris to Santiago via Tours and Bordeaux; (2) Vézelay to Santiago via Limoges, Moissac, and Toulouse; (3) Le Puy to Santiago via Conques and Toulouse; and (4) Arles and Saint-Gilles in Provence to Santiago via Saint-Guilhem-le-Désert and Toulouse. Pilgrims gathered at these jumping-off places and then, in groups or alone, walked to the grave of Saint James Major. Crucifixes were placed in prominent sites along the routes. The many monasteries, spaced about every twenty miles, served as inns. The prosperity of abbeys and priories grew as more and more pilgrims stopped to venerate the relics housed therein. The whole character of the pilgrimages to Santiago manifests the religious fervor of Romanesque times. Each individual believed that he should make this pilgrimage at least once during his lifetime. Indeed, in the eleventh and twelfth centuries, the trip on foot to Spain was more important than the journey to Rome. The exchange of ideas and visual impressions growing out of the pilgrimages was of paramount importance for Romanesque architecture and sculpture. This travel experience alleviated what has been overemphasized as the provincial insularities of the period.

The similarity of the "pilgrimage group" of churches — Santiago de Compostela, Saint-Martin at Tours, Saint-Martial at Limoges, Sainte-Foy at Conques, and Saint-Sernin at Toulouse, located in Spain and southwestern, western, and the center of southern France — bears witness to a homogeneity in point of view directly attributable to the exchange of architectural ideas that resulted from the pilgrimage. Sculptors and painters traveled and worked in monasteries along the route. It is therefore not surprising to find connections in style between sculpture at Santiago, Toulouse, and Conques or to discover the influence of Spanish forms, especially textiles, on the sculpture of western France. Yet, in spite of the international nature of this pilgrimage, Romanesque art tended to preserve its local, regional character.

The end of the barbarian attacks, the relative stability of feudalism, the rise of the Capetian line, the revival of trade and growth of towns, the excitement of the Crusades, and the religious fervor of the pilgrimage to the grave of Saint James — all contributed to the formation and development of Romanesque art, the first truly European style. In the next two-hundred years, from the late tenth and early eleventh centuries to the early years of the thirteenth century, an incredible pace of artistic innovation is manifested in Romanesque, Early Gothic, and High Gothic art. This study, limited to the art within the confines of present-day France, will concern itself in Part I with major monuments of French Romanesque.

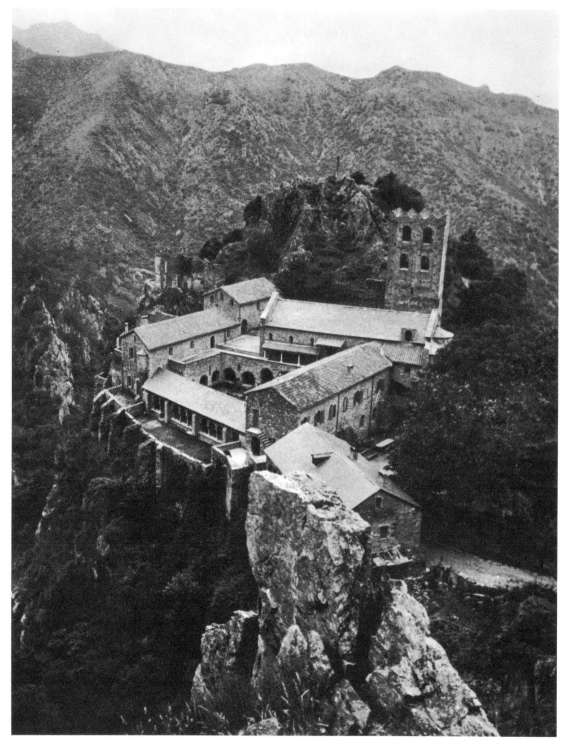

Fig. 1. Saint-Martin-du-Canigou, 1001–1026. From the south

The Monastic Site

Monastic sites were selected for their isolated character. Private prayer and corporate worship seemed to demand physical withdrawal from secular life. The quest for the salvation of souls and the search beyond the human for the divine presence seemed to transpire best in a self-contained and self-sustained community. Yet the nature of the Romanesque site varied according to the historical circumstance surrounding its construction and according to the geography, climate, and topography of the land. The variety of sites reflects the extraordinary vitality of Romanesque times.

The Abbey of Saint-Martin-du-Canigou (fig. 1) is dramatically situated on a jagged spur of the range of mountains called Canigou on the French side of the Pyrenees above Prades. The approach is a forty-minute climb on foot; in the course of this climb one is first confronted with the massive tower attached to the northeast corner of the church. A further tortuous walk reveals the entire monastic complex nestled into the live rock and, at the same time, extending out over the gorge on a terrace supported by man-made buttresses. The dramatic mountainscape forms a magnificent frame for the irregularly placed buildings.

In spite of damage from an earthquake in 1428 and extensive restoration in the early nineteenth century following its abandonment after the French Revolution, Saint-Martin-du-Canigou still epitomizes the ingenuity of Romanesque builders. The shape of the site necessitated the trapezoidal arrangement of the cloister, while lack of room to the south resulted in an unusual placement of structures opening off the cloister. One cannot help but wonder at the logistic problems involved in the procurement of materials and in construction on such a remote and uneven site.

Saint-Martin-du-Canigou (fig. 1) was built between 1001 and 1026 in two campaigns. Guilfred, Count of Cerdagne, wishing to atone for his worldly sins, subsidized both campaigns by a series of donations. A monk named Sclua supervised the construction. In 1009 Oliba, Bishop of Elne and Guilfred's brother, consecrated the abbey in honor of Saint Martin (upper church), the Virgin Mary (crypt or lower church), and the Archangel Saint Michael. Two years later the pope delimited the role played by the donor and insisted that abbots be freely elected according to the Benedictine Rule; and in 1014 the monk Sclua was elected as Saint-Martin's first abbot. More gifts from the count, plus the arrival of the bones of Saint Gaudérique, stolen from the Duchy of Toulouse with the count's help, resulted in a new building campaign and a final consecration in 1026. Count Guilfred, fearful of approaching death, abandoned his second wife and seven children and entered the monastery in 1035. Fourteen years later he died and was buried in a tomb which he had carved with his own hands in the live rock of the mountain.

The church itself was constructed on two levels. The lower church, or crypt, had three squat barrel vaults covering the nave and two aisles in the western half and six groin vaults over the eastern section. The upper church (see fig. 66) consisted of three small, narrow barrel vaults supported by eight squat columns. The continuity of the spaces of the nave is, however,

Fig. 2. Saint-Guilhem-le-Désert, XIth, XIIth centuries. From the south

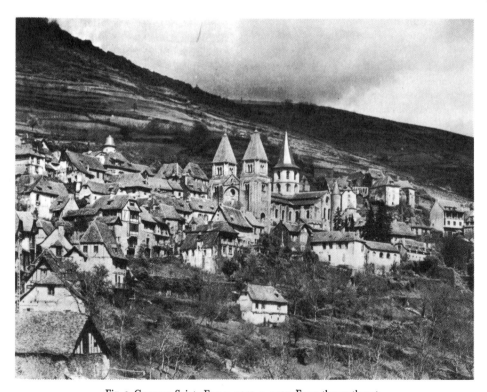

Fig. 3. Conques, Sainte-Foy, c. 1050–c. 1120. From the southwest

interrupted by the compound pier and the transverse arch which divides the upper church into two equal parts. The tentative and experimental nature of this early Romanesque church will be discussed in Chapter 5 (figs. 66, 71).

The monastery of Saint-Martin-du-Canigou was founded by Count Guilfred as a retreat for Benedictine monks and ultimately for himself. Its presence on the side of Mount Canigou manifests the personal struggle for salvation which characterized the early Middle Ages.

The history of Saint-Guilhem-le-Désert (fig. 2) goes back to Carolingian times. Guillaume, Count of Toulouse, Duke of Aquitaine, and master of the southern section of the Carolingian empire, was Charlemagne's lieutenant in the campaign against the Moors in Spain. His fame as a warrior was spread across Europe by the popular chansons de geste. In 804 he renounced his worldly life and became a hermit monk. Upon the advice of the Abbot of Maguelone, Guillaume constructed a small monastery named Gellone north of Montpellier in the barren gorge of Verdus on the left bank of the Hérault. In 806 Guillaume attended the meeting at Thionville during which Charlemagne established the succession of his sons. Charlemagne opposed Guillaume's wish to disavow his titles, but to no avail. Guillaume asked for and received a sacred relic of the True Cross.

The monastery grew rapidly after Guillaume's death in 812, largely as a result of the fame of this hero of the chansons de geste and the presence of the relic at Gellone. During the course of the eleventh century a new church was gradually constructed. The impressive nave (see fig. 69) is vaulted with a barrel, strengthened by transverse arches rising from each pier. Clerestory windows, directly under the springing of the vault, illuminate the interior. After dedication in 1076, an enlarged east end of the church and the first story of the cloister were both finished by about 1100 (see figs. 72, 76). Recent excavations in the existing choir have unearthed the crypt of the church, dedicated in 1076. The upper floor of the cloister was carved and put in place during the second half of the twelfth century. Large sections of this upper cloister, which had collapsed in ruins and been borrowed for service as a grape arbor elsewhere, are now beautifully reassembled in The Cloisters in New York City (a branch of The Metropolitan Museum of Art). The nave, cloister, and exterior of the chevet or east end of Saint-Guilhem-le-Désert will be discussed in Chapter 5 (see figs. 69, 71, 76).

The name of the monastery was changed from Gellone to Saint-Guilhem-le-Désert in the twelfth century. It became a recommended resting place on the southern pilgrimage route to Santiago de Compostela. Pilgrims stopped to venerate the famous relics and to recall the deeds of the renowned founder.

Gradually a town grew up around the monastic complex. Blocky houses piled up to the monastery, dominated by its square western tower. The entire silhouette of the present town and abbey is echoed by the craggy hills on each side of the valley (fig. 2). In contrast to Saint-Martin-du-Canigou, the horizontal areas of the site allowed the monastic plan to follow a regular pattern.

Sainte-Foy at Conques (fig. 3) is another famous monastery dramatically located in the middle of the Massif Central on the pilgrimage route to Santiago de Compostela between Le Puy and Moissac. The church of Conques and the remains of the cloister dominate the picturesque town. The pilgrim, as he turned off the winding road and climbed up the isolated valley, came to pray in front of the relics of Saint Foy, a girl martyred by order of Dacien in 303 at the age of twelve. After a rest in the guest house and prayers and services in the church, the pilgrim resumed his journey to Spain.

Conques is one of the three surviving monasteries of the "pilgrimage family" of churches which sprang up along the four major routes to Santiago. Saint-Martin at Tours and Saint-Martial at Limoges no longer exist, but the survivors, Conques, Saint-Sernin at Toulouse, and Santiago de Compostela still reveal marked similarities in their plans, in the shapes of their spaces, in the vaulting systems, and in the heights of nave vaults.

The first construction on the site at Conques was a simple oratory of the eighth century. In 819 the community became Benedictine, but the great impetus for expansion came with the arrival of relics of Saint Foy in 866 and in 883. A monk from Conques, after several years of plotting, stole the relics from the monastery of Agen and brought them triumphantly to Conques. Miracles occurred, and the pilgrimage to Conques and Santiago became more popular. These famous relics were housed inside a gold and jeweled statue of the late ninth and late tenth centuries, still in existence in the Treasury of Conques (see fig. 28).

The prosperity of the abbey in the eleventh century led to the construction of a new church, begun around the middle of the century and finished by 1130. Today, many of the monastic buildings have disappeared. Fragments of the cloister and the turret stairs which gave access between the church on high ground and the cloister at a lower level can be seen on the south side of the transept. Nineteenth-century alterations of the western façade have not spoiled the total impact of this monastic site buried in the middle of southern France.

The final two examples of monastic sites present a dramatic contrast of terrain and function (figs. 4, 5, 6). Mont-Saint-Michel, on the border of Normandy and Brittany, is a fortified monastery growing out of the live rock of an island surrounded by ocean and quicksand, while the Abbey of Mary Magdalene at Vézelay crowns a gentle hill in northern Burgundy. Mont-Saint-Michel played an important part in Norman and French history; Vézelay was the center of a pilgrimage as well as the jumping-off place for one of the four routes to Santiago de Compostela.

The history of Mont-Saint-Michel (figs. 4, 5) begins in the year 708 when the Bishop of Avranches was told in a vision to build a church in honor of the Archangel Michael on the mount, in what was then the forest of Scissy. The bishop constructed a crypt in the rock, and the following year a powerful tide ripped out the forest and converted the rock into an island. In 966, Duke Richard I of Normandy established thirty Benedictine monks on the mount after constructing a chapel. The great period of building took place in Romanesque times under the aegis of the Cluniac Order and following the marriage at Mont-Saint-Michel in 1017 of Richard II, Duke of Normandy, and Judith of Brittany. During the course of the eleventh century the top of the mount was leveled and crypts under the choir and transepts were constructed at the points where the church extended beyond the contour of the hill. By the end of the century, the Norman church in its entirety was completed; it can be seen in its eleventh-century form in a page from the *Très Riches Heures* of the Duke of Berry of about 1416 (fig. 4). This page was illuminated before the collapse of the Norman choir in 1421 and its subsequent reconstruction in the fifteenth century.

The manuscript page (fig. 4) shows the Mount completely surrounded by water. Fortified walls, gates, and towers rise directly from the edge of the ocean, while houses are clustered along the street which winds up to the abbey. Today a wide causeway connects town and mainland, and the façade of paired towers and part of the nave have disappeared. Although the illumination dates from the early fifteenth century, it reveals the church as it existed at the end of the eleventh century with Saint Michael and the dragon floating above it. The enormously thick retaining walls and buttresses and the dynamic Norman massing are clearly visible in the miniaturist's vantage point from the south.

In Gothic times (1203) the abbey became involved in the war between France and Normandy and England. The Mount sided with the Normans and was besieged by the Breton, Guy de Thouars. The Mount resisted the attack, but the village was burned, and fire damaged the outlying monastic buildings. Philip Augustus, King of France, won the abbey over to the French side by paying for the destruction wrought by his ally. This reimbursement and the continued support of the French monarchy brought about the construction of new monastic buildings. The Merveille (fig. 5) was erected in three stories along the

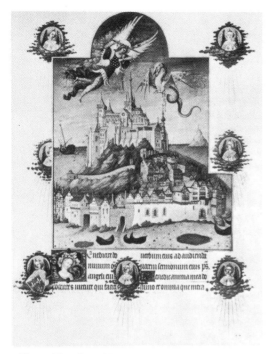

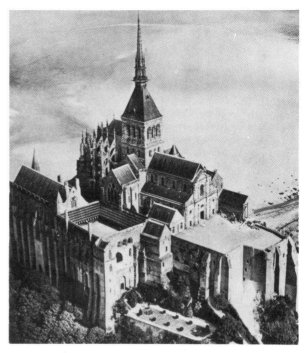

Fig. 4. Mont-Saint-Michel (XIth, XIIIth centuries) in 1416. *Les Très Riches Heures du Duc de Berry,* fol. 195v (Chantilly, Musée Condé)

Fig. 5. Mont-Saint-Michel. Air view from the northwest

Fig. 6. Vézelay, La Madeleine, 1120–1136. From the southwest

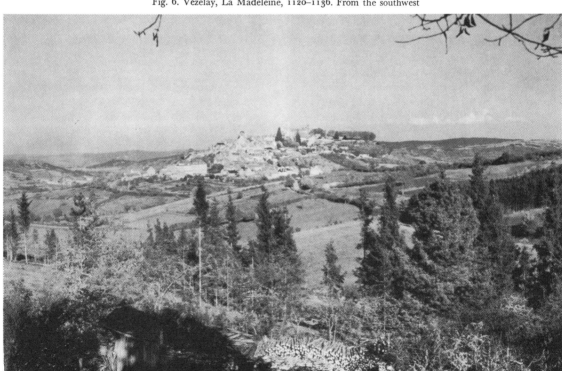

north face of the rock. This Gothic skyscraper, a horizontal monastic plan converted to the verticality of the sheer cliff of the Mount, was built between 1203 and 1221 and manifests the incredible ingenuity and engineering skill of Medieval builders. In contrast to Saint-Martin-du-Canigou (fig. 1), where space on the mountain spur was sufficient for a modified, horizontally planned monastery, the top of the rock of Mont-Saint-Michel is crowned by the church itself, and the monastic rooms, such as guest hall, storage rooms, monks' dormitory, refectory, and cloister, had to be piled up in three stories tangent to the vertical wall of live rock.

In the Hundred Years War the Mount resisted repeated attacks by the English, and again in the sixteenth century the Protestants tried unsuccessfully to reduce the abbey. In 1780, the façade and first three bays of the nave collapsed, and in 1793 the abbey was converted into a prison. In spite of further mutilations in the nineteenth century, Mont-Saint-Michel remains a powerful, mural manifestation of the religious-militant character of the early Middle Ages.

The stormy history of the town of Vézelay (fig. 6) and its monastery spans most of the Middle Ages. The abbey was founded in Carolingian times. This first monastic community, not on the hill, was destroyed by the Hungarians in 873. After their withdrawal, a new sanctuary was consecrated by Pope John in 878 on the present site. In the eleventh century belief in the existence at Vézelay of the remains of the body of Mary Magdalene began to spread; by 1050 the Pope confirmed the relics, and pilgrimages began. Vézelay was a dependent of Cluny by the end of the eleventh century, and the accomplishments of the first Romanesque campaign, the choir, transept, and perhaps parts of nave and narthex, were consecrated in 1104.

The orderly growth of both monastery and pilgrimage was interrupted rudely by a series of bizarre and tragic events. First, the townspeople of Vézelay, abused by the abbey's overtaxation, rose up in 1106, invaded the monastic grounds, and assassinated Abbot Artaud. Then there followed a feud between the Duke of Nevers and the Order of Cluny over the administration of the abbey. The Pope entered the dispute to protect Vézelay against the Duke (1116). However, three years later, followers of the Duke broke into the sanctuary and damaged the relics. In this instance, King Louis the Fat was called in to arbitrate. Finally, on July 27, 1120, a disastrous fire engulfed the monastery and killed more than a thousand people.

The present nave of the abbey was constructed between 1120 and its dedication in 1132, while the Early Gothic choir was begun in the 1180's. In the nineteenth century the west façade was overrestored by Viollet-le-Duc.

As though to compensate for its ill-fortune, several portentous events transpired inside Vézelay or within its shadow. In 1146, Saint Bernard, the great Cistercian abbot, read the papal bull and preached the sermon which launched the Second Crusade. So great was the crowd of barons and clergy that the event took place outside the walls. Barons from all corners of Europe, as well as King Louis VII and his Queen, Eleanor of Aquitaine, knelt before Bernard and dedicated themselves to this militant-religious cause. In 1190, before starting out on the Third Crusade, Philip Augustus, King of France, and Richard the Lion-Hearted met at Vézelay and agreed to forget their enmity and take up the sword together against the infidel.

Today Vézelay (fig. 6) is a classified, historical town. All plans for new construction must be submitted and judged to be compatible with the Medieval houses and monastery. As one looks at the town from the neighboring hill to the southwest, it is possible to imagine the gradual growth of the village around the abbey in the Middle Ages. The monastery crowns the eastern part of the hill. Two roads descend to the west, with smaller streets leading off each until the open market square is reached. Many houses date from the Romanesque period; most possess handsome vaulted cellars and subbasements of the eleventh and twelfth centuries. Around the town are remains of the rugged defensive walls which fol-

lowed the natural contours of the hill. One of the fortified gates still remains. Most of the monastic structures once attached to the abbey have long since disappeared; yet Vézelay as monastery and town has preserved a genuine Medieval character.

All five monasteries came into being under different historical and geographical conditions and played varying roles in Medieval life, but they all have features in common. They are all characterized by an ingenuity of planning and by a subtle use of terrain. All five reflect the builders' imaginative ability to adapt and transform the conventional monastic plan in solving problems of the individual site. Each has a unique history; each is today an impressive fragment in stone of an age of faith.

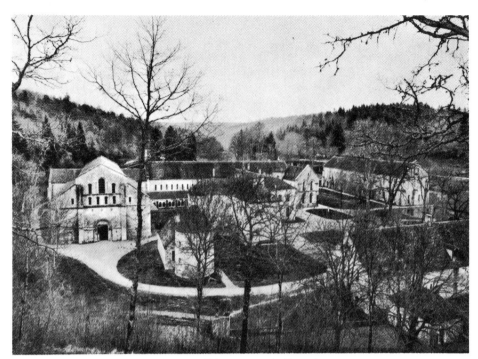

Fig. 7. Fontenay Abbey, 1139–1147. From the west

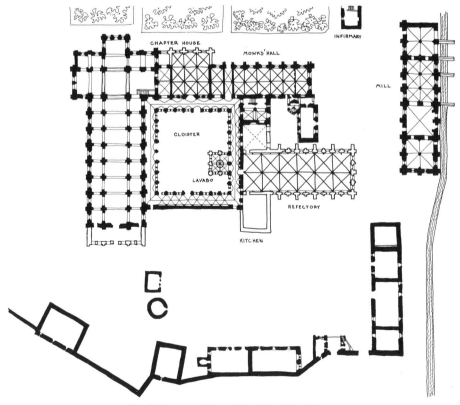

CHAPTER HOUSE

MONKS' HALL

INFIRMARY

MILL

CLOISTER

LAVABO

REFECTORY

KITCHEN

Fig. 8. Fontenay Abbey. Plan (after Bégule)

The Monastic Plan

THE ABBEY OF FONTENAY, in Burgundy (figs. 7–14), one of the best-preserved and least altered in western Europe, will be used to illustrate the major part of the monastic complex; details of other monasteries (figs. 15, 17–19, 21–23) will be discussed to present a more complete composite image of monastic planning. Fontenay, a Cistercian abbey begun in 1139, presents the monastic plan in its purest form. The Cistercian Order was founded in 1098 in ascetic protest against the growing luxuries of the Cluniac Order. A small band of monks, led by Abbot Robert of Molesme, journeyed to the forests of Cîteaux south of Dijon to live, pray, and perform manual work in the spirit of Saint Benedict's original teachings as set down in the Rules. The asceticism of Cîteaux attracted Stephen Harding in 1109 and Saint Bernard in 1112. Thereafter, the Order grew so rapidly that it surpassed the Cluniacs in number of monks and of communities. By the time of Saint Bernard's death in 1153 there were 343 Cistercian monasteries and almost 700 by 1200. The Cistercians dedicated themselves to a life of prayer and work. The simplicity of their way of life and the denial of any artistic frills are reflected in the chasteness of architectural forms, sparseness of ornament, and absence of figured sculpture in their abbey.

The plan of a typical monastery like Fontenay is a functional arrangement of spaces designed to serve the everyday life of the monks (fig. 8). The monastic day began its sequence of nine services in the choir at dawn and ended with nocturns sung or chanted after midnight. With this demanding schedule, the problem of circulation from dormitory to choir, to refectory, to monks' hall, to warm room, and to gardens had to be considered carefully. The cloister, with its four galleries, became the major link unifying the monastic complex. Around the cloister were grouped areas for prayer, reading, eating, working, and sleeping, while other detached structures included infirmary, mill, and guests' house and chapel. Rudimentary plans of the monastic complex date from the time of Saint Benedict in the sixth century. They were elaborated during the Carolingian period and reached perfection in the eleventh and twelfth centuries.

The Cistercians always selected secluded sites with the water and arable land necessary to make their monastery self-sufficient. Fontenay, founded in 1119 but constructed between 1139 and 1147, lies in a peaceful valley with an abundant stream. The arrangement of the monastery can be seen in the plan and views (figs. 7–14). Unless the topography of the land made it impractical, the choir of the church was oriented toward the east, toward Jerusalem and the Holy Land, with the cloister and surrounding buildings to the south of the church. As seen from a hill to the west (fig. 7 and bottom of plan, fig. 8), the church is at the left, circular pigeon roost and cloister in the center, remains of bakery, guest hostel, and gatehouse in the foreground. Since no women and children were allowed in the church and laymen only on special occasions, a guest house and private chapel served visitors, travelers, and guests. Above the eastern cloister walk is the monks' dormitory. To the right (fig. 7) are the remains of the warming room and refectory (completely altered and re-

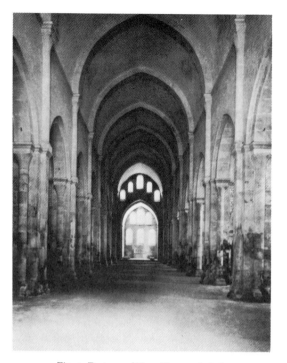

Fig. 9. Fontenay Abbey. Nave and choir

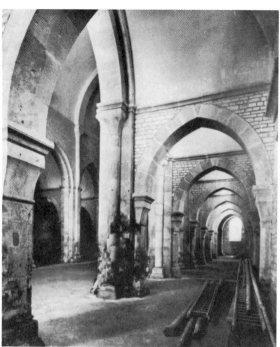

Fig. 10. Fontenay Abbey. South aisle

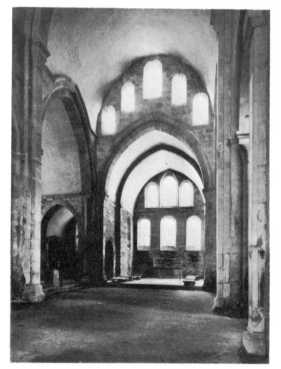

Fig. 11. Fontenay Abbey. Choir

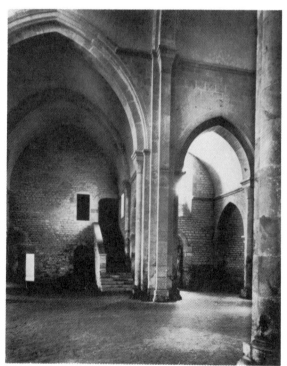

Fig. 12. Fontenay Abbey. South transept

built), with forge and mill structure and the infirmary beyond.

As viewed from the east (fig. 13 and plan, fig. 8) Fontenay, following the strict dictates of the Cistercian Order, presents a plain, rectangular choir flanked by short transepts. The lower floor of the lengthy attached building contains the sacristy (first window to the left of the south transept) and the chapter house (next three windows). The former housed sacred relics, liturgical vessels, and vestments, while in the chapter house the abbot and his senior advisers met to administer the monastery. The doorway to the left of the chapter house (fig. 13) allowed direct access from the cloister to the gardens. The remaining windows to the left lighted the monks' hall, where all were allowed to meet, read, copy manuscripts, and talk at certain specified times. The monks' dormitory of one vaulted room with no partitions constitutes the entire second floor of this structure (fig. 13). Chapter 22 of Saint Benedict's Rules reads:

> If possible let all sleep in one place; but if the number does not allow this, let them take their rest by tens or twenties with the seniors who have charge of them. A candle shall be kept burning in the room until morning. Let the monks sleep clothed and girded with belts and cords — but not with their knives at their sides, lest they cut themselves in their sleep — and thus be always ready to rise without delay when the signal is given and hasten to be before one another at the work of God, yet with all gravity and decorum.

The most important part of the monastic complex is the church. The nave, south aisle, and transept of Fontenay (figs. 9–12) exhibit the processional, longitudinal plan derived from Early Christian times. The repetition of piers and transverse arches crossing the vaults draws the onlooker toward the choir (fig. 11), which is the climactic focus. Since it is in the Mass that the divine is most clearly expressed, the choir is flooded with light from six windows. The forechoir, west of the choir proper, is accented by the five windows which illuminate the vaults adjacent to the transepts. The liturgy was focused on the two sacraments: Bap-

tism, by which one enters the living Church, and the Eucharist, by which life is nourished and perfected. This dual focus is given dramatic meaning by the processional movement down the nave to choir and to the high altar lighted by the eastern windows.

Direct access from cloister to church is achieved by a portal in the aisle bay flanking the south transept (fig. 12), while another door leads directly from the south transept into the sacristy to facilitate transportation of liturgical vessels from choir to storage. For Offices at night, the monks descended the stairs from the dormitory directly into the south transept (fig. 12) and took their seats in the monastic choir. One monk circulated among the meditating brethren. If his swinging lantern disclosed a sleeping monk, they exchanged plainsong chairs.

The church at Fontenay is covered with a pointed barrel vault of cut stone (fig. 9). Transverse arches, which grow out of massive piers, reinforce the vault and reduce the width of the span. These ribs and piers divide the nave vessel into rhythmic bays of space directed toward the choir. Aisles (figs. 10, 12) are also capped by pointed barrel or tunnel vaults. The aisle vaults, however, run at right angles to the axis of the nave. This transverse construction eliminates outward or lateral thrust. The aisle windows can thus be placed high and break out to the exterior above the roof covering the cloister walk (fig. 14). The Cistercian church at Fontenay possesses only unadorned or simply carved, floral capitals and has no stone pavement. A large part of Fontenay's appeal is derived from the directness of its statement in warm yellow-orange stone.

Saint Bernard's ideals of asceticism are clearly revealed in the simplicity of the church of Fontenay. Recent investigations have revealed the distinct possibility that Bernard himself laid out the plan, following an octave ratio (see bibliography: Otto von Simson). Each aisle bay is a square in plan, and each square is made into a cube by the horizontal stringcourse under the transverse barrel vault (see fig. 10). This interest in the octave, the square, and other ratios discov-

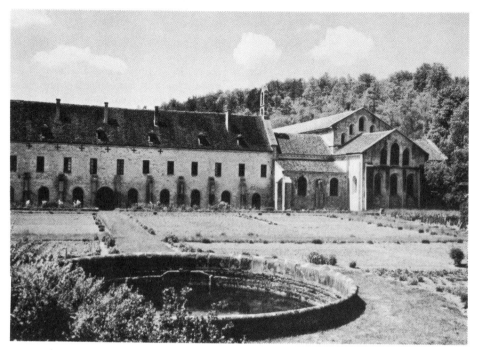

Fig. 13. Fontenay Abbey. From the east

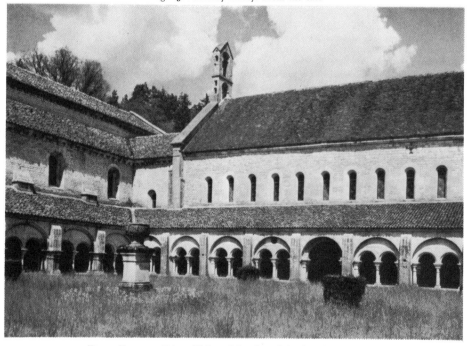

Fig. 14 Fontenay Abbey. Cloister (church on left; dormitory on right)

ered in Fontenay and other Cistercian churches leads to the conclusion that these structures were based on geometric proportions "according to the true measure" of Vitruvius and ultimately derived from the writings of Plato.

In contrast to the simplicity of the Fontenay cloister (figs. 14, 16), the Benedictine cloister of Saint-Trophîme at Arles, in Provence (north and east sides, figs. 15, 17), constructed between the 1130's and the 1150's, has sculptured piers and capitals depicting scenes from both Old and New Testaments. The Christian story unfolded in stone as monks strolled, read, and went about their daily schedule along these lighted walks. In the Arles cloister massive barrel vaults bend downward toward the open garden and are buttressed by thick exterior piers. Just as the arches of the nave of Fontenay established a directional sequence of rhythms, so do the piers and ribs alternating with arcades give the cloister walks at Arles a spatial order which is further dramatized by the patterned lighting (fig. 17). It is in these Romanesque cloisters, perhaps more than any other part of the monastery, that the sense of reflective peace and calm is most acutely felt.

In the chapter house the abbot, surrounded by the monks, directed the administration and discipline of the monastery. Chapter 3 of the Rules of Saint Benedict states: "Let the brethren give their advice with all the deference required by humility, and not presume stubbornly to defend their opinions; but let the decision rather depend on the abbot's judgment, and all submit to whatever he shall decide for their welfare. However, just as it is proper for the disciples to obey their master, so also it is his function to dispose all things with prudence and justice." If the abbot wished a secret vote, all the monks filed past a box and dropped in white balls for "yes" and black balls for "no." The administration involved admission of novices, sale or purchase of land, punishment for infraction of rules, and, on rare occasions, changes in the statutes. Although the total responsibility rested with the abbot, he often delegated many duties to others. In the Cluniac Order this delegation of responsibility is reflected in

various officers: the Grand Prior was in charge of the farms, the Claustral Prior controlled discipline, the Chamberlain managed the treasury, and the Cellarer handled supplies.

The chapter house of Fontenay (fig. 20) has Early Gothic ribbed vaults. Windows and the large central doorway give directly on the east gallery of the cloister. Most of the circulation to and fro between church and refectory or church and monks' hall passes by this room, so that its centrality reflects its important role in the total plan of the monastery.

Under different climatic conditions the Romanesque builders showed their ability to preserve the same relationship between parts of the monastery while shifting the major monastic structures to the north side of the church. This change is often found in abbeys in southern France, where the southerly situation of the church keeps much of the cloister in the shade. In Le Thoronet, a Cistercian abbey in Provence (figs. 18, 19), the plan is a mirror image of that of Fontenay. The main monastic, dependent spaces lie to the north of the church. Opening off the cloister walk on the right (fig. 19) are the sacristy and chapter house, while the dormitory is above. At Le Thoronet an open walk rests on the vaults of three sides of the cloister with access directly from the dormitory. The octagonal structure, the lavabo, on the north side of the cloister of Le Thoronet (fig. 19) contains basins for washing before entering the refectory or dining hall. The lavabo is almost always located on the side of the cloister opposite the church and directly across the cloister walk from the refectory. The refectories of Fontenay and Le Thoronet have disappeared, but the Abbey of Notre-Dame d'Aiguebelle, an active reformed Cistercian monastery, has a fine late twelfth-century one (fig. 21). Cistercian monks eat two meatless meals a day in silence while a monk reads from the Scriptures (note lectern at end of right wall, fig. 21).

The monastic kitchen is often a quite simple structure to the west of the refectory and not unlike the warming room which separates the refectory from the monks' hall. These two rooms were

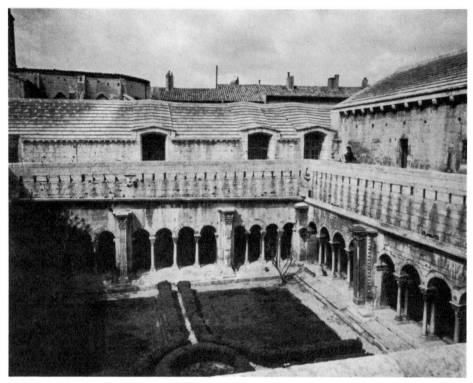

Fig. 15. Arles, Saint-Trophîme, 1140's–1150's. Cloister from the south

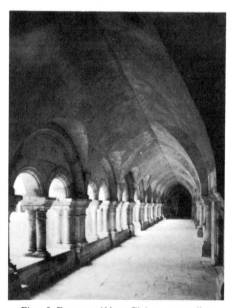

Fig. 16. Fontenay Abbey. Cloister, east gallery

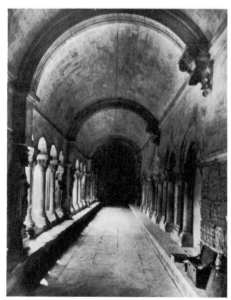

Fig. 17. Arles, Saint-Trophîme. Cloister, north gallery.

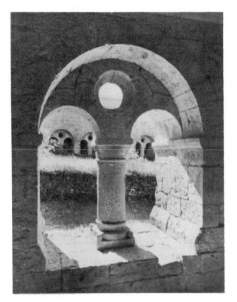

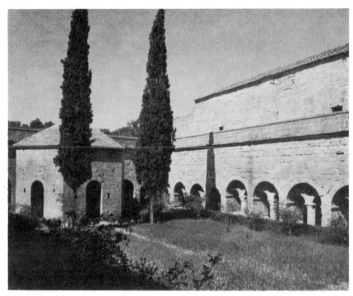

Fig. 18. Le Thoronet Abbey, mid XIIth century. Cloister Fig. 19. Le Thoronet Abbey. Lavabo and cloister from the south

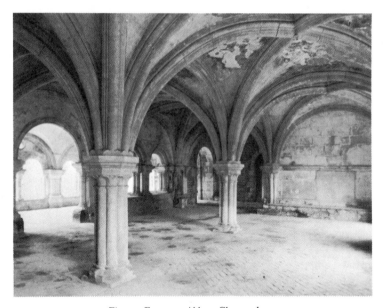

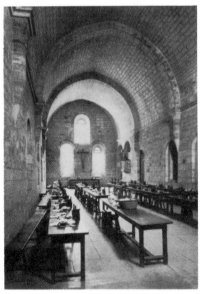

Fig. 20. Fontenay Abbey. Chapter house

Fig. 21. La Trappe d'Aiguebelle, XIIth centur
Refectory

Fig. 22. Fontevrault Abbey. Kitchen

Fig. 23. Fontevrault Abbey. Vaults of kitchen

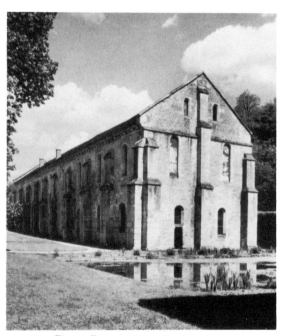

Fig. 24. Fontenay Abbey. Forge and mill

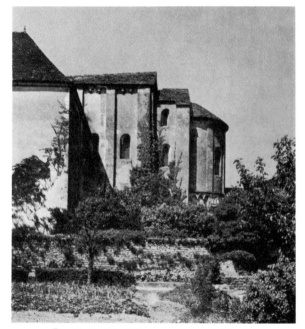

Fig. 25. Berzé-la-Ville, grange, c. 1100. Chapel

the only ones with heat in the entire monastic core. The kitchen at Fontevrault (figs. 22, 23), however, has complicated flues behind diaphragm arches, giving the exterior a dramatic silhouette which reminds one of expressionistic churches in Germany in the 1920's.

There are other buildings which contribute to the self-sufficiency of the monastery, but are not part of the major complex. They were sometimes attached to the exterior encircling wall and consisted of bakery, hostelry, chapel, and gatehouse or stood free as the infirmary, forge, and mill. Fontenay (fig. 24), for example, preserves an outlying building containing mill, blacksmith shop, and large storage areas.

Many monasteries became so large that neighboring fields produced insufficient grain. Cluny III, the Mother Abbey of the Cluniac empire, needed thirty farms or granges to satisfy its needs. Each grange had a chapel attached to the south side of the farmyard and was farmed by monks sent out from the abbey. A fine example of a grange chapel is Berzé-la-Ville (fig. 25), a favorite retreat of Abbot Hugh of Cluny. The finest extant Burgundian murals are preserved inside (figs. 112, 116).

The monastic plan in its entirety is a series of interior spaces logically arranged around circulatory galleries and staircases, designed to fulfill the needs of a life of contemplation, prayer, and corporate worship. The remaining parts of Fontenay, when combined with sections of other monasteries, reveal the functional clarity of the monastic plan. This visual harmony of related masses brings to mind outstanding achievements of twentieth-century architectural planning.

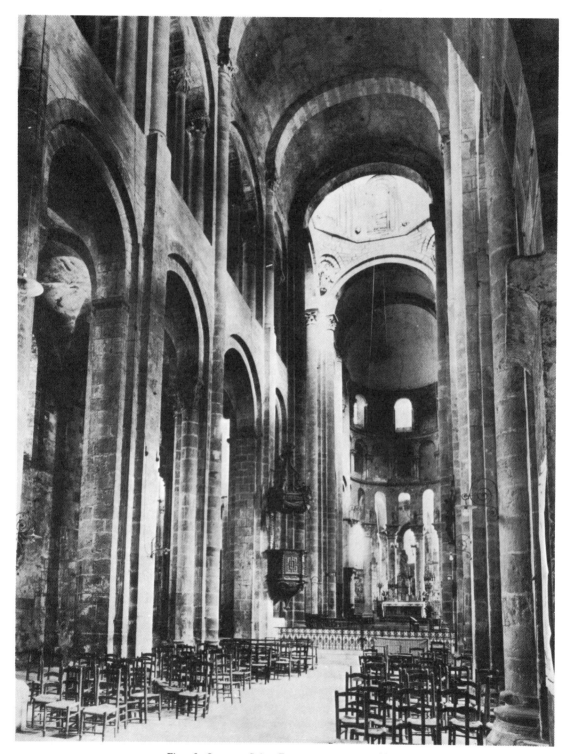

Fig. 26. Conques, Sainte-Foy, c. 1050–c. 1120. Nave

The Romanesque Church

I T IS THE CHURCH which is the key to the nature of Romanesque architecture. To the monastic church came the pilgrims to join the choir of monks in the liturgy of praise. Born to monastic life through the second baptism of their profession, the monks gathered in the church to dedicate their lives in Christ. To point up the qualities which establish the greatness of Romanesque, several outstanding monastic churches will be discussed: Sainte-Foy at Conques, on the pilgrimage route to Spain; Saint-Sernin at Toulouse, in southwestern France; the third church at Cluny; the Cluniac priory of Paray-le-Monial; and Vézelay, in northern Burgundy.

Conques is dedicated to Saint Foy, a girl twelve years old who was martyred at Agen in southwestern France in 303. Because of the presence of her remains in a monastery in Agen, miraculous cures transpired. In the ninth century a Benedictine monk from Conques spent several years planning the theft of the relics of Saint Foy and finally brought them to Conques. A reliquary statue (fig. 28) was made to contain these relics. The gold head, probably Roman of the fifth century, and possibly the portrait of an emperor, was joined to a wooden core to which thin plaques of gold were attached. This original reliquary statuette, 2 feet 9 inches in height, was made in the last quarter of the ninth century. As miracles increased at Conques, the statue was modified in the last quarter of the tenth century by the addition of a crown, earrings, gold throne, filigree work, and jewels including antique cameos and intaglios — mostly gifts of pilgrims. In the fourteenth century a pair of crystal balls and three mounts were added to the throne. Silver arms and hands date from the sixteenth century, while the copper plaques of the shoes and on the knees were fabricated in the eighteenth century. Miraculous cures of the blind and of workmen injured during the construction of the Romanesque church intensified the pilgrimage to Conques.

Sainte-Foy at Conques (figs. 26–36) was begun around 1050 and largely completed in the early decades of the twelfth century. Upon entering, the first impression is of a thin, soaring space, 68 feet high, flanked and crowned by yellow-orange stone (fig. 26). The sense of verticality is intensified by the rhythmic progression down the nave to the high altar. Piers with half-columns or flat pilasters and the transverse arches of the barrel vault in repetition establish a longitudinal and vertical impulse. The nave vessel is divided into compartments of space by the piers and by the pier extensions which rise up through the gallery and over the vaults. Progress, both visual and physical, down the nave to the high altar, becomes a unified, pulsating experience.

The piers (figs. 26, 27, 31), constructed of huge blocks laid horizontally, consist of a square core with four pilasters or half-columns on each side. The four elements are an integral, structural part of the pier. Each relates to and is continuous with arches which run down the nave, with transverse arches which cross the aisles (fig. 31), or with the pilasters or half-columns which extend up to the vaults (fig. 30). This organic articulation of pier has a structural logic which can be seen as one traverses the nave, looks back toward the façade (fig. 32), or gazes up at the vaults (fig. 30). The

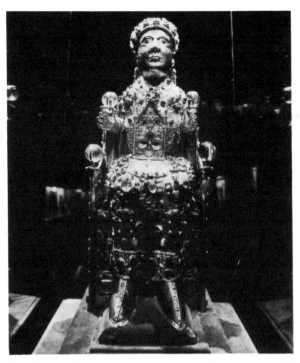

Fig. 27. Conques, Sainte-Foy. Cross
section through the nave

Fig. 28. Sainte Foye of Conques, last quarter IXth, last quarter Xth
centuries with later additions. Gold, precious stones, 2 ft., 9 in. high.
(Treasury of Conques)

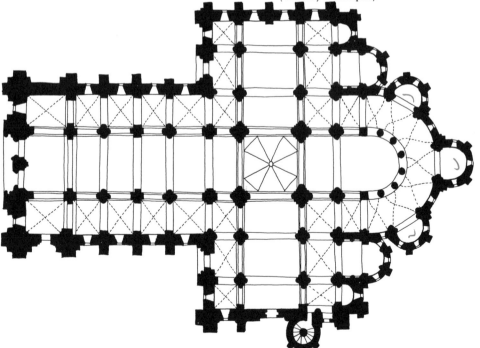

Fig. 29. Conques, Sainte-Foy, c. 1050–c. 1120. Plan (after Aubert)

piers give the impression of bearing tremendous weight, but this downward pressure appears balanced by the wide diameter of the supporting piers.

Light plays a dramatic role. Indirect light filters into the nave from the high windows under the groin vaults of the aisles and from the low apertures under the half-barrel vaults of the galleries (figs. 26, 30). The relatively dark nave is spotlighted at the crossing with direct down-lighting from the tower. Finally, the direct, clerestory windows in the choir together with light penetrating from ambulatory and radiating chapels focus attention on the high altar, the Table of the Lord. The shift from indirect to direct light points up the meaning of the liturgy and creates a warm tonality in the interior as it highlights the colored stone.

Structurally, this thin, aspiring space is made possible by thick walls and vaults (fig. 27). The barrel of the nave, some 2 feet thick, exerts an outward thrust which is met by the half-barrel vaults of the galleries running the length of both nave and transepts. These half-barrels, reinforced by diaphragm arches (vertical walls of masonry over an arch) behind each pier at the gallery level plus the exterior wall buttresses (figs. 27, 34), equalize the outward thrust of the nave vaults. The transverse arches across the nave vaults, which are a thickening of the vault itself and not like Gothic ribs supporting a webbing, have two functions: they thicken the vault above the piers and in their smaller arc reduce considerably the width of the span of the vaults. These transverse arches thus play an extensive part in the stability of the church and at the same time give a consistent, rhythmic unity to the interior space. The Medieval builder apparently arrived at this solution by trial and error. Modern mathematics and engineering, unknown to the Medieval builder, have demonstrated that these transverse arches strengthen the structure tremendously. This entire system of thrust and counterthrust is built of cut stone, directly and honestly handled. The thick walls, emphasized by the layers of planes in space, give Conques an impressive, rugged strength.

Critics have often called attention to the crude and apparently primitive character of Romanesque buildings like Conques. The logic of the structure and the emotional appeal of the harmoniously proportioned spaces belie this criticism. Further, upon close observation of the nave (fig. 26), it appears that the designs of the piers differ. Flat pilasters alternate with half-columns, setting up a different rhythmical beat. Is this sort of refinement a crude, barbaric idea, or is it rather positive evidence of the vitality and consummate creativity of Romanesque times?

From every angle, Conques is intellectually understandable: from the outside-inside and inside-outside. The plan (fig. 29) can be drawn after a careful study of the exterior. As one climbs the hill to the northeast of Conques or crosses the valley to the south (figs. 34, 36), one's response centers on the play of masses: the verticals of towers echoed by wall buttresses play against the longitudinal aspect of nave and transept. Originally the façade had a simple pedimental cap instead of the paired towers added in the nineteenth century; these latter detract from the sheer cliff of masonry with its military overtones. Seen from the hill above (fig. 36), the continuity of the nave space from the façade through the crossing tower to its termination in the rounded choir is clearly stated on the exterior. The fact that the nave of the transept is as wide as the main nave is also revealed (fig. 36). The breaks in the roof point up the position of the galleries flanking the major spaces and show that the roof is laid directly on the barrel vault of the nave and on the half-barrel of the galleries. Thus, not only is the interior disposition of volumes visible from the exterior but also the structural system is clearly suggested.

In the view from the east (fig. 35), new shapes emerge which give variety to the total massing and at the same time point up the functional use of each space within. The five tightly curved radiating chapels, three giving off the ambulatory and two off the transept, house statues and relics and were designed for private prayer. These rhythmically spaced chapels are refined into an architectural unity by the ambulatory and eastern aisle of the transept. Above the ambulatory rises

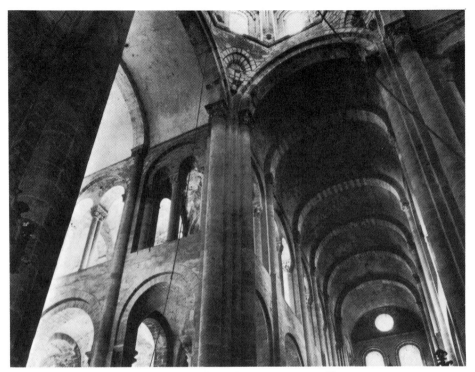

Fig. 30. Conques, Sainte-Foy, c. 1050–c. 1120. Nave
vaults from choir

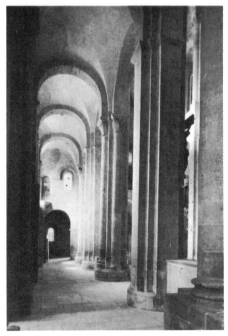

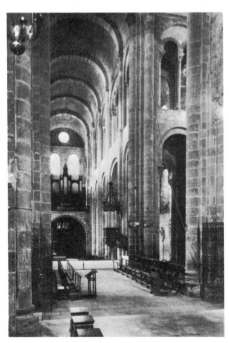

Fig. 31. Conques, Sainte-Foy. South aisle from the east

Fig. 32. Conques, Sainte-Foy. Nave from choir

the choir, with its clerestory windows and thick, arcaded walls. The flanking galleries stop short of the east end to allow the direct light to enter the choir. Finally, the octagonal tower, with bulging stair turret, emerges above the crossing. Instead of the contrast of verticals and horizontals, the east end of Conques piles up dramatically in a series of curved forms set against the mural flatness of the transept. Round-headed windows suggest the nature of the interior light.

The entire mass of Conques, with bold silhouette and mural self-containment, manifests the complete readability of Romanesque architecture at its finest. The sense of the stone, treated as bearing and sustaining material, is apparent in every detail. The obvious reflection of every interior function on the exterior gives Conques, in spite of its age, an appealing, modern quality.

A study of the carved capitals helps answer some of the unresolved problems of the order and date of construction (see bibliography: Fau, *Les Chapiteaux de Conques*, 1956). Work was begun during the abbacy of Odolric between 1041 and 1050. By 1065, when Étienne II became abbot, the eastern walls and chapels of the transept, the walls of the ambulatory and its three chapels, plus the lower sections of the choir proper, had been constructed in a reddish sandstone. The rest of the building was built of yellow limestone from a quarry six miles away. During the abbacy of Étienne II (1065–1087) the lower stages of the transept and nave were erected. It is possible that the galleries or tribunes of the choir and transepts were constructed during this period; yet there is evidence in documents and in the building itself that it was necessary to reconstruct these parts toward the end of the eleventh century. According to Fau, capitals from the older campaign (1065–1087) were re-employed. The galleries of the nave and finally the vaults of transept and nave were completed under abbots Bégon (1087–1107) and Boniface (1107–1119). The elaborate program of the capitals in the galleries indicates that they were used as picture books by monks and pilgrims in the Middle Ages instead of being simply admired as they are today by the few who gain access to the galleries.

In a recent study, "La Construction de l'abbatiale Sainte-Foy de Conques" (*Bulletin monumental*, 1965), Marcel Deyres, without any reference to Jean-Claude Fau's study of the Conques sculpture, attempts both to establish the chronology of the construction of Conques and to explain the discrepancies in sizes of the nave bays and the widths of the transept aisles (fig. 29). Conques I, a Carolingian church, was demolished in the eleventh century to allow for the erection of a larger Conques II, begun between 1041 and 1050. This second Conques, finished by the end of the eleventh century, included the radiating chapels, ambulatory with roof lower than present one, choir without galleries, transept with east aisles only and without galleries, and present nave with galleries. According to Deyres, Conques II, with transept vaults lower than the nave vaults, served as model for the churches of Auvergne and predated the pilgrimage churches of Saint-Sernin of Toulouse and Santiago de Compostela.

In testimony of the drastic changes which comprised Conques III, Deyres cites the similar size of windows of ambulatory and radiating chapels and the presence of a cornice roof connecting chapels and ambulatory as evidence for a lower roof over the ambulatory in the first campaign (fig. 35). He further argues that the third campaign, or Conques III, of the early twelfth century, which was inspired by Toulouse and Santiago de Compostela, involved the construction of galleries over the aisles of the choir and transept and necessitated the raising of the roof over the ambulatory to allow circulation at the gallery level. The western aisle was added to the transept to facilitate circulation of the increasing number of pilgrims. He explains that the narrow nave bay to the west of the crossing was included in the monastic choir, while the second, larger bay served as the space where pilgrims came to be blessed or to receive absolution.

Since Fau, in his book on the capitals of Conques, argues convincingly that the capitals of the gallery of the nave, carved in the early twelfth century, are later than those of the gallery of the transepts, the ingenious solution of Deyres is open to question. Further, as Carl Hersey has proved

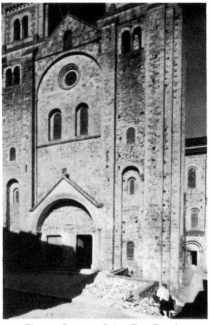

Fig. 33. Conques, Sainte-Foy. Façade

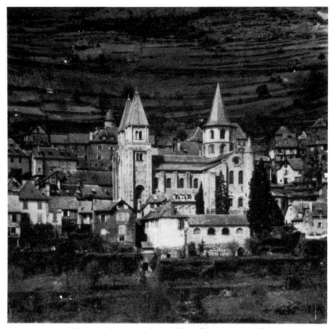

Fig. 34. Conques, Sainte-Foy. From the south

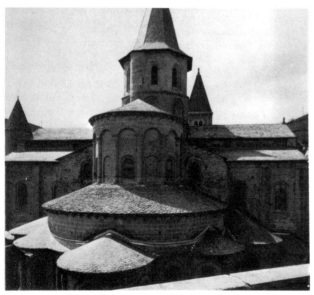

Fig. 35. Conques, Sainte-Foy. From the east

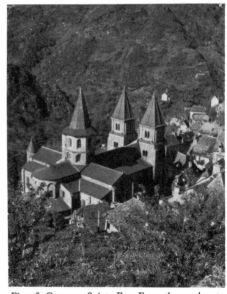

Fig. 36. Conques, Sainte-Foy. From the northeast

in his article on the destroyed Saint-Martin at Tours (*The Art Bulletin,* 1943: see bibliography), the various campaigns of Tours established the design for the pilgrimage churches. The ambulatory, with radiating chapels, was constructed at Tours as early as 903–918. The enlargement of Tours between 997 and 1014, consisting of a large church with wooden roofs, was replaced by barrel vaults around 1050. Thus, Saint-Martin at Tours served as model for Conques, Toulouse, and Santiago de Compostela. The raising of the roof over the ambulatory of Conques, which Deyres claims occurred in the early twelfth century during his Conques III campaign, was perhaps the result of a change in design and an enlargement of the program in the late decades of the eleventh century. Conques still awaits a detailed monograph.

The nave, plan, and exterior of Saint-Sernin at Toulouse (figs. 37–39) exhibit very close relationships to the design of Sainte-Foy at Conques. The nave of Toulouse (fig. 39) is crowned by a barrel vault of approximately the same height as that of Conques (68 feet), and the space is modulated by transverse arches resting on half-columns. The structural system of the main barrel over the nave buttressed by the half-barrels of the galleries, which rise above the groin-vaulted aisles, is identical in both monuments. It is only when the plans and certain details are contrasted that differences begin to emerge. Toulouse is much larger in length and width (359 feet long, as opposed to 173 feet for Conques). The nave has twelve bays, not five; each transept arm has four bays, not two; the choir is deeper; and four aisles flank the nave. The greater size of Toulouse results in five radiating chapels opening off the ambulatory and four off the east side of the transepts, as against three and two in the same locations in Conques. Saint-Sernin does not exhibit the subtle alternation of pier design found in the nave arcades of Conques. The addition of two aisles at Toulouse makes the exterior massing more complicated, as the roof over the outer aisles is lower than the roof protecting the vaults of the galleries over the inner aisles.

The exterior of Toulouse (fig. 37) and the nave reveal the fact that the church was constructed largely of brick, the local building material. The plaster and joints, painted to imitate masonry construction, have been removed from the second nave pier on the right (see fig. 39). The basic structure appears to be carefully laid-up courses of brick with stone courses interspersed. On the lower zones of the chevet and east side of the transepts and through the transept portals, the alternation of brick and stone can be seen (article by Scott, *Art Bulletin,* 1964: see bibliography). Along the flanks of the outer aisles and around the lower part of the façade another system involves essentially brick walls with cut stone reinforcing the windows and corners of the wall buttresses. Above the lower levels, brick is used throughout. The master builders who supervised the construction of Toulouse used brick to achieve the architectural forms which were conceived originally in stone in the earlier church at Conques and the even earlier but now destroyed church of Saint-Martin at Tours.

The history of Saint-Sernin goes back to the fourth century when Saint Saturnin (Sernin), apostle of Toulouse and its first bishop, was martyred and buried in a tomb near the walls. The construction of the present church commenced around 1080, when the abbey adopted the Rule of Augustine. The high altar was dedicated on May 24, 1096, by Pope Urban II in the presence of fifteen bishops. By 1096 the lower parts of the entire east end and the transept ends, as represented by the brick- and stone-banded construction, must have been completed (Scott: see bibliography). It seems clear that the exterior walls of the outer aisles and the lower zone of the west façade were finished by 1118 and the nave vaults during the early part of the second quarter of the twelfth century.

Santiago de Compostela, the goal of the pilgrimage to the grave of Saint James Major, begun before 1078 and constructed of stone, is almost identical in plan to Toulouse, except that it is slightly shorter and has only two aisles. These three monastic churches, plus Saint-Martial at Limoges and Saint-Martin at Tours, both destroyed

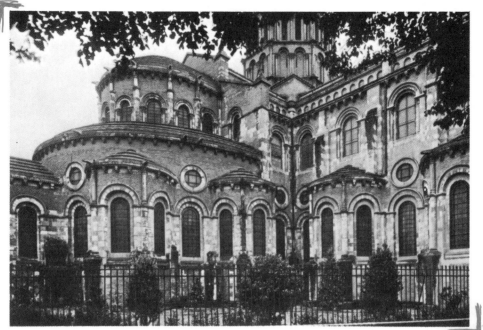

Fig. 37. Toulouse, Saint-Sernin, c. 1078–c. 1125. From the northeast

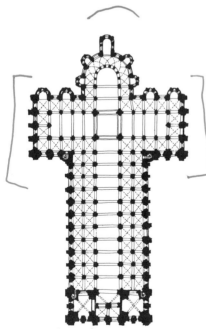

Fig. 38. Toulouse, Saint-Sernin. Plan (after Aubert)

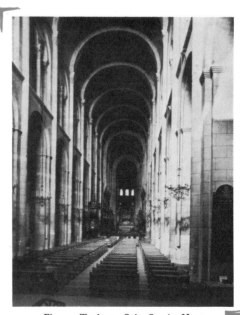

Fig. 39. Toulouse, Saint-Sernin. Nave

during and after the French Revolution, form a group of closely related buildings, the products of the exchange of ideas along the pilgrimage routes. These five monuments in their homogeneity of design transcend the general localism of Romanesque architecture.

Paray-le-Monial (figs. 40, 45, 46, 48, 51, 52, 55), begun at the very end of the eleventh century and largely completed by 1109, is a fine example of Burgundian Romanesque. Geographically, Burgundy is located at the physical as well as artistic crossroads where the influences of earlier vaulted Romanesque moved up the Rhône Valley to meet ideas such as clerestory lighting from the Ottonian empire across the Rhine. Paray-le-Monial was originally built as a priory under the jurisdiction of the Order of Cluny. In its forms, Paray-le-Monial reflects the great third church at Cluny which was almost completely destroyed after the French Revolution.

In contrast to the pilgrimage group of churches (Conques and Toulouse, figs. 26, 39), the nave of Paray-le-Monial (fig. 40) has greater vertical emphasis, although it is only 3 feet taller (71 feet, as opposed to approximately 68 feet of Conques and Toulouse). Several features contribute to the greater verticality of Paray-le-Monial. First, the nave arcade is higher and is crowned by a pointed arch. Instead of a gallery above the nave arcade, as at Conques and Toulouse, Paray-le-Monial has two stories (fig. 55): the triforium zone below, animated by pilasters and recessed arches, and a clerestory above with three windows. The addition of one story and the increased illumination resulting from clerestory windows further augment the soaring nature of the nave vessel. Finally, the vault of the nave (fig. 46) is a pointed barrel, modulated by thick transverse arches, as opposed to the round and more containing barrels of Conques and Toulouse. The pointed barrel vault exerts less outward thrust than a round barrel and therefore does not necessitate the flanking half-barrels of the galleries to buttress it (see Conques and Toulouse). Without galleries it is possible to design clerestory windows and illuminate the nave directly from the outside. Thus the

desire for more light is co-ordinated with structural innovation.

Fluted pilasters with Corinthianlike capitals strengthen and animate the triforium and nave arcade of Paray-le-Monial (fig. 55), in contrast to the semicircular or undecorated pilasters of Conques (fig. 32). These classical details were probably derived from Roman buildings in Burgundy, such as the Roman gate in nearby Autun (see fig. 54). The Romanesque master builders, however, completely transformed the borrowed Roman details; pilasters on the piers are elongated into unclassical proportions, while the soaring nature of the interior space has no counterpart in Roman architecture.

Lighting in the choir area of Paray-le-Monial is more abundant and more complicated than at Conques (fig. 40). The nave vault terminates in a vertical wall with three lights directly over the choir. The choir or forechoir is thus illuminated by its own clerestory windows plus the three perforations in the vertical wall. The half-dome of the apse and its clerestory windows are lower in height. Nine clerestory windows illuminate the apse of Paray-le-Monial, instead of three at Conques. The ambulatory has two stories of windows (figs. 40, 48, 52), and each radiating chapel has three apertures. Thus light penetrates the east end of Paray-le-Monial on four levels of elevation and in four different planes in space. As at Conques, the complete readability from inside to outside and vice versa is apparent.

Paray-le-Monial is a miniature version of the huge third church at Cluny (figs. 41–44, 47, 49, 50). Extensive excavations and numerous publications by Kenneth John Conant are the major source of present knowledge about all three churches at Cluny and their ever-expanding monastic complexes (see bibliography). The first church at Cluny, built between 915 and 927, proved to be too small for the growing monastic community by 955 so that a second church and monastery were begun, being completed by about 1040. Nothing remains today of this second church except what has been brought to light by Conant's excavations and study of drawings and engravings

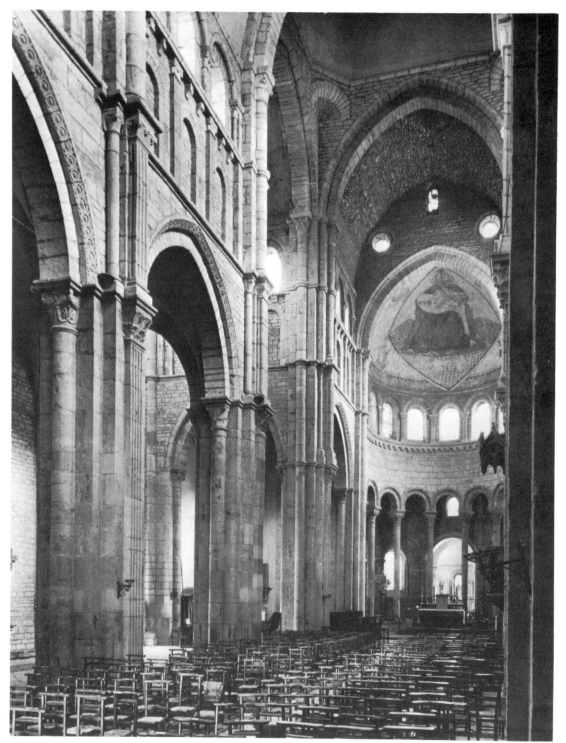

Fig. 40. Paray-le-Monial, priory, c. 1100. Nave

made before the French Revolution. By the 1080's there were two hundred monks at Cluny, as opposed to seventy in 1042, and the decision was made to build a third, much larger church. The official date for the commencement of work on Cluny III is September 30, 1088, but some preliminary work may have begun as early as 1086. The most important patron of Cluny was Alfonso VI, King of Spain, who gave large sums of money to Abbot Hugh. His contributions started as thank offerings for the capture of Toledo from the Moors on May 25, 1086, but he doubled his annual gift after meeting Abbot Hugh in Burgos in 1090.

Under Hugh, Abbot of Cluny from 1049 until 1109, work progressed rapidly. On October 25, 1095, Pope Urban II and members of his suite dedicated five altars in the choir. By 1100, as an inscription proves, both transepts had been completed except for towers (see plan, fig. 42). Most of the church, except for the nave vaults, was finished by the time of Abbot Hugh's death in 1109. Between 1109 and 1115 the major doorway into the nave was created, and by about 1120 the nave was vaulted. Five years later some of the nave vaults collapsed, but were reconstructed by 1130 when the church was finally consecrated by Pope Innocent II. The major patron of Cluny in the first three decades of the twelfth century was Henry I, King of England. The extensive narthex (see plan, fig. 42) was erected during the second, third, and fourth decades of the twelfth century. The western towers were not constructed until after 1200.

A comparison of the plans of Paray-le-Monial and Cluny III (figs. 42, 45) reveals the similarities of design, despite the marked difference in size. Cluny is 609 feet long (exterior measurement) with vaults 97 feet above the pavement, while Paray-le-Monial is only 206 feet long with vaults 71 feet in height. The entire church of Paray-le-Monial is a replica on a smaller scale of the chevet and eastern transept of Cluny. Both churches have aisleless transepts and ambulatories which are narrower than the square bays flanking the choir. Only three radiating chapels open off the ambulatory at Paray-le-Monial, as opposed to five at Cluny, and the short Paray-le-Monial transept has room for only one chapel opening off each arm. Cluny has two transepts, four aisles, and a nave of eleven bays (Paray-le-Monial has one transept, two aisles, and a nave of three bays). These Cluniac plans do not have the massive transepts with aisles and galleries characteristic of the pilgrimage group (see figs. 29, 38). The four aisles of Cluny III might be inspired either by Toulouse or the earlier Saint-Martin of Tours or by Early Christian basilicas in Rome, such as Saint Peter's or Saint Paul's Outside the Walls.

For over thirty years Kenneth Conant has devoted much time and energy to the excavations and study of Cluny under the sponsorship of the Mediaeval Academy of America. He is presently publishing a monograph which will contain the results of his extensive research. On the basis of measurements made on the site and the study of eighteenth-century plans, he has concluded that the master of Cluny, who laid out the third church, followed the principles of the golden section.

The nave of Cluny III (fig. 41), reconstructed by Kenneth Conant, exhibits the monumental, spatial grandeur of the interior space. Barrel vaults and transverse arches carried down by half-columns and pilasters to the pavement created a rhythmic repetition of bays down the nave. Light entered the nave directly through the clerestory windows and indirectly through the high windows under the groin vaults of the inner aisles and the lower windows of the outer aisles. As revealed in the longitudinal section (fig. 43), light penetrated the church on three different levels in elevation and in three different planes in space. The crossing towers over the two transepts broke the containment of the barrel vaults and with additional downward light led into the choir with its fresco of Christ in Majesty in the semidome and girdle of clerestory windows below. The total impact of the nave of Cluny III can be recreated by comparing the reconstruction (fig. 41) with two details of Paray-le-Monial (figs. 46, 55).

To achieve greater stability of the vaults, the

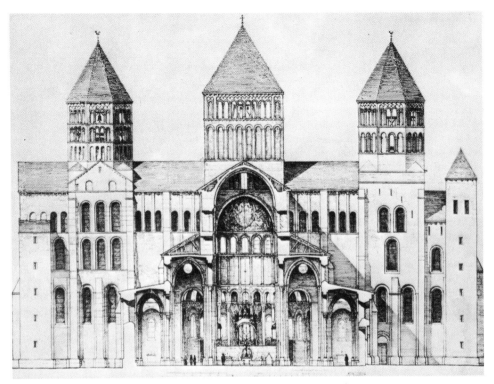

Fig. 44. Cluny, third abbey church. Cross section of nave,
elevation of large transept (Conant)

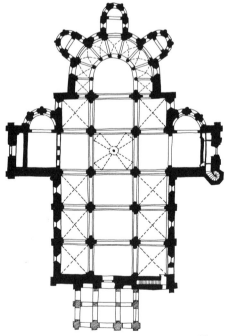

Fig. 45. Paray-le-Monial, priory, c. 1100. Plan

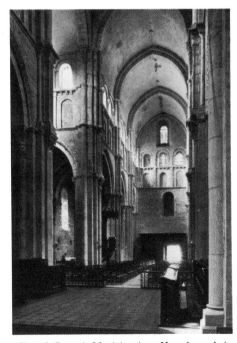

Fig. 46. Paray-le-Monial, priory. Nave from choir

Fig. 47. Cluny, third abbey church. From the southeast by Lallemand (c. 1787)

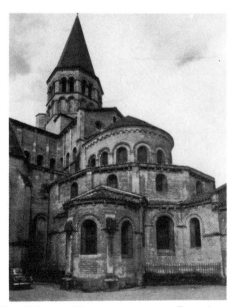

Fig. 48. Paray-le-Monial, priory, c. 1100. From the east

Fig. 49. Cluny, third abbey church. Portal and south transept

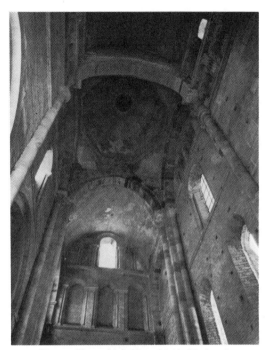

Fig. 50. Cluny, third abbey church. Vaults of south transept

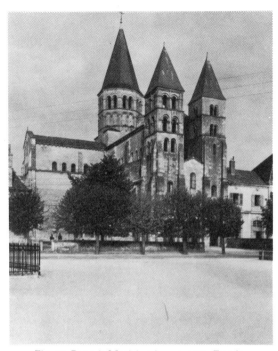

Fig. 51. Paray-le-Monial, priory, c. 1100. Façade

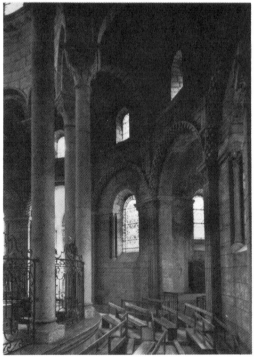

Fig. 52. Paray-le-Monial, priory. Ambulatory

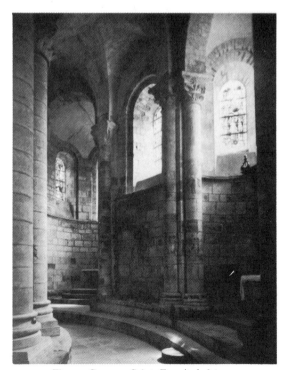

Fig. 53. Conques, Sainte-Foy. Ambulatory

barrels at Cluny were slightly pointed, and the pilasters, as they rose in sequence, were corbeled or extended out so that the width of the span of the vault was narrower than the distance across the nave between the piers (span at level of pavement 36 feet 5 inches and 34 feet 7 inches at springing of vaults, or a reduction of 22 inches: see bibliography). These unusual structural features can be seen in the cross section of Cluny, in the reconstruction of the nave (figs. 44, 41), and in views of Paray-le-Monial (figs. 40, 46, 55).

The precocious nature of the ambulatory and radiating chapels of Cluny can be imagined if details of Paray-le-Monial and Conques are contrasted (figs. 52, 53). The two stories of windows in the Paray-le-Monial ambulatory and the thinner proportions and more slender columns are in marked contrast to the squat massiveness of Conques. Fluted pilasters supporting carved arches give the surfaces an animation which is absent in the more stark and mural ambulatory of Conques. Only the major south transept of Cluny III (figs. 49, 50) and capitals of the chevet, plus fragments of sculpture and moldings, exist today; yet drawings made in the seventeenth century and eighteenth century (fig. 47), together with the existence of several priories inspired by Cluny, make it possible to reconstruct the exterior of this extraordinary abbey. The drawing by Lallemand (fig. 47), made from the southeast, shows Cluny III as it existed in 1787. Curved forms of radiating chapels are repeated in the ambulatory and choir above. The vertical repetition of forms is further accented by the octagonal towers over the crossing of the minor transept. The tallest, square lantern tower over the major crossing stabilizes the whole composition. Paray-le-Monial repeats, in its smaller scale, the dramatic organization of forms of the chevet of Cluny. From the exterior, the multiple heights of windows and the planes in depth in which the windows penetrated at Cluny suggest what must have been the complexity of the interior lighting. The absence of galleries above aisles imparts a more vertical character to the chevet than the horizontally organized massing of Conques and Toulouse (figs. 35, 37).

As viewed from the west, the transept of Paray-le-Monial (fig. 51) appears almost equal in length to the nave. Actually, the transept has two bays with clerestory windows separated by a wall buttress, and the nave three bays. The aisleless transept and the absence of galleries flanking the nave accent the thinness of the masses. The narthex, from which the towers rise (see plan, fig. 45), is narrower than the church; it is probably part of an older church. The narthex was rebuilt in the thirteenth and nineteenth centuries, while the towers were strengthened in the nineteenth century. In the late eighteenth century the fourteenth-century crossing tower was demolished and replaced by an unsympathetic dome. In the 1860's the dome was replaced, in turn, by the present pseudo-Romanesque tower. In spite of these restorations, the massing of Paray-le-Monial from east and west is impressive and suggests what must have been the monumental grandeur of the third church at Cluny.

The Cathedral of Autun, dedicated to Saint Lazarus and built after 1120, continues the Cluny III design, but with variations (fig. 56). The dimensions of the nave vessel are similar to those of Paray-le-Monial; the vaults are 76 feet high and the nave is 27½ feet wide (Paray-le-Monial is 71 feet by 30 feet, and Cluny III is 97 feet by 36 feet). The single clerestory window in each bay, in contrast to three at Cluny III and at Paray-le-Monial, reduces the lighting considerably and accentuates the massiveness of the nave piers. The influence of antiquity seen in the fluted pilasters and Corinthianlike capitals in Cluny III and Paray-le-Monial is intensified. Flat pilasters make up the four major sides of the nave piers, and the piers on the outer walls of the aisles have a flat pilaster instead of a half-round column. Perhaps the presence in Autun of two Roman gates (fig. 54) plus many other Roman ruins influenced the master builder.

All three Burgundian churches, Cluny III, Paray-le-Monial, and Autun, exhibit daring structural innovations and a precocious handling of light. Their soaring interior spaces, especially those of Cluny III, presage the interiors of High Gothic cathedrals. Yet the tall, thin spaces are still bounded by animated walls perforated by nave

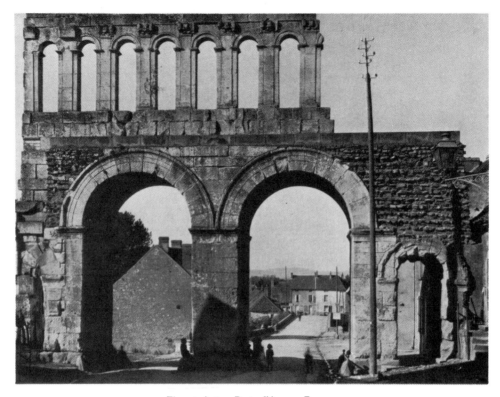

Fig. 54. Autun, Porte d'Arroux, Roman

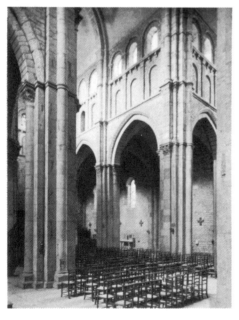

Fig. 55. Paray-le-Monial, priory, c. 1100. Nave
from south transept

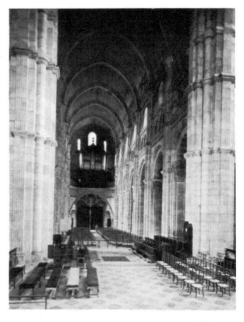

Fig. 56. Autun, Saint-Lazare, 1120–1130. Nave
from choir

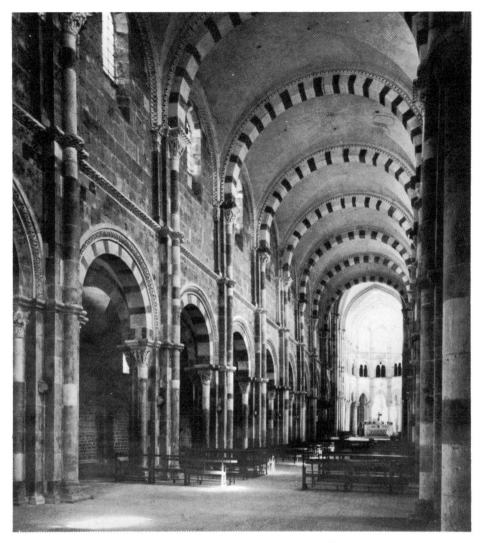

Fig. 57. Vézelay, La Madeleine, 1120–1136. Nave

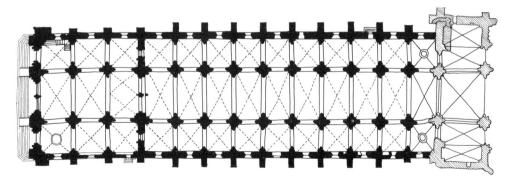

Fig. 58. Vézelay, 1120–1136. Plan of nave (after Salet)

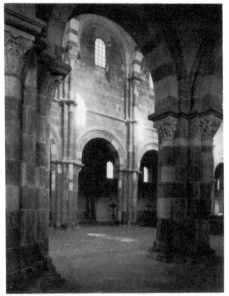

Fig. 59. Vézelay. Nave from south aisle

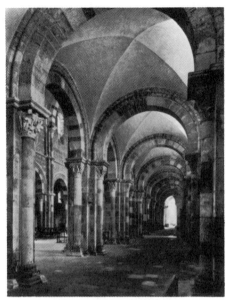

Fig. 60. Vézelay. South aisle

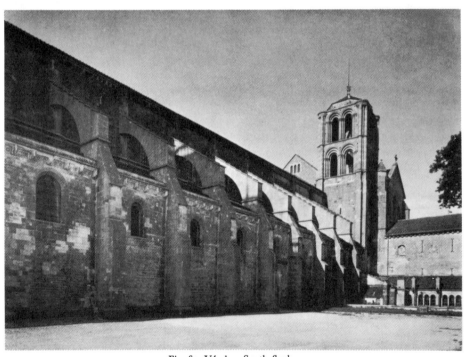

Fig. 61. Vézelay. South flank

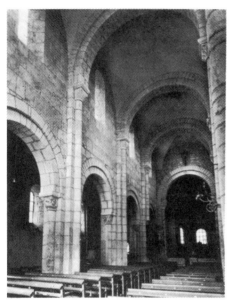 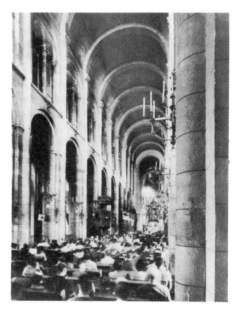

Fig. 62. Anzy-le-Duc, priory, late XIth century. Nave Fig. 63. Toulouse, Saint-Sernin, c. 1078–1130. Nave

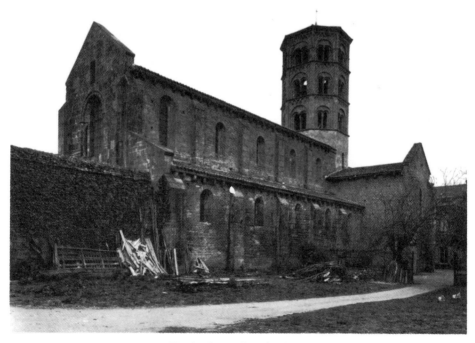

Fig. 64. Anzy-le-Duc. South flank

arcade and clerestory windows and supported by the thickness of the walls in a pure Romanesque manner. Cluny III and Paray-le-Monial are the products of a sensitive collaboration between the extraordinary Hugh of Semur, Abbot of Cluny for forty-nine years, and unknown but highly creative master builders.

The nave of the Abbey of Mary Magdalene at Vézelay (figs. 57–61), for the most part constructed after the fire of 1120, presents different spatial shapes and a different system of construction in contrast with both Conques and Paray-le-Monial. The interior volumes of Vézelay are much squatter in their proportions and are crowned by domical groin or crossed vaults. This vaulting allows the clerestory windows to penetrate up into the vaults, as opposed to Paray-le-Monial in which the pointed barrels rise from above the clerestory level. The high placement of clerestory windows and the accentuation of transverse ribs of alternating colored stones give each bay of the nave greater independence. The cadence of rhythmical sequences down the nave is slowed considerably. Light reflects off the vaults and imparts a yellow and yellow-orange to pink tonality to the entire interior.

It is possible to imagine pilgrims returning from Rome with vague impressions of the huge groin-vaulted baths or basilicas and transforming these ideas into a Christian edifice. The Roman structures of concrete had ornamental columns and entablatures attached to the bearing structure, while at Vézelay, as in all French Romanesque, half-columns and pilasters are an integral part of the construction. The Romanesque builder healed a schism between structure and decoration which frequently existed in Roman architecture.

The direct light, plus the coloristic stonework, gives a brightness to Vézelay which is quite different from the relative darkness of Conques (fig. 26). Views of the south aisle (fig. 60) and nave from the aisle (fig. 59) disclose more clearly the amplitude of both nave and aisles.

Flying buttresses were added to Vézelay in Gothic times (fig. 61), probably to stabilize the walls, which were bowing outward. A study of the Priory of Anzy-le-Duc, also in Burgundy, enables one to recreate Vézelay's original exterior appearance (figs. 61, 64). Anzy-le-Duc, older than Vézelay and dating from the late eleventh century, exhibits the same internal disposition: nave arcade, blank area above, and clerestory windows penetrating into groin vaults (fig. 62). Anzy-le-Duc utilizes the same articulated pier, but omits the horizontal abaci connecting capitals of the pier and the ornamental stringcourse above the nave arcade. Vézelay also has a short pilaster and capital from which springs the arch over the clerestory windows. The simple yet animated exterior of Anzy-le-Duc (fig. 64) resembles Vézelay with its Gothic buttresses removed.

The wide interior volumes of both Vézelay and Anzy-le-Duc possess a completely different mood than do the darker, taller naves of the pilgrimage group of churches such as Conques and Saint-Sernin at Toulouse (fig. 63). These pilgrimage churches, located in central and southern France and northern Spain, were all constructed in areas with more light than Burgundy, and this may well account for the relative darkness of their interiors, as against the Burgundian emphasis on fenestration and light.

In spite of their differences, these churches manifest the major qualities of mature Romanesque architecture. Since the wall alone with its attached buttresses must contain the thrust of the massive vaults, the mural emphasis dominates both the exterior forms and interior spaces. Each vaulting system is stabilized by counterthrusts, and each structural system limits the type and nature of lighting. Thus, light per se never was separated from the structural system, and a dynamic compromise between shape of space, construction, and lighting always resulted. For the sensitive eyes of twentieth-century travelers, Romanesque churches in France possess a vital clarity of expression, consistency of interior spaces, and harmony of exterior shapes which rank the architecture of this period among the greatest in European culture.

Evolution of Romanesque Architecture

OVER A HUNDRED YEARS of experimentation and gradual evolution lie behind the churches just discussed. Indeed, Romanesque as a whole is an extension and refinement of architectural ideas that date from the Early Christian era. The basilican plan, with its emphasis on simple horizontal massing, was the creation of the Early Christians in the fourth century, based largely on the transformation of the pagan Roman civic basilica. This longitudinal plan was gradually modified during and after the Carolingian period (late eighth and ninth centuries) by the addition of the soaring west façade, crossing tower, and monastic choir. But it was the tenth and eleventh centuries which witnessed the development of vaulted naves, ambulatories with radiating chapels, and more complex compositions of massing. In order to point up this evolution within Romanesque times (late tenth to early twelfth centuries), five interiors of naves, four exteriors, and four Provençal cloisters will be analyzed.

The nave of the priory of Saint-Étienne at Vignory (fig. 65) was constructed in the first half of the eleventh century. With its wooden, trussed roof and clerestory windows, Vignory is a somewhat belated extension into Champagne in eastern France of architectural ideas developed in the Carolingian and Ottonian empires. With the exception of the vaulted Palatine Chapel of Charlemagne at Aachen (late eighth century) and its copies, Carolingian monasteries continued the unvaulted tradition of Early Christian architecture. Semidomes over the apse and groins in the narthex and two-story chapels of the western massing were the only vaulted sections of longitudinally planned churches. Vignory does not contain any alternation of piers and columns which characterizes Saint Michael's at Hildesheim (early eleventh century) or Gernrode of the tenth century. Rather, Vignory has continuous square nave piers which support a doubled and arched false gallery opening into the aisles. Clerestory windows and a wooden roof illuminate and enclose the nave.

In contrast to Vignory, the nave and aisles of Saint-Martin-du-Canigou (1001–1026, fig. 66) are vaulted with barrel vaults supported by two sets of four shafts separated by two piers. The barrel vaults over the aisles buttress the slightly higher barrel of the nave. The nave arcade springs from simple capitals upheld by thin, short columns. Light enters the church only through small windows in the outside walls. Canigou is one of hundreds of small vaulted churches which can be found in northern Spain, on both sides of the Pyrenees, along the northern shores of the Mediterranean, and in northern Italy. This first Romanesque style, Premier Art Roman, extending from the 950's to the early eleventh century, is characterized by a simple basilican plan and vaulted nave and aisles, each terminating in an apse (see fig. 71 for the exterior of Canigou). Most churches of this early date are small, but, unlike their Carolingian and early Ottonian predecessors, they are vaulted.

The interior of the chapel over the narthex of Saint-Philibert at Tournus (figs. 67, 68) exhibits developing Romanesque forms. This part of Tournus was constructed between 1028 and 1056 and is thus one generation later than Canigou.

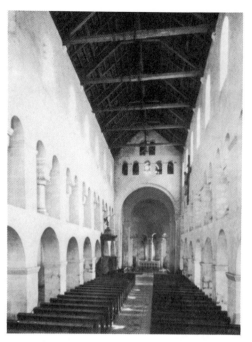

Fig. 65. Vignory, priory. c. 1050. Nave

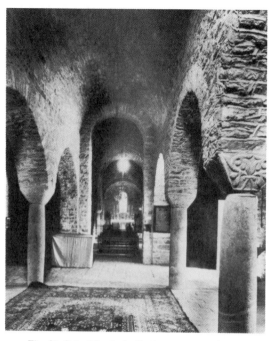

Fig. 66. Saint-Martin-du-Canigou, 1001–1026. Nave

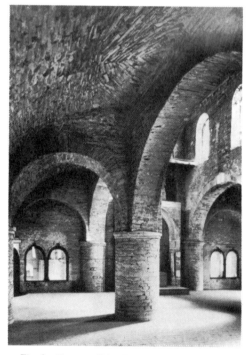

Fig. 67. Tournus, Saint-Philibert. Upper narthex,
1028–1056

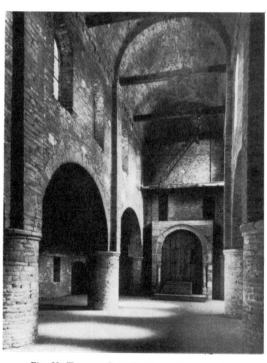

Fig. 68. Tournus, Saint-Philibert. Upper narthex,
1028–1056

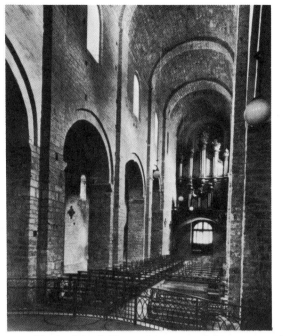

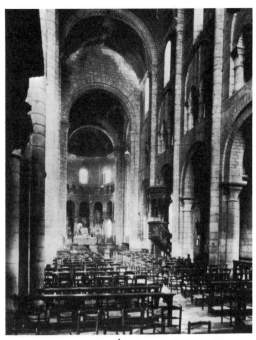

Fig. 69. Saint-Guilhem-le-Désert, c. 1076. Nave

Fig. 70. Nevers, Saint-Étienne, c. 1083–1097. Nave

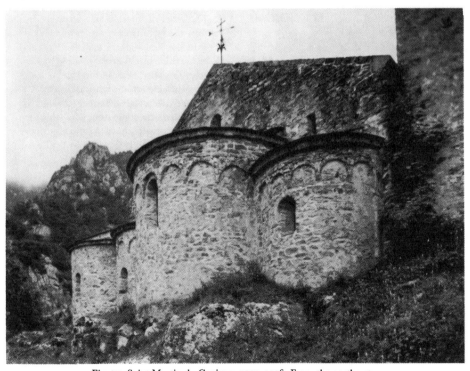

Fig. 71. Saint-Martin-du-Canigou, 1001–1026. From the northeast

From the short cylindrical piers supporting the nave arcade rise undecorated pilasters which become the transverse arches across the barrel vault of the nave. Stabilization of the structure is achieved by wooden tie beams, thick walls, and the half-barrel vaults over the aisles (see fig. 67). These half-barrels are strengthened by diaphragm arches. The nave rises considerably above the low aisles, and small clerestory windows, four to each bay, illuminate the interior vessel. Tournus is in Burgundy, where artistic currents from the northeast and the south met. The upper narthex of Saint-Philibert combines the vaulted systems from the south (Canigou) with the clerestory lighting from the unvaulted monasteries to the northeast (Vignory — a reflection). This synthesis of two quite divergent tendencies of early Romanesque architecture took place first in the second church at Cluny around 1000 or later. The upper narthex of Tournus manifests an archaic ruggedness; yet its forms and their organization forecast the later and more sophisticated naves of Cluny III and Paray-le-Monial.

The nave of Saint-Guilhem-le-Désert (fig. 69) was finished by the dedication of 1076 and is therefore one generation younger than the narthex of Tournus (figs. 67, 68). In Saint-Guilhem-le-Désert greater continuity exists between pier and nave arcade and pier and vault. The flat sides of the multiple piers continue into the nave arcade of two planes, while main pilasters extend from pavement to transverse arches. Like the Tournus upper narthex, the nave of Saint-Guilhem-le-Désert reveals the simple yet powerful forms of Romanesque prior to Cluny III and Conques and Toulouse.

Saint-Étienne at Nevers (fig. 70), in contrast to Saint-Guilhem-le-Désert, is mature Romanesque, roughly contemporary with the pilgrimage group of Conques and Toulouse. Saint-Étienne at Nevers became a Cluniac priory in 1068. Construction may have begun soon afterward but most of the church was built between 1083 and the dedication of 1097. In Nevers the piers, built of horizontal stone courses, are articulated by half-columns under the inner arch of the nave arcade. The convex edge of the matrix of the pier becomes the upper arch of the nave arcade and continues up through the gallery and clerestory. The half-columns on the inner faces of the piers are continuous from the pavement to the transverse arches of the barrel vault. The double arcade of the gallery, inset slightly, with its simplified, cubical capitals, has low half-barrel or quadrant vaults which buttress the nave walls. Up to this level Saint-Étienne resembles Conques and Toulouse (figs. 26, 39), but the addition of a third story with clerestory windows relates Nevers to Burgundian buildings such as Cluny II and the upper narthex of Tournus (figs. 67, 68). Nevers is located in the center of France and is only 99 miles from Cluny and 136 miles from Tours. The master builder of Saint-Étienne at Nevers seems to have simplified the pilgrimage-road plan of Saint-Martin of Tours or Conques, with its ambulatory and radiating chapels, and combined it with the Burgundian predilection for direct clerestory light.

The series of interiors in a sequence in time exhibits the creative interaction of geographical areas in the formation of mature High Romanesque architecture. From simple unvaulted churches (Vignory) or small dimly lighted vaulted buildings (Canigou), the master builders evolved taller nave vessels with clerestory lighting beneath barrel vaults. The crude stonework of the earlier structures gradually changed to larger, more carefully cut blocks and is climaxed by the fine ashlar masonry of Saint-Étienne at Nevers. This improvement in stereotomy, the art of stonecutting, parallels the greater sophistication of forms in the later churches such as Saint-Guilhem-le-Désert and Nevers.

The evolution of Romanesque from archaic, experimental forms to mature or High Romanesque can be seen in the exteriors of four monuments. One of the hallmarks of the first Romanesque style is the simple wall arcade or arched corbel table ornamenting exterior cornices (fig. 71, eastern chapels of Saint-Martin-du-Canigou, 1001–1026). The simple massing of aisles and nave, terminating in chapels or a triple apse, is typical of these small Premier Art Roman monasteries

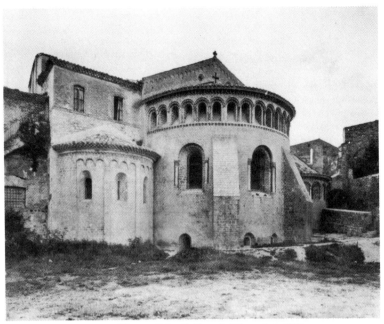

Fig. 72. Saint-Guilhem-le-Désert, late XIth
century. From the east

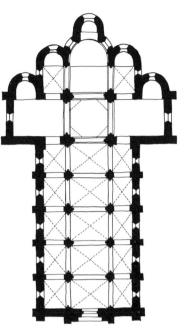

Fig. 73. Anzy-le-Duc, priory, late XIth
century. Plan (after Sunderland)

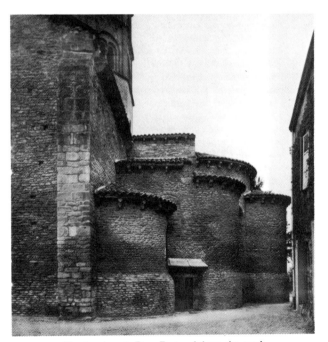

Fig. 74. Anzy-le-Duc. East end from the south

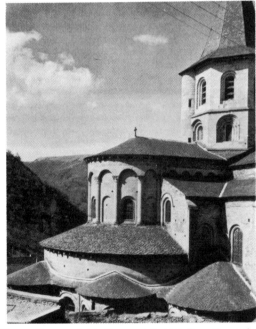

Fig. 75. Conques, Sainte-Foy, c. 1050–1120. From the northeast

(see fig. 1). By the end of the eleventh century, when the building program at Saint-Guilhelm-le-Désert was expanded by enlarging the east end of the church (fig. 72), the arched corbel tables are undercut niches and pilasters animate the side chapels. The crude stereotomy of Canigou has been superseded by more carefully cut stonework, and the stonework, in turn, makes possible the more subtle animation of the mural surfaces.

The chevet or eastern section of Romanesque churches increased in complexity of design during the course of the eleventh century. The Burgundian Anzy-le-Duc (fig. 74) has a series of chapels opening off its east side. This organization is quite different from the simple massing of Canigou and Saint-Guilhem-le-Désert, in which naves and aisles terminate in relatively shallow chapels (figs. 71, 72). As seen in the plan of Anzy-le-Duc (fig. 73), two small chapels or absidioles extend eastward from the transept arms, while deeper chapels flank the choir in echelon and the easternmost chapel extends the space of the choir. This repetition of similar curved shapes in different planes in space and in three heights gives the chevet of Anzy-le-Duc a rhythmic quality which has great visual appeal. The mid-eleventh-century plan of Anzy-le-Duc reveals the strong influence of Cluny II, begun around 955 and finished in the early decades of the eleventh century. Actually, the origin of the plan of Anzy-le-Duc does not stem directly from Cluny II, but by way of the Cluniac priory of Charlieu II in Burgundy (c. 1030–1094). The Charlieu plan is almost exactly repeated in Anzy-le-Duc (see bibliography: Sunderland); yet the vaults of Anzy-le-Duc (fig. 62) are a series of groins, not a barrel vault, as at Charlieu II. The chevet of Anzy-le-Duc was constructed during the middle of the eleventh century, while the nave dates from the last quarter of the eleventh century. The nave, as noted above, is the source of the nave design of Vézelay. Anzy-le-Duc was a dependency of Saint-Martin at Autun, but it reveals in plan the architectural importance of the destroyed second church at Cluny.

In her article "Symbolic Numbers and Romanesque Church Plans" (see bibliography), Elizabeth Sunderland, on the basis of careful measurements of Burgundian churches including Charlieu, Anzy-le-Duc, Paray-le-Monial, and others, suggests that their dimensions are multiples of the sacred numbers: three, four, five, seven, and ten. She writes: "Once the length of the 'foot' (which varied from 29.3 centimeters to 34.4 centimeters) was established for each church the dimensions of all of them turned out to be multiples of threes, fours, fives, sevens, and tens. One of the numbers was used as the basis for dimensions of length and another for dimensions of breadth." Further she states: "The conclusion can hardly be avoided that they are there for symbolic reasons. The designers, by crossing two sets of numbers, could include heaven and earth in the very measurements of their churches. As all other things pertaining to the church were embodiments of mediaeval number symbolism, it would seem not unlikely that the dimensions of churches were also symbolic."

Another important stage in the evolution of the Romanesque plan can be seen in the east end of Conques (c. 1050–1120, fig. 75). The introduction of an ambulatory circumnavigating the choir increases the internal circulation and establishes a harmony among the exterior shapes. Two chapels open off the transept arms, while three chapels animate the ambulatory (see plan, fig. 29). This design of ambulatory with absidioles originated in the tenth-century church of Saint-Martin at Tours (see bibliography: Hersey). It was developed further by subsequent building campaigns of Saint-Martin at Tours and then was employed in all the pilgrimage group of churches (Conques and Toulouse) as well as in churches in the Auvergne, the Burgundian Cluny III and Paray-le-Monial, and in churches in other regions of France. The ambulatory at Conques (fig. 53) states the interior continuity of circulation from aisles of nave through the aisles flanking the choir and around the ambulatory. The curving forms of the chapels are repeated in the larger curve of the ambulatory and echoed again in the smaller curve of the choir with its clerestory windows; the interaction of these curving forms co-ordinates in

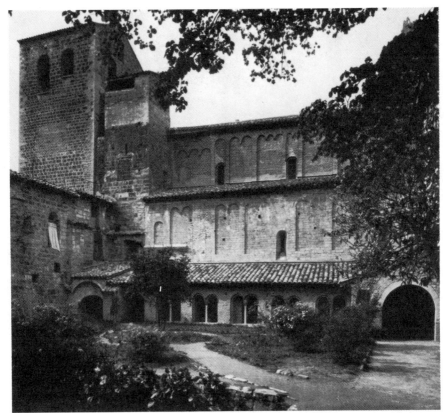

Fig. 76. Saint-Guilhem-le-Désert, XIth century. Cloister

Fig. 77. Arles, Saint-Trophîme, 1140's–1150's. Cloister

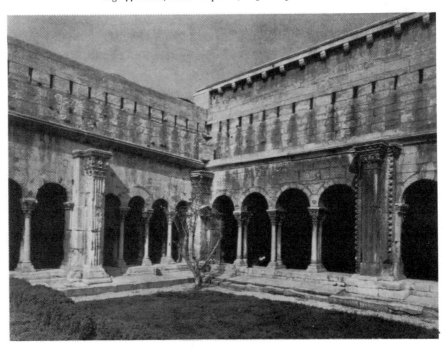

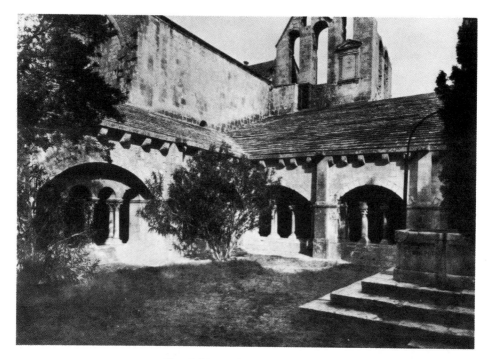

Fig. 78. Montmajour, 1150's. Cloister

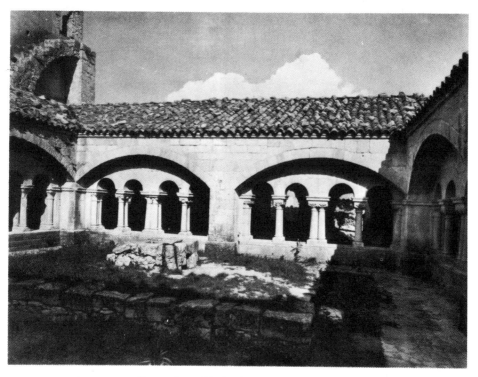

Fig. 79. Ganagobie, late XIIth century. Cloister

a dramatic pyramidal composition.

Provence, in southeastern France, is rich in Romanesque cloisters. The manner in which the cloister arcades are treated also reveals the nature of the evolution of Romanesque forms. The four cloisters illustrated (figs. 76–79) span roughly a century and a half. The earliest, Saint-Guilhem-le-Désert (eleventh century, fig. 76) is in the Hérault, to the west of Provence. It has heavy, square piers separating a pair of arches with a single shaft and capital. In the cloister of Saint-Trophîme at Arles (fig. 77), the piers have been elaborated by the addition of pilaster-buttresses which help stabilize the thrust of the barrel vaults of the gallery walk (fig. 17). Between these animated piers are arcades supported by paired columns making four openings. The left side (fig. 77) is the north gallery, dating from the 1130's or early 1140's, while the right side or east gallery was constructed in the 1150's. The difference in date can be seen in the size of the openings.

The next step in the evolution of cloister design is the connection of the piers with some form of arch which, in turn, frames the cloister arcades. Montmajour (1150's, fig. 78), only a few miles from Arles, has a small cloister in which the piers are articulated so that inner pilasters grow into the transverse ribs of the barrel vaults covering the gallery, while the outer attached pilasters are integrated with the roof. From the major matrix of the piers spring low arches which embrace the arcades of either three or four openings. A new rhythmic harmony of forms is achieved which is consistent with the structural logic of the cloister. A further refinement or, perhaps, overrefinement can be seen in the little cloister of Ganagobie, in the valley of the Durrance (late twelfth century, fig. 79). Here each arch embraces four arcades, but an additional pattern is set up by the bundle of four colonnettes which divide each bay and suggest smaller groupings within the larger one.

These comparisons (figs. 65–79) give some idea of the gradual transformation of simple, archaic beginnings to more sophisticated statements. Yet early Romanesque monuments such as Canigou possess a vitality and vigor of great artistic merit, in spite of the hesitancy of execution. It is not, therefore, an evolution which necessarily involves an improvement in quality as much as it is an evolution which moves from simplicity to greater complexity and involves more difficult problems of size, interior space, lighting, and massing.

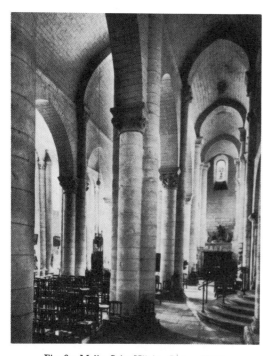

Fig. 80. Melle, Saint-Hilaire, Poitou, XIIth century. Nave

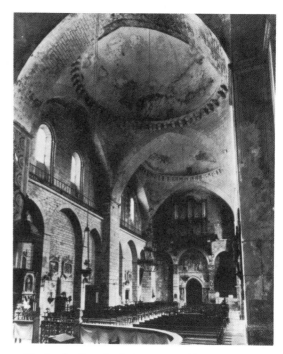

Fig. 81. Souillac, Aquitaine, c. 1130. Nave from choir

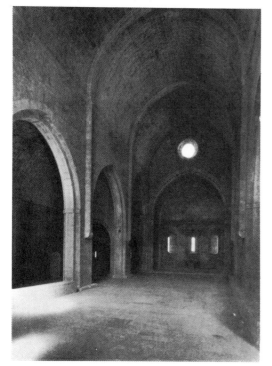

Fig. 82. Le Thoronet Abbey, Provence, mid-XIIth century. Nave

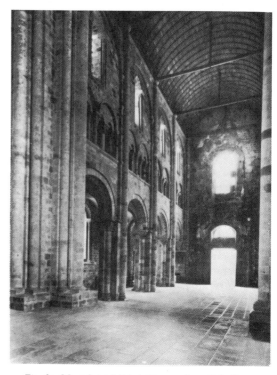

Fig. 83. Mont-Saint-Michel, Normandy, 1060's. Nave

Variety in Romanesque Architecture

IN SPITE OF the improved communication which the pilgrimages to the grave of Saint James Major in Spain and the Crusades to the Holy Land afforded, Romanesque architecture in France remains strongly regional. The "pilgrimage family" of churches — Santiago de Compostela, Saint-Sernin at Toulouse, Sainte-Foy at Conques (plus Limoges and Tours, now destroyed) — are exceptions to the localism of Romanesque times. These churches with the same plan, massing, and dimensions of interior space obviously reflect the international or interregional nature of the pilgrimage. Certain Cluniac ideas also extended beyond the borders of Burgundy, and the strict planning and unadorned surfaces of Cistercian monasteries, in emphasis of the dictates of Saint Bernard, became international. Yet French Romanesque architecture in its entirety was rooted in the local region and reflected the fragmentation of political authority in this period. The Capetians controlled small but rich areas around Paris, while the dukes of Burgundy, Aquitaine, Auvergne, Poitou, and Provence had only loose ties of allegiance to the king of France.

This chapter will make no attempt to discuss each local region, but rather by comparisons of interiors and exteriors suggest the extraordinary variety of imaginative solutions which can be seen in a small selection from the thousands of Romanesque monuments in present-day France.

The treatment of interior spaces is quite different in various geographic areas. Melle (fig. 80, first half of twelfth century) is one of hundreds of small churches in western France (Poitou-Saintonge). It is vaulted by three barrel vaults, one capping the nave and the other two over the aisles.

These hall churches rely on high windows in the exterior walls and indirect light reflecting from the vaults. Piers often consist of clusters of half-columns integrated with the transverse ribs across aisles and nave (fig. 80). A slightly different kind of Poitivin interior with barrel vault over the nave and groin-vaulted aisles can be seen in Saint-Savin-sur-Gartempe (fig. 120, discussed later in Chapter 7). The interior of Notre-Dame-la-Grande at Poitiers has the vaulting system of Saint-Savin, but compound piers similar to those at Conques and Toulouse.

In marked contrast with the interior spaces of Melle are the spaces of Souillac (about 1130, fig. 81). Here space is defined in three cubes crowned by domes. Souillac is one of the seventy-odd churches in western France (about half of them in the Périgord region) which are without aisles and have domes on pendentives, or spherical triangles. Along the sides of the aisleless nave, the walls of Souillac are articulated with blind arcades supporting a narrow exposed gallery and are perforated by clerestory windows above. The square bays, marked by the transverse arches and wall arches over clerestory windows, possess a spatial independence which completely alters the usual rhythms of Romanesque architecture. Just why this dome solution was popular in western and southwestern France has never been definitely determined. Contact with Byzantine buildings, such as San Marco in Venice, or a connection with the island of Cyprus, from which the Bishop of Cahors came, might explain the phenomenon. In spite of the possible influence of Byzantine forms, Souillac states its Romanesque character by the display of massive walls in multiple planes.

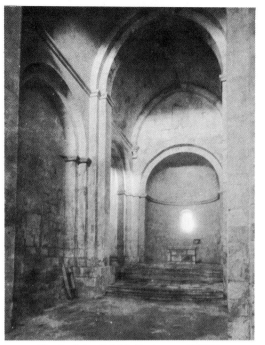

Fig. 84. Saint-Gabriel, Provence, mid-XIIth
century. **Nave**

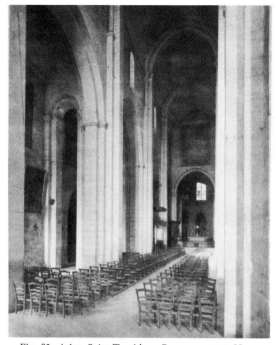

Fig. 85. Arles, Saint-Trophîme, Provence, 1152. Nave

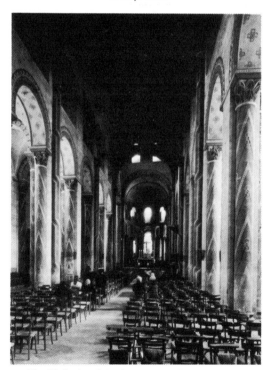

Fig. 86. Issoire, Saint-Austremoine, Auvergne, early
XIIth century. **Nave**

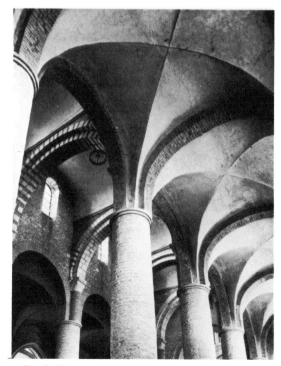

Fig. 87. Tournus, Saint-Philibert, Burgundy, 1028–1056,
vaults by 1120

Le Thoronet (fig. 82) is a Cistercian abbey in Provence, founded in 1136 but constructed in the middle of the twelfth century. Its chaste character, which is revealed in the cloister (fig. 18) as well as in the exterior and interior of the church (fig. 89), stems from the dictates of the Order of Cîteaux. The nave recalls the interior of Cistercian Fontenay (see figs. 9, 11). Le Thoronet's location in southeastern France, with its brighter light (as opposed to the darker Burgundian landscape), meant that less exterior light had to be admitted over the choir and in the apse. The apse also is different from the usual square-ended choirs of Cistercian churches. Instead of aisles vaulted with transverse barrels, as in Fontenay (fig. 10), Le Thoronet has three-quarter barrel vaults; the barrels spring from the outer walls and continue downward beyond their crowns toward the nave. These aisle vaults seem to be a Provençal regional development grafted onto the imported Cistercian format.

The third interior is the nave of Mont-Saint-Michel (1060's, fig. 83). The animated surfaces have no counterpart in Le Thoronet, while the repeated rhythms of the thin, tall bays are totally different from the low, square spaces of Souillac. Only four bays of the Norman nave remain (see fig. 4, a view of the exterior when the entire Norman church still existed). Norman interiors exhibit an extraordinary paradox. Articulated piers with half-columns extend up through the gallery and clerestory, and the matrix of the pier continues up to form an arch over each clerestory window. This construction would imply that the nave should be vaulted in stone, but all Norman naves were covered with wooden roofs (this one is modern) until the end of the eleventh century, when the Cathedral of Durham in England was vaulted with massive ribbed vaults, and until the early twelfth century in Normandy, when ribbed vaults were added to the two great churches at Caen. The nave of Mont-Saint-Michel reflects the rugged, military character of Norman architecture which can be seen in religious structures as well as in the typical Norman keep or donjon.

Although Saint-Gabriel and Saint-Trophîme at Arles (figs. 84, 85) have common characteristics, such as pointed barrel vaults and similarly articulated piers, they represent two different types of Provençal churches. Saint-Gabriel, situated in the midst of an olive grove eight miles north of Arles, has a single nave vessel (fig. 84), while Saint-Trophîme at Arles (fig. 85) has a taller nave lighted by clerestory windows and thin aisles vaulted with three-quarters of a barrel and strengthened by diaphragm arches behind each pier. The aisle vaults of Arles or a similar structure apparently influenced the construction of the Cistercian Le Thoronet.

It is often argued that these Provençal churches reveal the influence of neighboring Roman monuments, but the impact of antiquity is more clearly demonstrated in Provençal sculpture than it is in architectural forms (see Saint-Gilles, figs. 96, 97). Saint-Gabriel was constructed in the mid-twelfth century, and Saint-Trophîme was built in the second quarter of the century, the nave being completed by 1152. Saint-Trophîme reveals vague connections with Cluniac architecture, Cluny III and Paray-le-Monial (figs. 40, 41). This spread of Burgundian ideas down the Rhône Valley is synthesized with a Roman massiveness to form another kind of regional Romanesque architecture.

Issoire, dedicated to Saint Austremoine, the apostle of Auvergne, was constructed in the early twelfth century (fig. 86). The nave, flanked by aisles with groin vaults, is crowned by round barrel vaults which are buttressed by galleries capped by half-barrel vaults. In cross section and general design, Issoire is similar to the pilgrimage group of churches such as Conques to the south. Indeed, the dozens of Auvergnat churches are simplified versions of the pilgrimage plan and interior disposition. In Issoire, as in the majority of the Auvergnat churches, the engaged shafts, continuous with transverse arches under the barrel vault, are for the most part eliminated. In the view of the nave of Issoire the single transverse arch near the façade is invisible; yet the engaged shaft, which is further down the nave and supports nothing, tends to alter the rhythmical sequence of the bay. Four diaphragm arches, pierced by openings, sur-

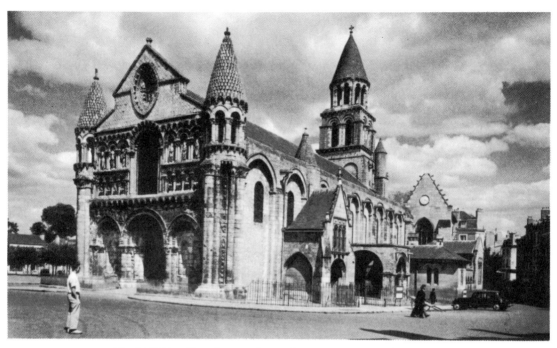

Fig. 88. Poitiers, Notre-Dame-la-Grande, Poitou, c. 1130. From the southwest

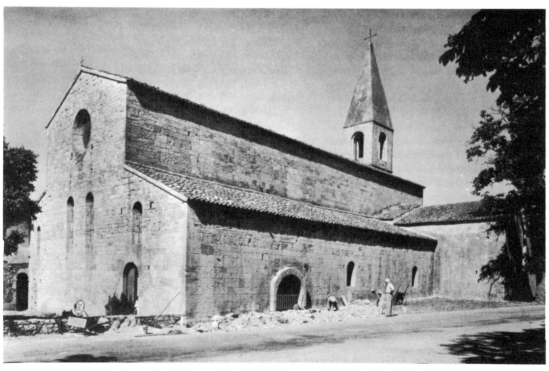

Fig. 89. Le Thoronet Abbey, Provence, mid-XIIth century. From the southwest

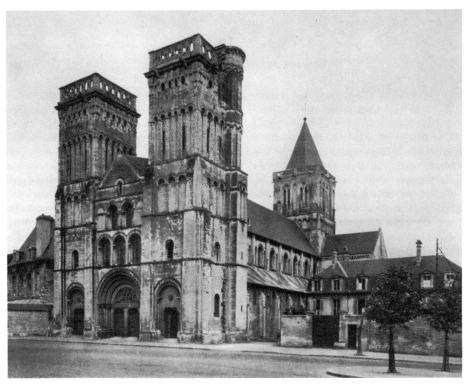

Fig. 90. Caen, Sainte-Trinité, Normandy, 1062 ff. From the southwest

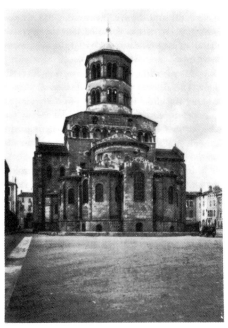

Fig. 91. Issoire, Saint-Austremoine, Auvergne, early
XIIth century. From the east

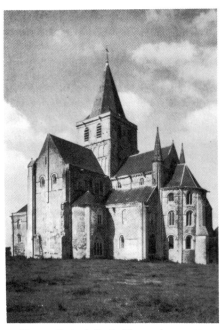

Fig. 92. Cerisy-la-Forêt, Normandy, c. 1100.
From the southeast

round the crossing and help sustain the tall tower (see fig. 91). The nineteenth-century painting which covers much of the inner surface of Issoire appears startling; yet perhaps the majority of Romanesque churches were painted originally.

Finally, the interior of the nave of Saint-Philibert of Tournus, in Burgundy (fig. 87), reveals an unusual type of vaulting. Between 1028 and 1056 the upper narthex of Tournus (see figs. 67, 68) and the outer walls, cylindrical piers, and aisles of the nave were constructed (see bibliography). In the early twelfth century, before the dedication of 1120, transverse barrels, rising from diaphragm arches, were erected over the nave vessel, allowing two clerestory windows in each bay. This vaulting system may be the source of the transverse barrels over the aisles in Burgundian Fontenay (see fig. 10). Spatially, the nave of Tournus has no counterpart in any other Romanesque building.

Exteriors of five churches (figs. 88–92) further point up the regional variety of French Romanesque. If Notre-Dame-la-Grande at Poitiers (early twelfth century, fig. 88) is contrasted with the Cistercian Abbey of Le Thoronet in Provence (mid-twelfth century, fig. 89), striking differences in surface and massing are evident. Poitiers has a pair of turret towers flanking the façade, which, in turn, is animated by arcades and an overlay of decorative and figured sculpture. Le Thoronet, with its unadorned surfaces, simple façade, and small crossing lantern, manifests the chaste puritanism of the Cistercian Order, while Notre-Dame-la-Grande at Poitiers is typical of hundreds of churches in western France which reflect the influence of the lavish court of Poitou. Although simple in plan and massing, these Poitivin churches cover their architectural simplicity with a profusion of sculpture.

Most Norman churches display elaborate façades with paired towers and large square lantern towers over the crossing. Queen Matilda's church at Caen, Sainte-Trinité (begun in 1062, fig. 90), reveals the same mural massiveness as seen in Mont-Saint-Michel. The tower portals lead into the aisles, while the larger, central portal, surmounted by three stories of windows and pedi-

mented roof, echoes the nave vessel. The articulated and animated surfaces without sculpture can be contrasted with the flat walls of Le Thoronet (fig. 89) and the profusely decorated Poitiers (fig. 88).

Finally, two exteriors of the apses of Issoire (Auvergnat, early twelfth century, fig. 91) and Cerisy-la-Forêt (Norman, early twelfth century, fig. 92) reflect two entirely different designs for the choir area. Issoire is typical of the Auvergne region, which lies southwest of Burgundy and west of the Rhône Valley. The radiating chapels, ambulatory, and choir are reminiscent of the pilgrimage group (Conques, fig. 35), but the aisleless transept climbs up through vaulted shoulders flanking the crossing to the octagonal tower. This unusual treatment of the crossing area, plus the coloristic volcanic stone, gives a regional individuality to these churches in the Auvergne, which reflects the fragmented authority of Romanesque times. In fortresses high in the mountains, the Counts of Auvergne defended their independence from the French crown until 1213, when Philip Augustus joined Auvergne to the royal domain.

In contrast to Issoire, the east end of Cerisy-la-Forêt (fig. 92) is less rounded and more severe. The nave projects eastward under the square lantern tower and is flat-ended. A three-story, rounded apse without ambulatory grows from the choir. The aisles terminate in squared-off chapels flanking the choir in echelon. Two-story chapels open off the east side of the transept. Many features of this typical Norman massing influence subsequent Early Gothic designs such as the Cathedral of Laon.

Marked regional differences may be discovered by traveling to the many exciting areas of France. The small ornate churches of Poitou-Saintonge, the domed structures of Périgord and other areas of western France, the Roman-inspired façades and vaulted naves of Provence, the mural, militant abbeys of Normandy, and the precocious churches of Burgundy, such as Cluny III, Paray-le-Monial, and Vézelay — all are varied aspects of the extraordinary creativity and diversity of Romanesque builders.

Romanesque Sculpture and Painting

ODAY it is difficult to comprehend the total significance of Romanesque sculpture and painting and their meaning and function for the peoples of the Middle Ages. Since sculptured portals and painted murals were found only in abbeys, priories, granges, and parish churches, since access to illuminated manuscripts was confined to monastic enclosures, and since illiteracy was dominant, it is easy to imagine that scenes from the Old and New Testament had an enormous, didactic impact on the populace. In an age in which everyone believed and life was oriented toward eternal salvation, the individual could discover the good Christian way and see the pitfalls of evil in the sculptural portals and murals. The full meaning of these depictions can be understood only within the context of the zealous spirit of the Medieval pilgrimage and the importance of Christianity in everyday life.

Romanesque sculpture is located on exterior portals such as Saint-Gilles-du-Gard (figs. 96–98), on inner narthex portals as at Vézelay (figs. 93–95), on piers in the cloisters of Moissac and Arles (figs. 102, 105), or on capitals in many parts of the monastery (see Anzy-le-Duc and Moissac, figs. 107–109). Traces of color on several portals suggest that originally Romanesque sculpture was polychromed. Frescoed paintings decorate crypt vaults and walls, chapels (Berzé-la-Ville, fig. 112), or nave vaults (see Saint-Savin, figs. 122, 123). Paintings in the manuscripts illuminated by monks in the scriptoria of monasteries (figs. 104, 113, 115) were available only to the minority who could read.

Most Romanesque sculpture is an integral part of the structure of the building. Instead of being applied or attached to the bearing wall as in Greek, Roman, or Renaissance architecture, the sculptural blocks are structural. Monumental figures and narrative scenes are not just architectural, in their relation to the building, but are also architectonic, vital sections of the working masonry.

The three portals inside the narthex of Vézelay in Burgundy, comprise one of the most impressive sculptural ensembles of this period. According to Adolf Katzenellenbogen's article (see bibliography) the large central portal (figs. 93–95) depicts the Ascension of Christ combined with the Mission of the Apostles. "Until the day when He was taken up, after He had given commandment through the Holy Spirit to the Apostles whom He had chosen" (Acts 1:2) sets the stage for Christ's role as Saviour of mankind through the teachings of the Apostles. The tympanum (fig. 93) shows Christ flanked by the Apostles. His power to save mankind (left side with quiet clouds and open books) and condemn (right side with stormy clouds and closed books) is clearly revealed, while the lintel, containing Lydians, Greeks, Africans, and others, manifests Christ's desire to preach the Gospel to all nations and convert all to Christianity. The trapezoidal compartments surrounding Christ and the Apostles contain the physically and mentally sick people who must be cured, while the archivolts, the double arch embracing the tympanum, emphasize the cosmic aspect of these events by containing the Signs of the Zodiac and Occupations of the

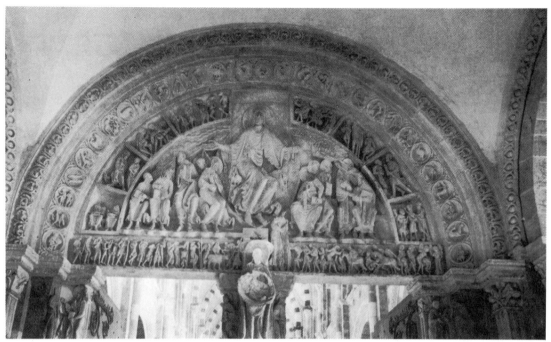

Fig. 93. Vézelay, 1120 ff. Central tympanum. "Mission of the Apostles"

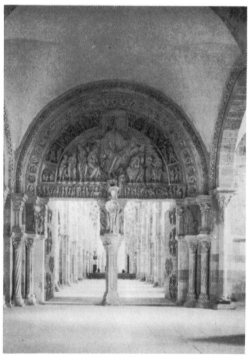

Fig. 94. Vézelay. Central portal

Fig. 95. Vézelay. Jambs, Peter and Paul

Months. Thus Christ is enthroned as the supreme ruler of space and time.

The side portals include the Adoration of the Magi, the Annunciation, the Visitation and the Nativity (south portal), and the Ascension and Christ's meeting with the Apostles on the road to Emmaus (north portal). The trumeau, supporting the lintel of the central portal (fig. 94), portrays John the Baptist, in emphasis of the fact that through Baptism one enters the Church, just as John had baptized Christ. On each side of the portal are pairs of Apostles conversing. Peter and Paul (fig. 95) are located on the right jambs.

In all probability this iconographical arrangement was established by Peter the Venerable, Prior of Vézelay between 1120, the year of the fire, and 1122, when he became Abbot of Cluny. Peter, a great theologian and authority on the Book of Isaiah, used Isaiah's prophecies for the content of the central portal.

According to Katzenellenbogen, the sculpture of Vézelay is also related to the Crusades. In 1095 Urban II, the Cluniac Pope, decided to launch the First Crusade from Vézelay, or Le Puy; yet the Council was actually held in Clermont-Ferrand. In his opening speech Urban urged the clerics to persuade all people to reconquer the Holy Land. Just as Christ had sent the Apostles forth to Christianize the world, so Christ's vicar, the Pope, should do the same. By 1099 Jerusalem was recaptured, and by 1132, when the sculpture was undoubtedly in place, the Holy Land was momentarily free from the infidel. However, by 1146, it was again necessary to take up arms against the Turks, and Saint Bernard launched the Second Crusade at Vézelay. The Vézelay portals thus reflect the First Crusade and prophesy the Second.

The Vézelay sculpture (figs. 93–95) exhibits a dynamic and nervous character. A northern intensity permeates all figures. Christ is pushed into the block with frontal chest, transfixed head, and thin legs suspended diagonally. Fluttering draperies animated by small folds and indentations further force up His dramatic and dominant position. The hierarchy of sizes, keyed to the hierarchy of importances, is accompanied by an increase in the amount of relief. Christ is the flattest figure; the flanking Apostles are more rounded to read against their background; while the small figures of lintel and side compartments are virtually in the round. The shift from flat relief to sculpture in the round set against a ground has the practical quality of making the sculpture more readable and meaningful.

At first glance, the tympanum (fig. 93) seems chaotic; yet close inspection negates this impression. The figure of Christ is centralized over the trumeau, pushed in a mandorla with head emphasized by the crossed nimbus and framed by the edges of the top compartments. These compartments are brought into harmonious relationship with the rest of the tympanum and lintel by the gradually shifting axis of the small figures. A kind of radiating geometry can be seen if the frames of the compartments are continued in straight lines into the tympanum. These subtleties of compositional design give order to the complexity of the subject matter.

Peter and Paul, on the right-hand jambs (fig. 95), epitomize the spiritual intensity of Burgundian sculpture. Peter with his keys, the founder of the established church, and Paul, the great preacher, are contorted anatomically and animated by swirling folds of garments. In spite of the actual and implied movement, the Apostles fit in and are a part of the architectural shape of the jambs.

Originally the tympanum and lintel were planned to rest on short pairs of columns (fig. 94), and the John the Baptist stood just above the pavement. However, during the course of its creation, the entire portal was elevated by inserting the side, jamb Apostles and raising the John the Baptist above a new trumeau (see bibliography: Salet). This transformation of the portal accounts for the confusion caused by the projection of John's head into the lintel (fig. 93).

In its encyclopaedic scope the Vézelay portals, together with the capitals in the nave and narthex (figs. 57, 59, 60), have a powerful effect on the sensitive visitor today. For groups of pilgrims gathered at Vézelay to start toward Spain or Jeru-

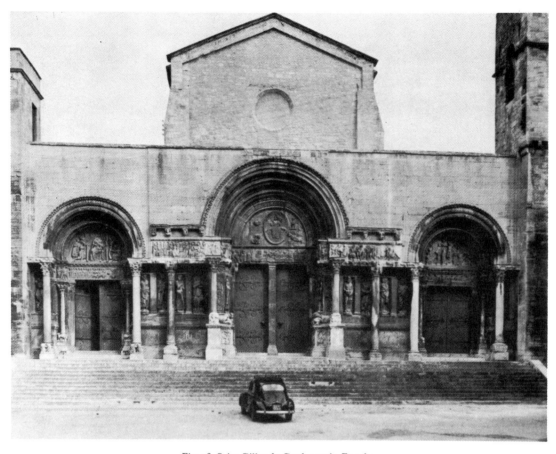

Fig. 96. Saint-Gilles-du-Gard, 1130's. Façade

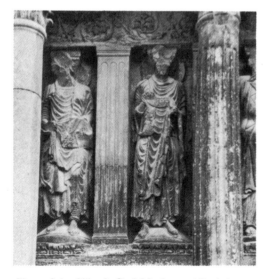

Fig. 97. Saint-Gilles-du-Gard. Matthew and Bartholomew

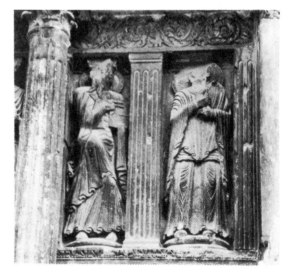

Fig. 98. Saint-Gilles-du-Gard. Thomas and James
the Less

salem in the twelfth century, the impact of this sculpture must have been even more vital and moving.

The largest exterior ensemble of Romanesque sculpture is the façade of Saint-Gilles-du-Gard on the edge of Provence (figs. 96–98). The superstructure of façade and nave was destroyed during the religious wars of the sixteenth century. Because of the abundant presence of Roman monuments, Provençal architecture and sculpture exhibit strong Roman influences (see nave of Arles, fig. 85). The design of Saint-Gilles resembles Roman triumphal arches similar to the arch in nearby Orange. Yet in contrast to Roman commemorative monuments with their added sculptures, the carved figures of Saint-Gilles are the modified frontal surfaces of blocks which support the portals and the façade.

The three portals of Saint-Gilles depict major events in the life of Christ. Twelve larger-than-life-size Apostles (figs. 97, 98) flank the central portal. The Virgin and Christ Child adored by the Magi occupies the left tympanum, while the Entry into Jerusalem decorates the frieze and lintel below. The upper frieze to the left of the central portal contains scenes such as Christ Cleansing the Temple and the Raising of Lazarus. The central tympanum, now modern, probably depicted the Last Judgement above the Last Supper, which is preserved in damaged condition on the lintel. The frieze continues to the right, with Christ being led before Pilate, undergoing the Flagellation, and Carrying the Cross. The final scenes of Christ's passion are located on the right portal; the Crucifixion is in the tympanum, and the Three Maries buying perfume and the Angel Appearing to the Maries after the Resurrection are on the lintel. Christ's life, His death, and His return in the Last Judgement are all clearly visible as one approaches and enters the church.

The carving of this enormous project involved many sculptors and began perhaps as early as the late 1120's, but certainly by the 1130's. Many scholars place the date of the façade construction much later, in the late twelfth and early thirteenth centuries. There seem to be no valid reasons for

this assumption, while considerable evidence exists to support the earlier dating. The iconographic programing of the façade was controlled by the clergy. The depiction of the Crucifixion, a rare subject in Romanesque sculpture, and the prominence accorded the Last Supper reflect possibly the strong stand taken by the monastery against an heretical group led by Peter of Bruys, who had denied the validity of the Mass. To emphasize his feelings, he and his colleagues stole the wooden crosses from Saint-Gilles, and on Good Friday they roasted meat in front of the abbey over a fire made of the crosses. A few days later the Church replied, and Peter and his companions were burned as heretics on the same spot. These events may have taken place as early as 1126 and as a result may have influenced the selection of some of the subjects on the portals.

Much evidence in the actual construction of the portals leads to the conclusion that the design changed as work progressed. Blocks of stone were inserted under the small columns flanking the side portals and under the monumental figures across the entire façade. Like the portal of Vézelay (fig. 94), the façade was heightened to accommodate the revised and more extensive iconographical program in the lintels and tympana (see bibliography: Salet). This empirical or trial-and-error approach is typical of Medieval architecture and sculpture.

At least six sculptors carved the twelve Apostles and two angels. Several of the six were then responsible for large sections of the tympana, lintels, and friezes in the superstructure. The large Apostles, like Saints Matthew and Bartholomew (fig. 97), have a lithic massiveness resminiscent of Roman sculpture; yet they are part of the thick blocks behind them and are pushed back between pilasters. Their disjointed articulation is typically Romanesque. In spite of Roman costume and vague references to pagan forms, these Apostles cling to the wall as bold, Christian heroes. The Matthew and Bartholomew are, however, vastly different from the thin, contorted, and animated Saints Peter and Paul of Vézelay, in Burgundy (fig. 95). The classical heaviness of the Saint-Gilles

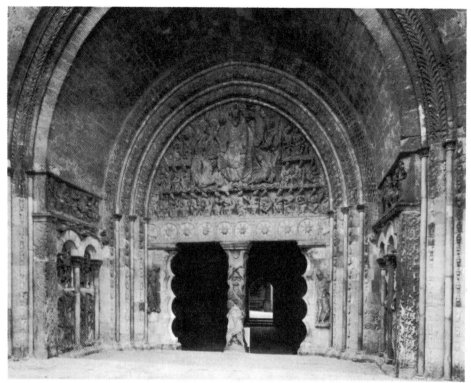

Fig. 99. Moissac, 1115 ff. South portal

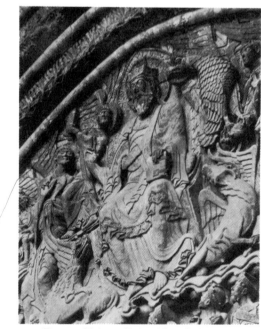

Fig. 100. Moissac. Christ of Last Judgment

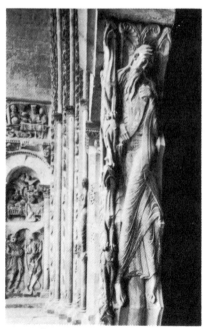

Fig. 101. Moissac. Trumeau

figures possesses none of the nervous linearism of the jambs of Vézelay. The Vézelay Peter and Paul reflect the northern point of view extending back to Irish and Anglo-Irish illuminated manuscripts of the eighth century, while the two Apostles of Saint-Gilles represent the Provençal Christian interpretation of Roman antiquity.

The adjoining Apostles at Saint-Gilles, Saints Thomas and James Minor (fig. 98), were obviously carved by a different sculptor, who was only slightly influenced by Roman art. The Thomas (on the left), with disjointed pose and drapery of flat folds and hems of repeated S-curves, was sculptured by an artisan from southwestern France. The work of several distinct personalities can be found in the other monumental statues as well as in the narrative sculpture on the superstructure of the façade. The entire program seems to have been conceived by the clergy, with six to eight sculptors and their assistants involved in the creation of the portals.

The most famous cloister and portal of southwestern France is to be found in the Cluniac Priory of Moissac, an important station on the route of Saint James. The sculpture of the cloister was carved by 1100, the tympanum of the portal by 1115, and the porches and trumeau in the 1120's. The portal is set inside a deep porch (fig. 99) and portrays the choice of good or evil and Christ's role as judge of the universe. The tympanum, depicting Christ in Majesty in His triumphant return to judge the world, is a literal transcription of the Apocalypse. Christ is seated on a throne, surrounded by the symbols of the four Evangelists, two angels, and the twenty-four Elders of the Apocalypse (fig. 100). On the front face of the central trumeau (fig. 99) are three pairs of adossed lionesses, climbing up the block in bold X-shapes. The sides of the trumeau contain Saint Paul and the prophet Jeremiah (fig. 101). The splays or inner sides of the porch portray the results of gluttony, luxury, and avarice on the left and the depictions of the Annunciation, the Visitation, and the Adoration of the Magi on the right.

The Moissac Christ bears some similarities to the Christ of Vézelay (fig. 93). Both are seated pre-

cariously on elaborate thrones with flattened bodies that deny corporeal existence and emphasize their spiritual, otherworldly presences. In spite of these general stylistic connections, the small, multiple folds of drapery of the Vézelay Christ are Burgundian and quite different from the large, flat folds and angular hems of the Christ of Moissac. Parallels in treatment of drapery exist between the Moissac Christ and the Saint Thomas of Saint-Gilles (fig. 98). Remnants of color can still be seen around the massive head of the Mossaic Christ.

The trumeau (fig. 101), a single block of stone, is one of the supreme examples of the architectonic treatment of animal and human figures. The crossed and interlocking lionesses point up the extensions of the northern barbarian animal style into the early twelfth century. This animal style, in various mutations, from southern Russia east to China and west to Ireland, lies behind Anglo-Irish manuscripts of the seventh and eighth centuries and contemporary Merovingian art on the Continent. This style of interlacing, entwining forms, possessing a nervous, non-Mediterranean and unclassical character, strongly affects Romanesque sculpture. The lionesses form scalloped profiles which are echoed in the concavities of the side jambs (fig. 101). Jeremiah is attenuated and contorted into a pose which repeats the scalloped shapes of both trumeau and side jambs. This distortion and dematerialization of form forces up the spiritual and psychological intensity of the entire trumeau.

Piers supporting monastic cloisters are another location often decorated with figured and ornamental sculpture (fig. 102, Moissac; fig. 105, Arles). The marble relief of Saint Bartholomew of Moissac is strongly reminiscent of funerary grave reliefs from Roman or Gallo-Roman times. The sculptural problem involves the ornamentation of a corner pier with a standing, low-relief figure. On all the corner piers and in the intermediate ones on each side of the cloister are reliefs similar to the Saint Bartholomew. The sculptor who carved this slab had in mind flat, grave reliefs with half-columns supporting an arch. Ro-

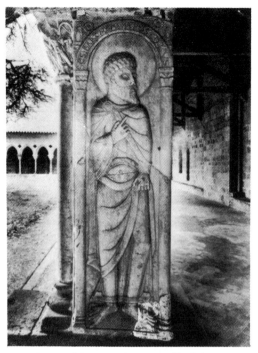

Fig. 102. Moissac, cloister, 1100. Bartholomew

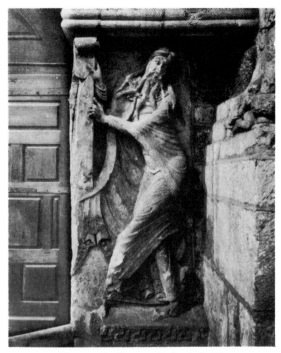

Fig. 103. Souillac, 1130's. Jamb, Isaiah

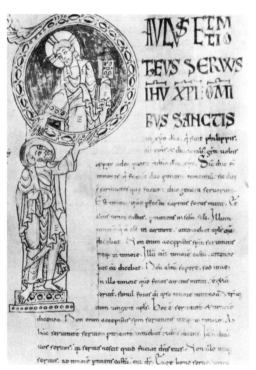

Fig. 104. *Commentary on Paul's Epistles*, 1086–1108
(Bibliothèque Municipale, Nîmes, Ms. 36)

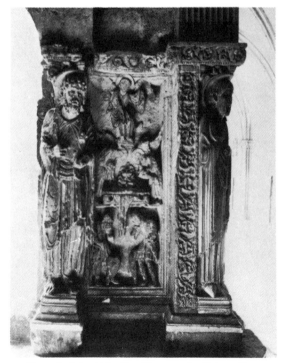

Fig. 105. Arles, Saint-Trophîme, 1140's. Cloister, Peter,
Saint Trophîme

settes fill the spandrels, following pagan custom. In contrast to Roman or crude Gallo-Roman reliefs, the Medieval sculptor is not concerned with any attempt at anatomical representation, but rather has flattened the figure into the block and animated it through gesture, position of head, and by a sensitive linear organization of the drapery. The figure seems to be hung on the block, rather than exerting a weight on the flared-out feet. A sense of power is expressed by this muted anatomy and extremely low-relief style.

The treatment of the northwest pier of the cloister of Saint-Trophîme at Arles (fig. 105) is much more elaborate when contrasted to the Moissac Saint Bartholomew. Architecturally, the Arles pier must support the barrel vault which covers the north gallery of the cloister. This barrel vault (fig. 17) is strengthened by transverse arches springing from capitals above Saint Peter on the left and Saint Trophîme on the right. Between Saints Peter and Trophîme is the low-relief of the Resurrection. The whole pier has three large figures and two relief panels, all integrated with the vaulting above. The Moissac piers supported a wooden roof (not the existing wooden roof), in contrast to the heavy barrel vault with transverse arches of the Arles cloister. Further, the Moissac pier was carved around 1100 in southwestern France, whereas Arles was created some thirty-plus years later in Provence.

The Saint Bartholomew of Moissac (fig. 102) and the reliefs in the ambulatory of the pilgrimage church of Saint-Sernin at Toulouse mark the beginning of monumental sculpture in southwestern France. If the Moissac pier of 1100 is contrasted with the tympanum of the portal of the same church carved some fifteen years later, a considerable stylistic evolution is evident. The Christ of the tympanum manifests a more dynamic handling of drapery and greater projections of the bodily forms from the background. Further, if the Moissac cloister relief is compared to the famous prophet Isaiah (fig. 103) from the nearby church of Souillac, carved in the late 1120's or early 1130's, there is an even more marked evolution of forms. The Isaiah at Souillac is a jamb figure

flanking the doorway. The scroll held by both hands and his twisting body fill the entire block. Halo and head with flowing beard complete the corner of the relief, while his feet, crossed legs, and windblown drapery animate the lower part of the relief. The sculpture has been transformed from a quiet, archaic stillness to an agitated, Baroque interpretation. This evolution of forms can be compared to the changing shapes of Romanesque architecture, such as the cloisters from different periods in the eleventh and twelfth centuries (figs. 76–79). The same direction from archaic, experimental simplicity to greater complexity can be seen in both the cloisters and the carved reliefs.

By a comparative study of the apostles Matthew and Bartholomew of Saint-Gilles (fig. 97) and the Peter and Paul of Vézelay (fig. 95), the Moissac Saint Bartholomew (fig. 102), the Souillac Isaiah (fig. 103), and the Arles reliefs (fig. 105), it is possible to observe contrasts between sculptures from three distinct regions of France. The two figures from Saint-Gilles, as well as the Arles pier, show an enormous debt to Roman art. Peter and Paul arguing on the jambs of Vézelay (fig. 95) portray the northern intensity of Burgundian art. In southwestern France we find another distinct style, but in this instance a style which is evolving. The simple, mural low-relief of the Moissac Saint Bartholomew changes into the more animated and nervously contorted tympanum and trumeau of the Moissac portal. The final stage of the development is the frenzied Prophet Isaiah of Souillac. Yet in spite of the dynamic movement found in both the portals of Moissac and Souillac, the way in which the drapery is rendered with emphasis on flat, ironed folds with pairs of lines separating major areas gives the sculpture from this region a different character from that of either Burgundy or Provence.

The basic dissimilarities between Provence and southwestern France can perhaps be seen best by studying a page from a manuscript in the Nîmes Library (Nîmes 36, fig. 104). This manuscript came from the Abbey of La Grasse, near Saint-Gilles, in Provence, and was written be-

tween 1086 and 1108. It is a Commentary on Paul's Epistles, composed of excerpts from the works of Saint Augustine. Since this manuscript was illuminated in Provence, connections in style between this page and the Apostles of Saint-Gilles and Arles (figs. 97, 105) should be expected. The treatment of the human form in terms of suggested anatomy, similar gestures, and related drapery exhibits family or regional relationships between manuscript and monumental sculpture. The date of this manuscript, plus the existence of others which were illuminated in the late eleventh or early twelfth century, is further evidence that the great façade of Saint-Gilles can be safely placed in the 1130's.

The largest amount of Romanesque sculpture consists of ornamental capitals on the interiors of monasteries (Anzy-le-Duc, fig. 107), capitals supporting arcades of cloisters (Moissac, figs. 108, 109), or capital and ornamental stringcourses which animate exteriors, such as the south transept window of Aulnay (fig. 110). Much of this sculpture is purely ornamental and consists of abaci or tops of capitals and moldings or cornices. Often, when figures are involved, the scenes have no religious significance.

The nave capital in Anzy-le-Duc (fig. 107), carved before 1100, depicts two bearded men wrestling or pulling each other's beards. On each side of the capital are two more men wrestling, while the two corners have bearded masks with tongues protruding and brows supporting the corner of the abacus above. The sculptural problem consists of the transition from half-column below to the square arch above (fig. 62, the nave of Anzy-le-Duc). The nonreligious and nondidactic nature of this capital leads to the following assumptions: (1) that the carvers were lay artists, (2) that the Romanesque mind took delight in things humorous and therefore possessed an artistic self-consciousness which is normally not associated with the Middle Ages.

The second capital, from Moissac (fig. 108), consists of pairs of lions whose feet embrace a male bust. These lions, with their necks arched back, become tangent to other lions on the flanking

faces of the capital. The structural and design problem involves the gradual transition from a pair of colonnettes to the rectangular, crowning abacus block from which springs the arcade. The stretched necks and forefeet join in the center of the capital, forming a kind of rosette. Indeed, the whole shape of the capital is the transformation of the Roman Corinthian or composite capital into a highly imaginative design consisting of lions echoing the shape of the acanthus leaves or scrolls and their forefeet forming the rosette often found in the middle of Roman capitals. Above the capital is the handsomely ornamented abacus block. It is the extraordinary quality of design of these Romanesque capitals that has captured the enthusiasm of many modern sculptors.

The capitals of Anzy-le-Duc (fig. 107) and Moissac (fig. 108) make one wonder what is the real significance ·of Saint Bernard's diatribe against the Cluniac Order, written to Abbot William of Saint Thierry. Saint Bernard, obviously writing from the point of view of the strict Cistercian Order, gave an incredibly sensitive interpretation of Romanesque sculpture; yet its meaning has often been lost to the modern reader. He wrote as follows:

> In the cloister under the eyes of the Brethren who read there, what profit is there in those ridiculous monsters, in that marvelous and deformed beauty, in that beautiful deformity? To what purpose are those unclean apes, those fierce lions, those monstrous centaurs, those half men, those striped tigers, those fighting knights, those hunters wielding their horns? Many bodies are there seen under one head, or again, many heads to a single body. Here is a four-footed beast with a serpent's tail; there a fish with a beast's head. Here again the fore-part of a horse trails half a goat behind it, or a horned beast bears the hind quarters of a horse. In short, so many and so marvelous are the varieties of shapes on every hand that we are tempted, to read in the marble than in our books, and to spend the whole day wondering at those things rather than meditating the law of God. For God's sake, if men are not ashamed of these follies why at least do they not shrink from the expense.

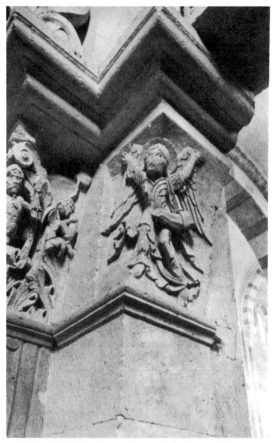

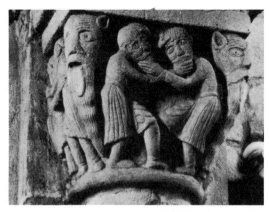

Fig. 107. Anzy-le-Duc, late XIth century. Nave capital

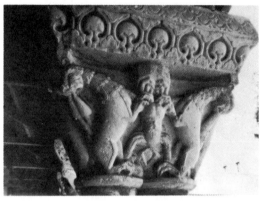

Fig. 108. Moissac, 1100. Cloister capital

Fig. 106. Vézelay, 1120 ff. Detail of right portal

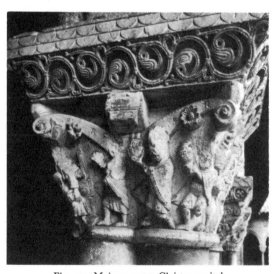

Fig. 109. Moissac, 1100. Cloister capital,
"Adoration of Magi"

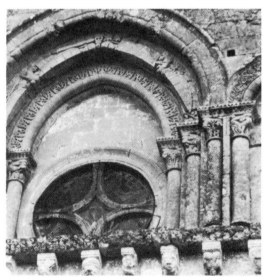

Fig. 110. Aulnay, 1130's. Window of south transept

As Meyer Schapiro has clearly demonstrated (see bibliography), Saint Bernard merely condemned these capitals because they represented to him an attitude competing with the contemplative spirit of his own strict Order. The existence of this diatribe, on the other hand, indicates the presence of a real sensitivity among laity and clergy in Romanesque times as well as differences of opinion about the use and focus of this sensitivity.

About half the capitals in the Moissac cloister deal with religious subjects. In the Adoration of the Magi (fig. 109), the Virgin and Christ Child and one Magus appear on the left, while the other two Magi occupy the convex shape on the right side. In order to balance the face of the capital and to imply movement to the left, two rosettes appear above the Magi, representing the stars which led them toward Bethlehem. Small, squat figures project out from the ground of the capital. Folds of drapery are repeated, and the rhythmic placement of feet forces up the action of the procession. Like the ornamental capital of Moissac (fig. 108), this one preserves the format of the Roman-Corinthian or composite capital. Above the heads of the Magi are abstracted scrolls which strengthen the corners of the capital. In the middle of each face of the capital is a rectangular projection where the rosette of the pagan model would normally be found. The three Magi bearing gifts thus approach the Madonna and Christ Child within the formal framework of a pagan capital. All references to locale and environment have been eliminated, and the main protagonists are given emphasis by their projection from the convexity of the block. At the same time, the figures and their placement reinforce the architectonic role of the capital as an integral part of the whole structure of the cloister. The Virgin and Christ Child emphasize the corner of the capital; yet their position beneath the tight volute of the tangential scrolls and the axis of the three Magi give this scene a forceful simplicity. In the ornamental abacus above (fig. 108), the fine quality of Romanesque ornamental carving is clearly portrayed. Crisp, undulating vines give off tightly rolled leaves which fill the center of each oval,

while secondary leaves animate the space between.

The capital above the jamb of the right portal in the narthex of Vézelay contains an angel with outstretched arms (fig. 106). This block was probably added to the portal at the same time that the central portal was raised in height. Some critics have interpreted the subject as an angel of the Last Judgement because of the oliphant suspended from the angel's shoulder; others see a connection with the Annunciation, Nativity, and Adoration of the Magi in the lintel and tympanum above and claim the angel is announcing the joy of the coming of Christ (see bibliography). Halo, raised arms, wings, and fluttery drapery cover the block, while the main axis of right leg, body, and head accents the convexity of the jamb. The dynamic and frenzied movement is Burgundian in spirit when contrasted with the more placid forms of the Moissac capitals in southwestern France (figs. 108, 109).

On the exterior of the south transept of Aulnay, in western France, is a handsomely ornamented transept window (fig. 110). An ornamental stringcourse of acanthus leaves, supported by corbels of masks, acts as the base of the window. Short columns with floral capitals and ornamented abaci make up the springing for the arches surrounding the window opening. In the middle arch or archivolt are four knights holding shields. The shields, resting on or piercing monsters, are bent at right angles to carry out the architectural role of the convex archivolt. The human form is broken and contorted to fit an architectural context. This purely ornamental sculpture is found on many Romanesque structures but is in greatest abundance in western France.

The extraordinary homogeneity of Romanesque art is clearly revealed by a comparison of four depictions of Christ in four different media: a sculptured Christ at Vézelay (fig. 111), a frescoed Christ at Berzé-la-Ville (fig. 112), a manuscript from Limoges (fig. 113), and an enameled Christ in the Musée de Cluny in Paris (fig. 114). The enamel dates from the middle of the latter half of the twelfth century, while the other three can be placed in the early years of the twelfth century. All

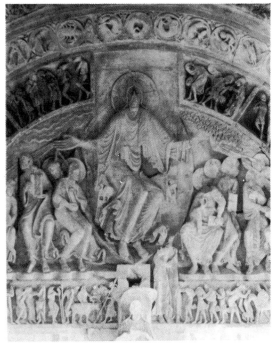

Fig. 111. Vézelay, 1120 ff. Christ and Apostles

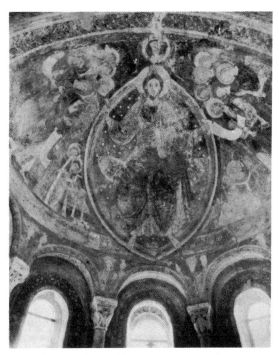

Fig. 112. Berzé-la-Ville, grange, c. 1100. Christ
and Apostles

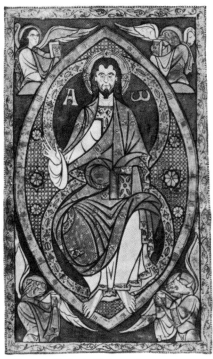

Fig. 113. Christ in Majesty. *Sacramentary of
Saint-Étienne at Limoges,* about 1100 (Bibliothèque
Nationale, Ms. Lat. 9438, fol. 58v)

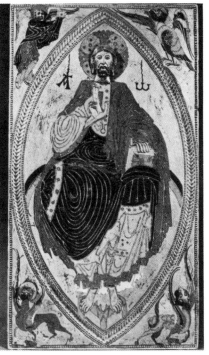

Fig. 114. Christ in Majesty. Enamel, c. 1175
(Paris, Musée de Cluny)

four interpretations of Christ portray the same attitude toward the human form: the body is dehumanized and flattened by repeated lines which drain the forms of physical substance. The difference in media affects the manner in which the forms are rendered; yet in all four a similar point of view exists. Frontal poses, elongated bodies, and small heads, intensified by staring eyes, emphasize the visionary nature of the Romanesque spirit. The hieratic poses and strong silhouettes impart a feeling of profound spiritual conviction.

The sculpture of the Vézelay tympanum (of which fig. 111 is a detail) has already been discussed. This closer view gives a clearer concept of the dynamic animation of the windblown drapery. The upper part of Christ's body is flattened into the mandorla, the symbol of eternity. In spite of the zigzag positioning of the lower part of His body, the axis of the whole tympanum remains strictly frontal and balanced. The overlay of linear convolutions and spirals gives the figure an epic energy.

Seven miles from the famous Abbey of Cluny, in Burgundy, lies the little dependent grange of Berzé-la-Ville (see fig. 25 for exterior view of the chapel). Inside the chapel of this grange are the finest extant Burgundian mural paintings (figs. 112, 116). Christ in Majesty surrounded by the twelve Apostles is depicted in the semidome of the apse (fig. 112). Christ is seated on a throne inside the almond-shaped mandorla; He is blessing Saint Paul with His right hand and giving a scroll to Saint Peter on His left. In style, this fresco reflects the huge mural which once decorated the choir vault of Cluny III; but instead of depicting Christ and the symbols of the four Evangelists, the Berzé-la-Ville mural includes the twelve Apostles. Several critics believe that the specifically Roman theme of Christ accompanied by the twelve Apostles suggests a strong relationship between the monks of Cluny and the Holy See in Rome. Saint Hugh gave specific donations to this grange and often used it as a retreat.

On the spandrels below the semidome are sainted virgins and martyrs holding lamps, and around the base are nine half-length figures of saints. The martyrdoms of Saint Blaise and Saint Lawrence, or perhaps Saint Vincent (fig. 116), are depicted within niches on the sides of the choir.

The Berzé-la-Ville muralists painted figures in reds, greens, purples, and whites against a blue background. The dark blue sets off the figures in warm tonalities. The figure of Christ has the same monumental, frontal pose as does the Vézelay Christ; yet the garments are treated somewhat differently, especially around the legs. In the fresco the overgarment, stretched across the legs, reveals the knees. This marked articulation is reminiscent of Byzantine art, and it is because of this characteristic that a critic recently dated these murals toward the middle of the twelfth century, when a strong Byzantine influence invaded western Europe. There are, however, manuscripts such as the Lectionary of Cluny (fig. 115), dated around 1100, that show this same Byzantine flavor which penetrated France directly from Italy or via Ottonian Germany. The marked stylistic connections between the carved Vézelay Christ and the Berzé-la-Ville murals, both Burgundian, reflect the strong regional style which transcended differences of media.

The other two depictions of Christ — one manuscript, one enamel — have identical iconography: Christ in Majesty in a mandorla surrounded by the symbols of the four Evangelists. The Sacramentary of Saint-Étienne of Limoges, approximately 1100 (Bibliothèque Nationale, Ms. Lat. 9438, fol. 58v: fig. 113), reveals a two-dimensional attenuated Christ. The illumination of the rectangular page of a manuscript presented a different design problem than did the decoration of a semicircular tympanum or the semidome in an apse. The Romanesque scribe in the monastic scriptorium has resolved this design problem by placing the Christ against an elaborate ground, surrounded by a figure-of-eight border and the almond-shaped mandorla. The patterned ground further flattens the figures. As in the fresco, the figures are painted in deep reds and whites against a blue background. Yellow and orange animate the mandorla and borders of the manuscript. In contrast to many Romanesque manuscripts, the

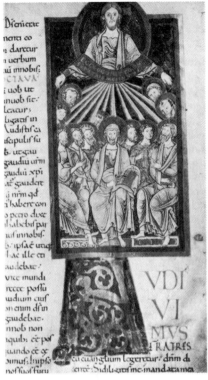

Fig. 115. Pentacost. *Lectionary from Cluny,* late XIth century (Bibliothèque Nationale, Ms. Nouv. Acq. Lat. 2246, fol. 79v)

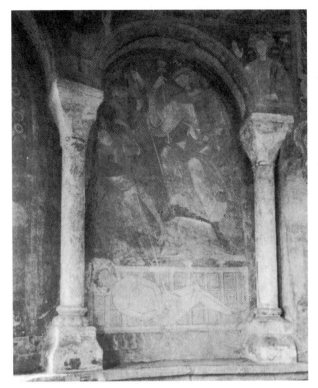

Fig. 116. Berzé-la-Ville, grange, c. 1100. Martyrdom

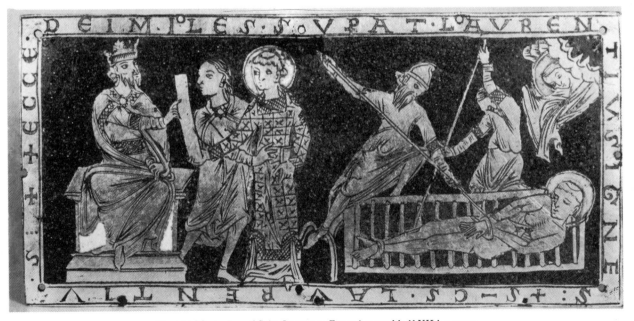

Fig. 117. Martyrdom of Saint Lawrence. Enamel, second half XIIth century, 3 3/4 in. by 8 3/16 in. (The Cleveland Museum of Art)

colors are rich and harsh. Forms suggest, as critics have noticed, an affinity with Ottonian art as well as with Byzantine. The impact of the Second Golden Age of Byzantine art can be found in many parts of Europe in the middle of the twelfth century but seems to have influenced Burgundy and central France early in that century.

The enamel in the Musée de Cluny in Paris (fig. 114) is one of the finest of the twelfth century. The figures exhibit many similarities with the three Christs just discussed. The composition is almost identical to that of the manuscript from Limoges. The technique is champlevé enamel, which involves cutting troughs or gouges in the copper plaque and filling the interstices with a vitreous compound, hardened by being fired in a kiln. This magnificent enamel is unusual because of the richness of blues and greens in the mantle and white, red, pale blue, and green in the undergarment over Christ's feet. The same color combinations decorate the symbols of the four Evangelists, which fill, in a typical Romanesque manner, the four corners flanking the curved mandorla. The figures are built by curving ridges of copper which indicate knees, legs, and arms but reveal little interest in three-dimensional forms. As in so many enamels, the five heads were cast separately and added to the plaque, and hands and feet are raised and gilded. The difference between relief of heads, hands and feet, and the flat bodies further emphasizes the disembodied nature of the forms.

Many of these enamels were made in Limoges, the major center of their manufacture in France. The marked similarities between many Limoges enamels and the Limoges manuscript (fig. 113) have suggested the possibility that this manuscript served as model. The provenance of this enamel has normally been assigned to Limoges; there is, however, some evidence that it might have been made in Spain, but by a French artisan.

These four depictions of Christ, in spite of differences of material (stone, plaster, parchment, and enamel), reflect the amazing, consistent homogeneity of Romanesque art. Line, whether carved or painted, imparts a powerful and nervous dehumanized spirituality.

Further cross references in style may be seen if a Cluniac manuscript and a detail from the murals of Berzé-la-Ville are compared. The Pentacost from the Lectionary of Cluny (Bibliothèque Nationale, Ms. Nouv. Acq. Lat. 2246, fol. 79v: fig. 115) is one of the rare yet mutilated manuscripts saved from the large scriptorium of Cluny, and it exhibits marked stylistic similarities to the martyrdom of Saint Vincent or Saint Lawrence of Berzé-la-Ville (fig. 116). The manuscript was written and illuminated before Abbot Hugh's death in 1109, and the frescoes of Berzé-la-Ville were painted soon after 1100. The manuscript has even more specific connections in style with the figure of Christ on the semidome of Berzé-la-Ville (fig. 112). The arrangement of draperies over the legs is identical in both the manuscript and mural. The heads of the Apostles, especially the treatment of hair and beards in manuscript and fresco, show marked resemblances. Long, thin hands with pointing second fingers and zigzag treatment of undergarments across the chests of the Christs and Apostles are apparent in both. Colors of the fresco and manuscript page are similar: blues, red ochres, gray-greens, and purple against a blue background. So analogous in style are the murals and the manuscript that they must be contemporary. It is tempting to suggest that the same artist worked on the monumental murals and in the scriptorium of Cluny.

The strong schematic folds of the Pentacost scene in the manuscript and the Martyrdom of Berzé-la-Ville (fig. 116) suggest the abstract articulation of form of Byzantine art. The fact that Abbot Hugh was the godfather of Henry IV of Germany and that strong ties existed between Cluny and the German Emperor is perhaps the basis for discovering Ottonian-Byzantine influences on Burgundian art. Abbot Hugh had been at Canossa on January 28, 1077, when Pope Gregory the Great agreed to receive the Emperor of Germany. On the other hand, contacts between Cluny and Italy, especially between Cluny and Monte Cassino, had always been close. Whether the Byzantine influence traveled across the Mediter-

ranean and through Italy to Burgundy, or whether it came up the Danube and through the Ottonian empire, both manuscript and murals show the impact of Byzantine ideas, transforming the Romanesque art of Burgundy into a style in which drapery gives the figures an anatomically articulated character.

The Martyrdom of Saint Vincent or Saint Lawrence (fig. 116) shows the compositional sensitivity of the Romanesque muralist. The artist is given a space framed by columns supporting an arch. The martyred figure fills the lower part of the space. The grill, on which he is being consumed by flames, is tipped upright to reveal the nude body of the saint. The Roman legate is seated on a throne holding a sceptre in his right hand while pointing to it with his left. His bending pose acts out the curvature of the arch, just as the silhouette of his back and head, as well as the globe of the sceptre, echo the same curve. The backs and heads of the executioners repeat the shapes of column, capital, and arch. Like the Prophet Isaiah at Souillac (fig. 103), this scene fills the entire space and echoes the outer frame. The total composition is harmonized by the play of diagonals of the staffs repeated by the linear paralleling of the legs of all three figures. Space is implied by overlapping forms. All figures are silhouetted against the blue background. Outlines are in red ochre, while garments are purple, blue-violet, or gray-green. The sense of dramatic movement is intensified by linear repetition in the drapery pulled across the thighs. The dynamic gestures of hands and the intense concentration of the gazes of the figures further force up the drama of the event.

The champlevé enamel plaque in the Cleveland Museum of Art (fig. 117) depicts the Martyrdom of Saint Lawrence and offers a fascinating contrast in composition with the Berzé-la-Ville martyrdom. The horizontal plaque is divided into two scenes: the sentenced Saint Lawrence being led away from the prefect and, with hands tied, held on the grill to suffer martyrdom. This enamel dates from the third quarter of the twelfth century and would seem to be of Saxon or Mosan

origin. Figures stand out against the flecked champlevé ground just as the Berzé-la-Ville figures are revealed against their blue ground. In the left half, the vertical arrangement of figures, with subtle gestures and suggested movement from left to right, is in marked contrast with the diagonal interlocking of the two executioners holding Saint Lawrence on the grill. If the spaces between figures are analyzed, there is an amazing balance between the passive and active sides of the plaque, a balance which suggests a refined sensitivity to the interplay of forms in space.

The most complete preserved synthesis of architecture, sculpture, and painting in French Romanesque art is the abbey church of Saint-Savin-sur-Gartempe, a few miles east of Poitiers (fig. 118). An extensive painting program, together with the sculpture of carved capitals inside a fine Poitevin church, affords the opportunity of studying Romanesque art as a total visual experience. The porch and its tribune gallery above, the barrel vault of the nave, the transept, choir, and radiating chapels, and the crypt were all frescoed after 1100. Today only the porch and its gallery, the nave, and the crypt, preserve their original painted surfaces.

The church of Saint-Savin is one of the earliest of Poitevin Romanesque (figs. 118–121). The lower part of the central west tower was completed around 1060, while the entire east end, including the transept, was probably finished by 1075. In another building campaign the first three, western, bays of the nave were vaulted between 1075 and 1085. At that time, the rest of the nave was probably surmounted by a wooden roof. A new campaign completed the barrel vault of the nave over the six eastern bays around 1115.

The handsome east end of Saint-Savin, with its ambulatory and five radiating chapels, piles up to the rugged, square crossing tower (figs. 118, 119). From the west side, the Romanesque porch, with its fourteenth-century Gothic spire, adds another vertical accent. Inside (figs. 120, 121) one is impressed by the slenderness of the nave as well as by the thinness of the supporting columns. The first three, western, bays have quatrefoil piers and

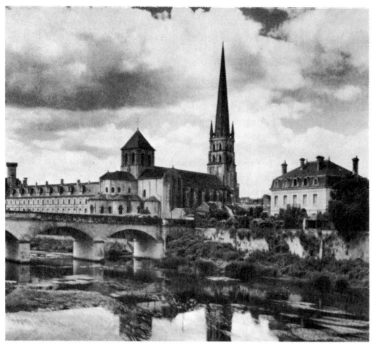

Fig. 118. Saint-Savin-sur-Gartempe, c. 1060–1115. From the east

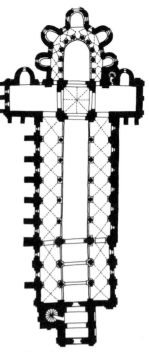

Fig. 119. Saint-Savin-sur-Gartempe. Plan

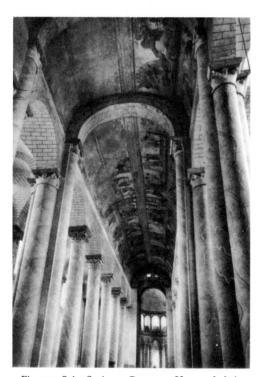

Fig. 120. Saint-Savin-sur-Gartempe. Nave and choir

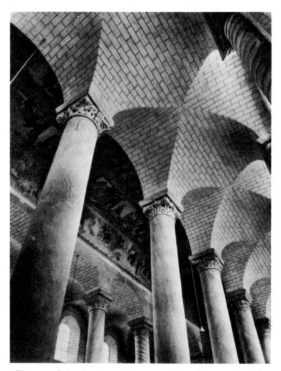

Fig. 121. Saint-Savin-sur-Gartempe. Nave from south aisle

transverse arches across the vaults, while the remaining bays have columns and capitals, but no transverse arches. The side aisles are vaulted with groin vaults which allow light to infiltrate the nave from a high level (fig. 121). Light reflected from vaults, piers, and pavement makes the paintings visible and readable. Burgundian churches such as Cluny III and Paray-le-Monial had murals only in the semidome over the choir and in lower chapels, but never along the vaults of the nave because light patterns from clerestory windows would have interfered. The interior of Saint-Savin, with its narrow nave dominated by the painted barrel vault, is a symphony of color — the color of the stone itself interacting with the painted columns and the painted ceiling.

Upon entering Saint-Savin (fig. 120), one is struck by the cohesive compositional arrangement of the frescoes. Steps lead down into the porch, which is decorated with the Second Coming of Christ and two rows of Apocalyptic scenes. After descending more steps, one enters the nave. Above are scenes from the Old Testament in four panels which progress toward the semidome of the choir. The choir originally contained Christ in Majesty and the symbols of the four Evangelists. In the nave the Old Testament scenes are arranged in long, thin panels. The story of the Creation is depicted in the northern side of the west bays and carries into the north half of the eastern bays with the stories of Abel and Noah. Scenes of the main events of the life of Noah then lead backward toward the façade in the south or right-hand half of the vault, followed by the building of the Tower of Babel, scenes from the lives of Abraham and Joseph, and finally Moses receiving the tablet of the Law and the cycle in the easternmost section of the nave vault. Thus the nave frescoes include Old Testament scenes up to Mount Sinai and prepare the visitor for the New Testament revelation which originally decorated transept, ambulatory, and chapels. To complete the whole iconographical arrangement of the church's architectural spaces, the tribune over the porch preserves scenes from the Passion of Christ, including the Descent from the Cross. Paintings in the crypt portray events in the lives of local Poitevin saints.

Technically, the murals of Saint-Savin (figs. 122, 123) are not true or buon fresco on wet plaster, but were painted on old plaster which was dampened just before the paint was applied. Certain areas, such as the pupils of the eyes and other facial delineations, were added after the wall was completely dry. Since this technique did not allow the paint to penetrate into the plaster, some details have vanished. In contrast to many frescoes, in which the cartoon or general outline of the major forms was transferred to the plaster with a metal point which indented the plaster, the painters at Saint-Savin drew the major silhouette lines directly on the vaults in reddish lines. This freehand drawing gives the entire mural a freshness and spontaneity. The colors are for the most part earth tones: red ochre, yellow ochre, green, and occasionally some black.

The size of figures in the Saint-Savin murals depends entirely on their location. In the paintings in porch, gallery, and crypt, the figures are relatively small because of the intimate relationship between observer and mural. The height of the nave vault, over 50 feet, demands figures in a much different scale if the mural is to be readable from the pavement. The clear outlines of architecture, figures, and trees in reddish color against the off-white background, together with the flat areas of color within the silhouettes, help give each individual scene a readable clarity.

Architecture, both structural and painted, unifies the murals of the nave. Transverse arches in the three western bays physically divide the scenes (figs. 119, 120). The muralist then painted an ornamental, transverse arch two bays to the east of the easternmost structural arch. From this point on, trees and other elements were introduced to lend similar separation of the major subjects in sequence toward the choir. As they unfurl, scenes have the character of a continuous series of events and thus are reminiscent of the Bayeux Tapestry, which was embroidered at about the same time.

One of the most dramatic moments in the cycle can be seen clearly from the south aisle (fig. 121). The artist has depicted the moment when

Fig. 122. Saint-Savin-sur-Gartempe. "Drunkenness of Noah"

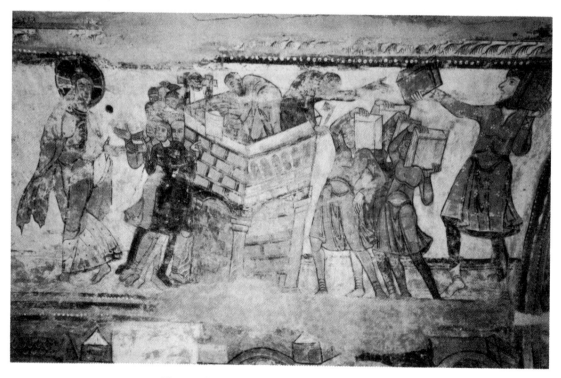

Fig. 123. Saint-Savin-sur-Gartempe. "Tower of Babel"

the Red Sea engulfs the Egyptian chariots as they pursue the Hebrews. Two scenes have been selected for more detailed discussion because of their good state of preservation and because they reveal the character and style which gives Saint-Savin its quality. The first depicts the Drunkenness of Noah (fig. 122). The action takes place in front of a walled town with roofs of houses appearing above. On the left, four women are emerging from a city gate and are expressing astonishment with fixed stares and bold gestures. In the right two-thirds of the scene are the three sons of Noah: Ham, on the left, and the other two sons, Shem and Japheth, covering the naked body of their father. The location of the sons and Noah within a tent is indicated by the flat areas of color behind each of the three sons and by the canopy of the tent over the middle. It is clear from a reading of Genesis that the Saint-Savin painter took great liberties in interpreting this event. Genesis 9:20 reads:

> Noah was the first tiller of the soil. He planted a vineyard; and he drank of the wine, and became drunk, and lay uncovered in his tent. And Ham, the father of Canaan, saw the nakedness of his father, and told his two brothers outside. Then Shem and Japheth took a garment, laid it upon their shoulders, and walked backward and covered the nakedness of their father; their faces were turned away, and they did not see their father's nakedness. When Noah awoke from his wine and knew what his youngest son had done to him, he said, "Cursed be Canaan; ..."

The painters or the clergy have selected the moment when the brothers are covering their father. But when Noah planted a vineyard, there was no town nearby, and the brothers are not turning away from their father's nakedness. Instead, Ham is pointing to his father. Further, in the passage from Genesis, there is no mention of the four female figures, who are probably the wives of Noah and his sons. The Romanesque painter thus took many liberties in his interpretation of the text in order to fill the rectangular panel.

Space is suggested and implied by overlapping planes and shifts of sizes. The women appear to have just come out of a gate; yet their heads overlap the lintel of the door, which in turn becomes the top of the city wall and cuts off large and more distant small houses. The strength of the lines defining the buildings is the same, whether the house is in the distance or near the wall. Figures and architecture are set against either the neutral background or flat-colored areas. The front plane is thereby maintained and reinforced. Ham's right foot overlaps the gate in emphasis of the drama of the discovery. The arbitrary horizontal lines of alternating red and yellow-orange under their feet, plus the three panels of green, brown, and green behind the three sons, imply a three-dimensional space, but preserve the flat murality of the vault. Space seems to climb; yet the position of feet and the inclination of the wall suggest the concavity in which the action is taking place.

The figures are delineated by strong, wide silhouette lines and equally broad contour lines. The quality of the lines is completely consistent with the action of the figures. The slow, majestic movement of the foremost female is quite different from the sinuous agitation of Ham. Between the silhouette and the contour lines, color is applied in flat areas. No attempt has been made to suggest modeling through changing hues or intensities. When the painter wished to imply shadows, contour lines were merely repeated in the same hue. The freshness of the poses, especially of Ham and his brothers, plus the stagelike gestures, gives this scene its appealing expressiveness.

The other panel portrays the building of the Tower of Babel (fig. 123). Again, the person who thought out the design has taken great liberties with the biblical text. Groups of people are constructing a tower out of big blocks of stone, not bricks. Free-standing columns with capitals and arches reflect in shape and ornamental surfaces the interior of the nave of Saint-Savin (figs. 120, 121). Two small people on top of the tower put stone blocks in place, while four larger ones approach with more blocks. The whole group to whom the Lord is speaking fills the left side of the scene. Genesis 11:1–10 reads as follows:

Now the whole earth had one language and few words. And as men migrated in the east, they found a plain in the land of Shinar and settled there. And they said to one another, "Come, let us make bricks, and burn them thoroughly" and they had brick for stone and bitumen for mortar. Then they said, "Come, let us build ourselves a city, and a tower with its top in the heavens, and let us make a name for ourselves, lest we be scattered abroad upon the face of the whole earth." And the Lord came down to see the city and tower, which the sons of men had built. And the Lord said, "Behold, there are one people, and they have all one language; and this is only the beginning of what they will do; and nothing that they propose to do will now be impossible for them. Come, let us go down, and there confuse their language, that they may not understand one another's speech." So the Lord scattered them abroad from there over the face of all the earth, and they left off building the city. Therefore its name was called Babel, because there the Lord confused the language of all the earth; and from there the Lord scattered them abroad over the face of all the earth.

The tower is used to divide the panel visually and to suggest the lapse of time between the two parts of the event. But it is being built of blocks of stones, carried with difficulty by four figures and with remarkable ease by the large right-hand figure. The latter is obviously enlarged to balance the Lord on the left. The graceful movement of the figures approaching the tower, as well as the motion of the flowing garments and twisted pose of the Lord, points up the dramatic quality which the Saint-Savin painter achieves within the limited syntax of line and flat color. Space throughout this panel is again implied by planes of flat color piled one on top of the other in alternating hues.

In both these panels it is the expressive quality of line through silhouette and contour and the animated poses which relate these frescoes to Romanesque sculpture such as the Prophet Isaiah of Souillac (fig. 103). The arbitrary articulation, with no emphasis on anatomical accuracy, interprets the biblical events with a vital boldness. All the Saint-Savin murals were painted in one campaign, although clearly they are the work of several muralists. Differences in quality are the result of varying degrees of sensibility among the various painters and their assistants. There is a sympathetic relationship of sculptured capitals and painted columns to the architecture and to the mural character of the frescoes; the frescoes, in turn, preserve and reassert the architectural surfaces of the barrel and other vaults and walls; and all combine to manifest the vital harmony between architecture and the visual arts which is characteristic of this extraordinary stage of the Middle Ages.

PART II

*Early Gothic of the
Twelfth Century*

Historical Background

In the Île-de-France, the small royal domain around Paris, a new kind of architecture, sculpture, and painting emerged in the late 1130's and 1140's. Established, and yet evolving, Romanesque features were synthesized with innovations to form a new Gothic style. Exteriors continued to be conceived in terms of a mural massiveness similar to Romanesque architecture, while ribbed vaults, employed in Norman Romanesque, were developed into more consistent structural systems. A new lightness of interior structure replaced the heavy, lithic piers and walls of Romanesque architecture. In the monastic church, walls and piers in multiple planes paralleled the longitudinal axis of the nave and emphasized the containment of the space, which served as the stronghold of God. The diagonally placed piers with attached colonnettes, co-ordinated with the crossed rib vaults above, added a dynamic movement to the interior spaces of this new Early Gothic style. The small windows, which had been mere perforations in the thick walls in Romanesque architecture, were replaced by large stained-glass windows which increased and transformed the nature of light and achieved a more fluid connection between interior and exterior spaces. These innovations and modifications of Romanesque result in the probing creativity of Early Gothic architecture which can be seen in the many experiments in plan, elevation, spatial treatment, and massing in all the cathedrals that will be discussed.

In sculpture and painting (stained-glass windows and illuminated manuscripts), the persistence of older Romanesque ideas was combined with different interpretations of the human form.

A new portal design, with three-dimensional jamb statues integrated with the architecture, reflected the diagonality of the nave piers. New iconographical programs replaced the more visionary Romanesque portals. Stained-glass windows flood the interiors with colored light, while a new monumentality pervades the figures in illuminated manuscripts.

Why did this new Early Gothic style come into being in and around the Île-de-France in the twelfth century? What were the social, economic, intellectual, and religious factors which paralleled this new style and which might account for its emergence? It is true that the Île-de-France had not produced a strong, regional Romanesque style; yet to argue that the vacuum thus created explains the birth and flowering of Early Gothic is fallacious. Rather, the twelfth century in its entirety, as contextualizing the specifics connected with the royal domain of France, must be understood as an extraordinarily vital period of intellectual reawakening. The eminent historian Charles H. Haskins, in his book *The Renaissance of the Twelfth Century* (1927), summarized the century as follows:

> This century, the very century of St. Bernard and his mule, was in many respects an age of fresh and vigorous life. The epoch of the Crusades, of the rise of towns, and of the earliest bureaucratic states of the West, it saw the culmination of Romanesque art and the beginnings of Gothic; the emergence of the vernacular literatures; the revival of the Latin classics and of Latin poetry and Roman law; the recovery of Greek science, with its arabic additions, and of much of Greek philosophy; and

the origin of the first European universities. The twelfth century left its signature on higher education, on the scholastic philosophy, on European systems of law, on architecture and sculpture, on the liturgical drama, on the Latin and vernacular poetry.

A summary of some of the innovations of the twelfth century listed by Haskins will reveal basic differences between the Romanesque and Early Gothic.

Although all learning and education, whether in the monastery, the court, the cathedral school, or the university, ultimately came under the jurisdiction of the papacy, a freedom of inquiry, new to the Middle Ages, emerged during the twelfth century. At the turn of the century education tended to be concentrated in the monasteries. The rise of cathedral schools soon superseded these, and around 1200 the University of Paris and a few other universities replaced the cathedrals as centers of learning. The school of the Cathedral of Chartres, through the writings of its chancellors and scholars and by its curriculum, reveals the revolution which transpired in the first half of the twelfth century (see bibliography: Klibansky, "The School of Chartres," *Twelfth-Century Europe and the Foundations of Modern Society,* Wisconsin). At Chartres greater emphasis on and appreciation of the physical universe led to a study of physical light. Bernard of Chartres, Chancellor of the Chapter and head of the school, based his instruction on scientific concepts derived from the Latin translations of the Greeks.

Thierry of Chartres, who was Bernard's younger brother and Chancellor of Chartres in 1141, when the west façade was under construction, wrote commentaries on Boethius *De Arithmetica* and *De Trinitate* and displayed a broad knowledge of the liberal arts in two huge manuscripts. Thierry's greatest contribution to teaching centered around his cosmological speculations, which were formulated in another book. As Klibansky states:

Through the Latin translation of, and commentary on, Plato's *Timaeus* by Chalcidius,

the scholars of the early Middle Ages had become acquainted with the classical formulation of the principle of causality and the importance of this principle had been stressed by the numerous exegetes of the dialogue. The emphasis laid in these expositions on Plato's doctrine that "Whatever comes to be must be brought into being by the action of some cause," and on the necessity to "give the reason" . . . taught the medieval scholar to look for the "legitimate cause" of every single phenomenon, as well as of the formation of the whole universe — a quest which, for him, was inevitably bound up with the search for the "legitimate reason."

For the first time in Medieval history the principle of causality was made available by the teaching and writing of Thierry of Chartres to large groups of scholars who came to Chartres from all over Europe. Chalcidius' commentary on Plato's *Timaeus* emphasized à divine will as the first cause of the existence of the world. As Klibansky further states:

Thus the main historical significance of *Timaeus* became evident. The medieval scholar could read into this work his own conception of a divine being and, at the same time, learn the postulate of strict rational thought, thus finding a way to reconcile the claims of reason and faith. While trying to comprehend the universe in his mind, he could continue to believe in a personal God, without the sense that reason and faith were in conflict or even unrelated to each other. Rather, the very idea of a personal God who, out of his goodness, ordered the cosmos becomes the warrant for the possibility of understanding it. Reason acquires a new dignity from its function of retracing and revealing the art of the divine craftsman; and a search for knowledge of the causes of things becomes the service of God. Thus, those who were attempting, for the first time in the Christian era, by their interpretation of the visible world, to free cosmology from the trammels of theological dogma could justly claim that they were not destroying the faith. Theirs was a new approach to the same faith, an approach that prepared the ground for modern scientific thought.

Under the leadership of Thierry, the cathedral school of Chartres became the center of the study of the liberal arts. The emphasis was on number, weight, and measure in the quadrivium (arithmetic, geometry, music, and astronomy), conceived as scientific instruments for use in the mind's attempt to understand religious truths; complementary to the study of the quadrivium was the study of the trivium (grammar, rhetoric, and logic), the disciplines necessary to express these ideas. Again, as Klibansky writes:

> Thus the seven liberal arts together give man both knowledge of the divine and the power to express it. But, in so doing, they fulfill at the same time another purpose. They serve *ad cultum humanitatis*, that is, they promote the specifically human values, revealing to man his place in the universe and teaching him to appreciate the beauty of the created world.

This Platonic view of the world had a decided impact on the Early Gothic Royal Portals of Chartres, especially on the right-hand portal, which contains images of the seven liberal arts (see Chapter 7).

In the cathedral schools the trivium and quadrivium were taught together with occasional vague and unsystematic instruction in theology, canon law, and medicine. Peter Abélard (1079–1142), brilliant philosopher and logician, added a new dialectic system of reasoning in his *Sic et non*, or Yes and no, and thereby helped to alter dramatically the methods of instruction as well as to foreshadow the thirteenth-century scholasticism of Thomas Aquinas. Following the Aristotelian concept of the function of logic, Abélard probed the contradictions of the Church Fathers with students who flocked to study with him. Coming from Brittany around 1100, Abélard studied and taught in Paris. From 1112 to 1118, he was head of the Cathedral School of Notre-Dame, but was forced to leave Paris following his personal tragedy which grew out of his relationship with Héloïse, niece of Canon Fulbert. Abélard taught again in Paris at Mont Ste-Geneviève in the late 1130's. In 1140, friends of Abélard prevailed upon

the Archbishop of Sens to invite Bernard of Clairvaux and Abélard to debate the nature of the Trinity in the Cathedral of Sens. Bernard secured condemnation of Abélard in advance of the confrontation, and Abélard, realizing that he was being tried, left the cathedral and appealed to the pope. Bernard forced his condemnation as heretic and his excommunication and banishment to a Cluniac dependency under the jurisdiction of the sympathetic Peter the Venerable. Abélard's analytic approach, however, was sustained by his pupils.

The preoccupation with Plato was gradually replaced by an interest in Aristotle, some of whose works were read in Latin translation in Chartres in the early 1140's. Aristotle's *New Logic* was translated by 1142. Abélard's assertion of man's ability to discover truths through systematic reason, together with the increasing knowledge of Aristotle, led gradually to the growth of the University of Paris in the late twelfth century. Students from the corners of Europe came here. Debate and discourse gave the city an electrifying atmosphere, pervading makeshift classrooms as well as the taverns and streets of the Île-de-la-Cité and the left bank. Subtle interpretations of theological truths were submitted to examination by Aristotelian logic in the attempt to explain faith by reason. This marked change in the intellectual climate of the twelfth century had its parallels in art in Early Gothic cathedrals and their sculpture and stained-glass windows.

Although the vernacular languages began to emerge out of local dialects in the twelfth century, written and spoken Latin was the common language of communication in the cathedral schools and universities as well as in all religious life and in transactions of legal matters. French was spoken in England during the twelfth century, but emerged in France as the language of officialdom only in the thirteenth century. With Latin as the universal language, the exchange of ideas between Italians, Germans, English, Spanish, and French scholars and students was greatly facilitated. Students sought out the specialists, wherever they might be located. This freedom of movement com-

bined with the institutions of the pilgrimages and the Crusades to form a mobile and in some ways a truly open society (see bibliography: Heer, *The Medieval World*). This new mobility is in turn reflected in the arts by the spread of Early Gothic from its place of origin in the Île-de-France.

Twelfth-century scholars were concerned primarily with Latin literature and with philosophy and the sciences. Many Greek manuscripts which existed in Hebrew versions were translated by the Arabs, and from Arabic they were rendered into Latin. Much of this translation was done in Toledo, in Spain, while other Greek writings were translated directly from Greek to Latin in Italy, especially in Sicily. In the twelfth century the works of Euclid and Ptolemy, along with the scientific discoveries of the Arabs, became known to the Latin West for the first time. This century witnessed the partial recovery of the writings of Plato and Aristotle; and the concurrent interest in measure and in a rational habit of mind had a pronounced impact on Early Gothic art.

The twelfth century was distinguished by a renaissance of Latin religious poetry, but it also witnessed the emergence of a new secular spirit in both Latin and vernacular literatures. This new regard and concern for the worldly did not result in the abandonment of the spiritual, but rather in a synthesis of the two. The autobiography is one example of this secularization. The relative anonymity of the Romanesque period began to give way to an interest in personal identity. Suger, Abbott of the Royal Abbey of Saint-Denis, outside Paris, provides a case in point. He felt that he should record for posterity what he had accomplished at Saint-Denis; he rationalized that a record of his accomplishments was important for the future of France, but apparently the autobiography also satisfied his own vanity. These accounts of Suger's administration and building campaigns do not read like Saint Augustine's *Confessions,* which was essentially one long prayer. Suger and Abélard both felt that their lives on earth were important not only to themselves but for eternity. Biography is another example of this secular tendency. In the early Middle Ages the lives of saints,

with their moralizing overtones, comprise the major biographical writings. Gradually the lives of contemporary figures came to be regarded as equally important. Secular history began to be as interesting as the literature concerned with the church. Perhaps the most pronounced indication of this new attitude is to be found in the type of literature read by both laity and clergy. Many theologians in the twelfth century felt that a clerk should know all facets of pagan literature, including Ovid's love poetry, which was read avidly.

Economic development, begun in the eleventh century, gained tremendous momentum in the twelfth. Trade from the Near East was intensified by the Crusades, while goods purchased at the famous fairs of Flanders and Champagne were transported to Germany, Italy, and further east. The new money economy, involving capital, investment, profit, and reinvestment, made commerce international. As trade increased, towns, especially those along major land or water routes, enlarged their walls. More and more towns gained their freedom from baronial control, and feudalism in its strictest definition declined. Since the communes of towns often controlled the trade routes, the attendant taxes made possible a new freedom of action for large sections of the populace. New and increased means of livelihood in an urban environment resulted in the emergence of a new leisure class. A merchant like the father of Thomas à Becket could send his son to be educated in Paris and Canterbury. Guilds increased in size and established strict rules for quality and prices of goods. Prosperity in this open society, in combination with deep-rooted faith, helped create the Cathedral Age. Communes, guilds, cathedral chapters, archbishops, bishops, nobles, and kings — all contributed in varying degrees to the construction and decoration of the cathedrals.

Two factors — the evolution of feudal institutions and the revival and reinterpretation of Roman law — help explain the growth and increasing prosperity of the royal domain of the Capetian kings of France. With the creation of money payments in lieu of personal service, kings and lords were able to hire mercenaries to control

and protect their vassals; and territorial states as such began to emerge. Educated lay officials, called baillis, became the king's representatives in all parts of his domain and commenced the governmental centralization which was finally realized in the thirteenth century (see Strayer, "The Development of Feudal Institutions," *Twelfth-Century Europe and the Foundations of Modern Society*). In the twelfth century for the first time Roman and canon law was studied as a logical discipline and administered by trained, professional jurists. Although this new jurisprudence deprived the king of the role of supreme judge, it brought administrative order to expanding states like France (see Kantorowicz, "Kingship under the impact of Scientific Jurisprudence," *Twelfth-Century Europe and the Foundations of Modern Society*).

Under Louis VI (Louis the Fat, 1108–1137) and Louis VII (1137–1180), the geographic area directly controlled by the monarchy grew considerably. At the beginning of Louis the Fat's reign, the royal domains consisted of the small Île-de-France around Paris, areas around Orléans and Senlis, and a small coastal strip. By clever marriages and by astutely playing one vassal against another, Louis began the gradual enlargement of the lands under royal control. Further, he helped towns gain their freedom from baronial overlords, and it was in the course of Louis the Fat's reign that the towns achieved intellectual leadership through their cathedral schools: Chartres emerged as a center of humanistic studies (see above) and Orléans as a center of legal studies. He aligned the monarchy with the church and appointed four archbishops. Under his rule the exchequer of France improved as the monarchy profited by the growing commercial wealth of the Île-de-France and its dependencies. His final act of arranging the marriage of his son, the future Louis VII, with Eleanor of Aquitaine resulted in the temporary union of the royal domain with the huge duchies of western and southwestern France.

Louis VII ascended the throne in 1137 and ruled until 1180. The development of closer ties between church and state gave Louis a spiritual power well beyond the usual royal dominion.

However, as a neurotically pious man, Louis at moments weakened the monarchy. The marriage with Eleanor of Aquitaine failed to produce a male heir. Louis divorced Eleanor in 1152, and she married Henry II of England. Thus the opportunity of uniting northern and southwestern France was lost, and the Plantagenets were firmly established on the Continent. Subsequently Louis VII married the heiress of the Count of Champagne, and Philip Augustus (Philippe II) was born.

Philip Augustus ruled France from 1180 to 1223. His reign, the most important in the history of Medieval France, extends into the High Gothic period. His policies continued those of his father and grandfather; he carried further the techniques of undermining the autonomy of local counts and added extensively to the lands under the direct control of the monarchy. By exercising his rights as feudal lord, he was able to control many royal marriages and thus increase the geographic expansion.

The dynamic change between Romanesque and Early Gothic times cannot be clarified without a short sketch of one of the most unusual individuals in the whole span of the Middle Ages. Suger, Abbot of Saint-Denis from 1122 until his death in 1151, was one of those extraordinary individuals who singlehandedly changed the course of history. As a legal, political, and spiritual adviser and close friend of both Louis VI and VII, Suger was motivated by two basic drives: (1) to strengthen continually the power and prestige of the king of France by arresting pressures and physical attacks from outside the boundaries of the kingdom and by perpetuating a spirit of harmony within the Capetian lands; (2) to rebuild and glorify the Royal Abbey of Saint-Denis, which had fallen into disrepair since the Carolingian era. Saint-Denis was the burial place of the French monarchy. Its location just north of Paris gave it an importance greater than would be thought from its appearance today, surrounded as it is by a suburb of Paris. Suger not only reformed the abbey but also on numerous trips to Rome strengthened the relationships between France

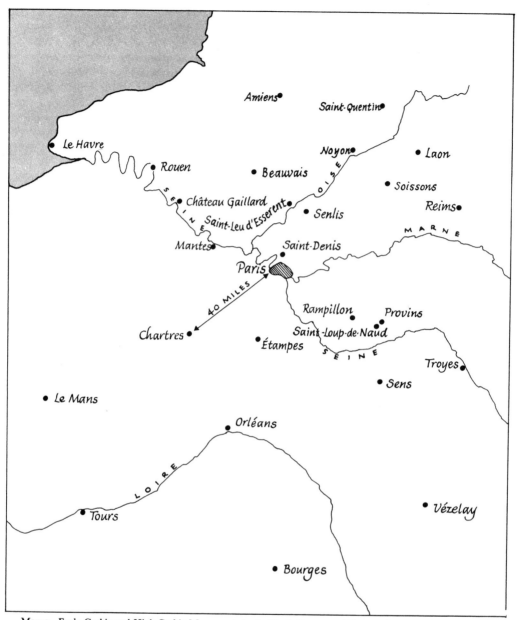

Map 2. Early Gothic and High Gothic Monuments in the Ile-de-France and Surrounding Areas (1130's–1230's)

and the papacy. He acted as a political intermediary between Louis VII and Henry I of Germany. After the Second Crusade was launched in 1147, Suger was appointed Regent of France and ruled the country while Louis VII, Eleanor of Aquitaine, and many of the knights of France were in the Holy Land. It is a measure of Suger's political power that he was able, during his regency, to prevent a coup d'état by Louis' brother.

Suger wanted to rebuild the abbey of Saint-Denis and fill it resplendently with gold altars and jeweled crosses, with all the opulence possible for the glory of God and of France. In carrying out his intentions, Suger recorded what happened to the abbey under his administration, describing in detail the two consecrations of 1140 and 1144. His writings, plus the fact that he had himself depicted in stained-glass windows and on the portals and had his name engraved in many inscriptions, indicate that Suger was a man of the world who delighted in things physical, in contrast to such a person as Bernard of Clairvaux, mystic, preacher, and educator, who strove for an ascetic anonymity. Suger's life and building accomplishments are symbolic of the paired ambitions (this-worldly, political; otherworldly, spiritual) of his time.

In spite of the revolutionary nature of the twelfth century, it remains difficult to explain why Early Gothic superseded Romanesque. In some buildings, such as Suger's Abbey of Saint-Denis, the break with Romanesque was abrupt and dramatic, while in other monuments, like Sens Cathedral, many Romanesque ideas were perpetuated. In his book *The Gothic Cathedral. Origins of Gothic Architecture and the Medieval Concept of Order* (1956), Otto von Simson interprets the Gothic cathedral as an image of the "Celestial Kingdom" or as "the symbol of the Kingdom of God on earth." As he states in the introduction: "I have tried not only to explore the meaning of the Gothic cathedral as a symbol but also to recapture the 'how,' the process by which symbolic instinct transformed vision into architectural form." Von Simson differentiates between modern and Medieval man's interpretation of the function and meaning of the symbol:

For us the symbol is an image that invests physical reality with poetic meaning. For medieval man, the physical world as we understand it has no reality except as a symbol. But even the term "symbol" is misleading. For us the symbol is the subjective creation of poetic fancy; for medieval man what we would call symbol is the only objectively valid definition of reality. We find it necessary to suppress the symbolic instinct if we seek to understand the world as it is rather than as it seems. Medieval man conceived the symbolic instinct as the only reliable guide to such an understanding.

Describing the impact of the Gothic cathedral on contemporaries, von Simson states:

The cathedral was the house of God, this term understood not as a pale commonplace but as fearful reality. The Middle Ages lived in the presence of the supernatural, which impressed itself upon every aspect of human life. The sanctuary was the threshold to heaven. In the admiration of its architectural perfection religious emotions overshadowed the observer's aesthetic reactions. It was no different with those who built the cathedrals.

The cathedral is thus considered a visionary symbol of the Heavenly Jerusalem by patrons, worshippers, and architects alike. Von Simson concludes his introduction as follows:

The Gothic cathedral originated in the religious experience, the metaphysical speculation, in the political and even physical realities, of twelfth century France, and in the genius of those who created it. I have tried to seize the singular nexus of living forces in Gothic form that is its lasting experience.

In Part I, entitled "Gothic Design and the Medieval Concept of Order," von Simson stresses the "transparent, diaphanous" nature of Gothic and points out that flying buttresses, ribbed vaults, and pointed arches represent the new Gothic technology which makes possible the creation of the Celestial Kingdom on earth. Von Simson argues that geometry was the basis of design, while physical light, penetrating Gothic interiors through stained-glass windows, was divine light by analogy:

In the physical light that illuminated the sanctuary, that mystical reality seemed to become palpable to the senses. The distinction between physical nature and theological significance was bridged by the notion of corporeal light as an "analogy" to the divine light. Can we marvel that this world view called for a style of sacred architecture in which the meaning of light was acknowledged as magnificently as it was in Gothic?

The similitude which linked physical light with divine light is not unlike the dual preoccupation (this world–other world) of Suger's career, not unlike the emergence of the church-state monarchy, and not unlike the emphasis in the cathedral schools on the interlink between logic and faith. Gothic architecture was born in the evolution of a new synthesis of this-worldly and other-worldly concerns.

The Abbey of Saint-Denis

WHEN ABBOT SUGER dedicated the narthex of Saint-Denis (figs. 124, 127, 129), June 9, 1140, and the choir (figs. 132–138), June 14, 1144, he partially realized his dream of rebuilding the Royal Abbey and unwittingly, or perhaps wittingly, founded a new tradition. As the most powerful patron of the twelfth century, Suger had at his command the personal prestige, political influence, and financial support to utilize the artistic talents of the best craftsmen in western Europe. With Suger's dedications the whole course of architecture and sculpture changed directions. A new design for the west façade with a system of integrated apertures and wall buttresses, a new portal design with monumental jamb figures, and a new concept of architectural space and light — all were inaugurated. Although the effects of these achievements in both architecture, sculpture, and stained glass are readily seen in later monuments of the Île-de-France, they transcend narrow geographical limits.

Suger's abbey was dedicated to Saint Denis, the first Bishop of Paris. Professor Sumner Crosby, of Yale University, in his books on Saint-Denis, has separated fact from fiction in the life of this saint. Saint Denis, one of seven bishops sent to Paris to convert the Gauls, was decapitated in the third century on the order of Decius. He was buried outside Paris in the area which then took his name. Saint Denis, being the oldest of the seven, became a national saint and is considered the first Bishop of Paris. More important than the facts concerning his life are the legends which sprang up around this patron saint of France. In the Middle Ages the legend confused Saint Denis with Diony-sius the Areopagite and recounted his conversion to Christianity by Saint Paul and his arrival in Paris with two companions. He was said to have been tortured and decapitated on Montmartre and then to have walked to Saint-Denis with head in hand, finally to be buried on the present site of the church. In the library of the abbey was a ninth-century translation of Greek texts supposedly written by Dionysius the Areopagite as well as a ninth-century commentary on the Areopagite by John the Scot. Although the original texts were forged by an unknown Syrian in the early years of the sixth century, Suger thought that they were actually written by Saint Denis, the first apostle to the Gauls and the patron saint of France. As Erwin Panofsky has so clearly stated in his book on Abbot Suger, the writings in these texts present a theology which combines the Christian doctrine with "fundamental oneness and illuminous aliveness of the world." As Panofsky states:

> According to the Pseudo-Areopagite, the universe is created, animated and unified by the perpetual self realization of what Plotinus had called "the One," what the Bible had called "the Lord," and what he calls "the super essential Light" or even the "visible son" — with God the father designated as "the Father of lights" and Christ as the "first radiance" . . . which "has revealed the Father to the world."

This emphasis on the metaphysical qualities of colored light certainly must have had a profound effect on Suger and is clearly evident in the design of the choir of his new abbey church. Divine light becomes the physical light of the new choir. This confusion between the writings of an unknown

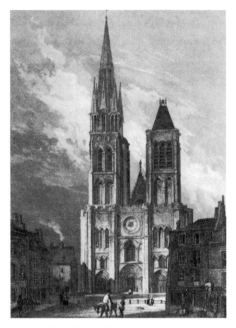

Fig. 124. Saint-Denis Abbey, c. 1137–1140. Engraving
of façade, c. 1820

Figure 125. Caen, Saint-Étienne, begun c. 1065. Façade

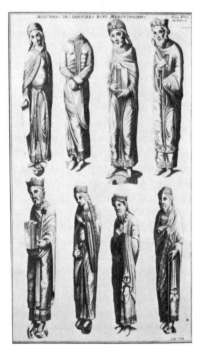

Fig. 126. Saint-Denis Abbey, 1140. Central
portal (Montfaucon)

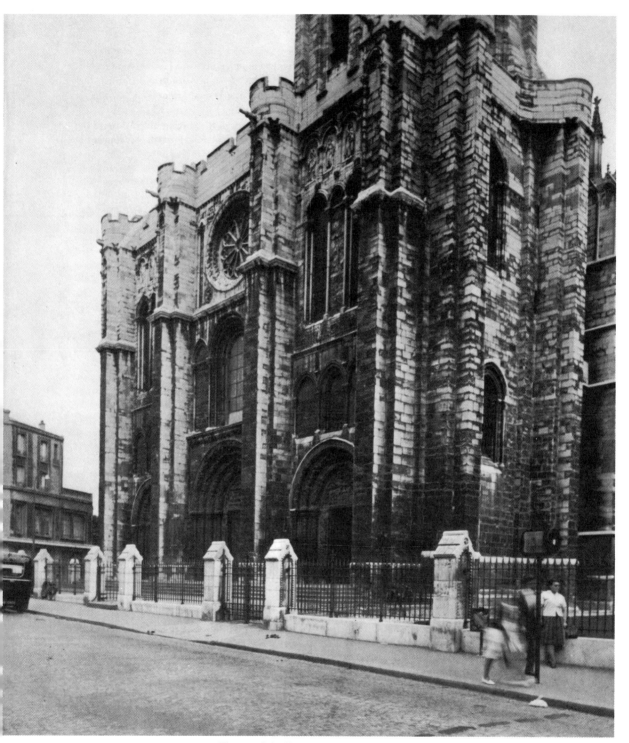

Fig. 127. Saint-Denis Abbey, 1140. Façade

Syrian and Saint Denis plays a dramatic part not only in Suger's narthex and choir but also in the glitter of the stained-glass windows and of the many liturgical objects which he ordered for the abbey.

The location of the abbey on the main route from Paris to the north and the fertility of the lands owned by abbey and monarchy made it possible for Suger to raise the necessary funds for his building campaigns. Revenue was received from the fairs held at Saint-Denis three times a year and from large donations by the aristocracy of France.

Since the seventh century all the kings of France had been buried in Saint-Denis. Furthermore, since 1120 Saint-Denis was the place where all the insignia of the monarchy were housed, including the most important insigne, the Oriflamme, the banner carried by the king in battle. In 1124 Louis VI, before leaving to defend France against the invasion of Henry V of Germany, journeyed to Saint-Denis to receive the Oriflamme. Again, Louis VII came to Saint-Denis to be blessed and to take the Oriflamme to the Holy Land in 1147.

The dramatic history of the abbey commenced with the large Merovingian church of the seventh century. A new church was consecrated in 775 and was one of the most impressive churches of the Carolingian empire. Within the walls of the Carolingian abbey was one of the most important monastic scriptoria of the time. In the year 832 a new chapel was added to the apse of the Carolingian church (see Carolingian plan inside twelfth- and thirteenth-century plans, Crosby, fig. 128). William the Conqueror donated funds for the construction of a tower. Relics, including a piece of the True Cross, a fragment of the crown of thorns, and an arm of Saint Simeon, aided the growth of the abbey.

When Suger was elected abbot in 1122, he found the rules of Saint Benedict interpreted in a lax manner. His desire to reform the monastery was furthered by the pleas of Saint Bernard, the great Cistercian. In the early years of his abbacy Suger reorganized the financial status of the abbey and reformed it internally. During religious festivals the abbey became so filled with worshippers that children and those who fainted were passed over the heads of the multitude and through the portals. This dangerous situation gave impetus to Suger's desire to rebuild the church.

He began the reconstruction of Saint-Denis by erecting a new façade and narthex supporting three upper chapels (figs. 124, 126–130). This first construction was on the west of the Carolingian church (fig. 128), since the latter had been, according to legend, built by King Dagobert in the sixth century and Christ and angels had appeared at the time of the dedication. Suger's new façade was the first to be designed with monumental entrances in which sculpture was completely synthesized with the architecture (figs. 124, 126, 127). The façade as a whole is divided into three sections by massive, articulated wall buttresses (figs. 124, 127). The focal point of the composition is the large central portal with its tympanum, containing the Last Judgement upheld by a trumeau. Above the portal is an arched window flanked by blind arcades, while the third story contains the first rose window of Gothic between two thin, blind arches. Over the smaller side portals rise two tiers of apertures, alternating from window and two blind arches to two taller openings beside a narrow arch. The down-up-down composition of the entire façade, the play of void and solid in triads, and the central emphasis of the simple rose window give rhythmic clarity and subtle variety to the whole design. This bold statement departs from the complete murality of Romanesque façades and is prophetic of the thirteenth century.

The spirit of innovation evidenced in the façade is not, however, without roots. The design was influenced by Norman buildings, such as William the Conqueror's Abbey of Saint-Étienne at Caen (fig. 125). The stark articulation of the wall buttresses, dividing the façade into three vertical bays, has passed from Normandy to the Île-de-France. However, the animation of surfaces by windows and arcades, the greater complexity of the buttresses, and the new portal design point up the dynamic originality of the Saint-Denis façade. When, with pomp and circumstance, the lower

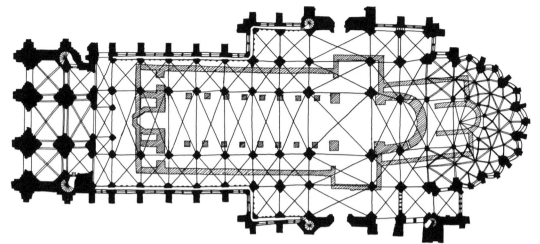

Fig. 128. Saint-Denis Abbey, Carolingian; narthex, 1140; chevet, 1144; nave, 1231 ff. Plan (after Crosby)

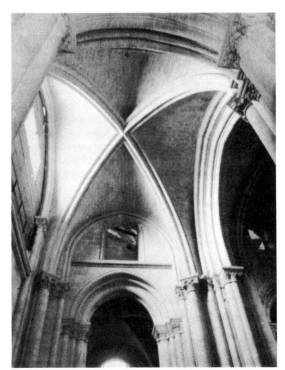

Fig. 129. Saint-Denis Abbey, 1140. Vault of narthex

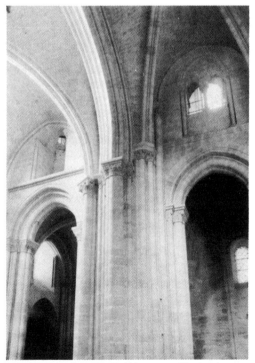

Fig. 130. Saint-Denis Abbey, 1140. Narthex

part of the new west end was consecrated in 1140, the first Gothic façade had come into being.

Unfortunately, time and unsympathetic restoration have damaged the façade extensively. Following 1771, the jamb statues, lintels, and central trumeau were removed, and the pavement in front of the portals was raised some five feet. Much of the surface of the façade, including a great deal of the sculpture, was recarved in 1839 (see bibliography: Stoddard, *West Portals of Saint-Denis and Chartres*). It is possible, however, to see the original, cohesive relationship between sculpture and architecture in an engraving of the façade (fig. 124). Fortunately, the nature of the sculptured jamb figures has been preserved in the form of drawings and engravings by the historian Montfaucon in the early eighteenth century (figures from the central portal, fig. 126). These jamb figures grow up from the convex bases below and are echoed in the archivolts embracing the tympanum. In contrast to the separation and isolation of parts in Romanesque portals such as Vézelay, Saint-Gilles, and Moissac (figs. 94, 96, 99), the Saint-Denis portals reveal a harmonious, continuous integration of figures, ornament, and architectural shapes, and in this integration the beginnings of Early Gothic are manifest.

The large narthex (see plan, fig. 128, and figs. 129, 130) is covered with Gothic ribbed vaults sustained by complicated piers. Ribbed construction which separates the bearing ribs from the webbing was first used by Romanesque builders in the Cathedral of Durham in the late eleventh century and in the two abbeys at Caen (vaulted by the 1120's). In the narthex of Saint-Denis, however, these ribbed vaults rise from complex piers made up of bundles of colonnettes which relate to the elaborate transverse ribs and to the simpler cross or diagonal ribs of the vaults. These piers in their diagonal arrangement transform the interior space. No longer are the spaces cubical, flanked by walls which reiterate the longitudinal axis down the nave. A diagonal undulation of wall, which echoes the diagonal arrangement of the splays on the portals, replaces the massive Romanesque murality.

In his *De Administratione,* as translated by Erwin Panofsky, Suger wrote:

We also committed ourselves richly to elaborate the tower[s] and the upper crenelations of the front, both for the beauty of the church and, should circumstances require it, for practical purposes. Further we ordered the year of the consecration, lest it be forgotten, to be inscribed in copper-gilt letters in the following manner:
For the splendor of the church that has fostered and exalted him,
Suger has labored for the splendor of the church.
Giving thee a share of what is thine, O Martyr Denis,
He prays to thee to pray that he may obtain a share of Paradise.
The year was the One Thousand, One Hundred, and Fortieth
Year of the Word when [this structure] was consecrated.

Because of the prominence given the lower stories of the façade, capped by crenelations, and because of the setback of the towers, Otto von Simson in his book *The Gothic Cathedral* interprets the façade as the gateway to heaven. The narthex with chapels above, however, is related to the double-storied west ends of Carolingian and Romanesque structures (see Tournus, figs. 67, 68). The first appearance of the rose window, the first use of columnar jamb statues placed in the diagonal splays of the portals, and the related diagonal organization of the piers in narthex and chapels and the co-ordination of piers with ribbed vaults — all manifest the originality of this first Gothic façade.

Even more important as a statement of the birth of Gothic is Suger's choir, which was constructed in the astonishingly short time of three years and three months (figs. 132–134, 136–138). The consecration on June 14, 1144, of twenty altars, nine in the crypt and eleven in the choir, with the active participation of King Louis VII, Queen Eleanor of Aquitaine, and seventeen archbishops and bishops, far surpassed in its ceremonial elaborateness the celebrations which Suger or-

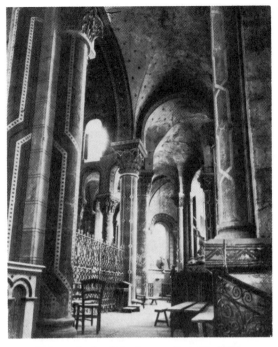

Fig. 131. Issoire, Saint-Austremoine, early XIIth
century. Ambulatory

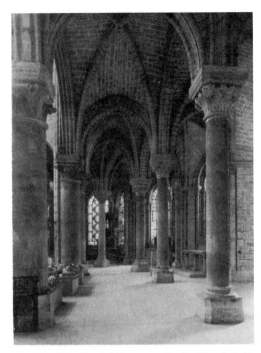

Fig. 132. Saint-Denis Abbey, 1144. South aisles of choir

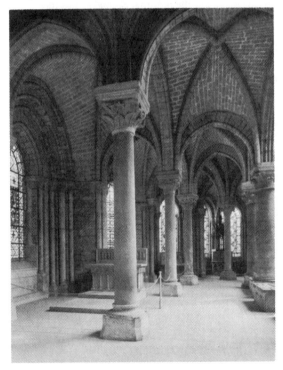

Fig. 133. Saint-Denis Abbey. North aisles of choir

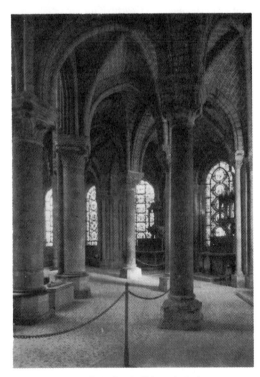

Fig. 134. Saint-Denis Abbey. Ambulatory

ganized for the dedication of the façade four years earlier. As Crosby's plan indicates (fig. 128), the new choir encircled and more than doubled the area contained in the Carolingian apse with its ninth-century addition.

Above the crypt, with its wide spaces and massive piers, rises the elegant choir. A row of twelve slender columns divides the space into two aisles circumnavigating the choir with its twelve piers. Seven shallow chapels grow off the outer aisle; each contains two large stained-glass windows (see fig. 134). The revolutionary character of this double ambulatory, with its lightness and airiness, is found in no earlier building. If contrasted with the Auvergnat, Romanesque church of Issoire (fig. 131), Saint-Denis appears to float in space. Heavy groin vaults and stout piers are replaced by slender columns from which spring the pointed transverse and round diagonal ribs (figs. 132, 133). Further, the greater concentration of structure in piers and wall buttresses at Saint-Denis allows larger windows (fig. 134). The lateral and vertical spaciousness is enhanced by the flood of colored light which penetrates each chapel through two windows. Suger's absorption with physical light as a reflection of divine light is clearly stated in architectural terms. Suger wrote of "a circular string of chapels, by virtue of which the whole church would shine with the wonderful and uninterrupted light of most sacred windows, pervading the interior beauty."

The architect solved the structural problem of reducing the outward thrust of the ribbed vaults of both the bays flanking the choir and those in the double ambulatory by combining pointed arches for the transverse and longitudinal ribs with round arches for the diagonal ribs (figs. 132–136). This combination of pointed and round arches brings the keystones of both the ribs and the webbing to an approximately uniform height. In order to have the crown of the vault in the center of the trapezoidal bay of the ambulatory, the ribs have been broken (figs. 128, 136). This structural and visually subtle solution is in marked contrast to the treatment of the ambulatory in the Île-de-France church of Morienval of 1122 or the

1130's (fig. 135). There the diagonal ribs curve in space, but their point of crossing does not coincide with the middle of the vault. What is unique about the interior of the Saint-Denis chevet is the completeness of the structural and spatial solutions at the very beginning of a new era.

In his *De Administratione*, Suger, for the inscription of the dedication of the choir in 1144, changed the date of the 1140 inscription and added the following:

> Once the new rear part is joined to the part in front,
> The church shines with its middle part brightened.
> For bright is that which is brightly coupled with the bright,
> And bright is the noble edifice which is pervaded by the new light;
> Which stands enlarged in our time,
> I, who was Suger, being the leader while it was being accomplished.

Suger did not live to construct the nave connecting his narthex and choir. Work was begun on exterior walls, but the building campaign was interrupted when Suger became Regent of France in 1147. All available funds were needed to sustain the ill-conceived struggles of the Second Crusade. The superstructure of Suger's choir was replaced in 1231 and the years following during the building campaign in which the narthex and chevet were joined. We do not know the nature of the superstructure of Suger's choir. Further knowledge awaits on the outcome of Crosby's studies.

The exterior of the choir of Saint-Denis (fig. 137) is less precocious. Indeed, the round-headed windows of the crypt framed by relieving arches are Romanesque, while the pointed windows framed by arches in the chapels are Gothic. The hesitant nature of the total design manifests the experimental nature of the 1140's.

In 1151, at the time of Suger's death, the exterior of Saint-Denis (see Crosby model, fig. 138) presented a strange silhouette: the massive, towered narthex at one end and soaring choir at the other, separated by the late eighth-century Carolingian church.

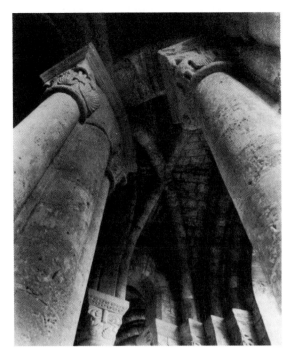

Fig. 135. Morienval, c. 1122 or 1130's. Vaults
of ambulatory

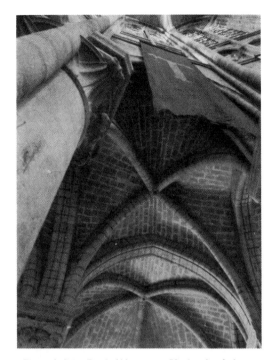

Fig. 136. Saint-Denis Abbey, 1144. Vaults of ambulatory

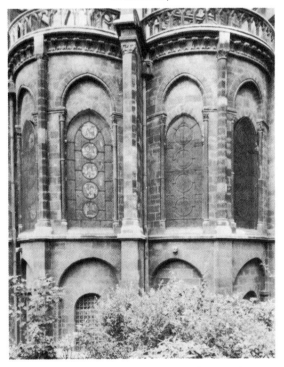

Fig. 137. Saint-Denis Abbey, 1144. Exterior of
crypt and chapels

Fig. 138. Saint-Denis Abbey. Reconstruction of exterior,
1144 (Crosby)

Although Suger was responsible for the organization of the chantier which constructed the narthex and choir, little mention is made of the architecture in the accounts of his administration. Much of his attention centered on the fourteen stained-glass windows (fig. 134) in the seven chapels as well as on the creation of altars and liturgical objects. His fascination for light became concentrated on colored light. Artists from all over western Europe were called to Saint-Denis to create a new choir screen, to construct monks' stalls, to build a huge main altar with enameled and gold cross encrusted with precious stones. Chalices, altars, and other objects of gold and jewels were made for the glory of the abbey and the French crown. Suger's delight in the glitter of gold and jewels drove him to try to surpass the wealth of the treasuries of the Byzantine emperor, about which he had heard from the returning Crusaders. Most of the objects, with the exception of his chalice in the National Gallery in Washington (fig. 422) and the Eagle Vase in the Louvre (fig. 421), have disappeared.

In looking at Suger's accomplishments in the light of what follows in the second half of the twelfth century, it is impossible to overestimate the importance of the Saint-Denis façade, narthex, and choir. The new west end paved the way for the dynamic experiments which were to culminate in the High Gothic façade of the Cathedral of Amiens; and the lightness of the double ambulatory, with its mass poised over voids flooded with colored light, is not surpassed in sheer elegance until the completion of High Gothic cathedrals.

There remain, however, several unanswered and probably unanswerable questions concerning the two building campaigns at Saint-Denis. It is known that Suger imported goldsmiths from Lorraine; and it can be surmised that the two architects, one for the façade and narthex and the other in charge of the construction of the choir, came from Normandy. Obviously, these two architect-builders were cognizant of structures other than those in Normandy. But what was the relationship between these architects and Suger, the patron? It is clear both from Suger's writings and from the

nature of the choir that the major motivating force behind these dramatic beginnings of Gothic was corporeal light as analogy to divine light, with the ultimate goal the creation of the Celestial Kingdom on earth. The identification of the writings of Dionysius the Areopagite with those of Saint-Denis, although a false identification, seems to have been of paramount importance; yet how much of the design of the abbey can be attributed to the dictates of Suger himself? Suger's extensive travels certainly had made him aware of contemporary building practices in most parts of western Europe. Before 1137, when work commenced on the façade, he had traveled to Rome five times, to Burgundy twice, to the Low Countries and Germany twice, and to western France in 1137. But as abbot, educated in the cloister, Suger was not a stonemason who had evolved into a master builder.

It would be futile to compare the relationship between unnamed architects and Suger with the relationship between Marcel Breuer and the Benedictine monks of Saint John's Abbey in Minnesota, whose collaboration resulted in the consecration in 1961 of an exciting, modern church of concrete and glass designed for the specific liturgical demands of the corporate worship of monks and congregation. On the other hand, one can perhaps speculate that the relationships were not too dissimilar, in spite of difference in time and place. Suger had ideas and dreams, and the architects possessed the structural know-how. Perhaps what then transpired was the creative exchange of ideas between builder and patron.

AFTERNOTE

For many years Sumner Crosby has been concerned with every aspect of the Carolingian, Early Gothic, and thirteenth-century Abbey of Saint-Denis (see bibliography). In a paper read at the International Congress of the History of Art in 1961 ("Abbot Suger's St. Denis. The New Gothic." *Studies in Western Art, Acts of the Twentieth International Congress of the History of Art,* Princeton, 1963, Vol. 1, 85–91), he tentatively suggested a geometrical system which Suger and his master builder may have used for the layout of the crypt and choir (dedi-

cated in 1144). As the result of a graduate seminar at Yale in 1965, which was followed by a group presentation at a symposium of the International Center of Medieval Art in Princeton, Crosby published a preliminary report ("Crypt and Choir Plans at Saint-Denis." *Gesta.* International Center of Medieval Art, Vol. 5, January 1966, 4–8). Crosby stresses certain disparities between the geometric scheme and the actual measurements of the crypt and choir. He further points out that measurements of the crypt and choir can be compared with measurements of the Carolingian church but that these measurements must be taken from varying locations, such as the nave side of the nave pier or at times, the center of the support. In spite of Crosby's qualifications, it seems to me that his conclusions are more than preliminary findings.

The point of departure for Crosby's proposal that there was an abstract scheme for the layout of the crypt and choir stems from Suger's statement in *De Consecratione:* "Moreover, it was cunningly provided that — though the upper columns and central arches which were to be placed upon the lower ones built in the crypt — the central nave of the old nave should be equalized, by means of geometrical and arithmetical instruments, with the central nave of the new addition; and, likewise, that the dimensions of the old side-aisles should be equalized with the dimensions of the new side-aisles, except for that elegant and praiseworthy extension, in [the form of] a circular string of chapels, by virture of which the whole [church] would shine with the wonderful and uninterrupted light of most sacred windows, pervading the interior beauty."

According to Crosby, the layout of the crypt and subsequently the layout of the choir were established by swinging cords from three equidistant points on a newly established axis and by subdividing twice the two 90-degree angles off the axis. Several measurements of the cords were related to the measurements of the Carolingian nave. Crosby further states: "The fundamental elements of a system based on three equidistant points, with eccentric circles and epicycles, or small circles, on the perimeter of the major circle will be recognized immediately by those familiar with medieval cosmological systems. They are the basic features of the astronomical system devised by Hipparchus in the second century B.C. and adopted by Ptolemy in the second century A.D." Ptolemy's treatise was not translated from Arabic into Latin until 1175, yet Crosby argues that the general principles of the Ptolemaic system were known in northern Europe earlier in the twelfth century. Crosby concludes: "Suger in his description of the choir mentions that it was 'raised aloft by twelve columns representing the number of the twelve Apostles and, secondarily, by as many columns in the side-aisles signifying the number of the [minor] Prophets!' Among many things not included in his writings is the fact that both the crypt and the choir were, by their plans, also symbolic of the order of the Universe. For Suger, of course, it was the Christian Universe."

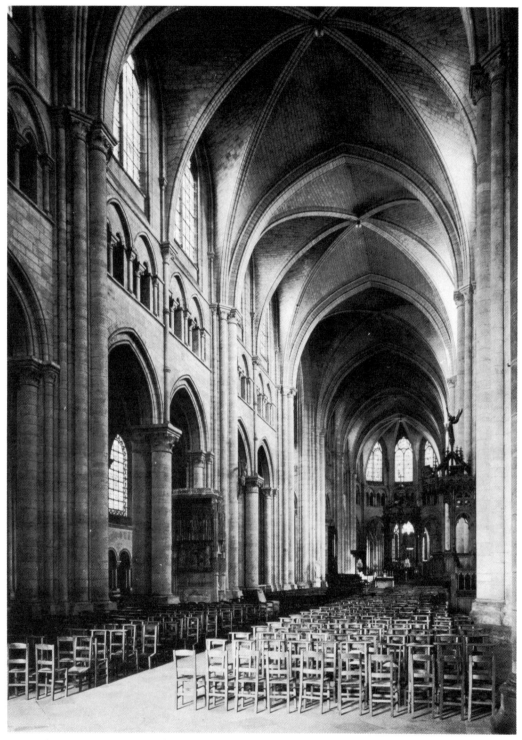

Fig. 139. Sens Cathedral, begun in 1130's. Nave

The Cathedral of Sens

Saint-Étienne (Stephen) of Sens is the first cathedral which is Gothic throughout (figs. 139–142); yet the ambulatory, the earliest part to be constructed, was not designed originally to have ribbed vaults. Construction may have been started as early as 1130, but certainly by 1140. Sens is located seventy-five miles southeast of Paris on the borders of Burgundy, Champagne, and the Île-de-France. Sens, a wealthy Roman capital, preserved its renown in the Middle Ages. The Archbishop of Sens had jurisdiction over the bishoprics of Chartres, Paris, Orléans, and others.

Archbishop Henry Sanglier (1122–1142), close friend of Saint Bernard, started the work on a new cathedral. No evidence exists concerning the progress by 1140, when throngs descended on Sens to witness the scheduled debate between Saint Bernard and Master Abélard on the essence of the Trinity. Likewise, no accounts reveal the status of the construction in 1152, when the momentous synod which resulted in the decree of separation of Louis VII and Eleanor of Aquitaine was held in Sens. But the choir of Sens was certainly finished by 1163, at which time the exiled Pope Alexander came there for a stay of eighteen months. On April 19, 1164, the Pope consecrated an altar in the choir.

The nave of Sens (fig. 139) was completed between 1175 and 1180. Many restorations and changes were carried out following the disastrous fire of 1184, which devastated much of the town and damaged the superstructure of the cathedral. The clerestory windows of the choir were enlarged and the outer sides of the vaults were heightened around 1230. At this time flying buttresses were added. Soon after 1310 the windows of the nave were increased in size. Three oval chapels were added to the simple ambulatory in the sixteenth and eighteenth centuries, and elaborate Gothic transepts were built in the sixteenth century.

The main vessel of Sens consists of five square bays, three in the nave and two in the choir (figs. 139–142, 144, 146). These bays are crowned by six-part vaults which spring from complex major piers. The intermediate supports are paired columns. Two square aisle bays flank each nave bay (fig. 146). The crossing is distinguished from the other bays by its four-part vault. The original short transepts, with single chapels extending eastward, have been completely transformed by the sixteenth-century additions. The original plan (fig. 140) was compact and essentially transeptless. Remains of the simple ambulatory, without radiating chapels, can be seen in two areas (fig. 141). In the plan and simplicity of its original spaces and in its original lighting, the east end of Sens had none of the precocious character of the Saint-Denis choir.

In its proportions the present nave of Sens seems squat, 81¼ feet tall by 49½ feet wide (fig. 139). The wide space would seem even lower if the vaults were restored to their original curvature. The desire for an abundance of light does not seem to have been a motivating factor in the design. The resulting relative darkness of Sens is in marked contrast to Saint-Denis. The large square bays, clearly determined by massive piers, give the space a compartmented character reminiscent of the domed churches of southwestern France (see Souillac, fig. 81). The rhythmical movement is

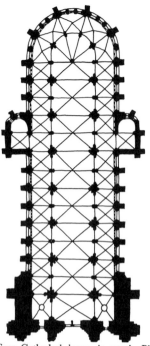

Fig. 140. Sens Cathedral, begun in 1130's. Plan (after Lefèvre-Pontalis)

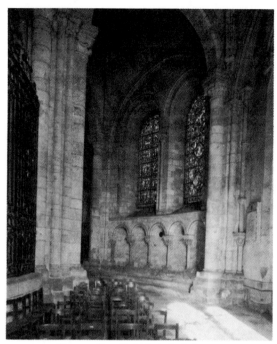

Fig. 141. Sens Cathedral. Ambulatory

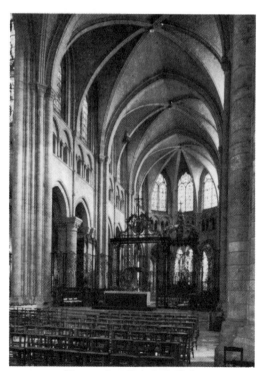

Fig. 142. Sens Cathedral. Choir

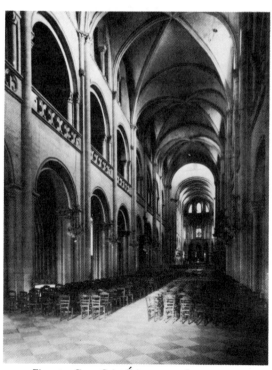

Fig. 143. Caen, Saint-Étienne, c. 1065; vaults, 1100–1120. Nave

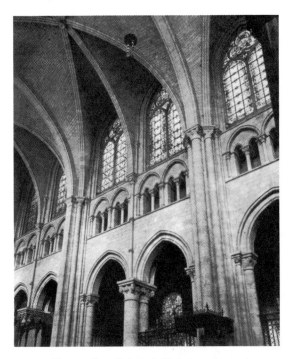

Fig. 144. Sens Cathedral. Choir from the south

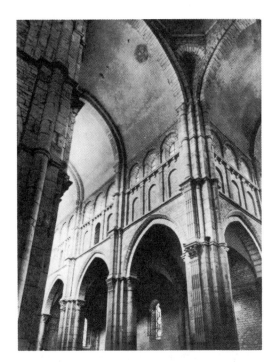

Fig. 145. Paray-le-Monial, priory, c. 1100. Nave
and crossing

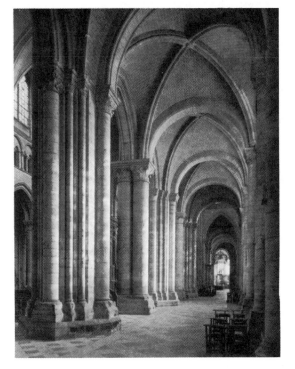

Fig. 146. Sens Cathedral. South aisle

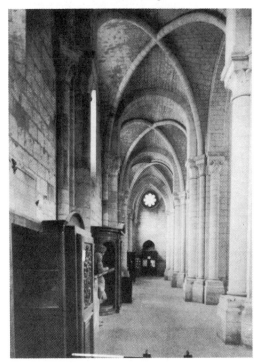

Fig. 147. Beauvais, Saint-Étienne, 1130–1140.
South aisle

slowed by the partial independence of each six-part vault. Between the nave arcade and the clerestory is a false triforium which admits light over the aisle vaults, but does not serve as a passageway. The elevation is thus comprised of three stories: nave arcade, triforium, and clerestory.

The use of ribbed vaulting throughout the cathedral is clearly a new, Early Gothic feature. The ribbed vaulting in aisles (fig. 146), nave, and choir (figs. 139, 142, 144) springs from articulated piers which establish a diagonal axis. One large column and four smaller ones rise to the five capitals at the top of the triforium. From this point the major transverse rib, the two diagonals, and the two wall ribs (over the clerestory windows) are sprung. The intermediate piers, consisting of pairs of columns, are connected somewhat hesitantly to the vaults by a single colonnette. The integration of pier and vault and the diagonal emphasis established by the major piers manifest the new Early Gothic spirit.

The three-story elevation of Sens seems to have been derived from nearby Cluniac churches in Burgundy, such as Cluny III and Paray-le-Monial (fig. 145), which have nave arcade, triforium, and clerestory with pointed barrel vaults above. In Sens the six-part ribbed vaults replace the barrel, but spring from the bottom of the clerestory. In terms of shape of space, the naves of Cluny III and Paray-le-Monial are more Gothic than the wide Sens nave.

The vaulting system of Sens was probably inspired by Norman Romanesque churches such as Saint-Étienne at Caen (fig. 143). Caen, built by William the Conqueror in the mid-eleventh century, was covered originally with a timber roof. In the early decades of the twelfth century, six-part vaults were sprung from the base of the clerestory, obscuring parts of the clerestory and lessening thereby the vertical effect of the nave. In a comparison of Sens and Caen (figs. 142, 143), structural and spatial similarities can be observed. However, Sens exhibits a more consistent articulation between major piers and vaults. Since Sens was designed in the light of new technology, a more harmonious relationship of parts transpired. Thus, the Cathedral of Sens combines in a new synthesis

the Burgundian elevation with Norman structural innovations.

The aisles of Sens (fig. 146) reveal an alternating system of major and intermediate piers and an attempt to integrate both piers with the four-part vaults of the square bays. In some places, such as over the paired columns, the transition from pier to diagonal rib seems awkward. By contrast, the vaulting of the south aisle of the church of Saint-Étienne of Beauvais (fig. 147), which was constructed in the 1130's, seems more consistent, in spite of the more archaic profiles of the ribs.

In the ambulatory at Sens those parts which have not been altered by the addition of later chapels (fig. 141) suggest a change in design. The blind arcade and round-headed windows are Romanesque stylistically, while the diagonal ribs, springing from corbels, appear to be an addition when the curving groin vault was converted to a ribbed vault. Thus the lower part of the ambulatory dates from the 1130's, while the superstructure was erected in the 1140's and after.

The Sens choir, especially its elevation, is similar to the new choirs of the Cathedral of Canterbury in England, built between 1175 and 1184. A fire in 1174 severely damaged the Romanesque church at Canterbury. The monks called in William of Sens to advise them. After considerable study, William dissuaded the monks from re-using the Romanesque piers and then proceeded to design and supervise the construction of a new cathedral. A chronicler, Gervase of Canterbury, kept an account of the proceedings in what is now a rare Medieval document. He recounts William's construction of machinery to unload stone brought across the Channel from quarries near Caen. He describes how William supervised the work in progress and how, in the fifth year, he fell from the scaffold and was badly injured. William was forced to give his orders from a litter and to entrust the supervision to a monk. Sensing that his days were numbered, William returned to his birthplace, and William the Englishman continued the work. This document reveals the fact that designer and supervisor (architect and contractor) were one and the same person.

Both Canterbury and Sens exhibit a conserva-

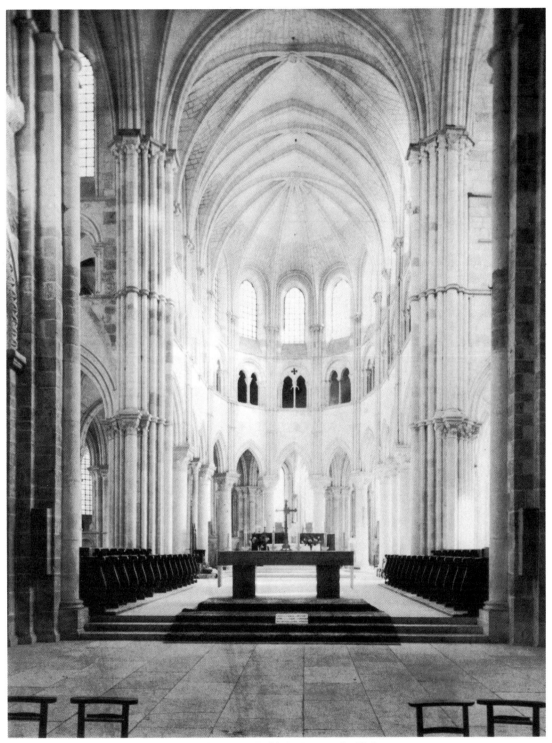

Fig. 148. Vézelay, La Madeleine, c. 1185. Choir

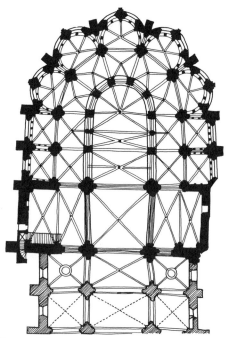

Fig. 149. Vézelay, c. 1185. Plan of choir (after Salet)

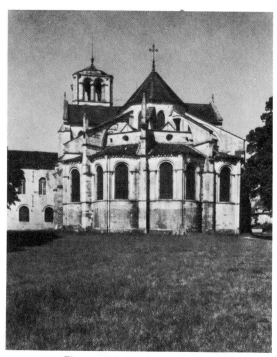

Fig. 150. Vézelay. From the east

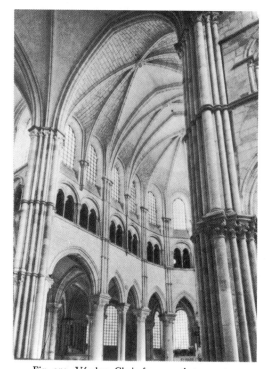

Fig. 151. Vézelay. Choir from south transept

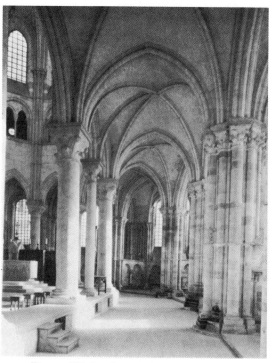

Fig. 152. Vézelay. South aisle and ambulatory

tive character, especially when compared to the choir of Saint-Denis. This conservatism is perhaps the result of the friendship between Archbishop Henry Sanglier of Sens and Saint Bernard. Otto von Simson, in his book *The Gothic Cathedral,* describes the relationship between the all-powerful archbishop and the great Cistercian, who resided in the not too distant Abbey of Clairvaux. Archbishop Henry became so worried about his worldly life that he prevailed upon Bernard to compose an essay entitled "On the Conduct and Office of a Bishop."

The building campaign at Sens and Suger's campaigns at Saint-Denis represent the beginnings of a new style. The remains of Suger's choir in plan, in spatial elegance, and in lightness seem more portentous. The accomplishments of Suger, however, should not detract from the creativity involved in the synthesis of ideas from two different Romanesque regions which resulted in the Cathedral of Sens.

Another Early Gothic structure, related to Sens, is the choir of the Abbey of Vézelay (figs. 148–152). Begun about 1185, the Vézelay choir was designed by an architect who knew Île-de-France structures. The plan of Vézelay (fig. 149) has a single ambulatory with radiating chapels and is thus simpler than the organization of Saint-Denis. Clerestory windows have not been enlarged since the twelfth century, nor have the outer sections of the vaults been raised, as at Sens. A study of Vézelay thus helps bring Sens back to its original condition. The Vézelay buttresses (fig. 150) were, however, added at a later date.

The three-story elevation and the domical profile of the vaults place the Vézelay choir in the family of churches and cathedrals which grew out of Sens. The wide proportions of the Vézelay choir reflect those of Sens and at the same time are sympathetic to the Romanesque nave (fig. 57). A diagonal view of the choir and a detail of the ambulatory (figs. 151, 152) reveal certain confusions of design. The first bay east of the crossing has a six-part vault, but no intermediate pier. The intermediate transverse rib rises from a bracket just above the triforium. The next bay has a cylindrical pier alternating with slender, paired columns. However, a four-part vault crowns the western half of the vault, while the eastern half is part of the webbed system of the rounded east end. Ribs over the paired columns rise from colonnettes which start at the bottom of the triforium area. The extra rib, extending from the intermediate support in the south ambulatory, is another hesitant detail (fig. 152). Critics disagree about the specific causes of these awkward moments. It has been suggested that a change of architects, plus the decision to construct transepts, resulted in the shortening of the choir. Another theory proposes a strong influence from northern France. The main interest for this study is that the very existence of unresolved details points up the trial-and-error procedure of the Medieval builder.

The cathedral at Sens and the choir of Vézelay are key examples of one kind of Early Gothic architecture. Both depend on the thickness of the wall to contain the thrust of the ribbed vaults; both possess wide nave spaces clearly divided by major and intermediate piers. In spite of their conservatism, they represent a Gothic synthesis of ribbed vaults, articulated piers, and new spatial modulations which will play an important role in the creation of High Gothic.

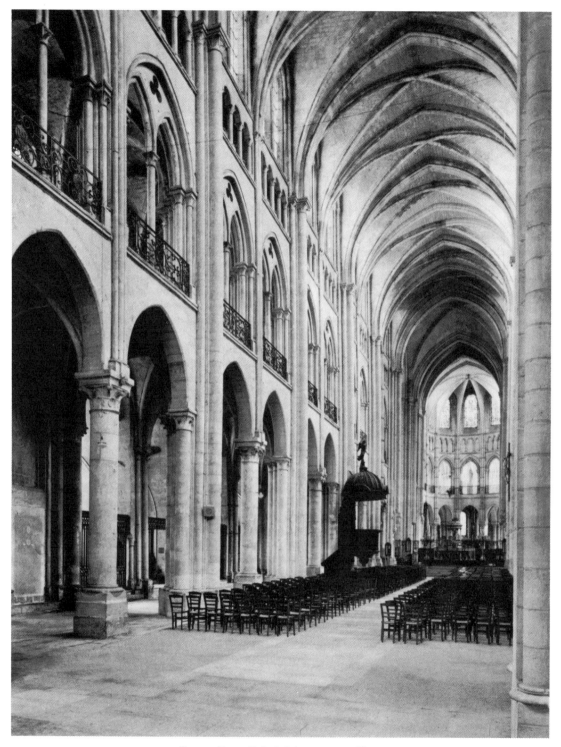

Fig. 153. Noyon Cathedral, begun c. 1150. Nave

The Cathedral of Noyon

Every Early Gothic cathedral possesses an individuality which makes it different, as a total architectural statement, from all others. Noyon (figs. 153–161) is no exception. Located due west of Laon, Noyon lies just outside the twelfth-century boundaries of the royal domain and just over sixty miles north of Paris. The town has a varied history. Here Charlemagne was crowned King of the Franks, and Hugh Capet was elected the first Capetian in 987. Noyon started as a Roman camp and became and remained an important trading center. Charles Seymour's book (see bibliography) gives a lucid analysis of the cathedral and at the same time sets it in its historical framework. His discussion of the historical, political-economic, and religious environment out of which the cathedral grew is a fascinating story which should someday be written for all Gothic cathedrals.

Noyon is centered in the Oise River basin and is surrounded by rich agricultural land. Traffic into the Seine via the Oise and on the two major roads, north and south from Paris to Flanders and east and west from the Channel ports to fairs of Champagne, made the physical location of Noyon of paramount importance. The taxes imposed on goods entering and leaving Noyon augmented the treasury of the chapter and the bishop-count.

As Seymour points out, the Bishop-Count of Noyon combined in one person the churchman and the feudal lord. Although a suffragan to the Archbishop of Reims, the Bishop of Noyon had an enormous jurisdictional and economic role in his town. His extensive revenues, when made available to the chapter of the cathedral, helped tremendously with the building campaigns. A series

of strong bishops dominated Noyon, starting in 1122 and continuing into the early years of the thirteenth century. All these bishop-counts served not only as the ecclesiastical bishops of Noyon but also as one of the king's twelve peers who advised him on the administration of the monarchy.

The monarchy did not contain Noyon within its boundaries, but only twelve miles distant is the royal town of Compiègne. In any external or internal disagreements, the kings of France usually backed the bishop-counts of Noyon. Louis VII made five visits to Noyon, and toward the end of the twelfth century Philip Augustus confirmed the charter of 1181 and resolved a series of disputes.

The commune, which operated under a charter of 1108, gave control to its richer members and, since it remained primarily a vassal of the bishop, had little legislative power. Thus, the commune, with the guilds, played only a small role in the construction of the cathedral. On the other hand, the cathedral chapter was closely associated with the building campaigns. The chapter, even though it was secularized in the twelfth century, still maintained a quasi-monastic form, with chapter house, treasury, and elaborate houses in front of the cathedral (see air view, fig. 161). The chapter consisted of sixty-nine canons; being immune from secular intervention, it exercised a great deal of power. Its vast holdings included mills, vineyards, and forests. Revenues came from outside the town as well as from tolls within the walls.

The prize possession of the Noyon chapter was the body of Saint Eloi, a seventh-century bishop. Saint Eloi was reputed to cure flowing ulcers and often served as the major protector of the Noyon-

nais. Besides being a national saint linked to the king, Saint Eloi was the patron saint of blacksmiths and goldsmiths. The presence of this important relic in Noyon was one of the chapter's prime sources of revenue.

A fire in 1131 heavily damaged the third church at Noyon. Between 1145 and 1150 a decision was reached to construct a new cathedral, for which a workshop was formed. By 1155 or 1160 the chapels of the choir were completed (fig. 156). According to Seymour, a second building campaign from 1165 to 1170 accomplished the completion of the ambulatory, the tower bays flanking the choir, and the exterior walls of the galleries of the choir. During this same period (1165–1170) the design of the unusual transepts was established. By 1185 the third campaign had accomplished construction of the upper choir, the transept arms, the treasury, Episcopal chapel, and the easternmost bay of the nave. Around 1190 one more bay of the nave was built, and by 1205 the last three were finished. The final building campaign, involving the construction of the west façade, was completed by approximately 1235. No attempt will be made to detail these campaigns, which Seymour has discovered, analyzed, and related to the shifting financial fortunes of the chapter.

The nave of Noyon (fig. 153) has a four-story elevation: nave arcade, gallery, triforium, and clerestory. The vaults were originally six-part, and their six-part make-up made meaningful the alternating system of supports (pier and intermediate column). The vaults were changed from six-part to four-part following a bad fire in July of 1293. During the restoration, flying buttresses, which were not part of the original design, were added. These flying buttresses were repaired in the fifteenth century. Extensive restorations were again necessary after the bombardments of World War I.

The slender proportions of the nave and choir of Noyon (fig. 153) differ markedly from the squat proportions of Sens (fig. 139). The latter, 81¼ feet tall, is actually 7 feet higher than Noyon from pavement to crown of the vaults; yet Noyon is only 29½ feet wide, as opposed to the 49½-foot width of the nave of Sens. Visually, Noyon achieves a

sense of verticality. The piling up of the four stories of nave arcade, gallery, triforium, and clerestory intensifies the soaring character of the space of Noyon, as opposed to the square proportions of Sens (fig. 139). By the introduction of the ribbed vaulted gallery over the aisles and a thick wall behind the triforium, the builders of Noyon were able to stabilize the thrust of the vaults. The four-story elevation would seem to have taken its origin in the nave of the Cathedral of Tournai, begun about 1110, although several examples of this elevation exist in the late eleventh-century Norman churches in England.

A closer comparison of Sens and Noyon reveals a decided evolution of design. The hesitant treatment at Sens of the shaft rising from the intermediate pair of columns (fig. 139), from the top of which spring the two wall ribs and the intermediate transverse rib, is transformed at Noyon (fig. 153) into the more logical bundle of three shafts which reflect the original disposition of the six-part vaults. Further, the ponderous and abrupt alternation of massive pier and paired columns at Sens shifts to a more gentle and rhythmic modulation in the Noyon nave. In spite of the diagonal shifts of the piers of Sens in the spirit of Early Gothic, the Romanesque sense of the wall dominates. By contrast, the reduction of the wall to a skeleton in Noyon, with the undercutting of the surface in the triforium and the complexity of the supports in the gallery, is clearly Gothic.

The choir of Noyon (plan, fig. 154, and figs. 155, 156, 159) is retrogressive when contrasted to Saint-Denis (figs. 128, 132). Small windows and the squat proportions of the ambulatory (fig. 156) give the east end of Noyon a mural heaviness which is completely different from the slender elegance of Suger's choir of 1144. The squatness is intensified by the left two piers (fig. 156), which were enlarged in the fifteenth century. The four original piers embrace the hemicycle. Noyon's single ambulatory, with its radiating chapels, is a more conservative plan when compared to the double ambulatory of the abbey of Saint-Denis and resembles the choir of Saint-Germain-des-Prés in Paris, dedicated in 1163. The Noyon choir has a four-story

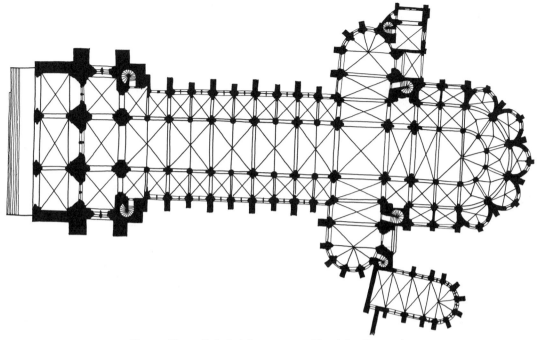

Fig. 154. Noyon Cathedral, begun c. 1150. Plan (after Seymour)

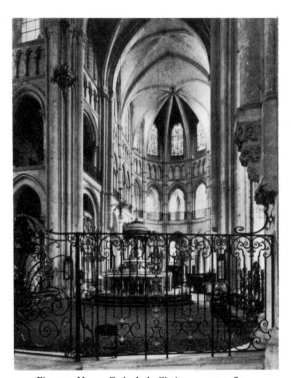

Fig. 155. Noyon Cathedral. Choir, c. 1150–1185

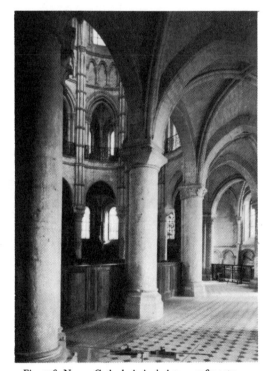

Fig. 156. Noyon Cathedral. Ambulatory, 1165-1175

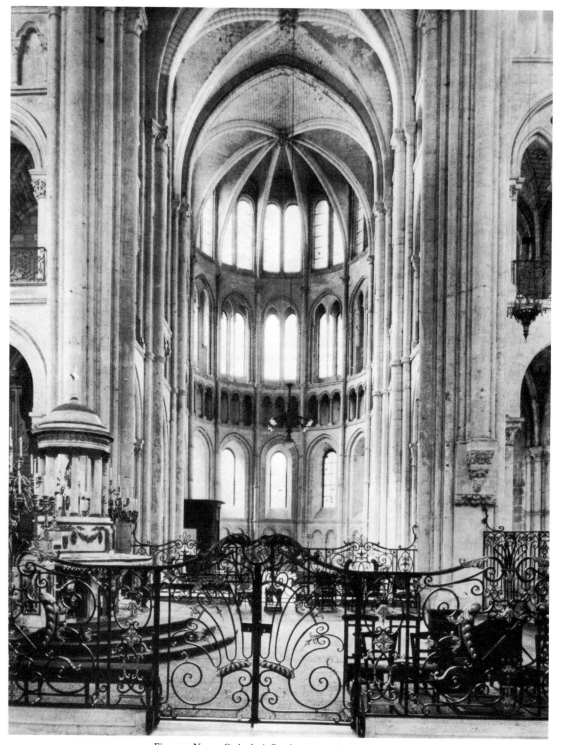

Fig. 157. Noyon Cathedral. South transept, finished c. 1185

division of nave arcade, gallery, blind triforium, and clerestory. The treatment of the triforium, with arcades but no passageway (figs. 155, 156), proves that the choir was designed earlier than the nave. The master builder, responsible for the choir, insisted on seven tiers of shaft-rings to bind the colonnettes into the walls. Greater structural clarity and an accent to the horizontal string-courses between stories results. This decorative nature of the choir is abandoned in the transept and nave.

The most creative part of Noyon is the transept (figs. 157, 158). The master builder, who finished the upper part of the choir, seems to have been responsible for the transept design and for the eastern bay of the nave, all finished by 1185. The architect devised an unusual solution for the aisleless, rounded transept arms. Instead of continuing with the customary four-story elevation of nave arcade, gallery, triforium, and clerestory, he started with a simple blind arcade at the base, then windows corresponding to the main nave arcade. He reversed the thin gallery and the triforium, so that the small triforium separates the lower ring of windows from the gallery windows. The clerestory windows add to the luminosity. This daring perforation of the wall to allow three stories of windows is completely different from the more mural choir (fig. 155). In order to make this fragile, seemingly structureless part stable, the architect constructed the floors of triforium and gallery of stones which extended from the inner wall to the outer face of the transept. These blocks of masonry, together with segments of barrel vaults over the triforium and gallery, help create the necessary solidity in the structure. The boldness of the transept design, in contrast to the choir, marks this architect as an important innovator. This imaginative design, however, had no discoverable influence on subsequent buildings. Rather, it appears to have been one of those sensitive yet isolated experimental moments of Early Gothic architecture. The notion of converting a solid wall into two membranes separated by passageways but joined structurally is an idea which came originally from Norman Romanesque. At Noyon there are three passageways, two on the interior in the triforium and gallery and one on the exterior behind the wall buttresses and in front of the clerestory windows (fig. 158).

The shift from six-part to four-part vaults makes the spatial continuity of the nave of Noyon somewhat confusing (fig. 153). The rugged alternation of multiple pier with single column is not continued into the arrangement of the ribs. As work progressed from east to west, minor changes were made, such as a lowering of the level of the pavement and a further opening up of the arcades of the galleries. Basically, the design established in the first, or eastern, bay of the nave continues to the façade. Again the consistency of forms between nave and choir, as played off against the different design of transept, gives the total interior space its exciting quality.

The façade of Noyon (fig. 160) takes us forward into the early years of the thirteenth century; yet its design (the massive wall buttresses, the play of vertical buttress and horizontal arches and arcades, and the squared proportions) relates it to twelfth-century façades.

If the exteriors of Noyon (figs. 158–161) are studied in relation to the plan (fig. 154), it is apparent that the total design, with heavy façade and triple, rounded transept arms and choir, is entirely different from the essentially transeptless Cathedral of Sens (fig. 140). At Noyon, towers were planned to flank the corner of choir and transepts (fig. 159). In the eighteenth century the top floors of these towers were removed. If these towers had been completed, the nature of the massing would resemble that of small Île-de-France churches like Morienval or other structures to the north and northeast of Noyon. The flying buttresses were added to the choir and nave after the fire of 1293. The choir buttresses were repaired in the fifteenth century and rebuilt in an un-Medieval manner in the eighteenth century. The addition of flying buttresses, following their invention in the nave of Notre-Dame in Paris during the 1180's, was not necessitated by impending structural failure, but rather by the desire to modernize the Early Gothic cathedrals.

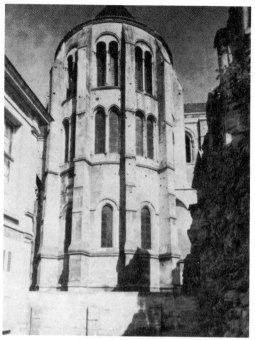

Fig. 158. Noyon Cathedral. Exterior of south transept

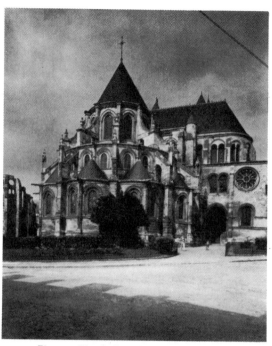

Fig. 159. Noyon Cathedral. From the east

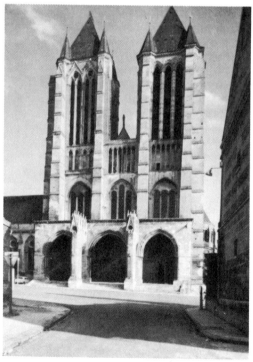

Fig. 160. Noyon Cathedral. Façade, completed
by c. 1235

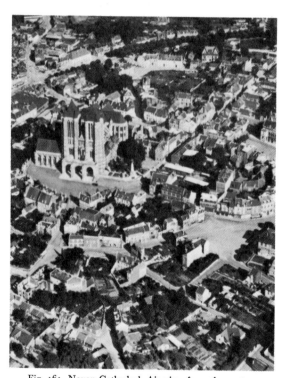

Fig. 161. Noyon Cathedral. Air view from the west

Noyon, like all Early Gothic cathedrals, is unique in its totality. The general character of the choir has counterparts in the choirs of Saint-Germain-des-Prés and Vézelay from the point of view of plan; yet the Noyon choir and the aisleless, rounded transept arms form a trilobed east end which is exceptional in the Île-de-France region but has connections with churches in Flanders and southern Germany. Rounded elements accented by vertical towers flanking the choir play against the massive west end (fig. 161). Related in structure to the four-story elevation of Laon, Noyon is remarkably different from Laon in massing and organization of interior spaces. Further, Noyon is completely dissimilar to the squat three-story Cathedral of Sens. As a whole, the massing of Noyon has a configuration quite different from that of any other Early Gothic cathedral. In spite of alterations in the thirteenth and subsequent centuries, Noyon possesses an intimacy of scale, consistency of forms, and, especially in the design of the transept, moments of great creativity.

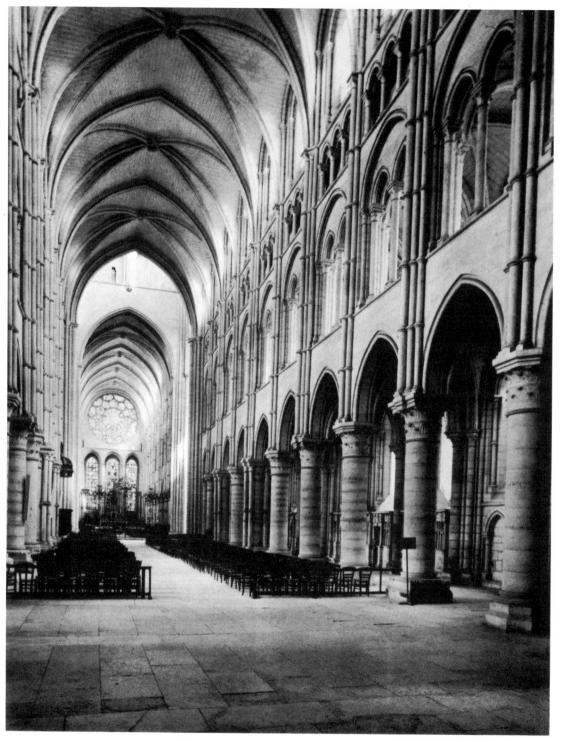

Fig. 162. Laon Cathedral, begun c. 1160. Nave

The Cathedral of Laon

THE CATHEDRAL OF LAON, dedicated to the Virgin Mary, rises dramatically from a thin ridge which dominates the surrounding, fertile plains (figs. 171, 172). Laon is twenty-seven miles northwest of Reims and sixty miles northeast of Paris. Both town and cathedral have had an intense, stormy history. A church founded by the Archbishop of Reims toward the end of the fifth century was the first structure raised at Laon. During the ninth century the last sons of Charlemagne battled the Capetians on this Carolingian site. There, on April 25, 1112, occurred one of the bloodiest revolts of the Middle Ages. The commune of the bourgeoisie and merchants rose up against Bishop Gaudri, who had annulled their charter. The commune burned the house of the treasurer of the cathedral chapter, and the fire then spread, burning the church of the tenth or eleventh centuries. The King of France, bought by the Bishop of Laon for a higher price than that offered by the commune, helped in the recapture of the town. Following this successful counterattack, there was more slaughter as the nobility took revenge. Soon afterward the peasants had their opportunity to devastate the town.

Three months after this disastrous conflict, seven canons and a group of lay clerics left Laon on a pilgrimage through France, carrying relics: a piece of the dress of the Virgin, a fragment of the sponge of the Passion, and a piece of the True Cross. Miracles were performed and funds raised. Later the entourage spent seven months traveling in England. With these funds a reconstruction of the previous church was undertaken, and the church was consecrated on August 29, 1114. This structure, however, was not large enough for the growing cathedral school, which was winning acclaim all over western Europe, nor was it of sufficient size to serve the expanding population of Laon. The prosperity of the town centered in the famous cloth industry, whose products were exported as far as Egypt. Revenue also accrued from the strategic location of Laon on the main route between Flanders and the Île-de-France to the south. With the re-establishment of the commune of Laon in 1130, together with the expansion of commerce, it was clear that a much larger cathedral was needed.

The present Cathedral of Laon was begun by Bishop Gautier de Montagne in the late 1150's. Work started in the south transept, and by 1170 the choir and the transept were almost finished. In 1178 a second architect-builder supervised the construction of the two eastern bays of the nave. A third building campaign, probably with a third architect, included the construction of the rest of the nave and the façade, lasting from around 1190 until 1215. The paired towers on each transept and the square lantern tower over the crossing would seem to have been planned from the outset, although the towers themselves may have been built by the second, or more probably the third, architect. In 1205 the choir, which was a simple polygonal mass with a single ambulatory (see plan, fig. 163), was demolished and the present, long, flat-ended choir added (fig. 169). Also, in the thirteenth century, flying buttresses were added to the entire cathedral, and structures including sacristy and small chapter house were fitted into the areas between the choir and the chapels opening off the east sides of the transept. In the late thirteenth and early fourteenth centuries, private chapels

were constructed between the pier buttresses. To return Laon to its former state, all the flying buttresses, the flat east end, and the chapels around the periphery of the cathedral must be eliminated. But with these additions and alterations, the Cathedral of Laon preserves its original twelfth-century character more completely than any other Early Gothic cathedral.

As at Noyon, the nave of Laon presents a much more soaring and vertical effect than the nave of Sens (contrast figs. 162, 153, and 139). The nave vessel of Laon is 79 feet by 35 feet, similar in its proportions to Noyon (74½ feet by 29½ feet), as opposed to Sens (81¼ feet by 49½ feet). If the naves of Noyon and Laon are compared (figs. 153, 162), many similarities are apparent, especially if the original six-part vaults are restored to Noyon. The same four-story elevation of nave arcade, vaulted gallery, triforium, and clerestory exhibits the continuation of the Noyon format in the slightly later Cathedral of Laon. The alternation of major compound piers with single intermediate columns at Noyon clearly reflects the original six-part vaults (fig. 153), while the Laon architects state the nature of the six-part vaults by alternating bundles of five shafts with bundles of three, but violate the logic of this system by having uniform cylindrical piers for the nave arcade, except in the easternmost bays.

Light enters the nave at Laon directly through the clerestory and indirectly through the gallery and aisle. The greater amount of light in Laon can be compared with the dark interiors of Romanesque churches and with the somber nave of the Cathedral of Sens. The emphasis on corporeal light as symbolic of divine light illuminating the kingdom of God on earth is clearly stated in the nave of Laon. Heaven and earth are merged in this worldly and divine light.

Progress toward the crossing is quickened by the dramatic, direct lighting from the square lantern tower (fig. 166). Transept arms with the same disposition of four stories extend from the crossing. The gallery continues around the ends of the transept (figs. 166, 167) in a manner typical of Norman Romanesque. The view across the transept gives the impression of a complete smaller church contained within the cathedral. Complete circumnavigation of the interior of Laon is possible on three levels: the aisles, the gallery, and the triforium. At the level of the gallery two-story chapels open off the east sides of both arms of the transept (fig. 168). These delightful chapels often served for marriages or, as in the case of the south chapel (fig. 168), for the treasury of the chapter, where the funds, controlled by the chapter, were guarded day and night until the Revolution. These elegant chapels have thin aisles around their peripheries. Layers of walls in a system originated in Normandy and Norman England are dramatized by light, as can be seen even more clearly in the walls of the nave.

The nave vaults consist of square bays divided into six parts (see plan, figs. 163 and 162, 166). The six-part vaults over square bays result, as in the Cathedral of Sens, in an alternation: five ribs converge at the major piers, three ribs at the intermediate piers. This alternation of five and three corresponds to the disposition of the ribs of the vaults. Above each of the major piers rise five colonnettes extending up the vaults: the central and largest colonnette supports a capital from which the transverse rib springs, the two flanking colonnettes grow into the diagonal ribs, while the outside colonnettes continue up the wall and terminate in the wall or longitudinal ribs over the clerestory. Above the alternating minor piers there are no diagonal ribs, so that the three colonnettes reflect and join the intermediate transverse rib and the two wall ribs. Thus the five–three alternation of colonnettes has a structural and visual logic which relates to the nature of the six-part vaults.

Upon closer observation, the nave of Laon indicates how the Medieval mind experimented with different solutions for structural and visual handling of the major and minor piers. Near the crossing the second architect added extra colonnettes to every major pier (figs. 162, 163) to reflect the structural differences in the vaults above. This variation occurs in the west of the crossing; then the architect, probably a different one, abandoned this idea, and the rest of the piers all the way to the

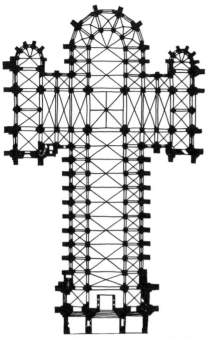

Fig. 163. Laon Cathedral, begun c. 1160. Plan
(after Lambert)

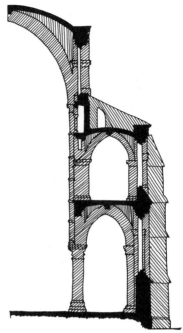

Fig. 164. Laon Cathedral. Cross section

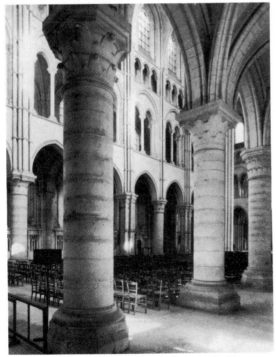

Fig. 165. Laon Cathedral. Nave from south aisle

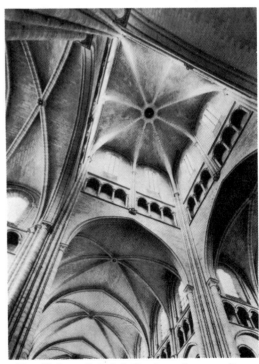

Fig. 166. Laon Cathedral. Crossing and nave vault

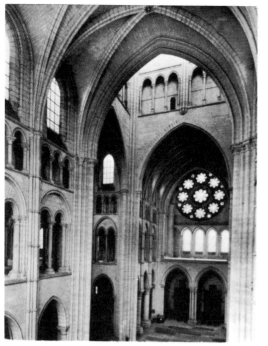

Fig. 167. Laon Cathedral. Transept from south gallery

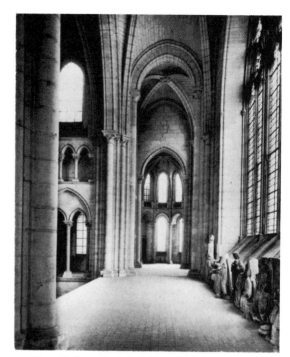

Fig. 168. Laon Cathedral. South gallery and chapel

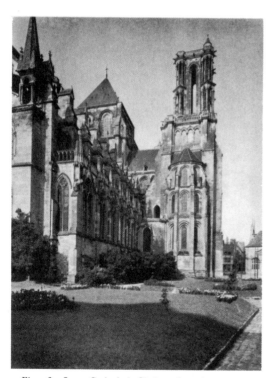

Fig. 169. Laon Cathedral. Choir and north transept

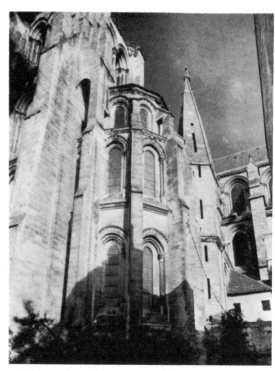

Fig. 170. Laon Cathedral. South transept and chapel

façade are unadorned. This desire to vary structural and visual pattern in reflection of structural function is typical of the empirical approach of the second half of the twelfth century. When the architect gave up the alternation of the piers, he continued a decorative alternation, which replaced the more overt structural alternation in the eastern bays. Capitals and bases of the cylindrical piers shift from octagonal to rectangular forms (fig. 163). This visual refinement seems to be an improvement over the rather crude and tentative handling of the piers near the crossing. What seems at first to have been an attempt at structural continuity between piers and vaults is transformed into a design of great visual sensitivity, but little structural logic.

In contrast to the Cathedral of Sens, Laon exhibits more spatial continuity, greater verticality, and more dynamic juxtaposition of volumes of nave and wide transept. The essentially transeptless arrangement of Sens and the absence of a crossing tower convert the big wide spaces into a sequence of slow rhythms extending from façade to choir. By contrast, the nave of Laon leads dramatically in the sequence of spaces defined by its taller and thinner bays to the well-lit crossing. From the square lantern tower it is possible to proceed laterally into the transepts to the same depth as existed originally in the rounded choir.

Diagonal views of the nave or transepts of Laon (figs. 165, 167) reveal the thick walls which are the major supporting elements. Clerestory windows are still apertures cut into walls, and a considerable amount of masonry remains between windows and the springing of the ribs. The counterthrusts which equalize the outward push of the vaults are a series of thick transverse arches under the roof and behind the triforium (cross section, fig. 164). These hidden buttresses and the thick walls support the vaults. The four-story elevation thus seems to have been dictated by the necessity of getting a heavy wall buttress up high enough to support the ribs at the points from which they are sprung. The flying buttresses, as already stated, were thirteenth-century additions. They were not necessary to counteract any structural weakness,

but rather to modernize the cathedral in accordance with the new High Gothic.

The plan and views of the interior of Laon account for the complexity of the exterior massing. Situated on the spine of a hill, the cathedral's silhouette is forever changing when viewed from different vantage points (figs. 171, 172). Five of the seven planned towers were completed: the two façade towers, the square lantern tower, and the two towers on the transept arms. Only the two eastern transept towers do not have upper stories. This profusion of towers gives Laon an emphatic verticality; yet the distances between towers emphasizes the lateral, horizontal extension of nave, transept, and choir as they fan out from the central square lantern tower.

The façade of Laon (fig. 174) is an elaborate articulation of solids and voids, in spite of the lingering mural overtones of Romanesque. The lateral disposition of nave and aisles is repeated in the triple division of the façade. At the same time, the four-story elevation (nave arcade, gallery, triforium, and clerestory) is echoed by the portals, the deep arches over the windows, and the arcaded passageway at the base of the towers. The contrast between Laon and Saint-Denis (figs. 124, 127) reflects the evolution of façade design between 1140 and the end of the twelfth century. The military caste of Saint-Denis, derived from Normandy, has evolved into the more deeply undercut surfaces, with their greater emphasis on light and shade. The small, central oculus in the façade of Saint-Denis is replaced by the wide rose window of Laon. The Laon façade establishes several planes in space: the protruding porches with their gables, the pinnacles or tabernacles between the porches, the main wall of the façade proper, and the deep reveals of the windows and the gallery.

One detail of the Laon façade suggests the somewhat hesitant, experimental nature of this stage in the development of Early Gothic — a hesitancy which parallels the indecisive treatment of the nave piers. The central section of the façade is wider in proportion to the flanking sections than it is, half a century before, at Saint-Denis, and this greater width, together with the size of the splay

Fig. 171. Laon Cathedral. From the southwest

Fig. 172. Laon Cathedral. From the north

Fig. 173. Laon Cathedral. North tower
(Villard de Honnecourt)

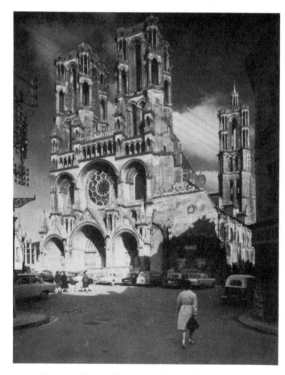

Fig. 174. Laon Cathedral. Façade, begun, c. 1190

surrounding the rose window, causes an awkward break in the horizontal, arcaded passageway.

Even without their planned wooden spires, the façade towers and the two completed transept towers (fig. 171) achieve a powerful verticality. The thirteenth century's appreciation of the Laon façade is attested by the drawings of the north tower in the Album or Lodge Book of Villard de Honnecourt, now preserved in the Bibliothèque Nationale in Paris (fig. 173). Villard, an architect born near Cambrai, not only designed and supervised the construction of buildings in northern France but also drew parts of buildings which excited him as he traveled through France and into Hungary in the 1230's. His drawings probably served as a textbook for students in the lodge, and later masters added notations to the album. Although Villard's drawing of the elevation of the Laon tower is not articulated in terms of perspective, it does exhibit a completely readable, shorthand interpretation of the spidery quality of the tower and the whimsical oxen which twist out from the turrets. By line alone Villard de Honnecourt has captured the elegant transparency of the Laon tower as it soars above cathedral and town. He wrote under his drawing of the plan of the north tower of the Laon façade:

> As you will learn from this book, I have been in many lands, but nowhere have I seen a tower like that of Laon. Here is the plan of the first story with the first windows. At this level, the tower has eight sides. The turrets are square, with their columns in groups of three. Then come small arches and entablatures and turrets with eight columns, and between two columns a bull. Then some more small arches and entablatures and eight-sided roofs. On each face there is a big arch to give light. By looking carefully at the drawings before you, you will perceive the whole arrangement and the way the turrets change shape. Remember that if you wish to build great buttress towers, they must project sufficiently. Take pains with your work and you will act prudently and wisely.

If the square-ended thirteenth-century addi-

tion to the choir (see original plan, figs. 163, 169) is eliminated, then the east side of Laon presents a horizontal massing accented by the verticals of the rounded choir and the three-story chapels projecting from each arm of the transept. This triple apsidal arrangement and the transept towers then lead up to and frame more clearly the square lantern tower over the crossing. Exterior passageways in the wall buttresses of the top sections of these superimposed chapels (figs. 169, 170) form embryonic flying buttresses similar to the passageways in the transepts of Noyon (fig. 158). This unusual feature, dating from the 1170's, was soon to evolve into the true flying buttresses of the nave of Notre-Dame in Paris.

One important difference distinguishes the transepts of Noyon (fig. 158) from the three-story chapels on the transepts and the original choir at Laon (figs. 168–170). At Noyon the planes of wall between the buttresses are semicircular, while the Laon chapels (and the original choir) have a radial arrangement of the wall buttresses, but the walls between are not curved. This polygonal arrangement at Laon makes the flat walls consistent with the stained-glass windows.

Laon, like all other Gothic cathedrals, employs but transforms ideas from earlier structures. Certainly Suger's façade influenced the design of Laon, while the square lantern and the multistoried chapels off the east ends of the transept are inspired by Norman buildings (see Saint-Trinité at Caen, fig. 90, and Cerisy-la-Forêt, fig. 92). The multiple towers of the Laon plan appear to exhibit a northern influence from such churches as Tournai in Flanders. But in spite of the impact of other provincial concepts on its design, Laon remains a unique structure. In plan, in the nature of its interior space, in the treatment of wall surfaces, and in elevation and dynamic massing, Laon is as entirely different from the cathedrals of Sens and Noyon as it is from other Early Gothic cathedrals yet to be discussed. In this writer's opinion, Notre-Dame of Laon is the most impressive of the Early Gothic cathedrals.

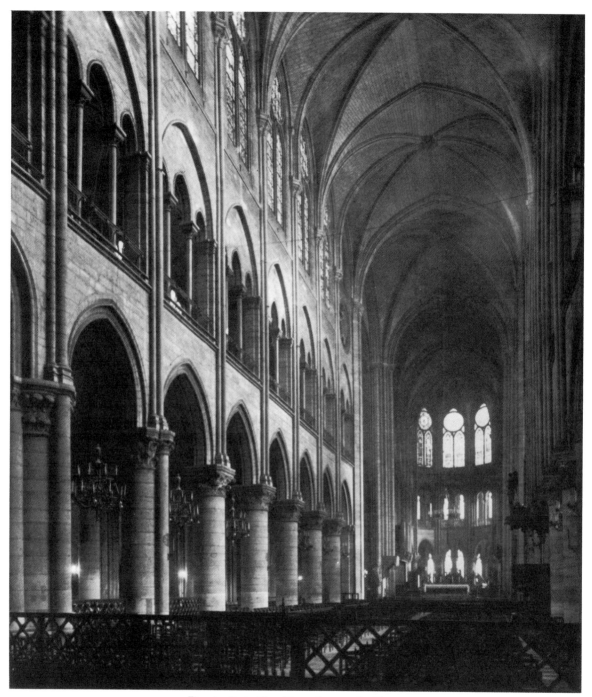

Fig. 175. Paris, Notre-Dame, begun 1163. Nave

The Cathedral of Paris

I N 1163 Bishop Maurice-de-Sully began construction of the Gothic Cathedral of Notre-Dame on the Île-de-la-Cité in the heart of Paris (figs. 175–185). Notre-Dame of Paris is the exception among Early Gothic cathedrals, primarily as a result of its sheer size. None of the cathedrals discussed had vaults higher than 81 feet above the pavement. In contrast to the huge Burgundian Romanesque church, Cluny III, which rose over 97 feet, the majority of Early Gothic cathedrals were smaller. Maurice-de-Sully's Paris, however, is the exception, since it rose to over 108 feet in height from the pavement to the crown of its vaults. During Bishop Sully's lifetime its 402-foot length was almost completed, and the façade was built under subsequent bishops in the first half of the thirteenth century. The cathedral's dramatic location in the center of Paris, flanked by the two branches of the river Seine and the place or parvis on the west side, has made Notre-Dame perhaps the best-known monument in western Europe. Unfortunately, Notre-Dame has suffered by substantial interior alterations and exterior additions. As one of the main symbols against which the French Revolution was directed, the cathedral sustained considerable damage. Nineteenth-century restorations reveal a lack of understanding of the intentions of the twelfth-century master builders.

The original construction of Notre-Dame embodies primarily the vision of Bishop Maurice-de-Sully, the Horatio Alger hero of the twelfth century. He was born the son of a peasant family near Sully on the Loire; he probably received his early education within the walls of the famous Benedic-

tine monastery of Saint-Benoît-sur-Loire and arrived in Paris in his youth. According to Allan Temko in his book on Notre-Dame of Paris, Maurice-de-Sully was probably born around 1120 and came to the city as early as 1137 to study in the schools there which were gradually growing into the University of Paris. He soon became a clerk in the cathedral chapter and later, at the age of twenty-seven became the subdeacon. Instead of following the traditions of the schools of Paris and developing into a great theologian, Maurice-de-Sully won renown for his sermons. From archdeacon he rose to become the elected bishop on October 12, 1160. His election put him in a position to mobilize all the necessary resources for the construction of a new, huge cathedral. Resources came from cathedral properties, which included castles, towns, mills, forests, and rights to special taxes, together with revenues from the large amount of real estate in the city of Paris itself. Over half of the land on the Île-de-la-Cité was owned or controlled by the cathedral chapter. In order to prepare the site, Maurice-de-Sully demolished the Merovingian and Carolingian churches and had cuts made in the huge Gallo-Roman ramparts. Pope Alexander, exiled in France, is traditionally believed to have laid the first stone of the choir in 1163. Alexander was in Paris during the same year to consecrate the choir of Saint-Germain-des-Prés. In the nineteenth century archaeologists probed the foundations under the cathedral and discovered that the footings were over 30 feet deep and consisted of carefully cut hard stone. The intention to erect the tallest cathedral is thus reflected in the preparation of the subfoundations.

On May 19, 1182, the altar of the choir was con-
secrated, but work had already begun on the nave
four years earlier. The second building campaign,
under the direction of a new architect, extended
from 1178 to the 1190's and included the comple-
tion of the nave, except for the westernmost bay
(fig. 175). Maurice died in 1196, and this second
campaign was finished by Bishop Eudes-de-Sully.
This bishop and his four successors built the fa-
çade in the first half of the thirteenth century.

Unfortunately, drastic changes were made in
the thirteenth century, altering the original char-
acter of the cathedral. Around 1225 the clerestory
windows of the entire church were enlarged in
width and height, and the triforium, which orig-
inally consisted of oculi between clerestory and
gallery, was eliminated. Chapels were also added
between the nave buttresses in the 1230's and be-
tween the buttresses of the choir in the 1270's. Be-
tween 1246–1247 and about 1257 Jean de Chelles
added a bay and elaborate façade to create the
north transept. The added bay and façade of the
south transept were begun by Jean de Chelles in
1258, but were finished by Pierre de Montreuil
after 1260 or 1261. During the transformation of
the clerestory, some flying buttresses were added to
the choir and the nave buttresses were changed
considerably. Because of the condition of the
church in the nineteenth century, Viollet-le-Duc
had to rebuild the flying buttresses. He did, how-
ever, change the interior bays adjacent to the cross-
ing back to their original disposition (fig. 183). It
is thus necessary to make many visual restorations
in order to turn the historical clock back to the
Notre-Dame of Maurice-de-Sully.

In spite of the enlargement of the clerestory
windows, Notre-Dame remains a relatively dark
cathedral. The choir is startling for its height and
for the design of the ribbed vaults in the unusual
double aisles which circumnavigate the choir
(figs. 177, 178). The actual plan, as envisaged by
the first architect under Maurice-de-Sully, in-
volved double aisles on each side of the nave vessel,
with no chapels opening off the outer aisle of the
ambulatory (fig. 176). This simple ambulatory of
two aisles was different from those of all other

Early Gothic cathedrals. In its squatness and dark-
ness, the ambulatory at Notre-Dame is certainly
vastly different from the double ambulatory with
shallow radiating chapels at Saint-Denis (fig. 128).
The whole concept of a massive, masculine struc-
ture in Paris can be contrasted with the abbey's
elastic lightness and airiness. These marked differ-
ences are even more significant when one realizes
that a whole generation separates their construc-
tion. Yet in the case of Paris, the entire choir rises
at least thirty or forty feet higher than the choir
projected by Abbot Suger.

The east end of Paris presented its architects
with a difficult design problem: the vaulting of
the trapezoidal bays around the double ambula-
tory. The architect handled this by designing the
inner bays around the choir as a series of three-
part vaults with extra columns between the major
columns (see plan, fig. 176, and fig. 178). This dia-
mond-shaped arrangement is carried to the outer
bays, so that a kind of diagonal line of thrust is
established from all inner columns to the outside
walls. The uniqueness of this solution is apparent
if the Paris plan is compared to the plan of Saint-
Denis, Sens, and Noyon. The later addition of a
girdle of chapels around the apse at Notre-Dame
has changed the lighting of the entire choir.

A second master assumed the supervision of
design and construction at Paris about 1178 and
was responsible for the nave starting with the west-
ern piers of the crossing and continuing toward
the façade. The second architect-builder contin-
ued the same four-story elevation and the same six-
part vaults rising from cylindrical columns. But,
interestingly, the axis of the cathedral shifts
slightly (fig. 176). The very nature of the western
piers of the crossing with their pilasters is different
from the eastern piers (see figs. 175, 183). In con-
trast with the dramatic alternation of supports of
the Cathedral of Sens or the more muted alterna-
tion of Noyon, Paris has uniform cylindrical piers
extending from the choir almost to the west façade.
In this feature, Paris resembles Laon, although at
Laon, in bays near the crossing, an attempt was
made, by the addition of many colonnettes, to set
up a rhythmical alternation which would relate to

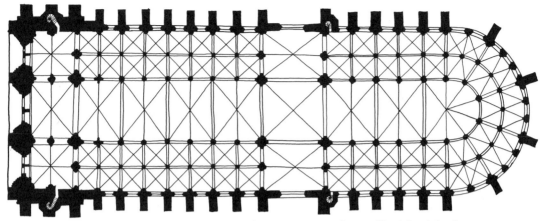

Fig. 176. Paris, Notre-Dame, choir 1163–1182; nave c. 1178–1200. Plan (after Aubert)

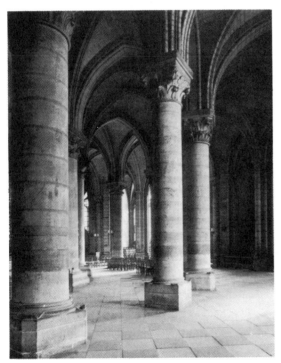

Fig. 177. Paris, Notre-Dame. Ambulatory

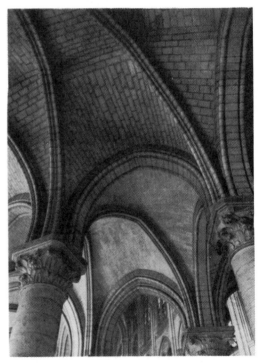

Fig. 178. Paris, Notre-Dame. Ambulatory vaults

the six-part vaults (fig. 165). The original disposition at Paris of nave arcade, gallery, triforium area with oculi, and small clerestory windows can only be seen in the detail of the crossing (fig. 183). This detail, when compared to the original cross section of the nave (fig. 181), indicates how the whole nave was supported.

It is unusual that the cathedral with double aisles should be the first one with monumental flying buttresses. As the cross section indicates (fig. 181), the buttresses are in two stages over the outer aisles. One stage is hidden under the roof of the gallery over the inner aisle, while the upper one stands free. The thrust of the domical six-part vaults is equalized by a complicated system of flying buttresses. Sections of thick walls around the clerestory windows still participate in the stability of the structure. Up until the 1180's, when these flying buttresses were invented, the twelfth-century builder-designer had relied exclusively on thick walls and on concealed buttresses behind the triforium (see original cross section of choir without flying buttresses, fig. 179). The second master of Paris made these hidden buttresses visible, and from that moment flying buttresses were to play a dramatic visual and structural role in Gothic architecture. It should be pointed out, however, that the buttresses of a single flight or arch over the double aisles which now exist in Paris were erected in the nineteenth century by archaeologists who were restoring the much-altered buttresses of the thirteenth century.

In Paris there is no alternation of the main piers of the nave. Whether major or minor, the piers are identical and cylindrical (fig. 175). Also, the shafts, which rise from the capitals of the piers to the vaults, are in bundles of three over each pier, not in bundles of five alternating with three, as in Laon (fig. 162). Thus, the builders of Paris did not reveal the convergence of five ribs (one transverse, two diagonals, and two longitudinal or wall ribs) over the major piers which support the six-part vault. Yet to help support the intermediate piers of the flying buttresses and to suggest the alternation, the architect created an alternating system in the supports which separate the double aisles (figs. 180, 182). Every other aisle pier is girdled with colonnettes, and each of the stronger aisle piers corresponds to the nave pier which has the greatest number of ribs above it. The master builder apparently realized that the convergence of more ribs above every other nave pier created a different outward thrust. In order to move this rhythmically alternating thrust to the outer walls, the architect reinforced every other short pier in the aisles. Whether the builder actually rationalized in this way, we do not know; yet, proceeding empirically, he took no chances, but simply transferred the usual alternating system from the nave piers to the aisle piers. Thus the aisles of Paris exhibit a subtle, refined effect which is normally seen in the nave (as at Sens and Noyon).

A third master, coming from the workshop of Chartres Cathedral (see bibliography: Branner), was responsible for the construction of the westernmost bay of the nave and the façade. This master took over the Paris workshop at the very end of the twelfth century. In the fourth bay of the nave, counting from the crossing, he changed the design of the piers of the nave arcade, following the format of the High Gothic Chartres, begun in 1194. Instead of the plain cylindrical piers of the rest of the nave, one colonnette was added to the major pier and four colonnettes to the intermediate pier. The piers with the single colonnette follow the design of the piers in the hemicycle at Chartres, while the strong pier with four colonnettes is based on those in the nave, transept, and choir of Chartres. The curious feature of this western bay is the location of the strong pier in the intermediate position under the six-part vaults where the intermediate transverse rib and the two wall ribs converge. To put it another way, the design of these High Gothic piers is not co-ordinated with the six-part vault.

In terms of the total impact of nave and choir at Paris, there seems to be little change in the design of the nave when compared to the choir. The second master made the nave about three feet wider than the choir, changed the design of the western crossing piers, and altered the nature of the arcade of the gallery. What is most important

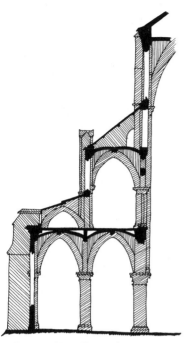

Fig. 179. Notre-Dame. Cross section
of choir (after Aubert)

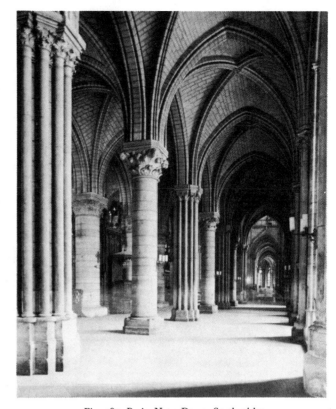

Fig. 180. Paris, Notre-Dame. South aisles

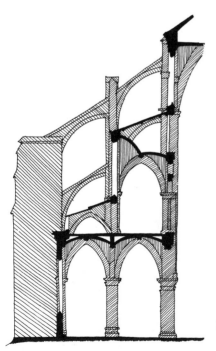

Fig. 181. Paris, Notre-Dame. Cross section of nave
(after Aubert)

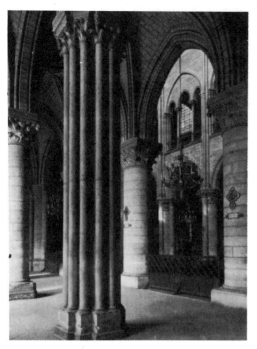

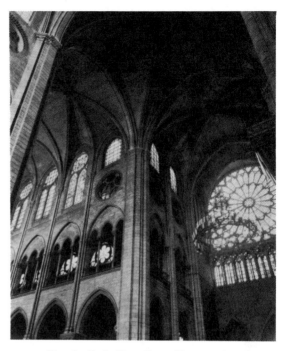

Fig. 182. Paris, Notre-Dame. South aisle and nave (sixth and seventh piers)

Fig. 183. Paris, Notre-Dame. Nave, crossing, north transept

Fig. 184. Paris, Notre-Dame, South flank

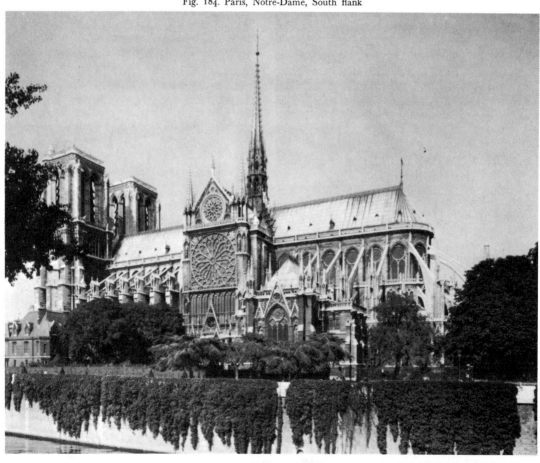

is the fact that this master developed a new dynamic technology to buttress the outward thrust of the vaults. In the south gallery of the nave he went even further and tipped upward one part of the four-part vaults so that an oculus could be placed there to give additional light. He thus made visible a new system of construction and then had the imagination to toy with it in unusual ways in the attempt to get more light into the nave proper.

The façade of Paris (fig. 185) was begun around 1200 by a third master. Work proceeded gradually, and by 1220 the base of the gallery of the kings had been reached. Around 1225 the rose window and flanking areas were finished, to be followed by the south tower around 1240 and the north by mid-century. In 1204, when the façade was being built, Philip Augustus had led the French army into Normandy, had captured the famous Château Gaillard built by Richard the Lion-Hearted in 1197, and had begun the final defeat of the English. As a symbol of the success of France, the façade proclaims this militant, masculine character. In spite of the fact that the façade was constructed in the thirteenth century, it still preserved, especially in the lowest story, a mural quality which relates it to Early Gothic architecture. The façades of Amiens, begun in 1220, by contrast represent the High Gothic point of view.

The three divisions of the façade of Notre-Dame in Paris belie the internal disposition of nave and four aisles. The massive play of verticals and horizontals brought into subtle equilibrium makes Paris one of the masterpieces of façade design. Originally, the pavement beneath the façade was about 12 feet lower, and a series of steps separated the cathedral from the ground. The lower part of the façade is a square 142 feet on a side. With the towers added, it becomes a square and one-half and has therefore a geometrical logic. The rose window is 32 feet in diameter and is no longer a penetration of the façade, as in the Saint-Denis façade of 1140, but now a dramatic oval which serves as a gigantic halo for the Virgin and Child sculpture at its base. Critics and architects have been captivated by the geometry of the façade. Le Corbusier made diagrams indicating its

modular control. All of this is perhaps speculation after the fact. What gives the façade its great power is its mural presence. The juxtaposition of the vertical buttresses, separating the three bays in elevation and played off against the major horizontals of the kings' gallery, brings a subtle synthesis of axes which imparts a strong sense of permanence.

The total massing of Notre-Dame of Paris is somewhat deceptive today because the exterior has been so radically altered and because areas all around the cathedral have been opened up. In the twelfth century, the Île-de-la-Cité must have looked quite different. As the cathedral was constructed under Maurice-de-Sully, buildings that were within its periphery were demolished, but many other buildings still existed nearby. He added his own Episcopal palace. The parvis, or place in front of the cathedral, was much smaller, and the parks to the east and south did not exist. Thus the cathedral towered over smaller groups of buildings and had, when viewed from a distance, a more dramatic presence than it now has.

Originally, the massing (fig. 184) was quite different. No chapels filled the spaces between the wall buttresses, and the transept arms did not project beyond the outer wall of the aisle. In the twelfth-century plan (fig. 176) Paris was essentially transeptless, but in mass, it did have short transepts rising above the double aisles. Paris, in contrast to the contemporary Cathedral of Laon, had no towers except on the façade and the wooden flèche or tower over the crossing. It had, however, a soaring mass interrupted only by the short, stubby transept arms. The width of the double aisles in elevation establishes a rhythm of vertical bays marked by the flying and pier buttresses. This sequence of rapid beats continues around the entire structure, changes in design with the choir devoid of flying buttresses, and ends abruptly against the massive west façade, which seems to keep the cathedral nailed to the ground.

The Cathedral of Notre-Dame in Paris is dramatic in its new concept of height, an innovation in Early Gothic architecture. Its importance in the evolution of Medieval architecture is demon-

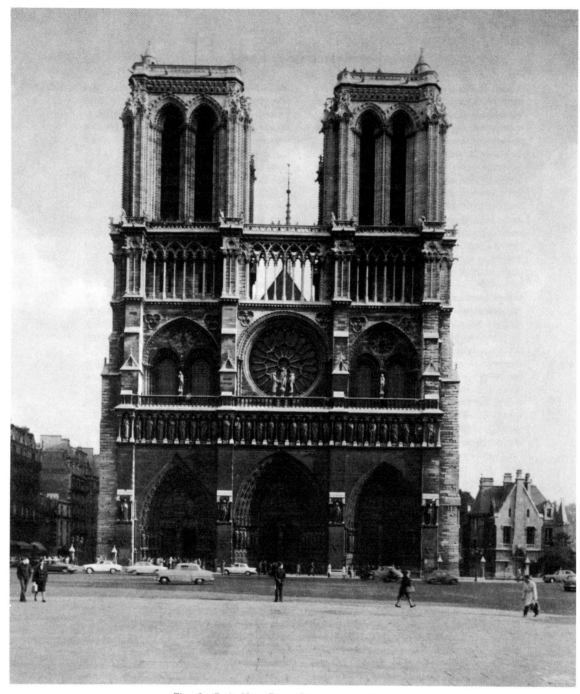

Fig. 185. Paris, Notre-Dame. Lower story c. 1200, rose
window story c. 1220, towers by 1250

strated by the invention of the first true flying but-tresses. The flying buttresses give the exterior of Paris a truly Gothic spirit. If the added buttresses of Noyon and Laon are removed, it is clear that the exteriors of these cathedrals have not devel-oped as far as their interiors. The sense of the wall parallel to the longitudinal axis of the interior predominates. The flying buttresses at right angles to this longitudinal axis reflect the new, Gothic sense of modulated surfaces which replaces the more mural and indeed Romanesque character of the church defined by its exterior walls.

In spite of alterations and mutilations, Paris remains impressive. Its enormous architectural presence is a symbol of the aspirations of king and bishop to build larger and more imposing cathe-drals for the glory of Christ and the Virgin Mary.

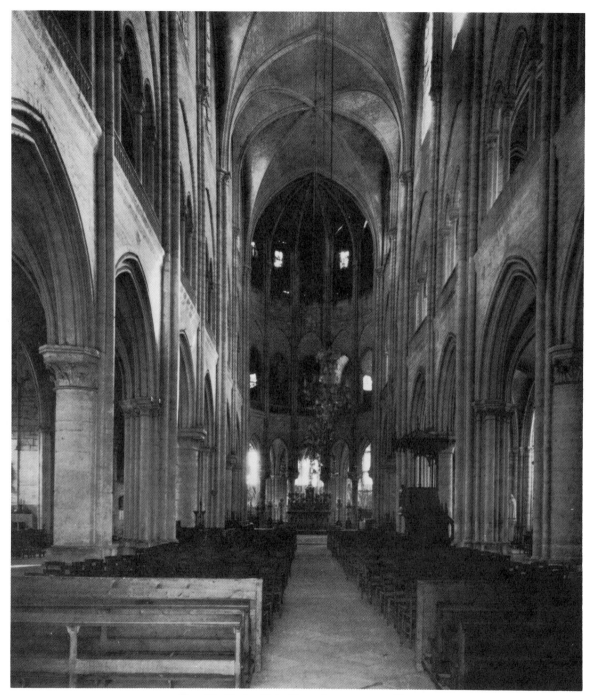

Fig. 186. Mantes, Notre-Dame, begun c. 1170. Nave

Notre-Dame at Mantes

THE TOWN OF MANTES, dominated by the collegiate church of Notre-Dame (fig. 191), is situated thirty-two miles down the Seine from Paris, fifty miles above Rouen. In the twelfth century, Mantes served as a bastion of the Capetian defense against the Anglo-Normans, but by 1204 English pressures on this region had ceased with the conquest of Normandy by King Philip Augustus of France.

In contrast to the Cathedral of Noyon, which was constructed largely through funds raised by the canons of the chapter, the church at Mantes was erected by the efforts of merchants, aided by the Capetian monarchy. The confraternity of merchants, formed in the early eleventh century, was given a charter by Louis VI in 1110. This confraternity raised funds by tolls and taxes. According to the charter, the King of France was to nominate the Abbot of Notre-Dame at Mantes. Both Louis VII and his successor Philip Augustus served as abbots in absentia and patronized the construction of Notre-Dame.

According to Jean Bony in his detailed articles on Mantes (see bibliography), work started about 1170 with the construction of the two exterior northwest piers, the façade up to the level of the gallery, and the first five, western, piers on the south flank. Between 1175 and 1180 the piers of the aisles and nave were built from west to east. In the decade of the 1180's the galleries or tribunes, except for the westernmost sections, and the piers of the flying buttresses were built. With the decision to employ flying buttresses, following the precedence of Notre-Dame of Paris, Bony believes that the proportions of the nave

were made more vertical. By 1200 the hemicycle and the two eastern six-part vaults were completed, as well as the flying buttresses without their present gutters and pinnacles (see plan, fig. 189). Work was apparently interrupted at the turn of the century, and when it was resumed between 1215 and 1220, the façade was completed up to the towers in the course of the 1220's. At the same time, the nave piers of the western six-part bay were altered and the galleries, clerestories, and vault were constructed. The south tower was begun in 1240; the first stage of the north tower was completed in 1250.

Many changes have modified the twelfth-century character of Mantes. In the second half of the thirteenth century a sacristy with treasury above was added to the north, while a new central chapel grew off the ambulatory. During the course of the fourteenth century, the right portal was reconstructed (fig. 193), four additional choir chapels were constructed, and large private chapels were attached to the south flank of the church (figs. 191, 192). In the late fourteenth century, the gallery bays above the right south aisle and all except the easternmost two over the left aisle were completely transformed. Finally, cracks in the north tower resulted in the decision to demolish it between 1845 and 1847. A new lighter tower was erected between 1851 and 1855. The gallery connecting the new north tower with the greatly altered south tower also dates from the nineteenth century.

Many features of Mantes, such as the transept-less plan (fig. 189), the flying buttresses, and the proportions of the nave vessel, show a relation-

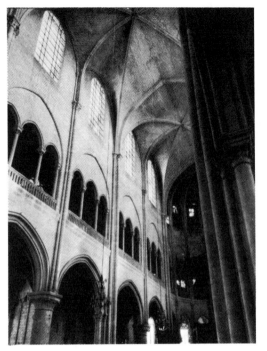

Fig. 187. Mantes, Notre-Dame. Nave and choir

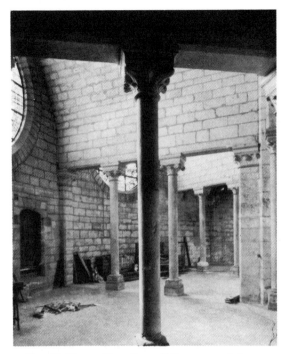

Fig. 188. Mantes, Notre-Dame. Gallery over ambulatory

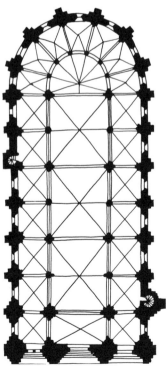

Fig. 189. Mantes, Notre-Dame.
Plan (after Bony)

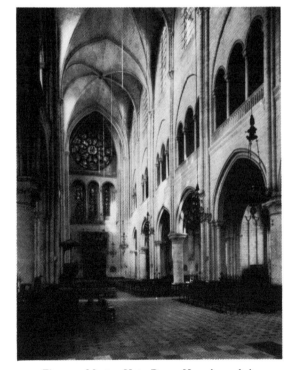

Fig. 190. Mantes, Notre-Dame. Nave from choir

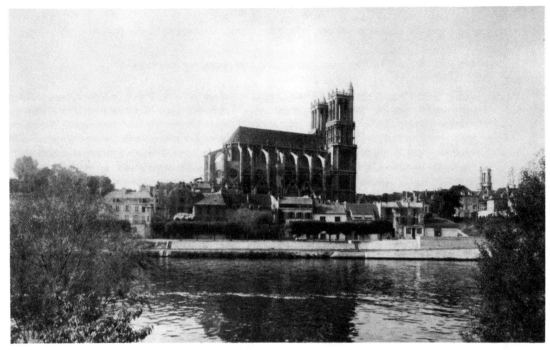

Fig. 191. Mantes, Notre-Dame. South flank

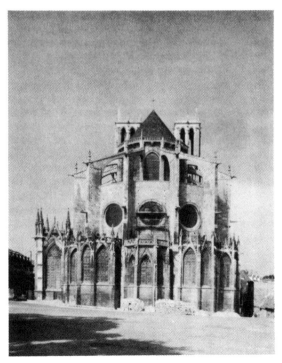

Fig. 192. Mantes, Notre-Dame. From the east

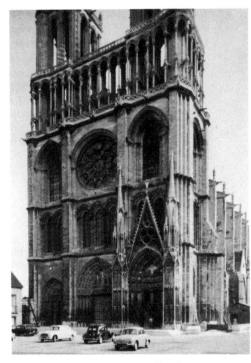

Fig. 193. Mantes, Notre-Dame. Façade, c. 1215–1250

ship to Notre-Dame of Paris. On the other hand, there are innumerable characteristics which are unique to Mantes. The nave supports, with their alternating systems of multiple piers and columns, are reminiscent of Noyon (compare fig. 153 with figs. 186 and 190). The three-story elevation — nave arcade, gallery, and clerestory (figs. 186, 190) — is numerically the same as the three-story elevations of Sens and Vézelay, but the proportions of the nave are similar to those of the four-story cathedrals of Noyon, Laon, and Paris. Perhaps the architect-builder was impressed by the oculi of the triforium at Paris, since the outside walls of the galleries of Mantes are pierced with round windows (figs. 188, 192). While the wall area between gallery and clerestory suggests a triforium, the builders of Mantes vaulted the galleries in such an unusual manner that no space is available for a triforium arcade or oculi, as in Paris. The transverse barrel vaults over the galleries, resting on piers and pairs of columns (fig. 188), are unique in Gothic architecture. The use of these barrels can be found in Roman, Merovingian, Carolingian (compare the galleries of Charlemagne's chapel at Aachen), and Romanesque building (compare the aisles at Fontenay and the nave at Tournus), but the use of these transverse barrels to stabilize the walls below Gothic ribbed vaulting has neither ancestor nor progeny.

The six-part vaults of Mantes (fig. 187) have an elegance and lightness, in contrast to the relative heaviness of those at Laon and Paris. One unusual feature is the stilting of both the major transverse and the intermediate transverse ribs in order to bring their crowns to the height of the longer diagonal ribs.

In spite of the addition of chapels and the reconstruction of towers, the exterior of Mantes presents a dramatic silhouette from all angles (figs. 191–193). The way in which the towers are played off against the vertical accents of the buttresses rising from a transeptless plan is expressive of the individuality of Mantes.

ASPECTS of three other twelfth-century structures point up the variety and experimental character of Early Gothic. The choir of Saint-Remi at Reims (figs. 194, 195), begun between 1170 and 1175, continues the four-story elevation of Noyon and Laon, but carries much further the reduction of the wall to a skeleton. A rhythm of apertures different from other twelfth-century structures is established between the single opening of the nave arcade, the double gallery, and the clerestory with its three windows. The triforium has six arcades and is linked to the clerestory by two shafts which grow into the wall ribs over the clerestory windows. This linkage of triforium and clerestory, which seems to have originated in the Cathedral of Arras about 1170 (see bibliography: Branner) appears at the end of Early Gothic. This phenomenon recurs in the cathedrals of Reims (1211) and Amiens (1220) and becomes one of the basic features of Rayonnant Gothic following the High Gothic. Thus a phenomenon which appears exceptional in twelfth-century Early Gothic becomes the usual design in the thirteenth century.

The ambulatories of Saint-Remi at Reims (fig. 195) and of Notre-Dame-en-Vaux of Chalons-sur-Marne (c. 1185–1190) exhibit an unusual solution of the vaulting of a single aisle and its deep radiating chapels. At the mouth of each chapel is a pair of free-standing columns, while single columns are attached to the sides of each chapel. From these columns spring the vaults of chapels and the ambulatory. This system of support results in an interpenetration of space and structure. The alternation of square and triangular vaults over the ambulatory imparts a unique vitality to the choirs of these two churches. This imaginative transformation of an older format (see Noyon, fig. 156) ends, however, in an artistic cul-de-sac because it exerts no influence on the High Gothic cathedrals.

The exterior of Notre-Dame-en-Vaux at Chalons-sur-Marne (fig. 196) reveals the four-story elevation which is stabilized by the heavy, archaic flying buttresses. Towers flank the choir, as in the east end of Noyon (fig. 159).

By way of contrast with Saint-Remi of Reims and Notre-Dame-en-Vaux, the choir of Saint-Quiriace (fig. 197), begun around 1160, grows

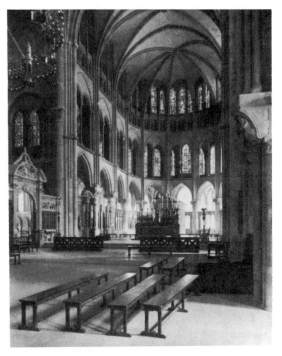

Fig. 194. Reims, Saint-Remi, begun c. 1170. Choir

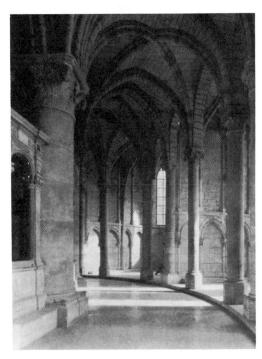

Fig. 195. Reims, Saint-Remi. Ambulatory

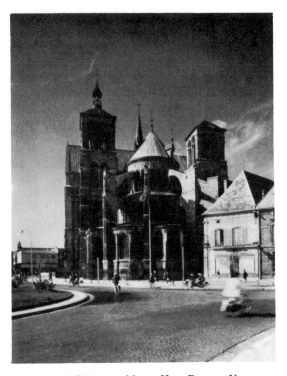

Fig. 196. Châlons-sur-Marne, Notre-Dame-en-Vaux,
c. 1185. From the east

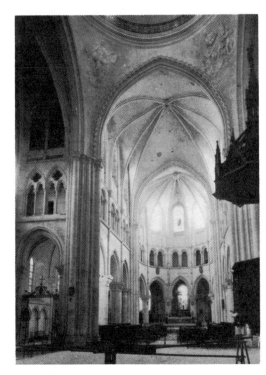

Fig. 197. Provins, Saint-Quiriace, begun c. 1160. Choir

out of the three-story elevation of Sens, only thirty miles to the south (fig. 139). The wide proportions of the nave and the shafts rising from the intermediate columns also recall the Cathedral of Sens. But the freak eight-part vault over three bays in the choir is unique in Medieval architecture.

All the twelfth-century cathedrals and churches considered in this discussion possess great individuality. An increasingly rich and competitive exchange of ideas and influences is clearly visible in the monuments. There are two major groups, one with an interior based on a three-story elevation and a larger group with interiors conceived in four stories. Plans and masses vary even more. The whole spirit of the twelfth century emphasizes experimentation with various structural solutions and with unusual spatial arrangements. Different, and at times conflicting, architectural ideas converge on the Île de France area from Burgundy, Normandy, and the north. Some ideas are reinterpreted into new solutions, only to be overlooked or discarded by subsequent architects. The trial-and-error approach to architecture characteristic of Early Gothic architecture has its parallels in the method of theological investigation of the period, as will be seen later in the discussion of the High Gothic of the thirteenth century. Each of these Early Gothic monuments states its own unique solution to spatial, structural, and lighting problems. The Abbey of Saint-Denis proclaims the birth of Gothic, with its articulated façade and ribbed vaulted narthex (1140) and its

precocious choir bathed in colored light (1144). In the Cathedral of Sens (1140's) an alternating system of supports below six-part vaults reveals the squat proportions and spatial rhythms of the three-story elevation. The Vézelay choir (1180's), the Canterbury choir (1170's ff.), and Saint-Quiriace at Provins (1160) continue the Sens formula, but modify it. In the cathedrals of Noyon (1150) and Laon (1160) a four-story elevation is employed, but the nature of the supports, the plans, and the masses is entirely different. Noyon's rounded and towerless transepts stand in marked contrast to the clifflike transepts of Laon with pairs of towers flanking the square lantern over the crossing. Notre-Dame of Paris (1163) has a unique plan of four aisles and no transept (in plan). The four-story elevation is a variant on that of Noyon and Laon, while flying buttresses are invented to stabilize the increased height. Mantes (1170's) exhibits influences from Paris, but also from other areas, while Saint-Remi at Reims (c. 1170) and Notre-Dame-en-Vaux at Chalons-sur-Marne (c. 1185) reveal an unusual handling of the vaulting of ambulatory and radiating chapels.

This extraordinary and creative variety can be found in all the major Early Gothic monuments in and around the Île-de-France. It will be the role of the thirteenth-century architects of Chartres, Reims, and Amiens to create a new synthesis out of the bold and dynamic cathedrals of the twelfth century.

Early Gothic Sculpture and Painting

THE WEST PORTALS of Chartres Cathedral, the best-preserved sculptural ensemble of the mid-twelfth century (fig. 198), are the sculptural counterpart of Early Gothic architecture. On September 5, 1134, a fire destroyed the town of Chartres. Contemporary reports state that although the church was engulfed in flames, it miraculously escaped damage. However, the Hôtel-Dieu, located only a few meters to the southeast of the church, suffered considerably, and damage to the west end of the church was apparently great enough to inspire a new building campaign. So great was the community's commitment to this reconstruction of the house of the Virgin Mary that men of all classes, in silence, pulled huge carts bearing the stones from the quarries. This cult of the carts reflects the religious enthusiasm of the building campaign.

Donations for one tower refer to the north or older tower of Chartres, while the Abbot of Mont-Saint-Michel reports two towers under construction in 1145. Since the sculpture of Chartres grows out of the more experimental portals of the west façade of Saint-Denis, dedicated in 1140, the date of the late 1140's is reasonable for the carving and erection of the Royal Portals of Chartres. These portals were thus carved some fifty years before the fire of 1194 which necessitated the construction of the High Gothic Cathedral of Chartres.

The portals (fig. 198) depict the scenes of the Incarnation in the right-hand tympanum, Christ's Ascension in the left portal, and Christ upon His return to earth surrounded by the symbols of the four Evangelists in the central tympanum. The capitals function as a horizontal frieze between archivolts and jamb figures and relate the life of the Virgin Mary and the Passion of Christ. The total comprehensive nature of the subject matter of these Early Gothic sculptural compositions has no parallel in Romanesque art. Vézelay (fig. 94), Moissac (fig. 99), and Saint-Gilles (fig. 96) are all conceived on a less encyclopaedic scale.

In his book *The Sculptural Programs of Chartres Cathedral*, Adolf Katzenellenbogen has discussed in detail the entire inconographical meaning of these Early Gothic west portals and the High Gothic transept portals. In this writer's opinion, Katzenellenbogen's book contributes more to the complete understanding of French Medieval sculpture than any other book yet written. The author describes the meaning of the west portals and how they reflect the thinking of the cathedral school of twelfth-century Chartres. In discussing the right-hand portal (figs. 214–216), Katzenellenbogen emphasizes the *new* lucidity and explicitness of the tympanum scene. He further stresses the sacramental importance of the Incarnation through the axial, vertical centrality of Christ in the Manger (Nativity), Christ on the altar (Presentation), and the frontal Christ on the Virgin's lap in the tympanum. The corpus verum, His real flesh and the true substance of the Eucharist, which is symbolized by this arrangement, reflects the leading role of the School of Chartres in the fight against heretical movements of the time. The second Lateran Council of 1139 had condemned those who denied the validity of the Eucharist. Thus, by the placement of Christ in the middle of both lintels and the tympanum, the School of Chartres is stating its agreement with

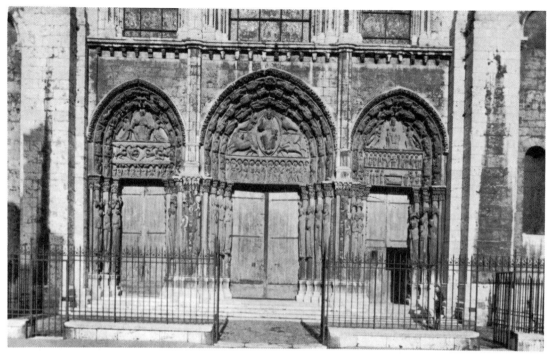

Fig. 198. Chartres Cathedral. Royal Portals, begun c. 1145

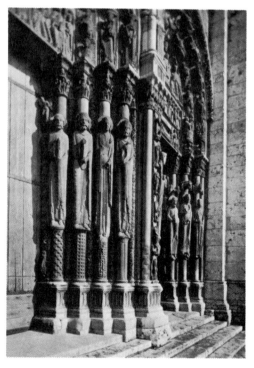

Fig. 199. Chartres Cathedral. Royal Portals, jambs of
central portal

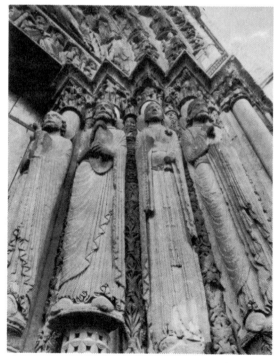

Fig. 200. Chartres Cathedral. Royal Portals, jambs of
central portal

the conclusions of the council and proclaiming its beliefs in stone for all who enter the cathedral to see. Further, the tympanum of the right portal portrays the Christ Child enthroned as Godhead Incarnate but also as Wisdom Incarnate, since the surrounding archivolts contain the seven liberal arts. The Cathedral School of Chartres based its beliefs on the writings of Boethius, and therefore indirectly on Plato, and utilized the liberal arts as intellectual vehicles for the understanding of theological doctrines. Thierry of Chartres, Chancellor of the School of Chartres at the time of the carving of the Royal Portals, had compiled a handbook of the seven liberal arts which stressed the importance of classical writings for the understanding of theological truths. The presence of Priscian, Aristotle, Cicero, Euclid, Boethius, Ptolemy, and Pythagoras on the archivolts is ample evidence that the School of Chartres inspired the allegorical approach to the sculptural program.

Katzenellenbogen interprets the large jamb statues (figs. 199, 200, 202) as a combination of the qualities of kingship and priesthood. Louis VII was praised in a letter of 1161 because "from the time he was anointed king, he had followed the humility of David, the wisdom of Solomon, and the patience of Job." The monumental statues are Old Testament figures possessing qualities of kingship and reflecting the attitude of the French monarchy toward the struggles between church and state. Abbot Suger had attempted to mediate a harmony between the priesthood and the monarchy, and it was undoubtedly Suger who determined the themes of the sculptural program of the Royal Abbey of Saint-Denis (see figs. 124, 126) in the late 1130's, or less than a decade before the Chartres portals.

In his chapter on form and content, Katzenellenbogen explains the majestic frontality and lack of tension in the jamb figures of the central portal by relating the figures to the treatises on the soul and body. William of Conches, of the School of Chartres, had attacked the theory that the body was an appendage of the soul and had argued that the soul was more active from within man. The Chartres figures, with their controlled animation

from within, together with their variety of mood, echo the protohumanism of the School of Chartres. A new sense of the power of reason, though reason still dependent upon divine wisdom, manifests itself in the entire conception of the Royal Portals. Thus, it would seem that the School of Chartres not only affected the iconography but also had tremendous influence on the formal style of the sculpture. The impact of the School of Chartres helps explain the great change between the portal of Vézelay in Burgundy and the Chartres portals carved only twenty-five years later.

Chartres' west portals establish a new relationship between sculpture and architecture (figs. 199, 200). The jamb figures are integral parts of the structural columns of the portal and rest on short, ornamented columns. In their convex mass they echo the projecting bases of the portals, the rounded capitals, the floral abaci, and finally the archivolts. These monumental figures are synthesized in form with the very structure of the portals. In a detail (fig. 200), hands, books, and noses repeat the shapes of bases and capitals. This complete integration of sculpture and architecture has no counterpart in Romanesque portals such as Moissac, which have flat jambs supporting the tympanum. The diagonal axis of the splays of each Chartres portal echoes the diagonal nature of Early Gothic piers supporting the six-part vaults as seen in the naves of Sens and Noyon.

The sheer quantity and variety of sculpture in the west portals of Chartres indicate that the portals must have been carved by six or more artists. The supervising sculptor or headmaster was responsible for most of the central portal (figs. 198–200, 202, 204). His figures possess a classic calm and a majestic forcefulness. The Christ of the tympanum (fig. 210) and the jamb figures (figs. 199, 200) have the same delicately carved drapery, suggesting the anatomy.

The jamb figures on the inner faces of the side portals are distinctly inferior in quality and must be the work of an assistant to the headmaster. The jamb figures on the right side of the right portal (fig. 199) are clearly related to the lost figures on the west portals of Saint-Denis of 1140 (figs. 126,

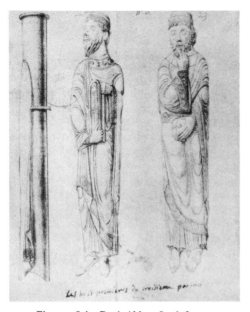

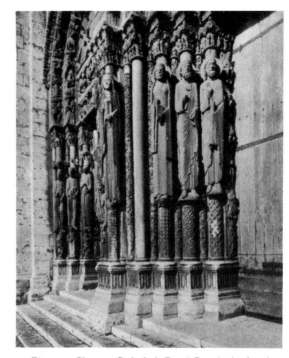

Fig. 201. Saint-Denis Abbey. Jamb figures, 1140 (Montfaucon)

Fig. 202. Chartres Cathedral. Royal Portals, jambs of central portal

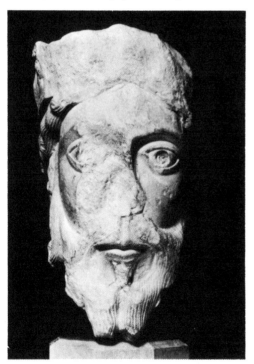

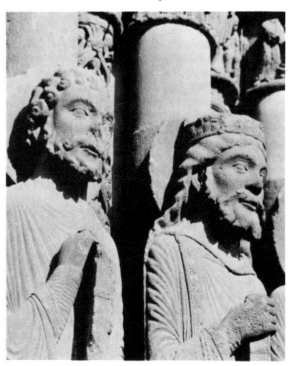

Fig. 203. Saint-Denis Abbey. Head (The Walters Art Gallery, Baltimore)

Fig. 204. Chartres Cathedral. Royal Portals, heads of central portal

201), and their disjointed anatomy, their smaller size, and the greater movement and complexity of pose show more affinity with Romanesque sculpture than do the figures of the central portal. The extreme left figures (fig. 202) are related to sculpture of the church of Notre-Dame at Étampes (fig. 205). The Étampes figures have disjointed anatomy and a mannerism in the treatment of drapery which are entirely absent from the work of the headmaster on the Chartres central portal. Since the three left-hand figures at Chartres do exhibit some influence of the headmaster's style, it is possible to speculate that the Étampes master and the Saint-Denis master came from Étampes and Saint-Denis and collaborated with the headmaster at Chartres.

The figures in the superstructure of the right-hand portal (figs. 214–216) are small-scale, narrative reflections of the headmaster's sculpture. The heads in the lower lintel depicting the Annunciation, the Visitation, the Nativity, and the Annunciation to the Shepherd are identical to those of the monumental statues on the central portal, suggesting that another assistant of the headmaster must have carved this sculpture. This phenomenon of collaboration was not, however, an innovation at Chartres; it is apparent that the Romanesque façade of Saint-Gilles of the 1130's was carved by six or eight sculptors.

The Chartres portals grew out of the earlier, more groping experience reflected in the west portals of Saint-Denis (1140) and in the portal of Étampes (figs. 201, 205). The over-all design of the portals is more synthesized at Chartres. A comparison of a head from the lost jamb figures of Saint-Denis now in The Walters Art Gallery, Baltimore, with heads from the central portal of Chartres (figs. 203, 204) reveals a marked evolution in the short span of a decade. The head and drawings and engravings of the jamb figures of Saint-Denis exhibit more disjointed anatomy. The archaic directness of the Saint-Denis style has given way to a maturer and more monumental conception at Chartres. The staring eyes of the birdlike face and the modeling of cheeks in three planes of the Saint-Denis head stand in marked

contrast to the softened and delicately continuous contours and to the sense of majestic calm and confidence that permeates the handling of the Chartres heads. As the new façade and choir of Saint-Denis of 1140 and 1144 mark the beginning of Early Gothic architecture, so the façade sculpture represents a new concept of portal design which is given expanded treatment and further resolution in the Royal Portals of Chartres.

During the second half of the twelfth century, within a hundred-mile radius of Paris, portals with jamb figures appeared in abundance. The Early Gothic cathedrals were developed in this same area. In contrast to twelfth-century architecture, which reflects a matured creativity from the late 1130's through the last decade of the century, early Gothic sculpture passes through an experimental phase at Saint-Denis and Étampes and reaches its apogee in the Royal Portals at Chartres. The majority of portals sculpted immediately after Chartres during the second half of the century show a decline in quality.

The portal of Étampes (fig. 205) has often been dated after Chartres. It is argued that the Étampes master carved the three left-hand figures on the Royal Portals and then went to Étampes to carve the portal of Notre-Dame. Étampes, far from being a sleepy little town between Chartres and Paris, as it is today, was a very important place in the Middle Ages. In Étampes, the Royal Château, not far from the church, was one of the most important summer homes of the kings. Many church councils were held in Étampes, and decisions such as those on the rival claims to the papacy were settled there. One of the most exciting moments in the history of the town was the assembly convoked by Louis VII in 1147. The meeting was held in the royal residence on February 16, and the final plans for the Second Crusade were made. Suger was against the launching of the crusade, but was overruled. Later in the day he was appointed Regent of France.

The style of Étampes is very close to Chartres (the three left-hand jamb statues), but a careful comparison of the monuments shows that the figures of Chartres possess more refinement than

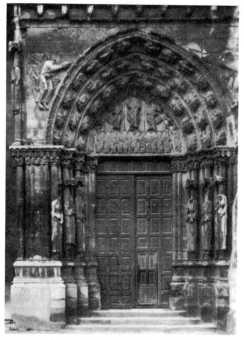

Fig. 205. Étampes, Notre-Dame. South portal, 1140's

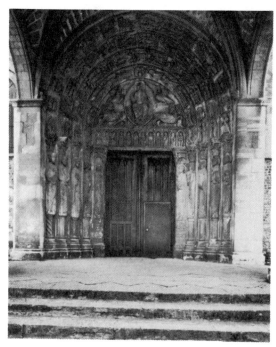

Fig. 206. Le Mans Cathedral. South portal, 1158

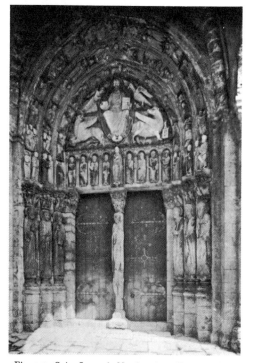

Fig. 207. Saint-Loup-de-Naud, priory. Portal, 1160's

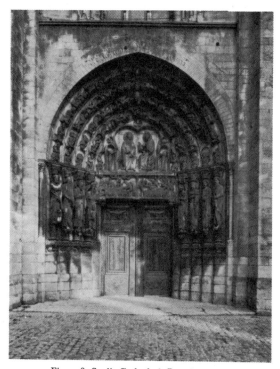

Fig. 208. Senlis Cathedral. Portal, c. 1175

those of Étampes and in details of drapery reveal some influence from the headmaster of Chartres, whose style dominated most later portals. While the portals of Saint-Denis exerted some influence, Étampes remained an isolated phenomenon.

The south portal of the Cathedral of Le Mans (fig. 206) was completed in 1158. It is obvious that the jamb figures, tympanum, and lintel were derived directly from the central portal of Chartres. It is only in the narrative archivolts that a new anecdotal tendency developed. The sculpture is flatter and less sensitive than the figures on the Chartres central portal. The jamb statues are pushed back into the wall and have lost the majestic presence of the Chartres columns.

Many other portals parallel this drying up of the Chartres formula. Perhaps the headmaster of Chartres died at an early age, like Masaccio, and no one with his artistic vitality was left to experiment and create new ideas. The little priory of Saint-Loup-de-Naud, a few miles southwest of Provins, has a single portal under a western porch (fig. 207). It is decorated with six jamb statues, a trumeau figure of Saint Loup, and a tympanum of Christ surrounded by the symbols of the four Evangelists. The portal dates from the 1160's. The Saint-Loup-de-Naud portal establishes the preeminence of Chartres as the inspirational force behind the sculpture of the Île-de-France into the 1160's. At the same time, the figures, especially Saint Loup, show a more pronounced interest in approximating actuality. The proportions are more squat than those of the Royal Portal figures, and the tendency to convert the archivolts into a sequence of narrative scenes is continued.

The portal between the west towers of the Cathedral of Senlis illustrates a final development of the Saint-Denis–Chartres style (fig. 208). Although north of Paris, Senlis is nevertheless in the heart of the Île-de-France. The portal was carved about 1175 and was thus completed sometime before the dedication of the cathedral on June 16, 1191. Architecturally the Cathedral of Senlis is another Early Gothic cathedral, but was omitted from the previous chapters because of its extensive alterations. The monumental sculpture of

Senlis represents a stylistic paradox. On the one hand, the tendency toward verisimilitude, with its emphasis on natural appearances, observed in the portal of Saint-Loup-de-Naud is intensified, while on the other hand, the Senlis figures are transformations of prototypes found in the west portals of Saint-Denis (1140). In contrast to the strong Chartrain character of most portals in the 1150's and 1160's, the Senlis jambs, which are nineteenth-century copies of the originals, have contorted poses, swirling drapery, and disjointed articulation. Actually, the portal design of Senlis is a throwback to the portals of Saint-Denis as they existed before they were modified in the late eighteenth and nineteenth centuries. In spite of the similarity in general format between the Saint-Denis and the Senlis figures, the treatment of folds, the irregular silhouettes, and the spirit of restlessness make the figures of Senlis quite different from those of Abbot Suger's façade. A whole new dynamism would seem to have broken through the stiff, academic versions of the Chartres portals. The vitality of this sculpture can be seen in the scenes of the Death and Resurrection of the Virgin on the lintel. The Virgin and Christ of the Coronation scene in the tympanum have voluminous, rhythmic draperies. Curves and countercurves contrast sharply with the calm majesty and aloofness of the Chartres Christ.

In the last two decades of the twelfth century, other portals such as those at Mantes and Sens continue to transform the ideas first started at Saint-Denis and matured at Chartres, while other trends appear in the badly damaged and overrestored portals of Laon Cathedral. In the High Gothic transept portals of Chartres Cathedral, these various traditions are pulled together in a synthesis that is new, yet strongly influenced by the Early Gothic west portals of Chartres of the 1140's.

A comparison of the Christs of Vézelay and Chartres points up the enormous difference between Romanesque and Early Gothic sculpture (figs. 209, 210). The Vézelay Christ, flattened into the matrix of the tympanum, is animated by a series of spiraling folds and fluttering termina-

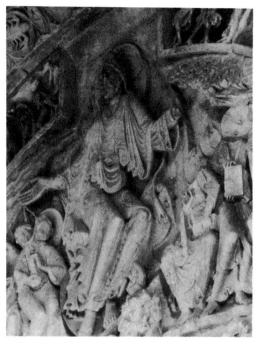

Fig. 209. Vézelay. Christ of central tympanum, 1120's

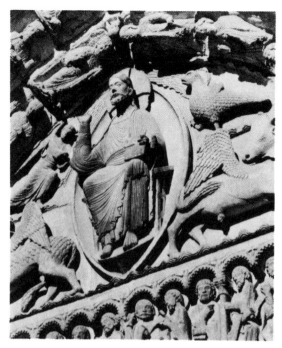

Fig. 210. Chartres Cathedral. Christ of central, west portal, c. 1145

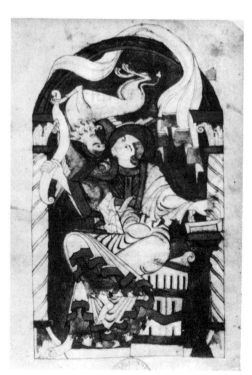

Fig. 211. Saint Mark. *Gospel Book from Corbie,* c. 1050. (Amiens, Bibliothèque Municipale Ms. 24, fol. 53)

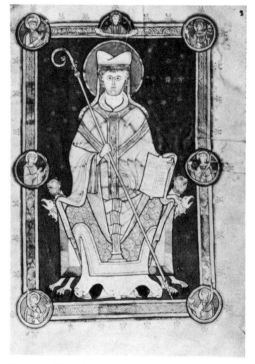

Fig. 212. Saint Augustine. Stories in form of *Psalms* from Abbey of Marchiennes, mid-XIIth century (Douai Ms. 250, Vol. I, fol. 2)

tions of drapery. The disjointed anatomy further dramatizes the epic and supernatural nature of this interpretation. This dynamic, nervous, and spiritual figure of Christ is in marked contrast to the monumental quietude of the Chartres Christ. The drapery folds of the Christ of Chartres reveal a new, plastic, three-dimensional form which projects out from the ground of the tympanum and gives Christ a physical presence in space, as against the mural quality of the Vézelay Christ. The Chartres figure represents a more humanistic approach to the human form. This change in style from 1120 to the 1140's reflects the environmental and philosophical changes involved in the shift from the monastic enclosure to the more urban atmosphere of the School of Chartres. Within one generation, a new world had come into being within the ever-changing context of the Middle Ages.

Similar changes in style can be found in a comparison of two manuscript pages. The Romanesque point of view pervades the depiction of Saint Mark (Amiens Ms 24, fol. 53: fig. 211), a manuscript illuminated in the Abbey of Corbie in the mid-eleventh century. The Saint Mark has the dynamic contortion and overlapping mural planes of Romanesque art. Indeed, the nervous intensity and the intertwining forms hark back to the barbarian style and its impact on Anglo-Irish art in the seventh and eighth centuries and on Carolingian art in the ninth century. In general format, the manuscript figure resembles the Christ on the Vézelay tympanum (fig. 93) and the Prophet Isaiah at Souillac (fig. 103).

The Saint Augustine from a manuscript written and illuminated around 1150 in the Abbey of Marchiennes (Douai Ms. 250, fol. 2: fig. 212) reflects a completely different point of view. All the nervousness and intensity of the Romanesque manuscript has quieted down into a monumental expression. This Saint Augustine resembles the Christ on the central portal of Chartres (fig. 210). The differences between manuscripts parallel stylistically the differences between the portals of Vézelay and of Chartres. This antithesis between the styles of Romanesque and Early Gothic fig-

ures can be explained by the intellectual atmosphere of a monastery as opposed to the atmosphere of the School of Chartres. While both manuscripts were illuminated in monasteries, the differences can perhaps be explained not only by changing atmosphere but also by a new wave of Byzantine influence which came into western Europe in the second quarter of the twelfth century. These Byzantine penetrations were not new to the Middle Ages. A strong impact of Byzantine art of the Second Golden Age can be discovered in the art of the Ottonians around 1000. In the opening years of the twelfth century, Byzantine art began to manifest itself in Burgundy, as seen in the frescoes of Berzé-la-Ville (fig. 112). By the mid-twelfth century the Byzantine influence had intensified and coalesced with the emergent humanism of the School of Chartres.

Toward the middle of the twelfth century a new kind of painting — stained glass — replaced frescoed murals as the dominant monumental painting in Early Gothic France. Stained glass of an earlier date exists, but the first large complexes of stained-glass windows were those that decorated Suger's choir of Saint-Denis (1144) and the west end of Chartres Cathedral of the late 1140's. The notion of colored and jeweled light fits completely the increased emphasis in Early Gothic architecture on the role of light as the illumination of Christ's dwelling on earth. The most famous Medieval windows are the three west windows at Chartres (fig. 213) above the Royal Portals and under the huge thirteenth-century rose window. On the right, the Tree of Jesse window, with its incredible blue, depicts Christ's genealogy, from Jesse to the Virgin Mary, and Christ enthroned. In a recent article (see bibliography), James J. Johnson has related this window to the ruler cult which gained great popularity in the twelfth century. This new cult not only conceived of kings as elected and anointed but also argued that upon coronation they assumed the semidivine status of the image of Christ on earth. Further, Johnson points out that the ancestors of Christ in the window are not framed by continuous branches of the Tree of Jesse, but by white fleur-de-lis, symbols of

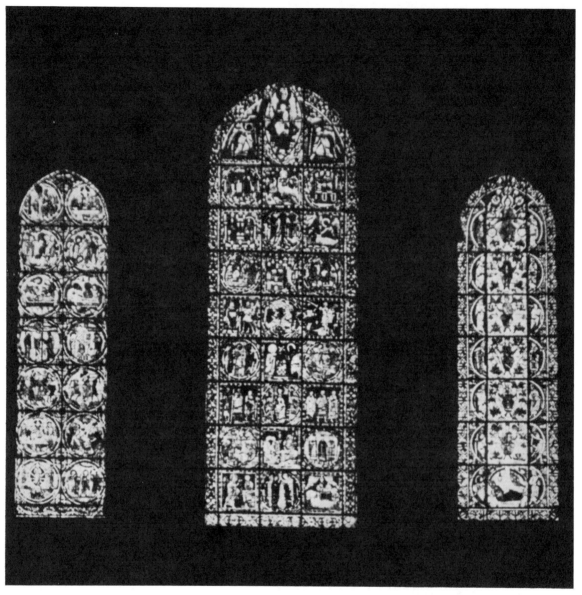

Fig. 213. Chartres Cathedral. West windows, late 1140's. Passion of Christ, Life of Christ, Tree of Jesse

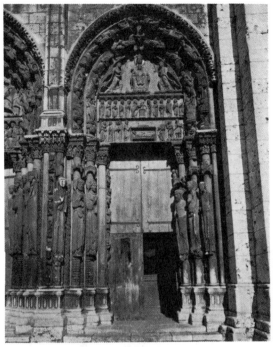

Fig. 214. Chartres Cathedral. Royal Portals, right portal, c. 1145

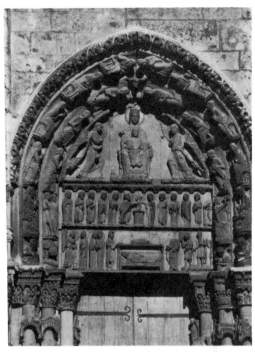

Fig. 215. Chartres Cathedral. Royal Portals, tympanum of right portal

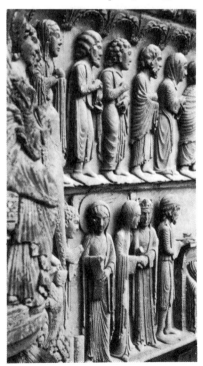

Fig. 216. Chartres Cathedral. Royal Portals, detail of right portal

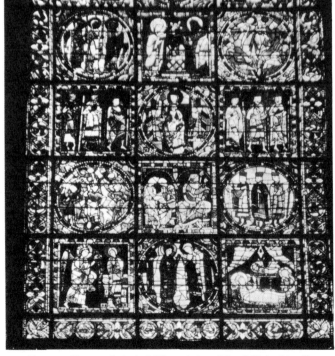

Fig. 217. Chartres Cathedral. West window, Life of Christ (detail)

purity and divinity and the heraldic emblem of the Capetians. Finally, Johnson examines the importance given the centralized Christ in the scene of the Entry into Jerusalem in the top of the central window, together with other evidence, and connects these Chartres windows with the Second Crusade of 1147.

The central window (fig. 213) depicts the major scenes of the life of Christ from the Annunciation to the Entry into Jerusalem. Bright yellows are added to the light blues, whites, greens, and ruby reds of the Jesse window. The left-hand window contains the Passion of Christ: Transfiguration, Last Supper, Betrayal, Crucifixion, Supper at Emmaus, and other scenes. Yellows and oranges give this window more coloristic intensity than the other two.

The Annunciation (lower left-hand panel of the central window, fig. 217) offers a clear insight into the art of stained glass. The Angel Gabriel and the Virgin Mary fill the square panel. The leading, set off against the rich red ground, provides the major silhouette lines. Facial features and inner contour lines were painted on large pieces of glass and then refired in a kiln. In spite of differences of media (lead, paint, and glass color), the proportion, pose, and treatment of drapery in these figures resembles the contemporary treatment of the figures on the lintel of the right portal, especially the identical scene of the Annunciation (figs. 215, 216).

The last sixty years of the twelfth century, starting with the dedication of Suger's façade at Saint-Denis in 1140, is a period called Early Gothic. This era has an integrity of its own which should not be given the questionable and negative title of "transitional." In spite of its experimental character, it possesses a homogeneity. The great four-story and three-story cathedrals reflect a vitality of their own. New structural techniques, a variety of spatial solutions, different plans, and different resulting masses make this period unique. Certain Romanesque features, such as the thick wall with its bearing and counterthrusting capabilities, as well as the mural and architectonic character of the sculpture, are continued; yet new complex supports articulated with ribbed vaults and new spaces, given diagonal axes, manifest the creation of a new point of view. Portals with jamb statues completely integrated with the structure and the architectural shapes of the entrances and the new large-scale programs of stained-glass windows further point up the artistic revolution which has transpired.

The new style of architecture, sculpture, and painting spread to the corners of Europe, largely through the good offices of the Cistercians, who became the carriers of Gothic architectural forms. The Early Gothic portal, as it appears outside the Île-de-France, is often transformed by the persistence of belated, local Romanesque traditions.

This Early Gothic world does not really end by 1200; its experimental and creative variety evolves into the powerful High Gothic synthesis in the cathedrals of Chartres, Bourges, Reims, and Amiens.

High Gothic of the
Early Thirteenth Century

Historical Background

DEFINITIONS of a style or point of view in art history are often vague and arbitrary; but just as Abbot Suger's Saint-Denis (1140 and 1144) reflects a dramatic departure from Romanesque, so the new synthesis and transformation of early Gothic forms in the cathedrals of Chartres (begun 1194) and Bourges (begun about 1195) mark the dramatic emergence of two kinds of High Gothic architecture. Both Chartres and Bourges are not only extraordinary monuments in themselves; they are also central in their influence on the design of subsequent monuments. The Chartres master omitted the gallery or tribune of the four-story cathedrals like Noyon, Laon, and Paris and rethought the relatively squat three-story elevation of the format of Sens and the choir of Vézelay at the same time that he increased the verticality of the twelfth-century four-story cathedrals. He created a new relationship of parts. The clerestory was greatly enlarged to equal the height of the soaring nave arcade, while the dark triforium passageway, similar to triforia in Noyon and Laon, acted as the middle, dividing zone. Further, the Chartres master developed a new nave pier with four attached colonnettes and employed, for the first time, a uniform four-part vault for each bay of nave and transept. In contrast to Early Gothic cathedrals, in which the ribs rise from capitals at the bottom of the clerestory, the Chartres ribs rise from a much higher point in the clerestory zone. Flying buttresses, invented for the nave of Notre-Dame of Paris in the 1180's, are used to stabilize the vaults and roof of the entire cathedral. Thick wall buttresses and flying buttresses, placed at right angles to the longitudinal axis of Chartres,

impart a dynamic animation to the exterior which is consistent with the interior treatment of nave and aisles. Forms identifiable as Gothic first appeared in church interiors, but in the relation of interior space and exterior mass, vestiges of a Romanesque mural emphasis remained and were not eliminated until late in the twelfth century, when flying buttresses were employed in the construction of the nave of Paris. As the discussion of Chartres will illustrate, the Chartres master, although dependent on the innovations of Early Gothic masters, created a new kind of Gothic — High Gothic. The plan, elevation, spatial treatment, structural system, and massing of Chartres (1194) influenced in turn the design of the cathedrals of Soissons (late 1190's), of Reims (1211), of Amiens (1220), and others.

The master of the Cathedral of Saint Étienne at Bourges (begun about 1195) retained more features of Early Gothic architecture than did the Chartres master. He continued to employ the six-part vaults of Laon and other twelfth-century cathedrals, with the resulting alteration in the design of the nave piers. However, with four aisles flanking the nave in a plan reminiscent of Notre-Dame of Paris, the Bourges master created an unusual lateral extension of space through the high nave arcade into the inner aisles with their triforia and clerestories. A smaller church of three stories thus echoes the elevation of the nave. Features of Bourges affected the design of later cathedrals such as the choir of Le Mans (1217), Coutances (1230), and cathedrals in Spain. The impact of Bourges, however, was not as strong or as widespread as that of Chartres in subsequent High Gothic designs.

A third kind of High Gothic is found in a large group of churches extending from England along trade routes across northern and northeastern France through Champagne and Burgundy to Switzerland. This third group of monuments is more conservative than either the Chartres group or Bourges group and their offspring. With relatively small clerestories and the triforia contained in arches, more ideas from the Early Gothic were continued into the early thirteenth century in this third, conservative High Gothic. An example of the conservatism in the Île-de-France is the nave of Saint-Leu d'Esserent (see Chapter 23). Thus a kind of reaction against the new High Gothic transpired in areas in and around the Île-de-France (see bibliography: Bony, "The Resistance to Chartres in Early Thirteenth Century Architecture").

The portals of the transepts of Chartres Cathedral, the façades of Amiens and Reims, and the early thirteenth-century stained-glass windows of Chartres reveal a distinct change in style when contrasted with the Early Gothic Royal Portals and twelfth-century windows of Chartres. More complex iconographical programs in sculpture and stained glass, different relationships between sculpture and architecture, and a new figure style all emerge in the first three decades of the thirteenth century. Sculptured portals and stained-glass windows as integral, functioning parts of the cathedral impart an extraordinary homogeneity to the High Gothic style.

The first High Gothic structures are certainly Chartres (begun in 1194) and Bourges (begun about 1195). The beginning of the period is sharply defined; however, it is more difficult to distinguish the time at which High Gothic evolves into another style and ceases to be High Gothic. By the 1230's High Gothic architects seem to have solved the majority of spatial and structural problems. In the 1230's and 1240's refinements of details suggest a new direction in Gothic toward a more decorative and linear style. This shift of emphasis toward solutions involving the elaboration of window tracery, the linkage of clerestories and glazed triforia, and the creation of royal chapels and smaller churches is a new creative phase of

Gothic, called Rayonnant, which extended from the 1230's through the fourteenth century. Rayonnant will be discussed in Part IV. However, in Part III an analysis of the façade of Reims, the choir of Amiens, and the superstructure of the choir of Beauvais will be included, although, strictly speaking, these parts of High Gothic cathedrals are Rayonnant, not High Gothic. Like the short-lived Periclean Age of ancient Greece and the early sixteenth-century High Renaissance in Italy, the High Gothic period was brief; it began in the 1190's and terminated in the 1230's.

The Capetian monarchs of the late twelfth and thirteenth centuries helped France become the most powerful nation in western Europe. The reign of Philip Augustus (1180–1223), perhaps the most important in the history of France, overlapped Early and High Gothic. King Philip found France a myth and made it a reality by quadrupling the size of the royal domain. Under his rule the monarchy moved from the defensive to the offensive. By aligning the monarchy with the towns and the small barons, Philip consolidated a central authority to which the great barons could be subordinated. A series of successful military-political campaigns brought extensive areas under Capetian control. By marriage to Isabella, daughter of the Count of Hainault, he acquired the Artois as dowry. The Count of Flanders and some of Philip's vassals in the north joined a league against Philip, only to be defeated and to lose more territory to France. The English controlled large sections of western and southwestern France. English misgovernment and Philip's successful invasion of Normandy reduced the English holdings on the Continent to Gascony and Poitou. The supposedly impregnable fortress of Château Gaillard was constructed in 1197 by Richard the Lion-Hearted to defend Normandy. In 1204 Philip Augustus laid siege to the château and captured it at the end of six months. His armies then continued down the Seine and drove the English from Normandy.

Ten years later a coalition of the Count of Flanders, John of England, John of Lorraine and Holland, and the German Emperor, Otto IV,

moved against Philip Augustus. Philip's son Louis defeated the attack from the west, and Philip himself was victorious over a larger army in the battle of Bouvines in July of 1214.

Philip's changes in the administration of government further curbed the power of the barons. The employment of bourgeois for legal advisers, as well as the expansion of the role of the baillis, gave new central control over the loose feudal system. He also increased the practice of granting charters of freedom to towns.

The climax of the Capetian line came with the rule of Louis IX (1226–1270), later canonized Saint Louis. Most of Saint Louis' reign coincides with Rayonnant art, not High Gothic. His father, Louis VIII, ruled only three years. Since Louis IX was only twelve years old in 1226, his mother, Blanche of Castile, was regent until her son gained maturity. She kept rebel barons in line by skillful maneuvers.

Saint Louis was tall and ascetic-looking. His plain dress, simple demeanor, genuine piety, and devotion to justice made him enormously popular. By his actions and behavior he embodied spiritual reverence and royal leadership.

Under Louis' rule the royal domain was enlarged and converted into a unified France. The Albigensian Crusade was successfully concluded and the southwestern borders of France firmly established. During these campaigns, Louis enlarged the fortified city of Carcassonne. By the marriage of his youngest brother, Charles of Anjou, to Beatrice of Provence in 1246, this large area of the southeast came under the crown's control. With the fall of Jerusalem and defeat of French troops in the Holy Land, King Louis became the leader of a series of Crusades which started in 1248 and continued periodically until his death in Tunisia in 1270.

Saint Louis improved the administration of France by creating enqueteurs (inquisitors) who checked on the baillis to assure him that justice was being maintained. The Parliament of Paris became a supreme court, and the right of appeal was extended. This extension of the powers of the royal court reduced the juridical powers of the feudal barons and curtailed their independence. These changes did not, however, destroy feudalism, but rather made it work in its purist sense. Royal policy evolved from a family-baronial orientation into national policy. In his relationship with the clergy, Saint Louis agreed to carry out the dictates of the papacy, but insisted on personally reviewing each case of appeal to the higher ecclesiastical courts. This insistence on secular review of ecclesiastical jurisprudence created a new synthesis of church and state.

Saint Louis' career as patron of the arts outshines even Louis XIV's seventeenth-century flamboyance. During the ninety years spanned by Saint Louis and his grandfather, eighty cathedrals and five hundred abbeys were constructed. Saint Louis was personally involved as major donor of many and participated in dedications in France and in the Near East. In the course of his reign the influence of French Gothic spread to the corners of the Christian world.

No country, with the possible exception of the Papal States, could match France in wealth, efficiency of government, and artistic creativity. England was engulfed in internal disputes, while Germany was divided into many feuding duchies.

The thirteenth century witnessed an extraordinary expansion of vernacular literatures. Until Gothic times, almost all literature had been in Latin, but in the second half of the twelfth century, romance languages emerged as the languages of literature. In northern France the chansons de geste, recounting episodes of chivalric heroism in the tradition of the legends of Roland, were the dominant literary form. In the south, the Provençal troubadour tradition, with its love lyrics, satires, and laments, achieved a rich but brief renaissance of poetry in the langue d'oc. In the thirteenth century, the chansons shifted emphasis away from epic stories of combat and conquest to interpretations of the courtly, cosmopolitan society. It became fashionable to reshape and rework tales of antiquity. The cathedral portals became the backdrops for the production of mystery and miracle plays. Town life as subject matter pervaded the stage, which until that time had been

dominated by religious productions.

Scholasticism was the prevailing mode of analysis, involving elaborate attempts to transform the whole corpus of knowledge into a fixed pattern and to relate all phenomena to the rational understanding of Christianity and God. As already stated, this philosophical endeavor to synthesize faith and reason had begun in the cathedral schools in the twelfth century, flowered in the universities during the late twelfth century, and came to a climax in High Gothic times. The Scholastic approach accepted certain fixed ideas of God, the Trinity, and so forth as basic postulates and developed those postulates through a deductive procedure. The evolution of Scholasticism became the greatest intellectual achievement of the Middle Ages.

Thirteenth-century scholars attempted to harmonize Aristotelian reason and Christianity. The University of Paris, recognized by Philip Augustus and Pope Innocent III in 1200, reverberated with discussion and debates on interpretations of Aristotle's treatises. But the renaissance of interest in Aristotle produced certain difficulties; his *Physics* argued that prime movers existed at the start of the world, but also insisted that matter had always existed. This insistence on the pre-existence of matter conflicted with traditional interpretations of the Book of Genesis. In his *Ethics* Aristotle stated that the purpose of life was to seek truth, but that with death, the mind and the search for truth dies. Obviously, this conclusion conflicted with traditional assumptions about the immortality of the soul. Church authorities banned the teaching of Aristotle's *Physics* and *Ethics* in 1210. Masters were allowed to read all of Aristotle, but were authorized to teach only his *Logic*. The preoccupation thus produced a puzzling dilemma, since some aspects of Aristotle reinforced Christian cosmology and others were in conflict with it. In 1231 Pope Gregory IX renewed the ban on the *Physics* and *Ethics,* but also appointed a commission to reconcile what were regarded as conflicts and contradictions within Aristotle's total philosophy — conflicts between the Aristotelian and Christian cosmologies. Scholastic philosophy,

given papal sanction, sought, in effect, to harmonize faith and reason. The conflict between the Christian and classical traditions and the elaborate attempts to resolve the conflict gave this period its dynamic and creative character.

The most complete resolution of this conflict was achieved in the writings of Thomas Aquinas. Born in Naples and educated in the university there, Thomas Aquinas became a Dominican friar in 1244 and spent nine years in the Papal Court. In the 1260's he was in Paris. In 1261, the papacy nominated Saint Thomas to supervise an authoritative translation and commentary on Aristotle. Between 1265 and 1272 he wrote the *Summa Theologica,* one of the great masterpieces of intellectual history. By arguing that there was no conflict between revealed truth and natural truth, since both originated in God, Saint Thomas synthesized Aristotelian thought and Christian faith. He used Aristotelian logic to demonstrate what were regarded as Aristotle's mistakes. In spite of Saint Thomas' moderate point of view, in 1277 the Bishop of Paris and the Archbishop of Canterbury condemned some 200 allegedly Aristotelian propositions. All these debates had sharpened men's minds, had created individuals capable of comprehending obstruction, and had formulated intelligible statements of the Christian faith.

The connection between Scholasticism and Gothic art is discussed in broad humanistic terms by Erwin Panofsky in his *Gothic Architecture and Scholasticism* (1951). He suggests that the methods of procedure and the "controlling principles" found in the *Summae* of the Scholastics were absorbed as "mental habits" by the architects in a cause-and-effect relationship. He discovers much exploratory probing in attempts of twelfth-century Scholastics to settle the conflict between faith and reason. This tentative formulation of principles relates to the variety found in Early Gothic architecture. By contrast he connects the more encyclopaedic and co-ordinated *Summae* of the thirteenth century with the design of High Gothic cathedrals. According to Panofsky, the controlling principle of Scholasticism and Gothic architecture is *manifestatio*: elucidation or clarification. Start-

ing in the early thirteenth century, the systematic articulation of the *Summae* as books with an over-all plan of chapters and subdivisions points to the ambition of the Scholastics: the achievement of a comprehensive and explicit order in their writings, "a postulate of clarification for clarification's sake." In general terms, Panofsky equates this attempt at clarification in the *Summae* with the "principle of transparency"—a dominant principle of High Gothic architecture.

At a more specific level Panofsky describes those analogous requirements which seem to govern the formal organizations of Scholastic writing and High Gothic architecture:

[1] Like the High Scholastic *Summa,* the High Gothic cathedral aimed, first of all, at "totality" and therefore tended to approximate, by synthesis as well as elimination, one perfect and final solution; we may therefore speak of *the* High Gothic plan or *the* High Gothic system with much more confidence than would be possible in any other period.

[2] The second requirement of Scholastic writing, "arrangement according to a system of homologous parts and parts of parts," is most graphically expressed in the uniform division and subdivision of the whole structure.

[3] The theoretically illimited fractionalization of the edifice is limited by what corresponds to the third requirement of Scholastic writing: "distinctness and deductive cogency." According to classic High Gothic standards the individual elements, while forming an indiscerptible whole, yet must proclaim their identity by remaining clearly separated from each other — the shafts from the wall or from the core of the pier, the ribs from their neighbors, all vertical members from their arches; and there must be an unequivocal correlation between them.

This penetrating analysis of High Gothic in terms of its "visual logic" as opposed to the functionalist or illusionistic interpretation will be discussed in the later chapters on the High Gothic cathedrals.

Panofsky's second principle common to both Scholasticism and High Gothic architecture is *concordantia,* a final solution by "the acceptance and ultimate reconciliation of contradictory possibilities." Conflicts in the Scriptures and their interpretations could be resolved only by pitting one set of authorities against another. In the twelfth century, Abélard in his *Sic et non* exposed marked disagreement among the authorities, whereas the thirteenth-century Scholastics attempted to resolve these disagreements by using Aristotelian logic. Panofsky views the emergence of High Gothic architecture in the cathedrals of Chartres, Reims, and Amiens as the final reconciliation of different experiments within the Early Gothic structure.

In spite of Panofsky's stimulating and penetrating analysis of Gothic style and its connection with Scholasticism as "mental habits," the unknown quantity remains the specific relationship between the Scholastics as patrons and the architects (master builders) as designers. Ample evidence exists to support the contention that the High Gothic master builders were emerging into a new professional status as architects; yet, as Panofsky clearly indicates, it is dangerous to overemphasize the impact of Scholastic patterns of thought on the conscious intentions of the designers of Gothic cathedrals. If these relationships between Scholasticism and the designers of Gothic cathedrals are given too much weight, the ingenuity and creativity of the individual architect tend to become submerged in the inevitability of the resolution of conflicting tendencies.

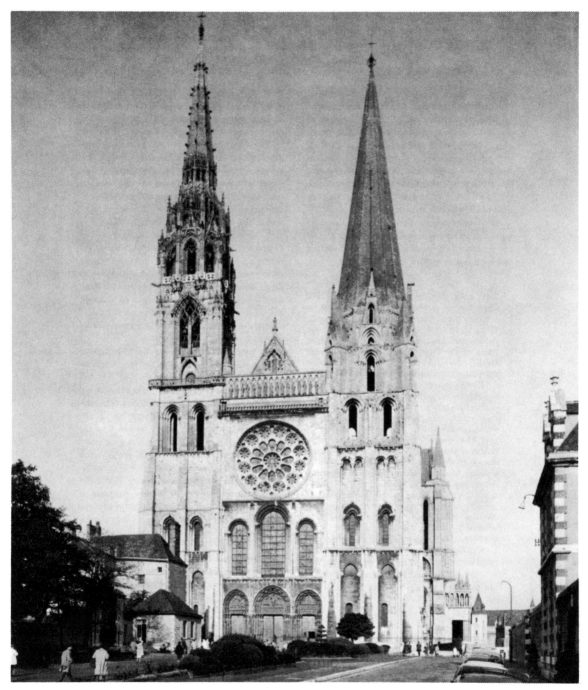

Fig. 218. Chartres Cathedral. North tower 1134, north
spire 1507, south tower begun by 1145, portals c. 1145,
rose window early XIIIth century

The Cathedral of Chartres

O N THE NIGHTS of June 10 and 11, 1194, a huge conflagration consumed much of the town of Chartres, including the Episcopal Palace and the eleventh-century Cathedral of Notre-Dame. The destruction excited a series of dramatic reactions culminating in the construction of the most famous Medieval edifice in Europe. A master builder, whose name is unknown, designed and supervised the erection of a new type of Gothic cathedral in the short span of twenty-six years. By 1220 the vaults, which soar 116 feet above the pavement through the 422-foot length of the cathedral, were completed. This prodigious achievement was the result of an extraordinary outburst of enthusiasm and energy difficult to explain in twentieth-century terms, since by habit we distinguish between religious fervor, economic interest, community pride, and political enterprise. The late twelfth-century man made no such distinction between religious and worldly concerns, and the creative explosion that built Chartres Cathedral took its energies from all aspects of Medieval life.

In retrospect, several factors can be perceived clearly. First, Chartres is the center of the cult of the Virgin Mary. According to legend, a pagan sanctuary existed there before the birth of the Virgin. This first church of Gaul is often connected with a sacred spring of pagan times. The presence of a statue of the Virgin and Christ Child, reportedly carved by Saint Luke, intensified the pilgrimages to Chartres, the Virgin's special house on earth. But the fame of Chartres in the Middle Ages was clearly established because of the presence of the Sacred Tunic worn by the Virgin at the time of the birth of Christ. As Otto von Simson has described in his book *The Gothic Cathedral* (see bibliography), this sacred relic acted as protector of the people of Chartres and as a symbol of the Virgin's palace on earth. Emperor Charles the Bald presented the Sacred Tunic to Chartres in 876. Many miracles followed. In 911 the Normans were thrown into panic and flight by the display of the relic, and in 1119 King Louis VI spared the city and Count Thibaut of Chartres because the Tunic was carried by the clergy and townspeople. The rebuilding of town and cathedral was considered futile directly after the fire of 1194. The catastrophe was interpreted as a sign of the Virgin's abandonment of the sanctuary because of the sins of mankind. However, Cardinal Melior of Pisa, a papal legate, persuaded the canons of the chapter to spend the majority of their vast revenues on the reconstruction and further organized a meeting of the townspeople. As von Simson writes:

> Before this crowd he [the Cardinal of Pisa] repeated his plea with an eloquence that brought tears to the eyes of his audience. And, by what seemed to be a happy coincidence, at this very moment the bishop and chapter appeared carrying in solemn procession the Sacred Tunic, which contrary to general belief had, safe in the cathedral crypt, survived the conflagration undamaged. The wonderful occurrence caused an incredible impression. Everyone pledged the possessions he had salvaged to the reconstruction of the sanctuary. The Medieval temper, as we can often observe, was given to sudden changes from despair to joy. In Chartres it was now suddenly

believed that the Virgin herself had permitted the destruction of the old basilica "because she wanted a new and more beautiful church to be built in her honor."

The religious energy which began the construction of the new Gothic Chartres is thus clearly revealed; yet the means by which the rebuilding was accomplished with such rapidity remain to be discussed. The Chapter of Notre-Dame was one of the most famous in Christendom. The chapter agreed to commit most of its enormous revenues through 1197 to the construction of the cathedral. Von Simson continues:

> The ecclesiastical province of Chartres was at that time possibly the largest and wealthiest in France; even Rome referred to it simply as the "great diocese." Encompassing an area of 100 by 130 miles — 911 parish churches, not counting those in the town of Chartres — its grain harvests and silver alone yielded the bishop the immense income of nearly $1,500,000 in modern money annually. The total revenues of his chapter exceeded those of the bishop by far. The dean alone drew an income that would today be over $700,000 a year.

Further donations from the wealthy townspeople of Chartres, who were famous for the exportation of lace, harnesses, and weapons, greatly augmented the income of the cathedral. The fame of the relic of the Sacred Tunic brought funds in the form of donations from many sources outside the boundaries of France. Von Simson states:

> The Gothic cathedral of Chartres was the work of France and of all France as no other great sanctuary had ever been before. The cathedral windows bear magnificent testimony to the national effort. I have mentioned those contributed by the guilds. Along with them appear the ancient feudal houses of the Île-de-France as donors: Courtenay, Montfort, Beaumont, Montmorency. The Counts of Chartres, but especially the royal house, made great contributions. The entire composition in the north façade, consisting of a rose and lancet windows and exalting Mary and her Biblical ancestors, was given by Queen Blanche, the mother of St. Louis. All corresponding windows in the opposite transept were donated by Peter of Dreux, Duke of Brittany.

The religious and economic sides of Medieval life are interlocked. Without the cathedral as its center of focus, not only the religious but also economic life of Chartres was threatened with meaninglessness. To quote again from von Simson:

> Here the economic life of the entire city centered primarily in four great fairs, which, by the end of the twelfth century, had acquired nearly the reputation of the fairs of Brie and Champagne. The major fairs of Chartres coincided with the four feasts of the Virgin (Purification, Annunciation, Assumption, and Nativity), which drew innumerable pilgrims to the cathedral. As the fairs, in all probability established by the cathedral chapter, had originated in these festivals, so they remained dependent upon them. Religious souvenirs and devotional objects were purchased by pilgrims in very considerable quantities. At the fair of the Nativity (called the Septembresce, as the birth of the Virgin was celebrated on September 8), such articles seem to have comprised the bulk of all goods sold. These devotional objects were most often small leaden images of Our Lady or of the Sacred Tunic, but the more well-to-do pilgrims liked to take home real chemisettes, which, when blessed by a priest, were thought to be beneficial to the expectant mother, and even to protect the knight who wore them under his armor in battle.
>
> Thus, even the manufacturer in sale of textiles — the most famous product of the region — profited directly as well as indirectly from the cult of the Sacred Tunic. This is even truer for the producers of victuals — the bakers, butchers, fishmongers — and the merchants of Beauce wine, the quality of which was once famous. During the festivals of the Virgin, business throve for all these tradesmen. Their professional organizations, the guilds, figure very conspicuously, as the modern visitor notices with astonishment, among the donors of the stained-glass windows of the reconstructed sanctuary. In fact, the five great windows in the chevet that honor the Virgin and are in a sense the most important of all were the gifts of merchants, primarily the butchers and bakers. These translucent compositions thus seem to have retained something of the emotions,

of the sense of attachment to their cathedral, that animated the merchants and craftsmen of Chartres in 1194.

Without the great basilica their professional life would indeed have been hardly imaginable. The fairs of the Virgin were held in the *cloître* of Notre-Dame, that is, in the immediately adjoining streets and squares that constituted the property of the chapter and stood under its jurisdiction. The dean guarded the peace and security of the fairs. Merchants erected their stands in front of the canons' houses. The three squares just outside the cathedral were the scenes of the most lively activity. Fuel, vegetables, and meat were sold by the southern portal of the basilica, textiles under the northern one. At night strangers slept under the cathedral portals or certain parts of the crypt. Masons, carpenters, and other craftsmen gathered in the church itself, waiting for an employer to hire them. Even the selling of food in the basilica was not considered improper if carried on in an orderly fashion. At one time the chapter had to forbid the wine merchants to sell their product in the nave of the church, but assigned part of the crypt for that purpose, thus enabling the merchants to avoid the imposts levied by the Count of Chartres on sales transacted outside. The many ordinances passed by the Chapter to prevent the loud, lusty life of the marketplace from spilling over into the sanctuary only show how inseparable the two worlds were in reality.

The King of France appointed the Bishop of Chartres, and thus the See of Chartres was one of the royal episcopates. During the twelfth century the Capetians used the See of Chartres to increase the royal domain. By marriages and strategic appointments, the kings of France created a rapport between themselves, the Count of Chartres, and the bishop. The fire of 1194, once the Sacred Tunic was discovered safe in the crypt, unleashed a relentless religious enthusiasm which brought every facet of Medieval society into focus on the erection of a new, more resplendent home for the Virgin Mary.

As the pilgrim approaches the façade of Chartres (fig. 218), the history of French Medieval architecture from 1134 to 1513 is dramatically presented. The bottom of the north tower (begun in 1134) in its massiveness and mural presence suggests the Romanesque, while the more undercut surfaces of the south tower (begun by 1145) denote Early Gothic. The south tower, one of the most impressive in France, rises over 300 feet. The thin, blind arches with pierced windows of the first story shift to a second division comprising a pair of windows, deep in the masonry and framed by colonnettes supporting the archivolts, and the double blind arcades. The colonnettes, dividing each blind arcade, rise in an unusual manner from the keystone of the windows below. The third tier repeats in variation the lower part of the second story. Finally, the transition from square tower to octagonal spire is accomplished by projecting tabernacles at the corners and taller but more complicated ones on the four flat faces of the tower. The emphasis on the many planes in space created by diagonal splays or sides of each of the apertures is Gothic (figs. 218, 228, 229).

Between the west faces of the towers are the Royal Portals (fig. 218), surmounted by the three twelfth-century windows (discussed in Chapter 15). The composition of the entire façade of Suger's Saint-Denis of 1140 (fig. 124) has been simplified and placed between the towers. The High Gothic rose window, completed in the early thirteenth century, and the three twelfth-century windows illuminate dramatically the western end of the nave (fig. 225), but from the exterior the rose window damages the proportions of the south tower. To fully appreciate the south tower as a totality, one must look at it from the south side of the cathedral (figs. 228, 229).

Finally, the north spire, designed by Jean de Beauce in the early sixteenth century, completes the façade and imparts a dynamic asymmetry to the whole composition (fig. 218). The exuberant curving and flowing elements reflect the dynamic spirit of Late Gothic in the north, which is contemporary with the High Renaissance in Rome. Every part of the entire façade was modern when it was constructed — every part a moment in the history of the cathedral between 1134 and 1513, the date of completion of the north spire.

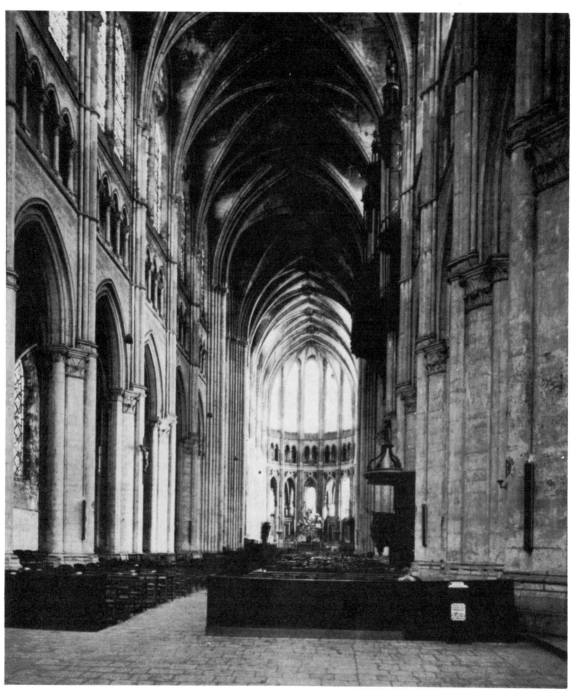

Fig. 219. Chartres Cathedral, begun 1194. Nave

A series of disastrous fires punctuated the entire history of the Cathedral of Chartres. The large late Carolingian church was destroyed by a fire in 1020. Ten years later the new church of Bishop Fulbert was consecrated. An illuminated page of a manuscript of 1028 shows this church with a large, central western tower and nave extending almost to the length of the present cathedral. Shallow transepts were constructed toward the middle of the eleventh century. In the late eleventh or early twelfth centuries porches were added to the transepts and to the west end. Around 1075 William the Conqueror had donated a tower. On September 5, 1134, a huge fire destroyed the town and engulfed the cathedral which, according to pious accounts, escaped miraculously. Actually, damage must have been severe to the west end of the church, since work commenced at once.

This first campaign, still preserved, started with construction of the lower part of the north tower (fig. 218). The famous "Cult of the Carts," beautifully described in Henry Adams' *Mont-Saint-Michel and Chartres,* came into being. People of noble birth and humble peasants came to help pull the carts laden with stone from the quarries some distance from Chartres. This act of devotion to rebuild the Queen's House on Earth has rarely been equaled in recorded history. By 1145 two towers were under construction, with the south tower completed in the 1160's. The Royal Portals and the three stained-glass windows above were in place by 1150. As already described, the horrible conflagration of 1194 swept the town and burned most of the wooden-roofed cathedral, sparing the western parts constructed between the fire of 1134 and the 1160's. The narthex, with vaulted gallery above, saved the portals and three stained-glass windows. The present façade exhibits those parts which were saved from the fire of 1194: the bottom of the north tower, the south tower in its entirety, the portals, and the three twelfth-century windows. The huge rose window is part of the High Gothic cathedral, to which we must now turn our attention.

Upon entering the cathedral (fig. 219) the visitor is struck by the soaring verticality of the nave vessel, the multiplicity of the repeated bays, the rich luminosity of the stained glass, and the warmth of the masonry. The new High Gothic features which create this verticality and make possible the colored light are the uniform nave piers with four attached columns; the uniform bundle of five shafts over each pier; the huge clerestory, 45 feet high and as tall as the nave arcade; a new clerestory window with two tall lancet windows crowned by a rose window; the four-part vault over each rectangular bay; and the flying buttresses re-enforcing an entire cathedral for the first time in history. Each bay (see especially fig. 224) is emphasized by the equal size of nave arcade and clerestory and by the plane of the wall, which remains the same in the spandrels over the nave and triforium arcades and on the inner surfaces of wall around the windows. The springing of the vaults from a point considerably above the bottom of the clerestory further accentuates the vertical sweep of the nave. A balance between the verticality of each bay and the longitudinal, directional impetus down the nave to the high altar is established by simple stringcourses which separate the triforium from both clerestory and nave arcade and by the repetition of similar piers and bundles of colonnettes. The six bays and the crossing of the transepts (see plan, fig. 222, and figs. 220 and 221) are similar to the nave except in the triforium, which has five arches, as opposed to four in each bay.

The nave and transepts of Chartres follow the shapes and proportions of the nave vessels of the four-story cathedrals of Noyon, Laon, and Paris as originally constructed (figs. 153, 162, 175). Chartres is much taller than Noyon and Laon and is slightly taller than Notre-Dame of Paris. The Chartres nave, however, is three-story like the nave of Sens (fig. 139) or the choirs of Canterbury and Vézelay (fig. 148), but does not continue the wide proportions of the three-story cathedrals. The Chartres master, by constructing a rectangular bay with four uniform piers rising to a four-part vault, instead of a six-part vault over six supports, eliminates the alternation of supports of Sens and

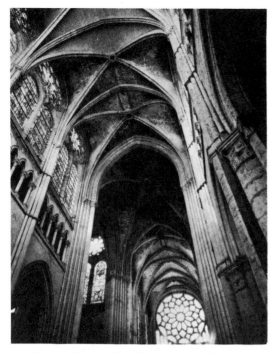

Fig. 220. Chartres Cathedral, begun 1194. Transept
from the south

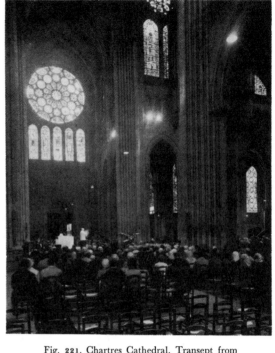

Fig. 221. Chartres Cathedral. Transept from
the north (service)

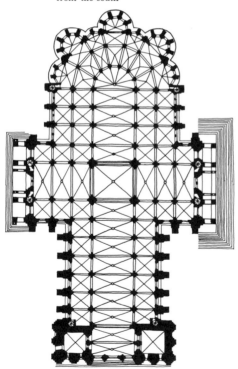

Fig. 222. Chartres Cathedral. Plan, 1194–1220
(after Dehio)

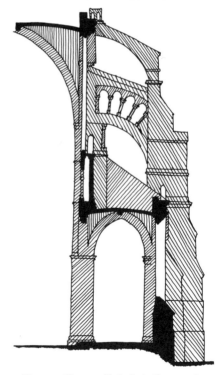

Fig. 223. Chartres Cathedral. Cross section

Noyon and the alternating piers of the eastern bays of the nave of Laon. It would almost seem as though the Chartres master had been influenced by the uniformity of plain piers, with three shafts above, of the eastern part of the nave of Paris. But Paris, like Sens, has a massive mural character which is quite different from the undercut surfaces and multiple planes of wall found in Noyon and Laon. Chartres combines these two conflicting Early Gothic tendencies by preserving the mural massiveness of Sens and Paris (in its original disposition) and by suggesting more undercutting of the wall, like Noyon and Laon, in its triforium. The Chartres master thus synthesizes the divergent characteristics of Early Gothic and dramatically establishes a new kind of Gothic.

In elevation, the Chartres nave reflects the influence of Sens and other three-story churches with its nave arcade, triforium, and clerestory (fig. 139). However, the triforium at Sens is not a passageway, but merely an opening which allows light to enter the areas over the aisle vaults. Further, at Sens the triforium is divided by the colonnettes of major and minor piers and does not function visually as a continuous colonnade with a strong horizontal axis. Here, again, the architect of Chartres was influenced by the forms of the three-story churches, but he treated the triforium in a manner closer to the triforia of Noyon and Laon. Thus, by eliminating the gallery of the four-story cathedrals (Noyon and Laon) and by increasing the proportions and size of the nave arcade and clerestory, the Chartres architect created a nave vessel which in its three stories only superficially resembles the Sens nave.

By using uniform piers and four-part vaults over each bay, the Chartres master avoided the large space cubes of the nave of Sens, where each cube extends from major pier through paired columns to major pier and is crowned by domical six-part vaults. The alternating system of major and minor supports of Noyon (fig. 153) and its original six-part vaults and the groping experimentation with an alternating system at Laon near the crossing (fig. 162) is transformed at Chartres into a more harmonious, rhythmic sequence of spaces

from façade to high altar. Finally, the elimination of the gallery was made possible by the use of flying buttresses, and a bolder and yet simpler elevation was created. The clarity and logic of the interrelation between pier and colonnettes and the ribs of the vault and the balance of clerestory and nave arcade equally divided by triforium are vastly different harmonies from those achieved in the hesitant boldness of Sens and the multiple stories of Noyon, Laon, and Paris. The Chartres master seems to have resolved the design problems of the Early Gothic, as he evolved a new majestic co-ordination of elements.

The plan of Chartres established the pattern for subsequent High Gothic cathedrals (fig. 222). The nave, with its seven bays, flanked by two aisles, passes through wide, aisled transepts and culminates in the choir. The increase in width in the choir, with its four aisles, reflects the growing veneration of the Virgin Mary in the late twelfth- and early thirteenth-century church. The double ambulatory around the choir has an inner aisle corresponding to the aisles of the nave and an outer, narrower aisle animated by seven radiating chapels, three deep ones and four shallow ones. The plan of the chapels was determined by the three large eleventh-century crypt chapels which were reinforced after the fire of 1194. The shallow absidioles, on the other hand, required entirely new substructures. This Chartres plan, with variations, is repeated in the cathedrals of Soissons of the late 1190's, Reims (begun in 1211), and Amiens (started in 1220).

The over-all originality of the Chartres plan should not obscure the fact that the architect borrowed and transformed ideas established by other twelfth-century master builders. The wide transepts do not show any influence from Paris and Sens, but suggest an indebtedness to Laon (fig. 163). The plan of Laon reveals a similar relation of transepts to nave, but the original choir of Laon was surrounded by a single aisle and no radiating chapels. To be sure, Paris has a double ambulatory, but again it has no radiating chapels (fig. 176). Further, the Paris ambulatories have a unique system of vaulting which is completely

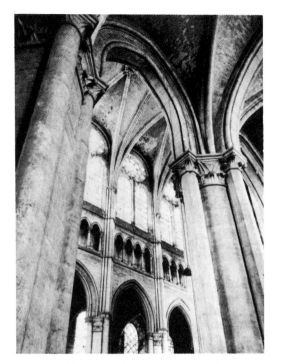

Fig. 224. Chartres Cathedral, begun 1194. Nave from south aisle

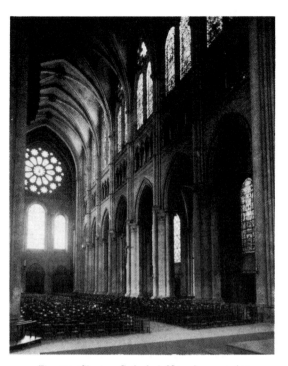

Fig. 225. Chartres Cathedral. Nave from crossing

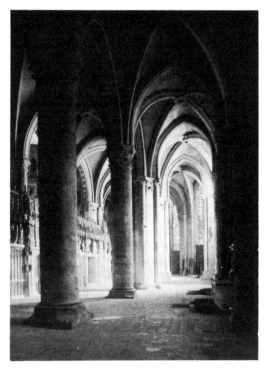

Fig. 226. Chartres Cathedral. South aisles of choir

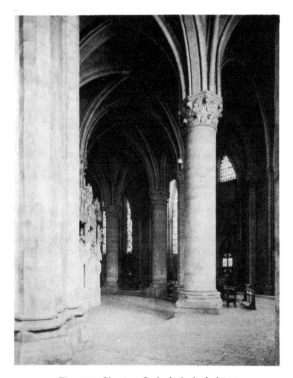

Fig. 227. Chartres Cathedral. Ambulatory

different from that of Chartres. It would seem as though the Chartres master was inspired by Suger's choir of Saint-Denis (fig. 128). The inner ambulatory of Chartres has the same number of bays (seven) and similar handling of broken ribs. The outer aisle of Saint-Denis is shallow, with each of the seven bays growing into a concavity which forms one of the seven radiating chapels. At Chartres the outer aisle has a four-part vault in front of the three deep absidioles and a five-part system which extends into the shallow chapels. The Chartres ambulatory, however, is much larger and darker than Suger's chevet. In developing a new plan for Chartres, the master accepted the direct influence of at least two Early Gothic structures (Saint-Denis and Laon) and indirectly the influence of several. All these influences he combined and transformed into an essentially original design.

The structural system of Chartres co-ordinates and harmonizes various Gothic innovations. First, all the vaults are four-part ribbed vaults, as opposed to the six-part vaults of Early Gothic. Each bay consists of a four-part vault, rectangular in plan and flanked by a single aisle bay. As already stated, this uniform system of vaulting gives continuity to the nave space, in contrast to the more compartmented character of Sens, Laon, and Paris (figs. 139, 162, 175). Further, in four-part vaults the number of ribs rising above each pier is uniform: one transverse rib, two diagonals, and two longitudinal or wall ribs connected with a bundle of five colonnettes. From the point of view of construction, both the wooden centering, on which the vaults are constructed, and the buttressing are simplified by the use of the four-part vault, as opposed to the six-part vault with its alternating number of ribs. The four-part vaults had been used in parts of earlier Gothic cathedrals, but never before in an entire structure. Flying buttresses were first employed in the last two decades of the twelfth century in the Cathedral of Paris (fig. 181). The Paris buttresses appeared originally only on the nave and were complicated in design because of the necessity of springing, in two flights, over the double aisles. At Chartres the buttresses

are employed for the first time throughout the entire cathedral and are joined by an arcade (figs. 228–230). A third stage of buttresses was added while the cathedral was being completed.

Since the Medieval builders did not possess engineering mathematics to calculate the thrust of vaults, they were forced to proceed empirically. Even though the Chartres master placed flying buttresses at the springing of the ribs, he retained the heavy transverse wall at the triforium level behind each bundle of shafts (fig. 223). This transverse wall was necessary to the structure of both Laon and Noyon before flying buttresses were added to those churches in the thirteenth century (see original Laon cross section, fig. 164). The Chartres architect was taking no chances and reused a structural member now made obsolete by the invention of flying buttresses. The Chartres master also preserved some of the wall around the clerestory windows (figs. 220, 224).

The visual subtleties of the interior of Chartres are often overlooked because of the overwhelming effect of the stained-glass windows and the relative darkness of the interiors of nave, transepts and choir. A close scrutiny of the nave supports (figs. 219, 224, 225) reveals that they are not identical in design, but alternate down the nave and across the transepts from round pier with four octagonal colonnettes to octagonal pier with round colonnettes. Further, this alternation does not stop with the capitals of the piers, but can be seen in the largest in each of the bundle of colonnettes which rises to the springing of the ribbed vaults. This major colonnette continues the octagonal or round shape of the four colonnettes engaged to the piers below. The wall piers along the exteriors of the aisles repeat this same alternation. There is no structural reason for this alternation, since the vaults of four-part division do not create the support problems which the six-part vaults of the twelfth-century cathedrals did. The six-part vaults by their very nature had five ribs springing from the major piers and three from minor piers, and the alternation as at Sens and Noyon thus had structural significance. At Chartres this decorative alternation is either a design lag or a sensitive

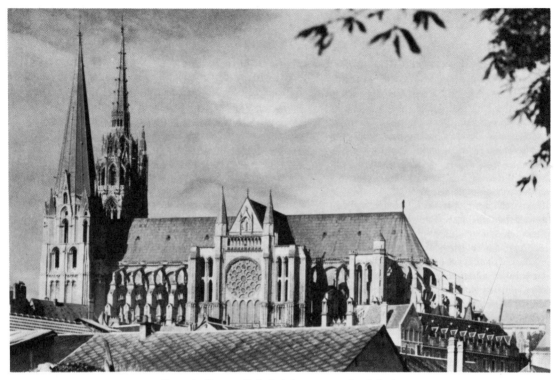

Fig. 228. Chartres Cathedral, begun 1194. South flank

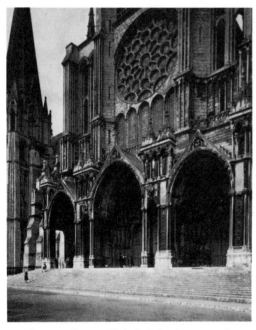

Fig. 229. Chartres Cathedral. South tower and
south transept

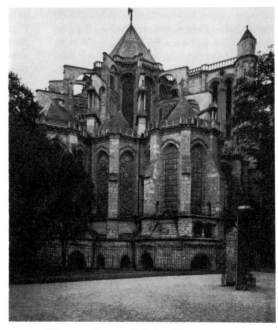

Fig. 230. Chartres Cathedral. From the east

visual refinement. There are similar structural-visual ambiguities in Romanesque. The nave of Conques (fig. 26) has a continuous barrel vault which is thickened over each nave pier by large transverse arches. The piers, however, shift in design from wide, flat pilasters to half-columns on all four sides. This decorative alternation appears in the aisles also. Conques, like Chartres, possesses a visual subtlety which transcends the demands of the structural system.

In the supports separating the inner and outer aisles of choir and ambulatory at Chartres, the nature of the alternation and its rhythmical sequence is changed still more radically than in the nave and transepts (figs. 226, 227). Starting with the pier in the south transept and moving east with the supports separating the double aisles, the alternation changes from octagonal pier with round colonnettes to two simple round columns (fig. 227). Then follow another octagonal pier with round colonnettes and a round pier with octagonal shafts. The strengthening of these two last piers with engaged shafts is logical structurally, since they are the inner supports for towers flanking the choir (fig. 228). Around the curved part of the ambulatory (fig. 227) are simple columns which change from one round to single octagonal to two round to single octagonal to single round: A, B, AA, B, A rhythm. The north side of the choir repeats the design of the south. To give greater emphasis to the ambulatory and to the outer aisles and radiating chapels, the floor level rises two steps in the hemicycle of the outer aisle. This shift in level and the sensitive changes of supports, combined with the stained glass in the major and minor radiating chapels, makes the double ambulatory of Chartres one of the supreme moments in all Medieval architecture.

Chartres was always a building in progress, never a building finished (fig. 228). The two completed towers do not belong to the High Gothic period. The twelfth-century south tower, in spite of its height, is not proportioned to the thirteenth-century nave vaults of Chartres plus the 40-foot roof above. The early sixteenth-century north tower fits the proportions of the High Gothic nave

better than the spire of the south tower. The flank of the church (figs. 228, 229, 235) suggests that plans were made for seven more towers: two flanking each transept, two flanking the choir, and a square lantern tower over the crossing. The bases of the first six are completed to the top of the clerestory windows. The lantern must be imagined as rising from the huge piers of the crossing of the nave and transepts. Circular staircases are located in the inner piers of the transepts and on the eastern corner piers of the choir towers. From a distance, a horizontal axis seems to dominate Chartres (fig. 228); yet the horizontality is given a vertical countertheme by repeated wall and flying buttresses. If all towers had been completed, this relation of horizontal theme to vertical countertheme would have been reversed: the soaring accents of the towers would have dominated the massing of the cathedral.

The treatment of the transepts, with towers on each end, shows a connection with Laon (figs. 171, 172), while the employment of towers flanking the choir is reminiscent of Noyon (fig. 159). Further, the general design of a rose window over a row of lancet windows (figs. 228, 229) is a refinement of the format developed in the transepts of Laon (figs. 171, 172). If the tower over the crossing had indeed been intended as a square lantern, then the massing of Chartres would be even closer to that of the Cathedral of Laon. However, the seven incomplete towers, not counting the western ones, plus a new wall surface with buttresses at right angles to the axis of the cathedral, give Chartres a new and dramatic configuration.

The nature of the exterior of the transepts was altered during the thirteenth century (see bibliography). The north transept started with a single portal and was then converted to a triple portal façade. The south transept (fig. 229) was designed from the start to have three portals. However, large sculptured porches were added to both transepts in the second quarter of the thirteenth century. Both are dominated by huge rows of windows flanked by the massive bases of the towers (figs. 228, 229).

The flying buttresses of nave and transepts

spring from massive wall buttresses (figs. 228, 229). As seen in the cross section (fig. 223), the pair of buttresses, tied together by an arcade, abut the clerestory wall below and just above the springing of the ribs. The abutment of the wall buttresses at this relatively low level was changed to a higher level in later cathedrals such as Soissons, Reims, and Amiens to counter the tremendous impact of wind on the huge roofs which rise about the flat crowns of the vaults. The decision to add the third tier of buttresses at Chartres was perhaps the result of the influence of later cathedrals on Chartres while it was still under construction.

A view of the choir (fig. 230) shows two of the three large radiating chapels, which have five stained-glass windows, alternating with shallow chapels containing two windows (see plan, fig. 222). Below these chapels are the windows which give light to the huge crypt. The lack of co-ordination between crypt windows and the windows in the three large chapels, as opposed to the consistency of design of both crypt and shallow chapels, proves that the Chartres architect after the fire of 1194 re-used and strengthened the eleventh-century crypt chapels for the substructure of the large ambulatory absidioles, but constructed new foundations for the shallow chapels. The flying buttresses around the choir are more complicated than those of the nave and transepts because they need to spring in two flights over the double ambulatory.

The analysis of Chartres reveals that the unknown Chartres master created a new kind of Gothic. He was able to design a new plan which became a model for many later High Gothic cathedrals. He established the High Gothic by using the four-part vaulting system, flying buttresses, new nave piers, and the three-story elevation of nave arcade, triforium, and clerestory. The harmonious combination of these elements differentiates High from Early Gothic and gives Chartres its unique position in the evolution of Medieval architecture. The Chartres master knew the experimental cathedrals of the twelfth century. He knew Sens and other monuments with three-story elevations and certainly was cognizant of the plan and mass-

ing of Laon as well as the nature of interior surfaces and the triforium of Laon. At the same time, he had not overlooked the daring quality of Suger's choir or the flying buttresses of Paris. What makes Chartres such an extraordinary artistic achievement is the fact that this master was able to use ideas from the past in a new way, resolving them into a great synthesis.

Finally, one of the most impressive qualities of Chartres Cathedral is its dramatic location on the highest ground of the town. Whether seen from the fields of the Beauce, from the southeast (fig. 235), or from the west at night (fig. 234), the cathedral dominates the skyline of the town. The twentieth-century pilgrim reacts at first emotionally and then intellectually to its qualities. These intuitive and rational reactions manifest a union of faith and reason.

In spite of the amount of research undertaken since the 1880's, there is paradoxically no agreement among scholars on the question of how the Cathedral of Chartres was built after the fire of 1194 (see bibliography). Was it constructed from east to west, as German scholars tend to think, or west to east, as French Medievalists argue? The paucity of documents and the present lack of a carefully measured plan further complicate the problem. Grodecki, in an article of 1951 on the transept portals (see bibliography), summarizes the documents and verifies the conclusions of the west-to-east theory of Lefèvre-Pontalis (1904). A flight of steps on the flank of the cathedral is mentioned in a document dealing with King Philip Augustus' investigation of an uprising in 1210. Other documents indicate that the upper vaults were completed in part at least by 1220, and on January 1, 1221, the canons made preparation for the assignment of seats in the choir stalls. A wooden porch attached to the south wing of the transept was used by merchants until it was ordered to be removed in 1224 to make possible the addition of the triple porch to the south transept. By 1216 and 1217 stained-glass windows had been donated for the clerestory and the aisle of the choir. With these sparse documents and a careful study of the transepts, Grodecki concludes that the north transept

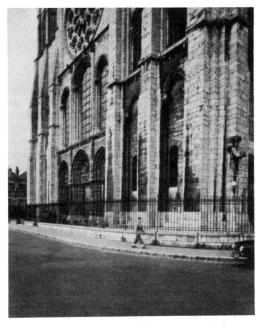

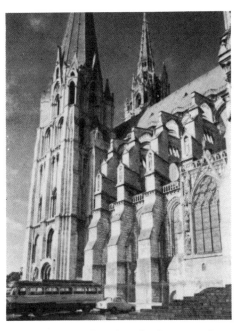

Fig. 231. Chartres Cathedral. North tower 1134, portals c. 1145, south tower 1145 ff.

Fig. 232. Chartres Cathedral. South tower and nave

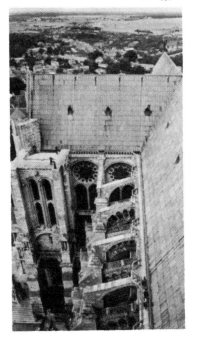

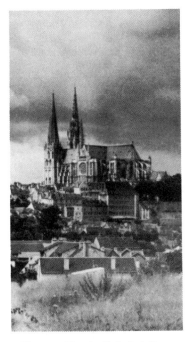

Fig. 233. Chartres Cathedral. From the north spire

Fig. 234. Chartres Cathedral. At night

Fig. 235. Chartres Cathedral. From the southeast

was built with a single central portal before 1210; also that the south transept with its three portals was constructed before 1217 or 1220 and that the side portals of the north transept, which were created before 1220 or 1224, necessitated substantial changes in the buttresses of the towers flanking the north transept. Grodecki agrees with Lefèvre-Pontalis, that the nave was constructed before the choir because the nave buttresses appear to be earlier than those of the choir. Further, Grodecki argues that the windows in the choir aisles are more advanced in design than those in the aisles of the nave. The document of 1210 which mentioned the stairs at the time of the uprising also mentioned altars in the choir. The question, however, still remains whether the choir was the present sanctuary of Chartres or a temporary choir in the nave.

Paul Frankl, in an article on the chronology of Chartres (1957: see bibliography), attacks the west-to-east theory of construction. He opposes Grodecki's arguments dating the windows and the glass of the nave as earlier than the choir windows and claims that the arguments for the late date of the buttresses of the choir can be dismissed by the fact that they were rebuilt in the fourteenth century, following the structural trouble with the crossing mentioned in the appraisal of 1316. Frankl further asserts that the nature of the three western bays of the nave with their diminished width, together with the unfinished nature of the area between the western towers, makes it impossible to conclude that this part of the construction was the earliest after the fire of 1194. He points to the way in which the buttress of the southwest tower is cut back to make room for the pinched stained-glass window in the right aisle of the nave; he notes that the vaults between the two west towers are tipped up to admit the thirteenth-century rose window; and he questions the idea that the work would have started in this makeshift manner. In other words, this makeshift indicates an accommodation of the new nave, advancing from the choir to the twelfth-century façade and towers which had survived the fire of 1194. Frankl argues that after the four eastern bays of the nave were built, the clergy talked the Chartres master into giving up his plan for a whole new west façade to go with the High Gothic cathedral, and therefore the master had to compromise in the western bays of the nave to accommodate the older twelfth-century portals and the bases of the north and south towers. Frankl concludes that the first master, whom he designates as Master A, was responsible for reinforcing the three deep Romanesque chapels and for adding the shallow crypt chapels under the shallow absidioles. This part of the construction of the choir involved preserving the old and adding new construction; Frankl feels that this phase was completed by 1195 or 1196. Because of the lack of continuity between the crypt and the radiating chapels above, Frankl states that a new master, Master B, took over as head of the workshop in 1195 or 1196 and was responsible for the design of the choir ambulatory and the radiating chapels. Since there is no break in the design, Frankl regards Master B as responsible for the transept and nave. Finally, he assumes that a Master C took over around 1224 and was responsible for the porches of both transepts and the upper parts of the transept façades.

Grodecki, in an article published in 1958, proves that the top buttresses, the third stage of buttresses, were not added in the fourteenth century, but were built during the course of work in the thirteenth century. He further proves that the triple arrangement of the flying buttresses of the choir was conceived from the start of the work. Therefore, he argues that the top buttress on the nave was added as a result of the co-ordinated design of the choir and that the west-to-east theory is the better of the two. His sequential arrangement of the buttresses is as follows: the nave first, then the buttresses on the east side of the transept, then the choir buttresses before 1220. He further reiterates his contention that the stained-glass windows of the nave are earlier than those of the choir and at the same time disagrees with Frankl that a change of masters occurred after the completion of the augmented crypt. He concludes that the first Chartres master came from the Laon or Soissons area and was responsible for the nave, transept,

and choir up to the vaults of the choir and that construction took place in that order. The second architect, whom Grodecki assumes succeeded to the leadership of the workshop in 1216 or 1217, was responsible for the flying buttresses of the choir, the towers of the transepts, the triple portals on both transepts, and the jubé of the choir. Frankl, in an article of 1961 (see bibliography), agrees with Grodecki's conclusion that the choir buttresses were all constructed in the thirteenth century. However, he reiterates his belief that all the twenty-three lancet windows in the choir were fabricated between 1205 and 1216 and are thus earlier than the stained-glass windows in the nave. He further argues that the buttresses of the choir must have been in place by 1216 or 1217 and are therefore earlier than those of the nave. Frankl attacks the French theory of the provisional or temporary altar in the nave and argues that the reports which mentioned several altars in 1198 and another document of 1210 mentioning altars refer to altars in the actual choir itself, and not in a provisional choir. Frankl finally argues against any provisional choirs and believes that the new stalls for the canons ordered in 1217 replaced older ones which had been in use in the present choir. In an article published posthumously in 1963 (see bibliography), Paul Frankl studies the one hundred seventy-four stained-glass windows, especially from the point of view of the designs of the armatures. He traces the evolution of the forms of armatures, assigns masters to areas of windows, and uses dates connected with donors wherever possible. He concludes that the first windows were those in the lower choir (1203–1215), then in the clerestory of the choir (1205–1216), in the aisles of the nave (1214–1220), in the clerestory of the nave (1217–1227), and finally all transept windows between 1214 and 1240. On this basis he again affirms his argument for the east-to-west construction of the cathedral.

Thus, we have arguments on both sides, for a west-to-east theory by Grodecki and others, and an east-to-west theory by Frankl. Perhaps further careful research, based on detailed measured drawings, will resolve this debate. It should be kept in mind that the fame of Chartres, the extraordinary funds expended by the chapter, and the general enthusiasm of the whole of Christiandom for the rebuilding of the Virgin's Palace on Earth all may indicate a mass of workers unprecedented in the construction of a cathedral. This rapidity of construction makes the problem of ascertaining the sequence of construction all the more difficult.

There are several other unanswered questions concerning Chartres Cathedral. Who was the Chartres master? From what workshop did he come to Chartres after the fire of 1194? What were his relationships to the clergy — the bishops, canons, and School of Chartres? Unfortunately for history, the plaque which probably contained the name or names of the Chartres architects has disappeared from the great labyrinth extending across the entire nave of the cathedral. The labyrinth, a geometric scheme to honor the builders and clergy, is still *in situ* at Chartres, but any reference in its center to those responsible for the construction of the cathedral has long since disappeared. On the basis of a study of the cathedral itself, it seems clear that the first master of Chartres came from the area around Soissons and Laon. The connections between the general massing of Chartres Cathedral and the forms of Laon, plus the nature of the surfaces of the triforia of both Chartres and Laon, would lead one to this conclusion. Further, it is possible that the three-story elevation of the abbey church of Saint-Vincent of Laon may have also influenced the establishment of the High Gothic three-story elevation in the construction of the Cathedral of Chartres. Whether or not the architect actually came from this region northeast of Paris, he certainly knew the cathedrals of Noyon, Laon, Paris, and Sens.

The relationship between architect and clergy, however, is even more debatable. It is clear from a study of the sculpture of Chartres and from the writings and events of the School of Chartres that the impact of the clergy on the sculptors was very great. As has been pointed out in Katzenellenbogen's book on the sculptural programs of Chartres, the whole design of the portal, the selection of subject, and the basic interpretation of

scenes seem to have grown out of a combination of the debates on the liturgy at the time, historical events and relations to heretical movements, and the specialties of the theologians in the School of Chartres itself. If this close connection between clergy and sculptors can be established, was there a comparable working relation between the clergy and the master builders? Further, to complicate the situation, it is quite clear that the master builders were the over-all supervisors not only of the construction of the cathedral but also of the erection of the sculptured portals and the putting in place of the stained-glass windows.

As stated in Chapter 16, Panofsky, in his book *Gothic Architecture and Scholasticism,* suggests that the methods of procedure and the "controlling principles" found in the *Summae* of the Scholastics were absorbed as "mental habits" by the architects in a cause-and-effect relationship. Panofsky equates the principle of "elucidation or clarification" found in the writings of the early thirteenth-century Scholastics with the "principle of transparency" found in Gothic buildings. Chartres, with its huge clerestory windows as tall as the nave arcade, fits this definition. Indeed, an evolution toward greater transparency can be seen if the designs of the windows of the aisles of the nave are contrasted with those of the choir. The former consist of a single window in each bay, while in the choir each bay is illuminated by two lancets surmounted by a rose. Thus, if we assume that the aisles of the choir are later than those of the nave, which seems plausible, we can also assume that the architect augmented the amount of transparency during the time-span of the construction of Chartres.

On more specific levels Panofsky discusses the analogous requirements which seem to govern the formal organization of both Scholastic writings and High Gothic architecture. These requirements, which, taken together, are a brilliant definition of High Gothic, can be clearly illustrated in the design of Chartres Cathedral. By creating a new plan, a new elevation, and a new co-ordinated structural system, which influenced profoundly the design of subsequent cathedrals, the architect

of Chartres, like the Scholastics, achieved "one perfect and final solution" or a "totality." The logical subdivisions of the parts such as plinths, piers with attached colonnettes, capitals, and arcade add up to form the nave arcade. The triforium is clearly separated from both the clerestory and the nave arcade by stringcourses; yet the bundle of five colonnettes connects the nave arcade with the ribbed vaults. Thus, like the structure of Scholastic writings, Chartres proclaims its "arrangement according to a system of homologous parts and parts of parts," and at the same time each part of the elevation has a visual identity as well as being a portion of a logically conceived whole.

As already discussed, the Chartres architect was influenced by Early Gothic three-story structures such as Sens Cathedral and Saint-Vincent at Laon. At the same time, he utilized the triforium of the four-story cathedrals such as Laon and Noyon. The final massing of Chartres reveals a close relationship with that of Laon, while the mural sense and the use of flying buttresses stems from Notre-Dame in Paris. Panofsky views the principle of *concordantia* — "the acceptance and ultimate reconciliation of contradictory possibilities" — as a principle common to both Gothic architects and the Scholastics. The design of Chartres seems to bear this out.

Panofsky in *Gothic Architecture and Scholasticism* defines lucidly Early Gothic, High Gothic, and Late Gothic styles. His is a forceful analysis of the "what" of Gothic. The "why" and "how" of Gothic architecture are superbly recounted in Otto von Simson's *The Gothic Cathedral,* discussed in Chapter 8. As von Simson points out, the motivation (the "why") behind the construction of Gothic cathedrals was the desire to create the Celestial Kingdom on earth, with the sanctuary as the "threshold to heaven." In order to create this House of God (the "how"), architects and patrons were concerned with corporeal light as analogous to divine light and geometry (measure). Von Simson proves that the Early Gothic Royal Portals (discussed in Chapter 15) are proportioned "according to true measure." The square and triangle

are found in each of the three portals, while the proportions of the golden section can be found in one of the jamb statues of the central portal and approximated in others. Von Simson suggests that the geometrical organization of the Royal Portals was conceived in the School of Chartres and furnished to the masters in charge of the work of carving the portals.

In discussing the High Gothic Chartres (pp. 207–211) von Simson points out that the architect used the measurement (16.44 meters) of the side of the Early Gothic square south tower to establish the width of the crossing. From this measurement the architect calculated the length of the crossing (13.99 meters) by employing the pentagon. Further, the total width of Chartres equals the height of the vaults above the pavement. Von Simson suggests that the Chartres architect also employed the geometry of the pentagon and golden section for the dimensions of the elevation and at the same time alternated the design of the nave piers so that two rectangular nave bays would read as a square. The architect thus seems to have constructed Chartres in terms of preconceived geometrical and proportional measurements involving the square, pentagon, and golden section. But did the Chartres architect possess this preoccupation with geometry, or was he following the dictates of the clergy? On the basis of Villard de Honnecourt's Lodge Book, it would seem that the architect was a supercraftsman who had worked his way up from the quarry to become a superior cutter of stone and finally the supervisor of the whole fabric; yet all the drawings in the Lodge Book, whether of figures or architectural details, show an all-embracing concern for geometry.

In the case of the design of Chartres, the role of the clergy in the interchange of ideas between patron and architect can perhaps be clarified. As von Simson indicates, Peter of Roissy, distinguished scholar, Chancellor of the Cathedral School from about 1208 to 1213, and generous contributor to Chartres, wrote a *Manual on the Mysteries of the Church*. Although the first part of this manual is concerned with an allegorical analysis of the Christian basilica, most of the text seems to

refer to contemporary architecture. It treats of three- and four-story elevations of churches and the alternation of major and minor piers of the nave. Following an interpretation of windows, Peter of Roissy emphasizes the symbolic importance of the square in the design of churches and towers and the stones used in the construction. Von Simson writes: "The square thus recalls for Peter the moral perfection of man (it is the ancient notion of the 'square' man) and the 'unity' of the Ecclesia, which was mystically prefigured in Noah's ark and Solomon's Temple." This emphasis on the square or design *ad quadratum*, as already indicated, appears not only in the design of the Early Gothic south tower and Royal Portals of Chartres but also in the design of the High Gothic Cathedral of Chartres.

Since Peter of Roissy played an important part in the program of the transept portals, as Katzenellenbogen has proved, and since the architect or architects of Chartres supervised the construction of the cathedral as well as the carving of portals, it follows that Peter of Roissy probably influenced the design of Chartres. The cathedral canons must have selected the Chartres architect and then collaborated with him, as Suger collaborated in the construction of the narthex (1140) and choir (1144) of Saint-Denis.

This exchange of ideas between patron and architect should not diminish an estimate of the creativity of the Chartres master builders, who achieved an extraordinary synthesis of many Early Gothic experiments. Von Simson writes as follows:

> In the Cathedral of Chartres the architect has realized the cosmological order of luminosity and proportion to the exclusion of all other architectural motifs and with a perfection never achieved before. Light transfigures and orders the compositions in the stained-glass windows. Number, the number of perfect proportion, harmonizes all elements of the building.
> Light and harmony, it is to be noted, are not merely images of heaven, symbolic or aesthetic attributes. Medieval metaphysics conceived them as the formative and ordering principles of creation, principles, however,

that only in the heavenly spheres are present with unadulterated clarity. Light and harmony have precisely this ordering function in the Gothic cathedral. The first architectural system in which these principles are completely realized is that of Chartres.

In May 1962 the author met Jan van der Meulen at Chartres. He and his wife were measuring the plan and various levels of the cathedral. On the basis of his detailed study of the plan and its modifications and lack of alignment of the joints (which indicate interruptions in the construction) and of the evolving forms of plinths, capitals, and moldings, he told me that the nave of Chartres was built from east to west and vaulted before the choir. Just as this book was being sent to the publisher, a preliminary report by van der Meulen on his large forthcoming study arrived by mail ("Histoire de la construction de la cathédrale de Chartres après 1194," *Bulletin de la Société Archéologique d'Eure-et-Loir,* 1965, 81–121).

Van der Meulen follows the approach of Hans Kunze (*Fassaden Problem der französischen Früh- und Hochgotik,* Leipzig, 1912), who argued that a plan for an entirely new cathedral, involving the demolition of the west façade, was designed after the fire of 1194. In the subsequent decade the idea of demolishing the twelfth-century west end of the cathedral and replacing it with a High Gothic façade was abandoned, and as a result the design of the transepts was modified. Van der Meulen in his report concludes that the first construction, following the original design, consisted of the four eastern bays of nave with aisles vaulted and wooden roof over the nave. This part of the structure was tied into Fulbet's façade and served as a provisional church. He cites as evidence the break in masonry in the triforium level of the fifth bay (counting from the crossing) and chains reinforcing the eastern bay of the nave, which had no crossing

to buttress it. Contemporary with this campaign, work started on the choir, but the original plan of the choir had five chapels opening off the ambulatory, not seven as at present.

According to van der Meulen, a decision was reached to abandon the new west façade and to change the plan of the apse of the cathedral from five to seven bays with seven radiating chapels. The aisles of the choir were vaulted and a temporary wooden roof placed over the choir. The construction of the high vaults follows: (1) vaults of nave from east to west, including the construction of the modified three western bays of the nave in their entirety; (2) vaulting of crossing; (3) vaulting of choir, one bay of north transept, one bay of south transept, in that order. The abandonment of the projected new west façade resulted in the extensive enlargement of the transepts. As originally planned, the transept was to have single portals and no towers. Evidence exists in the west aisles of the north transept to prove this point. The transepts were then constructed, north first, followed by the south transept. Sculpture carved for the new west façade was then placed in the transept portals. He believes that some of the figures of the central portal of the north transept and of the right portal of the south transept were carved originally for the west façade.

In general, he argues that the nave is earlier than the choir. Since the preliminary report has no plans, measurements, or illustrations, it is impossible to verify van der Meulen's conclusions. Yet it should be pointed out that the evolution in the buttresses from nave to choir, the increase in the size of the windows of the aisles of the choir when contrasted with the aisle windows of the nave, and the modification of the western bays to tie in with the existing twelfth-century façade — all answer the criticisms raised against both the east-to-west and the west-to-east theories of the construction of Chartres. It is to be hoped that Jan van der Meulen's book will solve the fascinating riddle of how Notre-Dame at Chartres was constructed.

The Cathedral of Soissons

AFTER THE DESIGN of Notre-Dame at Chartres was established in the years immediately after 1194, High Gothic architecture in and around the Île-de-France seems to have evolved in two major directions. Some masters resisted the innovations of Chartres and re-used many Early Gothic features in new combinations (see bibliography: Bony article). Other master builders either came directly from the Chartres workshop and designed new structures or were profoundly influenced by the new High Gothic synthesis of Chartres. The master of Soissons, as Carl F. Barnes, Jr., has clearly demonstrated in a recent article (see bibliography), was a member of the Chartres atelier (figs. 238–244). He came to Soissons in the late 1190's, perhaps as early as 1197 but certainly by 1200. He brought with him many of the new ideas of the Chartres master. However, a study of Soissons and comparisons with Chartres reveal many differences in design which emphasize the originality of the Soissons master within the format established by the master of Chartres. Further, the presence of the just-completed twelfth-century transept seems to have had an effect on the thirteenth-century design of the choir and nave.

Soissons is just sixty miles northeast of Paris and thirty-five miles west of Reims. The south transept was begun in 1176 on land donated by Nivelon de Chérizy, who became bishop in 1176. The superstructure of the transept was probably completed before the new master arrived from Chartres in the late 1190's. Roul d'Oulchy, the provost of the chapter from 1193 to 1208, donated three chapels. An inscription preserved at Soissons proves that the choir was completed by 1212, for the canons celebrated Mass for the first time on May 13 of that year. Work seems to have progressed quite rapidly after completion of the choir; the nave was completed about 1225 and the façade by 1250. The façade of the north transept and the west towers are fourteenth-century.

A comparison of the naves of the cathedrals of Chartres and Soissons (figs. 219, 236) demonstrates many similarities of design. In elevation the sides of the nave at Chartres show a tall nave arcade below and a clerestory of the same size above, the two separated by the horizontal band of the triforium. This was the new High Gothic proportion established by the Chartres master and repeated almost exactly in the choir and nave at Soissons. Within this general proportion, various aspects of the Chartres treatment are repeated: the bay elevations in both cathedrals have the same flat planes; the arcades of the triforia are on the same planes as the spandrel walls of the two nave arcades. The clerestory windows are handled similarly by the two masters: the windows are embraced by remnants of wall and organized as two lancets with an oval aperture above. In spite of all these features which prove that the master of Soissons came from the workshop of Chartres, there are many differences between the two designs. Soissons (fig. 236) seems much lighter and less mural than Chartres (fig. 219). The massiveness of Chartres has been transformed at Soissons by a thinner and more elegant treatment of walls and supports. The actual height of the nave vaults from the pavement at Soissons is less than that at Chartres (Soissons, 97½ feet; Chartres, 116 feet); yet the greater width of the Chartres nave gives the inte-

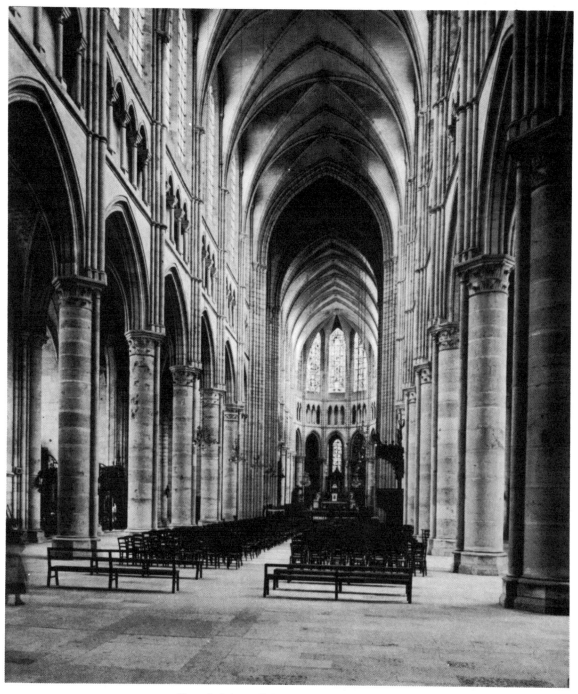

Fig. 236. Soissons Cathedral, begun c. 1197. Nave

rior of Chartres a squatter proportion. The Soissons master, in planning the piers of the cathedral, used as his model the piers of the hemicycle of the choir of Chartres, so he must have either seen them or been familiar with their design. These piers had a single engaged colonnette attached to the inner face. The stucco decorations which were added to the choir of Chartres in the eighteenth century now make this comparison difficult, but old plans of the Chartres choir preserve the original design, with the single colonnette attached to the major face of each pier. Thus the Soissons architect utilized the simple pier of the hemicycle of the Chartres choir, as opposed to the pier with four colonnettes which occurs in the Chartres nave and transepts. This more complex treatment of piers became an integral part of the High Gothic formula, as reflected in Reims and Amiens.

There is also the possibility that the Soissons master was impressed by the single colonnettes or shafts of the south transept, which rise from the pavement up through the gallery and triforium to the springing of the ribs. The Soissons master may have wished to continue the visual simplicity of this twelfth-century architectural statement in the design of the nave piers. He also repeated the Chartres triforium, with its arcade of four apertures, but made some basic changes in the design of the clerestory windows. The Chartres master had developed a new clerestory window with two lancet windows surmounted by a large rosette. At Soissons the master heightened the lancet and crowned the window with a relatively smaller oculus. This variation of the Chartres treatment intensifies the verticality of Soissons, which is further augmented by the more pointed nave arcade itself.

There are other carry-overs in the Cathedral of Soissons which demonstrate that the Soissons builder knew Chartres intimately. These details include the handling of sculpture and the treatment of ribs and keystones. A further discussion of these features can be found in the article by Carl Barnes (see bibliography).

The plan of Soissons (fig. 239) follows the plan of the Cathedral of Chartres in many of its features. In both cathedrals a nave of seven bays leads to a crossing designed to carry a lantern tower; and the ambulatory at Soissons, with its radiating chapels, seems to grow out of the design for Chartres. At Soissons, however, the architect simplified the east end of the cathedral by flanking the choir proper with only single aisles. This change of the Chartres plan was probably caused at Soissons by the presence of the twelfth-century south transept, which would have had to be subjected to partial destruction if four aisles had been constructed. The Soissons architect simplified the double ambulatory of Chartres into a single one tied in by its vaulting with five radiating chapels. The Chartres chevet, with its three large radiating chapels separated by four shallow ones, was, of course, determined by the existence of the crypt at Chartres. Since no old crypt existed at Soissons, the builder simplified and regularized the Chartres plan. The Soissons master used the vaulting system of the westernmost radiating chapels of Chartres and repeated this design around the entire east end at Soissons. The ribbed vaulting of the ambulatory of Soissons is also related to the treatment of the inner ambulatory of the cathedral of Notre-Dame in Paris.

From the point of view of construction, the Soissons master kept the transverse hidden buttress behind the triforium and above the aisles of Chartres (fig. 243), but placed the flying buttresses in a different location. At Chartres the two buttresses, connected with an arcade, are located relatively low; this location necessitated, according to recent studies (see bibliography), the addition of a third stage of buttresses during the course of construction. The Soissons master raised the lower stage of the buttresses and made their incline more acute. The upper flying buttress at Soissons functions like the upper two at Chartres and helps stabilize the vaults and the wind pressure on the roof. The photograph taken of Soissons after the extensive damage of World War I (fig. 243) shows clearly this transformation of the system of thrust and counterthrust of Chartres into a simpler and more logical form. Finally, the Soissons master continued the new system of construction, spring-

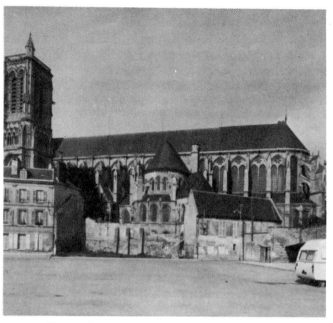

Fig. 237. Soissons Cathedral, begun c. 1197. South flank

Fig. 238. Soissons Cathedral. South transept, begun 1176

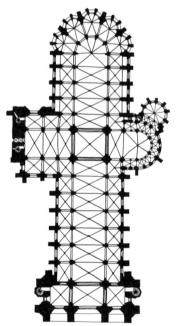

Fig. 239. Soissons Cathedral.
Plan (after Brunet)

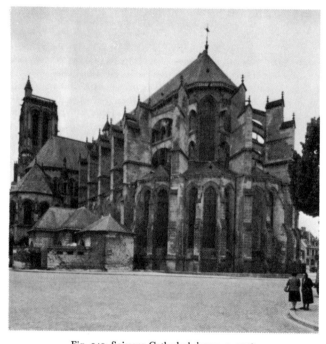

Fig. 240. Soissons Cathedral, begun c. 1197.
From the east

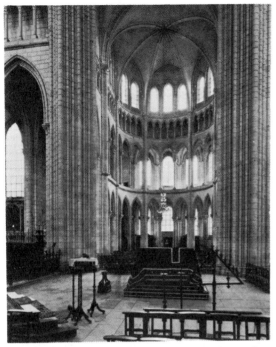

Fig. 241. Soissons Cathedral. South transept, begun 1176

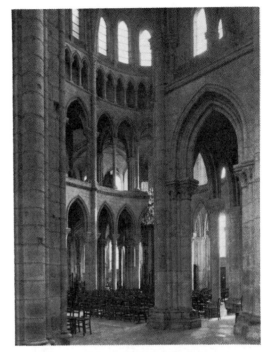

Fig. 242. Soissons Cathedral. South transept

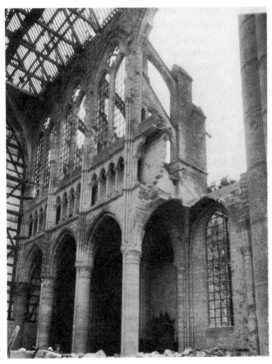

Fig. 243. Soissons Cathedral. Nave after World War I

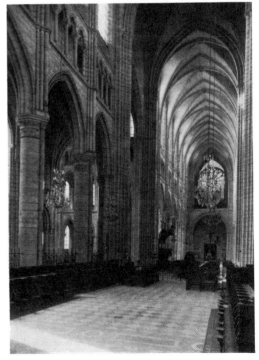

Fig. 244. Soissons Cathedral, begun 1197. Choir and nave

ing the ribs in a series of horizontal courses of masonry. This system was one of the Chartres master's major contributions to Gothic construction.

The exterior of Soissons obviously has many differences from that of Chartres (figs. 237, 228), primarily because of the presence of the twelfth-century south transept at Soissons. If the east ends of the two cathedrals are compared (figs. 230, 240), the regularity of the radiating chapels at Soissons is in marked contrast to the alternation of large and shallow chapels as seen in the Cathedral of Chartres. Further, the massive two-stage buttresses at Soissons are less complicated, though they swing over the single ambulatory, as opposed to the double ambulatory of Chartres. The outside piers supporting the flying buttresses at Soissons frame the radiating chapels in a logical fashion and give a consistency to the design of the chevet. This consistency is lacking at Chartres, where the design had to accommodate the transformed older crypt and where the supports for the buttresses are hidden between the alternating deep and shallow radiating chapels. The thick extra arches around the clerestory windows of Chartres are in marked contrast to the relatively thin and more pointed arches which frame the windows over the choir of Soissons.

Within Soissons itself the most dramatic contrast is that between the south transept, begun in 1176, and the choir and nave, begun in the late 1190's (figs. 237, 240). In spite of the simple flying buttresses of the transept (fig. 238), which were not part of the original design but were added later or more probably during its construction, the south transept presents a mural character quite different from the more animated surfaces of the exterior of the nave (fig. 237) and apse (fig. 240). Indeed, the ambiguity between the exterior and interior of the south transept (figs. 238, 241, 242) is typical of most Early Gothic architecture. At Soissons this ambiguity is terminated by the vital harmony of the High Gothic forms of nave and apse.

The interior of the south transept possesses an intimate elegance which is captivating (figs. 241, 242). In spite of the handsome proportions of the High Gothic nave and choir, it is the Early Gothic transept to which one repeatedly returns. Its first three stories, the arcade in front of the aisle, the gallery, and the triforium, are all lower in height than the triforium of the nave. This juxtaposition suggests how the architect of Chartres created the High Gothic proportions by eliminating the gallery and by making the nave arcade include the combined height of what would have been nave arcade and gallery. A delightful deep chancel opens off the east side of the south transept. The fragility of this transept and its chancel belies the notion that all Early Gothic is ponderous. Like Suger's choir, this detail of Soissons has a distinct quality that is unmistakable. This quality points up the danger of regarding the whole evolution of Gothic as a continuous improvement. The accomplishments of High Gothic, great as they may be, should not be allowed to displace many creative moments of Early Gothic. In this sense, preference for High Gothic as opposed to Early Gothic is a matter of personal taste, not a value judgement.

What is fascinating about the Soissons south transept is the possibility that its elegance actually influenced the Soissons master, as he came from Chartres to Soissons. The fact that the walls of the Cathedral of Soissons are thinner and reduced in mass as compared to those of Chartres would seem to indicate the possible influence of the twelfth-century construction on the new master who took over the chantier of Soissons. The elegance of the south transept, then, may be part of the reason for the changes which the Soissons master made in the Chartres High Gothic formula. This possible influence of the earlier Soissons architecture on the new does not, however, detract from the total impact of the entire Cathedral of Soissons. Perhaps what happened at Soissons is a relatively unique situation in which the twelfth-century program, which involved the south transept, became almost continuous with the new idea imported from Chartres and the new idea itself underwent a sea change as a result of the existing south transept. In no other High Gothic cathedral in France is there such a dramatic juxtaposition and such an effective interpretation of both Early and High Gothic.

The Cathedral of Reims

Wʜᴇɴ ᴛʜᴇ ꜰɪʀᴇ of May 6, 1210, consumed much of the town of Reims and damaged the cathedral beyond repair, the choir of Soissons was nearing completion and Chartres had been under construction for sixteen of the twenty-six years needed for the virtual completion of its vaults. Jean d'Orbais, who supervised the laying of the first stones in the south side of the choir on May 6, 1211, must have known the new High Gothic designs of Chartres and Soissons, the latter only thirty-five miles to the west of Reims. Indeed, Notre-Dame of Reims (figs. 245–257) stands architecturally as a bold development of ideas clearly stated at Chartres and Soissons; yet the master builders gave Reims its impressive originality by combining new design features with reinterpretations of the older Reims tradition.

In 1914, the shelling of Reims set fire to the roof and to the scaffolding around the north tower and as a result calcined the left portal and much of the tower. Subsequent bombardments damaged buttresses and sculpture and penetrated the vaults in many places, doing incalculable damage to the interior. When restorations were beginning in 1918, excavations were carried out under the supervision of the architect Denoux, assisted by Hans Reinhardt. As a result of these excavations and the recent publication of Hans Reinhardt's monograph (see bibliography), some light has been shed on the history of the cathedral prior to the fire of 1210.

Around 400, Bishop Saint Niçaise moved the Episcopal See to the center of Reims and, according to Reinhardt, occupied part of the Roman baths. Following the martyrdom of Saint Niçaise and others by the Vandals in 407, funds were raised for repairs; but it was not until the late fifth century that a small, two-aisled church with narthex and a separate baptistry was completed in time for the baptism of King Clovis of the Franks in 496. Remains of this first church, dedicated to the Virgin, were unearthed in the present nave and east of the crossing.

During the Carolingian period, as the importance of Reims increased, a new cathedral based on the monastery of Saint-Riquier at Centula was constructed by Archbishop Ebbon after 817. Some foundations of this double-ended cathedral, with its four turret towers, were unearthed in the post–World War I excavations, but the details which would substantiate the reconstruction proposed by Reinhardt are wanting. If the Carolingian Reims does indeed echo Saint-Riquier, Reinhardt makes the interesting observation that the present thirteenth-century transepts with circular windows in the middle zone (figs. 247, 252) are a reflection of the elevation of the transepts of the Carolingian cathedral. In 976, the west end of the Carolingian cathedral was razed, the nave extended by three bays, and a new central porch and tower erected. This new scheme is reflected in the central western porch towers of Saint-Benoît-sur-Loire, Chartres, and other monuments of the late tenth and early eleventh centuries. According to Reinhardt, the nave was probably rebuilt with alternating piers and columns at the same time.

In 1152, Archbishop Samson (1140–1160) destroyed the western central tower, added two bays to the nave, and erected a twin-tower façade emulating Suger's façade of Saint-Denis (dedicated

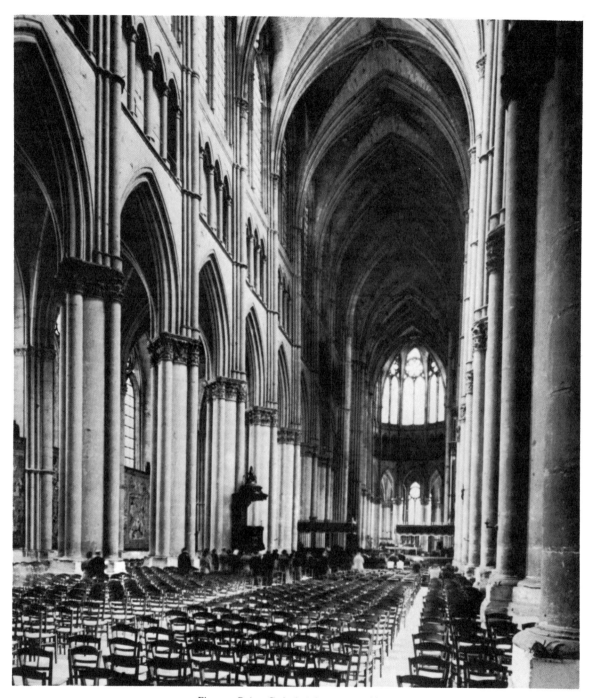

Fig. 245. Reims Cathedral, begun 1211. Nave

1140). Further, he added a new choir, with single ambulatory and five deep radiating chapels, east of the crossing of the Carolingian cathedral. It is quite possible that this choir influenced both the design of the choir of Saint-Remi at Reims begun about 1170 (figs. 194, 195) and Jean d'Orbais' existing choir begun in 1211, but the lack of detailed information about the excavations makes further comparisons difficult. Parts of Archbishop Samson's Early Gothic cathedral, which were vaulted, survived the fire of 1210. His choir had to be razed so that the High Gothic one could be constructed. However, the Early Gothic façade remained until the mid-thirteenth century.

The stormy history of Reims in the thirteenth century is partially documented. Documents dealing with the cathedral itself record the fire of May 6, 1210, the laying of the first stones above ground on May 6, 1211, the authorization by the archbishop in 1221 of the use of the easternmost chapel of Saint James by the canons, and the installation of the chapter in the completed choir on September 7, 1241 (see bibliography: Reinhardt, and articles by Branner). The rate of progress of the construction of the cathedral is open to various interpretations. A chronicle relates that "the work progressed with prodigious speed for twenty years," but papal bulls granting indulgences and requesting donations in 1221, 1246, and two in 1251 suggest that the chapter was having difficulty in raising funds. At Reims, the chapter seems to have played the major role in providing money through revenue from housing and mills. In 1213, the need for outside funds caused the chapter to translate the cranium of Saint Niçaise into a shrine, and by the 1220's more funds were necessary to construct the complicated and expensive upper stories of the choir. The burghers of Reims had to subsidize the coronation of Louis VIII in 1223. Further, the citizens of Reims did not have a sympathetic relationship with the cathedral chapter and archbishop, as at Chartres. Disturbances between citizens and chapter and archbishop intensified, culminating in a riot in 1233 in which the people of Reims beseiged the archbishop's palace, attacked the chapter, and

killed one marshal. Archbishop Henry of Dreux (de Braine) had demanded a percentage of the money the burghers were lending to the towns of Troyes and Auxerre, and the burghers rebelled. As a result of the riot, the chapter fled in 1233 and did not return until 1236, when Saint Louis (Louis IX) pronounced sentence against the burghers of Reims. These internal difficulties would seem, at least, to suggest a slowing down of the construction of the choir and perhaps explain why the choir was not completed and occupied by the chapter until 1241 (see bibliography: Reinhardt, Branner, and Frisch).

Upon entering the Cathedral of Reims (fig. 245), the visitor is struck by the soaring nature of the nave vessel. Yet this verticality is brought into repose by the juxtaposition of the bundles of shafts and the repeated pointed arches played against the horizontal bands of the capitals of the nave arcade and the stringcourses bounding the triforium. The bigness of scale is emphasized by the high bases from which the nave arcade rises (fig. 245) and by the boldness of the colonnettes and moldings. The very size of the nave, with crowns of vaults about 123 feet above the pavement, imparts a feeling of impressive monumentality. If the nave is compared with the naves of Chartres and Soissons (figs. 219, 236), it is possible to see how the Reims architects continued the Chartres High Gothic design (1194), but made major changes which give Reims a different and original character. The Reims nave is only 7 feet taller than Chartres, but it is 9 feet narrower (44½ feet, as opposed to 53½ feet for Chartres). Reims is considerably taller than Soissons, which was only 97½ feet high. The nave arcade of Reims (figs. 245, 249, 250) is characterized by the logical relation between the four colonnettes surrounding the major pier, the moldings which spring across the nave arcade itself, and the bundle of five colonnettes which rise up to the vaults. The Reims architects evolved a new floral capital which decorates not only the tops of the four engaged colonnettes surrounding the pier but also the matrix of the pier itself. This uniform decoration creates a continuous band of ornament sur-

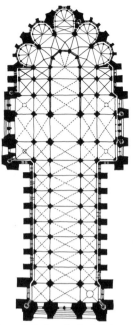

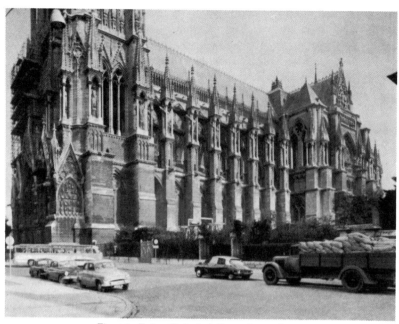

Fig. 246. Reims Cathedral, begun
1211. Plan (after Reinhardt)

Fig. 247. Reims Cathedral. From the southwest

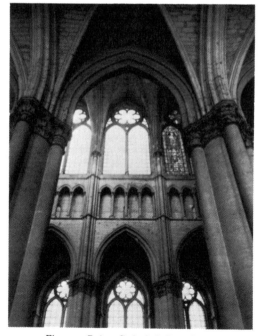

Fig. 248. Reims Cathedral. Exterior and interior
elevation of nave (Villard de Honnecourt)

Fig. 249. Reims Cathedral. Bay of nave

rounding the top of each pier, and these bands in turn emphasize the horizontal continuity from pier to pier down the length of the nave arch. At Chartres (fig. 224), the inner colonnette, attached to the nave pier, has no capital and attempts visually to serve as the springing of the main shaft on top of an intermediate base. The awkwardness of this design at Chartres is eliminated in the uniform capitals of the Cathedral of Reims. At Soissons (fig. 236), the single shaft attached to each pier of the nave and choir seems much too slender and unsubstantial for the bundle of shafts which rise to the vaults. Thus it would seem that the Reims architects utilized the Chartres design of capitals in the nave arcade, but improved on the total continuity between the nave arcade and the rising shafts above. Further, the alternation between octagonal piers with round colonnettes and round piers with octagonal colonnettes at Chartres is eliminated at Reims, since all the piers are treated uniformly. This decorative alternation at Chartres, as has already been pointed out, was either a design lag reaching back to the alternating systems of many twelfth-century Early Gothic cathedrals or a subtlety which, in this case, the Reims architect abandoned. As at Soissons, the nave arcade of Reims is more pointed, and as a consequence the arch approaches closer to the triforium level. The multiplicity of moldings which make up the arch of the nave arcade itself at Reims further emphasizes the diagonal continuity from the bundle of five colonnettes back on an angle into the arch itself and thus avoids the abrupt juxtaposition of the flat major arch against the smaller moldings, as at Chartres.

It is in the clerestory windows themselves that the most original contribution of the Reims architect can be seen most clearly (figs. 248–250). In contrast to the Chartres clerestory (fig. 224), with its two lancets surmounted by a small wheel window, all three of which appear to have been cut out of the clerestory wall, the Reims architects have evolved a total membrane of tracery in which the two lancets, the rose, and the spandrels are glazed. This treatment of the framing of the window in tracery, together with the reduction of

wall surface, reduces the weight of the superstructure and makes the clerestory window larger in terms of its amount of glass. The wall rib, or longitudinal rib, is now pointed and thus completely consistent with the pair of pointed windows in the clerestory, with the four arches of the arcade of the triforium, and with the pointed arch of the nave arcade. This invention of tracery by the Reims architect had an enormous impact on subsequent monuments.

The single ambulatory, with five deep radiating chapels, is vastly different from the double ambulatory of Chartres (compare figs. 246, 256, and 222, 227). The massive cylindrical and octagonal piers which divide the two ambulatories at Chartres give to that monument a heavy quality not found in the more elegant and more linear treatment at Reims. This elegance at Reims, which is seen most clearly in the deep radiating chapels (fig. 256), is reminiscent of the choir at Saint-Remi at Reims (begun 1170, fig. 195); and the similarities suggest that the master builder, Jean d'Orbais, was influenced by the Early Gothic of Saint-Remi. The deep chapels of Saint-Remi, with the pair of free-standing piers in front of their entrances, do bear a visual resemblance to the ambulatory of the Cathedral of Notre-Dame of Reims. Thus it is possible to suggest that the buildings already in existence at Reims, Saint-Remi and Archbishop Samson's twelfth-century choir, may have had an impact on the High Gothic cathedral begun in 1211. But for all the influences of Chartres and the Reims environment, the originality of Notre-Dame at Reims is clearly stated in the new dynamic proportions of the nave, the more consistent treatment of the capitals of the nave arcade, and the new solution for the design of the clerestory windows.

There are certain refinements in the choir and nave of the cathedral at Reims which are often overlooked. In the triforium of the hemicycle of the choir the colonette, which separates the two arches of this zone, continues up into the clerestory and becomes the main mullion separating the pair of lancet windows. This connection between triforium and clerestory can be seen in the

choirs of Saint-Remi at Reims (begun 1170, fig. 194) and the church at Orbais (begun about 1200). The local Reims tradition is thus being asserted and refined in the cathedral. In the triforium of the nave, the middle column of the arcade is slightly wider than the other two columns and thus suggests subtly a connection between it and the middle mullion of the clerestory window. It is of interest that Villard de Honnecourt, in his drawing of the nave elevation of Reims (fig. 248), exaggerated the relative thickness of this middle column and dramatized the connection between triforium and clerestory. The debatable date of Villard's trip from Picardie to Reims will be discussed later.

A comparison of the plans of Chartres and Reims (figs. 222, 246) reveals their family relationship. Both cathedrals have double aisles flanking the choir, wide transepts, and a nave flanked by single aisles. However, after these major similarities are observed, many differences begin to emerge. The Cathedral of Reims, as finally completed, lengthens the nave by two bays, if the areas encompassed by the towers are omitted. At the same time that the architects of Reims lengthened the nave, they also shortened the length of the choir by one bay and reduced each transept arm from three bays in width to two bays. The shortening of the choir of Reims necessitated that the major choir be pushed into the nave of the cathedral. This location of the choir as it extends into the nave is perhaps a reflection of its location in the Carolingian cathedral of Reims. The major change which Jean d'Orbais made from the Chartres formula was the reduction from two ambulatories to the single ambulatory and the shift from the alternation of shallow and relatively deep chapels at Chartres to five deep chapels, with the central one on axis being slightly deeper than the others. Further, at Chartres, because of the existence of the earlier crypt and its modification to support the new choir following the fire of 1194, the architect reinforced the three major chapels and built new supports for the four shallow chapels. Since the Reims architect was not under any necessity to accommodate previous construction,

he built five deep chapels opening off five trapezoidal bays of the ambulatory, in contrast to the more complicated vaulting system which exists in the seven bays in both inner and outer ambulatories at Chartres. Thus the rather complicated plan of the east end of Chartres is simplified considerably in the choir of Reims. Again, the influence of the twelfth chevet of Archbishop Samson or the deep chapels of Saint-Remi of Reims may have had its effect on the design.

The Reims master builders eliminated the transverse wall hidden under the sloping roof behind the triforium. This hidden buttress, reminiscent of the Early Gothic buttressing systems of Laon (fig. 164), Noyon, and other Early Gothic cathedrals, was no longer necessary after the invention of flying buttresses. In Chartres (fig. 223) the architect had continued the use of this large hidden buttress, in spite of the employment of flying buttresses around the entire cathedral. However, the Chartres master builder placed the pair of buttresses so low that a third stage had to be added during construction. The Soissons master continued the use of this buttress under the roof over the aisle (fig. 243), but placed the buttress higher to equalize the thrust of the vaults and wind pressures on the roof. The Reims architects, besides eliminating this hidden buttress, continued the high placement, as at Soissons. In the choir of Reims (see drawing of Villard de Honnecourt, figs. 254, 253) the flying buttresses rise in two stages or levels from massive piers between the deep radiating chapels. This first flight terminates in the piers rising from the supports which separate the ambulatory from the radiating chapels (see plan, fig. 246). The second flight in double buttresses continues up to the clerestory. At Chartres (fig. 230), a single buttress spans the outer aisle of the ambulatory, while three flying buttresses, the lower two joined by an arcade, span the inner aisle. The Reims architects thus simplified and regularized both the plan and the structural system of Chartres, following the pattern developed in the Cathedral of Soissons.

The exterior of Reims (figs. 247, 248, 252–254) manifests an extraordinary consistency be-

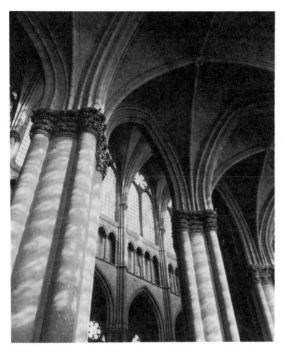

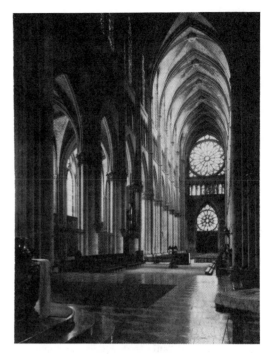

Fig. 250. Reims Cathedral, begun 1211. Nave from south aisle

Fig. 251. Reims Cathedral. Choir and nave

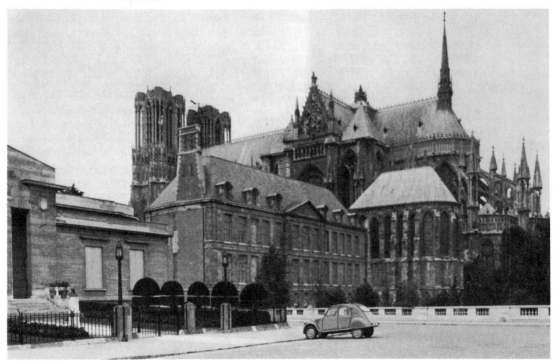

Fig. 252. Reims Cathedral. South flank

tween the inside and outside of the cathedral. The soaring nature of the nave of Reims has its counterpart in the verticality of the buttresses as they grow up into the arcaded pinnacles from which the flying buttresses take off to buttress the nave. The aisle windows are completely related in design to the clerestory windows and are reflected on a smaller scale in the blind and open arcades of the pinnacles of the buttresses. This complete consistency of shapes can best be seen in the drawings of Villard de Honnecourt of the interior and exterior elevation of the nave (fig. 248). The sense of planes in space moving from the aisle windows up through the buttresses to the clerestory windows is completely in harmony. As originally planned by the master builders, Reims was to have had seven towers, two flanking each of the transepts, a lantern rising above the crossing, and the two western towers. The plan of Chartres called for nine towers: seven like the seven at Reims plus two flanking the choir. The master of Reims eliminated the two towers flanking the choir, and since the transept of Reims is narrower than that of Chartres, he planned a greater concentration of towers surrounding the central lantern. The Chartres architect certainly was influenced by the massing of Laon, with its four transept towers. The Reims architect, on the other hand, seems to have reverted to the simpler massing of Laon, but given it more concentration by shortening the transepts by two bays. As at Chartres, the superstructure of the towers flanking the nave and the lantern tower were never built. Thus, in both massing and plan, Reims tends to be a simplification of the Cathedral of Chartres.

If the east ends of the cathedrals of Chartres, Soissons, and Notre-Dame of Reims are contrasted (figs. 230, 240, 253), a clear evolution of forms can be seen. As already pointed out, the alternating deep and shallow chapels of the Cathedral of Chartres are the result of the re-use of the crypt of the earlier cathedral; yet the lancet windows penetrating the thick walls between the wall buttresses of the radiating chapels and between the flying buttresses in the clerestory are vastly different from the larger voids with mullioned windows

designed by the Reims builders. The connection between Chartres and Soissons is much closer, as one would expect, since the choir of Soissons was completed by 1212, just at the time when Reims was beginning. But even in the choir of Soissons (fig. 240) the walls appear thinner over the clerestory windows than those at Chartres, as the superstructure is gradually being lightened. Thus, the more mural nature of both Chartres and Soissons is changed into a more open structure of wall and strut which braces the superstructure of the cathedral. Further, the buttresses of Soissons are much more massive and archaic when compared with the more elegant buttresses with pinnacles at the Cathedral of Reims. The most important difference, however, between the east end of Reims and that of Chartres and Soissons is clearly the new design of the windows. In general, the architects of Reims have animated the surfaces through the use of mullions and by the ornate pinnacles on top of the buttresses, and this animation has increased immeasurably the vertical nature of the exterior of the cathedral.

The problem of how fast the work on the cathedral progressed and for what parts each of the five architects was responsible remains to be discussed. The 34-foot labyrinth, which was placed in the third and fourth bays of the nave around 1290, contained small images of four architects in the corners with accompanying inscriptions and in the center Aubri de Humbert, archbishop in 1211, or the archbishop when the labyrinth was made. The labyrinth was suppressed in 1779, but a drawing of it made around the end of the sixteenth century and five descriptions of it, dating between 1645 and 1779, are preserved. Time and the wearing action of thousands of feet rendered the inscriptions less discernible by 1779. The descriptions indicate that Jean d'Orbais started the choir; Jean de Loup was master for sixteen years and started the portals; Gaucher de Reims, master for eight years, worked on the voussoirs and portals; and Bernard de Soissons did five vaults and the façade rose window during his thirty-five years as master. The latter is mentioned in a tax list in 1287. The fifth architect, Robert

de Coucy, who died in 1311, directed more work on the façade.

Counting backward from 1287 or 1290, when the fifth architect supposedly took over the workshop, it is possible to divide the 80 or 77 years as follows: Bernard de Soissons (35 years), 1252–1287 or 1255–1290; Gaucher de Reims (8 years), 1244–1252 or 1247–1255; Jean de Loup (16 years), 1228–1244 or 1231–1247; and Jean d'Orbais (the remaining years), 1210–1228 or 1210–1231. Most scholars have attempted to use these dates as the point of departure for the study of Reims and assign parts of the cathedral to each master builder. In a recent article and a review of Reinhardt's book, Robert Branner (see bibliography) questions this approach. He studied the structure in detail with special reference to capitals and moldings, determined the campaigns of construction by direct architectural evidence, and then reinterpreted the worn inscriptions. His conclusions indicate four building campaigns; and he argues that Gaucher de Reims was master of the workshop for 18 years, not 8 (XVIII, not VIII as in the first description or VII as in the other three), and he determines the periods of each architect as follows: Jean d'Orbais (1210–1220), Jean de Loup (1220–1236), Gaucher de Reims (1236–1254), and Bernard de Soissons (1254–1289).

The campaigns established by Branner (see bibliography) seem to be more logical than those of Reinhardt. The first campaign (1210–1220, Jean d'Orbais) included the ground floors of the entire east end (chevet) and of the transept and the outer walls of the eastern three bays of the nave. Reinhardt has proved that the chapel on axis, dedicated to Saint James, was in use by the canons in 1221. During the second campaign (1220–1236, Jean de Loup), the triforium and clerestory of chevet and transept were completed and two more bays of the aisle walls were constructed, along with the twelve eastern piers of the nave. The riots following 1233 slowed down the progress of the work. Branner argues that the chevet and south transept were ready for the vaults, but the work on the crossing, the north transept, and six bays of the nave had not been carried as far. Around 1225 an abortive project for the façade was planned at the terminus of a nave of eight bays. Most of the sculpture for this scheme is now on the two north transept portals. Some sculpture on the existing façade (right portal, right jamb) remains from the first project. A second project for the façade was established in 1228–1230. The date of the remaining jamb statues in the late 1220's and 1230's of the second project agrees with comparative, dated portals. The third campaign, after peace was established (1236–1254, Gaucher de Reims), completed the chevet for the installation of the canons in 1241. The vaults assumed a higher curve. In the 1240's and into the 1250's the vaults of the transepts and five western bays were completed from east to west. The fact that capitals in triforium and clerestory are significantly different from previous ones suggests that a new workshop took over after 1236. Gaucher de Reims devoted considerable time to the lower zones of the west façade, as stated in the labyrinth. Branner's fourth campaign (1254–1289, Bernard de Soissons) saw the construction of the four western bays and the completion of the vaulting of the five western bays, as the inscription in the labyrinth indicates. The capitals of the nave piers are similar to those in the triforium of the chevet of Amiens (about 1250) and in later monuments. Bernard de Soissons made changes in the design of the façade and completed the zone of the rose window by 1260. The evidence in the monument itself seems to bear out Branner's conclusions. Until a more detailed study is made, such as Seymour's study of Noyon and Branner's monograph on Bourges, Branner's conclusions about Reims seem highly plausible.

In spite of the long span of time necessary to complete Reims, from its beginning in 1211 until the nave was completed in 1290, the last three architects respected the original concept of Jean d'Orbais. Changes were made in moldings and capitals, but the general format as originally established was continued, and the resulting unity of the entire interior and exterior bears witness to that fact.

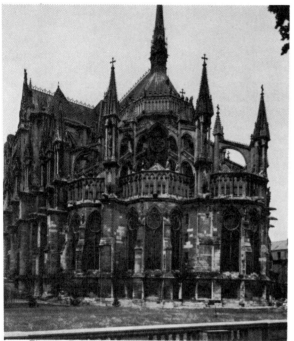

Fig. 253. Reims Cathedral, begun 1211. From the east

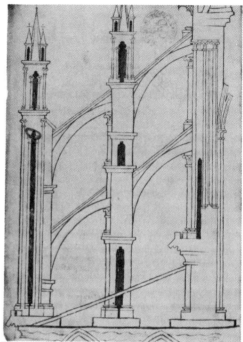

Fig. 254. Reims Cathedral. Flying buttresses of choir
(Villard de Honnecourt)

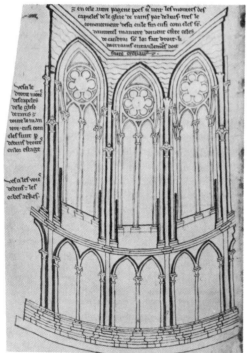

Fig. 255. Reims Cathedral. Interior elevation of chapel
(Villard de Honnecourt)

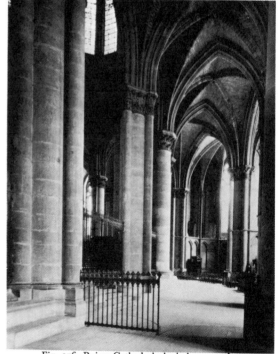

Fig. 256. Reims Cathedral. Ambulatory and
radiating chapel

In the Album or Lodge Book of the architect Villard de Honnecourt are five drawings of Reims Cathedral: a window of the side aisle, the elevation of the exterior and interior of the nave bay, an interior and exterior elevation of a radiating chapel, a page of templates and pier plans, and the buttresses of the choir. The question immediately arises, when did Villard visit Reims? And did Villard make these drawings from the actual building or from sketches or projects existing in the workshop? Reinhardt (see bibliography) argues that Villard visited Reims about 1220 because of the fact that the drawing of the interior of one of the radiating chapels has no vaults (fig. 255). This interpretation assumes that Villard was drawing from the building as he saw it. However, it is just as conceivable that Villard was interested in revealing clearly the interior of the radiating chapel and for that reason left out the vaults. In his drawing of the exterior and interior elevations of the nave (fig. 248) he omitted the flying buttresses and the vaults on the interior in order to simplify and clarify his drawing. Branner (see bibliography) argues for a late date of about 1245 for Villard's visit. He believes that Villard must have made all the drawings from the actual building itself, and the inclusion in his drawings of the nave elevation would preclude an earlier date. He further argues that almost all of Villard's drawings are inaccurate and that his drawing of the buttresses of the choir (fig. 254) shows these inaccuracies because the clerestory as drawn has no room for the rose window. The dating of Villard's trip involves the question of whether small-scale shop drawings existed in the middle years of the thirteenth century or not. If Villard's trip was indeed in the 1240's, it is clear that he took many liberties with his sketches of the nave elevations, because he added at the base of the aisle windows an arcade similar to the one in the radiating chapels of the choir. Other critics have suggested dates in the decade 1225–1235, about 1230, and after 1235. Arguing from the point of view of a detailed study of the sculpture on the choir and its relation to the sculpture of the north transept and the west façade, Teresa Frisch (see bibliography) sets the date

of his trip at 1232 or 1233. Her conclusions are based on her belief that the two north transept portals, the choir statues, and the Visitation group on the west façade were carved between 1224 and 1231 and that the first five bays of the nave were built between 1231 and 1247. This date of 1232 or 1233 assumes that Villard was able to interpolate the elevation of the nave from that of the choir or that he had access to drawings in the workshop of Reims itself. The difficulty of being conclusive about his trip really derives from the question of what the Album of Villard de Honnecourt actually is. Is it merely a sketchbook, a kind of doodle book with drawings of items which captured the imagination of Villard? Or is it a how-to-do-it book which was a basic part of the paraphernalia of a builder's lodge? Perhaps a clue to this question can be drawn from one of the plates in the Album depicting one of the windows of Reims and a drawing of the Virgin and Child. Its contents preclude the date of 1220 because the nave walls must have been in place. The caption states simply: "This is one of the windows of Reims, in the area of the nave, as it stands between two pillars. I had been invited to go to Hungary when I drew this, which is why I liked it all the more." This kind of casual, personal comment suggests that the book was more of a recorded, visual diary of his trips. Certainly Villard was impressed by the new Reims. To make the elevation clearer, he removed the flying buttresses from the exterior elevation on the left and omitted the vaults on the drawing of the interior (fig. 248). His marginal notes, whether for his own use or for the apprentices in the lodge or later masters, read as follows:

Here are the elevations of the Church of Reims and the inner and outer walls. The first entablatures of the side-aisles must be crenelated so that there may be a passageway before the roof. The inner galleries (triforium) are at the level of this roof. Above these vaults and entablatures we find outer passageways which allow circulation in front of the window sills. The last entablature must have crenelations to permit passage before the roof. Here is the model of all the elevations.

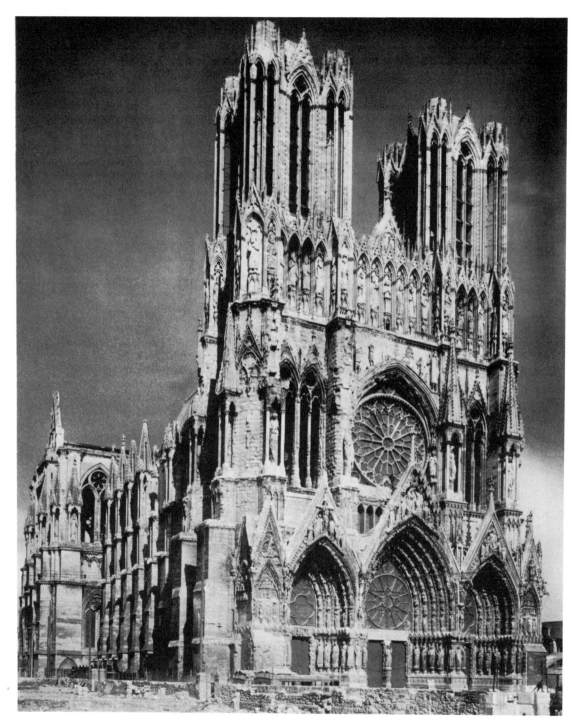

Fig. 257. Reims Cathedral. Façade, begun 1230's

Finally, the notation on the elevations of the chapels of the cathedral of Reims reads as follows:

And on this page you may see the elevation of the chapels of the Church of Reims from the outside, from the base to the top just as they are. If those of Cambrai are done properly, they should look like this. The upper entablature must have crenelations.

The drawings, with their marginal notations, thus seem to this writer to be very informal sketches that often take liberties with what he may have seen in an actual building or perhaps in the workshop itself; and the remarks concerning Cambrai seem to tie in to the history of Reims, which makes the date of 1231 or 1232 reasonable. Clearly the last word has not been said about the visit of Villard, but it is obvious that the early date of 1220 does not make sense, whereas the early thirties seems to be a more justifiable possibility. Whether Villard, at the time of his visit to Reims, was an apprentice or an architect is also debatable. It is plain that much of the sketchbook is based on geometry and that the drawings are not skilled drawings but sketches, often very inaccurate, a visual record of the parts of various buildings which excited Villard's imagination.

The present façade of Reims (fig. 257) was designed in the late 1220's or early 1230's. Sculpture for this second project was carved from the late 1220's through the 1230's. Gaucher de Reims probably changed the format of the upper parts of the portals to include the steep pinnacles containing sculptural scenes. This shift to an emphasis on multiple gables may derive from the façade of Saint-Niçaise of Reims, which was begun about 1231. The rose-window zone was finished by 1260, but the north tower was not completed until 1460, as an inscription on it indicates.

As a result of the slow progress of the work and the sea changes in design, the Reims façade is no longer High Gothic. The gables of the portals overlap the intermediate arcaded zone, and the central gable penetrates up into the rose window. This overlapping of elements in the façade represents a new kind of Gothic, quite different from the logical and classic balance of the façade of Amiens, the epitome of the High Gothic façade (fig. 258). The fact that the Reims façade is no longer High Gothic should not detract from its impressive, soaring monumentality. In its organization, the façade presents a direct reflection of the interior disposition of the cathedral (figs. 251, 257). The form of the nave arcade is repeated in the central portal. The latter, with its tympanum glazed, creates a transparency similar to the nave arcade in front of the aisles. The triforium continues around the west end of the nave (fig. 251) and is visible on each side of the gable of the central portal (fig. 257). The shapes of the clerestory windows are reflected in the huge rose window and in the pair of open lancet windows in each tower. The buttresses of the nave are visible through these apertures in the towers. The two-storied pinnacles from which the nave buttresses spring are carried around the façade and animate the corners of the towers (figs. 247, 257). This remarkable integration of the interior disposition and exterior design, together with continuity between the flanks of the exterior and the façade, and the aspiring verticality of the whole—all mark the façade of Reims as one of the supreme moments of the Middle Ages.

In spite of damage suffered during its long history and the necessary reconstruction still in progress, Reims is one of the most impressive structures in Europe. The dynamic, soaring interior space, the clarity of the repetition of piers and bays, the new concept of clerestory windows, and the monumental façade add up to more than the mere development of ideas initiated at Chartres and Soissons. Indeed, the masters of Reims did know and respect the High Gothic models, but they also respected the older Reims tradition. Their creative synthesis of the "modern" of High Gothic with the provincial heritage of Reims gives Notre-Dame at Reims its unique quality.

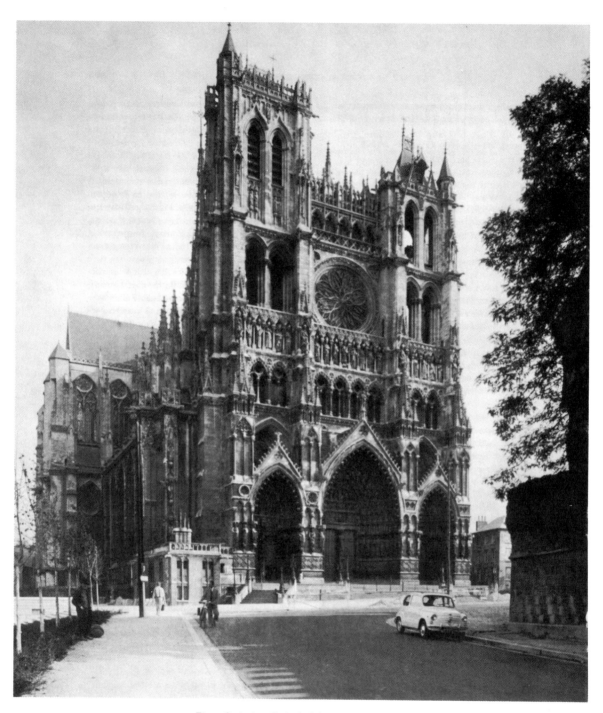

Fig. 258. Amiens Cathedral, begun 1220. Façade

The Cathedral of Amiens

THE CATHEDRAL OF AMIENS, begun in 1220 (figs. 258–269), is on one hand the climax of the refinements of the High Gothic heritage from the Chartres design (1194) via Soissons (late 1190's) and Reims (1211) and, on the other hand, the origin of a new kind of Gothic which comes into being in Paris in the late 1230's and 1240's. The master builder, Robert de Luzarches, did not merely reuse and refine the forms of Chartres, Soissons, and Reims, but reinterpreted in an imaginative way older, Early Gothic ideas.

The history of Amiens before the thirteenth century was punctuated by disasters. The Normans destroyed a church in the late ninth or early tenth century. Another cathedral was burned in 1137; and the new one consecrated in 1152 was consumed in the fire of 1218. However, the church of Saint Firmin (first Bishop of Amiens), which was located in the area now occupied either by the north transept or the north aisles of the choir, withstood the conflagration and housed services until the High Gothic nave was completed in 1236 (see bibliography: Durand) or 1233 (see bibliography: Branner). The distinguished Bishop Evrard de Fouilloy, and his successor, Geoffroy d'Eu, who died in 1236, and the dean of the chapter, Jean de Boubers, theologian and later cardinal, raised the necessary funds for the rapid construction of the façade up to the gallery of the kings and the nave, built from west to east, and the west aisles of the transept by about 1233. Robert de Luzarches designed and supervised the construction of this campaign. In the early 1230's the ground story of the transept terminals was being erected, and Thomas de Cormont succeeded Robert de Luzarches. By 1236 or slightly earlier, Thomas de Cormont completed the second campaign, which included the construction of the eastern aisles of the transept and the aisles of the choir, using materials prepared by Robert de Luzarches. Further Thomas de Cormont designed and erected the radiating chapels (see Branner).

If Branner's assumption is correct that Thomas de Cormont left Amiens for Paris early in the 1240's, Regnault de Cormont, Thomas's son, became the master of the third campaign. This third campaign proceeded slowly from the 1240's until 1269, when the vaults of the choir were completed. The Crusade of 1248–1254 and a fire of 1258 help account for the long span of twenty-eight years during which the fabric of Amiens was finished. The order of work probably proceeded as follows (see Branner): superstructure of western side of transept, upper part of choir (clerestory of hemicycle after fire of 1258), and vaults of transept and choir by 1269.

In contrast to the procedures of construction of the majority of cathedrals (Sens, Noyon, Laon, Paris, Bourges, Soissons, Reims), in which the choir was built first, Amiens was constructed from west to east because of the presence of the church of Saint Firmin, which could be used for services. The three architect-builders — Robert de Luzarches, Thomas de Cormont, Regnault de Cormont — and Bishop Evrard de Fouilloy were depicted on the labyrinth put in place in 1288 but destroyed in 1828.

The façade of Amiens (figs. 258, 269, and 315, 316) is an imposing harmony of verticals and hori-

zontals. The deep triple portals, reflecting the internal division of the nave and its flanking aisles, are framed by wall buttresses and crowned by gables. The zones of relief sculpture and jamb figures continue across the frontal plane of the buttress piers. The three jamb figures on the front face of each buttress support the blind arcades. The capitals of these arcades are continuous with those from which the archivolts of the portals spring (figs. 315, 316). The deep arches, with glazed windows partially hidden behind the gables of the side portals, repeat the height of the nave arcade and the original windows of the aisle. At the same height as these arches are the square bases of the pinnacles which are a continuation of the wall buttresses framing the portals below. Behind these square elements is the major wall plane of the façade. This front wall is revealed in each portal at the point where the diagonal splays shift to an axis perpendicular to the façade (figs. 258, 315, 316). The tops of the complicated pinnacles rise up into the open gallery stage, which corresponds to the triforium level on the interior of the cathedral. This zone has four major arches subdivided into eight arches with four quatrefoils in front of the nave and two arches containing four small ones in the base of the towers. The next stage consists of the gallery of the kings. This zone and the rose window above, flanked by the pair of arches in the towers, echoes the shapes of the clerestory windows (fig. 269). The ornamental moldings which frame and divide the two galleries are continuous around the flank of the cathedral and mark the setbacks on the corners of the towers and the divisions of the piers from which the flying buttresses spring.

The façade up to the gallery of the kings was completed by 1236. The rose window was replaced by the present Flamboyant one around 1500. The towers themselves were not begun until 1366, when work started on the south tower. The north tower was completed by 1401 or 1402. In the nineteenth century Viollet-le-Duc made changes in the gallery of the kings and rebuilt the top of the north tower and the structure between the towers. Originally, the design envisaged the towers rising

free, with the gable of the roof projecting above the rose window. The Amiens façade, in spite of the changes in design since its High Gothic inception and its completion in the late Middle Ages, exhibits an extraordinarily harmonious relationship among three vertical bays, the framing buttresses, and the major horizontal stories. Even though the wall buttresses and pinnacles overlap the horizontal divisions, the clarity of each part is never blurred. Multiple planes in space are stated by the piers of the towers, the wall of the façade, the passage behind the arcaded gallery, and the setback of the rose window. This characteristic — the receding planes in each zone of the façade — is employed in the bay elevation of the nave.

The place which the façade of Amiens occupies in the dynamic evolution of Medieval architecture can best be seen if Amiens is contrasted with earlier and later monuments. The massive, mural presence of the Abbey of Saint-Denis, dedicated in 1140, is vastly different from the undercut, animated surfaces of the façade of Amiens. At Saint-Denis (figs. 124, 127) the thin lancet windows and the small rose are mere perforations in thick walls. This façade clearly owes an enormous debt to Romanesque architecture, especially Norman Romanesque (fig. 125). However, as already pointed out, new ideas such as splayed portals with columnar, jamb statues, plus the rose window, mark this façade as vastly different in its total concept from any previous Romanesque structure. The buttresses rise up to the level of the towers in an uninterrupted sweep, and the walls in the spandrels above the portals continue on up to the towers with no recession in space. The organization of the horizontal elements in a down, up, down arrangement emphasizes the vertical elements as opposed to any juxtaposition of verticals and horizontals.

The façade of Laon Cathedral (begun around 1190, fig. 174), although it still contains a considerable amount of wall surrounding the windows, is vastly different from the façade of Saint-Denis and indeed points in the direction of the façade of Amiens. The portals are set under deep

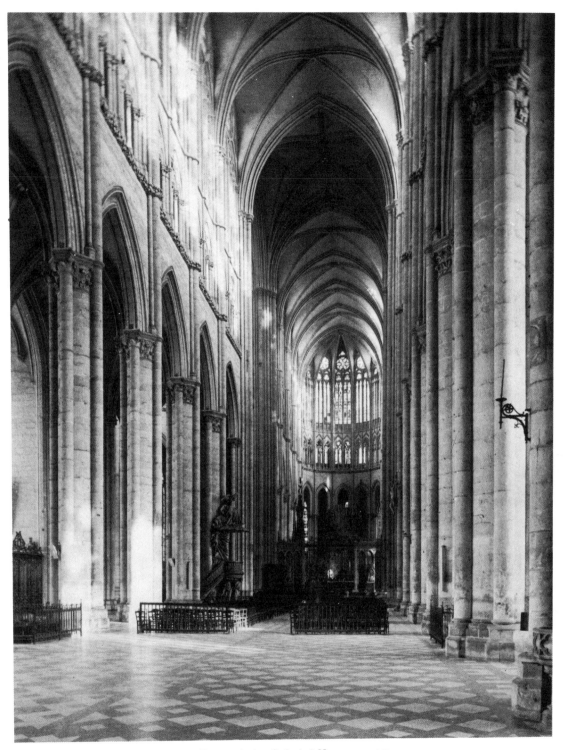

Fig. 259. Amiens Cathedral. Nave, 1220–1233

porches crowned by gables. This idea undoubtedly influenced the architect of Amiens. In contrast to Saint-Denis, with its small rose window flanked by blind arches, the rose of Laon now echoes the total width of the nave. This enlargement of the central rose window has made its crown higher than the flanking deep arches under the towers and has resulted in a break in the arcaded gallery above. This manipulation of the surfaces, by setting portals and windows deep behind the front wall of the façade and by animating the base of the towers with an arcaded gallery, is vastly different from the murality of Saint-Denis. In the treatment of the surfaces of the west towers of Laon, erected perhaps as late as 1215, we see a closer parallel with the handling of the façade of the Cathedral of Amiens. The actual towers of Laon perhaps owe a debt to the design of the transept towers of the Cathedral of Chartres.

The west façade of Notre-Dame in Paris (fig. 185) is much more massive and heavy than the façade of the Cathedral of Laon (fig. 174). Its triple portals do not reflect the nave and four aisles of the interior. It was begun around 1200; the second stage of construction included the rose window, finished by about 1225; the north and south towers were completed in the thirteenth century. The mural sense of the lower zones of Paris is in marked contrast to the undercut nature of the faade of Laon. Yet the rose window, occupying the width of the nave flanked by the double arched openings in the base of the towers, does have its counterpart in the façade of Laon. With an enormous increase in the height of the nave of Amiens, as opposed to the two Early Gothic cathedrals of Laon and Paris, the arrangement of the stories must change considerably. The rose window is placed much higher in the total composition, with two horizontal zones between the rose window and the triple portals below. It would seem as though the architect of Amiens used features from both Paris and Laon and combined them in a new way in his total concept for the façade of Amiens. Since the upper stories of the façades of Paris and Amiens are contemporary and the superstructure of Paris is considerably

more ornate than the lower stories, Branner, in his book *St. Louis and the Court Style,* suggests that the façade of Amiens influenced the evolving design of the upper gallery and towers of Paris.

Although the Amiens façade, begun in 1220, represents a synthesis of earlier designs, it is clear that the design of the façade of Reims (fig. 257) goes beyond the equilibrium established at Amiens. The façade of Reims, first designed in the 1220's, underwent many changes during the 1240's and 1250's. The rose-window zone was not completed until 1260. The clear distinction between vertical accents and horizontal stages, as seen in Amiens, is shifted to a system of overlapping areas which gives Reims a different kind of unity. Forms are elongated, gables extend up into stories above, and a new elegance of surface replaces the relatively more solid treatment of zones at Amiens. The façade of Reims, with its use of glass in the tympana and five gables, three over the portals and two animating the piers of the towers, suggests a debt in its design to the faade of the church of Saint-Niçaise at Reims, which was begun in 1231. The façade of Saint-Niçaise, however, develops out of the design of Amiens. Thus the façade of Amiens seems to stand as the climax of the High Gothic period in its clarity and logical relation and balance of parts, whereas the façade of Reims is another kind of Gothic.

The nave of Amiens reaches the epitomy of verticality (figs. 259, 261, 262). The crowns of the vaults are 137 feet above the pavement, 14 feet taller than the nave of Reims (fig. 245). The proportions of Amiens are thinner, since the width of the naves of Reims and Amiens is approximately the same, 45 feet. The major dimensional change in Amiens is the height of the nave arcade and aisles, that is, 60 feet, as opposed to 53 feet at Reims. (The entire nave of Ste.-Foy at Conques could almost be placed inside the nave arcade of Amiens!) Further, with the increased height of the nave arcade of Amiens, the nave arcade almost equals the height of the triforium and clerestory combined. In Chartres, Soissons, and Reims, the triforia separated nave arcade and clerestory, which were of roughly the same dimension. The

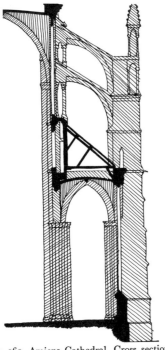

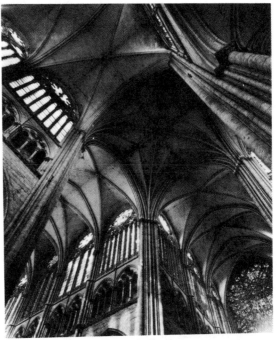

Fig. 260. Amiens Cathedral. Cross section
(after Durand)

Fig. 261. Amiens Cathedral. Crossing, transept, nave

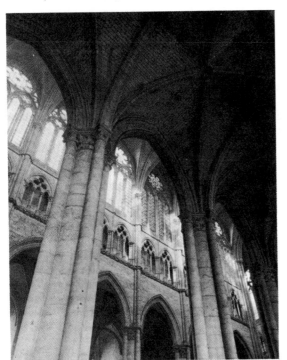

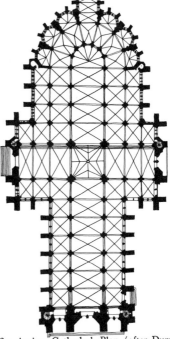

Fig. 262. Amiens Cathedral, begun 1220. Nave from
south aisle

Fig. 263. Amiens Cathedral. Plan (after Durand)

soaring nature of the nave of Amiens is accentuated by the continuity between nave piers and the bundles of colonnettes, by the physical connection of triforium and clerestory, by the transparency of the huge clerestory windows, and by the multiple repetition of tall bays down the nave to the crossing and through the choir to the hemicycle.

Robert de Luzarches, the Amiens architect, either transformed the Chartres format directly or knew the Chartres design as it had been interpreted in later monuments. By comparing details of Chartres (1194), Soissons (late 1190's), and Reims (1211) with Amiens (1220), the subtle changes in form can be studied (figs. 224, 236, 249, 262). The Amiens master rejected the horizontal floral friezelike capital of Reims and returned to the Chartres capital and the organization of the arch of the Chartres nave arcade. However, he changed the nature of the capital above the colonnette on the nave side. By eliminating the elaborate base from which the bundle of five colonnettes rise, as at Chartres, the Amiens master was able to achieve greater visual continuity between nave pier and the rising colonnettes. Only a simple curved abacus separates the engaged shaft of the nave pier from the major colonnette above. The ornaments on the Amiens capitals are more three-dimensional in their projections than the Chartres capitals. Above the abacus of the Amiens piers the master builder reduced the number of colonnettes from five, as it appeared in Chartres and Reims, to three and eliminated the alternation which can be seen in the larger respond or colonnette at Chartres. This reduction from five to three responds between the spandrels of the nave arcade suggests a greater thinness of the structure in comparison to the more massive quality of both Chartres and Reims.

To accent the separation between the nave arcade and triforium levels, the Amiens builder has converted the simple torus molding of the stringcourse of Chartres and Reims into a larger, floral molding. It is possible that he wished to transfer the horizontal continuity achieved by the floral capitals in the nave of Reims and place that horizontal accent on the molding at the base of the triforium.

The triforium in each of the bays in the naves of Chartres and Reims consists of an arcade of four apertures. At Amiens, however, the architect divided the triforium into two arches encompassing, in turn, three smaller arches (fig. 262). Over the three arches is a trefoil. This division of the triforium into an arcade, with relieving arches surrounding it, is not a new invention of the Amiens master, but a rethinking of Early Gothic design such as the false triforium of the Cathedral of Sens (figs. 139, 144). The wall rib or formeret does not begin at the nave arcade capitals, as in Chartres, Soissons, and Reims, but starts from its own plinth at the base of the triforium. This change accounts for the reduction at Amiens from five colonnettes to three above in the zone of the nave arcade. By starting the wall rib at the base of the triforium, the architect pushes the outside wall of the triforium back from the spandrels of the arch of the nave arcade. No connection exists between the triforium and clerestory at Chartres, while at Reims, in the hemicycle of the choir only, a colonnette rises between the two arches to grow into the central mullion of the clerestory window above. This unification of triforium and clerestory was not new with the Cathedral of Reims, as already indicated, since in the choir of Saint-Remi at Reims (1170's) the triforium and clerestory had been unified (fig. 194). In the nave of the Cathedral of Reims, the middle column of the triforium arcade was widened slightly to suggest a connection between triforium and clerestory, but the overt unification of triforium and clerestory was created by the Amiens master; a colonnette rises between the two arches of the triforium and is attached to the mullion which divides the clerestory window. The Amiens architect takes a twelfth-century idea of the major organization of the triforium and combines it with the tendency established at Reims to suggest the linkage of the triforium and clerestory by actual moldings. Thus the Amiens architect created a synthesis of older

ideas and recent ideas and came up with a totally new solution. By setting the wall of the triforium back behind the spandrels of the nave arcade and by repeating the diagonals of the bundle of engaged colonnettes back into the springing of the arches of the triforium, the Amiens architect has repeated the diagonal placement of the colonnettes on the nave piers in the triforium level and established thereby more visual relationship between triforium and nave arcade.

Jean d'Orbais of Reims transformed the design of the clerestory windows of Chartres from a pair of lancet windows surmounted by a rose window cut out of the thickness of the wall into a true window with tracery and with the glazed spandrels surrounding the rose (fig. 249). Robert de Luzarches of Amiens continued the trend of this evolution and made the clerestory windows of Amiens even more complicated (fig. 262). Two major lancet windows are divided into two more, each pair having a rosette above it. On top of these four lancet windows he placed a large rose window. Thus, the subdivision of elements already stated at Reims is carried to its logical conclusion in the clerestory windows of Amiens. It is this kind of subdivision of parts into repeated smaller parts, combined with the conversion of wall to thin membranes and glass, which lies behind the new type of Gothic architecture about to be created in the area around Paris. Further, the clerestory of Amiens is set back behind the plane of the major wall of the triforium below. This setback establishes a sequence of planes from nave arcade to clerestory, moving back in depth as the stories rise. The same treatment is found in the façade of Amiens. In contrast to the massiveness of the top two stories of Chartres — a massiveness which is continued in the general treatment of Reims — the Amiens architect adds a new elegance by reducing the amount of wall and making the openings more elegant and more complicated.

In a general way, the elegance and lightness of the nave of Amiens seems to have its counterpart in the nave of Soissons. The Amiens architect seems to have possessed an extraordinary awareness of many older structures and was apparently not afraid to reach back into history and revive older forms, combining them with a general trend already well established.

If the four High Gothic cathedrals which have been discussed are considered in the light of the accomplishments of the Early Gothic cathedrals, it is clear that the most creative architect is the unknown master who designed Chartres. He established the High Gothic plan, the High Gothic elevation, and the structural system which made the new spatial concepts possible. The architects who designed Soissons, Reims, and Amiens changed the proportions, increased the physical height, and made subtle refinements of certain details. Yet the basic, creative thinking which reconciled contradictory possibilities by putting divergent twelfth-century ideas into a new synthesis can be seen first and often most clearly in Chartres, the first High Gothic cathedral. The fact that the Chartres architect established a High Gothic norm does not discount, however, the quality and creativity of the refinements achieved in Soissons, Reims, and Amiens. These refinements — a reduction of wall surface and weight, reduction of the size of ribs and colonnettes, increase in verticality of nave vessel, suggestion of the connection between parts (Reims triforium), actual joining of parts (Amiens triforium and clerestory), development of more elaborate clerestory windows, and, finally, the increased subdivision of parts into smaller parts — all these refinements are variations on a major theme.

Following the parallel relationships between the Scholastic thinking and architecture which Erwin Panofsky discusses in *Gothic Architecture and Scholasticism*, Amiens would seem to be the architectural *Summa* which regards all past buildings as instances of architectural authority. The complete transparency of the clerestory windows floods the interior of Amiens with light just as the new ordering of Scholastic thought had clarified the *Summae* of the theologians. The logic of each part in the Amiens elevation, as well as the summation of all parts into a complete totality,

evinces a parallelism with the very nature of the written *Summae*.

Like the forms of the nave, the plan of Amiens (fig. 263) follows the High Gothic format established at Chartres. The architect of Amiens seems to have by-passed the plan of Reims (fig. 246) for the earlier plan of Chartres (fig. 222). The choir of Amiens consists of four bays as at Chartres, and not three as in Reims. Further, the wide transept arms of three bays of Chartres are continued, rather than the shorter transept of two bays. However, the outer bays of the Amiens transept are considerably narrower than the two flanking the crossing. The single ambulatory of Amiens recalls that of Reims, but it consists of seven bays, in contrast to the five bays of the east end of Reims. The seven radiating chapels of Amiens hark back to the seven at Chartres and are not like the very deep five radiating chapels of the Cathedral of Reims. The design of the uniform chapels of Amiens is similar to that of the three larger radiating chapels of Chartres. It would thus appear that the plan of Chartres had more of an influence on Amiens than that of the plan of Reims. This return to an earlier monument for inspiration can perhaps be explained by the fact that older traditions in Reims, such as the chevet of Saint-Remi, had a strong impact on the design of the Cathedral of Reims. This facet of the Reims tradition had no impact or influence on Robert de Luzarches. The major chapel on axis at Amiens does extend much farther beyond the flanking radiating chapels and in this instance stands as a development of the deeper central radiating chapel of Reims. In cross section (fig. 260) the structural system of Chartres and Reims is repeated, but the nave buttresses of Amiens resemble those of Soissons and Reims in their high placement and in their two stages. The incline of the flying buttresses of Amiens increases the pitch of the buttresses of Reims.

During the last campaign of Amiens (1240's–1269) the superstructure of the transept and choir was constructed (figs. 261, 265–267). In a view up into the crossing of the nave and transept (fig. 261), it is apparent in the clerestory of the eastern-

most bay of the nave and in the bays in the transept on each side of the crossing that the tendency of subdivision of parts has been carried even further than in the nave. The large pair of lancets divides into two, which, in turn, become four for a total of eight small lancets. The fact that the eastern bay of the nave and the two bays and the transepts are slightly wider than the bays in the nave and the choir explains this change in design (plan, fig. 263). By 1269, the third architect-builder of Reims finished the east end of Amiens, including the star-vaulted bay of the crossing.

The superstructure of the east end of Amiens exhibits marked differences from that of the nave and façade. The tendency in the nave to convert the elevation into a screen of mullions and tracery is augmented by glazing the back or exterior wall of the triforium and thus converting it into a zone emitting light. In Reims and in the nave of Amiens, the large transverse wall behind the triforium, as it exists in Chartres (fig. 223) and Soissons, was eliminated, but a pitched roof protects the vaults of the aisles. In the east side of the transepts and around the entire east end of Amiens, low pyramidal roofs over the aisle vaults made it possible to convert the outer wall of the triforium into a glazed screen (figs. 264, 267). With both clerestory and triforium glazed and with moldings connecting these two, the choir becomes essentially a two-story elevation. The triforium in the choir (fig. 265) is more elaborate, with triple lancets crowned by cusped arches and three trefoils in the tympana, as opposed to the large single one in the triforium of the nave. An ornamented gable crowns each pair of arches. This more extensive undercutting of the surface, combined with the conversion of triforium and clerestory to a cage of glass, is a new and elegant kind of Gothic, called Rayonnant.

The exterior of the east end of Amiens (figs. 264, 268) is much more vertically oriented than the chevets of Chartres and Reims (figs. 230, 253). At Chartres, the wall buttresses from which the flying buttresses spring are somewhat awkwardly hidden in the re-entrant angles between the seven alternating deep and shallow chapels, while at

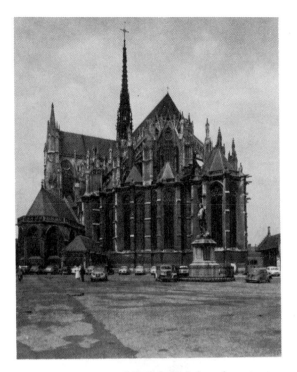

Fig. 264. Amiens Cathedral. Choir from the east,
late 1230's–1269

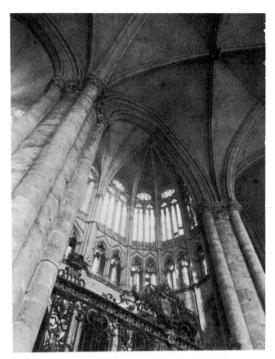

Fig. 265. Amiens Cathedral. Choir from south aisle

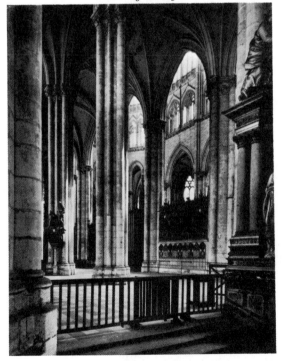

Fig. 266. Amiens Cathedral. Aisles and choir from
north transept

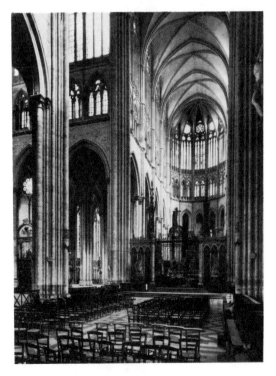

Fig. 267. Amiens Cathedral. Choir from nave,
late 1230's–1269

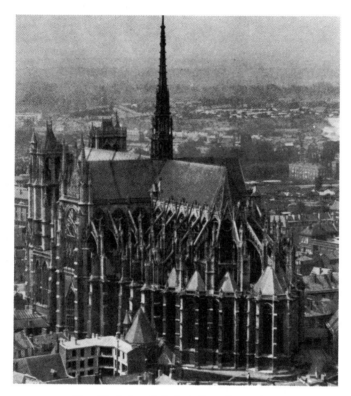

Fig. 268. Amiens Cathedral. From the southeast

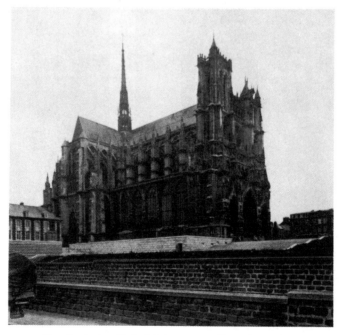

Fig. 269. Amiens Cathedral, begun 1220. From the northwest

Reims these supports project out between the angles of the five radiating chapels. The differentiation between supports for flying buttresses and the wall buttresses of the chapels is thus clearly stated at Reims. In the chevet of Amiens (fig. 264), the exterior of the piers supporting the flying buttresses resembles the wall buttresses of the seven radiating chapels, so that the entire girdle of chapels appears as a continuous sequence of bulging glass surfaces divided by vertical struts. The clarity and logic of the chevet of Reims is more High Gothic in spirit.

In the upper sections of the chevet at Amiens, the flying buttresses spring in two flights from large concave piers (figs. 264, 268). The outer short flight consists of a single buttress; the larger, inner flight, comprising two stages connected by an arcade, is an elaboration of the system of the flying buttresses of Chartres. The elaborate pinnacles in two series, plus the exterior gables rising above the clerestory windows, give Amiens a lacelike surface which seems to hide the structural system. The emphasis on shifting surfaces and the overlapping of stories is related to the interior of the choir of Amiens and to the contemporary façade of the Cathedral of Reims.

The total massing of Amiens, as seen from the Perret Tower (fig. 268) and from the northwest (fig. 269), is considerably simpler than the exteriors of Reims and Chartres (figs. 252, 228). The planned nine towers of Chartres were reduced to seven planned at Reims, and at Amiens the master builders apparently abandoned the unachieved seven- or nine-tower ambition in favor of two western towers and a spire or flèche. This reduction of towers tends to give Amiens a more compact mass. The western towers are dwarfed by the 137-foot nave capped by the extensive wooden roof. Amiens forgoes animation of mass for animation of surfaces. This simplification of massing seems to contradict the tendency to elaborate the surfaces. From 1292 on into the fourteenth century, chapels were added between the extended nave buttresses, so that the nature of the lower part of the flank of the cathedral has been substantially transformed (fig. 269).

The nave and façade of Notre-Dame at Amiens are the climax of the refinement of the High Gothic design of Chartres; yet certain features of the façade, such as its emphasis on receding planes and elaboration of surfaces, and certain characteristics of the nave, such as the subdivision of parts and greater manipulation of the wall — all are prophetic of the new Parisian style of the late 1230's and 1240's and the decades following. The superstructure of the Amiens chevet represents this new Gothic period.

Paul Frankl, in his Pelican book *Gothic Architecture*, wrote as follows:

The shafts which rise uninterruptedly from the floor to the vault and those which unite the triforium with the windows combine with the heightened emphasis on verticalism to produce fusion between arcade, triforium, windows, and the space in the vault — while the Gothic relief creates a flowing connection between one bay and the next, and between the nave and the aisles. Standing at the entrance, one is aware of the existence of the aisles, owing to the profile of the row of piers, in the same way as one feels that the space within the cathedral continues smoothly through the triforium and the windows into the space outside. These are the formal themes of the Gothic style.

To understand the *artistic* result of this form, one must recognize its meaning. St. Bernard did not like churches to be too high; to his mind the decisive factor was the monk in his humility and devotion. In a cathedral he was prepared to allow a greater display of luxury, because here the purpose was to impress the simple minds of laymen, but even here he would have set a limit, and would no doubt have preached withering sermons in condemnation of the cathedrals of the thirteenth century. To the minds of Robert de Luzarches and of his bishop, Evrard de Fouilloy, however, the decisive factor was God. Their aim was to present every possible expression of the combination of sublimity, majesty, and might, with lucidity, harmonious wealth, and a sense of the infinite, and to create a formal symbol worthy of God. Their church was to look as if it did not belong to this world.

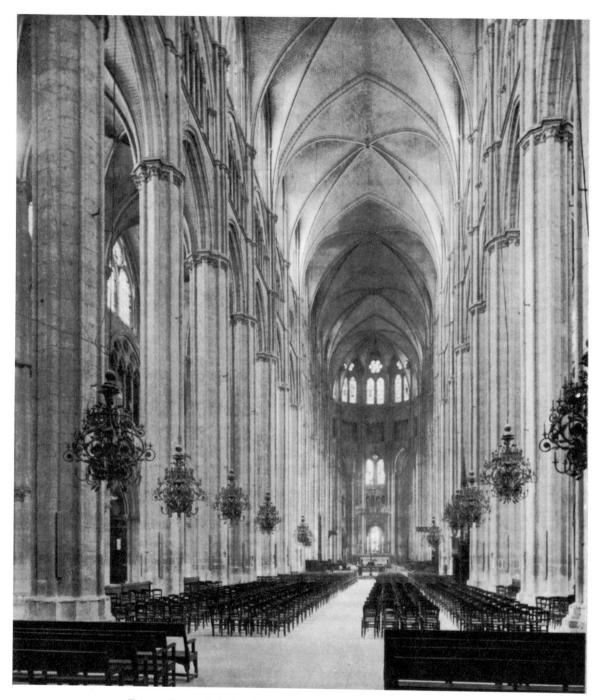

Fig. 270. Bourges Cathedral, begun 1195. Choir, 1195–1214; nave, 1225–c. 1250

CHAPTER 21

The Cathedral of Bourges

THE TOWN OF BOURGES, 140 miles south of Paris and in the exact center of France, is dominated by the Cathedral of Saint-Étienne (figs. 270–280). From the point of view of chronology in the evolving Gothic, this chapter should follow the one on the Cathedral of Chartres. Bourges was begun in 1195 at the same time that the site of Chartres was being cleared and construction was beginning after the fire of 1194. The master of Chartres created a High Gothic format which served as the model for the masters of Soissons (late 1190's), Reims (1211), and Amiens (1220), the great cathedrals north and northeast of Paris. The master of Bourges evolved a completely different kind of High Gothic, and the influence of Bourges, second only to that of Chartres, can be seen in a series of cathedrals in northwestern and western France and Spain. Robert Branner's recent book *La cathédrale de Bourges et sa place dans l'architecture gothique* points up the uniqueness of Bourges and its importance in the main stream of Gothic architecture.

Upon entering Bourges, the visitor is struck by the extreme verticality of the nave arcade rising up to the small triforium and clerestory (fig. 270). This soaring space is capped by the large square bays of six-part ribbed vaults. The relative tallness of the nave arcade is further accentuated by the piers, with their eight slender attached colonnettes. The vertical space of the nave vessel clearly dominates the total composition, but part of its prominence is shared by the unusual organization of the tall inner aisles — the aisles nearest the nave. The vertical space of the nave is echoed in the elevation of the inner aisle with its arcade, triforium, and clerestory. The emphasis on the inner aisle gives the total space of Bourges an extension laterally either at right angles to the nave or in a diagonal direction. The space then seems to move down the nave toward the high altar and also diagonally across the cathedral, finally terminating in the low outer aisles with their windows. The even spacing of the colonnettes around the larger piers, which alternate with others slightly smaller in diameter, further emphasizes the movement of space from the nave vessel into the spaces of the inner aisles. The full diameter of the piers is continued up between bays through the triforium to the springing of the vaults. Each bay is thus framed by the shafts and the continued convexity of the piers themselves. Further, the shafts attached to the nave piers have no capitals on the nave side and grow directly up to the bundle of shafts which relate to the ribbed vaults. To complete this continuity between piers and vaults, the Bourges master alternated the bundle of shafts above the capital of the piers: five shafts for the major pier and three for the intermediate pier. These five shafts grow up into the transverse and two diagonals and two wall ribs over the major pier and the single intermediate transverse arch and the two wall ribs over the intermediate pier.

Working from the outer aisles into the inner and finally into the nave vessel itself, the spaces pile up in a great pyramid. This pyramid is dramatized by the light entering the low aisle windows, the intermediate clerestory of the inner aisle, and the high clerestory of the nave vessel. Thus the light is at three levels of height and in three planes

223

in space from the outer wall to the inner aisle to the nave vessel itself.

These major secondary and minor spaces are completely continuous around the entire cathedral. The climax of the nave vessel is the choir, with its clerestory and triforium, while the inner aisles, with their triforium and clerestory, are continuous around the ambulatory. This concept of a smaller church within a larger church is a completely new phenomenon in Gothic architecture, but it can be found in a group of major Romanesque monasteries. In Cluny III (figs. 41–44), with its five aisles, the inner aisle was illuminated by a clerestory, the outer aisle by lower windows, and the nave by windows under the pointed barrel vault. Three planes of light at different heights, together with a piling up of the interior spaces, are the Romanesque solution of the same type of spatial disposition. The question naturally arises whether the master of Bourges was familiar with Cluny III, only 135 miles southeast of Bourges. Indeed, Bourges is halfway between Paris and the Burgundian masterpiece; and just as the builders at Reims Cathedral were influenced by the provincial heritage of Reims, so the master of Bourges may have been influenced by Burgundy.

The unique nature of the interior of Bourges can perhaps best be clarified if Bourges and Chartres are contrasted (figs. 270, 219). The equal sizes of nave arcade and clerestory, divided by uniform triforium, give the nave of Chartres a balance between the void of the nave arcade and the glazed surface of the clerestory. This harmonious set of proportions imparts a sense of clarity and balance to the nave of Chartres. The single aisles of Chartres serve as a foil to dramatize the rising rectangular bays with their four-part vaults which repeat in multiple elements down the nave. The squat nave piers, with their four strong colonnettes, serve as the springing of the major nave arch and the uniform bundles of five shafts. The master of Chartres inserted an impost between the capital of the nave arcade and the rising shafts and thus created a horizontal repeat of the capitals, which in turn is echoed in the horizontal stringcourses framing the triforium above. At Chartres the triforium serves as a dark horizontal band between the clerestory windows above and the semidark nave arcades below.

The height of the nave vessels of the two cathedrals is almost identical — 118 feet — but the balanced and essentially additive nature of the nave of Chartres is entirely different from the solution of the masters of Bourges. The enormously tall nave arcade at Bourges, its verticality emphasized by the eight evenly spaced, thin colonnettes, immediately relates the visitor to the space of the nave, but at the same time introduces the tall thin spaces of the inner aisles. The Bourges masters did not spring the bundle of shafts from a wide plinth, but had them rise directly from the abacus of the capital. Thus there is more continuity between the shafts attached to the nave piers and the bundle of colonnettes rising up to the springing of the vaults. Further, at Bourges, the projection of the piers themselves out beyond the wall of each bay is carried up to the springing of the vaults. The vaults spring from the base of the clerestory not a third of the way up the clerestory, as at Chartres. In general, the nave arcade, triforium, and clerestory of Chartres tend to contain the visitor's view and force his gaze down the nave toward the high altar; the treatment of the nave arcade of Bourges, with the inner aisles illuminated, tends to emphasize a duality of impression: one toward the high altar, the other laterally into the secondary spaces. The six-part vaults of the nave of Bourges tend also to slow the rhythm of repeated elements down the nave and further emphasize a diagonal treatment of space. In the second half of the 1190's, Chartres and Bourges stand as two distinct kinds of High Gothic architecture.

Before turning to a more detailed discussion of Bourges, it is necessary to discuss the historical and economic context out of which the Cathedral of Saint-Étienne grew.

Bourges, an important fortified town under the Romans, had been acquired around 1100 by Philip the First of France. As part of the royal domain, the defense of Bourges was in charge of the French monarchy. The kings of France, according

to Branner, played a very small role, if any, in the construction of the cathedral. Much more important for their part in the Cathedral of Saint-Étienne were the archbishops of Bourges, vassals of the crown, who supervised a huge diocese which included Limoges, Clermont-Ferrand, Cahors, Le Puy, Mende, Albi, and Rodez and were also primates of Aquitaine. These distinguished personages gave Bourges enormous prestige. Henri de Sully, Archbishop of Bourges from 1183 to 1199, was the brother of Eudes de Sully, Bishop of Paris. This relationship naturally raises questions about the influence of the Cathedral of Notre-Dame in Paris on the design of Bourges Cathedral. Henri de Sully increased the size of the chapter from thirty to forty canons. His follower in office, Saint Guillaume (1199–1210), conducted offices in the new choir in 1209 when about to depart for the Albigensian Crusades. He caught cold and died in January 1210. The choir, unfinished at this time, perhaps contributed to his demise.

The chapter of Bourges, according to Branner, played a much larger part in the construction of Bourges than did the archbishops. Their control of land as far distant as Beaulieu and the rich agricultural economy of the Berry, much of it administered by the provost of the canons, helped tremendously in the financing of the chantier. The chapter not only administered the funds for the construction but seems to have hired the architects and to have approved the first design for Bourges. The very size of the program of Bourges was established by the chapter for a choir of forty canons and a lower clergy numbering two hundred.

The history of Bourges prior to 1195 involves, as is the case with most cathedrals, a series of older buildings with extensions added. In the eleventh century the older cathedral was rebuilt with its eastern sections terminating against the old fortified ramparts of Bourges. It is possible that the apse of the cathedral was placed in one of the old defense towers. Transepts were added to the east end in the second third of the eleventh century, while around 1172 a new campaign to enlarge the cathedral to the west took place with the ad-

dition of a porch and narthex with three portals. As a result of excavations carried out in 1952 in the north aisle of the choir, Branner discovered evidence of a fire. According to his calculations, the fire must have taken place between 1191 to 1193 and 1195. The old nave damaged by the fire was repaired to house services until the completion of the new High Gothic choir. A charter of Archbishop Henri de Sully of 1195 describes a gift of a considerable amount of money to the chapter for repair of the old cathedral and implies a decision to rebuild. Thus, sometime in 1195, the chapter hired a master architect to design a much larger and more glorious cathedral. This charter, plus stylistic relations between the chevet and other dated monuments, leads to the conclusion that Bourges was begun in 1195.

In 1181, Philip Augustus had given the authorization to the cathedral chapter to build beyond the fortified ramparts of Bourges. The difference in level between the area inside the walls where the eleventh- and twelfth-century cathedral stood and the level outside the ramparts is 18 feet. Thus, the first campaign, beginning in 1195, involved the construction of a large crypt with double ambulatory to serve as a substructure for the totally new choir above. According to Branner, the first major campaign extended from 1195 to 1214 and involved the construction of the entire chevet. Branner further divides this major campaign into three phases. First (1195–1205) was the construction of the crypt with its double ambulatory and the first straight bay of the choir up to the level of the vaults of the inner aisle. The first Bourges architect clearly utilized the plan of the Cathedral of Paris as the major inspiration, as can be seen from the double aisles of the crypt and choir above and the original disposition of double ambulatory without radiating chapels. It seems that the chapter, because of the cult of the relics, forced a change in the design with the addition of the small radiating chapels standing on piers and corbeled out from the walls (fig. 278). Also the triangular bays of the outer aisle of the crypt are related to the plan of Notre-Dame in Paris. A second phase (1202–1208), partially over-

lapping in time the first phase, involved the construction of the choir inside the ramparts up to the level of the intermediate vaults; while a third phase, probably under the supervision of a second architect, witnessed the completion of the vaults of the inner aisles and the upper triforium, clerestory, and vaults of the entire chevet. The entire eastern half of the cathedral was finished in nineteen years, as attested by charters of 1214 and 1216.

The extraordinary complexity of the east end of Bourges can be seen in a study of details of the interior and exterior (figs. 270, 275, 278). From the interior (fig. 277) the windows in the outer aisle, seen in conjunction with the clerestory windows of the inner aisle and climaxed by the three lancets with rose window of the nave-vessel clerestory, gives a consistency of forms to the double ambulatory. This piling up of light areas in three planes is clearly revealed in the exterior of the choir (fig. 278). The outer aisle, with lancet windows flanking the small three-windowed radiating chapels, is surmounted by a pair of lancets in the clerestory of the inner aisle and finally by the pair of lancets with rosette in the upper clerestory of the choir itself. Small apertures aerate and give light to the wooden roofs over the vaults of all three levels. The buttresses, with their very steep pitch, spring in two flights and two stages. The upper flight, however, has a continuous profile from the outer piers to the clerestory. The double pinnacles connected by arcades, surmounting the piers of the buttresses, are an addition of the nineteenth century. The division between the buttresses and each bay as it climbs and recedes in space is completely consistent with the spatial organization on the inside. Many of the design ideas of this first master of Bourges seem to have their counterparts in the area northeast of Paris. The short lancet windows of the clerestory, with a rose window above, find parallels in many late twelfth-century churches and cathedrals in the northeast. The treatment of the triforium of both the inner aisle and the main choir — an arcade contained within a larger arch, which in turn hides a thick relieving arch — is a design and structural feature derived from this same area. However, the spatial use to which the master of Bourges puts these Early Gothic ideas is entirely new. His creativity can best be seen in the new way space is interpenetrated by construction and activated and dramatized by light that enters in three major levels of the interior. The arrangement of the trapezoidal bays, narrowing toward the small radiating chapels in the outer ambulatory of the choir, alternating with triangular bays (fig. 271), does not come from northeast of Paris, but rather from a series of structures in and around Étampes, as Branner has proved.

The second major campaign at Bourges, begun around 1225, follows a procedure similar to the system employed in the chevet: first, exterior of aisles of the nave; then, beginning of work on the façade (around 1228 to 1230); toward 1235 work on the inner aisles; around 1245 start of work on the main nave vessel; and, finally, most of the façade by 1255. Branner interposes many refinements of the chronology within these phases by reference to other dated monuments. The nave of Bourges, completed in roughly thirty years, points to the conclusion that the design of the first master of Bourges was respected by the master who designed the nave and façade. The same system of supports and a similar disposition of inner aisle and outer aisle continue down the length of the entire nave. It is possible, however, to see many changes in details when the choir and nave are contrasted (figs. 277, 272, 273). This third architect of Bourges was working in the second quarter of the thirteenth century, so that many ideas of High Gothic as it evolved made themselves felt in the subtle changes of the first Bourges master's designs. The clerestory windows of the main nave vessel now contain more glass, since the three taller lancet windows are surrounded by mullions and the rose occupies more of the upper part of the clerestory itself. The main triforium now has pointed arches in the arcade with a quatrefoil cut into the tympanum above, as opposed to the round arches and unadorned tympanum in the triforium of the choir. The nature of the triforium over the inner aisle in the

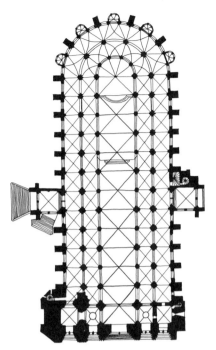

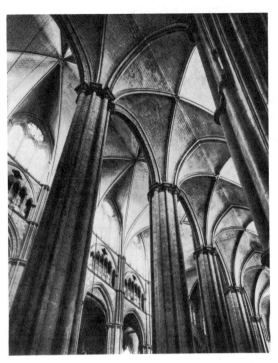

Fig. 271. Bourges Cathedral, begun 1195. Plan
(after Branner)

Fig. 272. Bourges Cathedral. Nave from inner aisle

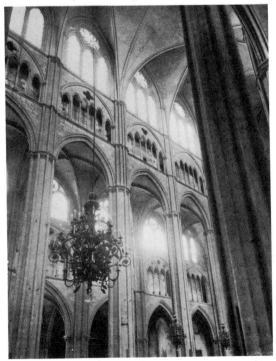

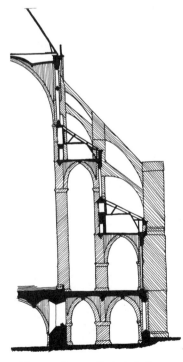

Fig. 273. Bourges Cathedral. Nave from south aisle

Fig. 274. Bourges Cathedral. Cross
section (after Branner)

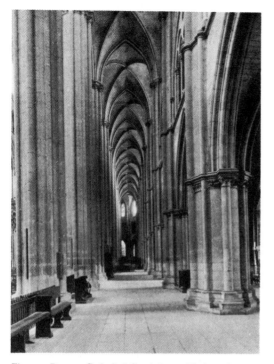

Fig. 275. Bourges Cathedral. South inner aisle from the west

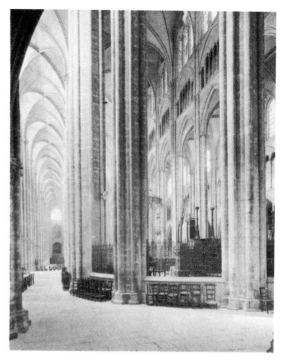

Fig. 276. Bourges Cathedral. South aisle and choir from the east

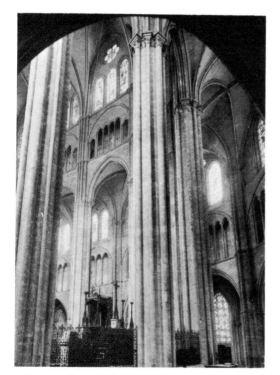

Fig. 277. Bourges Cathedral. Choir and ambulatory, 1195–1214

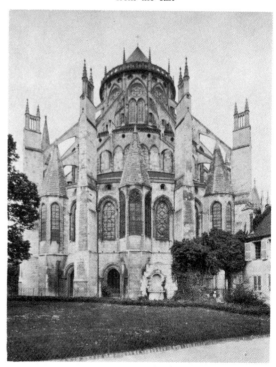

Fig. 278. Bourges Cathedral, begun 1195. From the east

nave (figs. 272, 273) reveals even more differences than that of the high triforium. The simple triforium in the choir, with an arcade of four openings framed by a single arch, now becomes an arcade of four cusped openings surmounted by a pair of pointed arches, each of which culminates in a quatrefoil contained within another arch. The surface complexity of the nave of Bourges has its counterpart in the evolving Gothic forms of the nave of Amiens in the 1220's.

The third Bourges master, according to Branner, thickened the construction of the nave walls and eliminated metal reinforcements which had been utilized in the choir. However, he repeated the subtle alternation in size of major and minor nave piers, but continued the even distribution of the eight attached colonnettes and their groupings as they rise up through the triforium to the springing of the six-part vaults. The intermediate piers between inner and outer aisles (fig. 275) recall vaguely the bundle of shafts surrounding the intermediate piers in the aisles of the Cathedral of Notre-Dame in Paris (figs. 180, 182). The division between the first major and second major campaigns can be seen on the exterior (fig. 280), where the buttresses rise to a higher position on the clerestory walls and the design of the clerestory windows changes in certain details. This third Bourges architect re-employed the sculpture carved for the extension of the cathedral in the twelfth century. He placed it in the lateral portals which give entrance directly into the flank of the cathedral.

The most impressive part of the work of the third Bourges master is the design of the façade (fig. 279). Unfortunately, time has not been kind to the façade of Bourges. In the fourteenth century, a huge buttress had to be attached to stabilize the south tower. Late in the same century, the large arch over the central window was suppressed and a late Gothic rose window put in the central bay. In the fifteenth century work continued on the north tower, but the heaviness of the masonry caused it to collapse, and a new tower was not completed until 1542. All the jamb sculpture was destroyed by the Huguenots. Branner has made a reconstruction of the façade as conceived by the third Bourges architect. The originality of this concept can still be seen today. The problem of echoing the spaces of the four aisles and the nave on the exterior is successfully solved by the Bourges architect as he makes the outer portals reflect the outer aisles but also tie in with the larger width of the towers rising above. To suggest the inner aisles, the vertical bays and portals flanking the central bay are narrowed. Further, to achieve this five-portal effect, the architect narrowed the width of the nave bay (plan, fig. 271) as it approached the west façade. The architect is thus able to suggest an interior-exterior relationship on the façade and yet resolve the façade into a harmony with the two towers which rise above the nave itself.

The impressive exterior of Bourges, as seen from the east or from the south (figs. 278, 280), has no transepts interrupting the continuous repetition of flying buttresses from the south tower along the nave around the entire chevet up to the east face of the north tower. The addition of chapels along the nave after the thirteenth century only slightly mars the extraordinary unity of concept in the massing of Bourges. The massing of Bourges, with no transept and crossing tower, is entirely different from the nine-towered massing of Chartres or Reims, with its reduced number of towers. Indeed, Bourges, with its lack of transepts, is entirely different from the five-aisled Notre-Dame in Paris (fig. 184). From the exterior, the piers and buttresses divide the massing into a series of vertical bays, each of which contains the three glazed areas in three planes in depth and at three different heights.

By its very nature, the complexity of the spatial composition of Bourges is difficult to emulate; yet the design of Bourges did influence subsequent monuments. The major buildings influenced by Bourges are: Saint-Martin of Tours (about 1211), the choir of Burgos (1221/2–1230), the choir of the Cathedral of LeMans (1217 ff.), the Cathedral of Toledo (1227 ff.), and the Cathedral of Coutances (after 1230). The notion of a church within a church, as developed at Bour-

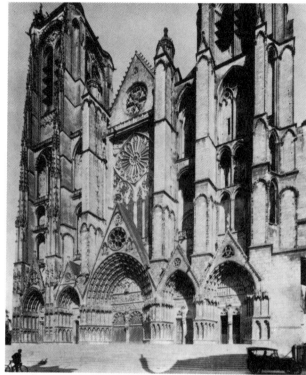

Fig. 279. Bourges Cathedral. Façade, finished 1255

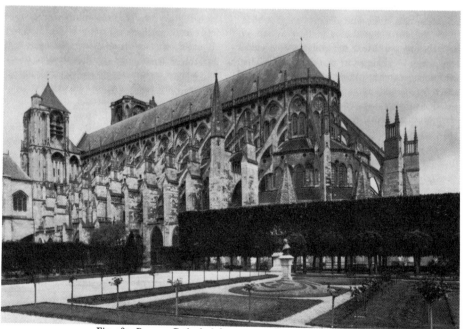

Fig. 280. Bourges Cathedral, begun 1195. From the southeast

ges, is the major feature which is utilized in later buildings. In each instance the influence of Bourges undergoes a sea change as the Bourges features are transformed by other provincial traditions or by ideas coming from other parts of France.

The Cathedral of Saint-Julien at Le Mans (figs. 281–283) reflects just such a combination of influences: from local tradition, from Bourges, and from new building campaigns in other areas. Its chevet is dramatically situated high above an open square (fig. 281). Land was acquired for the new choir about 1217, and several years were involved in constructing the immense subterranean areas as foundations for the radiating chapels and double ambulatory above. The process of construction was comparatively slow, so that the superstructure of the choir was not finished until the 1250's. The seven radiating chapels give the exterior of the chevet a compact base from which the complicated and dramatic flying buttresses spring. The outer buttresses consist of three buttresses, one above the other, while the inner flight consists of two. On the interior (fig. 283), later architects changed the superstructure to a two-story interior with nave arcade and a rudimentary triforium with a railing for passage and a clerestory above. In essence the interior of the main vessel of the choir of Le Mans is a two-story church and therefore has its stylistic parallels with the two-story tendency of the nave of Amiens. The superstructure of the choir, in its arrangement and forms, has evolved beyond High Gothic. In the inner aisles of the choir, the three-story elevation of arcade, triforium, and clerestory is the major feature which stems from the design of the Cathedral of Bourges. The Romanesque nave of Le Mans, which was rebuilt between 1145 and 1158 following fires in 1134 and 1138, stands in marked contrast to the soaring verticality of the choir. The alternating major pier, with single column making a square bay crowned by early domical four-part vaults, is, in its mural presence, quite different from the undercut surfaces of the choir.

By the end of the first quarter of the thirteenth century there were basically three kinds of High Gothic architecture completed or under construc-

tion in France. Chartres, finished essentially by 1220, stands for the major High Gothic style, which by 1225 was in existence (1) in the choir of Soissons, where work was progressing on the nave, (2) in the choir of the Cathedral of Reims, and (3) in the beginning of work on the nave of Amiens. This High Gothic point of view at Chartres utilized several Early Gothic features in a new combination. Flying buttresses were used throughout, and a new set of proportions was established, with huge clerestory windows equal in size to the nave arcade separated by the thin arcade of the triforium. This Chartres format, with its narrow bays made up of a multiplicity of parts, stresses throughout the sense of the wall in space. The major volumes of the nave dominate the total composition, and the secondary spaces of single aisles flanking the nave serve as foils to point up the verticality of the nave vessel itself.

A second kind of High Gothic derives from a more conservative group of churches which seem to be reactions against the High Gothic created by the master of Chartres (see bibliography: Bony article). This conservative reaction against the new High Gothic formula can be found in churches scattered from England across northern and northeastern France into Burgundy and Switzerland along the major routes of the fairs. The major characteristic of this group of smaller monuments is their continuation of many ideas of the Early Gothic of the Noyon, Soissons, and Reims areas. These features include multiple passages in the wall and normally shorter clerestory windows as well as supports which omit any engaged colonnettes. This group of churches seems to represent the Gothic which was exported to regions such as Burgundy and further to the east. This conservative area thus tends to surround the Île-de-France area which includes the major High Gothic cathedrals.

A third kind of High Gothic is that developed by the master of Bourges. Bourges, in turn, influences the design of cathedrals in northwestern and western France and in Spain. The Bourges master rethought more ideas from Early Gothic than did the master of Chartres; yet, like the

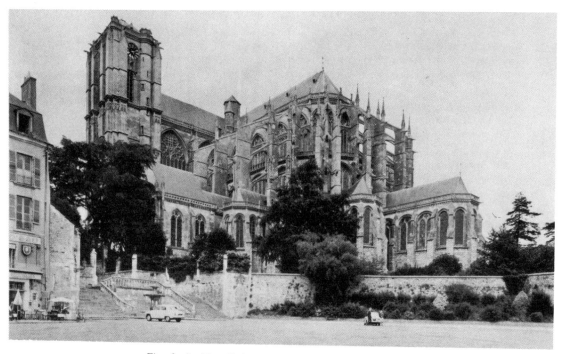

Fig. 281. Le Mans Cathedral, begun 1217. From the southeast

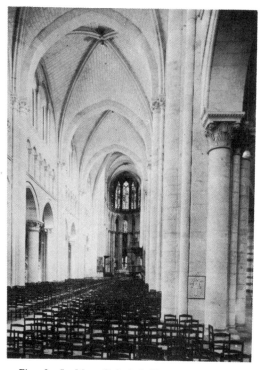

Fig. 282. Le Mans Cathedral. Nave, c. 1145–1158

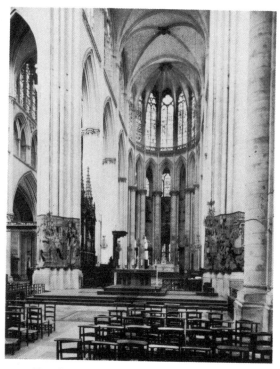

Fig. 283. Le Mans Cathedral. Choir, begun 1217

latter, he created a new and different synthesis out of these ideas. He continued the six-part vault of Early Gothic, with the slightly alternating supports down the nave, and employed the short clerestory. The Bourges master, however, invested the entire structure of Bourges with a new dynamic spatial sequence which is completely different from the nature of the nave of Chartres and of the monuments which grew out of the design of Chartres. The masters of both Chartres and Bourges seem to have had their training in the areas northeast of Paris; but when given the task of designing new cathedrals for Chartres and Bourges, the difference in the personalities of the two artists caused a varied interpretation of what was basically the same heritage of ideas. The extraordinary creativity of these two major masters, the masters of Chartres and Bourges, results in two distinct High Gothic structures. Both of these structures have their progenies, but the impact of Chartres is the more important for future monuments.

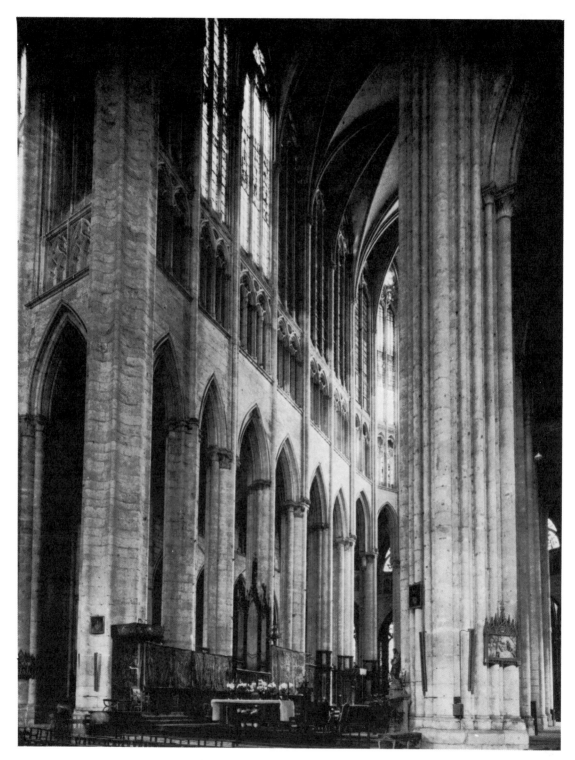

Fig. 284. Beauvais Cathedral, begun c. 1225. Choir

The Cathedral of Beauvais

Oɴʟʏ ᴛʜᴇ ᴄʜᴏɪʀ and transepts of Saint-Pierre of Beauvais were finished; the vaults of the choir collapsed in 1284; the crossing tower fell in 1573. Today, with the small Carolingian nave (fig. 293) and towering choir, Beauvais stands as an awe-inspiring fragment. The crown of the vaults of the choir rises 157 feet 6 inches above the pavement, 20 feet higher than the nave of Amiens and 40 feet higher than the nave of Chartres. Beauvais (figs. 284–293) was begun after the great cathedrals of Chartres, Bourges, Reims, and Amiens. The master of Beauvais combined ideas derived from these earlier monuments with innovations of his own to create a new synthesis. The rebuilding of Beauvais after 1284, however, makes it difficult to reconstruct the original design.

The nave of the Carolingian church of Beauvais, the Basse-Oeuvre, still stands (fig. 293). Its choir was destroyed in the sixteenth century so that the crossing and transepts of the existing cathedral could be constructed. In the mid-tenth century a second church, dedicated to Saint Peter, was erected to the east of the Carolingian structure. This church was damaged by fire in 1180 and was probably destroyed in a second fire in 1225. Between 1225 and 1272, a new Gothic apse and choir were completed, but in 1284 the upper vaults of the ill-fated cathedral collapsed. The reasons for this tragedy are conjectural. Either the foundations were insufficiently solid to support the enlarged superstructure or the architect of the upper triforium and clerestory lacked skill commensurate with his ambition. The latter is perhaps the more plausible explanation. Between 1284 and 1322, six additional piers were constructed in the choir proper and four new piers were erected between the double aisles to compensate for the failure of the thirteenth-century campaign. This reconstruction changed greatly the nature of the main vessel of the choir.

In 1500, following the termination of the Hundred Years War, Martin Cambiges was hired to design the transepts. The south transept was built between 1500 and 1548 and the north one between 1510 and 1537. Discussion concerning the nature of the crossing tower commenced in 1544, and it was finally decided to build it mostly of stone, three stories of stone and one of wood. This crossing tower, of the unprecedented height of 497 feet, was erected between 1558 and 1569. In the following years, the bishop and chapter, fearful of the stability of the tower, called in experts, who advised the immediate construction of bays of the nave to support the west side of the crossing. More outside advice was sought in 1572. As a result, masons were ready to reinforce the supports on April 17, 1573; but on April 30, 1573, the west supports and most of the tower collapsed. None of the workmen dared to demolish the remaining sections. Finally a criminal won his freedom by completing the demolition.

In a recent article (see bibliography), Robert Branner has reconstructed the original design of the master of Beauvais (fig. 285) and corrected the date of documents dealing with the start of construction. Bishop Milon de Nanteuil (1217–1234) started the Gothic chevet in 1225. A charter of November 3, 1225, which the bishop published, stated that the chapter must uphold his decisions and must contribute one-tenth of its revenue, plus

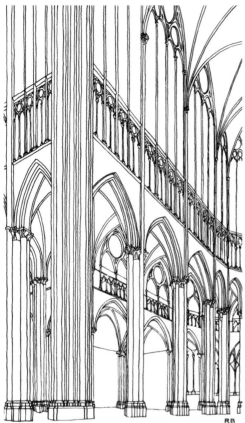

Fig. 285. Beauvais Cathedral. Reconstruction of choir (Branner)

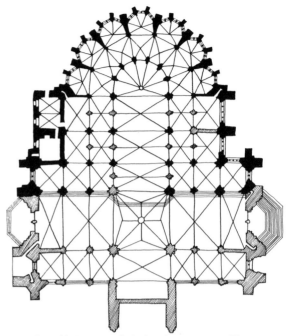

Fig. 286. Beauvais Cathedral, begun c. 1225. Plan (after Leblond)

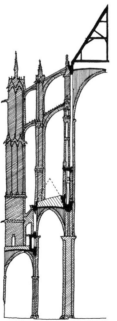

Fig. 287. Beauvais Cathedral. Cross section (after Leblond)

other resources from the diocese, for a period of ten years. Further, the bishop had the charter confirmed by a papal legate on November 11, 1225. On the basis of these documents, plus extensive donations by Bishop Robert de Cressonsac (1237–1248), a careful study of the building itself, and comparisons with other dated monuments, Branner established the campaigns of construction of Beauvais. The first master of Beauvais was in charge of the chantier from late 1225 until about 1245. Work progressed rapidly for five or six years on the foundations of the chevet, the radiating chapels, and the outside aisles of the choir. In the 1230's the process slowed down, but the piers of the hemicycle and the choir were in place by about 1238. Between the late 1230's and about 1245 the upper parts of the ambulatory and the inner aisle of the choir were constructed. For a short time a second master supervised the construction of the piers and vaults of the aisles of the transept, while a third master, taking over the workshop between 1250 and 1255, erected the triforium and clerestory of the choir and the flying buttresses by 1272.

The plan of Beauvais (fig. 286, without dotted lines) is practically identical with that of Amiens (fig. 263). Both cathedrals have a single ambulatory with a set of radiating chapels. The chapel on axis at Amiens is much deeper, but the plan of the other chapels, including the arrangement of the windows, and the location of all buttresses and piers for the flying buttresses are the same in both monuments. The choir of Beauvais originally had three bays, as opposed to four in Amiens. In Beauvais the eastern two bays are wider, with aisle bays of rectangular shape, as opposed to the square bays of Chartres and Reims. This system of rectangular bays is also found in the four aisles of the Cathedral of Bourges.

At Amiens work commenced with the façade and nave (1220–1233). The chevet was begun in the 1230's, with a deep chapel on axis probably finished by 1240. Since Beauvais was begun in 1225, the plan and lower parts of the chevet were constructed before the east end of Amiens. If it can be assumed that Robert de Luzarches, master of Amiens, had not sketched a plan for the chevet of Amiens in 1220, the plan of Beauvais of 1225 preceded and served as model for the chevet of Amiens and for the chevet of Cologne Cathedral, begun in 1248. The seven radiating chapels of Beauvais were perhaps inspired by Chartres, although their uniformity of size and attachment to a single ambulatory is similar to Reims. Following the collapse of the vaults in 1284, the additional piers and ribs (see plan, fig. 286, dotted lines) converted the four-part vaults to six-part vaults. The original plan before modifications proved that the first conception of Beauvais grew out of the Chartres-Reims tradition. Like Jean d'Orbais of Reims, the Beauvais master was not content to copy the plan of either Chartres or Reims, but rather used ideas from both monuments to create an original plan.

The most unusual part of the interior of Beauvais is the design of the ambulatory and inner aisles of the choir (figs. 288, 290). The aisles are 69 feet 8 inches high, as opposed to 60 feet for the aisles and arcade of Amiens. The arcade of the choir was lowered when the additional piers were constructed. In the hemicycle (figs. 284, 285) the original height is preserved. A diagonal view of the choir (fig. 288) or a view from the inner aisle (fig. 290) reveals the three-story elevation of the ambulatory and inner aisle. Above the arcade, which opens into the radiating chapels or the outer aisle, are a triforium and clerestory. This feature creates a church within a church and resembles the treatment of the inner aisles of the cathedrals of Bourges and Le Mans (figs. 272, 277, 283). Light enters the chevet through the triple windows of the radiating chapels and the lower windows of the outer aisle, through the clerestory of the inner aisle and ambulatory, and finally through the glazed triforium and clerestory of the main vessel. Light on three levels and in three planes of space emphasizes a diagonal movement of space which recalls the choir and nave of Bourges. The first master of Beauvais in the years after 1225 synthesized ideas from the Chartres-Reims design with the spatial complexity of Bourges and Le Mans.

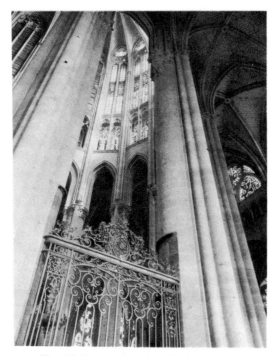

Fig. 288. Beauvais Cathedral. Choir, ambulatory
from aisle

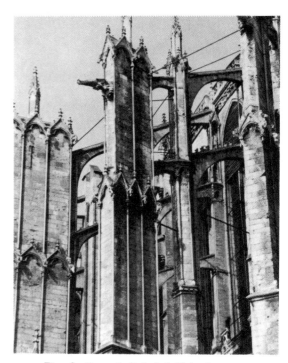

Fig. 289. Beauvais Cathedral. Flying buttresses

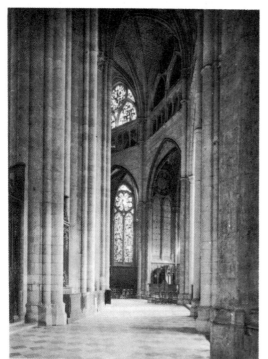

Fig. 290. Beauvais Cathedral. Aisle of choir, ambulatory

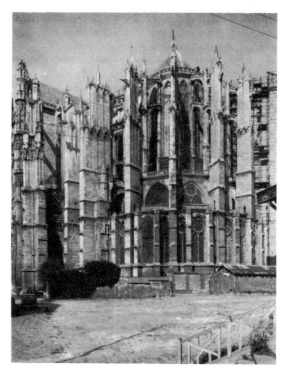

Fig. 291. Beauvais Cathedral, begun c. 1225.
From the east

The treatment of the triforium-clerestory of the inner aisle and ambulatory of Beauvais (figs. 288, 290) is, however, completely different from the design of Bourges and Le Mans. The triforium consists of an arcade of eight openings, each crowned by a cusped arch. Originally, small windows on the outer wall illuminated the triforium and made it, according to Branner, the earliest glazed triforium. The even height of the arcade comes from the Chartres-Reims tradition and was not influenced by the more complicated treatment of the triforium of the nave at Amiens. The cusped arches of Beauvais appear in the later triforium of the choir of Amiens (fig. 267). The Beauvais triforium of the inner aisle and ambulatory is linked to the short clerestory by a central attached colonnette and two colonnettes at the extremity of each bay which grow up into a pair of pointed arches of the clerestory (figs. 288, 290). A central colonnette tied the triforium with the clerestory in the hemicycle of Reims Cathedral and in the nave of Amiens, but the master of Beauvais eliminated the wall rib and joined the triforium and clerestory in one element. The pair of pointed arches in the clerestory stage are crowned by a large rose window. The stories are not clearly separated; the wall is treated as a screen, rather than a structural support. This treatment, as in the nave of Amiens, is prophetic of the Parisian architecture of the 1240's. The use of monolithic colonnettes (colonnettes en délit) to separate the bays of the ambulatory and to serve as the springing of the transverse ribs is an Early Gothic technique re-employed in an elegant manner (fig. 290).

As seen from the exterior, the relatively squat proportions of the radiating chapels (fig. 291) and the treatment of the windows recall the east end of Reims (fig. 253). The more attenuated proportions of the radiating chapels of Amiens (fig. 264) are later in date. The low, essentially flat roofs over the radiating chapels and outer aisles of Beauvais allow light to enter both the triforium and clerestory of the ambulatory and the inner aisles of the choir. The connections in form between Reims and Beauvais suggest the possi-

bility that the master of Beauvais came from the Reims workshop. As Branner has pointed out, Milon de Nanteuil, Bishop of Beauvais, was formerly provost of the metropolitan See of Reims. He was provost at the time of the fire of 1210; he participated in the problems of starting the reconstruction of the cathedral and probably called the master of Beauvais from Reims to Beauvais in 1225.

The original six piers of the choir and the six of the hemicycle, designed by the first architect (figs. 284, 285), were in situ by about 1238. The Beauvais master attempted to link the piers and the colonnettes which rise to the vaults by simplifying the molding at the top of the inner colonnettes and by constructing the latter of a smaller diameter than the other three colonnettes. As Branner indicates, in one pier (the northwest, fig. 284) the colonnette is continuous from the base of the pier to the vault, but the top molding of the capital and the impost of the three colonnettes above were cut away after the capital was in place. This uninterrupted movement from pavement to the springing of vault, like the interpenetration of triforium and clerestory in the inner aisles and ambulatory, is a decided transformation of the Chartres formula.

The upper part of the main vessel of the choir does not preserve its original form. In a reconstruction (fig. 285) Branner has eliminated the extra piers added after the collapse of the high vaults in 1284 and has revealed the nature of the glazed triforium and clerestory as it probably looked in 1272, the date of the completion of the choir. Branner argues that the third architect of Beauvais began work on the superstructure between 1250 and 1255; he heightened the vaults and attenuated the design projected by the first master. As it existed in 1272, the glazed triforium was linked to the four windows of each bay of the clerestory by three continuous colonnettes, which, in turn, divided the triforium into four sections, each containing a pair of arches. In the hemicycle (fig. 284) the original connection between triforium and clerestory can be seen.

To equalize the thrust of the vaults, rising to

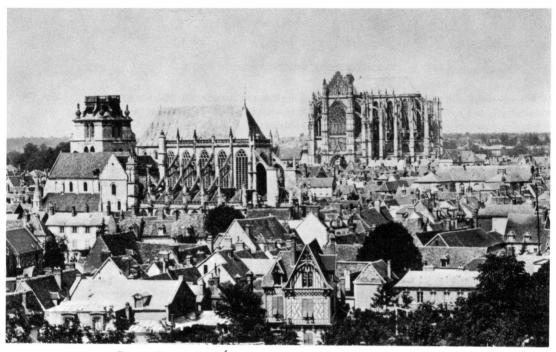

Fig. 292. Beauvais. Saint-Étienne, choir, after 1506; Cathedral, begun c. 1225

Fig. 293. Beauvais Cathedral. Carolingian nave, transept

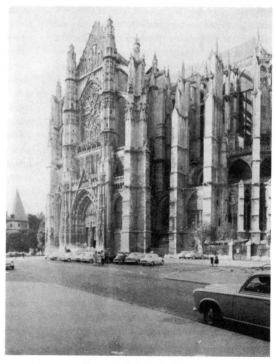

Fig. 294. Beauvais Cathedral. Transept, XVIth century; choir

157 feet 6 inches, the third Beauvais master erected the tall thin piers from which the flying buttresses spring in two flights and two stages (figs. 289, 291). These spidery arches (cross section, fig. 287), placed so high above the radiating chapels, seem to float in space. Added metal tie rods further dramatize the fragility of the buttresses. Following the collapse of the vaults in 1284, the choir was reconstructed by 1322. The transepts were constructed in the sixteenth century in the ornate and dynamic Flamboyant style (figs. 293, 294). The lacelike surfaces of the south side of the transept (fig. 294) echo the elongated elegance of the exterior of the chevet, but appear strange indeed when contrasted to the Carolingian nave (fig. 293). The remnant of the modest Carolingian structure appears as a midget beside a giant.

In the late 1190's the master of Soissons refused to repeat the design of Chartres. Although trained in the Chartres workshop, he imparted a lightness to the Cathedral of Soissons which reflects a sympathy with, or the influence of, the south transept of Soissons, begun in the 1170's. Jean d'Orbais, the first master of Reims in 1211, transformed the Chartres format by deepening the radiating chapels and linking the triforium and clerestory in the hemicycle of the chevet. The Chartres formula was thus altered by a reaffirmation of the Rémois tradition of Saint-Remi of Reims, begun in 1170. In the nave and façade of Amiens, started in 1220,

Robert de Luzarches combined the Chartres-Soissons-Reims format with a reinterpretation of older Early Gothic features, such as the design of the triforium. However, he increased the linkage of the triforium and clerestory and treated the wall as a screen with many planes in space. The first master of Beauvais, commencing the construction of the chevet in 1225, further modified the Chartres-Reims formula and designed a plan which served as model for the chevet of Amiens. He continued the trend of reducing the wall to a screen and increased the interpenetration of triforium and clerestory. In his design of the ambulatory and inner aisle of Beauvais, he revealed his knowledge of the cathedrals of Bourges (1194) and probably Le Mans (after 1217) when he crowned the ambulatory and inner aisle with a triforium and clerestory. However, it was only the idea of a church within a church, giving the interior of Beauvais its pyramidal section, which the master of Beauvais employed from the Bourges innovation. Instead of continuing the design of the inner aisle of Bourges or Le Mans, the Beauvais master created a new triforium and clerestory joined into one story. Thus, the chevet of Beauvais, in spite of its rebuilt and altered condition today, is a dramatic synthesis of the two major High Gothic formats: the High Gothic of Chartres and of Bourges.

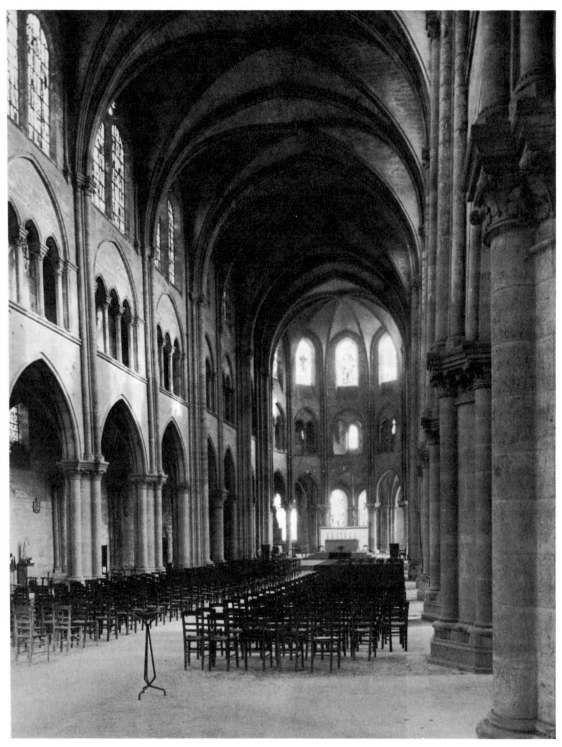

Fig. 295. Saint-Leu d'Esserent. Choir, c. 1170; nave, early XIIIth century

Saint-Leu d'Esserent and Rampillon

It would be misleading to conclude the discussion of High Gothic architecture in France without including an analysis of one or two small churches. Hundreds of parish churches and monastic priories were constructed during the twelfth and thirteenth centuries. Their relatively small size often necessitated changes in design; yet their main stylistic features echo the evolving and ever-changing styles of the Gothic cathedrals. In its major campaigns of construction, Saint-Leu d'Esserent, originally a Cluniac priory, reveals the whole history of Gothic from its experimental stage in the first half of the twelfth century through an Early Gothic to a High Gothic phase (figs. 295–303). No documents exist to help determine when various parts of the church were begun or completed. However, it is possible to recreate the history of Saint-Leu d'Esserent by studying all its parts in detail and by comparing and contrasting it with documented monuments.

Saint-Leu d'Esserent, dedicated to Saint Leu or Saint Loup, Bishop of Sens, who died in 623, now serves as the church for the small community of the same name on the bank of the river Oise just west of Chantilly, twenty-five miles due north of Paris. As viewed from across the Oise (fig. 303) and from the southeast (fig. 298), the towers flanking the choir dwarf the tower of the façade. The mural emphasis in the chapels and clerestory seems inconsistent with the flying buttresses. From the side (fig. 296) the lack of rapport between nave and façade is clearly revealed. The aisles of the nave project out beyond the narthex (fig. 299). Upon entering Saint-Leu d'Esserent, the visitor is struck by the squat proportions of the nave vessel

(fig. 295). The three-story elevation of nave arcade, triforium, and clerestory is continuous down the nave and around the choir, but the treatment of each element in the elevation changes after the sixth bay of the nave (figs. 295, 301, 302). In the hemicycle and the two eastern bays, one with a four-part vault and the western one with a six-part vault, the clerestory windows are small. The triforium contains two arches, and the piers of the six-part bay alternate between major and minor piers (figs. 301, 302). The six western bays of the nave have uniform piers, four-part vaults, larger triforia, and a clerestory of two lancets crowned by a rose. Further, the nave is out of alignment with the west narthex (figs. 299, 301), and engaged half-columns and remnants of a portal of a much smaller size are visible on the east wall of the narthex.

The known history of Saint-Leu d'Esserent is of little help in explaining the inconsistencies of size, scale, and alignment or in determining what part of the priory was built when. An analysis of alterations and restorations does, however, help reconstruct the original character of the church. In 1081, Hugues, Count of Dammartin, established Cluniac monks at Saint-Leu d'Esserent. A small church already existed, located in what is now the middle of the present nave. Soon after 1081 the priory constructed a larger Romanesque structure. Fragments of this building can be seen on the interior wall of the narthex (figs. 301, 302) and in the door in the north aisle. A dispute between the monks and townspeople resulted in the meeting of Raoul, Abbot of Cluny, and Robert, Count of Clermont, on February 24, 1176. A forti-

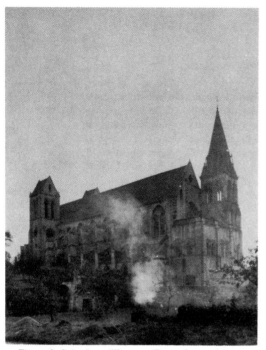

Fig. 296. Saint-Leu d'Esserent. From the northwest

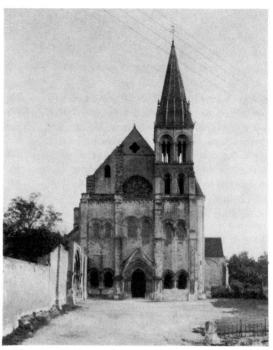

Fig. 297. Saint-Leu d'Esserent. Façade, second quarter of XIIth century

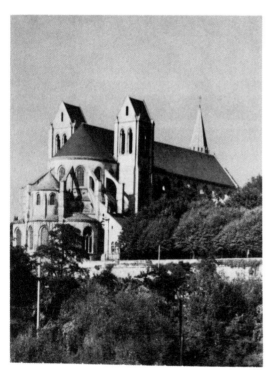

Fig. 298. Saint-Leu d'Esserent. Choir from southeast, 1170–1180's

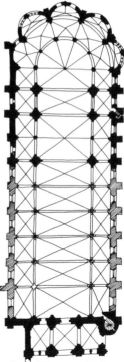

Fig. 299. Saint-Leu d'Esserent. Choir, 1170's–1180's; nave, early XIIIth century. Plan (after Lefèvre-Pontalis)

fied house was given to the priory, and half the proceeds of the local fair were turned over to the monks. No other documents exist which would help in clarifying the campaigns of construction.

According to M. Paquet, the chief architect of the Monuments Historiques (see bibliography), a crack in the clerestory level of the chevet necessitated the construction of the upper stage of the flying buttresses in the late twelfth century. The lower stage of buttresses of the choir was originally hidden under the roof over the ambulatory. Apparently, sometime after the completion of the nave its walls began to bow outward (figs. 295, 301). Since the single upper stage of the buttresses of the nave proved an insufficient counterthrust for the vaults, additional buttresses in one or two stages were added over the aisles. In the nineteenth century, metal tie rods were placed across the six western bays of the nave to stop the continuing deformation of the walls. These tie rods stabilized the church until World War II. In 1943 the Allies were forced to destroy the road leading from the Saint-Leu quarries to the Pas-de-Calais. The deep quarries, which had supplied the stone for Versailles and for much of seventeenth- and eighteenth-century Paris, were being used by the Germans for the assembly of rockets, which were then transported to the launching sites on the coast. In the process of bombing the road which circumnavigates the chevet of the priory, two large bombs penetrated the church, one near the façade and one between the towers flanking the choir. An ingenious system of reinforced concrete within the walls of the clerestory and tied to interlocking arches over the vaults has made possible the elimination of the unsightly metal rods across the nave and has completed the stabilization and restoration of the structure.

On the basis of a study of Saint-Leu d'Esserent itself and by comparison with other monuments, it is possible to reconstruct its campaigns of construction. In the second quarter of the twelfth century a decision was made to enlarge the existing Romanesque structure by the addition of a narthex of three bays with gallery above and two towers, following the Cluniac tradition (figs. 297,

299). By the 1130's and 1140's ribbed vaults of an experimental nature were utilized in many monuments which were still essentially Romanesque in their forms. The narthex and porch were vaulted with simple ribbed vaults of domical profile, while the façade maintains its mural character with strong Norman overtones. Old photographs of the façade prove that the lower pointed windows of the narthex are the result of nineteenth-century restorations.

Since the east end of Saint-Leu d'Esserent is much larger in dimension and scale than the façade, it is clear that the monks decided to start a much more ambitious program on the new land to the east of the apse of the old Romanesque church. The slope of the terrain toward the Oise River required the construction of thirty feet of massive footings under the radiating chapels and the ambulatory (figs. 298, 303). The plan of the chevet (fig. 299) has many points of similarity with that of the cathedrals of Noyon and Senlis and with the church of Saint-Germain-des-Prés in Paris. All have five radiating chapels growing out of a single ambulatory; all are more conservative than Suger's daring solution at Saint-Denis (fig. 128). The shallow radiating chapels recall those of Senlis, begun in the 1150's and finished in the late 1160's. If the interior of the ambulatories of Noyon (fig. 156) and Saint-Leu d'Esserent (fig. 300) are compared, the similarity of design is apparent, although the moldings of the transverse ribs suggest a later date for the latter. Since the radiating chapels of Noyon were completed by about 1165, this part of Saint-Leu can be dated about 1170. One unique feature of Saint-Leu d'Esserent is the alternation in two places of the size and construction of the supports for the hemicycle (fig. 300). Four of the piers are squat and built of horizontal courses of masonry, while two are slender monoliths.

The choir proper, consisting of arcade, triforium, and clerestory, has no connection with the four-story elevation of Noyon, Laon, or Notre-Dame in Paris. In the area directly around Paris in the last decades of the twelfth century, there are three different solutions of the treatment of

the Early Gothic elevation. Notre-Dame of Paris (fig. 183) has four stories (nave arcade, gallery, triforium with oculus, and clerestory). The collegiate church of Mantes (figs. 186, 187) and the Cathedral of Senlis preserve the vertical proportions of the four-story church, but eliminate the triforium and are thus three-story structures. Saint-Germain-des-Prés and Saint-Leu d'Esserent eliminate the gallery, but treat the openings into the unlit roof area over the ambulatories as though they were the openings of galleries. Thus the elevation of Saint-Leu d'Esserent consists of an arcade, false triforium, and clerestory, a system which first appeared in Early Gothic in the Cathedral of Sens (c. 1140, figs. 140, 142). The fact that the elevation of Sens bears a relationship to the Cluniac monasteries of Burgundy should not be forgotten. It is the system of Sens and the choir of Saint-Germain-des-Prés which the master of Saint-Leu d'Esserent employed in the chevet. Since a gallery was omitted, heavy buttresses under the roofs covering the ambulatory were essential to meet the thrust of the vaults of the apse. Today these buttresses are exposed and comprise the lower tier of the flying buttresses. The sloping roof, which protected the vaults of the ambulatory, has been removed, and the exterior walls have been modified. An extra chapel at the triforium level was added in the thirteenth century. The upper stage of the buttresses was added after (or more probably during) the completion of the superstructure in the 1180's or early 1190's. The apse of Saint-Leu d'Esserent is thus a three-story Early Gothic structure. Saint-Leu d'Esserent, together with Saint-Vincent of Laon (1174–1205, and now destroyed: see bibliography), in their three-story elevation of arcade, triforium, and clerestory, contains the germ of the High Gothic Cathedral of Chartres.

The first two bays of the choir consist of a rectangular four-part vault flanked by aisles from which rise a pair of towers and a square six-part bay with alternating compound piers and plain columnar supports (figs. 299, 301). This Early Gothic system, in which the space is compartmented in large cubes crowned by domical vaults,

is reminiscent of Sens Cathedral (fig. 139) and Noyon (fig. 153). At Saint-Leu d'Esserent, the three largest colonnettes of the major piers rise to capitals from which spring the transverse and diagonal ribs, while the smallest colonnettes are continuous with the wall or longitudinal ribs. Small, single lancet windows perforate the clerestory of these choir bays. This part of the priory, the choir, was probably completed by 1200.

The third campaign, with six bays of the nave (figs. 295, 301, 302), reveals both the continuation of ideas started in the choir and innovations which reflect the High Gothic style. The uniform piers with four attached colonnettes, the four-part vault, the three-story elevation, the clerestory window with two lancets surmounted by a rose, and the flying buttresses are the new High Gothic style first formulated by the master of Chartres Cathedral. The squat proportions of the nave, which is only 66 feet high, continues that of the Sens-like choir, while the design of the triforium follows the Early Gothic format of the triforium of the choir with its apertures resembling those of a gallery. The nave bays, as contrasted with the six-part vaults and alternating supports, dramatically juxtapose the High Gothic and Early Gothic points of view. The master who supervised the campaign of the nave in the early years of the thirteenth century attempted to keep a harmonious relationship between choir and nave by continuing both the wide proportions and the treatment of the triforium. He increased the arcade of the triforium to three openings, made the arch embracing the arcade more pointed, and doubled the size of the clerestory by employing a pair of lancets surmounted by a single rose. The great width of the nave in relationship to its height proved to be insufficiently stabilized by the single-stage flying buttresses. The deformation of the walls, which appeared only in the nave (figs. 295, 301, 302), required the addition of lower stages of flying buttresses and tie rods. The situation was not solved finally until the drastic surgery following the severe damage inflicted during World War II.

The plan of Saint-Leu d'Esserent (fig. 299),

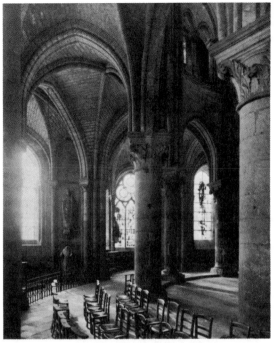

Fig. 300. Saint-Leu d'Esserent. Ambulatory, c. 1170

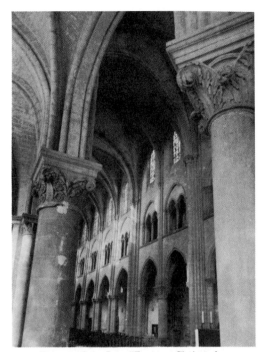

Fig. 301. Saint-Leu d'Esserent. Choir and nave

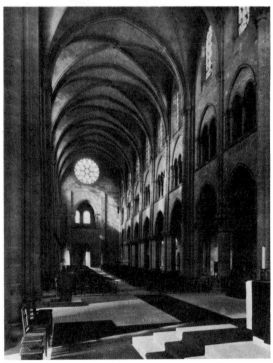

Fig. 302. Saint-Leu d'Esserent. Choir, c. 1170 ff; nave early XIIIth century

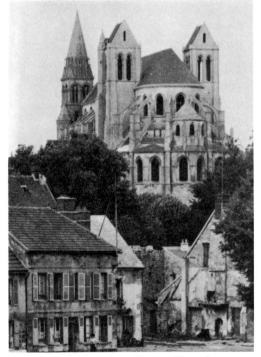

Fig. 303. Saint-Leu d'Esserent. From the east.

with two aisles and no transepts, follows a precedent established by Notre-Dame at Paris and found in many monuments in the environs of Paris. Towers flanking the choir can be seen in Noyon Cathedral and in early Romanesque structures like Morienval. Toward the end of the third campaign, in the westernmost bay of the nave the axis was shifted so that the nave could join the much older narthex. A decision must have been reached to abandon any scheme of erecting a new High Gothic façade of the same scale as the choir and nave. The final statements of the Middle Ages at Saint-Leu d'Esserent are the fourteenth-century windows which replaced the twelfth-century ones in the southernmost radiating chapel (fig. 298) and the late Gothic Flamboyant west rose window. Saint-Leu d'Esserent, in all its parts, reflects the whole history of Gothic architecture. The façade contains experimental Gothic technological ideas within a Romanesque format; the east end is three-story Early Gothic reflecting the elevation of Sens Cathedral; the nave is High Gothic, yet respecting some older Early Gothic features; certain details were added in the late Middle Ages. In spite of the many periods represented in Saint-Leu d'Esserent, there are an exquisiteness of scale, a forcefulness of statement, and a sympathetic harmony of parts which mark this priory as a distinguished monument.

THE dramatic silhouette of the great Gothic cathedrals discussed in previous chapters manifests the importance of the cathedrals in urban life. As the major place of worship in the town, as the backdrop for religious plays and the great fairs, and as the climax of pilgrimage, the cathedral states its central role in Medieval life by its majestic size and its location on the highest terrain within the walls of the town. During religious holidays and fairs, the peasants traveled from farms to town to sell their produce and to participate in the public life of the urban community. Yet hundreds of country churches existed to serve the peasantry in its daily life. Rampillon is such a church.

Rampillon is forty-two miles southeast of Paris

on the frontier of two parts of Brie, one of which was controlled by the King of France and the other by the Count of Champagne. In spite of the hostility between Thibault IV, Count of Champagne, and Queen Blanche of Castile, Regent of France in the 1220's, Brie remained a prosperous province. The famous fairs of Champagne at Troyes (forty miles southeast of Rampillon) and at Provins (eleven miles east of Rampillon) drew merchants from England, Flanders, France, and Italy, as well as the local peasants. In 1284 Champagne became part of the royal domain through the marriage of Jeanne de Navarre, the last Countess of Champagne and Brie, and the future Philip the Fair of France. Rampillon had been under the jursidiction of the Archbishop of Sens since 1122. Only parts of one of the two earlier churches exist in the present structure. The main benefactor of the church in the thirteenth century was Jeanne de Prunai, wife of the Seigneur of Vienne, who transferred the control of the church to the templars of Saint-John of Jerusalem.

The existing church (figs. 304–307), situated on a gentle rise in the fertile plain and surrounded by farms, is a High Gothic cathedral in miniature. It is 122 feet long, and the vaults rise only 46 feet above the pavement, about one-third the height of those at Reims Cathedral. Like the naves of the cathedrals of Chartres, Soissons, and Reims, the main vessel of Rampillon is divided into three stories: nave arcade, triforium, and clerestory; and following the High Gothic style of these cathedrals, the piers of the nave have four attached colonnettes, and four-part vaults crown the rectangular bays. Because of its small size, the master of Rampillon, who probably received his training in the workshop of the Cathedral of Reims, redesigned the High Gothic elevation. The clerestory is slightly taller than the triforium, while the nave arcade is only twice as high as the triforium. The height of the triforium, which is a passageway and thus of paramount importance to the scale of the building, has remained constant, and the clerestory and nave arcade have been considerably reduced in size. The Rampillon master

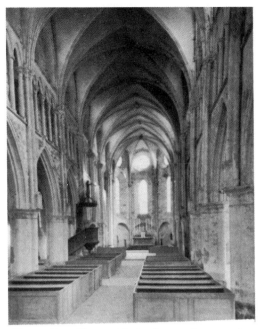

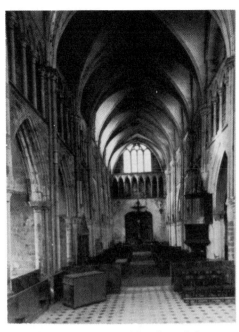

Fig. 304. Rampillon, parish church, second quarter of
XIIIth century. Nave

Fig. 305. Rampillon. Nave from choir

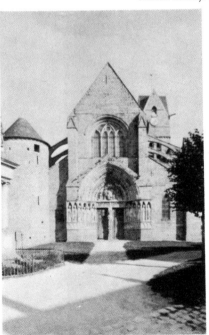

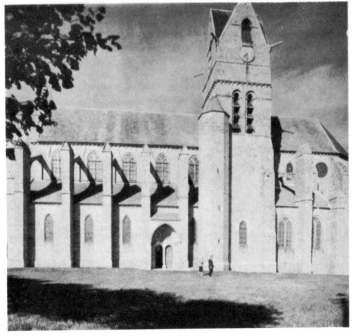

Fig. 306. Rampillon. Façade

Fig. 307. Rampillon. South flank

widened the High Gothic proportions to create sufficient space for the congregation. If the proportion of Reims were reduced correspondingly, the nave of Rampillon would be only 16 feet wide.

The oldest parts of Rampillon are the base of the tower, in the third bay of the south aisle, and the plan of the choir (fig. 307). These areas are probably remnants of the second of the two churches of the twelfth century. Work on the present church seems to have progressed from east to west. The simple aisleless choir, round at its base and polygonal above, is illuminated by lancets crowned by oculi. The oculi perhaps reflect the treatment of the triforium in the Cathedral of Paris (fig. 183), which seems to have influenced several monuments in the environs of Paris, such as the church at Mantes, where the exterior windows of the gallery consist of oculi (fig. 192).

The three eastern bays at Rampillon are earlier than the nave. The clerestory windows consist of single lancets, while the piers and engaged colonnettes exhibit variety when contrasted with the uniform treatment of all elements in the five western bays. The second pier from the east on the south aisle (fig. 305) has three colonnettes which rise uninterruptedly to the springing of the ribs. This pier supports the twelfth-century tower and was probably modified during the thirteenth-century campaign. The pier directly opposite on the north side (fig. 305, pier on right) has five colonnettes rising from a capital — a design which recalls the nave piers of Chartres Cathedral. The piers of the five western bays are uniform, with four attached colonnettes and capitals having a simplified base of ornament around their entire circumference. The capitals seem to be a provincial simplification of the treatment of the Reims capitals. Only three colonnettes, instead of five as at Reims, rise to the springing of the ribs.

Several unusual features of the superstructure of Rampillon make it different from the High Gothic elevations of Chartres, Soissons, and Reims. First, the ribs spring from a multiple capital at the level of the capitals of the triforium arcade. This low point of springing of the vaults

resembles that of the choir of Canterbury (1174 ff.), the trinity chapel of Canterbury (1179 ff.), and the choir of Saint-Remi at Reims, begun in 1170 (fig. 194). Further, the clerestory is set back under a containing arch behind the inner plane of the nave arcade and triforium (figs. 304, 305). The longitudinal rib is no longer a wall rib framing the clerestory window, but is the continuation of the inner plane of the nave arcade and triforium. This setback of the clerestory, lightening the weight of the superstructure, and the subordination of the horizontal stringcourses framing the triforium to the colonnettes and ribs are both features which can be seen in several monuments in Burgundy, such as Notre-Dame at Dijon (1220 ff.). At Rampillon, the passageway through the arch embracing the clerestory (as at Dijon and in other related monuments) is eliminated. The interior of Rampillon is thus not just a small variant of the High Gothic of Chartres and Reims, but has many stylistic connections with the group of conservative monuments surrounding the Île-de-France which react against or resist the High Gothic solutions by rethinking older twelfth-century solutions (see bibliography: Bony article).

From the flank (fig. 307) Rampillon appears as a simple, horizontal mass interrupted by the clock tower. The transeptless plan, with the tower growing out of an aisle bay, is similar to the organization of Saint-Leu d'Esserent. From the point of view of plan alone, Rampillon, like Saint-Leu d'Esserent, is related to several transeptless plans in the environs of Paris which, in turn, reflect the Cathedral of Notre-Dame in Paris. The single stages of the flying buttresses spring from plain piers. Before the lower buttresses of Saint-Leu d'Esserent were added to the original single stage of high buttresses along the nave, the flank of Saint-Leu d'Esserent resembled that of the nave of Rampillon.

Progress of the construction of Rampillon can be followed on the exterior (fig. 307). The clerestory windows of the eastern bays are small, single lancets. This treatment continues in the aisles of the nave, but the clerestories of the nave have twin lancet windows with glazed tops. The final

campaign of Rampillon, involving the reconstruction and enlargement of the two south aisle bays east of the tower, resulted in a change of the windows. The façade (fig. 306) is simply composed; the width of the nave is echoed in the central bay, with its splayed portal and large round-headed clerestory window flanked by wall buttresses. The central bay is flanked by the flat terminations of the aisles and on the northwest corner by the squat, circular tower. The shapes of the piers of the flying buttresses on the flank are repeated on the wall buttresses of the façade. The portal, containing the Last Judgement in its tympanum and the Twelve Apostles on the jambs, concentrates attention on the doorway. The style of the sculpture owes a debt primarily to ateliers of Reims Cathedral and, secondarily, to monuments in the Île-de-France.

Rampillon (see bibliography) is usually dated in the second half of the thirteenth century, around 1270. The aisle bay under the clock tower is late twelfth-century, but the rest of the church, built from east to west, can be dated in the second quarter of the thirteenth century. If it is assumed that a provincial church does not lag behind developments in the design of urban cathedrals, it is possible to argue that Rampillon was finished in the 1240's. All the architectural ideas, as well as the style of the sculpture, can be found in monuments spanning the first three decades of the thirteenth century.

Rampillon is more than a country simplification and reduction of a cathedral. Features derived from the High Gothic cathedrals, such as Reims, are combined with regional traditions of a transeptless plan (Paris area) and unusual handling of clerestory (Burgundy). The homogeneity and clarity of statement and the imaginative transformation of High Gothic ideas at Rampillon point up the universal quality of High Gothic, whether in the great cathedrals or in a little church on the fertile plain of Brie.

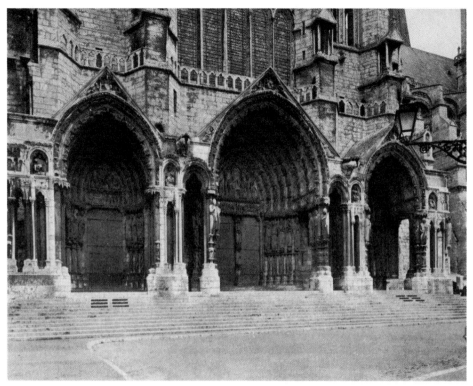

Fig. 308. Chartres Cathedral. North transept, 1204–1224

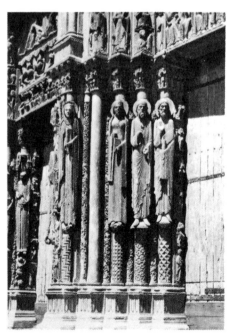

Fig. 309. Chartres. Royal Portals, c. 1145

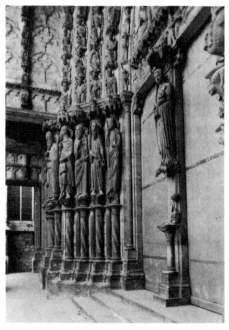

Fig. 310. Chartres. North transept, central portal, 1204–1210

High Gothic Sculpture and Painting

JUST AS the master builders of Chartres, Bourges, Reims, and Amiens used the past as authority and created a new High Gothic architecture, so the sculptors of the thirteenth-century portals synthesized divergent ideas to develop a new Christian classicism of great dignity and power. Stained-glass windows and manuscripts reveal the same High Gothic synthesis. This chapter will concentrate on the transept portals of Chartres and the façades of Amiens and Reims. It will include analysis of four Coronations of the Virgin of different size and in different media and two of the stained-glass windows at Chartres. The discussion of a series of Madonnas will recapitulate the evolution of Medieval sculpture and lead directly into Part IV.

The transepts of Chartres Cathedral were carved some fifty years after the Royal Portals of the west façade. After the fire of 1194, work commenced on the single central portal of the north transept, probably as early as 1204 (fig. 308). In that year the cathedral received a relic of the head of Saint Anne taken during the sacking of Constantinople in the Third Crusade. The presence of Saint Anne and the Virgin on the trumeau of the central portal might be related to the gift of this relic to Chartres, although the iconographical connection between Saint Anne and the Old Testament is logical in the context of this portal. The single portal of the north transept was completed about 1210. The three portals of the south transept (figs. 311–314) were planned from the start and were begun about 1210 and finished by 1217 or slightly later (see bibliography). The program to expand the north transept, which necessitated changes in the buttresses, involved the addition of the side portals and porches and was finished by about 1220 to 1224. An order to remove wooden shops attached to the south transept, dated 1224, establishes the time for the commencement of the porches of the south transept. The sequence of dating is as follows: north central portal (1204–1210), three south transept portals (1210–1217), north transept side portals and porches (finished by 1220 to 1224), and south transept porches (after 1224).

The Chartres north transept, erected in two stages (figs. 308, 310), includes in part the following subjects: (left portal) Adoration of the Magi in the tympanum, the Nativity and the Annunciation to Shepherds on the lintel, and the Annunciation and Visitation on the jamb statues; (central portal) the Coronation of the Virgin in the tympanum, Her Death and Resurrection in the lintel, and Patriarchs and Prophets on the jambs; (right portal) the Temptation and Suffering of Job on the tympanum. The three portals of the north transept and huge rose window and lancet windows above are dedicated to the Virgin Mary and to the Old Testament. The increasing veneration of the Virgin in the early thirteenth century is stressed by Katzenellenbogen in his analysis of the Coronation of the Virgin in the central tympanum of the north transept (see bibliography and fig. 324). Medieval Scholastics read two passages of the Old Testament as predictions of the Virgin's triumph, and these passages, together with a letter of the Pseudo-Jerome of the ninth century,

were read during the canonical hours of the Assumption Week. These readings seem to have been the main source of this scene. Further, Peter of Roissy, Chancellor of the School of Chartres (1208–1213), probably wrote a commentary on the Song of Songs which emphasized the interchangeability of Mary and the Church and thus the Church as Christ's Bride.

As Katzenellenbogen has indicated, Peter of Roissy also wrote a commentary on the Book of Job and presumably selected the subject of Job on the dung heap for the right tympanum to depict Job's suffering as a prefiguring of Christ's bodily suffering and to symbolize the establishment of the Church as Christ's Body. The entire north transept, with Mary as the Mother of Christ (left tympanum), Mary triumphantly enthroned with Her Son (central tympanum), and the Church as the suffering Body of Christ (right tympanum), is a lucid and powerful statement in stone attacking the heretical argument which denied that Mary was the true Mother of Christ. In 1210 Renaud of Mouçon, Bishop of Chartres, and many leaders of the Church fought in the crusade against the Albigensian heretics in the south of France. Their action in suppressing the heretics is reflected in the program of the north transept of the church. The whole program of the north transept was thus clearly spelled out by the clergy and reflects the contemporary problems which the church was attempting to resolve.

The jamb figures of the left side of the central portal of the north transept (fig. 310) are Old Testament patriarchs and prophets who prefigured Christ (arranged in historical order from left to right: Melchizedek, Abraham, Moses, Samuel, and David). In contrast to the figures on the west portals of Chartres (fig. 309), these figures possess more freedom of pose. Abraham holding the head of Isaac turns to his right, while Moses gazes diagonally into space. The strict frontality and rigid axis of the west portal jambs is relaxed; yet each figure continues to be an integral part of the architectural splay of the portal. The figures, resting on short columns and crowned by canopies, are echoed in the curving archivolts above.

The separation of the short columns from the jamb statues by moldings and the sculptured corbels and the use of projecting canopies over the statues emphasize the horizontal zones of the portal more than those zones are emphasized in the west portals. The slender attenuation of the jambs of the west central portal is reduced to normal proportions in the north portal, and greater emphasis is placed on gestures in lateral directions. The drapery reveals more anatomy and suggests more movement than do the vertical, architectonic folds of the figure of the Royal Portals. Heads are given greater individuality through varying treatment of beards and hair.

The Saint Anne holding the Virgin on the trumeau of the central portal of the north transept (figs. 310, 324) echoes in pose and in confining silhouette the supporting pilaster of which it is an integral part. The slight turn of Anne's head is balanced by the axis of the Infant Virgin. Above the loose folds which flare out over her ankles and feet, Anne's garment accents the verticality of the trumeau. There is no counterpart to these curving folds on the west portals, either in the jamb statues or in the enthroned Madonna and Child on the right tympanum (figs. 214, 215). The source of this more relaxed and resolved point of view can be found in the damaged and greatly restored sculpture of the Cathedral of Laon (1180's to 1190's).

The sculptors of this portal certainly knew the portal of Senlis (about 1175, fig. 208) and the west portals of Laon; yet at Chartres the dynamic movement through swirls of drapery, twisted poses, and undercutting of surfaces is quieted by the influence of the Chartres tradition as established in the west Royal Portals (1140's). A sense of calm pervades the Old Testament heroes and Saint Anne. Like the master builder of Chartres, who combined diverse elements of Early Gothic structures to create the first High Gothic cathedral, the sculptors of Chartres established a synthesis out of the dynamic late twelfth-century portals tempered by the frontal rigidity of the earlier Chartres portals. Moses, Samuel, and David, the right-hand three (fig. 310), still preserve the col-

umnar character of the west portal figures, but each is personalized and humanized.

The south transept of Chartres is dedicated to Christ and stands for the established, historical Church on earth (figs. 229, 311–314). On the central portal the Beau Dieu, Christ the Teacher, makes up the trumeau (fig. 318). The Apostles, who spread His teachings, adorn the jambs, while Christ the Judge (in the Last Judgement of the tympanum) sits enthroned between John and the Virgin, surmounted by the instruments of His Passion. The left portal is dedicated to the Martyrs who gave their lives for Christ and the Church. The tympanum contains Christ the Supreme Martyr flanked by two angels, while the lintel relates the stoning of Saint Stephen. On the right portal (fig. 314), which is dedicated to the Confessors whose virtuous lives affirm their faith in Christ, are scenes from the lives of Saint Martin and Saint Nicholas. On the left side of the lintel, Saint Martin on horseback gives half his cloak to a beggar. Above this scene in the tympanum, Christ wearing the part of the cloak given to the beggar appears to Saint Martin in his sleep. On the right side, Saint Nicholas drops a purse containing dowries into the house of a poor man whose daughters were about to lead lives of ill repute. In the tympanum above, people come to the tomb of Saint Nicholas to be cured by blood coming from his tomb. The top of the tympanum is completed by a half-length Christ flanked by angels. These three portals, together with the north transept and the porches of both transepts, give a more complete history of the Church in all its aspects and ramifications than any other sculptural ensemble of the Middle Ages.

The jamb statues on the right side of the central portal include (from left to right) Saints Paul, John, James Major, James Minor, and Bartholomew (figs. 311, 312). In style they are so close to the jamb figures of the north central portal that the same sculptor or sculptors would seem to have worked on both. The Christ of the Last Judgement (fig. 311) is no longer the terrifying and abstract judge of Romanesque art (see Moissac, fig. 100), nor is he the aloof Christ of the Chartres west portals (fig. 210). This Christ, seated stiffly between the Virgin and John, is calm and merciful. All three figures, as well as the angels holding the instruments of the Passion, project outward from the background. The thrones, clouds, and other details on the lintel suggest a physical environment. As Katzenellenbogen points out (see bibliography), the stylistic changes between the Royal Portals and the transept portals reflect the shift from the rigorous ideology of the School of Chartres toward the more humanistic emphasis of the Aristotelians at the University of Paris.

The jamb statues of the right portal of the south transept (fig. 314) are more massive and expressive than the Apostles on the central portal (fig. 312). The three right-hand figures (Saints Martin, Jerome, and Gregory) have long heads with parted lips and long noses. These individualized faces and the more complicated composition of lintel and tympanum suggest a new and different artist or atelier, perhaps coming from Sens (about 1190–1200).

The inner three jamb figures of the left portal of the south transept (Saints Stephen, Clement, and Lawrence, fig. 313) are stiffer and more frontal than the Apostles on the central portal and were probably carved by an assistant of the sculptors working on the central portal. These three belong to the original campaign, while Saint Theodore, on the left, was carved after 1224 for the new campaign of the porch. A new and implied movement and militant energy are manifested, and greater individualism is emphasized in his face. Saint Theodore still needs the wall to support him, as no interest in anatomical articulation existed in the Middle Ages. Instead, a kind of ideal, harmonious balance between spirit and body is achieved.

The west façade portals of Notre-Dame at Amiens (figs. 315, 316), begun in 1220 following the fire of 1218, contain the purest and most classic arrangement of subject matter. Without the necessity of considering an older structural ensemble as at Chartres and without the problem of changes in design and program as at Reims, the clergy and designers of the Amiens façade could

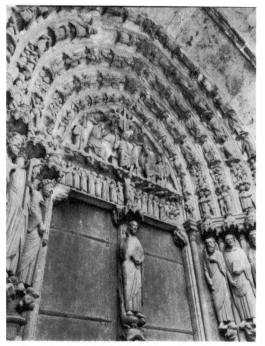

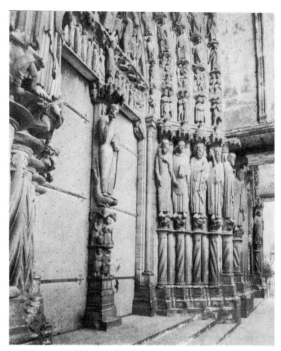

Fig. 311. Chartres. South transept, central portal,
1210–1217

Fig. 312. Chartres. South transept, central portal,
1210–1217

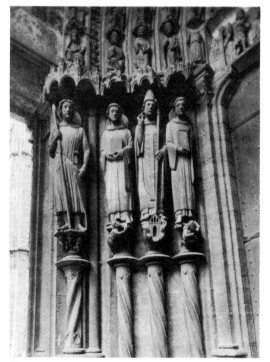

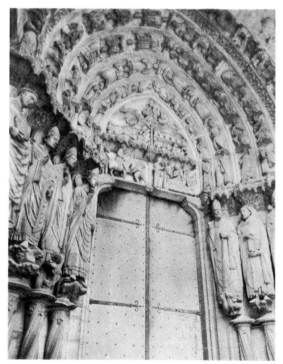

Fig. 313. Chartres. South transept, left portal. Theodore
after 1224; other three, 1210–1217

Fig. 314. Chartres. South transept, right portal,
1210–1217

collaborate on a uniform design of extraordinary consistency and meaning which was completed in from ten to fifteen years.

The right-hand portal, dedicated to the Virgin Mary, has the Coronation of the Virgin and Her Death and Assumption in the tympanum and lintel, following the arrangement of the central portal of the north transept at Chartres. The trumeau consists of the Virgin and Child, while the jambs include the Annunciation, Visitation, Presentation, Adoration of the Magi, and Solomon and the Queen of Sheba. The Annunciation and Visitation also derive from the Chartres north transept. The left portal is dedicated to Saint Firmin, the first Bishop of Amiens, who appears on the trumeau. The jamb statues are the saints of the diocese, and the quatrefoils beneath the figures function as a Book of Hours, containing the Labors of the Month and the Signs of the Zodiac.

The statues on the front planes of the four pier buttresses are the twelve Minor Prophets, who were regarded as having predicted the coming of Christ (see bibliography: Katzenellenbogen). The pairs of quatrefoils under each prophet illustrate Old Testament passages and depict the acts, visions, and prophecies of the prophets and hint at the coming salvation or damnation of mankind. In an hierarchy of importance, the twelve Minor Prophets in groups of three on each pier lead directly into the outer four statues on the splays of the central portal, which are the four Major Prophets. Beside these piers of Major Prophets are the twelve Apostles, who are Christ's chosen witnesses. The Apostles stand above pairs of quatrefoils containing images of the virtues and vices. The six Apostles on each side of the portal flank the Beau Dieu, Christ the Teacher, while above the door is the Last Judgement with Christ in the tympanum and Michael weighing the souls of the blessed and the damned in the double lintel. Thus the worshipper, upon approaching the façade, first sees the Minor Prophets, who prophesy the coming of the Messiah and whom he could originally identify by names painted on their scrolls. Upon nearing the concavity of the central portal, the worshipper passes between the

four Major Prophets and then the twelve Apostles, to be confronted by Christ the Teacher on the trumeau (fig. 318) and Christ the Judge above. As Katzenellenbogen states:

> The meaning of the two figures, the Beau Dieu and Christ the Judge, at the very entrance to the Church, that to medieval theology was the earthly image of the City of God, cannot be better explained than by quoting Saint Jerome: "But He stood in the door because by Him we come unto the Father and without Him we cannot enter the City of God, so that He may admit the worldly but reject the unworldly; for in the door is the Judgment."

The iconographical program of the Amiens portals (fig. 316) represents the ideas of the clergy, either bishop or chapter or both, while the designer of the portals was the master builder, Robert de Luzarches, who supervised the construction of the façade up to the gallery of the kings and the nave between 1220 and 1233. Since the rebuilding of the cathedral after the fire of 1218 proceeded from west to east, work on the portals began at once and became an integral part of the construction of both façade and nave. Instead of porches like those which were added to the south transept of Chartres or porches and side portals like those which were the result of the enlarged program of the Chartres north transept, the deep portals of Amiens are integrated with the pier buttresses which frame the portals and extend upward to divide the façade into three bays. The Chartres transept portals and porches (fig. 229) project out considerably in front of the bases of the towers and planes of the stained-glass windows and emphasize the horizontal organization of the transept façades.

At Amiens (figs. 315, 316) the bases in two zones, one with an all-over four-leaf-clover pattern and the other with two tiers of quatrefoils, extend out diagonally from the doorways and then define the rectangular pier buttresses. The jamb statues are placed along the splays of the portals and around the pier buttresses. On the front face of each of the four pier buttresses, the Minor Prophets stand on socles above two tiers of

three quatrefoils. From canopies over their heads rise three shafts culminating in two-pointed arches; in the area above these arches are two quatrefoils (original disposition on the two right piers only). Flanking the gables of the portals are two-pointed arches crowned by a single quatrefoil. Thus, in each pier a sequence of forms unites the horizontal zones of the portals with the rising façade (from bottom to top of the piers: two piers of three quatrefoils, three jamb statues supporting two arches, two quatrefoils, two arches, and one quatrefoil). Each horizontal zone across the entire façade is kept distinct, but shapes such as the quatrefoils and the thin-pointed arches are repeated vertically to unite the portals with the façade as a whole. A similar and related subtlety in design can be seen in the nave of Amiens (figs. 259, 262). The nave arcade, triforium, and clerestory are clearly separated by horizontal stringcourses, but the triforium and clerestory are connected vertically by the shaft which divides the two arcades of the triforium and continues upward to separate the four windows of the clerestory into two groups. These principles of subdivision within zones and of rhythmic repetition of forms in a vertical direction to suggest an interlocking of horizontals are a mark of the creativity of Robert de Luzarches. A logical and encyclopaedic program is thus synthesized with an imaginative formal design in the west portals and façade of Amiens.

If contrasted with the High Gothic portals of the Chartres transepts (figs. 310–314) and the Early Gothic west portals of Chartres (fig. 309), the individual portals of Amiens exhibit marked changes of design. In the Chartres portals (west, late 1140's, and transepts, 1204 ff.), jamb statues stand on short columns rising from staggered bases. The ornamented colonnettes between the statues of the west portals extend without interruption from bases to the historiated capitals, while in the transept portals horizontal moldings separate the short columns and colonnettes from the jamb figures; and canopies, projecting in front of a straight cornice, divide the jambs from the archivolts. The greater emphasis on horizontal

division in the Chartres transepts, when compared to the Royal Portals, is intensified in the organization of the Amiens portals (figs. 315, 316). At Amiens the splays of the portals, including the lowest ornamental tier, the zone of quatrefoils, and the wall behind the jamb statues, extend out diagonally and then shift to an axis of ninety degrees off the front plane of the façade to mark the depth of the pier buttresses. The jamb statues stand on deep consoles and in front of the columns to which they are attached. These columns continue above the canopies to floral capitals and convex abaci, from which rise the sculptured archivolts. The jamb statues of Amiens project more from the wall than those at Chartres. The narrow zone between the canopies above the statues and the archivolts is contiguous with the lower lintel in the side portals (fig. 315) and with the undecorated flat arch above the Beau Dieu on the central portal (fig. 319). The relative smallness of the floral capitals minimizes the separation of the jambs and the archivolts. The horizontal division of the portals is still apparent; yet the suggested overlapping of zones echoes the treatment of the triforium and clerestory in the nave. The archivolts are more pointed than those at Chartres and have their counterpart in the sharply pointed nave arcade.

The jamb statues on the left of the central portal (right to left: Paul, James Minor, Thomas, Matthew, Philip, Simon or Jude, Ezekiel, and Daniel — Major Prophets and a Minor Prophet) are conceived as individual figures; their heads are raised, lowered, or turned. Most of their attributes were recarved in the nineteenth century, and one suspects that the surfaces of the figures have been tampered with.

A comparison of the Beau Dieu of Chartres (after 1210, fig. 318) and the Beau Dieu of Amiens (after 1220, fig. 319) suggests a different interpretation of the human form as well as an evolution within High Gothic sculpture. The Chartres Beau Dieu, an integral part of the block supporting the lintel, is contained within the strict silhouette of the trumeau. His right arm and hand are pressed against His chest. The drapery is animated by

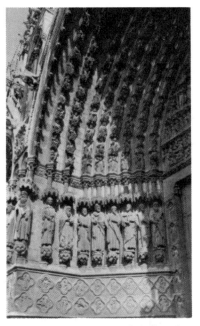

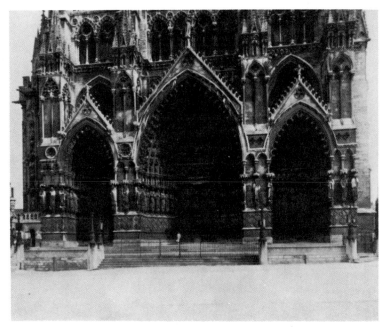

Fig. 315. Amiens Cathedral. Central
portal, 1220's

Fig. 316. Amiens Cathedral. Façade, 1220's

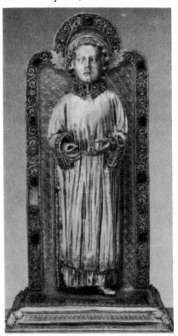

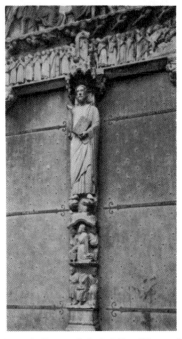

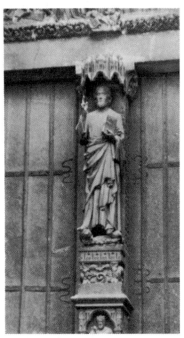

Fig. 317. Reliquary statuette of Saint Stephen,
region of the Meuse, c. 1220, silver gilt, 17 in.
(The Metropolitan Museum of Art,
The Cloisters Collection)

Fig. 318. Chartres Cathedral. Beau Dieu, south
transept, 1210 ff

Fig. 319. Amiens Cathedral. Beau Dieu, central
portal, 1220 ff

many small folds, but the bulkiness of the Christ is preserved. He stands as a massive teaching Christ suspended in space. Although the Amiens Christ echoes the shape of the trumeau, a new freedom pervades the entire figure. His blessing hand extends forward, and the undercut drapery creates pockets of shadow which animate the surface. A greater verticality is achieved by the upward sweep of deep folds, and great interest in suggested anatomy appears in feet and hands. The lithic character of the Chartres Christ becomes more relaxed in the physical presence of the Christ of Amiens. These differences between the two Christs echo the differences in the architecture of the two monuments. The nave of Chartres has more masonry preserved around the clerestory windows and the walls of the nave arcade. The triforium and the clerestory are all on the same plane. The interior of Amiens is taller and more soaring; surfaces are more complicated in the triforium and clerestory, and each zone recedes in depth. This evolution in Gothic architecture from clear division of parts and emphasis on the plane of the wall with windows cut out of the masonry (Chartres after 1194) to a design with interlocking parts, duplication of planes and depth, and increasing verticality (at Amiens after 1220) parallels the evolution of High Gothic sculpture as seen in the Christs of Chartres and Amiens.

The majestic poise, classic grandeur, and spiritual calm of monumental High Gothic sculpture are revealed with equal clarity in small objects such as the superb reliquary of Saint Stephen in The Cloisters, The Metropolitan Museum of Art (fig. 317: see bibliography). This silver-gilt reliquary, made about 1220, is 17 inches high and depicts Stephen, the first Christian martyr, standing in front of an elaborate panel. Originally a Bible, containing a relic of the Saint, was held by his sensitive hands. Semiprecious stones and glass decorate the panel and borders of his Deacon's vestments. The Stoning of Stephen and his Vision of Christ is engraved in copper-gilt on the back of the reliquary. Although the statuette was made in the Meuse Valley in eastern Belgium, it exhibits the strong influence of French High Gothic sculp-

ture. The engravings on the back show stylistic connections with the followers of the goldsmith Nicholas of Verdun, while the figure of Stephen resembles in gesture and stance such jamb statues as the Stephen of Chartres (second figure from left, fig. 313). Stephen's garments are more freely modulated than the tight cloak of the Beau Dieu (fig. 318) of Chartres, yet less undercut than the deep folds which envelop the Amiens Beau Dieu (fig. 319). In the evolution of High Gothic sculpture this reliquary seems to stand between the Chartres Christ and the Amiens Christ. It exhibits the poised idealism of High Gothic at its finest.

The sculpture of Notre-Dame at Reims originally included over 2,300 figures, 211 over life-size (fig. 257). In contrast to Amiens, where work progressed rapidly and followed the original design of 1220, the façade of Reims underwent many transformations during a considerable span of time. Unfortunately, many ill-conceived restorations were carried out in the seventeenth, eighteenth, and nineteenth centuries. In 1914 the scaffolding encasing the north tower burned and severely damaged the sculpture of the left-hand portal, and bombardments in World War I further damaged the fabric of the cathedral and its sculpture and stained glass.

The earliest Gothic campaign at Reims consisted of the Prophets on the right side of the right portal (fig. 257). These statues, which were probably carved around 1215, exhibit strong connections with the Chartres transepts, especially with the jambs on the north central portal (fig. 310). At the same time the influence of the Rémois tradition, as seen in the sculpture of Saint-Remi of Reims, has caused certain alterations in the borrowed Chartrain format. The first project for the entire façade can be dated around the middle of the 1220's or slightly earlier. This campaign extended to the very early 1230's, and it included the reliefs on the exterior of the radiating chapels (fig. 253), the portals of the Saints and the Last Judgement on the north transept, and the Visitation group on the central portal of the façade (fig. 320). The sculpture of the north transept portals was planned for the west façade, but a new ex-

panded design for the façade (around 1228 to 1230) caused a change in its placement.

The Visitation group (fig. 320) is part of the first major campaign; but the rest of the jambs in the façade, with the exception of the earlier Chartrain Prophets, belong to a new program in design carried out in the 1230's. The Mary and Elizabeth of the Visitation are related in their classical overtones to the chevet reliefs and the north transept portals. Heavy voluminous robes, covering their heads and pulled across their waists, suggest Roman togas. The undercut folds reveal an articulated anatomy which is the antithesis of the Medieval point of view. The sculptor who carved these two figures must have studied Roman sculpture — perhaps the figures which once decorated the Roman triumphal arch in Reims. He seems to have transformed some pagan model, such as the Roman citizens of the Ara Pacis of Augustus, into Christian heroes. The influence of antiquity is not unusual, for it makes sporadic appearances throughout the entire span of the Middle Ages. This classical point of view came from a variety of sources: directly from pagan monuments, by way of early Christian art with its continuing dependence on antiquity, or from the Byzantine Second Golden Age and its revival of the Hellenic spirit. The Reims Visitation group is one of many small renaissances like the Carolingian renaissance and like some of the sculpture of Saint-Gilles (fig. 97).

When Villard de Honnecourt visited Reims on his way to Hungary (probably in the early 1230's), he was not only interested in the architecture, as his drawings of the nave, flying buttresses, and radiating chapels indicate (figs. 254, 255), but also in the Reims sculpture. Two figures in the Album or Lodge Book in the Bibliothèque Nationale in Paris (fig. 321) are possibly free adaptions of the Visitation group with the figures reversed. The sex, heads, and feet have been changed, but the treatment and organization of the drapery bear a remarkable similarity to the monumental jambs. The Virgin's drapery in the statue, especially the cloak bunched in and flowing from her left hand, is similar to the right-

hand drawing. The drapery pulled across the stomach of Saint Elizabeth has its counterparts in the left-hand figure in the Villard drawing. Further, both drawings possess the same proportions and the same anatomical articulations as the carved figures. Even the gestures and positions of the hands correspond.

Directly beside the Virgin of the Visitation is the Virgin of the Annunciation (fig. 320). This statue, carved by a different sculptor in the early 1230's, possesses none of the classical character of the Visitation group. Rather, the drapery falls in plain tubelike folds and terminates in simple V-shaped folds. The pinched and sharp features of the Virgin's face have none of the fullness and roundness of the heads of the Virgin and the Elizabeth of the Visitation. The classic repose of the Virgin in a pure High Gothic spirit can be contrasted with the classical character of the Visitation figures and their obvious reflections of antiquity. Since many parallels exist between the Virgin of the Annunciation at Reims and the sculpture on the façade of Amiens, it is safe to conclude that this second sculptor came from the Amiens workshop.

The Presentation in the Temple, which includes Joseph, the Virgin and the Christ Child, the priest Simeon, and the servant, occupy the left splay of the Reims central portal (fig. 323). Many of the statues on the Reims façade have been interchanged or rearranged, but the discovery of the sculptor's marks on the statues and the splays has made it possible to reconstruct the original disposition (see bibliography: Reinhardt). The Presentation as planned had Joseph on the left facing the servant and the Virgin and Child and Simeon each moved one jamb to the right. The Presentation as initially conceived was broken into two pairs of figures, and not arranged as one all-inclusive scene. The Virgin and Child and Simeon are very similar to the Virgin of the Annunciation. The gentle, straight folds with feet projecting beneath mantles, as well as the sharp facial features and gently curving hair, reveal the same sense of majestic grace in all three jamb statues.

The figures of Joseph and the servant, to-

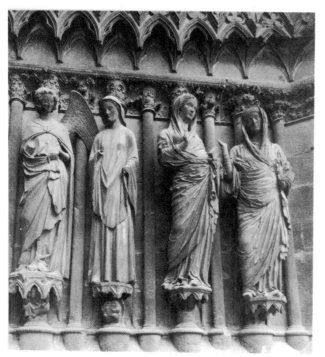

Fig. 320. Reims Cathedral. Central portal:
"Annunciation," 1230's; "Visitation," early 1230's

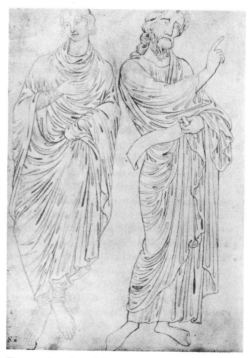

Fig. 321. Apostle and Prophet (Villard de Honnecourt)

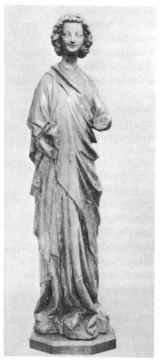

Fig. 322. Angel. School of
Reims, XIIIth century, 29
in. (The Metropolitan Mu-
seum of Art, The Cloisters
Collection)

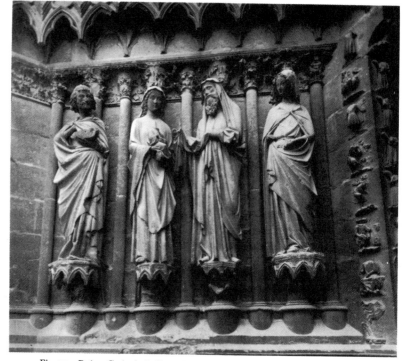

Fig. 323. Reims Cathedral. Central portal, "Presentation in Temple," c. 1240

gether with the angel flanking the Virgin of the Annunciation (figs. 320, 323), suggest greater movement. The angel was located originally on the left splay of the left portal, but has been interchanged with another angel. In all three statues — Joseph, servant, and angel — the downward action of drapery of the Virgin and Child and Simeon is replaced by circular rhythms around the arms and an upward sweep of folds from the feet, which are enveloped in drapery. In contrast to static, suspended poses, the Joseph, servant, and angel twist in space and appear to rise from their pedestals. The heads are relatively smaller and are more animated. Clearly a different sculptor carved these three jamb statues in the mid-1230's or slightly later. Thus, on the jambs on the central portal of Reims there are three distinct styles: the classical Visitation group, with marked anatomical articulation and heavy forms, animated drapery, and rounded faces; the Virgin of the Annunciation, Virgin and Child, and Simeon, with elegant slim forms, static poses, and sharp pointed countenances derived from Amiens; Joseph, the servant, and angel of the Annunciation, with greater movement and expression. The Visitation group was carved around 1230, the two Virgin Marys and Simeon in the mid-1230's, and the Joseph, angel, and servant slightly later. Both the first and third styles have an enormous influence on the sculpture of Strasbourg and monuments in Germany.

In The Cloisters in New York (The Metropolitan Museum of Art) is an angel carved in oak (fig. 322) which is 29 inches high, one of a pair and similar to an angel in the Louvre. All three show strong stylistic connections with the Joseph, servant, and angel of the Annunciation and other figures on the left portal of Reims, especially the smiling angels. The faces, animated by a smile and framed by complicated interlocking curls, and the sweeping, rising drapery with its deep folds have many counterparts in the sculpture of Reims.

Many sculptors were involved in carving the sculptures of Reims in the course of about a half-century The façade as a whole (fig. 257) does not manifest the harmonious balance of architecture and sculpture seen in the transepts of Chartres and the west portals of Amiens. Stained-glass windows have replaced the tympana, and scenes normally in High Gothic tympana are placed in the gables over portals.

In Part I, four figures of Christ in four different media (figs. 111–114) portrayed the homogeneity of the Romanesque point of view, and in Part II, sculpture and stained glass (figs. 214–217) revealed the Early Gothic style. To point up thirteenth-century Gothic, four Coronations of the Virgin of different sizes and in stone, ivory, and illuminated manuscript will be discussed. They will include the monumental Coronation in the tympanum of the central portal of the north transept of Chartres (1210, fig. 324), the Coronation of the Virgin in a manuscript in The Pierpont Morgan Library in New York (1230's, fig. 325), the small portal from Moutiers-Saint-Jean, now in The Cloisters in New York (1260's, fig. 326), and an ivory about one foot in height in the Louvre in Paris (about 1260, fig. 327). As a subject, the Coronation of the Virgin typifies the Mariolatry of the thirteenth century. The Coronation scene first appears on portals in the twelfth century at Senlis (about 1175, fig. 208) and at Laon (1190) and is included in all major High Gothic sculpture ensembles such as Chartres, Paris, Amiens (on the right portal), and in the gables over the central portal of Reims. Katzenellenbogen, in his book on the sculpture of Chartres, has explored the origins of the story of the Coronation of the Virgin. The canonical books of the New Testament do not include details of Mary's death, resurrection, and entry into Heaven, to be crowned by Her Son. However, passages in the Old Testament can be read as predictive of the ultimate triumph of the Virgin, while the liturgy read during the feast day of Mary's Assumption (ascribed to the Pseudo-Jerome of the ninth century) includes the following: "The Queen of the World is translated today from Earth . . . and already has reached the Palace of Heaven . . . and with joy the Savior lets Her share His Throne." The source of the subject therefore is found in

the liturgy itself; yet its total allegorical meaning is based on the Medieval belief that Mary and the Church were interchangeable. Katzenellenbogen described the relationship as follows: "Medieval theology had established a perfect parallel between Mary and the Church. According to the Gospels, Mary was both Virgin and Mother of Christ. Having been chosen by the Lord as the vehicle of the Incarnation, she was considered to be the Bride of God. The Church was likewise defined as the Bride of Christ so as to give the faithful a clear understanding of her close, permanent and loving union with the Savior." Thus these depictions glorify the moment when the Virgin, following Her death and bodily resurrection, is crowned in Heaven by Her Son. As the Church, Mary is the Virgin Mother as well as His Bride.

The monumental tympanum and lintel of the central portal of the north transept of Chartres (fig. 324) includes the Virgin's Death, Resurrection, and Coronation by Christ. The first two scenes, separated by a column, fill the lintel. Her bodily resurrection in the right half emphasizes the stand of the School of Chartres and the Church against heretical groups which denied that the Virgin was the Mother of Christ. In the tympanum, Christ and the Virgin are enthroned under an elaborate trefoil arch symbolizing the Heavenly Jerusalem. Angels, swinging censers, fill the voids above their heads, while two large kneeling angels occupy the corners. The composition is balanced by architectural elements and by the placement of figures. The large columns, supporting the canopy, divide the tympanum into three parts. Two colonnettes flank the Virgin and give Her an emphasis equal to the emphasis on Christ, who in turn sits on a slightly higher throne and is somewhat larger than Mary. The step or bench on which the feet of the Virgin and Christ rest and the horizontally placed legs of the angels establish the ground line of the tympanum, while the wings of the angels and the undulating clouds follow the curvature of the arch and serve as a foil for the archivolts. The position and axis of the heads of the Virgin and Christ are emphasized by

the break in the arch of the canopy and by the placement of the small angels swinging censers. A subtle relationship of solids and voids is achieved in the entire composition. Drapery in multiple folds reveals knees, legs, and arms and connects the Virgin and Christ by diagonal rhythms. Countenances remain expressionless; yet the import of the event is clearly stated by the physical projection of the figures from the background and by their inward turn. The classic, solemn forms arranged with extraordinary subtlety interpret these momentous events with great nobility and majesty.

The second Coronation of the Virgin is an illuminated page from a Book of Hours in The Pierpont Morgan Library in New York, dated in the 1230's (Morgan Ms. 92, fol. 14: fig. 325). The ornamentation of a manuscript page obviously presents a design problem different from the filling of an architectural tympanum. The rectangular page is filled at the bottom by the enthroned Virgin and Christ flanked by a pair of candlesticks and crowned by an arch of five angels. One of the angels is placing the crown on the Virgin's head. Purple and blue, the dominant colors, set the figures in front of the raised gold background. Gold lines accent the hems of the drapery. The style of the figures, with their folds revealing legs and arms, is related to the style of the Chartres tympanum. In spite of its small size, 4½ inches by 3¼ inches, the manuscript page possesses a monumentality similar to High Gothic portals.

The Coronation portal from Moutiers-Saint-Jean (fig. 326) represents a different problem: the design of a small entrance into the transept of a monastic complex. Instead of prophets who prefigured Christ on the jambs, as at Chartres (fig. 310), King Clovis and his son, King Clothar, patrons of this Burgundian monastery in the late fifth and sixth centuries, dominate the portal. The forerunners of Christ are relegated to niches in the piers which originally supported a porch. The massiveness of the patrons, their bulky projection from the splays, and the individuality of their faces place this portal in the 1260's, when the monastery had its most active building program.

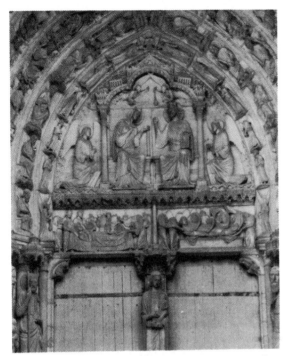

Fig. 324. Chartres Cathedral. "Cononation of Virgin," north transept, central portal, 1210

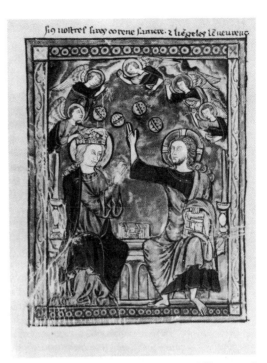

Fig. 325. "Coronation of Virgin." *Book of Hours,* 1230's, 4 1/4 in. by 3 1/4 in. (The Pierpont Morgan Library, Ms. 92, fol. 14)

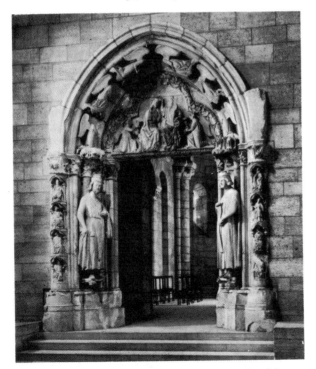

Fig. 326. Moutiers-Saint-Jean. Coronation portal, 1260's (The Metropolitan Museum of Art, The Cloisters Collection)

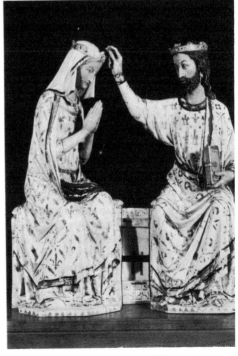

Fig. 327. "Coronation of Virgin." Ivory, about 1260, 11 in. by 10 1/2 in. (The Louvre, Paris)

In the small tympanum without lintel, Christ is actually crowning the Virgin, while two angels, bearing candlesticks, kneel in the corners. A trefoil arch of grapevines embraces all four figures. The relative heaviness of the archivolt of six angels echoes the massive patrons who dominate the jambs. This portal has an intimate personal flavor, in contrast to the epic grandeur of the Chartres portal. The garments of the Virgin and Christ are carved with more angular folds, and the forms of the figures appear flatter against the background when contrasted to the tympanum figures of Chartres. Ornament, muted in Chartres, is more important in the total composition at Moutiers-Saint-Jean. Traces of color appear on jambs and superstructure.

Moutiers-Saint-Jean was sacked three times during the religious wars and almost completely destroyed during the French Revolution. The jamb figures were in a garden and later in collections in Paris, while the doorway was walled up. Today the portal is back in one piece and beautifully installed in The Cloisters in New York. In style, this portal is related to other Burgundian monuments of the second half of the thirteenth century and represents a regional variant of the monumental art of the Île-de-France.

The Coronation of the Virgin in the Louvre in Paris is one of the finest Gothic ivories (fig. 327). Each figure, except for the extended arms, was carved around 1260 out of one piece of ivory almost one foot in height. Ivory as a material is obviously limited in size. Its rarity, as well as the rich gloss of its surfaces, made it a popular material for statuettes, small private altars, and liturgical objects. Much of the original polychromy still exists on the Louvre Coronation. Hems of the garments are black and gold, while the linings of the cloaks are blue. Gold fleurs-de-lis and castles indicate that the ivory probably belonged to a princess of the House of Bar, related to Saint Louis. Faces and hands are tinted in flesh tones. In composition, the Virgin and Christ, together with the flanking angels (not illustrated), echo the curving arch of a Gothic tympanum. In spite of the relationship between ivory and sculptural por-

tals, the ivory Coronation possesses an exquisiteness and elegance different from monumental stone sculpture. In the style of drapery and content, the Louvre ivory is much closer to the tympanum of Moutiers-Saint-Jean than to the Chartres sculpture and to the illuminated manuscript. The massive and iconlike aloofness of the Chartres figures is transformed into a more intimate interpretation. The thin, elongated figures, with accent on repeated V-folds, are similar to the contemporary Burgundian portal.

Only two of these four Coronations, namely, the Chartres portal and the illuminated manuscript (Morgan Ms. 92), are specifically High Gothic. The other two belong to the third quarter of the thirteenth century, during which the classic and idealized equilibrium of the High Gothic evolved into a more elegant point of view. However, in the larger context of thirteenth-century Medieval art, all four reveal the homogeneity similar to that evident in Romanesque and Early Gothic art.

The art of stained glass reached its apogee in the early decades of the thirteenth century. Since one of the basic motives for the creation of Gothic was the transformation of mural stone walls into transparent skins of glass to illuminate the soaring spaces and to instruct the worshippers, the art of stained glass became the most important Gothic painting. For the twentieth-century visitor to Chartres or Bourges cathedrals, the colored light in the chapels, aisles, transept, and nave has an emotional, aesthetic, and religious appeal. At the same time, the nature of physical light can only be understood intellectually. This dual reaction to the luminosity of Gothic cathedrals is vastly different from the Medieval concept of light. In the course of the Middle Ages, physical light became a direct symbol of the divine light. Divine light unites Heaven and the Church, which is the Body of Christ; it gives order and meaning to the cathedral and to the scenes depicted in the windows. Peter of Roissy, Chancellor of the School of Chartres from 1208 to 1213, wrote: "The paintings in the Church are writings for the instruction of those who cannot read . . . the paintings

on the windows are Divine writings, for they direct the light of the true sun, that is to say God, into the interior of the Church, that is to say the hearts of the faithful, thus illuminating them."

Fresco, tempera, and oil painting involve pigments, mixed with a binding medium, applied to opaque surfaces. Stained-glass windows are made visible by the light that passes through the colored glass. Light often mixes adjacent pieces of glass of different colors and turns, for example, red and blue to purple. Blue and red are the basic hues of twelfth- and thirteenth-century glass. Blue allows the greatest penetration of light, while red allows the least. The glass, made in bulk, consists of one-third sand and two-thirds potash of beechwood. The restricted number of hues is made by adding metallic oxides to the molten mixture: oxide of cobalt for blue, cupric oxide for red, copper dioxide for green, oxide of manganese for purple, and dioxide of manganese for yellow. The master glaziers probably laid out the pieces of glass on a full-size cartoon of parchment placed on a surface of boards. First the pieces had to be cut and trimmed to fit the composition; then details of drapery, anatomy, facial expression, and ornament were painted in grisaille on the individual pieces of glass, which were refired to fuse the drawing to the glass. The next step was the casting of the leading in molds to accommodate the various shapes and thicknesses of glass pieces, which were then soldered in place. The thick lines of lead established the main silhouettes of the individual composition or figures. Each scene or figure was then set in an iron frame, and the frames were tied together by an armature attached to the stone frames of the windows. The whole process of creating a window involved several groups of artisans: glassmakers, master glaziers, blacksmiths, and perhaps other specialists.

The most complete set of stained-glass windows dating from the mid-twelfth and early decades of the thirteenth century is found in the Cathedral of Chartres. Of the original 186, 172 separate windows remain, comprising an area of over 2,000 square meters. The known donors include kings and nobles (44 windows), clergy (16 win-

dows), and guilds and corporations (42 windows). Some of the guilds which donated windows were: cooperers, carpenters and wheelwrights, wine merchants, clothiers, bankers, blacksmiths, masons-stonecutters-sculptors, silversmiths, weavers, furriers, bakers, tanners, shoemakers, vine growers, water carriers, armourers. Several guilds raised funds for more than one window. The number and variety of the donors manifests the enthusiasm concentrated at Chartres.

The size, design, and color of each window are determined by its location in the cathedral. In the aisles and in the ambulatory, with its radiating chapels, the windows contain scenes of the lives of saints and martyrs, of Old and New Testament themes, all detailed and clearly visible; while the clerestory windows and lancets under the transept rose windows each contain one or two single figures or two large superimposed scenes which can be read from the pavement some hundred feet below. The windows on the north side of the cathedral tend to have more blue glass, which transmits more light, while more red appears in the south windows. The ultimate locations of the various windows in relation to the orientation of sun, towers, and buttresses had to be considered by the stained-glass worker in his selection of colors, amounts of each hue, and sizes of figures.

At Chartres the majority of the windows in the aisles of the nave, transept, and choir, and around the ambulatory exhibit no organized iconographical program. Rather, the choice of subject seems to have been influenced by the desires of the donors, and the random distribution of the subject seems to have resulted in part from the rapidity with which the windows were made (between 1203 and 1222). However, in four places in the cathedral a carefully conceived program was achieved. The rose window on the west façade depicts the Last Judgement (fig. 225), which complements the subjects of the three mid-twelfth-century windows and the Royal Portals below. In the choir the clerestory window on the nave axis contains the Virgin and Child in Majesty above the Annunciation and Visitation. The remaining clerestory windows refer to Christ's

lineage in the Old Testament. The rose and lancet windows of the south transept, together with the three sculptured portals, glorify Christ and the established Church. Both the windows and the portals were probably donated by Pierre Mauclerc and Alix of Thouars (House of Brittany-Dreux), who are depicted distributing alms under the Beau Dieu of the central trumeau (fig. 318). The rose window of the south transept contains Christ in Majesty in the center surrounded by the evangelists and angels, while the lancets reveal the Virgin and Child in the center flanked by the four Evangelists on the shoulders of the four Prophets. These windows complement the figures of Christ the Judge in the central portal, Christ the Teacher on the trumeau, the Apostles who preach and convert, the Martyrs who gave their lives for Christ (left portal), and the Confessors (right portal) who affirmed Christ's teachings.

The portals and porches and the stained glass of the north transept form a majestic iconographic whole glorifying the Virgin Mary and Her mother, Saint Anne (fig. 328). As already discussed, these portals portrayed Mary as the Mother of Christ (left tympanum), Mary enthroned with Her Son (central tympanum), and Saint Anne holding the Virgin on the central trumeau. The rose window depicts the Virgin and Christ Child in the center surrounded by doves of the Holy Spirit, angels, the twelve kings of Judah who were Mary's ancestors, and twelve Minor Prophets. The center lancet of Saint Anne and the Virgin repeats the central sculptured trumeau (fig. 310). The other lancets, from left to right, include Melchizedek, David, Solomon, and Aaron, while the fleur-de-lis of France and the castles, the insigne of Spain, decorate the corners between the rose and the lancets. The window was given by Blanche of Castille, Regent of France in the years following 1227. The rose window of the north transept is predominantly a rich blue, with backgrounds of red and thin white borders. Yellow animates the insignia of the royal houses. The large figures in the lancet windows, with garments of purple, blue, green, and white, recall in their poses the controlled but flowing drapery and the quiet features of the Old

Testament jamb statues on the central portal below (fig. 310). Vibrant color permeates this entire arm of the transept, uniting the exterior and interior in a symphony of divine light and spiritual meaning.

The Good Samaritan window in the south aisle of the nave (figs. 329, 331) was donated by the shoemakers, who are depicted plying their trade in the three lowest panels. The lowest quatrefoil includes (from the bottom section across the middle to the top section) Jesus relating the parable, the departure of a certain man from Jerusalem, the thieves leaving the woods and stripping the man of his raiment, and the priest and Levite passing him by. The intermediate zone contains the Samaritan binding his wounds and transporting him to the inn (fig. 331). The lowest part of the middle quatrefoil concludes the parable and portrays the Samaritan taking care of the man in the inn. The rest of the window recounts Genesis, from the creation of man through the temptation and expulsion from the Garden of Eden to the slaying of Abel by Cain, climaxed by Christ the Savior, symbolic of the Good Samaritan.

Red and blue are the dominant hues, with red backgrounds emphasizing the main axis of the central panels of the quatrefoils and intermediate rondels and blue dominating the other sections. The ornamented borders have more red glass than blue, while the figures, especially those of Adam and Eve, are off-white against a dark ground. An exterior metal armature ties the windows to the surrounding masonry, and an inner metal armature divides the window into geometric shapes set against a patterned background of blue squares and red lines. In contrast to the twelfth-century Chartres windows (figs. 213, 217), in which scenes fill squares or rondels occupying most of the window, the thirteenth-century stained-glass workers evolved an elaborate geometric armature for the historiated scenes. Each scene is told in simple human terms with muted suggestions of landscape and locale. The leading which joins individual pieces of glass inside the metal armature establishes the main silhouettes of the figures,

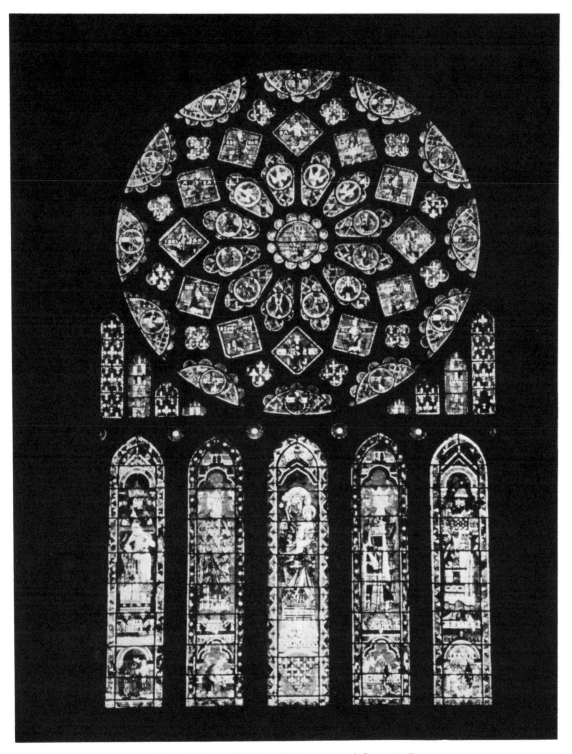

Fig. 328. Chartres Cathedral. North transept window, 1227 ff

while added and fused lines accent features and contours of drapery.

The squat figures, with stiff poses characteristic of the mid-twelfth-century windows, are quite different from the more slender, active figures in the Good Samaritan window. Indeed, if the treatment of the human form in the Life of Christ window (fig. 217) and the lintels of the right-hand west portal (fig. 216) are contrasted with the figures of the Good Samaritan window (fig. 331) and the smaller sculpture such as the Death and Assumption of the Virgin in the lintel of the central portal of the north transept (fig. 324), the basic differences between Early and High Gothic art are revealed. A new freedom of pose and expression replaces the hieratic attitudes of Early Gothic.

A detail of a window (fig. 332), originally set in the choir of the Lady Chapel of the Benedictine Abbey of Saint-Germain-des-Prés in Paris between 1244 and 1255, exhibits the spread of the style of Chartres to Paris and makes possible a closer scrutiny of the art of the stained-glass worker. The Lady Chapel was destroyed in 1805, and parts of the windows were temporarily mounted in Saint-Denis, only to pass into the hands of dealers in Paris. Today sections of the double windows of the Legend of Saint Vincent can be seen in The Metropolitan Museum in New York and in The Walters Art Gallery in Baltimore; one panel is in the Victoria and Albert Museum in London. This detail, one of the eight original panels in Baltimore, depicts two angels lifting the soul of Saint Vincent to Heaven. Saint Vincent, who was deacon of the Church of Saragossa in Spain, was martyred by order of Diocletian. The selection of scenes from the Legend of Saint Vincent for the Lady Chapel grew out of the presence of a relic of the tunic of the Saint brought back by the Merovingian king, Childebert, from his campaigns against the Visigoths and presented to Saint-Germain-des-Prés before that church's dedication to Saints Stephen and Vincent and to Holy Cross in 558. Further, King Louis, the son of Philip Augustus, took the jawbone of Saint Vincent from a monastery in southern France during

the crusade against the Albigensians in 1215 and presented it to the abbey.

The composition is organized with the dead Vincent on a couch filling the bottom of the quadrant and with a pair of angels holding the mandorla with Saint Vincent's soul in the upper section. The shapes of individual pieces of glass and the dominant lines of the leading give balance to the design. Blue glass of various densities serves as the background, while accents of red, green, and yellow force up the over-all blue tonality. The flesh tones are a light, neutralized yellow. The mosaic background between the scenes consists of squares bordered with red and animated by painted floral fillers. The floral border on the left is a modern reconstruction. The folds of garments, the silhouettes, and the features of heads and bodies are drawn lines on the pieces of glass, and these lines emphasize the horizontality of Saint Vincent and the upward surge of the angels bearing his soul. The economy and clarity of statement, contained within a simple geometric shape which is in turn an integral part of a larger composition, manifest the subtlety of the art of stained glass.

LITTLE is known about stained-glass workers as individuals; yet it is certain that some went from Chartres to Bourges and to Sens. The influence of the designs of Chartres can be seen in monuments in Normandy, the Île-de-France (as at Saint-Germain-des-Prés), Burgundy, and Spain. The window compositions, their scenes integrated with a mosaic ground, influenced the art of illumination. A page from a Bible in The Pierpont Morgan Library in New York (Morgan Ms. 240, fol. 4: fig. 330) shows the direct relationship between the treatment of stained-glass windows and that of book illuminations. The text occupies two slender panels; eight scenes fill the rondels in the two larger panels. The spaces between the rondels are filled with colored squares and floral trefoils (compare the Good Samaritan window, figs. 329, 331). The individual scenes have more figures and suggest in their arrangement and overlapping a limited space. When compared to figures in the

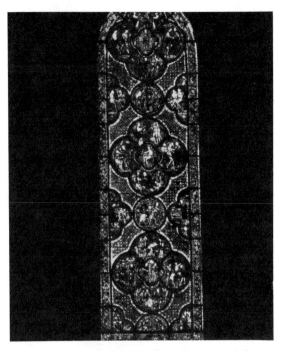

Fig. 329. Chartres Cathedral. Good Samaritan window

Fig. 330. Apocalypse of John XXI, 5–9. Bible, 1230–1250, 11 1/8 in. by 8 3/16 in. (The Pierpont Morgan Library, Ms. 240, fol. 4)

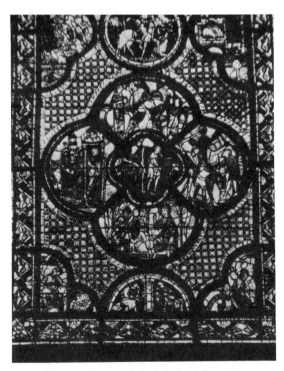

Fig. 331. Chartres Cathedral. Good Samaritan window (detail)

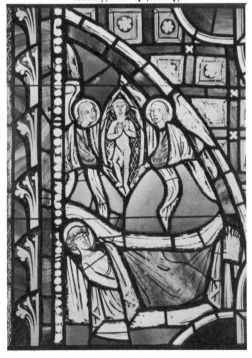

Fig. 332. Death of Saint Vincent. Detail of window from Saint-Germain-des-Prés (The Walters Art Gallery, Baltimore)

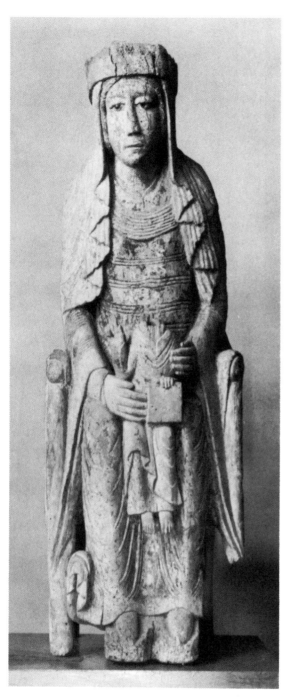

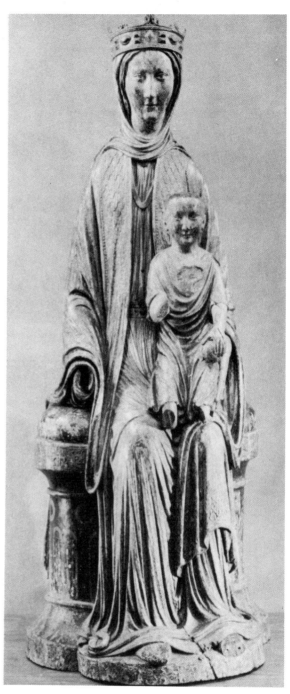

Fig. 333. Virgin and Christ Enthroned, c. 1120.
Burgundian, wood, 40 1/2 in. (The Metropolitan
Museum of Art, The Cloisters Collection)

Fig. 334. Virgin and Christ Enthroned, c. 1200.
Polychromed oak, 61 1/16 in. (Museum of Fine
Arts, Boston)

Chartres windows or the detail from Saint-Germain-des-Prés, those in the manuscript possess more bulk and movement.

A series of Madonnas (figs. 333–338) from the early twelfth to the end of the fourteenth centuries illustrates both the changing attitude toward the rendering of the human form and the changing interpretation of the Virgin and Christ Child. The entire evolution from the hieratic and spiritualized Romanesque statues through the classic majesty of High Gothic to the dramatic individualism of Late Gothic reveals the dynamic evolution of sculpture in Medieval France.

The earliest statue is the Romanesque Burgundian Autun Virgin (fig. 333) in The Cloisters in New York (The Metropolitan Museum of Art, 40½ inches in height). This Virgin and Child originally contained a relic in an aperture in the back, perhaps a piece of the Virgin's veil which was once located in Autun. In its iconlike pose and its denial of anatomical articulation, this statue is related to cult statues of central France, especially of the Auvergne. This interpretation of the Mother of God as a throne for Christ and as an object of veneration in Herself was associated with the worship of pagan idols by many pilgrims from the north. The rigid Christ Child is suspended in front of the transfixed Virgin, whose lap is nonexistent. Her expressionless, poetic face and the immobility of both figures bespeak an otherworldly spirituality. The linearism of the multiple folds and of the windblown hems beside her feet and the thinness of her body and head resemble the sculpture of Autun, carved between 1120 and 1132. General stylistic connections with Vézelay in Burgundy (figs. 93–95) are also apparent, although the Vézelay sculpture possesses more dynamic animation. This small statue of one piece of walnut reveals traces of green on the Virgin's gown, vermilion on the hems of her robe, and black on her hair. Her eyes are inlaid with lapis lazuli. This statue is of superb quality and unique in Burgundian art.

The life-size enthroned Madonna and Child in the Museum of Fine Arts in Boston (61 1/16 inches in height, fig. 334) was carved at the very beginning of the thirteenth century, some eighty years after the Autun statue. In contrast to the transfixed pose and mural flatness of the Romanesque sculpture, this statue possesses an amplitude of three-dimensional organic form which separates the Christ Child from the Mother. Drapery reveals knees, legs, arms, and feet, which are no longer bent into the front plane of the block, as in the Autun Virgin. A new sense of humanity pervades both figures, while polychromy and rich costume impart a regal character to the Queen of Heaven. A metal crown with jewels originally adorned Christ's head. Psychological rapport between statue and observer is encouraged by the almost human relationship between Mother and Child; yet both figures remain frontal, serene, and idealized. The closest parallels in style are found in the transepts of Chartres, especially in the tympanum of the Coronation of the Virgin and the Saint Anne holding the Virgin on the trumeau (figs. 310, 324) and in the right portal of the north transept, as Hanns Swarzenski has clearly demonstrated (see bibliography). The drapery, spreading over the feet of the Virgin, is closely related to the handling of drapery in the Virgin of the Coronation and the trumeau of Saint Anne. Yet the oval head of the Virgin also recalls the sculpture of the Royal Portals of Chartres. Like the Chartres transept sculpture, this Virgin and Child is a synthesis of ideas coming from many parts of western Europe — a synthesis which marks the commencement of the High Gothic era. The idealized and relaxed forms manifest a new age completely different from both the Romanesque of the Autun Virgin and the Early Gothic of the Royal Portals of Chartres.

Another Madonna (fig. 335) in The Cloisters (The Metropolitan Museum of Art) was carved between 1247 and 1250 and came from the choir screen of the Cathedral of Strasbourg, which was demolished in 1682 (see bibliography). As depicted in a drawing of about 1660 of the choir screen, the Madonna was one of eight statues which filled the spandrels of the arches. Originally the Christ Child was seated on a rosebush and was offering His Mother a piece of fruit. Two an-

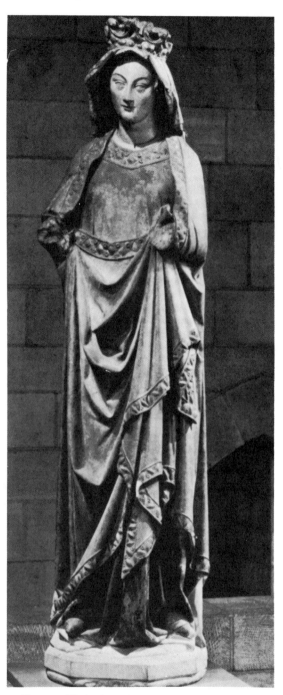

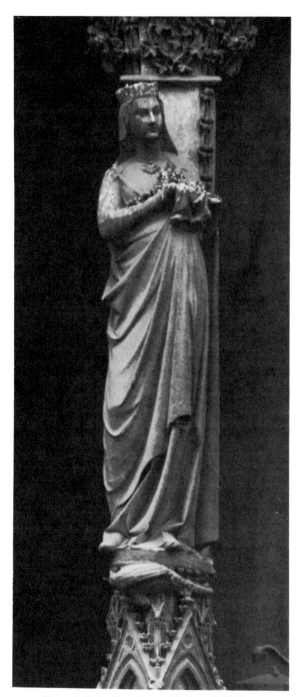

Fig. 335. Virgin from the choir screen of Strasbourg Cathedral, 1247–1250. Gilded and polychromed sandstone, 58 1/2 in. (The Metropolitan Museum of Art, The Cloisters Collection)

Fig. 336. Paris, Notre-Dame. Virgin and Child on trumeau of north transept, 1250's

gels held the Virgin's veil, and a pair of angels appeared above. The statue is 58½ inches tall. Much of the original polychromy is preserved. The Virgin's bodice and undergarment are blue-green; her mantle is gold paint over a red ground. Flesh colors animate the cheeks and the eyes. Painted jewels enhance the hems, the drapery, and Her crown. The folds of Her mantle are more deeply undercut than those of the Boston Virgin and Child and are similar to the Beau Dieu of Amiens (fig. 319). The closest stylistic connection can be found in the Reims sculpture, the figures in the Presentation of the Virgin (fig. 323). Details of the drapery and the treatment of faces of the Reims sculpture are related to the Strasbourg Virgin and to other statues from the choir screen now in the Musée d'Oeuvre at Strasbourg. The head of this Virgin in The Cloisters is fuller and fleshier than the more pointed and pinched heads of Reims; yet it is clear that the Strasbourg sculpture grew out of the Reims school, and historically the High Gothic spread from Strasbourg to Germany. In its majestic pose, ethereal features, and idealized presence, the Strasbourg Virgin is a magnificent example of mature High Gothic, while the Boston Virgin and Child stands at the beginning of the High Gothic period.

Contemporary with or probably slightly later than the Strasbourg Virgin is the Madonna on the trumeau of the north transept of the Cathedral of Notre-Dame in Paris (fig. 336). The folds of her draperies surge upward to her hands, which once held the Christ Child. A new gradual twist in the axis of the figure imparts a dynamic quality completely foreign to the three previous statues. The Virgin's gaze, her right arm, and the direction of the folds emphasize the Christ Child. The classic repose of High Gothic is transformed into an active relationship between Virgin and Child.

In the fourteenth century, the quiet dignity of High Gothic changed into a more anecdotal interpretation. Another Virgin and Child in The Cloisters (The Metropolitan Museum of Art) is a fine example of the relaxed and sometimes overrefined art of the fourteenth century in the Île-de-France (fig. 337). The grinning Christ Child grasps His Mother's veil, while the Virgin's pose assumes a gentle S-curve. The original color, including the Virgin's blue mantle over orange bodice and Christ's red tunic, adds a graciousness and charm to this life-size statue.

The Madonna and Child on the trumeau of the Chartreuse de Champmol at Dijon (fig. 338) projects a Baroque, dramatic presence which is greatly different from the idealism of High Gothic. The Virgin and Child, carved by Claus Sluter between 1386 and 1393, portrays the psychological intensity of the late Middle Ages. The arms and the drapery project beyond the edges of the trumeau. Multiple, undercut folds rise up from the Virgin's right foot to the Christ Child, while smaller, curvilinear folds cover her left leg. The jagged silhouettes and the diagonal axes of arms and drapery force up the dynamic movement. The Virgin and Child are now physically connected by their gazes, axes, and the fluid interpenetration of drapery.

The mural simplicity and rigidity of the Autun Virgin (1120, fig. 333) change to a more articulated repose in the Boston Virgin (1200, fig. 334) while the Strasbourg Virgin (1247–1250, fig. 335) stands as a resolution of early High Gothic sculpture. The Paris Virgin and Child (c. 1250, fig. 336) suggests a new direction with a slight twist of its forms, and the Virgin and Christ Child (fig. 337) displays the refined style of the fourteenth century. The restlessness and dramatic action of Claus Sluter's Virgin and Child connotes a new age: the late Late Middle Ages.

A similar stylistic evolution transpired in ancient Greece. The archaic boldness of the sixth-century B.C. sculptures have their counterparts in Romanesque art, while early classic art (500–450 B.C.) bears a relationship to Early Gothic, such as the Royal Portals of Chartres. The classic Periclean age has its parallels in High Gothic (the Boston and Strasbourg Virgins), and the refinements of the fourth-century B.C. statues of Hermes by Praxiteles are reminiscent of the fourteenth-century Madonna and Child in The Cloisters (fig. 337). The Baroque explosion of Hellenistic art in such monuments as the Victory of Samothrace has many stylistic connections with the Late Gothic portal of the Chartreuse de Champmol in Dijon.

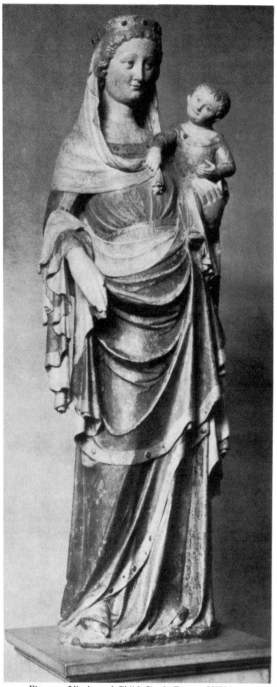

Fig. 337. Virgin and Child. Ile-de-France, XIVth century, painted limestone, 68 in. (The Metropolitan Museum of Art, The Cloisters Collection)

Fig. 338. Claus Sluter. Dijon, Chartreuse of Champmol. Virgin and Child on trumeau, 1386–1393

PART IV

From Rayonnant to Flamboyant

Historical Background

THE STUDY of French art of the period 1240 to 1500 depends on the definition of styles such as Rayonnant and Flamboyant, and the study also requires a general dating of these styles. The art of the period was not ahistorical; a careful scrutiny of the architecture, sculpture, and glass of a given cathedral reveals the ways in which master builders, sculptors, and stained-glass workers were familiar with older monuments, aware of contemporary experiments in other cathedrals, and at the same time struggling with new ideas of their own. Since each monument is a series of permanent moments in a dynamic development, it is unfortunate that art historians are compelled for the sake of clarity to divide Medieval art into periods with labels. The early Medieval Scholastics avoided chapter divisions and wrote continuous commentaries, but we are forced to emulate the thirteenth-century Scholastics and divide Medieval art into historical periods.

In Part I, Romanesque France, we saw how the High Romanesque Burgundian builders of Cluny III and Paray-le-Monial created tall, directly lighted structures by synthesizing the dark, vaulted interiors of nave and aisles of Early Romanesque churches with the high unvaulted naves of Ottonian churches, with their clerestory windows. In spite of the proto-Gothic nature of the soaring, well-illuminated space of Cluny III, the abbey and its Cluniac dependencies reveal the massive, mural character of Romanesque. Windows are perforations in the thick walls which parallel the axis of the church. At the same time, embryonic Gothic structural innovations, such as ribbed vaults and hidden buttresses, appeared in

Norman Romanesque churches. From the late 1130's to the 1190's (Part II), the Early Gothic builders, in search of more light, experimented with different plans, elevations, and structural systems. In 1194 and 1195 the masters of Chartres and Bourges created two different High Gothic syntheses based on the knowledge of many Early Gothic monuments (Part III). These two cathedrals became the models for two different kinds of High Gothic design. In both cases, however, the masters combined older ideas with innovations. Soissons (in the late 1190's), Reims (1211), and Amiens (1220) continued the Chartres format with variations, while Le Mans, Coutances, and others grew out of the design of Bourges. In the cathedral at Beauvais (1225) features from both of the two different evolutions within High Gothic coalesced.

In the 1230's and 1240's in and around the Île-de-France, new features made their appearance. The choir of Amiens, begun around 1236 with the superstructure erected from the 1240's to 1269, has a glazed triforium, multiple planes of walls and colonnettes, and an interlocking of triforium and clerestory. The logical separation of zones characteristic of the naves of Chartres, Soissons, Reims, and Bourges has been transformed into a dynamic interpenetration of stories dramatized by the increase of light through the glazed triforium. The choir of Amiens is no longer High Gothic. Indeed, the germ of this change is clearly revealed in the nave of Amiens, erected between 1220 and 1233.

This new point of view is usually labeled Rayonnant, from "rayonner," meaning to radiate or shine. The term was originally used to describe

the more elaborate window tracery of churches from the mid-thirteenth through the fourteenth centuries. In many studies, Rayonnant bore the connotation of academic, mannered, and decadent. More recently (see bibliography: Bober and others) Rayonnant has been correctly interpreted as representing a positive style in all the arts — a style which is the natural, creative evolution from High Gothic. Design problems, which did not concern the High Gothic master builders, are carried to their logical conclusions in the Rayonnant period. Thus the façade of Reims, with stained glass instead of sculpture filling the tympana and steep gables which overlap arcades above, represents a new kind of Gothic which emphasizes the linear and reflects an increased interest in the play of light and shade. A personal preference for High Gothic should not distract us from the recognition of the creativity of the Rayonnant masters.

There is little agreement among scholars about when Rayonnant began. Frankl (*Gothic Architecture,* 1963: see bibliography) avoids the issue and lumps all architecture from 1194–1195 to 1300 under the heading of High Gothic. French critics such as Lasteyrie and Focillon (see bibliography) tend to terminate High Gothic in the mid-thirteenth century and label as Rayonnant the spread of the new Parisian style. Branner (see articles and *St. Louis and the Court Style,* 1965) studies in great detail the architecture of the period 1230–1300 and invents a new term, the "Court Style." He regards the Court Style as having its origin in the 1230's or earlier, particularly in the Cathedral of Amiens. By the 1240's this new style was formulated in Saint Louis' chapel, Sainte-Chapelle in Paris. The major flowering and spread of the Court Style, from Branner's point of view, took place after Saint Louis' return from the Fourth Crusade in 1254.

If High Gothic is defined as an architecture with logically separated horizontal zones in elevation and with an over-all clarity of forms without emphasis on decorative and linear detail, it follows that the High Gothic period terminates in the 1230's. In cathedrals such as Reims (begun 1211), in which the progress of construction was slow and

later architects respected the original format of the interior, the High Gothic can be regarded as extending into the 1240's. But it does not follow that the façade of Reims or the choir of Amiens is High Gothic. It seems plausible to interpret parts of Amiens and the façade of Reims as the creative beginning of a new style and to limit High or "classic" Gothic to the cathedrals of Chartres, Bourges, Soissons, Reims (choir and nave), and Amiens (façade and nave). Gradually, with different emphases and new experiments, a new point of view emerged, called Rayonnant. As architects, sculptors, and painters used the present as a point of departure for experimentation, Rayonnant had its own evolution, just as we saw in Romanesque, Early Gothic, and High Gothic. The major structural and spatial solutions were mastered by High Gothic cathedral architects, while subsequent architects concentrated on refinements of older designs and on the construction of small chapels and parish churches. As interpreted in this study, Rayonnant is a positive, creative period beginning in the 1230's and extending through the fourteenth century.

The fifteenth and early sixteenth centuries witnessed a further evolution of Gothic. While the Florentine Renaissance was rejecting Gothic forms in favor of a Roman artistic vocabulary, the north continued to evolve and transform the Gothic vocabulary. A new kind of unity, expressed by curving, emerging, and disappearing forms, manifested itself in architecture, sculpture, and painting. This style is called Flamboyant — flame-like — a term that was suggested originally by the nature and shape of Late Gothic tracery. Both Rayonnant and Flamboyant possess an integrity and unity of point of view markedly different from Early and High Gothic. Yet, to be understood as periods within the dynamic evolution of Gothic, the Late Middle Ages must be seen in the light of the history of France between the mid-thirteenth and the early sixteenth centuries.

The history of France during the middle decades of the thirteenth century was dominated by the personality of Saint Louis (Louis IX, 1226–1270) and by the role of Paris as capital of France

and cultural center of western Europe. As ruler, Louis IX controlled all of present-day France west of the Meuse, Saône, and Rhône rivers except Aquitaine in the southwest; as pious and devout king, who was later canonized, he combined church and state in his person and in his administration of justice. Before Louis IX the Île-de-France had been a center of artistic influence; during Louis' reign Paris became the fountainhead of a new Gothic style, called Rayonnant. Architects converged on Paris and, in the dynamic atmosphere of the court, created a different Gothic in the construction at Saint-Denis (1230's and 1240's), the completion of the Sainte-Chapelle by 1246, and the addition of transepts to the Cathedral of Notre-Dame in the late 1240's, 1250's, and 1260's. At the same time, ateliers in Paris were producing sculpture, stained glass, manuscripts, enamels, and goldsmith work. This Rayonnant style, called the Court Style by Branner, became the new-phase Gothic style which spread to the provinces of France and through western Europe. As these Parisian ideas were transported, regional and national characteristics and tradition caused many transformations of the Rayonnant style.

The subsequent development of Gothic art was rendered complex and discontinuous by a series of wars and other disasters. In the fourteenth and fifteenth centuries, France was devastated by the Hundred Years War. In order to take over the revenues from the export of wine from southwestern France and cloth from Flanders, Philip IV (The Fair, 1285–1314) started an abortive war in 1294. Peace was concluded in 1303, and five years later Edward II of England married one of Philip's daughters. Philip the Fair's three sons ruled France for only fourteen years, and upon the death of his last son, Charles IV, in 1328, Edward III, the grandson of Philip the Fair, laid claim to the throne of France. Although the succession of the French crown passed to Philip's nephew, Philip VI of the House of Valois (1328–1350), the issue of the dynastic claim to the throne of France served as the pretext for the beginning of the Hundred Years War.

The first phase of the Hundred Years War extended from 1337 to 1380 (see bibliography: Ferguson, *Europe in Transition*, 1300–1500). Since Philip VI and his successor, John the Good (John II, 1350–1364), failed to organize a large army, the English ravaged western France. French armies met disastrous defeats at Crécy (1346) and Poitiers (1356) at the hands of the English army, which was well balanced between cavalry and infantry. At Crécy the heavily armored French knights suffered enormous losses from the accurate volleys of the English longbowmen, while at Poitiers the French knights fought dismounted but were cut down by archers, by men-at-arms, and by an attack on their rear guard. John II was captured at Poitiers and not ransomed until four years later under the Treaty of Brétigny in 1360. By then a third of France was under the control of Edward III; yet his army was too small to occupy territory permanently. Charles V (1364–1380), the son of John II, organized a truly royal army, paid it regularly from income derived from taxes, and placed it under the command of Constable Bertrand du Guesclin. Du Guesclin refused to meet the English in pitched battle; rather, he harassed the enemy by raids and recaptured cities with the help of the populace. By 1380, at the time of the death of both Charles V and du Guesclin, the English controlled only the port of Calais.

Between 1380 and 1415 internal difficulties in both England and France precluded open warfare. Edward III died in 1383, and Charles VI (1380–1422) mismanaged France when sane. During the periods of his insanity, France was ruled by his brother, Louis, Duke of Orléans. A power struggle arose between the Armagnacs, under the Duke of Orléans, and the Burgundians. In 1407, Louis, Duke of Orléans, was assassinated by John the Fearless, Duke of Burgundy, and civil war between the Armagnacs and Burgundians ensued.

The mad King Charles VI of France, and Paris, were both under Armagnac control; and Henry V of England (1413–1422) chose this opportunity to proclaim himself King of France and invade the Continent. At the Battle of Agincourt (1415) Henry V's longbowmen destroyed the French army, made up mostly of the Armagnac faction.

The French repeated the mistake of the Battle of Poitiers (1356) and dismounted. This tactical error, plus the ankle-deep mud, resulted in a slaughter. With improved siege artillery, Henry V conquered Normandy. In 1419 the Armagnacs murdered John the Fearless, Duke of Burgundy, and as a result, the English and Burgundians became allies. Later the Burgundians seized Paris and King Charles VI, and by the Treaty of Troyes (1420) Charles VI allowed his daughter Catherine to marry Henry V of England and at the same time ceded the right to the crown of France to Henry V instead of to the Dauphin, whose legitimacy was open to question. Henry V died in 1422, two months before the demise of Charles VI, and the throne of France passed to Henry VI, who was only ten months old. The French populace, whose hatred of the English invaders increased as the devastation continued, were led by the Dauphin Charles from his capital in Bourges. It was difficult to have much confidence in the ineffective and irresponsible Dauphin. Ferguson writes:

> What was needed was a forceful personality who could focus the nascent patriotism of the French people, allay their doubts concerning the Dauphin's legitimacy, and inject energy and purpose into the shiftless government of the "King of Bourges." That need was met with miraculous effect by the inspired peasant girl, Joan of Arc, who appeared in the Dauphin's court in 1429. Speaking in the name of God, whose will had been revealed to her through celestial voices, she proclaimed Charles the true king of France, rallied his army to lift the siege of the strategically important city of Orléans, and led the Dauphin through enemy territory to be consecrated and crowned at Reims. Though Joan was later captured by Burgundian forces who sold her to the English, and though Charles did nothing to save her from being condemned as a heretic and burned at the stake, the surge of national sentiment she had aroused could not be checked. In 1435 Philip the Good [Duke of Burgundy] abandoned the losing English cause, and made peace with Charles on terms which left him free from feudal obligations for the fiefs he held in France. The Burgundian duke now held an independent princi-

pality, which included, besides the duchy and county of Burgundy, all the provinces of the Netherlands; but any future danger to France in such a powerful neighbor was for the moment compensated by his break with England. Having only the English to fight, Charles [VII, 1422–1461] was able during the next twenty years to drive them from one city and castle after another, until in 1453 only Calais remained of all their ancient holdings on the continent.

The devastation caused by the Hundred Years War was not the only disruptive force of late Medieval France. In 1348 the Black Death struck western Europe. This bubonic plague, brought from the Near East by rats in merchant ships, killed between a third and a half of the population in two years and recurred several times during the second half of the fourteenth century. The Hundred Years War, plus the Black Death, caused a marked decline in the economy of France. Further, the fairs of Champagne and the overland trade routes through France were replaced by the merchant fleets of the Genoese and Venetians.

In spite of economic decline and depopulation, several factors emerged which altered the social and political structure of France. The rise of a money economy marked the disintegration of the manorial system; produce and services for the use of land changed to a system of rents, wages, and buying and selling and resulted in the gradual decline of serfdom. The rise of a merchant aristocracy to meet the demands of upper clergy and nobles for luxury goods was in effect the emergence of a mercantile capitalism. The kings could borrow money directly from wealthy merchants and thus make themselves independent of feudal lords. Further, Philip IV (the Fair, 1285–1314), in order to raise money for wars against England and Flanders, instigated in 1294 the right to tax all subjects. This direct taxation hastened the decline of feudalism and the creation of the centralized state (see Ferguson, *Europe in Transition*). The royal administration of justice, together with the division of France into districts controlled by the officers of the king, set the stage for monarchical absolutism which evolved at the end of the

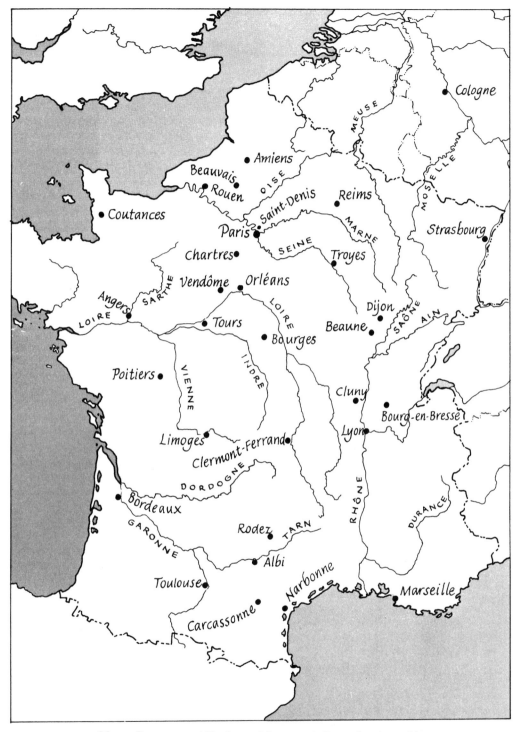

Map 3. Rayonnant and Flamboyant Monuments in France (1230's–1530's)

fifteenth century. The Estates General, consisting of clergy, nobles, and bourgeoisie, was convened less and less during the fourteenth century, and the monarch emerged as the absolute ruler of France.

The authority of the papacy over secular rulers declined considerably during the late Middle Ages. In 1294 both Philip IV and Edward II levied taxes on the clergy for the defense of their respective countries; two years later Boniface VIII (1294–1303) issued a bull condemning this practice, but the secular powers continued to assert themselves. The Bishop of Pamiers was tried in a royal court in 1301 and convicted of treason. This violation of the clerical immunity from the jurisdiction of secular courts resulted in another papal bull, *Unam Sanctam,* which proclaimed the superiority of the spiritual over the temporal powers. Philip IV, with the approval of the Three Estates, summoned the Pope to appear before a General Council and sent his adviser to Rome to deliver the summons. With the help of the Colonna family, Philip's adviser seized the Pope and held him prisoner in the town of Anagni. Although the Pope was freed several days later, the event clearly demonstrated the weakness of the papacy and conversely the growing power of the French monarchy. The Pope died soon afterwards and was succeeded by the Archbishop of Bordeaux, Clement V (1305–1314). Since Rome was unsafe, the French Pope traveled in France and finally settled in Avignon, in Provence, where the papacy remained for nearly seventy years. This Babylonian Captivity, a name derived from parallels with the captivity of the Jews in Babylon, was dominated by France. All seven Popes were French, as were the large majority of the cardinals. The French prevented Benedict XII (1334–1342) from getting together with the German emperor, and thus the election of the emperor proceeded without papal confirmation.

The extravagance of the papal court at Avignon, the increase in direct taxation by both king and papacy, and the death of many clerics during the plague greatly weakened the clergy. An antipapal and anticlerical sentiment arose. In 1377, Gregory XI moved the Curia back to Rome. In 1378 the Pope died and the Archbishop of Bari, Urban VI (1378–1389), was elected. Although the French cardinals participated in Urban's election, they were afraid of both the Pope and the unsettled and antagonistic climate of Rome. They fled Rome and elected Robert of Geneva, Clement VII (1378–1394). Thus began the Great Schism, with a Pope in both Rome and Avignon, which lasted almost forty years.

The arrest of Boniface at Anagni, the Babylon Captivity, and the Great Schism challenged the fundamental High Gothic principle: "the unity of Christendom under two divinely ordained universal powers, the *sacerdotium* and the *imperium*" (Ferguson, *Europe in Transition*). Debate in the twelfth and thirteenth centuries focused on the rival claims of papacy and empire, but no one questioned the divine origin of these co-ordinate powers. In the fourteenth century the French kings demanded for France the same powers that the Emperors possessed. Royalist authorities argued that the pope's authority was delegated for administrative purposes only and that his authority did not encompass church property. Further, General Councils could be convened to overrule the authority of the popes. In 1409 the Council of Pisa failed to heal the schism; further it added a third claimant. The Council of Constance (1414–1417), however, deposed two popes, forced a third to abdicate, and elected Martin V (1417–1431). In the fifteenth century the papal government emerged as the first absolute monarchy. Finally, in 1438 Charles VII, by the Pragmatic Sanction of Bourges, asserted the freedom of the French church and assumed the majority of its revenues (see Ferguson, *Europe in Transition*).

The concern of Scholastics in the twelfth century and first three quarters of the thirteenth concentrated on the reconciliation of Aristotelian logic and Christian faith. The truths of Christian doctrines were submitted to reason, and theology and philosophy were synthesized. In 1277 parts of the writings of Thomas Aquinas and the teachings of the Latin Averroists, who were pure Aristotelians, were condemned by the Archbishops of

Canterbury and Paris. During the next two decades the synthesis of faith and reason was attacked in the Universities of Oxford and Paris. Two Franciscans, in their teaching and writing, furthered the separation of philosophy and theology. John Duns Scotus (c. 1266–1308) was born in Scotland and taught at Oxford and Paris. Ferguson (*Europe in Transition*) writes:

As a Realist he asserted the real existence of universal essences common to all members of a given genus or species. All men, he argued, share a common human nature, and the essence of that human nature, which the intellect can comprehend by the process of abstraction, is a universal. But there is also in each individual man, something which is peculiar to him alone. . . . Scotus called this individual entity *haecceitas* (thisness), as distinct from the universal *quidditas* (whatness). The distinction may convey little meaning to the modern mind untrained in medieval metaphysics. It conveyed little to the mind of Erasmus. Yet it was an important contribution to the great debate that had occupied the intellect of Western Europe for two centuries. It marked the beginning of a shift in emphasis from preoccupation with universal essences to concern with individual things.

A second element in the philosophy of Duns Scotus that was to echo through the centuries was his exalted conception of the absolute freedom and omnipotence of God. By asserting that God's will is not bound by any necessity, but is absolutely free and spontaneous, Scotus decreased the area of what could be proven by natural reason to be necessary attributes of the Divine Being, and thereby drove a wedge between philosophy and theology.

William of Ockham, the second Franciscan, was born between 1290 and 1300 and died during the Black Death in 1349. He was educated in Oxford and taught there until 1324. After being summoned to Avignon to answer charges leveled against his doctrine, he fled in 1328 to the court of Louis of Bavaria and defended Louis in his struggles with the papacy. Ferguson writes:

The political theories he developed in the course of his defense of the rights of both Church and state against papal absolutism were an important contribution to medieval political thought, and they played a significant rôle in the development of the Conciliar Movement.

He opposed any substitution of reason for faith, and thus disagreed with the positions of both the Augustinian Platonists and the Aristotelians such as Aquinas. As Ferguson states:

In contrast to both these positions, Ockham maintained that real knowledge comes only from direct and immediate intuition of individual existent things. We can know only individual objects with certainty. Further, Ockham asserted that only individual things actually exist, and that if a thing exists it must be individual. The genera and species, the essences and natures, all the universals of the Realists can have no real existence, for if they did exist they would be individual and so could not exist in a number of different things. Moreover, if they did exist we could not know them since they cannot be perceived by direct intuition. The universals, in short, are merely names or terms — whence the designation of his philosophy as Nominalist or Terminalist.

The rejection of reason to solve Christian doctrines led to skepticism among many of Ockham's disciples. Ferguson writes:

Finally, Ockham's destruction of the medieval synthesis of philosophy and theology, his sole reliance upon faith, and his insistence upon both the omnipotent will of God and the isolated existence of the individual soul opened the way for Luther's radical break with Catholicism and for Calvin's doctrine of predestination.

The formation of modern scientific theory with its empirical method owes an enormous debt to Ockham and his thirteenth-century predecessors.

This shift from an emphasis on reason to an emphasis on faith, with its accompanying skepticism concerning universals, led to mysticism and at times heretical speculation. The impact of the

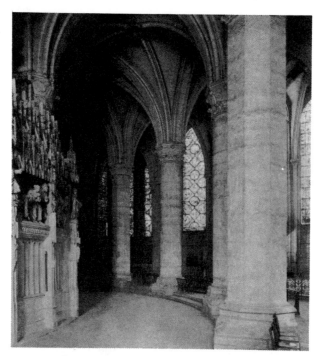

Fig. 339. Chartres Cathedral, begun 1194. Ambulatory

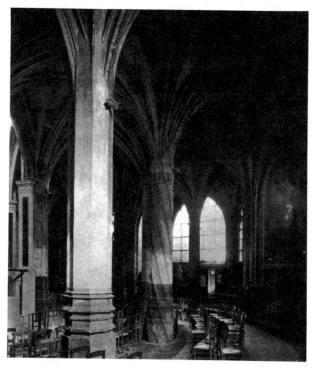

Fig. 340. Paris, Saint-Séverin. Ambulatory, late
XVth century

Black Death, the Hundred Years War, the Baby-
lonian Captivity, and the Great Schism led to ex-
tremes of religious piety bordering on hysteria
and to excessive gaiety (see Huizinga, *The Wan-
ing of the Middle Ages*). The singleness of concern
which in the twelfth and thirteenth centuries was
concentrated in the cathedrals, with their sculp-
tured portals and stained-glass windows, became
fragmented with extremes of wealth and poverty
and with extremes of mystical speculation and
anticlerical feelings. These dramatic changes be-
tween Early and High Gothic and the Late Mid-
dle Ages are manifested in the arts, particularly in
the visual energies of Flamboyant architecture
and sculpture.

To clarify basic differences between High and
late Late Gothic (Flamboyant), the ambulatory
of Chartres Cathedral will be contrasted with the
ambulatory of the church of Saint-Séverin in
Paris (figs. 339, 340). Most of the nave and all of
the choir and the double ambulatory of Saint-
Séverin were constructed in the late fifteenth cen-
tury, while the east end of Chartres was erected in
the early thirteenth century. Over two hundred
and fifty years separate these two monuments.
Both are Gothic, one High "classic" Gothic and
the other Late "Baroque" Gothic or Flamboyant.
The disparity of treatment of Medieval forms ex-
hibits the extremes of Gothic. Between these ex-
tremes, another phase of Late Gothic, Rayonnant
architecture, extending from the 1230's through
the fourteenth century, is both a development and
transformation of High Gothic forms and the
prophecy of Flamboyant. The contrast of the
"before" of High Gothic and the "after" of Flam-
boyant will help to define the middle ground of
Rayonnant.

The view of the Chartres ambulatory (fig. 339)
reveals the four easternmost piers separating the
inner and outer aisles. The alternating scheme of
one octagonal pier, two cylindrical piers, and one
octagonal is terminated on each end of this
rhythm by a pair of single cylindrical piers, mak-
ing the total of six (see plan, fig. 222). This
rhythmical sequence is a variant on the subtle al-
ternating system of piers found in the nave and

transepts. The internal self-consistency and unity
of the Chartres ambulatory is established through
repetition and variation of a family of forms start-
ing with the square plinths at the bottom. These
plinths have octagonal tops from which the octag-
onal or cylindrical piers rise. The capitals, consist-
ing of two tiers of ornament, are slightly different
when they crown the octagonal or the cylindrical
piers. In the case of the cylindrical piers, the
lower tier of the capital is circular, whereas
an octagonal lower zone surmounts the octagonal
piers. From the octagonal abaci of the capitals
spring the four-part vaults which crown the trape-
zoidal bays. The octagonal capitals and abaci are
logically related to the eight ribs which spring
from them: two transverse ribs, the two ribs which
follow the curvature of the ambulatory, and the
four diagonals which spring across the four adja-
cent bays. Thus, visually and structurally the
ambulatory of Chartres has a unity of form in the
sequence of shapes from base, to shaft, to capital,
to ribs; yet each part has retained its own integ-
rity. The ambulatory is unified through an addi-
tion of parts, resulting in a balance between the
downward curving and weighing elements of the
superstructure and the supporting piers and bases.
A logic both visual and structural is achieved in
all the parts.

In contrast to the clarity of statement and
additive harmonics of Chartres, the ambulatory
of Saint-Séverin in Paris reveals marked differ-
ences in every feature (fig. 340). The plinth under
the octagonal piers of Saint-Séverin is octagonal
and therefore echoes the shape of the support
above. The treatment of the entire plinth, with
its multiple moldings, gives it a prominence in
the total design which is quite different from the
muted treatment of the same elements at Chartres.
From this elaborate base rises the octagonal pier.
The convex edges continue on up and disappear
into the vaults. No capital separates the shaft from
the ribbed vaults; rather, moldings grow out of
the shaft and become a series of ribs in the vaults
above. Thus, what starts as decoration in the form
of moldings, emerging from the matrix of the pier,
finally becomes ribs, a progression from decora-

tion to structure. Instead of a unity based on the addition or summation of multiple parts, as at Chartres, the octagonal pier of Saint-Séverin, together with its base and ribs above, establishes an instantaneous unity of similar shapes and of merging forms. In the second pier of Saint-Séverin a spiral action permeates the whole design. In the plinth the spiral is an edge which establishes the twisting nature of the whole pier. The raised moldings which establish the polygonal and diagonal nature of the pier spiral their way up and vanish in the webbing between the ribs. The ribs themselves start as moldings and become ribs. Instead of the four-part vaults which crown the curving bays of the Chartres ambulatory, many additional ribs convert the vaults of Saint-Séverin into a multiple statement of light and shade. In contrast to the clarity of the Chartres ambulatory, the interior of Saint-Séverin is more pictorial and more concerned with light and shade. This leads to an emphasis on the diagonal, which is Baroque in its forms and in the way details move in space. It is small wonder that the highly expressive quality of the Saint-Séverin ambulatory, like the Eiffel Tower, captured the imagination of Robert Delaunay, who did a whole series of paintings in this ambulatory.

The Chartres ambulatory epitomizes the balance of faith and reason combining Christian faith with Aristotelian logic, while Saint-Séverin manifests the emotionalism of the Late Gothic mystics and nominalists. Two distinct styles are revealed in this contrast, both growing out of different moments in the Middle Ages. Chartres proclaims its classic stability, clarity, and balance, while Saint-Séverin dramatizes the fluid interrelationship of parts which results in a highly charged dramatic unity.

Rayonnant Architecture

WITH the pronounced differences between High Gothic and fifteenth-century Flamboyant Gothic in mind, it is necessary to discuss the Rayonnant monuments which exhibit new directions in design in the 1230's and the 1240's. One of the earliest examples of the Rayonnant style is comprised by the new superstructure of the choir, the transepts, and the nave of Saint-Denis (figs. 341, 342). Abbot Suger had been unable to fulfill his dream of rebuilding the Royal Abbey. He had completed a new narthex in 1140 and a new choir in 1144, but the Carolingian nave, which was to have been replaced, remained as the connecting link between these two Early Gothic fragments (figs. 128, 138). Before Suger's death in 1151, foundations for a new nave were started; yet financial problems and other difficulties within the monastery caused work in the nave to be suspended.

The finances of Saint-Denis improved in the 1220's and were augmented by gifts from the kings of France. A new building campaign started in the choir in 1231 (see bibliography: Crosby and Branner) or earlier (see bibliography: Frankl) with the construction of four new piers in the crypt and the reconstruction of the piers and the main arcade of the choir. According to Branner, work progressed rapidly in the 1230's, and by 1237 the north transept arm and most of the choir were completed. In 1241, when work was again suspended, the choir and transept were virtually finished and the lower parts of the nave were under construction. During the 1240's and 1250's the altars in Suger's choir were redecorated and the

transept glazed (see Branner). Work resumed on the nave in the 1260's, and the final dedication took place in 1281.

Pierre de Montreuil is mentioned in a charter of 1247 as a "mason of (or from) St. Denis," and for many years scholars assumed him to have been the architect of the thirteenth-century building campaign. But Pierre de Montreuil is not given the title of Master of the Works in the charter, and little if any building was going on at Saint-Denis in the 1240's; therefore Branner argues that Pierre de Montreuil was not the architect responsible for the design of the thirteenth-century campaign. There are striking similarities between the superstructure of the choir of the Cathedral of Troyes, begun in 1228 after a hurricane had damaged the structure, and Saint-Denis, begun in 1231. On the basis of these similarities Branner argues that the so-called "Saint-Denis master" was responsible for the new design of Troyes Cathedral and the design of Saint-Denis after 1232 or 1233. Branner believes that this Saint-Denis master began his career in Paris, went to Troyes in 1228, and then took over the workshop of Saint-Denis in 1232 or 1233 after another master had finished the piers of the choir. This Saint-Denis master was responsible for the design and construction of choir and transept and the beginnings of the nave. Branner states that the Saint-Denis master designed the royal chapel at Saint-Germain-en Laye in 1238. Further, in the stylistic connections between Troyes (1228), Saint-Denis (1232 or 1233), and Saint-Germain-en-Laye (1238), Branner sees the evolution of a single architect. The fact that these three buildings are, according to Branner, completely different from the

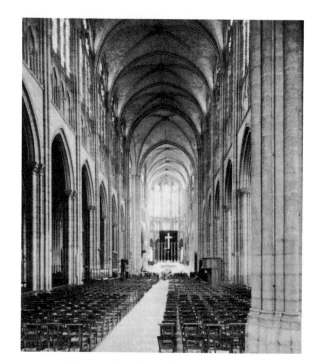

Fig. 341. Saint-Denis Abbey. Nave, 1231 ff

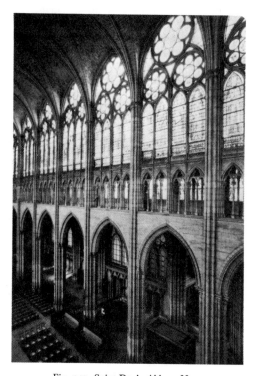

Fig. 342. Saint-Denis Abbey. Nave

lost refectory of Saint-Germain-des-Prés (1239) and the destroyed Virgin chapel of the same church (about 1245) — both the work of Pierre de Montreuil — proves that this master was not the architect of Saint-Denis. Branner's conclusions contradict the traditional attribution of Saint-Denis to Pierre de Montreuil.

The width of the nave of Saint-Denis (figs. 341, 342) was determined by the foundations begun under Suger and by the width of Suger's choir. The modest height of the new nave, 84½ feet, made a relatively sympathetic junction between nave and Suger's narthex. The High Gothic pier, with four attached colonnettes terminating in a capital, was abandoned in preference for the uninterrupted rise of a bundle of shafts from the plinth above the pavement to the springing of the vaults (five shafts in the choir and three in transept and nave). This elimination of the capital on the inner faces of the piers can be seen in the major piers of Early Gothic cathedrals such as Sens, Noyon, and the choir of Saint-Leu d'Esserent (figs. 139, 153, 301, 302). However, at Saint-Denis the bundles of colonnettes are more elegant and animate each pier, not just the major pier in an alternating system of supports. The small floral capitals, rising from slender shafts (fig. 341), support the inner and outer arches of the nave arcade, as in the nave of Sens (fig. 139); yet the heavy and squat proportions of the Sens major piers have been greatly attenuated and lightened. This creative reinterpretation of an older scheme is only one facet of this new kind of Gothic.

The triforium of Saint-Denis is separated from the nave arcade by a horizontal stringcourse which does not continue across the bundle of colonnettes, as in the naves of Chartres, Soissons, Reims, and Amiens. Rather, the stringcourses terminate at the edges of the triforium, as in the stringcourses above and below the triforium at Sens (fig. 139) and those dividing all four stories in the nave at Noyon (fig. 153). On the other hand, at Saint-Denis the separation of the nave arcade from the triforium is tied in with the concept of linking the triforium with the clerestory and making the two zones appear to be one story. The sloping roofs outside the triforium, protecting the vaults of the aisles, are flattened, and the outer walls of the triforium passage are perforated with windows. This glazing of the triforium increases the light and tends to blend triforium and clerestory. The hesitantly glazed triforium of the inner aisle of the choir of Beauvais (1225, figs. 288, 290) is earlier than Saint-Denis but the glazing of the triforium of the main nave vessel occurred for the first time in the choir of the Cathedral of Troyes after 1228 and at Saint-Denis after 1232 or 1233. The glazed triforium of the eastern side of the transept and the choir of Amiens, dating from the 1240's to 1269, and the superstructure of Beauvais are the result of the influence of Troyes, Saint-Denis, and other Rayonnant buildings. It is tempting to speculate that the Saint-Denis master was excited by the precocious nature of Suger's chevet, which marked the emergence of Gothic from Romanesque, and evolved another kind of Gothic out of a new synthesis of Early and High Gothic innovations.

The glazed triforium of Saint-Denis is linked with the clerestory by a series of colonnettes. The outer pair of colonnettes in each bay rise to capitals from which spring the wall ribs. Inside the outer pair of colonnettes are another pair which grow into the mullions of the clerestory windows. On the same plane as the inner pair are colonnettes which divide each pair of triforium arches and continue up into the mullions of the clerestory windows. Three colonnettes, dividing the four arches of the triforium into two pairs, also connect triforium with clerestory. Thus an armature of colonnettes in multiple planes in space unites triforium and clerestory just as the three shafts of the nave piers connect the nave arcade with the triforium-clerestory.

The Saint-Denis master, by joining two stories, continues the tendency already begun in High Gothic. In the nave of High Gothic Reims (figs. 245, 248, 249), the central shaft of the triforium is wider than the others and echoes the central mullion of the clerestory windows, while in the choir of Reims, following the Rémois tradition as seen in Saint-Remi at Reims (c. 1170, fig. 194), colon-

nettes connect the triforium and clerestory. The nave of Amiens, constructed between 1220 and 1233 (figs. 259, 262), carries the linkage further by rethinking an older twin-unit form of the triforium and connects triforium and clerestory with a single colonnette in the middle of each bay and by the paired colonnettes, one on each side of each bay. The Saint-Denis master thus extended the physical connection between triforium and clerestory which Robert de Luzarches had instigated in the nave of Amiens and increased the unity of the two stories by glazing the triforium and by increasing the number of colonnettes which extend from triforium to the clerestory. The overlapping of stories, the multiple planes in space and elevation, and the two stories of glazed windows manifest a new Gothic: the Rayonnant. The transept of Saint-Denis, with its elaborate radiating rose window and glazed triforium, further emphasizes the originality of the Saint-Denis master's design.

In the choir, the level of the triforium was raised three times as the work progressed from east to west (fig. 341). In the transept and nave, which has no raised crypt, the height of the nave arcade equals the combined height of the glazed triforium and clerestory. With the linkage of triforium and clerestory and the glazing of both, the transept and nave of Saint-Denis tend to read as a two-story structure in elevation. A similar proportional relationship between nave arcade and triforium-clerestory can be seen in the nave of Amiens (1220, figs. 259, 262), but the Saint-Denis master intensified visually the similar dimensions of nave arcade and triforium-clerestory by converting the latter to a transparent wall of tracery and glass.

When Saint-Denis is viewed from the outside, the four aisles flanking the transept and the four towers on the corners, separated from the main vessel of the transept by flying buttresses, result in a new kind of fragmented massing which is different from the compact massing of Reims and Amiens. Thus, in massing and in the interior disposition of stories, with nave arcade linked to the superstructure by continuous colonnettes and triforium tied to clerestory by mullions and by light,

Saint-Denis replaces the logical separation of parts of High Gothic with a new creative emphasis which can be regarded as decorative but which also enjoys an architectural vitality in the way light is increased, in the way zones are interlocked, and in the treatment of the wall surfaces as a play of multiple planes in space.

SAINTE-CHAPELLE AT PARIS

Perhaps the purest Rayonnant structure is the Sainte-Chapelle, the palace chapel on the Île-de-la-Cité in Paris (figs. 343–346). In 1239 Saint Louis (Louis IX) negotiated with Beaudoin II, his cousin and the Emperor of Constantinople, for the acquisition of the Crown of Thorns. Other relics, such as part of the True Cross, iron lance, sponge, and nail of the Passion, arrived by 1241. Louis met the bearer of these relics, walked barefoot through the streets of Paris, and placed them in a small treasury in the palace. The planning of a new chapel suitable to house these sacred treasures started perhaps as soon as 1239, but certainly by 1241 (see bibliography: Branner). The fabric of the building was completed probably by 1246, but the final consecration did not take place until April 26, 1248. The west window (not shown in illustration) was replaced by a Flamboyant rose in 1485. In 1630 the roof burned. During the Revolution the chapel sustained considerable damage, which resulted in the repainting of interior surfaces in the nineteenth century.

As originally planned and constructed, Sainte-Chapelle was connected to the palace by a two-storied porch. The two levels of the porch were carried into the chapel as a lower level for the court retainers and an upper chapel for the royal family. This plan followed the scheme established by Charlemagne in his late ninth-century Palatine Chapel at Aachen. Charlemagne sat on a throne in the high gallery, while servants and the lesser nobility stood in the lower floor. In contrast to the octagonal, central space which unites the two stories at Aachen, a floor separates the two in the Sainte-Chapelle (figs. 343, 344), following the design of the archbishop's chapel at Reims and of other Gothic chapels. The royal chapel at Ver-

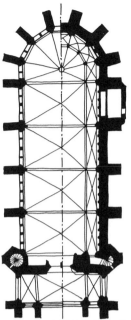

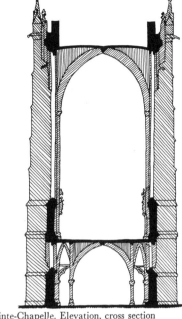

Fig. 343. Paris, Sainte-Chapelle,
1241–1248. Plan (after Frankl)

Fig. 344. Paris, Sainte-Chapelle. Elevation, cross section
(after Frankl)

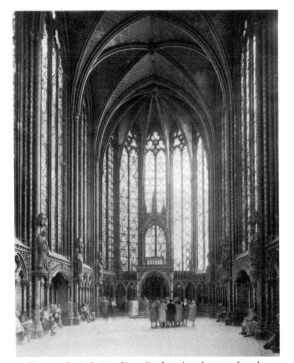

Fig. 345. Paris, Sainte-Chapelle. Interior of upper chapel

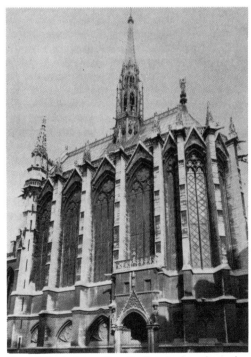

Fig. 346. Paris, Sainte-Chapelle. Exterior from the south

sailles is a return to the Aachen concept. The low ground story of Sainte-Chapelle has a narrow aisle and ambulatory (see right-hand half of plan, fig. 343, and fig. 344). In the aisles, the stilted transverse ribs are reinforced by internal buttresses, a unique structural system. The upper floor consists of four bays with four-part vaults, an apse, and a porch (see left-hand half of plan, fig. 343).

The upper, major level of Sainte-Chapelle, intended for the worship of the royal family and the display and safekeeping of the sacred relics, is an intimate, sparkling, jewellike space (fig. 345). As a shape, it is twice as high as it is wide (see cross section, fig. 344). More than three-quarters of the total height consists of stained-glass windows. The lower part, or dado of each bay, is animated by an arcade of three arches with paired openings. Elaborate floral ornament surmounts the arches, while the spandrels are filled with angels. Pieces of colored glass and gilt designs further animate the surfaces. All surfaces were painted, probably in a manner similar to the nineteenth-century restoration. The colonnettes which flank each bay rise to the springing of the diagonal ribs. The larger, main shafts run from the pavement up to the transverse rib. The twelve Apostles, standing on corbels and crowned with elaborate canopies, overlap the opaque base or dado and the beginning of the stained-glass windows. This placement of the twelve Apostles half over the opaque base and half in the translucent window area enhances the unity of the interior space. Springing from the top of the dado are the pair of shafts which rise and grow into the longitudinal rib. Thus the same interlocking of levels seen at Saint-Denis is continued in the royal chapel, and the total interior space tends to read as a single cage of glass with a small, dark base. The design of the arcade of the dado, with trefoil arches surmounted by a quatrefoil, is repeated in the tracery of the stained-glass windows above. Over the altar is an elaborate platform with angels on the spandrel and on the inner face of the arch. Covering the platform is an ornate shrine to accent the placement of the relics. The upper platform is reached by elegant flanking spiral staircases. This entire shrine was constructed after 1254 and largely restored in the nineteenth century.

The whole structure of the interior has been reduced to concentrated bundles of supporting elements and tracery holding the glass in place. This daring structural economy made it necessary to brace the windows with iron chains; but the chains were threaded through the windows in such a way as to resemble the metal rods to which the glass is attached. The elaborate painted surfaces, together with the vibrant color of the stained-glass, have led Branner to state as follows: "I am proposing here that Sainte-Chapelle was literally construed as a reliquary, an enormous mock-metal shrine complete with imitation repoussé Apostles along the sides, and with effects of enamels and chased gold, the whole turned outside-in." In the broadest sense, all religious buildings are reliquaries; but in the case of Sainte-Chapelle, the painted walls, the carved surfaces, the twelve Apostles projecting from the wall, and the intensity of color of the walls and the light cast on the interior give this chapel a new coloristic character which indeed reflects the small-scale reliquaries of the thirteenth century.

The vision of Sainte-Chapelle as an enormously enlarged reliquary can be felt equally from the exterior (fig. 346). The lower level of the chapel is stated on the outside in the short window, with its spherical bottom molding. The base or lower story of the upper chapel is revealed in the blank wall in the next zone, the blank wall animated by the projected pier buttresses. The small lower level is in sharp contrast to the soaring nature of the slender elegant windows above. The windows extend up into the gables which, in turn, rise to the height of the crowning parapet. This overlapping of the gable and windows is a new feature in Sainte-Chapelle; it influenced the upper part of the choir of Amiens Cathedral and other subsequent monuments. The finials crowning the wall buttresses are a product of the nineteenth-century restorations. The entire chapel manifests the whole theory of the French kingship; as Pope Innocent remarked: "The Lord has crowned you (Louis) with His Crown of Thorns."

There has been much speculation about the identity of the architect of Sainte-Chapelle. Several scholars have argued that Pierre de Montreuil was the man. Recently, Branner (*St. Louis and the Court Style*, 1965), on the basis of the close stylistic relationship between the arcade of the dado of the radiating chapels of Amiens Cathedral and the dado of the lower and upper chapels of Sainte-Chapelle and the clear resemblance between the tracery of the Amiens chapels (fig. 264) and the windows of the upper chapel of Sainte-Chapelle (fig. 346), has proved that the architect of the royal chapel was Thomas de Cormont, the second architect of Amiens. In the 1230's Thomas de Cormont took over the Amiens workshop from Robert de Luzarches; he completed the eastern aisles of the transept and the aisles of the choir and finally designed and erected the radiating chapels around the choir. It is in the latter that the marked similarity between Amiens and Sainte-Chapelle is most evident. Many of the features of the style of Thomas de Cormont were already suggested in the nave of Amiens (1220–1233), designed by Robert de Luzarches. Thus the Cathedral of Amiens, the last great High Gothic cathedral (façade and nave), stands at the end of the evolution within High Gothic. At the same time, the nave of Amiens by Robert de Luzarches (1220–1233), with its dissolution of surfaces, the interlocking of triforium and clerestory (figs. 259, 262), and the emphasis on multiple planes, contains the features which Thomas de Cormont refined into Rayonnant in the radiating chapels of Amiens in the late 1230's and in Sainte-Chapelle in the 1240's. Amiens is High Gothic in the process of becoming Rayonnant. The upper part of the choir at Amiens, with its ornate glazed triforium and clerestory, constructed slowly between the 1240's and 1269 under the direction of Regnault de Cormont, Thomas' son, is Rayonnant (figs. 264–268).

THE exteriors and interiors of the north and south transepts of the Cathedral of Notre-Dame of Paris also reveal the evolving Rayonnant of the late 1240's, 1250's, and 1260's. Between 1246 or 1247 and about 1257 Jean de Chelles added a bay and

façade to the north transept (fig. 183). The huge window and glazed gallery beneath resemble the transepts of Saint-Denis. On the exterior, the five steep gables appear to be a miniature variant of the lower story of the façade of the Cathedral of Reims. The south transept of Notre-Dame of Paris (fig. 184) was begun by Jean de Chelles in 1258, but constructed under the direction of Pierre de Montreuil in the 1260's. Pierre de Montreuil became master of the works in Paris in 1265. The design of the south transept follows that of the north transept, although the details are more elegant.

The fully developed Rayonnant style came into being in Paris and its environs. It then spread north and northeast to Beauvais, Amiens, and Strasbourg, eastward to Troyes and Burgundy, and south to the Midi. In the second half of the thirteenth century Rayonnant became the primary phase of the Gothic style, as its influence spread through France and western Europe.

SAINT-URBAIN AT TROYES

The church of Saint-Urbain at Troyes illustrated the creative evolution of Rayonnant ideas in Champagne. Even though Rayonnant originated in the Paris area, the Parisian Rayonnant underwent an unusual sea change in style when it penetrated the provinces, as the plan, interior, and exterior of Saint-Urbain reveals (figs. 347–349). On May 20, 1262, Pope Urban IV wrote the Abbess of Notre-Dame-aux-Nonnais and arranged for the purchase of houses and land for a church to be dedicated to his predecessor, Urban — Pope and martyr. Urban IV (the son of a cobbler) was born on the site of the church. The church was intended to honor his patron saint as well as his father. Following his education as priest, he became archdeacon of churches at Reims and Liège, apostolic legate in Germany (1248), Bishop of Verdun (1252), and Patriarch of Jerusalem (1255); he was elected Pope in 1261 (see bibliography: Salet). Work on the church at Troyes commenced in 1262. The Pope died in 1264, but his successor, Pope Clement IV, encouraged the rapid construction of the choir and transept, which were completed by 1265. The planned consecration

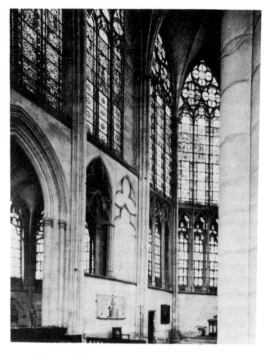

Fig. 347. Troyes, Saint-Urbain, 1262 ff. Choir

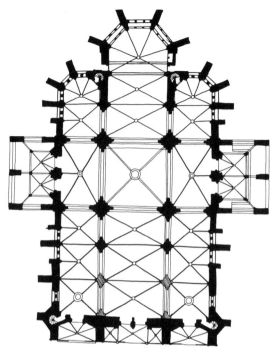

Fig. 348. Troyes, Saint-Urbain. Plan (after Salet)

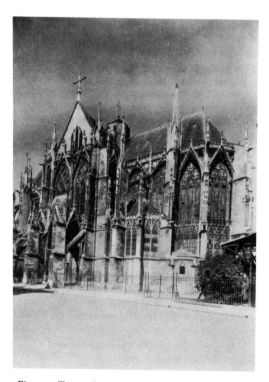

Fig. 349. Troyes, Saint-Urbain. Exterior from the south

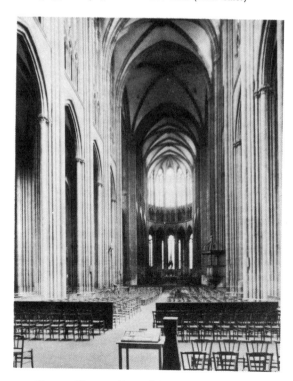

Fig. 350. Clermont-Ferrand Cathedral, 1262 ff. Nave

of May 22, 1266, did not transpire because the Abbess of Notre-Dame-aux-Nonnais instigated a sack of the church and the destruction of the altar. In the summer of 1266, a fire burned the roofs of the choir and interior scaffolding. These two set-backs, which necessitated rebuilding, plus the difficulty of raising funds, slowed the progress of the construction. By the end of the thirteenth century, the choir, transept, and porches, the exterior aisle walls of the three-bay nave, the piers and nave arcade of the eastern bay, and the lower story of the façade were completed (plan, fig. 348). The nave arcades of the two western bays were completed in the late fourteenth century in time for the consecration of July 11, 1389. The superstructure of the nave was not erected until 1902. Between 1839 and 1876, the houses attached to the choir and nave of Saint-Urbain were purchased, and a major restoration was started in 1876. The upper stories of the present façade, as well as the superstructure of the nave, were not built until after 1890.

The original design, by the architect Jean Langlois (Johannes Anglicus), consists of a short nave of three bays with aisles, a square crossing flanked by rectangular bays which continue the aisles, and a choir of two bays ending in a five-sided apse, with aisles also terminating in five-sided chapels (fig. 348). An unusual feature can be seen in each bay of the aisles of both choir and nave, in which an extra rib divides the exterior wall into equal parts, one blank and the other glazed with twin windows. Extra ribs divide the exterior walls of the transepts into two large windows and two entrances, while elaborate vaulted porches are stabilized by flying buttresses springing from freestanding piers (fig. 349). The whole church is only 163 feet long.

The choir, with its polygonal apse (figs. 347–349), is basically two stories of glass rising above a plain dado or base. In the apse, two layers of tracery allow for a passageway between the front tracery and the glazed tracery in the triforium (fig. 347). The large clerestory above is joined with the triforium by moldings. The apse, in its entirety, reads essentially as a cage of glass of one

story with a minor division separating what could pass for a triforium and the clerestory above. The slenderness and elegance of the moldings force up the brittle and yet exquisite nature of the choir. In the easternmost bay of the choir, half of the bay is a wall with tracery imposed upon it (fig. 347). This mural effect, accented by the tracery, masks the circular staircase which gives access to the superstructure (plan, fig. 348). This separation of a bay into half wall and half opening is continued up into the clerestory with the membrane of wall blocking off one of the four vertical lights of the clerestory window. This new idea at Troyes is perhaps the origin for the unusual treatment of the walls between the chapels in Saint-Nazaire at Carcassonne. The sense of the wall made up of glass held in place by slender traceries, which we have seen in Sainte-Chapelle in Paris, is continued in the choir of Saint-Urbain. All the colonnettes move without being interrupted from the plain walls of the dado through the two glazed stories to the springing of the vaults. The system of overlapping of parts which was seen in the nave and choir of Saint-Denis and at Sainte-Chapelle in Paris is repeated with variations.

The exterior of the choir echoes this delicate treatment of the details of the interior (fig. 349). In Sainte-Chapelle the clerestory windows grew up into the gables. This idea is carried further in the elaborate east end of Saint-Urbain. Ornamented gables and a carved balustrade with pinnacles give a linear accent to the exterior. The transept porches, with the complicated vaulting over the two portals, are made more dramatic by the three free-standing piers from which flying buttresses spring to stabilize the inner vaulted areas. This emphasis on free-standing piers with diagonally placed buttresses which culminate in the elaborate gables over the porches further portrays the elaborate, metallic surfaces which are a prominent feature of the Rayonnant style. The two-dimensional surface of the wall is dissolved in the glass and the slender, surrounding bands of stone. Any sense of weight is replaced by hovering surfaces bounded by thin supports.

The church of Saint-Urbain at Troyes bears

witness to the fact that Rayonnant architecture is not just a refinement of details derived from the great High Gothic cathedrals but involves experimentation in the design of plan, in the spatial handling of interior elevations, and in the organization of exterior masses and surfaces – all of which result in an emphasis which is entirely different from that of High Gothic architecture.

THE CATHEDRAL OF CLERMONT-FERRAND

The first significant penetration of Rayonnant Gothic into central and southern France can be seen in the Cathedral of Clermont-Ferrand in the Auvergne (fig. 350), designed by Jean des Champs, and in other cathedrals designed by the same master (see below). Although the original plan to rebuild Clermont-Ferrand dates from 1248, the actual construction, based on a new design, commenced in 1262 (Branner, *St. Louis and the Court Style*, pp. 141–142). In 1262 Louis IX and his court were in Clermont-Ferrand for the marriage of Isabella of Aragon to his son Philip. By 1275 the radiating chapels were available to the clergy. Pierre des Champs, son of Jean, completed the choir, transept, and first bay of the nave between 1287 and 1325. The western bays of the nave were constructed between 1340 and 1359. The façade, however, was not completed until the nineteenth century.

In 1272 Jean des Champs was responsible for the design of the choirs of the cathedrals of Narbonne and Toulouse; in the following year he began the Cathedral of Limoges, which is practically identical in plan, elevation, and size to the Cathedral of Clermont-Ferrand. This family of structures in turn influenced the design of the Cathedral of Rodez, begun in 1277. Thus five large cathedrals, all begun in the third quarter of the thirteenth century, reveal the extension of Rayonnant architecture southward, just as the cathedrals of Strasbourg (1240) and Cologne (1248) exhibit the spread of Rayonnant to the northeast.

Unlike the small collegiate church of Saint-Urbain at Troyes (figs. 347–349), Clermont-Ferrand is a large cathedral (fig. 350). The shape of the interior space and the disposition of the eleva-

tion recall High Gothic cathedrals such as Chartres and Reims. A closer study of the interior, however, reveals basic differences between a Rayonnant and High Gothic treatment of elevations. The shafts of the piers at Clermont-Ferrand rise uninterruptedly from the plinths to the springing of the vaults. This treatment follows the elevation established at Saint-Denis in the 1230's (figs. 341, 342). The number of shafts changes in Clermont-Ferrand from three in the choir to five in the nave. The choir follows the three-shaft design of the nave of Saint-Denis. In Clermont-Ferrand the triforium and clerestory are linked by shafts which rise from the base of the triforium up into the mullions of the clerestory windows, and the connection is further emphasized by the gables over the triforium openings, which accent the verticality of each arcade of the triforium. This treatment of the triforium, with the added gables above the arcade and the penetration of the arcade up into the gables, recalls not only the treatment of the choir at Amiens (fig. 267) but also the treatment of the exterior of Sainte-Chapelle (fig. 346). The architect, Jean des Champs, must have known both the choir of Amiens, which was being completed in the 1250's and 1260's, and Sainte-Chapelle.

There are, however, three important differences in Clermont-Ferrand when compared with any contemporary Île-de-France monument. First, the triforium is not glazed, as was the case with the triforia of Saint-Denis, the choir of Amiens, and the church of Saint-Urbain at Troyes. Secondly, Jean des Champs retained a strip of wall to flank each bundle of shafts in the triforium and clerestory. Further, the triforium passageway does not parallel the axis of the cathedral; it is a semicircular passageway which bulges outward from the exterior triforium wall. It would seem that Jean des Champs was concerned with emphasizing the wall surfaces which flank the colonnettes and with accenting the vertical stability of the structure itself.

In plan Clermont-Ferrand follows the general format of High Gothic cathedrals, especially Reims. The five radiating chapels have a narrow rectangular bay in front of the actual chapel itself and are thus deeper than in most High Gothic de-

signs. This deepening of the radiating chapels follows the handling of the chapel on axis in the Cathedral of Reims. At Clermont-Ferrand the treatment of the radiating chapels makes the design of the flying buttresses on the east end of the cathedral more complicated.

The cathedrals of Clermont-Ferrand and Limoges are essentially identical in plan, elevation, and massing. The fact that a single designer — in this case Jean des Champs — could be responsible for the design of four large cathedrals is a new phenomenon in the thirteenth century. A study of Early Gothic buildings of the twelfth century and the High Gothic buildings from the 1190's up through Amiens Cathedral, begun in 1220, reveals quite clearly that each structure was the creation of an architect–master builder who not only designed but remained to supervise the entire construction. This is not to say that master builders did not travel. Soissons was certainly designed by a person who came from the Chartres workshop, while the Reims architects knew both Chartres and Soissons, yet were imbued with the local Reims tradition; but the Early and High Gothic master builders combined in one person the roles of architect, engineer, and contractor. Jean des Champs was a new phenomenon, an itinerant architect who traveled in various parts of France and who seems to have been responsible for the design of structures. As an architect, he was apparently dependent on northern French models; but Jean des Champs also made changes in the plans and elevations of those models, and he gave his personal, individual stamp to the buildings he designed.

SAINT-NAZAIRE AT CARCASSONNE

The spread of Rayonnant Gothic from the Île-de-France to southwestern France is superbly illustrated by the choir of the Cathedral of Saint-Nazaire at Carcassonne (figs. 351–354). In 1240 the people of Carcassonne revolted against the crown and were driven from the city and dispersed. The fortified "old city" was occupied, and seven years later the populace was recalled and built a new fortified city across the river Aude. By 1267 the

chapter had sufficient funds to plan a new choir to be added to the Romanesque church in the old city. In 1269 Louis IX granted the necessary land for the new building campaign. The proportions of the Romanesque nave, begun around 1096, were matched in the proportions of the new choir, which was conceived in terms of a wide transept, eastern aisle and chapels, and apse. Work commenced in 1269 and was largely completed by 1321. The stained glass of the transepts was fabricated in the late thirteenth century, while the glass in the east side of the church dates from the late fifteenth and early sixteenth centuries.

The Romanesque nave (fig. 352) has a pointed barrel vault, animated by transverse arches and buttressed by slightly lower pointed barrel vaults over the aisles. The two western bays are supported by massive compound piers with engaged half-columns over pilasters rising to the springing of the transverse ribs. In the four eastern bays there is a pronounced alternation of supports: compound piers alternate with plain cylindrical piers (figs. 351, 352). The cylindrical piers are similar to the nave supports of Tournus (fig. 87), while the general character of the three barrel vaults with no gallery or clerestory resembles the interiors of churches in western France such as Melle (fig. 80). The strong alternation of supports has no counterpart in any structure in southwestern France. Thus, the nave of Saint-Nazaire at Carcassonne seems to stand as an extension into southwestern France of Romanesque architectural ideas from western France.

It is probable that the original design for the Rayonnant choir of Saint-Nazaire at Carcassonne called for two bays in each arm of the transept; but as constructed, the transept has three bays in each arm (fig. 351). On the east side of the transept is a narrow aisle (fig. 353) reminiscent of the aisles in the lower chapel of Sainte-Chapelle. Six narrow chapels flank the aisle. Each chapel is separated from its neighbor by a membrane wall rising to the height of the blind arcade extending along the eastern wall of the choir. Above this wall rises open tracery, consisting of two apertures crowned by cusped arches with three trefoils at the top. It

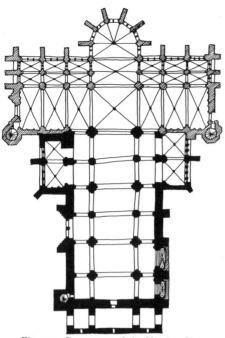

Fig. 351. Carcassonne, Saint-Nazaire. Plan (after Frankl)

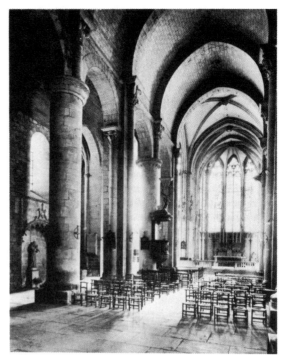

Fig. 352. Carcassonne, Saint-Nazaire. Nave, begun 1096

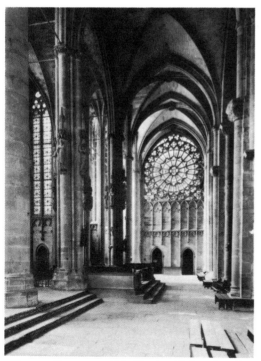

Fig. 353. Carcassonne, Saint-Nazaire. Choir and south transept, 1269–1321

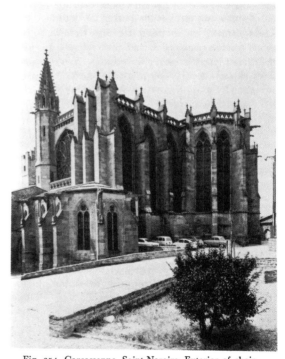

Fig. 354. Carcassonne, Saint-Nazaire. Exterior of choir, 1269–1321

is possible that this unusual feature of Saint-Nazaire was inspired by the half-walls in one bay of the choir of Saint-Urbain at Troyes (fig. 347). The flat eastern faces of the chapels are reminiscent of Cistercian planning. The transept arm itself is only slightly higher than the Romanesque nave. The aisle and the chapels continue the same height of the main transept vessel, a treatment similar to the treatment of space in a hall church. The equal height of nave and aisle is similar to the squat lower level of Sainte-Chapelle.

The Rayonnant architect seems to have been very conscious of the subtle alternation of major compound pier and cylindrical pier in the Romanesque nave, for he repeats with variation this alternation in his design of the Rayonnant transept. The two piers flanking the entrance to the choir consist of four half-columns treated as integral parts of the compound pier. Statues standing on corbels and crowned by canopies, like the Apostles at Sainte-Chapelle, decorate all four faces of each of these piers. The next two piers extending to the south (fig. 353) and to the north in the transept are plain cylindrical piers crowned by a simple floral molding. If the nave and transept of Carcassonne are contrasted (figs. 352, 353), it is clear that the sensitive design of the Romanesque master builder has been rethought in Gothic terms by the unknown Rayonnant architect.

In the transept ends (fig. 253) a blind arcade capped by a triple cusped arch animates the lower zone and continues across the east end of the choir to include the membrane walls separating the six chapels. A second zone of blind arcading extends up to the elegant rose window. The whole design of the transept reveals the same refined elegance that characterizes the north transept of Saint-Denis and Sainte-Chapelle (fig. 345) as well as the transepts of Notre-Dame in Paris.

From the exterior (fig. 354) the choir, except for its flat roofs, which are characteristic of southern France, shows a strong relationship to Sainte-Chapelle (fig. 346).

The quality of Saint-Nazaire at Carcassonne seems to derive from the architect's extraordinarily sensitive consideration of the Romanesque

nave to which he was adding the choir. He repeats the notion of high aisles and echoes in Gothic forms, but with a different rhythm, the alternating system of the supports of the nave piers. The architect of Saint-Nazaire at Carcassonne was conscious of the 150-year-old nave, and at the same time he was aware of the developing Rayonnant in northern France, especially in the design of the tracery. It is this subtle synthesis of past and present that gives the cathedral its vital yet subtle originality.

THE CATHEDRAL OF ALBI

In contrast to both the Cathedral of Clermont-Ferrand and the choir of Saint-Lazare at Carcassonne (figs. 350–354), the Cathedral of Sainte-Cécile at Albi manifests the indigenous tradition of the Midi, and more specifically Languedoc (figs. 355–357). Whereas Clermont-Ferrand and the related cathedrals in southwest France, designed by Jean des Champs, and Saint-Lazare at Carcassonne exhibit the spread of an Île-de-France style, the Cathedral of Albi, with its wide interior space flanked by compartmented chapels and with the imposing, fortified mass of its exterior, is a new kind of Gothic firmly rooted in the architectural traditions of the Midi. At the same time, it is a bold statement reflecting the tortured history of southern France.

When Albi was begun in 1282, the official crusade against the Albigensians had long since terminated, but there were many secret societies of heretics, and there was considerable unrest as a result of the ruthlessness of the Inquisition's continued attempts to expose and destroy heresy. In response to the unrest, the new bishop, Bernard de Castanet, started construction of a fortified cathedral on August 15, 1282. Besides being Bishop of Albi, Bernard de Castanet was Inquisitor of Languedoc and Vice-Inquisitor of France. The Catharans — the pure ones — were called Albigensians, after Albi, where so many of the heretics were located. They were ascetics whose beliefs opposed orthodox Catholicism. As Previté-Orton stated (see bibliography):

To the Albigensians the material world and matter were evil, the dominion of the evil spirit. Against him stood the good God of the New Testament, whose kingdom was of the spirit, not of this material world. Human souls were spirits imprisoned in the evil material flesh, and to be freed by the Catharan belief and practices. The Catholic belief in bodily resurrection as well as the whole Church system of sacraments was untrue. Only the unregenerate passed into another material body. There followed from these extreme tenets an extreme of asceticism. All propagation of the evil flesh was the enlargement of the Devil's Kingdom; marriage was one of the fleshly sins. All food that had been sexually begotten was unlawful — milk and eggs as well as meat — for it was the prison of the spirit. Fish were allowed owing to an ignorance of natural history, but otherwise the strictest vegetarianism was enjoined.

Fortunately for the continuation of the human race, only the fully initiated — a minority — subscribed to these precepts, while the majority venerated those initiated.

The Albigensian heresy originated in the twelfth century and included vast numbers of the poorer classes and of the lesser nobility. In the early years of the thirteenth century, Count Raymond VI of Toulouse was on the verge of being initiated, and Cistercian missionaries were sent to Languedoc by the Pope to end the heresy. In 1204 Pierre de Castelnan, the Pope's legate, and Arnold-Amalric, Abbot of Cîteaux, organized the orthodox vassals and excommunicated Raymond VI. Philip Augustus, King of France, was too preoccupied with the war against the English to give military aid. In 1208, Pierre de Castelnan was murdered, and in the following year, lords and prelates gathered at Lyon and launched the Albigensian Crusade. Led by Count Simon de Montfort, the crusaders captured Béziers and burned over seven thousand inhabitants in the cathedral on July 22, 1209. Most cities soon capitulated. A conflict then arose between Count Simon de Montfort, who wanted to seize all lands, and Pope Innocent, who only wished to abolish the heresy. The orthodox King, Peter II of Aragon,

formed a league of nobles, but was defeated by Count Simon in September 1213 at Muret. Simon de Montfort became Count of Toulouse and Duke of Narbonne, but was killed trying to capture Toulouse in 1218. The final phase of the crusade involved the capture of Avignon in 1226 by King Louis VIII and a decree attaching the land of the heretics to the royal domain. One more revolt was suppressed before the final Treaty of Paris of 1229. On one level the crusade against the Albigensians was a religious crusade to wipe out heresy, but, as Count Simon's desire for conquest indicates, there were political and economic motivations blended with the religious intention of the crusade.

The Cathedral of Albi was begun in 1282 by Bishop Bernard de Castanet, who as Inquisitor continued a ruthless persecution of the surviving Albigensians. Later, in 1301, when returning from Toulouse, he was met by an angry mob and forced to retreat to and remain in a convent for several months. The heresy was officially terminated, but the threat of uprisings was ever present; it is small wonder that Bishop Bernard started the construction of a fortified cathedral. In spite of the fact that funds for construction had been available for several decades, the progress of work after August 15, 1282, was slow. By 1310 only the eastern six bays of the twelve were erected (plan, fig. 356). Between 1382 and 1397 the major part of the cathedral was completed. Final consecration took place on April 23, 1480. At the very end of the fifteenth century galleries were inserted in the tall, thin chapels flanking the nave. Around 1500 the huge coro with choir stalls and rood screen was placed in the eastern half of the cathedral (fig. 355), and Franco-Italian artists painted the interior in the late fifteenth and early sixteenth centuries. The upper three stories of the huge, doorless west tower were finished in 1485; the elaborate Flamboyant south porch (fig. 357) was constructed between 1519 and 1535.

The interior of Albi is a single vessel of twelve bays terminating in an apse with five five-sided chapels. Twelve square chapels open off each side of the nave; originally they extended to the level

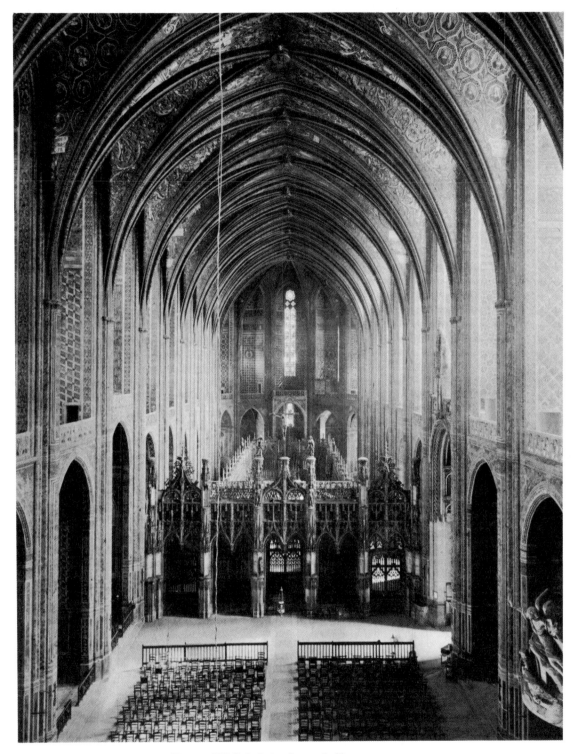

Fig. 355. Albi Cathedral, 1282–1390's. Nave; coro, c. 1500

of the vaults (figs. 355, 356). The height of the vaults from the pavement is 97½ feet, and the interior width of the nave, including the flanking chapels, is also 97½ feet. The total interior space is thus a square in section. A modest amount of light enters through tall, thin windows in each chapel. The walls, perpendicular to the axis of the nave and separating the chapels, serve as massive buttresses for the four-part vaults. These internal buttresses terminate outside in cylindrical piers which look like gigantic organ pipes wrapped around the exterior (fig. 357).

The wide, single space and the massive brick piers find no counterpart in the choir of Saint-Lazaire at Carcassonne (figs. 352–354) or in the cathedrals designed by Jean des Champs (fig. 350). The origins of Albi lie in the architectural traditions of southwest France, where there was a preference for a single nave. Many Romanesque churches, such as Souillac (fig. 81), Cahors, and Angoulême, had single naves covered with domes on pendentives. The pilgrimage church of Saint-Sernin at Toulouse (figs. 37–39), with its nave and four aisles, is based on the plan of Saint-Martin at Tours and is exceptional in southwestern France. When Gothic ribbed construction replaced Romanesque barrel, groin, and domed vaults, many structures with single naves were modernized (see nave of the Cathedral of Toulouse, 1219). In the Cathedral of Albi we see this regional tradition given a new and expressive magnitude. Albi, in turn, influenced other monuments in the Midi, such as the two churches outside the walls of Carcassone, the church at Taur, and Saint-Bertrand-de-Comminges, as well as structures in Catalonia.

The coro or enclosure, which occupies the six eastern bays, separated the clergy from the laity. Most of the coros in cathedrals were destroyed in the eighteenth or nineteenth centuries. Although the coro, containing choir stalls and altar with its elaborate rood screen or jubé across the entire nave (fig. 355), was damaged in 1794 and seventy statues destroyed, it remains the best-preserved in France. Constructed and ornamented around 1500, it is Flamboyant in style. The jubé has five openings, the side openings allowing circulation

around the exterior of the coro itself. The three central doorways give in to a narthex with elaborate pendant vaults and two circular stairways climbing to the balcony. Every surface of jubé and choir screen is animated by curving tracery and statues in niches. The exquisiteness of jubé and coro serves successfully as a countertheme to the starkness of the nave.

From the exterior, the Cathedral of Albi presents a bold silhouette accented by the enormous western tower without portals (there was access only between nave and tower). The flat roofs, characteristic of the Midi, and the uninterrupted cliff-like walls, animated by turret buttresses, reveal the enormous difference in massing in contrast to the massing of northern French cathedrals. All the elements of the northern cathedral complex — outer aisles with sloping roofs, clerestory windows with direct light into the nave, and the huge roof containing the forests (forêts) protecting the vaults — have been replaced by vertical brick walls rising from ground to cornice. No planes move inward in space, and a blocklike mass results. The material, red brick of uniform size, instead of individually cut stone, forces up the mural and military character of the exterior.

On the south side of the Cathedral of Albi, a fortified door with steps leading up to the entrance was constructed between 1397 and 1410. The Flamboyant portal in stone abuts the choir and is in turn buttressed by a brick tower. Steps climb up to the ornate stone porch over the south entrance, built between 1519 and 1535 (fig. 354). Round arches filled with flamelike tracery are supported by compound, cylindrical piers with ornate pinnacles. With their undercut surfaces of stone, both portal and porch intensify the simplicity of the brick flank of the cathedral, just as the Flamboyant coro and jube function in the interior.

The Cathedral of Albi reveals the creativity of a region outside northern France. Gothic construction, developed around Paris, made possible the wide, ribbed vaulted nave of Albi, but the architect of Albi combined these imported ideas with a new buttressing system and with a new spatial concept to create a monument which is orig-

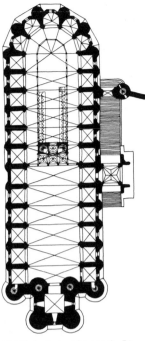

Fig. 356. Albi Cathedral, 1282–1390's. Plan (after Rey)

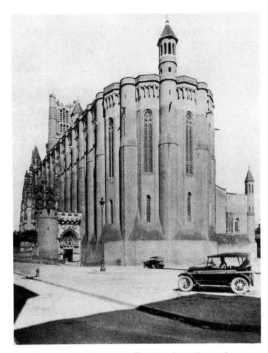

Fig. 357. Albi Cathedral. Exterior from the southeast

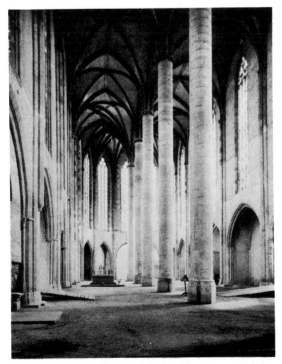

Fig. 358. Toulouse, Church of the Jacobins. Nave and choir

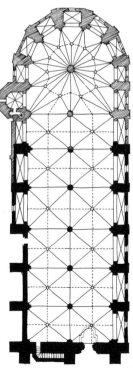

Fig. 359. Toulouse, Jacobins: Choir, 1285–1298; nave, 1330–1385. Plan (after Lambert)

inal and at the same time reflects the architectural and historical character of southwestern France.

CHURCH OF THE JACOBINS AT TOULOUSE

The Church of the Jacobins at Toulouse (figs. 358–360) is more elegant and in many aspects more unusual than the Cathedral of Albi. By 1230, when the church was begun, the Mendicant Order of Dominicans had been established for fifteen years. Saint Dominic, born in Spain in 1170, had become the leader of a group of wandering preachers who had attempted to combat the Albigensian heresy in southern France. The Dominican Order was founded in Italy in 1215, and the first church under its jurisdiction was constructed in Bologna in 1221. The first large Dominican church, however, was the Church of the Jacobins in Toulouse, which became the Mother Church of the Order. On January 28, 1369, the body of Saint Thomas Aquinas was brought from Italy, where he had died in 1274, and placed in a tomb in the Church of the Jacobins.

The first stone of the original Church of the Jacobins at Toulouse was laid on December 22, 1230. Until the results of the excavations, conducted by Maurice Prin, were published in 1955 (see bibliography), the existing nave (fig. 358) was thought to be the first church. However, the excavations unearthed foundations of walls outside the present church. This larger church had two naves of unequal size with the wider of the two naves on the south, reserved for the congregation, while the northern nave contained the friars' choir. This church had five bays, a flat-ended choir, and a wooden roof. It was probably completed by 1263. The lower part of the present façade, excluding the buttresses but including the south portal, belong to this campaign. Between 1285 and 1298 the present choir, including an additional bay of the nave and the tower, were added to the east of the first church (see plan: fig. 359). In the fourteenth century (1330–1385) the original church was demolished and the existing, vaulted double nave erected (fig. 358). In the sixteenth century the simple rectangular chapels of the choir

were enlarged into polygons, and the chapel on axis was converted into a large square with a lantern in the early seventeenth century (fig. 360). A new tomb for the remains of Saint Thomas Aquinas was built between 1623 and 1627. In the Revolution the monastery was closed. During the nineteenth century the church was used as a stable for cavalry, and the vaults of many of the chapels were destroyed. The windows have now been restored to their original size, but the monastic choir in the left or north nave (fig. 358) is no longer in existence. Thus the Church of the Jacobins seems to have been built in three campaigns: five western bays with wooden roof, 1230–1242; extra bay and choir, both vaulted, 1285–1298; destruction of old nave and erection of present, vaulted nave, 1330–1385.

The nave of the Jacobins (fig. 358) reveals an unconventional treatment of space, since it is neither a large vessel flanked by lower aisles nor a single space bounded by chapels, as at Albi. Instead, the space consists of two naves of equal height divided by a row of seven cylindrical piers. The two naves are 65 feet wide and 260 feet long, while the piers are 71½ feet tall, and the height of the vaults is over 84 feet. Light from tall, thin windows illuminates the interior. The walls were constructed of brick, like those of Saint-Sernin at Toulouse (figs. 37–39), but the nave piers, the ribs of the vaults, and the piers with their rising shafts and archivolts along the sides were built of stone masonry. This unusual plan of the Jacobins seems to have derived from the specific function of the church. Because of the violent temper of the times, the clergy and laity were separated. The Friars' choir, surrounded by a wall, was located in the north nave with direct access to the cloister through a portal in the third bay. Following the observations of Viollet-le-Duc, subsequent critics stated that a staircase in the façade connected the monastic choir with a large pulpit over the single portal. Sermons were thus delivered to the congregations in the south nave from a pulpit over the single, right-hand portal, and the preacher could gain direct access to this pulpit from the monastic choir without passing through the congregation.

This delightful solution of circulation has now been disproved. There are other theories which partially explain this separation into two naves. The architect may have known the pilgrimage church of Rocamadour, with its two naves, which was constructed in the late twelfth or early thirteenth centuries (see bibliography: Rey). In plan Toulouse resembles Cistercian refectories, which have off-center pulpits designed for reading during meals (see bibliography: Lambert). The Church of the Jacobins in Paris, begun earlier than the Jacobins of Toulouse and destroyed during the Revolution, originally had a single nave, and then a second one was added. If the Jacobins at Toulouse is compared with Saint-Nazaire at Carcassonne, certain similarities are seen, such as choir aisles as high as the transepts and the emphasis on slender supports. In spite of the vague connections between the Church of the Jacobins and other monuments, it is probably less ambiguous to argue that the plan and distribution of spaces of the Church of the Jacobins of Toulouse had their origins in the specific requirement of the Dominicans — a separation of the monastic choir, monastic community, and university in the north nave and walled cloister beyond from the south nave where orthodoxy was preached to a heretical and potentially rebellious laity.

The choir, added between 1285 and 1298, is an amazing Rayonnant concept. The entire eastern choir was conceived as a central plan with twenty-two ribs springing from a single pier. Around the pier are eleven triangular bays, two related to the naves and nine connected with the bays above the nine chapels. Each triangular bay is divided into three parts by extra ribs which spring from the central pier and branch into a pair of ribs connected with the outer walls. All the keystones of the vaults are connected by a simulated ridge-rib of blue paint which is carried into the two naves to relate the nave to the choir. The choir, with its skyrocket effect of ribs rising from a central pier, is a unique solution which recalls the vaulting of chapter houses in English cathedrals such as Salisbury (1280).

From the exterior (fig. 360) the Church of the Jacobins seems to be a structure with a single nave stabilized by massive brick wall buttresses which, in turn, are strengthened and connected by the thick arches that frame the windows. The surfaces are modulated by three major planes in depth: the wall buttresses, the wall above the arches, and the windows set back in niches. Oculi light the area above the platform over the vaults, a space used by Toulousians for refuge from the Huguenots in the sixteenth century. The change in the design of the wall buttresses between the fifth and sixth bay (counting from the façade) reveals the break between the major thirteenth- and fourteenth-century building campaigns. The exterior of the Church of the Jacobins had an enormous influence on subsequent buildings in southern France.

SAINT-OUEN AT ROUEN

In spite of the fact that the Benedictine Abbey Church at Saint-Ouen at Rouen in Normandy was constructed over a two-hundred-year span, its major architectural forms still exhibit the purity and elegance of Rayonnant (figs. 361–363). The choir of the present church was begun in 1318 and completed in 1339, but the superstructure of the nave was not finished until 1536. After a cessation of work of over a hundred years, the builders of the nave respected the design of the choir and made alterations only in window mullions, piers, and moldings. In contrast to the Cathedral of Albi and to the Church of the Jacobins in Toulouse, Saint-Ouen represents not a provincial adaptation, but a direct evolution of Rayonnant forms established in Paris and its environs in the 1230's, 1240's, and 1250's. Regional traditions of Normandy have had little effect, if any, on the design of Saint-Ouen, while Albi and the Jacobins in Toulouse acclaimed their indebtedness to the whole spirit of the Midi.

The first church of Saint-Ouen at Rouen, which housed the relics of Saint Ouen, the Archbishop of Rouen who died in 698, was destroyed by the Vikings in 841. The Romanesque abbey, constructed between 1056 or 1066 and 1126, was severely damaged by a fire in 1136 (see bibliogra-

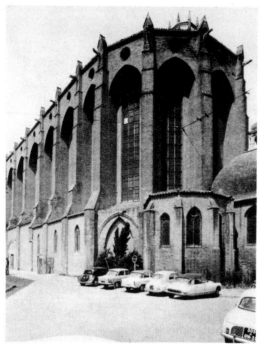

Fig. 360. Toulouse, Jacobins. Exterior from the southeast

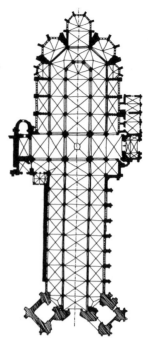

Fig. 361. Rouen, Saint-Ouen: choir, 1318–1339; nave finished 1536. Plan (after Masson)

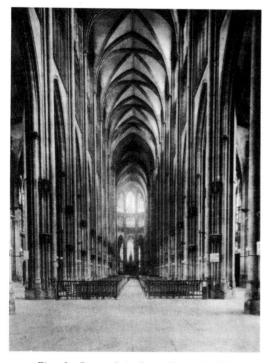

Fig. 362. Rouen, Saint-Ouen. Nave and choir

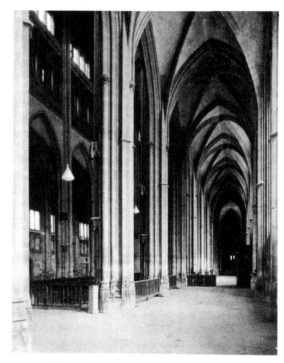

Fig. 363. Rouen, Saint-Ouen. South aisle

phy: Masson). Remains of this church exist in the form of a chapel opening off the north arm of the transept of the present church (see plan, fig. 361). Another fire in 1248 ravaged much of the city of Rouen, further damaging the church, and in 1318 the decision was reached to build an entirely new church. Between 1318 and 1339 the entire choir, with its ambulatory and radiating chapels, and the piers of the crossing and of the single western aisle of the transepts were constructed. Little progress was made during the Hundred Years War. The transept vaults were not in place in 1441. By 1492 the nave piers and exterior walls of the three western bays of the nave were erected, and between 1492 and 1515 these bays were vaulted and the nave piers and vaults of the five western bays were constructed. The vaults of the western bays were not in place until around 1536. The unusual façade, with its paired towers set at forty-five degree angles to the front plane, was constructed to a height of 63 feet in the sixteenth century (see plan, fig. 361). After 1845 this façade was demolished and the present, more traditional one was substituted. Saint-Ouen was damaged internally by the Huguenots in 1562, and much of the sculpture was destroyed and mutilated during the French Revolution.

In plan, the choir of Saint-Ouen reveals the creative adaptation of High Gothic cathedral design for a smaller structure (fig. 361). Three large chapels and two small ones open off the ambulatory. The choir of three bays is flanked by aisles and six chapels. In the mid-thirteenth to fourteenth centuries chapels were added between the buttresses of many Early and High Gothic cathedrals (as at Laon, Paris, Bourges, and Amiens), but in Saint-Ouen these chapels are an integral part of the original design. The slight change in axis between the fifth and sixth bay of the nave (counting from the west) reveals the division between the first and second phases of the construction of the nave.

The interior of the choir of Saint-Ouen (fig. 362) clearly portrays the linear elegance of Rayonnant. The glazed triforium of the sides of the choir is divided into six sections and further subdivided

by mullions into twelve narrow apertures. These divisions and subdivisions are echoed in the major design of the clerestory windows. In the narrower bays of the hemicycle (fig. 362) the division of three major openings of the clerestory over three of the triforium can be seen. The central window in the radiating chapel on axis repeats the design above. Along the sides of the choir, the windows on the outer walls of the chapels between the buttresses repeat the forms of the clerestory windows, so that a consistency of design exists in all three stories. Voids in the form of light become more important than structure, which is reduced to a pattern of lines against the ground of glass. The triforium is not connected to the clerestory by colonnettes, as in the nave and upper choir of Saint-Denis (figs. 341, 342); yet the increase in the heights of the glazed triforium in relation to clerestory, plus the large windows of the chapels flanking the choir and the windows in the aisles of the nave, increases the importance of light as it is framed by thin mullions and bundles of shafts.

As at the Abbey of Saint-Denis, the shafts rise from the plinths to the springing of the ribs without the interruption of capitals (fig. 362). The vertical sweep of the major shafts of the choir is broken by a corbel supporting canopies; originally these contained statues, as in Sainte-Chapelle and in the choir of Cologne Cathedral. The capital from which the nave arcade springs has been reduced from the size of the High Gothic capital to a floral interlude between the colonnette and the major molding of the arcade. Indeed, the simplicity of the High Gothic pier, with four attached colonnettes (see Chartres, Soissons, Reims, Amiens), has been replaced by colonnettes and moldings which accentuate the linear nature of the interior.

In the nave, constructed in the fifteenth and early sixteenth centuries, the bays are slightly narrower, with five divisions of aisle windows, glazed triforium, and clerestory instead of the six in the choir; and the traceries, instead of being cusped arches, trefoils, and rosettes, consist of a conservative kind of Flamboyant tracery which harmonizes with the Rayonnant choir. The nave piers (figs.

362, 363) also exhibit an evolution of form, as the plinths are no longer a series of horizontal elements from which the pier with its attached shafts arise. Rather moldings are duplicated and grow from bases of different heights. A pair of concave pilasters on each side of the colonnette and the capital, which supports the transverse rib, grow up into the webbing of the vault. From the inner edge of these pilasters emerges a molding which becomes the diagonal ribs. A molding two-thirds of the way up these pilasters relates the aisles to the niches for statues, which are on the two diagonal sides of each pier in the nave (fig. 362). This merging of elements, molding into structure and structure into molding, is no longer Rayonnant but Flamboyant, "Baroque" Gothic and is similar to the style of the choir of Saint-Séverin in Paris (fig. 340).

On the exterior (not illustrated), dramatic, thin buttresses in two flights and two stories reflect the refinement of the interior. The crossing tower is Flamboyant, with many forms which recall the early sixteenth-century north spire of Chartres Cathedral (fig. 218). The original façade,

with its diagonal placement of towers, would seem to have been the natural outgrowth of the design of the nave piers (figs. 362, 363), since in plan the piers and towers are similar.

Rayonnant architecture as seen in Saint-Denis, Sainte-Chapelle in Paris, Saint-Urbain in Troyes, the Cathedral of Clermont-Ferrand, Saint-Nazaire at Carcassonne, and Saint-Ouen in Rouen is the natural development of ideas created by the High Gothic architects. Some critics consider these monuments as the ultimate culmination of High Gothic, while others regard their overrefinement as a sign of decadence or decline. Clearly, Rayonnant architecture, with its emphasis on overlapping elements, on light almost to the exclusion of structure, and its greater emphasis on linear pattern (as opposed to the structural logic of High Gothic), is quite different from the earlier phases of Gothic. Yet Rayonnant is creative. New concepts of intimate spaces flooded with light, new types of plans, and differently animated surfaces all manifest another and original phase of Gothic architecture.

ℐlamboyant ℳrchitecture

Contemporary with Early and High Renaissance architecture in Italy, the Flamboyant style of the fifteenth and early sixteenth centuries is the last stage in the evolution of French Gothic architecture. Early and High Gothic architecture was born in the Île-de-France. The impact of High Gothic on structures in western Europe was soon replaced by that of the Parisian Rayonnant Gothic, the exportable Gothic. When exported, Rayonnant often became fused with local traditions, as the Cathedral of Albi and the Church of the Jacobins at Toulouse bear witness. The origin of Flamboyant architecture is still being debated. Possible influences from late English Gothic on the formation of Flamboyant Gothic do exist; yet it can be argued with equal validity that Flamboyant Gothic developed out of Rayonnant, independent of the evolving English Gothic.

CHURCH OF THE TRINITY AT VENDÔME

Parts of the Trinité at Vendôme — the six western bays of the nave and the façade (figs. 364–366) — illustrate superbly this last flowering of the Middle Ages. The original abbey church at Vendôme was Romanesque, dedicated in 1040 (see bibliography: Plat). The transept and crossing piers of this church were incorporated in the present structure. Angevin vaults were added to the transept arms in the thirteenth century. By the end of the thirteenth century Vendôme was partially in ruins, and in 1306 the monks decided to rebuild the entire church. A new Rayonnant choir, with ambulatory and five radiating chapels, was accomplished between 1306 and 1318. This chevet has two deep chapels opening laterally off

the hemicycle and an even deeper chapel on the main axis (plan, fig. 365). Between these three are two smaller chapels. The large side chapels, together with the Romanesque transept, make a double transept. The glazed triforium with quatrefoils in the lower zone and with pointed cusped arches above is joined by mullions to the clerestory. The piers of the choir are surmounted by twelve colonnettes: three in the aisles are crowned by capitals from which spring the transverse and diagonal ribs; six shafts (three on each side of the pier) have capitals supporting the archivolts of the main arcade; three (uninterrupted by capitals) rise from the pavement to the vaults. This duplication of elements and overlapping of parts, together with the glazing of the triforium and its intimate connection with the clerestory, is Rayonnant and is an elaboration of the style of such monuments as the nave of Saint-Denis and the choir of Saint-Urbain of Troyes (figs. 341, 347).

In the next major Rayonnant building campaign between 1343 and 1357 (see bibliography: Plat), the western Romanesque piers of the crossing were strengthened and the two easternmost bays of the nave were erected. Instead of the pier with twelve colonnettes as in the choir, the piers of these two bays have sixteen colonnettes. Three colonnettes rise to the springing of the nave vault, three relate to the ribs of the aisle, and five on each side of the piers terminate in the capitals from which the multiple moldings of the archivolts of the nave arcade rise. The triforium and clerestory repeat the design of the windows in the choir.

The progress of construction was interrupted by the Hundred Years War. The church was

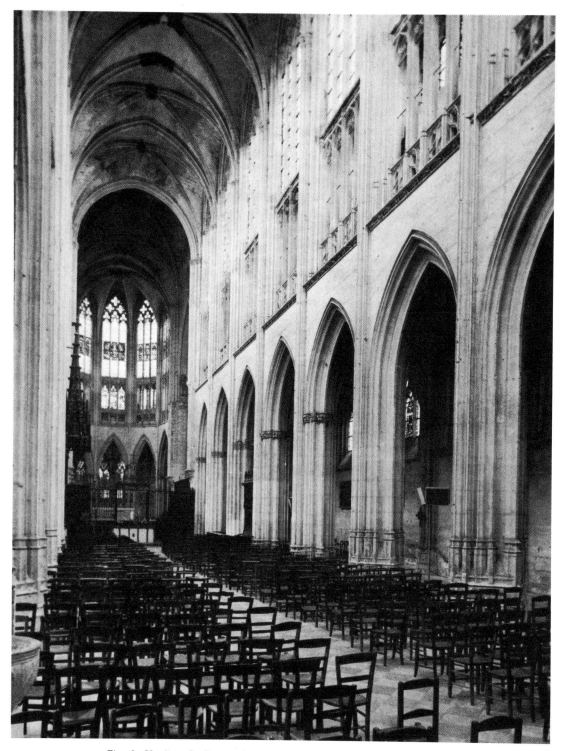

Fig. 364. Vendôme, La Trinité. Choir, 1306–1318; nave, 1343–1357 and 1450–1507

sacked by the English in 1362. Around 1450 two more bays, which include the third and fourth piers from the crossing, were added to the nave (fig. 364). These piers reveal subtle differences when compared with the eastern, Rayonnant piers. The shafts, which extend from the bases to the vaults, no longer exist as a bundle of three separate colonnettes. Rather, thin, convex moldings fill the re-entrant angles between the shafts, while the moldings of the nave arcade are increased in complexity. The general organization of the openings in the triforium and clerestory remains the same, but the tracery is no longer Rayonnant, but Flamboyant. Diagonal flamelike mullions replace the geometric quatrefoils in the base of the triforium, and the simple cusped arches of the upper part of the triforium now have reverse-curve or ogee arches framing the elaborate trefoils. Tracery in the clerestory windows consists of curvilinear, interweaving elements.

The last four, western, bays of the nave were constructed between 1485 and 1507. Individual parts, which have a visual relation to the ribbed vaults, are further dissolved into extra moldings which animate the colonnettes. No capitals separate the pier from the archivolts of the nave arcade, and the piers as a whole have been transformed into a complex series of moldings. Large multiple plinths or bases have replaced the lower, simpler ones in the eastern part of the nave. A dynamic linear interpretation of parts connects the nave arcade and the triforium and clerestory in a new and original manner. The result is instantaneous unity, as opposed to an additive unity we associate with High Gothic.

In spite of the fact that the Gothic sections of Vendôme were constructed in four major campaigns (incorporating a Romanesque transept), the interior remains unified. The major elevations and shapes of apertures remained constant during the two hundred years involved in the completion of the church. The design of piers, archivolts, and moldings, however, underwent a gradual sea change as the Rayonnant point of view was gradually replaced by the Flamboyant style. This evolution does not echo the dramatic kind of change

involved in the creation of High Gothic or in the experiments of Early Gothic. Rather, it resembles the subtlety of the emergence of Rayonnant out of High Gothic architecture.

The exterior of Vendôme reflects the same sequence of styles as those existing in choir and nave. The elegant buttresses of the Rayonnant choir spring from relatively simple piers. The design of the pinnacles, niches, and gargoyles becomes more ornate and elaborate during the construction of the nave. The façade (finished by 1507) is a superb example of Flamboyant design (fig. 366). The contrast between its flowing forms and the mural presence of the free-standing Romanesque south tower of the 1120's intensifies the solidity of the tower and heightens the dynamic fluidity of the façade. The tower was originally connected to an eleventh-century porch in front of the Romanesque church. Side portals of the Flamboyant façade open into the aisles of the nave and are separated from the central portal by large piers encrusted with small niches for statues. The tympana of all three portals are filled with flamelike tracery. Reverse curves form small gables over each entrance, while other curved moldings grow into small gables over each portal. Over the central portal the small opaque gable is framed by the larger gable, which is filled with undulating tracery. The spandrels over the side portals and the triforium level above the central portal are further animated by tracery of a similar design. The gable over the central portal overlaps the large west window, which corresponds to the clerestory. The all-over flame motif animates the entire façade. A sense of continual growth from pavement to roof is achieved. Divisions between zones and elevations are blurred by overlapping elements, and instantaneous unity replaces an additive or multiple unity.

It is quite possible that Jean de Beauce was the architect who designed the four western bays of the nave and the façade. It is known that he lived in Vendôme as late as 1506 and that he went to Chartres (only forty-three miles to the northeast) in 1507 to construct the north spire of the cathedral (fig. 218). The exuberant surfaces of both the

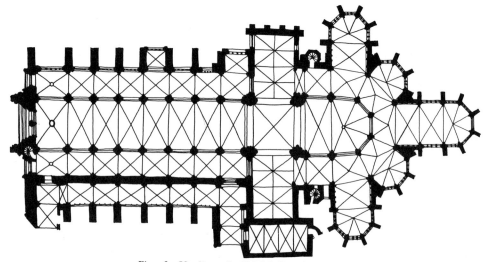

Fig. 365. Vendôme, La Trinité. Plan (after Plat)

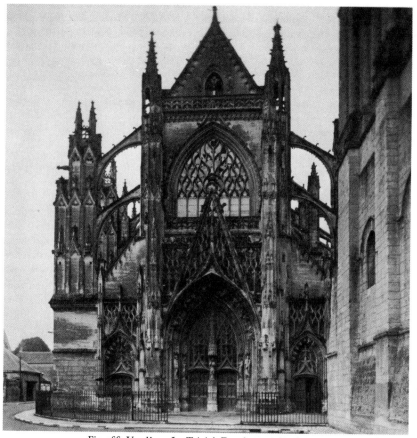

Fig. 366. Vendôme, La Trinité. Façade, completed 1507

spire of Chartres and the façade of Vendôme are similar; both reflect the dramatic character of Late Gothic France.

SAINT-MACLOU AT ROUEN

Rouen, near the mouth of the Seine in Normandy, is rich in late Gothic religious and secular architecture constructed after the termination of the Hundred Years War. On May 30, 1431, Jeanne d'Arc was burned at the stake by the English in the Place du Vieux-Marché in Rouen. By 1450, however, the English were driven from Normandy, and a great period of building ensued. Saint-Maclou, begun in 1434 (figs. 367–369), is a fine Flamboyant parish church which, like so many structures at Rouen, was heavily damaged by bombardments in June 1944. Located just to the east of the cathedral, Saint-Maclou replaced a smaller church of the late thirteenth century. The architect, Pierre Robin, designed Saint-Maclou in 1434. The nave was finished by about 1470. Another architect, Ambroise Havel, probably made a new design for the façade in 1477. By 1487 the west rose window was completed, and the façade, with its five-sided porch, was built between 1500 and 1514. The present stone spire over the crossing was erected in 1868 and replaced the original wooden one, which had been demolished in 1736 (see bibliography: Perkins).

As a parish church, Saint-Maclou is only 180 feet long, with vaults that rise 75 feet above the pavement. The choir has two bays, the nave three bays; thus the crossing with its tower is located roughly in the middle of the church (fig. 367). The organization of the ambulatory and radiating chapels differs markedly from High Gothic plans. There is no chapel on axis; a pier of the hemicycle and the wall dividing the easternmost chapels lie on the main axis of the church instead of a radiating chapel and a bay of the ambulatory. The four hexagonal chapels, opening off four ambulatory bays, emphasize the diagonal movement of space. The entire east end is one-half of an octagon. The four chapels flanking the choir and the six chapels flanking the nave are part of the original design

and not additions, as they were in many twelfth- and thirteenth-century cathedrals.

The height of the nave arcade almost equals the combined height of the triforium and clerestory, with the result that the elevation reads as two stories, the dark base of the nave arcade below and the glazed superstructure above. The triforium is animated by an arcade of four arches with flamelike tracery, and the clerestory is subdivided into four openings surmounted by reverse-curve moldings. The surfaces of the piers of the crossing (fig. 368) are animated by a series of moldings, rather than by individual shafts or colonnettes. The nave piers have multiple moldings which continue over the nave arcade and three colonnettes on the nave side which rise up and grow into the transverse and the two diagonal ribs. The absence of pier capitals in the nave arcade recalls the western nave bay of Vendôme (fig. 364), but the elimination of the capitals between engaged colonnettes and the ribs of the vaults reflects the further overlapping of zones. The sense of unity achieved at Vendôme by the addition of nave arcade and clerestory is replaced at Saint-Maclou at Rouen by one surging, flowing impression which then becomes subdivided into nave arcade and upper double zone. Since the choir and nave of Saint-Maclou were constructed in one relatively short campaign, they possess greater homogeneity than the ever-changing choir and nave of Vendôme (fig. 364).

The façade and porch of Saint-Maclou (fig. 369) reveal the new concepts of surface and mass of the Flamboyant period. The porch of five bays is bowed out in front of the plane of the façade (plan, fig. 367). The four side openings, the outer pair blind and the inner one related to the portals, are placed in a diagonal relationship to the frontal plane of the west end of the nave and of the central portal, in contrast to High Gothic façades (see Amiens, fig. 258) or to the contemporary church of Vendôme (fig. 366). The sense of recession laterally from the central portal implies a dynamic movement quite different from the more static, vertical sequence of parts in High Gothic architecture. The rounded piers between the por-

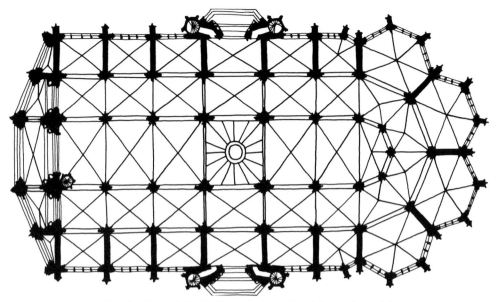

Fig. 367. Rouen, Saint-Maclou, 1434–1514. Plan (after de Lasteyrie)

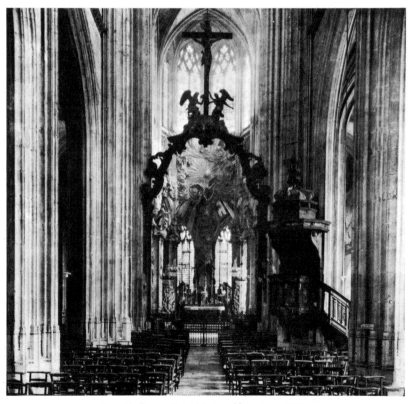

Fig. 368. Rouen, Saint-Maclou. Nave, 1434–1470

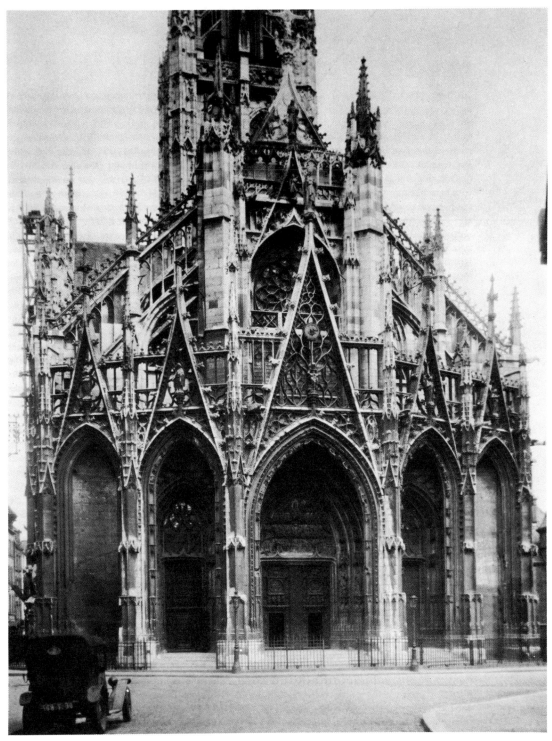

Fig. 369. Rouen, Saint-Maclou. Façade, 1500–1514

tals were originally encrusted with statues in niches set on their angles. This sculpture, plus blind niches and crowning finials, further transforms the structural relations of the façade elements as they had been realized in High Gothic, and the end result is not structure in space, but surfaces animated by light and shade. Gables filled with flamelike tracery and a single statue rise from the five portals and overlap the flying buttresses and the western rose window. The gable over the central portal is repeated in the gable over the west window and in the gable rising above the façade and is finally echoed in the gables surmounting the crossing spire. The horizontal screen connecting the five gables has its counterpart in the arcades above the west window. The animated, undercut surfaces of piers, gables, and buttresses, all of which are crowned by finials studded with crockets, enhances the unity of the whole façade. The steep pitch of the flying buttresses and the even steeper angle of the gables converge on the crossing tower and imply a kind of central massing over a central plan. The lateral and vertical movements stated in shifting planes and interpenetrating parts impart a Baroque dynamism to Saint-Maclou which is quite different from the more conservative Flamboyant façade of Vendôme or the south transept of the Cathedral of Beauvais (1500–1548, fig. 294). If the piers were replaced by engaged columns and gables by classical entablatures, the façade of Saint-Maclou at Rouen would invite comparison with late Greek architecture or with seventeenth-century buildings designed by Borromini.

CHOIR OF SAINT-ÉTIENNE AT BEAUVAIS

The parish church of Saint-Étienne at Beauvais was originally Romanesque, constructed after 1072. By the 1120's and the 1130's the aisles of the nave were covered with experimental ribbed vaults (fig. 147). In 1180 a fire destroyed two-thirds of the town of Beauvais and necessitated the construction of new vaults over the nave of Saint-Étienne in the early thirteenth century (see bibliography). Following damage to the crossing tower sustained during a storm in 1480, it was demol-

ished, and the parishioners decided to construct a new choir. In 1506 work began on the new elaborate choir (figs. 370–372) to replace the older, smaller Romanesque choir. The design of the piers, the two-story elevation, and the complexity of vaults state the major characteristics of the Flamboyant style. On May 15, 1522, the main altar was dedicated, but by 1544 the choir had not been joined to the Romanesque transept. At that time, the architect of the Cathedral of Beauvais and the architect in charge of Saint-Étienne reported on the best procedures to link choir and transept. In 1548 funds were still being raised for this last campaign, which involved new vaults over the crossing and transept and the completion of the bays to the east of the south transept (fig. 372). The large northwest tower, which involved some demolition and modification of the north aisle, was constructed between 1583 and 1674.

The choir of Saint-Étienne, with vaults 85 feet high, dwarfs the twelfth- and thirteenth-century nave (fig. 292). In plan (fig. 370) the choir proper, consisting of four bays flanked by aisles and eight chapels, terminates in a trapezoidal bay. The bays of the ambulatory form a flat east wall broken only by the single chapel on the main axis. In the main vessel of the choir (fig. 371) the triforium, which had appeared to be part of the clerestory in Saint-Maclou at Rouen (fig. 368), was eliminated in favor of the semiopaque nave arcade and the large clerestory filled with glass. The piers, which undulate in section, are animated by eight convexities. One pair of convexities grows into the multiple moldings of the main arcade, while the second pair branches into the diagonal ribs. The largest convexity grows into the lowest molding of the transverse rib, and other moldings of the transverse rib emerge from the wall. From each pier in each bay spring two diagonals which form a nine-part vault with four keystones.

In the two bays to the east of the south transept (fig. 372), the star vaults exhibit even greater curvilinear complexity than the vaults over the choir. The major diagonals start as moldings on the convex section of the pier and become ribs, and two additional ribs, called tiercerons, rise from the

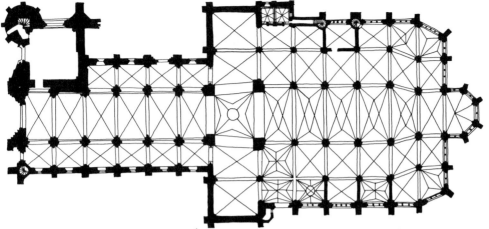

Fig. 370. Beauvais, Saint-Étienne, choir, 1506–c.1550. Plan (after Leblond)

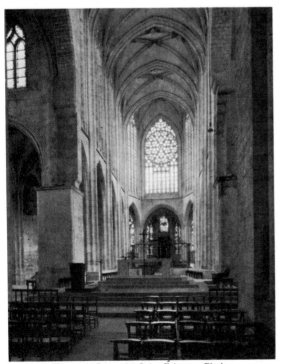

Fig. 371. Beauvais, Saint-Étienne. Choir

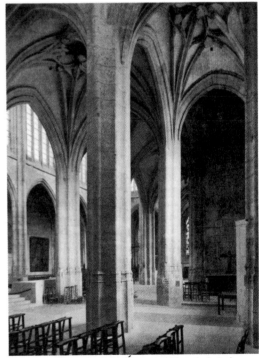

Fig. 372. Beauvais, Saint-Étienne. Aisles of choir from
south transept

corners of each bay. Extra ribs or liernes branch out from the twelve diagonal ribs and with their reverse curves tie all the ribs together in a star pattern. The next chapel to the east (fig. 372) is vaulted by an even more complicated system of suspended ribs and hanging pendants. The logic of the High Gothic vault is replaced by an exuberance of interlocking elements which conceals the webbing. The piers in the south transept and the bays to the east (fig. 372), like the piers in the ambulatory of Saint-Séverin in Paris (fig. 340), illustrate a transformation from structure to decoration and back to structure, and there is a sense of growth continuous from pavement to vault. An all-pervading unity is achieved instantaneously.

From the exterior (fig. 292), the large windows of the clerestory repeat those of the side chapels in size and design. Flying buttresses in two flights start as single buttresses and branch into two against the intermediate pier and against the clerestory. Like the interior, the exterior is unified by the repetition of similar elements joined by the linear accents of the flying buttresses.

The simplification of the pier into undulating moldings, the reduction of the elevation to two stories, the duplication of ribs, and the sense of growth from pier to ribs and moldings to ribs — all manifest the nature of the final statement of Late Gothic architecture.

THE CHURCH OF BROU AT BOURG-EN-BRESSE

The Church of Brou on the outskirts of Bourg-en-Bresse, in the Jura, contains private chapels and oratories, three large tombs, elaborate choir stalls, carved retable, jubé or rood screen, and stained-glass windows (figs. 373–377). It was constructed on the orders of an extraordinary donor for fascinating reasons. As a totality of Flamboyant architecture, sculpture, and stained glass, Brou manifests succinctly both the spirit of the late Middle Ages and the kind of patronage which fostered that spirit. However, in many details, especially in the tombs and windows, Renaissance ideas presage the end of the Middle Ages.

Brou was built between 1513 and 1532 (see bibliography), but the reason for its construction dates from 1480, when Philip, Count of Bresse and later Duke of Savoie, was injured in a hunting accident. His wife, Margaret of Bourbon, grandmother of Francis I, made a vow to rebuild the small priory of Brou if her husband survived. Margaret of Bourbon died without having fulfilled her vow. She had, however, revealed her intentions to her husband and to her son, Philbert the Handsome. Philbert died suddenly in 1500, and his wife, Margaret of Austria, saw his untimely death as a punishment for not having carried out the vow of Philbert's mother. Margaret of Austria, daughter of the Emperor Maximilian, had lost her mother at the age of two and a year later had been installed in the court of Louix XI of France and at the same time married to Charles the Dauphin. This marriage was repudiated when Charles VII married Anne of Brittany. At sixteen, Margaret married the heir apparent of Spain, who died several months later. She next married Philbert the Handsome, but after three years he caught cold while hunting and died. Thus, at the age of twenty-four, Margaret of Austria became a widow for the second time. As the wise and well-educated Regent of Holland (Pays-Bas) and the province of Franche-Comté, Margaret of Austria now proceeded to consummate her mother-in-law's vow.

Work started in 1506 with the construction of new monastic buildings, including two additional cloisters. Soon afterward Margaret left Bourg-en-Bresse to live in Malines, near Brussels. In November 1512, Louis van Boghem, a Flemish master mason, was selected by Margaret and sent to Brou. He returned to Malines, where Margaret signed a contract and approved the plans which he and others had developed. In June 1513, Van Boghem arrived back in Bourg-en-Bresse and started the construction of the Church of Brou. In 1516, Van Boghem asked John of Brussels to design the tombs. Six years later the entire choir, most of the transept, the base of the tower, the aisles of the nave, and many of the smaller statues of the three tombs were completed (plan, fig. 373). Between 1526 and 1532 the large figures of the tombs and

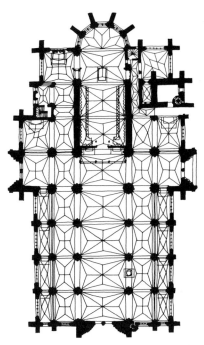

Fig. 373. Bourg-en-Bresse, church of Brou. Plan
(after Nodet)

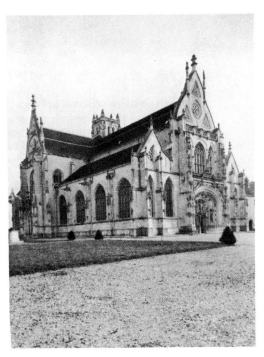

Fig. 374. Brou, church, 1513–1532. From the northwest

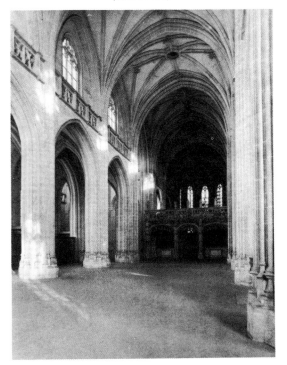

Fig. 375. Brou, church. Nave, rood-screen, choir

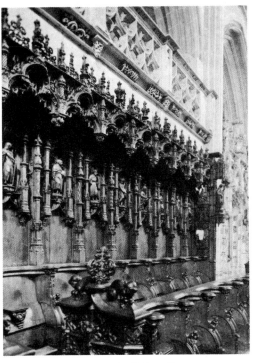

Fig. 376. Brou, church. Choir stalls, 1530–1532

west portal were executed by Conrad Meyt, a German trained in Flanders, and by his brother Thomas and two assistants. The stained-glass windows (1525–1530), designed by Flemish artists, were made by three stained-glass workers from Lyon, which is only forty miles southwest of Bourg-en-Bresse. The oak choir stalls (1530–1532) were carved by a local artisan, Pierre Terrason, and assistants from Flemish designs. The ceramic-tiled pavement of the choir (1531–1532, subsequently destroyed) was made by François de Canarin after Italian Renaissance designs. The master of the work, Van Boghem, made two trips a year to report to Margaret on the progress of the construction. Margaret, however, died of an infected foot on December 1, 1530, well over a year before the church was completed and consecrated on March 22, 1532. In the following June her body was brought to Brou. Brou, with its tombs, retables, stained glass, and elaborate pavement, was completed in nineteen years; yet the donor who had participated in all facets of its design and execution and who had financed its creation never saw it.

The exterior of Brou (fig. 374) does not exhibit the consistency of forms and surfaces seen in Vendôme and Saint-Maclou at Rouen (figs. 366, 369). Some of the inconsistencies occurred because the façade was completed after the death of Margaret of Austria, and some are the result of subsequent alterations and restorations. Proper handling of drainage was never sufficiently designed. Water damage increased after the lead roof was remade in 1557. Restorations, begun in 1759, changed the exterior configuration in many respects. The spire over the crossing and the ornate imperial crown with globe over the tower were removed. A new hipped roof replaced the single pitched roof over the nave. Originally, gables similar to the two in front of the aisles had risen above each bay along the flanks of the church. These gables were removed. When it was completed in 1532, the façade and sides of Brou must have been much more unified than they are in the modified structure existing at present.

The five vertical divisions of the façade reflect the interior disposition of nave flanked by two aisles and two rows of chapels (plan, fig. 373); yet the design of the pair of gables terminating the aisles and chapels tends to blur the relative size of the interior compartments. The central section of the façade is divided into three horizontal zones by two balustrades animated by Flamboyant tracery. The segmental arch over the portals shifts to three pointed arches at the level of the clerestory windows and culminates in three triangular openings around a rose window with a gable framed by reverse curves. The variety of shapes of the apertures is quite different from the repetition of similar shapes in the façades of Vendôme and Saint-Maclou at Rouen. The central portal includes kneeling statues of Philbert and Margaret and angels, presented by their patron saints to the Ecce-Homo in the center of the tympanum, statues of Peter and Paul in the jambs, and Saint Nicholas on the trumeau. These statues by Conrad Meyt and his assistants show an Italianate Renaissance articulation, but are placed in a Late Gothic ambient.

The organization of interior spaces and their interrelationships (fig. 375) was designed around the multiple functions of the church. The seventy-four stalls for the monks occupy two bays of the choir, with easy access to the monastery (fig. 376). The monastic choir is separated from the laity by a thin wall with doorway and by the triple-arched rood screen in the crossing. In the eastern bay of the choir are located the three tombs, Margaret of Bourbon in a niche in the south side, Philbert in the center, and Margaret of Austria in the north side (fig. 377). To the north of this choir bay and the tomb of Margaret of Austria is her chapel, with the large stone retable depicting the Joys of the Virgin and stained-glass windows. Margaret's two private oratories, on two levels connected by a staircase, are adjacent to her chapel (plan, fig. 373). Each oratory has a fireplace, and an ingenious diagonal opening was designed to make it possible for Margaret to see the high altar in the apse and yet participate privately in the offices of the monks. Margaret was also to have access between her oratories and her private apart-

ments in the convent by a gallery between the upper oratory and the passageway across the rood screen. The chapel of Lourent de Gorrevod, Margaret's counselor, the governor of Bresse, opens off the north arm of the transept, while the chapel off the south arm of the transept was designed for Abbot Antoine de Montécuto. The lower story of the tower and a chapel, plus the passageway to the monastery, occupy the area south of the choir.

The church proper with its nave of four bays, two aisles, and eight narrow chapels is roughly the same size as the choir complex with its attendant chapels and oratories (fig. 373). Indeed, the center of the crossing is approximately in the middle of the church, which is 234 feet long. The plan of Brou is thus evenly divided: one-half for the monastic choir, special chapels of Margaret of Austria, and other dignitaries; the other half, the church proper for the laity. It is tempting to speculate about the role of the patron in the inception of the unusual features of this plan. Certainly the varied functions of monastic services, private prayer and worship, public worship, and burial are all clearly articulated in the plan. The multiple functions of the church of Brou, designed essentially to satisfy the desires of the aristocratic Margaret of Austria, are vastly different from the security precautions involved in the design of the Church of the Jacobins in Toulouse.

The nave of Brou (fig. 375), only 68 feet high, is relatively wide when contrasted with the interiors of Vendôme and Saint-Maclou at Rouen (figs. 364, 368). The two-story elevation consists of nave arcade and clerestory with a passageway behind a balustrade at its base. Each pier rises from a complicated polygonal base in a series of thin colonnettes and moldings and continues without interruption into the nave arcade and up across the thick transverse rib and major diagonal. Two additional ribs, or tiercerons, emerge from the concavities between the transverse and major diagonals in the four corners of each bay, and the four additional ribs (liernes) along the crowns of the webbing create star vaults with five keystones which are similar to the vaults in the bays to the east of the south transept of Saint-Étienne at

Beauvais (fig. 372). The continuity between the bases and vaults is typically Flamboyant.

In the choir, the nave arcade, clerestory, and star vaults are the same as in the nave, but the arcade is half-filled by a thick wall against which stand the choir stalls (figs. 376, 377). Above the stalls is an open gallery protected by a balustrade which repeats in design the one at the base of the clerestory. This open gallery in front of the half-filled-in arcade (fig. 377) was obviously planned to allow the donor to circumnavigate the choir at the level of the upper oratory and to participate in the services in the monastic choir while, at the same time, remaining unobserved. The details of the ribs and keystones are carved more elaborately and with more precision in the choir and chapel than in the nave. The vaulting over the chapel of Margaret of Austria is the most complex of any of the vaulting systems, with thirteen ornate and painted keystones marking the intersections of the ribs (see upper right, fig. 377).

The rood screen or jubé (fig. 375) which separates the monastic choir from the laity consists of three segmental arches; the side arches open into niches with altars, while the central one frames a double door. Curvilinear tracery is suspended from the arches, and three undulating gables fill the spandrels and overlap the balustrade. The balustrade itself is an ornate version of those in the choir and nave and supports seven statues. The jubé at Brou is more two-dimensional than the rood screen at Albi (1500, fig. 355). The regularity and rectangularity of the piers are Renaissance in form; the superstructure is Flamboyant.

Margaret's desire to fulfill the vow of her mother-in-law is reflected most clearly in the elaborate oak choir stalls and in the three mausoleums. Margaret wished to combine a splendid place of worship for the monks with suitable burial places. The prayers of the monks would guarantee the salvation of her soul and the souls of her mother-in-law and husband. The three tombs were designed by John of Brussels in 1516. For the next six years, while the architecture of the tomb was being erected, a group of sculptors, mostly Flemish, carved the smaller statues. Between 1526

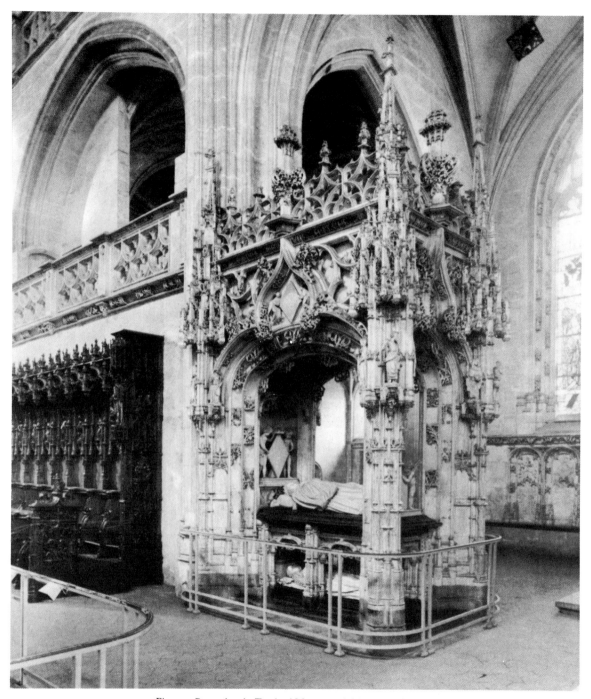

Fig. 377. Brou, church. Tomb of Margaret of Austria, 1516–1532

and 1531 Conrad Meyt, his brother, and two as-
sistants carved the effigies and larger statues out
of marble which had been transported from Car-
rara, Italy, with great difficulty. The tomb of Mar-
garet of Bourbon in the right-hand or south side
of the choir (not illustrated) has the sarcophagus
and effigy in a deep niche flanked by elaborate
piers with multiple pinnacles. The mourners, or
pleurants, on the sarcophagus and the architecture
with its reverse-curve tracery are Flamboyant. The
effigy of Margaret and the nude angels holding
escutcheons are Renaissance. The free-standing
tomb of Philbert, the husband of Margaret of Aus-
tria and son of Margaret of Bourbon, juxtaposes
the Late Medieval and Renaissance styles more
obviously than does the tomb of Margaret of Bour-
bon. The lower section is Flamboyant; yet the
careful articulation of both effigies in Carrara
marble, separated by a black base surrounded by
six nude angels, is Renaissance.

The tomb of Margaret of Austria (fig. 377) is
an elaboration of the niche tomb of her mother-
in-law. One side is attached to the pier, while the
other three sides are free-standing. The entire
tomb recalls the huge south portal of the Cathe-
dral of Albi (fig. 357). The complex corner piers
culminate in elaborate pinnacles joined by minute
flying buttresses. The superstructure of these piers
resembles the north spire of the Cathedral of Char-
tres (fig. 218). The two effigies rest on black marble
slabs. The dead effigy shows the gangrenous leg
which caused her death. The traceried canopy is
aligned with the balustrade over the choir stalls.
This lavishness of surface is consistent with the
architecture and with the design of the oak stalls.

The choir stalls (fig. 376), executed between
1530 and 1532 by Pierre Terrasson and his local
assistants, were designed in Flanders. Old Testa-
ment figures animate the north stalls, and figures
of the New Testament decorate the south. The
red-orange of the oak stalls contrasts with the blue-
black marble slabs under the off-white effigies and
with the light pink stone of the choir and tombs.
The blue ceramic floor (now destroyed) of Italian-
ate design, plus the yellows, reds, blues, and greens
of the glass windows in the choir and Margaret's
chapel, further dramatizes the coloristic nature of
the choir (see right-hand side, fig. 377).

Margaret is depicted with Philbert, her hus-
band, in two stained-glass windows. At the bottom
of the central window of the apse, Margaret and
Philbert kneel with their patron saints, while
two scenes are superimposed: Christ appearing to
Mary and Christ appearing to Mary Magdalen.
The Flemish designer of the latter scene derived
the composition from Dürer's woodcut of the
of the Small Passion. The large window on the
north wall of Margaret's chapel contains five
panels depicting the Assumption of the Virgin
(see part of window in fig. 377). Again Philbert
and Margaret kneel in the foreground. The com-
position of the Assumption was adapted from a
woodcut by Dürer who, in turn, knew either Ti-
tian's original design or the engravings after Ti-
tian by Italian print makers. Local stained-glass
workers from Lyon executed the windows between
1525 and 1530. The organization of space and
treatment of figures in the windows are Renais-
sance; the frames are Flamboyant.

The church of Brou — its architecture, sculp-
ture, stained glass, and ceramics — came into be-
ing as a result of the specific desires of the wealthy
donor. No expense was spared to fulfill the vow
of her mother-in-law, to create suitable tombs for
herself, her husband, and her mother-in-law, and
to make it possible for the monks to pray in com-
fort for the souls of both Margarets and Philbert.
Because so much of the interior of Brou is intact,
it illustrates more clearly than most churches the
character of the late Late Middle Ages and its in-
terweave of Medieval and Renaissance points of
view.

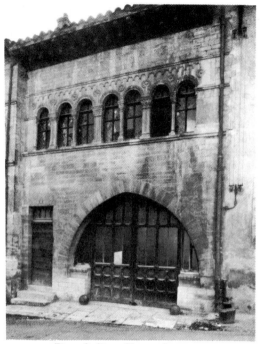

Fig. 378. Cluny. House, after 1159

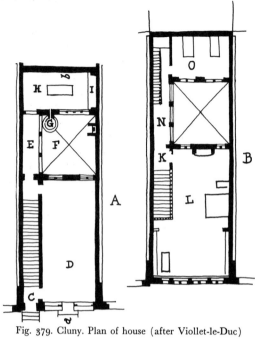

Fig. 379. Cluny. Plan of house (after Viollet-le-Duc)

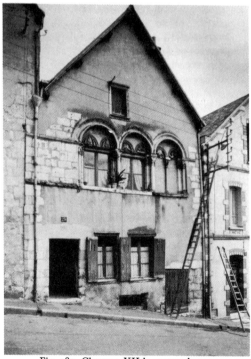

Fig. 380. Chartres. XIIth century house

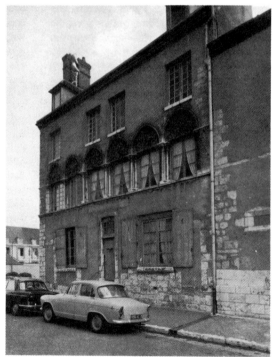

Fig. 381. Chartres. XIIIth century house

Secular Architecture

So far in this study, discussion has centered on religious architecture — monasteries, cathedrals, and churches — with their attendant sculpture and painting. Because of the dominant role of the church in every facet of Medieval life and the concentrated effort involved in the construction of religious edifices, it is the abbey church, parish church, or cathedral which dominates the Medieval town and is, in that sense, the focus of its architecture. In the Romanesque period, towns grew up around the monasteries, which normally were situated on the high or protected ground. At Vézelay (fig. 6) concentric defensive walls protected the growing town, while at Mont-Saint-Michel (fig. 4) the sea and fortified walls on the shore line proved invincible. In the more open world of the Gothic era, the bold outline of the cathedral with its towers animates the silhouette of the town (see Laon, figs. 171, 172). The cathedrals with the bishop's or archbishop's palace and chapel in their shadow became the centers of this new world, and their importance displaced that of the monastic centers. At Noyon (fig. 161) the individual houses of the canons of the chapter are arranged regularly in front of the façade of the cathedral, and adjacent to it are open squares for the fairs and religious plays.

In the years since the Middle Ages, the majority of Medieval secular architecture has been destroyed and replaced, whereas the churches have been repaired and restored. There are, however, enough houses left to show how people lived in the Middle Ages and, at the same time, to demonstrate the stylistic connections between secular and religious architecture. Five houses will be discussed to illustrate the evolution in domestic design from the twelfth to the fifteenth centuries. One palace and a hospital will be included to show the variety of problems solved by Medieval patrons and architects.

HOUSES OF TWELFTH TO FIFTEENTH CENTURIES

Because of the importance of the Mother Abbey of the Cluniac Order, the town of Cluny, with its shops and dwellings, came into being in the eleventh and twelfth centuries. Here many Romanesque houses, mostly constructed after a fire in 1159, still exist (figs. 378, 379). For reasons of economy in construction and in use of land, as well as protection, each house has common walls with its neighbors. No separation existed between the place of work and the dwelling. Only the façade of the house in Cluny (fig. 378) has been preserved; the rest has been rebuilt. The plan, however, has been reconstructed by Viollet-le-Duc (fig. 379). The ground floor (fig. 379, A) had two entrances: the side door in front of the stairs and the main door leading into the shop or store (D). This large opening under the pointed arch (fig. 378) lighted the interior and advertised the whole manufacturing process of each guild to the townspeople. A passageway (E) passed by an open court (F) with a well (G) to the kitchen (H), with its huge chimney. The open courtyard served as an out-of-door room inside the mass of the house. The second floor (fig. 379, B) contained the huge family room (L) with fireplace, bed, and other furniture and back bedroom (O). A third floor under the eaves with access by two staircases served as sleeping areas for apprentices or for storage. As a

whole, the plan combined working and living in an ingenious manner.

The outer walls were constructed of stone, while the inner partitions were built of timbers. The façade (fig. 378) has lost what was originally its upper story together with deep bracketed eaves (see reconstruction in Viollet-de-Duc, *Dictionnaire*, VI, 224). The pointed arch, framing the entrance to the shop, reflects the treatment of the nave arcade of Cluny III (figs. 41, 43, 50) and the shape of the barrel vaults with transverse arches over the nave. The windows of the second floor (fig. 378) repeat the treatment of the triforium of Cluny (figs. 41, 43). This arcade of the house's façade is supported by piers alternating with columns and animated by Corinthianlike capitals; it follows the forms used in the abbey church. The combination of pointed and round-headed arches echoes the play of shapes in the entire nave of Cluny III.

Three houses in Chartres (figs. 380, 381, 382) reveal the evolution of forms in façades from the twelfth to the fifteenth centuries. The first house (fig. 380) dates from the second half of the twelfth century and has suffered considerably. The top floor has been modified, and two of the three double windows of the second floor have lost their central columns. The round arches and the grotesques in the tympana suggest the Romanesque, but the pairs of openings in each of the arches springing from columns have their counterpart in the Early Gothic south tower of the Cathedral of Chartres (fig. 218).

In the Middle Ages a series of houses belonging to canons of the chapter surrounded the cathedral at Chartres (see air view of Noyon, fig. 161). A much-damaged thirteenth-century house, across the street from the north tower of Chartres, is the only one of this series that remains (fig. 381). Mullions originally supported each tympanum and divided the windows into two apertures. The pointed arches and the floral tympana are different from the related elements in the twelfth-century house (fig. 380). It is quite possible that originally this was a double house.

In the Place de la Poissonnerie (fish market) at Chartres is the fifteenth-century House of Salmon (fig. 382). This house is typical of the fourteenth- and fifteenth-century town-house construction in northern France and northern Europe; it is constructed of interlocking timbers with the interstices filled with brick which, in turn, were covered with stucco. Elaborately carved brackets support each floor and make it possible to corbel out each successive story. More interior space for living is gained by this corbeling technique, and each floor helps protect the one below from the weather. The gable of the roof parallels the curve of the street and allows room for dormer windows. Houses of this type in England with a veneer of clapboard served as model for seventeenth-century houses in New England.

HOUSE OF JACQUES CŒUR AT BOURGES (1443–1451)

In contrast to the relatively simple houses just discussed, the House of Jacques Cœur at Bourges (1443–1451, figs. 383–385) is an elaborate town residence with separate apartments, a large dining room, kitchens, chapel, and art gallery. Jacques Cœur was a financial genius who amassed a fortune in Mediterranean trade with his fleet of ships; at the same time, he brought order to the treasury of Charles VII, King of France. Two years after his house was completed, Jacques Cœur was falsely accused of poisoning the king's mistress, Agnes Sorel. Sentenced to jail by judges who owed him money, he escaped after two years and went to Rome to serve the pope in the Near East. In 1456 he died on the Island of Chios.

For the site of his house Jacques Cœur purchased part of the old fortifications of Bourges. He re-used a portion of the exterior curtain wall and three towers (plan, fig. 383, S, R, Q) in the house. The asymmetrical break in the town walls is echoed in the whole asymmetry of plan and massing (figs. 383–385). The plan of the ground floor (fig. 383) reveals the great attention paid to creating a commodious way of life for the owner and his guests. The street side of the house curves, partially paralleling the outer walls of the fortifications (fig. 385). Equestrian and pedestrian en-

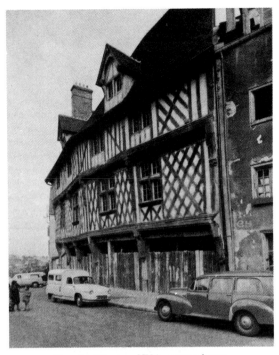

Fig. 382. Chartres. XVth century house

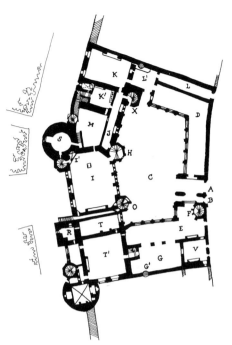

Fig. 383. Bourges. House of Jacques Coeur, 1443–1451.
Plan (after Viollet-le-Duc)

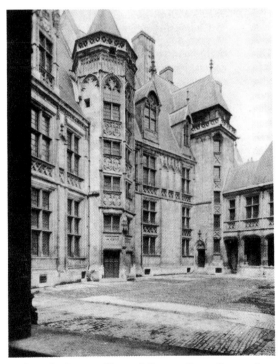

Fig. 384. Bourges. House of Jacques Coeur. Courtyard

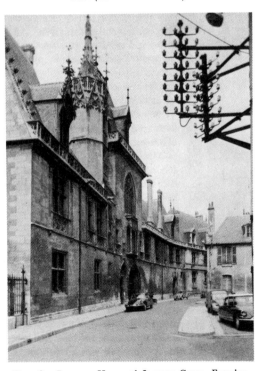

Fig. 385. Bourges. House of Jacques Coeur. Exterior

trances (fig. 383, *A, B*) give into the open courtyard (*C*). A service entrance (*L*) leads to the kitchens (*K*) and (*K'*), with their ovens. The gallery (*D*), opening into the court, sheltered the poor who were periodically served from Jacques Cœur's kitchen. To the left of the main entrance is a staircase (*F*) giving direct access to the chapel on the second floor (fig. 385). The dining room (*I*) is entered through the staircase marked *H* (left of fig. 384). It contains an eighteen-foot fireplace at one end, a trap door and hoist descending to the wine cellar, and a musicians' gallery entered by another spiral staircase. The corridor (*J*) connects the kitchens with the dining room, while adjacent to the dining room is a pantry (*M*) with a pass through to facilitate serving. The apartment marked (*P*) and (*P'*) has its own entrance. On the second floor there are several separate apartments for Jacques Cœur and his family and guests. The owner appears to have occupied the four-room apartment over the kitchens and pantries with a circumnavigating corridor which led through the large salon over the dining room and thence to his picture gallery which, in turn, was connected with the vaulted chapel over the front entrance. This elaborate chapel has murals by a Flemish artist in the form of angels painted on the webbing between the ribs. The whole plan points up Jacques Cœur's concern for privacy and easy circulation both vertically and laterally. Not until the advent of modern architecture has there been a domestic building with so much attention expended on the commodious function of everyday life. The symmetrical Renaissance palace or the huge palace of Versailles had corridors running through all the apartments — and no running water. Jacques Cœur's house was elaborately designed with all conveniences. His pigeon roost in the attic made it possible for him to get early notice of the cargoes his ships were bringing into Marseille; thus he could determine the price of commodities in advance.

The interior view of the courtyard (fig. 384) shows two of the stair towers. The left-hand one opens into the dining room and spirals up to the main salon. The corner tower on the right opens

into the kitchen. Sculpture over the tympana of each doorway is related to the interior function of the rooms. Many of the rooms are of different widths, and the roofs are of different heights and varying pitches. Dormer windows and the tops of the stair towers further impart a jaggedness and freedom to the silhouette. Blind arcades, traceried windows, and an ornamented balustrade animate the surfaces in the spirit of the Late Middle Ages (see Vendôme, fig. 366, and the church at Brou, figs. 374–377).

The curving façade on the street (fig. 385) is dominated by the tall chapel and its attached stair tower. The large window of the chapel has Flamboyant tracery. The top of the stair tower, with its ornate interlocking pinnacles, recalls Flamboyant towers such as the north spire of Chartres Cathedral. Beneath the chapel window is a large niche which originally contained an equestrian statue of King Charles VII. Low-relief statues of two maidservants awaiting the return of their master fill two adjacent niches. Cockleshells and hearts, Jacques Cœur's emblems, appear on bronze knockers and elsewhere. The remarkable financier, who served both king and pope, built this unusual house for himself but enjoyed it for only two years.

PALAIS DES CONTES AT POITIERS

Behind the Palais de Justice in Poitiers are the remains of the Palais des Contes, the castle of the Counts of Poitou (fig. 386). The great hall, 160 feet by 63 feet, was constructed in the early years of the thirteenth century. Tiers of blind arcades decorate the side walls, while the roof consists of a wooden truss, restored in the seventeenth and again in the nineteenth centuries. The narrow end wall originally had four pairs of lancet windows. Between 1384 and 1386 Jean, Duke of Berry, had his architect, Guy de Dammartin, erect a huge fireplace in three parts across the end of the hall (fig. 386). Above the fireplaces and springing from the balcony, three arches with gables and Flamboyant tracery without glass were constructed in front of the four pairs of lancet windows, and the ends of this wall were converted to spiral stair-

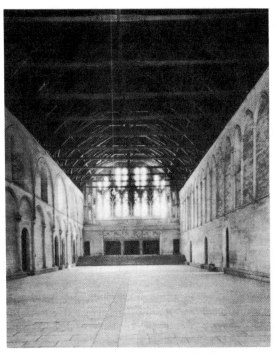

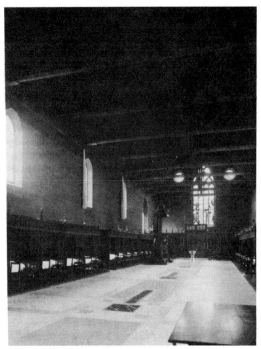

Fig. 386. Poitiers. Palais des Contes. Interior, early
XIIIth century, and fireplace, 1384–1386

Fig. 387. Beaune. Hospital, 1443–1451. Interior

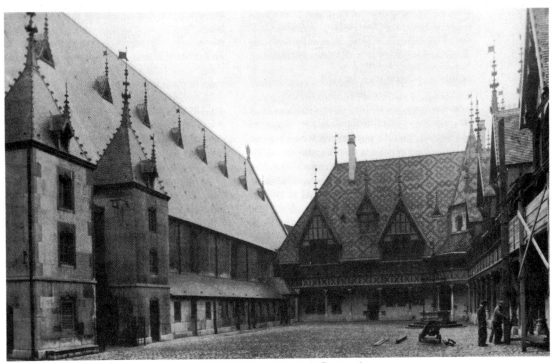

Fig. 388. Beaune. Hospital. Courtyard

cases. Each arch is subdivided into four arches, the central two in front of the wall separating the paired lancet windows, and the other two in front of the lancets. An unusual rhythm of paired lights and darks is thereby established. The date (1384 to 1386) makes this end wall one of the earliest Flamboyant designs. Its curvilinear Late Gothic surfaces are in marked contrast to the simple thirteenth-century walls along the sides.

HÔTEL-DIEU AT BEAUNE (1443–1451)

In 1443, Nicolas Rolin, Chancellor of Burgundy, after obtaining authorization from the pope, founded the hospital in Beaune. In a long document of August 4, 1443, he described in detail the purpose of the hospital, the architectural program, and the equipment, together with an outline of the system of administration and a plan for financing the Hôtel-Dieu in perpetuity. Rolin, a lawyer in the Parliament in Paris, Counselor of John the Fearless, Duke of Burgundy, and Chancellor for Philip the Good, his son, was the behind-the-scenes administrator of Burgundy for forty years until his death in 1462. Since the Dukes of Burgundy controlled both Burgundy and much of the Low Countries, Nicolas Rolin's role as chief adviser was of enormous importance. In 1438 and 1439 (see bibliography), a great famine, attended by epidemics, caused heavy mortality, especially in Burgundy. In 1442 the chancellor acquired the necessary land in Beaune, and the pope exempted the hospital from feudal taxation and from the control of the bishops of Autun and Beaune. Work began in the following year, and on December 31, 1451, the chapel was consecrated; the first patients entered the next day. This large project, covering an area of over 250 feet by 170 feet, stands today as the fulfilled dream of an extraordinary patron. Chancellor Rolin wished to construct a hospital of thirty beds for the poor. The main ward of the hospital was so organized that the patients could easily celebrate divine services at eight o'clock each morning, administered by priests whom the chancellor had appointed. Further, each Monday at eight in the morning alms

in the form of white bread were to be distributed to the poor outside the main entrance.

The hospital was constructed in the form of a large quadrangle (fig. 388). As one enters the vestibule through the elaborate gate, the main infirmary opens to the left (fig. 387 and left-hand mass in fig. 388). The single space still contains the original thirty enclosed beds along the sides and the chapel behind a screen. Each patient was cared for from a narrow corridor running behind the beds, while the patients were fed from the inner large space. Tall, thin windows illuminated the interior. The chapel contained a large stained-glass window with scenes of the Passion and portraits of Nicolas and his wife, Guigonne de Salines; the window was destroyed during the French Revolution. The wall screening the chapel is a nineteenth-century restoration of the Flamboyant screen, which was also demolished during the Revolution. A multipaneled painting of the Last Judgement by the Fleming Roger van der Weyden, including portraits of the donors, hung behind the altar. It is now one of the glories in the Museum of the Hôtel-Dieu. Tapestries at present in the museum originally adorned the lower walls of the chapel. The curved wooden vault of the ceiling is strengthened by horizontal timbers and vertical tie beams, which are brightly painted with escutcheons. In spite of the loss of the Cross and the destruction of the stained-glass windows, this room, with its double but integrated functions, served admirably as a hospital ward down to modern times.

As seen in the courtyard (fig. 388), a cloister walk with open gallery above connected the large ward and chapel (on the left) with an apartment for guests and with the infirmary, bakery, kitchen, pharmacy, and sleeping and eating accommodations for the Sisters. Many structures, such as operating rooms, were added in the nineteenth century to form a second courtyard. The entire hospital was restored between 1875 and 1877, and new roofs imitating the original ones were erected between 1903 and 1906. The courtyard (fig. 388), with its free-standing well, was constructed of timbers. The steep pitched roof covered with multi-

colored tiles is penetrated by large and small dormer windows. The coloristic surfaces, as well as the architectural forms, recall Flemish architecture of the fifteenth century, which Nicolas Rolin certainly knew well.

Today, Nicolas Rolin is known visually as a patron of the arts through his portrait with the Virgin and Christ Child in the famous Rolin Madonna by Jan van Eyck, in the Louvre in Paris, and by his portrait in the Last Judgement by Roger van der Weyden in Beaune. However, it is often forgotten that Nicolas Rolin conceived of, constructed, and organized the administration of the unusual Hôtel-Dieu at Beaune.

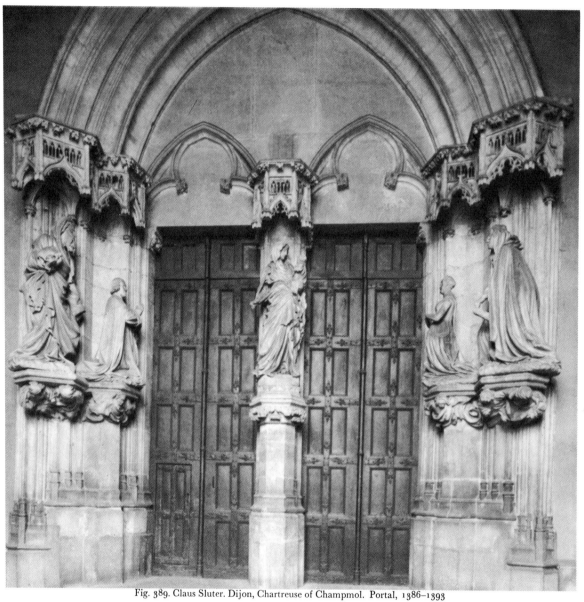

Fig. 389. Claus Sluter. Dijon, Chartreuse of Champmol. Portal, 1386–1393

Late Gothic Sculpture

THE EMERGENCE of Rayonnant and Flamboyant points of view in sculpture has already been mentioned at the end of Chapter 24. The elegance of the fourteenth-century Virgin and Child in The Cloisters (The Metropolitan Museum of Art, fig. 337), its surfaces accented by linear rhythms, resembles Rayonnant architecture such as that at Sainte-Chapelle in Paris (fig. 345), Saint-Urbain at Troyes (fig. 347), and the choir of Saint-Ouen at Rouen (fig. 362). The strong linear emphasis, with its brittle overtones, can be seen in statue and buildings alike. This Virgin and Child (fig. 337) and the corresponding Rayonnant structures do not display the monumental, classic repose of High Gothic structure (Chartres transepts, figs. 310–314; Amiens façade, figs. 315, 316; the Strasbourg Virgin, fig. 335) or the sculptural grandeur of High Gothic architecture (Chartres, fig. 219; Reims, fig. 245; Bourges, fig. 270). Instead, a new interest in decorative surfaces animated in multiple planes in space replaces the massiveness of the High Gothic.

The final flowering of the Late Middle Ages in the late fourteenth, fifteenth, and early sixteenth centuries can be seen in Flamboyant monuments such as the fireplace in the Palais des Contes at Poitiers (fig. 386), in the nave and façade of Vendôme (figs. 364, 366), and in Saint-Maclou at Rouen, Saint-Étienne at Beauvais, and the Church of Brou (figs. 367–377). The flamelike tracery of the architecture, with its diagonal movement, imparts a new kind of instantaneous unity to both interior and exterior. The clear separation of zones and elevation, characteristic of High Gothic architecture, dissolves into dynamic all-over surface patterns. In sculpture this dynamic movement can be seen clearly in the Virgin and Child of the portal of the Chartreuse de Champmol by Claus Sluter, a native of Holland (fig. 338). The jagged silhouette and the swirling curving drapery of Sluter's Madonna and Child echo the shifting surfaces of Flamboyant architecture. It is to the sculpture of Claus Sluter at Dijon, created under the patronage of Philip the Bold, that we must now turn our attention.

Philip the Bold (1342–1404), Duke of Burgundy and fourth son of King John the Good of France, was one of the greatest warriors, statesmen, and patrons of the late Middle Ages (see bibliography). At the age of fourteen, he won fame through his heroic defense of his father at the battle of Poitiers (1356). In 1361 another Philip — Philip of Rouvre — died of the plague at the age of seventeen, and the rule of Burgundy by Capetians, unbroken since 1031, ended. By skillful maneuvering, mostly on the part of Philip the Bold himself, King John established his son as governor of Burgundy in 1363 and then as Duke in 1364, after he had determined that direct annexation of Burgundy to the crown would be unacceptable to the Burgundians.

Philip of Rouvre had been engaged to Margaret of Flanders, daughter of Louis of Mâle, the Count of Flanders. Since Margaret would inherit large parts of the Low Countries upon the death of her father, her hand in marriage was sought by the son of Edward III of England. The French crown and Philip the Bold opposed this marriage, which would have united wool-producing England and Flanders with its rich cloth industry.

With the help of the pope, who forbade this English marriage of distant cousins, and with the aid of Margaret of France, the grandmother of Margaret of Flanders, arrangements were concluded for the marriage of the Duke of Burgundy and the heiress of Flanders. On June 19, 1369, Philip and Margaret were married in the church of Saint-Bavon in Ghent; and on the death of Louis of Mâle, Count of Flanders, in 1384, Philip the Bold and his wife inherited about a third of modern Belgium, including the towns of Ghent, Ypres, and Bruges, as well as sections of northern France.

In the campaigns against the invading English, starting in 1372, Philip the Bold led the French army in successful harassing tactics which ended in the Truce of Bruges in 1375. Again in the late 1370's Philip avoided pitched battles and thwarted the English army. The revolt of Flemish towns was terminated by Franco-Burgundian intervention in 1382, and in the following year the English were driven out of the Continent. By 1385 Philip the Bold had reconciled his differences with the towns of Flanders at the peace of Tournai. With his territorial holdings consolidated, Philip proceeded to expand his domain through strategic marriages of his children. His astuteness as statesman resulted in a period of peace and prosperity. On April 27, 1404, he died of influenza in his sixty-third year.

As patron of the arts, Philip the Bold followed the example of his older brothers, Louis of Anjou and Jean, Duke of Berry. He imported Flemish and French illuminators to expand his extensive library of secular and religious books. Both Philip and Margaret commissioned numerous series of tapestries from Arras and from other centers of weaving. Great expense was lavished on furniture, china, objects of gold, and costumes, as well as on many residences: in the Île-de-France, a castle and a house in Paris; in Flanders, six castles; in Burgundy, a town house in Dijon, several manors, and a hunting lodge. Besides enlarging and refurnishing these residences, Philip the Bold decided to erect a monastery near Dijon to house twenty-four Carthusian monks and to serve as mausoleum for the Dukes of Burgundy. In 1377

and 1383 land was acquired, and in 1383 the first stone was laid by Margaret herself; the dedication took place on May 24, 1388. The monastery consisted of a church for the monks and for the royal tombs, several chapels, a large cloister with twenty-four individual houses for the monks, and a small cloister with refectory, kitchen, chapter house, and a sacristy. Drouet de Dammartin was the architect in charge of the works. Jean de Marville, sculptor, started work on the Duke's tomb in 1385. Claus Sluter from Holland joined him as assistant in 1385 and succeeded him as chief sculptor on his death in 1389. Philip the Bold expended such colossal sums of money on the monastery, tomb, portal, Well of Moses, many altarpieces by Flemish artists, and church furniture, as well as on the refurbishing of his many castles, that at the time of his death in 1404 his sons had to pawn some of their father's silver to pay for his funeral in Flanders and for the elaborate procession which took six weeks to transport his body from Flanders to Dijon.

THE PORTAL OF THE CHARTREUSE DE CHAMPMOL AT DIJON

The portal of Champmol (figs. 338, 389) may have been started by Jean de Marville as early as 1386. In all probability, however, the entire portal, completed by 1393, is the work of Claus Sluter. The portal, which opens into the church of the monastery, has as its subject the introduction of the donors to the Virgin and Christ Child by their patron saints. The Virgin and Christ Child are depicted on the trumeau, the kneeling Duke Philip and his patron saint, John the Baptist, on the left splay, and Margaret of Flanders and her patron, Saint Catherine, on the right. Both donors kneel with hands clasped in adoration, while the position of the moving saints suggests that Philip and Margaret are being presented physically to the Christ and the Virgin. Donors appeared on portals as early as 1140 in the central tympanum of Saint-Denis and on the portal of Paris just after 1163. But in both these portals, Suger and Maurice-de-Sully are small figures dominated by the central subject: by the judging Christ at Saint-

Denis or by the enthroned Madonna and Child in the Paris tympanum. In the Gothic portal from Moutiers-Saint-Jean of the 1260's (now at The Cloisters, fig. 326), the tympanum of the Coronation of the Virgin crowns the whole portal, while Kings Clovis and Clothar, as patrons of the monastery, dominate the jambs. Here, however, in Philip the Bold's monastery of Champmol no tympanum sculpture exists, and the donors are not standing isolated from the tympanum or trumeau, but are caught up in the religious drama as they kneel and adore the Virgin and Child on the trumeau. The donors and their patron saints are as large as the trumeau figure, and the donors are actual portraits of the Duke and Duchess. The whole interpretation becomes a personal, dramatic episode — a kind of religious drama linking the real with the heavenly.

In contrast to the vertical axes of High Gothic portals (figs. 310–316), the main axis of this Flamboyant portal is horizontal. To be sure, the patron saints and donors are reflected in the bases and archivolts above, but the main emphasis is placed on the horizontal panel of figures. Large brackets and elaborate canopies create deep niches for the jamb figures. The trilobed, pointed arches and similarly elaborated canopy over the Virgin and Child tie the splays to the trumeau. The High Gothic preoccupation with harmony of architecture and sculpture here gives way to a preoccupation with the drama of the specific and human event.

The figures of the Virgin and Child (figs. 338, 389) are not contained within the silhouette of the trumeau block, as they would have been in Early and High Gothic sculpture. The Virgin's right arm extends toward the Duke. The twist of her body and the surging folds of her cloak imply a dynamic movement. The Virgin gazes intently at the Christ Child. Philip's face is a remarkably penetrating portrait which forecasts the approaching Renaissance; yet the voluminous mantle, completely enveloping his body, is Medieval in the way it hides the articulation of the anatomy. The badly damaged statue of Margaret is garbed in contemporary costume. Both saints, with the em-

blems of their attributes, move and look toward the Christ Child. The whole portal radiates a psychological intensity which manifests the violent tenor of the late Middle Ages.

The art of northerners, such as Claus Sluter from Holland, never reveals the monumental reserve of French artists. A mid-fifteenth-century wooden statue of John the Evangelist, originally part of a Calvary group carved in Touraine and now in the Louvre in Paris (fig. 390), is an effective comparison with the portal at Champmol. In both the portal and statue the undercutting of surfaces and the movement in pose and drapery exhibit the dynamism of the Late Gothic Baroque; yet the sculptor of the Saint John, like the painter and illuminator Jean Fouquet, interprets his subject in a quieter and more controlled manner. The expressionless face of Saint John is reminiscent of classic High Gothic sculpture and of portraits by Fouquet, David, Corot, and Cézanne.

THE WELL OF MOSES AT DIJON

The Well of Moses takes its name from the figure of Moses, one of the six Old Testament Prophets depicted in this group (figs. 391, 393). Originally the monument stood free in the middle of the cloister, surrounded by the individual houses of the twenty-four Carthusian monks. This strict Carthusian Order separates the monks from each other and allows congregation and conversation only once or twice a month. The monks use the cloister as a cemetery. The free-standing sculptural group rose up from a spring. The base, containing six Prophets, originally supported a free-standing Calvary group of a crucified Christ, the Virgin, Saint John, and Mary Magdalene. Only the upper part of the figure of Christ is preserved (in the Musée des Beaux-Arts at Dijon). The Prophets, by their predictions inscribed on the scrolls which they hold, tell of the coming of Christ. Above, Christ makes the supreme sacrifice for the sake of humanity, and the Well itself is a complex symbolization of the blood of Christ and the Resurrection, the fountain of life. The use of the cloister as cemetery intensifies this emphasis on the cycle of birth, death, and resurrection. The

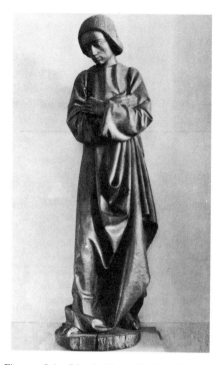

Fig. 390. Saint John the Evangelist. Touraine; mid-XVth century wood, 54 in. (The Louvre, Paris)

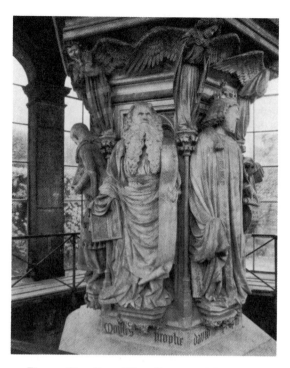

Fig. 391. Claus Sluter. Dijon, Chartreuse of Champmol. Well of Moses, 1395–1405

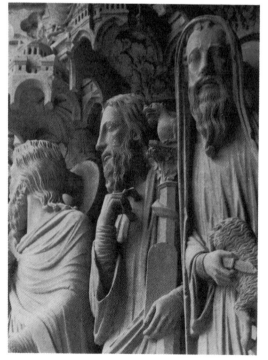

Fig. 392. Chartres Cathedral. North transept, 1204–1210

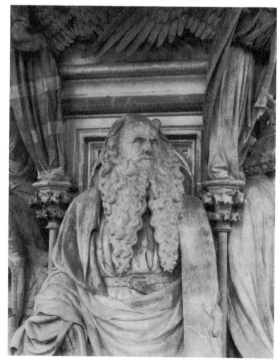

Fig. 393. Claus Sluter. Dijon, Chartreuse of Champmol. Well of Moses (head of Moses)

sources of this iconographical program were undoubtedly mystery plays. The whole dramatic interpretation of the figures suggests scenes being acted by costumed players.

The Well of Moses was commissioned by Philip the Bold in April 1395. Claus Sluter finished the Calvary group by June 1399, when the four statues were transported from his large studio in Dijon to the monastery. Although Sluter fell ill in 1399 and finally went to live in the monastery at Saint-Étienne in Dijon in 1404, he finished the Moses, David, and Jeremiah in 1402. The entire Well was carved by early 1405. Claus Sluter died in late January 1406. Jean Malouel, a Fleming, polychromed the statues, and Hermann of Cologne did the gilding. A goldsmith, Hennequin d'Att, made metal glasses for the Prophet Jeremiah and a diadem for Mary Magdalene. The reds, oranges, and blues of the mantles of the Prophets and pleurants (weepers), as well as the gilded details, are still visible today.

The architecture of the Well of Moses consists of a six-sided base and heavy cornice (fig. 391). The central core of the monument is treated in panels partially framing the Prophets. At the corners, tiny colonnettes rise from a thin base to small capitals which support the pleurants. The Prophets project outward from the wall and stand on console brackets. The dominance of sculpture over architecture is in marked contrast to the balanced emphasis on sculpture and architectural forms in High Gothic portals such as the transepts of Chartres and the Amiens façade (figs. 310, 316).

The heavy, billowy folds of the mantles which envelop the Old Testament figures in the Well of Moses hide the articulation of the forms and yet create a moving dynamism which gives the Well its emotional impact. Moses' right arm (fig. 391) covers the thin colonnette as his body twists in space. The scroll in his left hand, together with the deeply cut drapery, creates a symphonic rhythm which undulates from Prophet to Prophet around the Well.

In the composition the forms of the pleurants serve as a transition from base to the Calvary group; their tears intensify the drama and emotionalism of the entire monument. The heads of the Prophets are highly individualized. Claus Sluter is thought to have used models from the Jewish section of Dijon. The head of Moses (fig. 393) recalls the head of Laocoön or other Hellenistic statues or sculpture by the seventeenth-century Italian Bernini; it has a long, thick, animated beard. Two horns protrude from the forehead in a mistaken transposition for rays of light. The eyes are deeply set and partially closed; wrinkles appear on cheeks and brow. Surfaces are animated by furrows and gouges which create pockets of shadow. The inward intensity of Moses' countenance is reminiscent of the paintings of another Dutchman, Rembrandt van Rijn. How far the Middle Ages had changed and evolved since the early years of the thirteenth century may be seen if this Moses is contrasted with the Moses of the central portal of the Chartres north transept (fig. 392). The Chartres head is idealized and essentially immobilized. Moses is not depicted as an old man, but a few wrinkles suggest middle age. Beard and hair surround the face and impart a quiet dignity. The figure of Moses on the Well possesses no surfaces which are free from undercut or projecting details. Moses is depicted as an old man who has suffered. The flowing beard and intense gaze are completely different from the classic calm of the Chartres Moses.

THE TOMB OF PHILIP THE BOLD

The tombs of Philip the Bold and his son, John the Fearless, originally were located in the church of the Chartreuse de Champmol. Philip and Margaret constructed the monastery to serve as their mausoleum and to house Carthusian monks who would pray for their souls. Work began on Philip's tomb as early as 1385 (figs. 395, 397), but it was not completed until 1406 or later, after the Duke's death in 1404. Since Claus Sluter died in early 1406, Claus de Werve, Sluter's nephew and assistant after 1396, must have carved parts of the tomb. Both tombs are now exhibited in the Musée des Beaux-Arts in Dijon.

In contrast to the elaborately carved sarcophagus of Philip the Bold's tomb (fig. 396) or the dou-

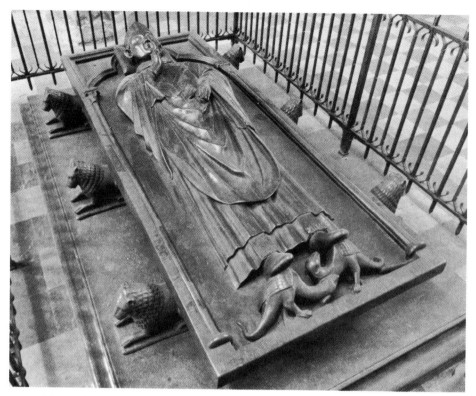

Fig. 394. Amiens Cathedral. Tomb of Bishop Geoffrey d'Eu, died in 1236, 7 ft. 10 in. in length

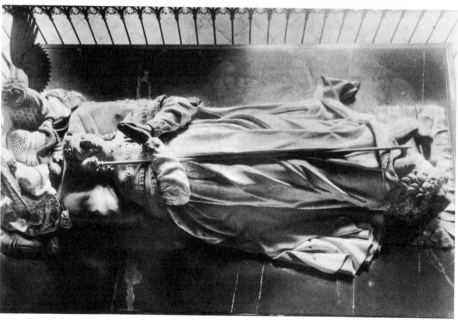

Fig. 395. Claus Sluter and Claus de Werve. Tomb of Philip the Bold, 1385–1406 (?)
(Dijon, Musée des Beaux-Arts)

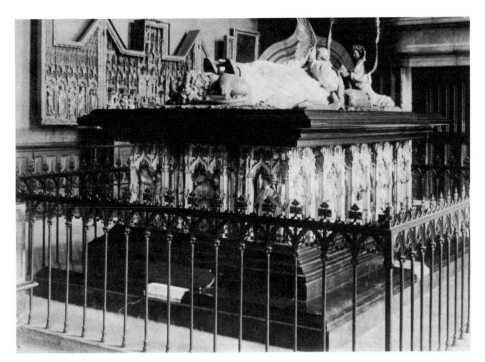

Fig. 396. Claus Sluter and Claus de Werve. Tomb of Philip the Bold, 1385–1406 (?)
(Dijon, Musée des Beaux-Arts)

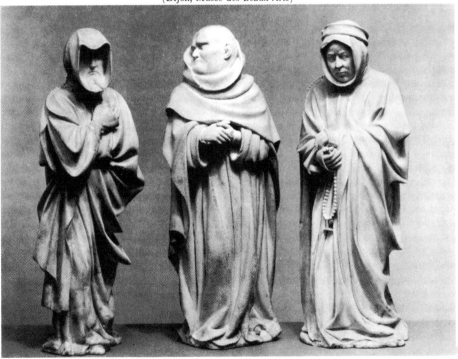

Fig. 397. Claus Sluter and Claus de Werve. Three Mourners from Tomb of Philip the Bold.
Vizille alabaster, c. 16 1/2 in. (The Ceveland Museum of Art)

ble effigy with ornate canopy of the tomb of Margaret of Austria in the Church at Brou (1516–1532, fig. 377) the thirteenth-century tomb of Geoffroy d'Eu, Bishop of Amiens, is remarkably simple (fig. 394). Bishop Geoffroy d'Eu succeeded Bishop Everard de Fouilloy, who began the new High Gothic Cathedral of Amiens in 1220. Geoffroy d'Eu became Bishop in 1222, and by the time of his death in 1236, the façade and nave of the cathedral were completed. The tombs of both bishops are now in the nave of Amiens. The effigy of Geoffroy d'Eu (fig. 395) is one piece of bronze 7 feet 10 inches in length, an extraordinary example of bronze casting. Six lions crouch on the bronze pedestal and support the effigy. The Bishop's feet rest on two dragons: the head, resting on a pillow, fills the center of a trilobed arch. The right hand is raised in blessing. The drapery defies gravity, but the figure has a three-dimensional bulk which is in marked contrast to the dematerialized flatness of Romanesque sculpture such as the Bartholomew in the cloister of Moissac (fig. 102), but resembles closely the jamb statues and the Beau Dieu of the Amiens façade (figs. 315, 316, 319). Indeed, the tomb effigy is conceived as a standing figure which is placed in a horizontal position.

If the effigies of Bishop Geoffroy and Philip the Bold are compared (figs. 394, 395), the marked differences separating High Gothic sculpture from the Late Medieval conceptions are clearly revealed. The Bishop's head is not a personalized portrait of the deceased; Philip's head is. The Bishop's face has been generalized and is similar to several on the façade of Amiens. Claus Sluter has forced up the individuality of Philip's face, just as he had done in his portrait of the Duke on the portal of Champmol (fig. 389). Above Philip's head two angels kneel and hold his helmet, or basinet, while his feet rest on a lion. Philip's elaborate costume, trimmed with fur and lace, envelops his body and falls to the black marble slab on which the statue is lying. Voluminous, curving folds recall both the portal and Well of Moses of the Chartreuse de Champmol and have no counterpart in the static monumentality of Bishop Geoffroy d'Eu of Amiens.

The sarcophagus of Philip the Bold's tomb (fig. 396) is an ornate, Flamboyant series of double niches alternating with single recessed niches. The niches originally contained forty-two mourners. When Philip died in Flanders in 1404, his body was transported to Dijon in solemn procession accompanied by paid mourners. These mourners are recalled in the sculptured figures, each about 16½ inches high and carved in Vizille alabaster. The figures express every conceivable psychological reaction to the Duke's death and to the procession. Some react to the decomposition of Philip's body by holding their noses. Others, like the three now in the Cleveland Museum of Art (fig. 397), are more reflective and compassionate. The jagged silhouettes, the deeply undercut garments, and the different twisted poses give each mourner a penetrating individuality.

These three sculptural monuments from the Chartreuse de Champmol manifest the major characteristics associated with the Late Middle Ages. As in the surfaces of the Flamboyant façade of Saint-Maclou in Rouen or Vendôme (figs. 366, 369), a restless motion moves from figure to figure, across the portal, around the Well, or around the tomb of Philip. No longer are parts added one to another to create a total composition, but dramatic sculptural rhythms of the flamelike tracery give an instantaneous pictorial unity to the whole. The sequential logic of the High Gothic, which integrates and balances sculpture and architecture, has evolved into a dynamic design in which architecture and sculpture dissolve into each other. The idealized calm of the High Gothic has given way in the Flamboyant to a new emphasis on psychological animation and dramatic reality. Sculptural figures emerge as stage images; they are no longer majestic, static symbols, but active projections of human and dramatic roles.

Illuminated Manuscripts

THERE ARE some Romanesque murals still in existence, and Gothic stained glass can be regarded as a combination of mosaic and painting techniques, but the greatest quantity of painting that remains to us from the Middle Ages is in manuscripts. Some murals once adorned the walls of mansions and castles, but the majority have been destroyed. Most of the manuscripts were written and illuminated for the liturgy of the church (see bibliography). Since the Mass or Eucharist is a supreme sacrament of the Christian church, many books such as the Gospels, Sacramentaries, and Missals were written for the celebrant of the Mass. Other manuscripts such as Breviaries, Psalters, Books of Hours, and Prayer Books were created for daily devotional prayer, either public or private. Commencing in the fourteenth century, an affluent aristocracy commissioned illuminated books for personal use and for the joy and pleasure of collecting.

To summarize the changing attitudes toward the treatment of the human form and of space during the Middle Ages, illuminations from eight manuscripts, one panel picture, and one tapestry, all selected from collections in the United States, will be discussed in chronological order (figs. 398–407). The earliest and latest manuscripts depict the Evangelist Saint Mark, while the six other manuscripts, the panel, and the tapestry interpret the Annunciation, the Angel Gabriel appearing to the Virgin Mary.

The Saint Mark of the Four Gospels (fig. 398) in The Pierpont Morgan Library in New York (Morgan Ms. 728, fol. 63v: 8⅜ in. by 6⅝ in.), illuminated between 845 and 882 in the diocese of

Reims, illustrates the Carolingian synthesis of northern, barbarian intensity and southern reflections on classical antiquity. The nervous linearism of the folds, the interlocking of the figures, and the staring eyes hark back to the nonhuman art of the nomadic barbarians. (The art of the nomads had become the basis of the interlaced Anglo-Irish art in the seventh and eighth centuries.) In the Saint Mark, the spirit of this two-dimensional and dehumanized point of view is combined with a breath from antiquity, probably penetrating the scriptoria of what is now northern Europe through the circulation of Early Christian manuscripts. Relationships with antiquity are found in the muted illusion of space behind the Evangelist, in the suggested three-dimensionality of his thigh, legs, and arms, and in the pose of the Evangelist with lectern, so reminiscent of pagan philosophers and Early Christian prophets. Pale blues and grays against a layered ground of orange, dull green, red, and blue reinforce this monumental concept. The Evangelist stares intently at his Gospel, while his symbol, the lion, appears above the crenelated wall in the background. The Carolingian renaissance successfully combined these two antithetical traditions: the northern, dehumanized intensity and the Mediterranean monumental classicism. Indeed, the sustained and shifting struggle between the northern and classical points of view is, to oversimplify, the story of Medieval art.

The first Annunciation is in an initial "D" in a Sacramentary illuminated in the scriptorium of Mont-Saint-Michel in the late eleventh century (fig. 399). This manuscript is in The Pierpont

Morgan Library (Morgan Ms. 641, fol. 24: 2¾ in. by 3¼ in.). It was made for use in a monastery in the diocese of Rouen, probably Fécamp. The Gospel of Saint Luke (Luke 1:26–32) describes the Annunciation as follows:

> In the sixth month the angel Gabriel was sent from God to a city of Galilee named Nazareth, to a virgin betrothed to a man whose name was Joseph, of the House of David; and the virgin's name was Mary. And he came to her and said, "Hail, O favored one, the Lord is with you!" But she was greatly troubled at the saying, and considered in her mind what sort of greeting this might be, and the angel said to her, "Do not be afraid, Mary, for you have found favor with God. And behold, you will conceive in your womb and bear a son, and you shall call his name Jesus."

This Norman Romanesque interpretation of the Annunciation avoids environment as it emphasizes contextually the two protagonists within the initial which, in turn, animates the page of text.

The interlace of the borders reflects the Anglo-Irish art of pre-Carolingian times. Both figures are arranged to echo the oval frame, as are the figures in the Romanesque frescoes of Berzé-la-Ville (fig. 116). The oversize hands, angular gestures, disjointed anatomy, and general mural character of the forms beneath the drapery manifest the Romanesque style. However, the profile of the Angel and the face of the Madonna suggest vague connections with antiquity. Both figures seem to float against the green background. Gabriel's cloak is orange and tan with light green highlighting his wings; the Virgin's gown is blue-green over a pink undergarment. The light colors and the wide contour lines tend to flatten the figures against the dark ground. In comparison, the Carolingian Saint Mark is relatively nervous; yet in many other Romanesque monuments, such as Vézelay (fig. 93), Souillac (fig. 103), and the Saint Mark from a Gospel book (about 1050, fig. 211), the psychological intensity of pre-Carolingian and Carolingian art has continued into the eleventh and early twelfth centuries.

The second Annunciation (fig. 400) is in a twelfth-century book of scenes from the Life of Christ in The Pierpont Morgan Library (Morgan Ms. 44, fol. lv: 9³⁄₁₆ in. by 6⁷⁄₁₆ in.). It occupies an entire page. The Angel Gabriel and the Virgin are suspended against a background of gold leaf within an elaborate floral frame of blue, orange, pink, and green. The Angel wears a tan mantle over a red undergarment with white wings highlighted by blue and has a green halo. The Virgin's undergarment is white; the cloak is blue and green. The figures appear to hang in an ambiguous space, with their feet touching the border. Wide lines accent the silhouettes and define the folds of drapery. Movement is not as overtly stated as it is in the Romanesque Annunciation (fig. 399). The statuesque simplicity of this Annunciation is reminiscent of the same scene in the Early Gothic Royal Portals of Chartres Cathedral (figs. 215, 216) and in the Chartres windows of the Life of Christ (fig. 217), both of the 1140's. This illumination is so close in composition, pose, and treatment of drapery to the Chartres sculpture, and especially the stained-glass window, that one critic suggested that this unusual manuscript is a pattern book made by one of the Chartres stained-glass workers (see bibliography: Porcher). Even though the stylistic connection between window and illumination is apparent, the manuscript was probably created in the last quarter of the twelfth century, perhaps as late as 1200 in southern France, possibly at Limoges. As a pattern book it could be related to the fabrication of enamels. Whatever its original use may have been, the quieter, more statuesque interpretation of the event has its stylistic parallels with Early Gothic sculpture and painting.

The High Gothic Annunciation (fig. 401) is in a Book of Hours of the 1230's in The Pierpont Morgan Library (Morgan Ms. 92, fol. lv: 4¼ in. by 3¼ in.). In contrast to the Romanesque initial (fig. 399) and the Early Gothic Annunciation (fig. 400), this page depicts Gabriel and the Virgin Mary standing on a narrow shelf of space rather than suspended against a uniform ground. The moving drapery, with hems of gold leaf, suggests more of the anatomy beneath the garments. The

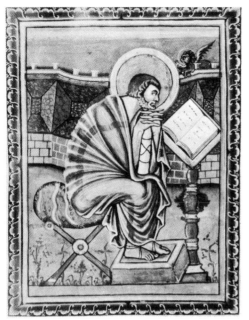

Fig. 398. Saint Mark. *The Four Gospels* produced in Reims, between 845 and 882, 8 3/8 in. by 6 5/8 in. (The Pierpont Morgan Library, Ms. 728, fol. 63v)

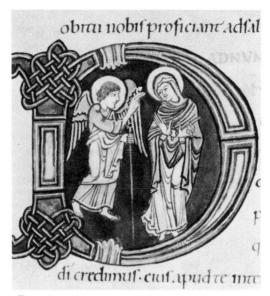

Fig. 399. "Annunciation," initial D. *Sacramentary* produced at Mont-Saint-Michel, late XIth century, 2 3/4 in. by 3 1/4 in. (The Pierpont Morgan Library, Ms. 641, fol. 24)

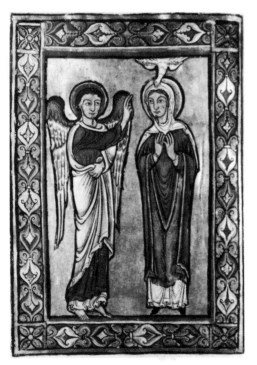

Fig. 400. "Annunciation." *Scenes from the Life of Christ,* c. 1200, 9 13/16 in. by 6 7/16 in. (The Pierpont Morgan Library, Ms. 44, fol. iv)

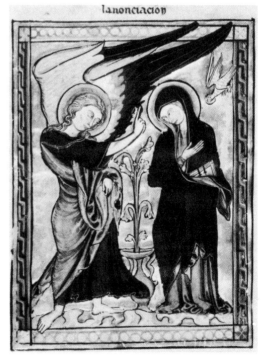

Fig. 401. "Annunciation." *Book of Hours,* 1230's, 4 1/4 in. by 3 1/4 in. (The Pierpont Morgan Library, Ms. 92, fol. iv)

colors are more intense and tend to give more solidity and weight to the forms. Gabriel has a deep blue undergarment with cloak of reddish purple. The underside of the cloak is green, and his halo is orange. The Virgin's mantle is dark blue over a purple undergarment. The background is raised gold leaf. The strong connections between the Coronation of the Virgin from the same manuscript (fig. 325) and the Coronation of the Virgin of the Chartres north transept (fig. 324) has already been discussed. In style, the figures of the Annunciation have their counterparts in monumental High Gothic sculpture, especially the contemporary Annunciation at Reims Cathedral (fig. 320).

The fourth Annunciation (fig. 402) is a page in the tiny *Hours of Jeanne d'Évreux* in The Cloisters (The Metropolitan Museum of Art, fol. 16: 3⅝ in. by 2⅜ in.). This exquisite manuscript was painted by Jean Pucelle for Queen Jeanne d'Évreux of France as a gift from her husband, Charles IV, between their marriage in 1325 and the King's death in 1328. By the end of the fourteenth century, this Book of Hours was one of the treasures in the possession of Jean, Duke of Berry. It is tempting to speculate about the influence this little gem might have had on the tapestries, sculpture, and stained glass which the Duke commissioned for his twenty castles in Berry and Bourges.

As Panofsky states: "He [Jean Pucelle] was no less important in the development of painting in the north than were Giotto and Duccio in the development of painting in Italy." The work of Jean Pucelle and his atelier created a synthesis of Parisian ideas with influences from both the north and south. The compositions of Sienese paintings by Duccio and others influenced their work. At the same time, the northern French and English delight in animating margins with fanciful and whimsical drolleries became known to the illuminators of Paris. In spite of the impact of Italy and the north, Parisian elegance remains the dominant quality. The manuscript includes the calendar, the Hours of the Virgin, the Hours of Saint Louis, the Seven Penitential Psalms, and the Eight Canonical Hours of the Day for prayer; it was designed expressly for the Queen's private devotions. The little Annunciation (fig. 402) serves as the frontispiece for the Hours of the Virgin. Gabriel is kneeling, and the Virgin is standing at a small tabernaclelike structure with angels peering out of the balcony niches. Inside the initial "D" is Queen Jeanne d'Évreux reading a book, with her major-domo sitting to the left. Angels, one of whom is strumming a stringed instrument, appear along the sides, while a game of frog-in-the-middle decorates the bottom of the page. The latter is a game involving a person sitting with his legs crossed who must catch one of his tormentors without getting up. As pointed out in articles (see bibliography), the manuscript includes hundreds of these minute figures acting out in sprightly fashion the popular games of the fourteenth century. The majority of these marginal scenes have no connection with the subject of the page, as is the case in this Annunciation, but rather give an intimate insight into Medieval life. The manuscript is of particular interest to musicologists and to specialists in the art of Medieval armor.

The figures, painted in grisaille, have elongated S-shaped poses characteristic of fourteenth-century Rayonnant art. The Virgin, in style, invites comparison with the Parisian Madonna and Child in sculpture of the same period, also in The Cloisters (fig. 337). The curving folds created by light and shade intensify the action. Color, including reds, yellow-oranges, and pale blues, enhances the architecture, tints the faces and hands, the halo and the wings, and creates a muted frame for the gray figures. In contrast to the thirteenth-century Annunciation (fig. 401), in which the protagonists stand in a narrow space against a gold ground, Gabriel and the Virgin in this manuscript are contained in a deeper space formed by the receding lines of architecture. The front of the little tabernacle or church has been removed, Gabriel overlaps the bay serving as a narthex, and the Virgin occupies the main squarish room. An informal yet consistent perspective suggests an actual room which is much too small for the Virgin; yet space exists around both figures; this was not the case in the eleventh-, twelfth-, and thirteenth-century

Annunciations (figs. 399–401). Jean Pucelle was the first northern artist to come in contact with the new experiments with space by Italian painters such as Duccio and Giotto. In the case of this Annunciation, Jean Pucelle was influenced by Duccio's Annunciation of the Virgin and the Annunciation of the Death of the Virgin from his famous Maestà (1308–1311). Pucelle borrows these revolutionary spatial ideas, but as Panofsky states: "He recreated rather than copied these models." He must fit his doll architecture to the manuscript page as a whole.

Almost as important as the Annunciation are the activities of the angels and the game of frog-in-the-middle. The imaginative and droll marginalia in other folios of humans turning into beasts and vice versa go back in history to the nonreligious Romanesque capitals (Anzy-le-Duc, fig. 107) and to Anglo-Irish manuscripts and the art of the nomadic barbarians. Their ultimate interpretation can be seen in the paintings of Jerome Bosch and in the etchings of Jacques Callot. Jean Pucelle's imagination imparts a captivating charm to these real and imaginary figures.

The consistently high quality of the miniatures in this Book of Hours suggests that Jean Pucelle, as head of the workshop, illuminated the entire manuscript. Pucelle's interpretation of the Annunciation is more intimate than the High Gothic interpretation (fig. 401). The actuality of the event is forced up by the pictorial space which envelops it, and the separation of narthex and chapel clearly defines the total meaning of the confrontation of Gabriel and the Virgin. The elegance of the silhouettes, with their fine gradations of light and shade, has its counterparts in Rayonnant architecture, such as the contemporary choir of Saint-Ouen at Rouen (fig. 361), or the Rayonnant sculpture, like the fourteenth-century Madonna and Child in The Cloisters (fig. 337). The exquisiteness of surfaces of building, statue, and painting gives a positive homogeneity to these Rayonnant works of art.

The Annunciation in the *Gotha Missal* (fol. 110: fig. 403), recently acquired by the Cleveland Museum of Art, was illuminated about 1375, fifty years later than the *Hours of Jeanne d'Évreux* (fig. 402). On the basis of stylistic comparisons with other manuscripts known to be the work of Jean Bondol, the *Gotha Missal* can be attributed to Bondol and his atelier (see bibliography). Jean of Bruges, called Jean Bondol, was born in Bruges and was active in Paris between 1368 and 1381. As valet de chambre of Charles V, Jean Bondol illuminated many manuscripts for the King and made the cartoons of the famous Apocalypse tapestries for Charles's brother, Louis I, Duke of Anjou. Internal evidence in the nature of the script and special celebrations of the Mass prove that the manuscript was made for use in Paris and further suggest that the *Gotha Missal* may have been created for Charles V himself for use in his private chapel. The *Gotha Missal* contains twenty-two small miniatures and a double-page frontispiece of the Canon of the Mass, plus two miniatures added in the early thirteenth century by the Bedford master.

The kneeling Gabriel and standing Virgin Mary are framed by a quatrelobe contained within a rectangle highlighted by a gold border. God the Father occupies the upper left-hand corner, while an angel suspends an altar cloth behind the Virgin, who is standing in front of a foreshortened throne. The dove of the Holy Spirit overlaps the two panels of the composition. The figures stand or kneel on a narrow shelf of space against a deep blue background of twenty-four heads of angels with overlapping halos. The figures are painted essentially in grisaille with a graded modeling from light to dark which establishes each figure as a three-dimensional mass in space. Some blue is added to the darker areas of the drapery, and the flesh tones are tinted. Silhouette lines are strengthened to set off Gabriel from the background of the angel heads and to establish the Virgin in front of the altar cloth and throne. The sense of space is heightened by the bulk of the figures themselves. Expressive gestures and animated facial features force up the significance of the event. Jean Bondol reacted against the decorative bent of the followers of Jean Pucelle. He started with the grisaille treatment of Pucelle, but by eliminating lines and

concentrating on subtle modulations of light and dark he imparted a new solidity to the figures. According to Panofsky (see bibliography) this new emphasis on solidity is derived from Flemish art. The toy floating architecture so essential to the handling of space in the Annunciation of the *Hours of Jeanne d'Évreux* (fig. 402) is no longer necessary in the *Gotha Missal,* since the figures themselves with their pervading tonal luminosity establish their own spatial existence against the ground of angel heads. If Jean Pucelle can be called the Duccio of the north in the 1320's, Jean Bondol can be called the Giotto of the north in the 1370's.

The small Annunciation in the Cleveland Museum of Art (fig. 404), painted in tempera on a wooden panel, marks the emergence of panel painting out of the northern manuscript tradition. This painting, 13¾ inches by 10 inches, formerly in the collection of Arthur Sachs, is considered to be of the School of Paris dated about 1390, although Panofsky and others have suggested a Bohemian provenance. Its precious elegance of line suggests the art of the illuminated manuscript, while the hems of the drapery, accented by gold, the decorative splendor of Gabriel's wings, and the stylized gestures are strongly reminiscent of Sienese painting, especially Simone Martini's Annunciation in the Uffizi in Florence. The Infant Christ descends from God the Father in the upper left-hand corner toward the Virgin, who is seated on an elaborate Rayonnant throne. The graceful, swinging folds of drapery recall the Annunciation of Jean Pucelle (fig. 402). In contrast to the Annunciation of Jean Bondol (fig. 403), the figures possess less bulk and are less psychologically charged. The thin face of the Virgin and the off-white flesh tones relate the Cleveland panel to painting such as the Parement de Narbonne in the Louvre (1375), thought to have been painted in Paris. The dark blues, bright reds, and yellow-oranges of drapery and throne set against a gold ground with halos in raised gold are typical of the decorative richness of the International Style.

The Cleveland panel of the Annunciation (c. 1390, fig. 404) and the last illuminated Annunciation of this series from the *Belles Heures of the Duke of Berry* (1410–1413, fig. 405) in The Cloisters (The Metropolitan Museum of Art, fol. 30: 9⅜ in. by 6⅝ in.) exhibit the so-called International Style in its early and latest stages. As Panofsky writes (*Early Netherlandish Painting,* pp. 66–67):

> This style, a scintillating interlude between the sober sturdiness of the Bondol generation and the shining perfection of the great Flemings, is often referred to as the "International Style" and not without justification. While all the great historical styles were international in that they were practiced in different countries, most of them did not, in themselves, result from a blend of different tendencies. The Gothic, the Renaissance, the Baroque, and the Rococo owed their existence to the genius of one particular nation or even region and conquered others by way of unilateral expansion. The style of around 1400, however, though formulated on French soil, had come into being by the interpenetration and ultimate fusion of the Gallic as represented by the French, the Latin as represented by the Italians, and the Anglo-Germanic as chiefly represented by the Flemings; and where it spread to Germany, to Austria, to Spain, to England, to Flanders, and even back to Italy — the reflex from north to south beginning and steadily growing from ca. 1370–1380 — it did so, as it were, by way of multilateral repatriation.

The *Belles Heures* of the Duke of Berry (fig. 405) was one of the three hundred manuscripts known to have been in the library of this famous patron. The accounts of the Duke's secretary, Jean Flamel, read: "These hours were made to order of the very excellent and mighty Prince Jehan, son of the King of France, Duke of Berry and Auvergne, Count of Poitou, Étampes, Boulogne, and Auvergne. Flamel." The 224 folios, with 94 full-page illuminations and 54 in-column illustrations, plus calendar vignettes and border illuminations, were the work of Pol de Limbourg and his brothers and were created between 1410 and 1413, when the atelier began the *Très Riches Heures du Duc de Berry,* now in the Musée Condé at Chantilly.

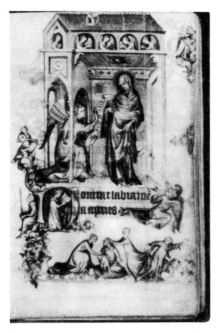

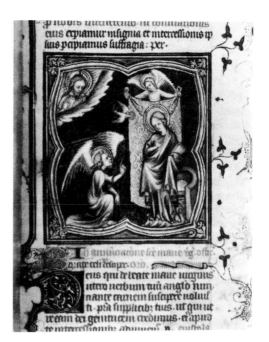

Fig. 402. Jean Pucelle, "The Annunciation." *Hours of Jeanne d'Évreux,* 1325–1328, 3 5/8 in. by 2 3/8 in. (The Metropolitan Museum of Art, The Cloisters Collection, fol. 16)

Fig. 403. Jean Bondol. "The Annunciation." *Gotha Missal,* c. 1375 (The Cleveland Museum of Art, fol. 110)

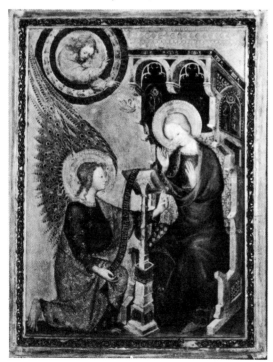

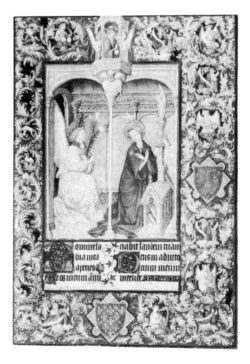

Fig. 404. "Annunciation." Tempera panel, School of Paris, c. 1390, 13 3/4 in. by 10 in. (The Cleveland Museum of Art)

Fig. 405. The Limbourg Brothers. "Annunciation." *Les Belles Heures du Duc de Berry,* 1410–1413, 9 3/8 in. by 6 5/8 in. (The Metropolitan Museum of Art, The Cloisters Collection, fol. 30)

Pol, Herman, and Jehanquin Malouel were probably born in Limbricht in Guelders, rather than in Limbourg, as some scholars had assumed. In 1399 two of the brothers were apprenticed to a goldsmith in Paris. Probably all three brothers were working with miniaturists in Paris at the turn of the century. In 1401 or 1402, en route to their homeland, they were captured in Brussels. Philip the Bold, Duke of Burgundy, paid their ransom, since they were the nephews of his court painter, Jean Malouel. In 1402–1403 two of the brothers were engaged by Philip the Bold to illustrate a Bible. By 1410 the brothers were in the employ of Philip the Bold's older brother, Jean, Duke of Berry. At Bourges the Limbourg brothers illuminated the *Belles Heures* (fig. 405) between about 1410 and 1413 and the *Très Riches Heures du Duc de Berry* between 1413 and their deaths in an epidemic in 1416. Born in Flanders, with its great tradition of painting, educated further in goldsmith work and manuscript illumination in Paris, the Limbourg brothers then came in contact with the altarpieces and sculptural monuments commissioned by Philip the Bold for the Chartreuse de Champmol, with paintings by their uncle Jean Malouel and by Melchior Broederlam, and with the sculpture of Claus Sluter. In the court of Jean, Duke of Berry, in Bourges, the vast library of the Duke, including manuscripts by Jacquemart de Hesdin, illuminator for the Duke since 1384, was available for their study. Thus, by birth, training, and because of the artistic activities of their two great patrons, the Limbourgs were exposed to all contemporary currents of art.

Many of the folios in the *Belles Heures* reveal the strong influence of Italian art. The barren abstracted rocks of the Nativity or the Saint Michael slaying the dragon are derived from Italian sources. Iconographical details in the Annunciation (fig. 405), such as the Virgin with crossed arms and Gabriel carrying lilies, are also inspired by Italian painting. The elaborate, floral border of the Annunciation, with the coat of arms of the Duke, is completely different from the spiky elegance of the borders on the other folios and was probably based on an Italian manuscript in the Duke's library. Other scenes such as the Flight into Egypt echo Broederlam's altar wings in Dijon, while the Charlemagne page is clearly influenced by the Nine Heroes tapestries commissioned by the Duke of Berry in 1385. In spite of this apparent eclecticism, the Limbourgs not only made a synthesis of these various sources but also made many innovations: noteworthy are their treatment of the Crucifixion as a night scene and the tender pathos of the Descent from the Cross and the Lamentation. Brilliant colors give a jewellike vibrancy to each page. A new atmospheric depth is achieved by graded blue skies which grow lighter at the horizon line, and the scene of Saint Nicholas calming the storm and saving a ship full of mariners points up the sensitivity of the Limbourgs' reaction to natural phenomena. The architectural backdrops still possess a toy-stage-like character reminiscent of Jean Pucelle and Duccio. Castles, monasteries, towers, and gates are an integral part of each composition; yet in the *Très Riches Heures,* for example, in the Saint Michael folio (fig. 4) depicting Mont-Saint-Michel, the actual town and monastery are clearly depicted. The *Très Riches Heures,* left incomplete at the death of the Limbourg brothers, exhibits an intensification of their interest in precise observation of actualities.

In the Annunciation of the *Belles Heures* (fig. 405), the figures of the Angel and the Virgin repeat the elegant poses and subtle manipulation of drapery apparent in the Cleveland panel (fig. 404). The ultramarine blue made from lapis lazuli on the Virgin's mantle and also in the ground for the floral border, together with the intense red of the tips of Gabriel's wings, are in marked contrast to the less intense color of the Cleveland panel and to the muted color of the Annunciations of Jean Bondol and Jean Pucelle (figs. 403, 402). The figures are squat and sculptural in Jean Bondol's Annunciation (fig. 403), while they remain somewhat transfixed in the Cleveland panel (fig. 404). In the Limbourg Annunciation, a relaxed courtly grace permeates the two figures.

The barrel-vaulted chapel with its round-arched doorway and blind arcading and the in-

clined floor in perspective creates an illusion of real space. Obviously, the chapel would be too small if the Virgin and Gabriel stood up; yet the toy architecture of Jean Pucelle (fig. 402) is now made more convincing. The slender supports of the double arch and of the arcade in the background recall the architecture in the Well of Moses and the scenes of the Annunciation and Presentation in Broederlam's altarpiece in Dijon. The Virgin kneels on a prie-dieu from which rises a pedestal supporting a statue of Moses, symbolic of the Old Law as the Annunciation is symbolic of the New Law. The page as a whole (fig. 405) illustrates the last stage and virtual end of the illuminated manuscript tradition. The co-ordination of script and miniature in an all-over two-dimensional design has vanished. The Limbourgs have painted a scene within a frame and an arcade as seen through a window with a panel of texts beneath it, the whole surrounded by a three-dimensional border. In an attempt to unite these disparately treated elements, the central column supports a tabernacle containing God the Father and angels which extends up into the border. This tabernacle tends to destroy the plane of the floral frame. The initial "D" of the Romanesque manuscript (fig. 399) and the Annunciation of Jean Bondol (fig. 403) are part of a total composition of miniature and text which preserve and enhance the page. Indeed, in the tiny Pucelle Annunciation (fig. 402), the architecture suspended in space and supported by an angel, the secular game, the initial "D" containing Jeanne d'Évreux, and the other marginalia are all harmonized into a single composition. In the *Belles Heures* (fig. 405) the Limbourgs have cut a deep hole in the page and by so doing have ushered in the great era of panel painting.

The interrelationship between illuminations and tapestries can be seen if the Annunciation of the *Belles Heures* of the Duke of Berry (fig. 405) is compared to the large tapestry from Arras in The Metropolitan Museum of Art (11 ft. 4 in. by 9 ft. 6 in.: fig. 406). The pictorial elaboration of both manuscript page and tapestry manifests the courtly art of the late Middle Ages. The weavers

of Arras suggest space within the chapel in which the Virgin is enthroned, but preserve the over-all mural character of the tapestry by repeated patterns of flowers, bushes, trees, and clouds. In a compositional sense, the Arras tapestry is more homogeneous than the illuminated page by the Limbourgs. The design of the chapel, the placement of Gabriel, the pose of the Virgin, and the design of her lectern are so close to Broederlam's altar panels in Dijon that it is possible to say that he or his assistant designed the cartoon for the tapestry. The Virgin's garment is blue with red borders, while the Angel's cloak is green with red undergarment. Rich blues, reds, and greens in foliage play against the tan architecture. In spite of the linear convolutions of the drapery hems and the treatment of details such as the rose and lilies, the broad patterns of color and abstracted nature play against the chapels and the figures and impart a monumental scale to the tapestry.

Like the Carolingian Gospels from Reims (fig. 398), the first manuscript discussed, the last one depicts Saint Mark with his symbol, the lion (fig. 407). It was painted by Jean Bourdichon of Tours about 1510 and is in the Sterling and Francine Clark Art Institute (see bibliography). Painted in tempera, heightened with gold, on parchment, the illumination was originally the frontispiece of the Gospel of Saint Mark; but after removal from the manuscript, it was mounted on an oak panel with a gold-colored foil border to simulate a panel painting. Saint Mark is seated in front of a carved desk, writing his Gospel. The head of a lion fills the lower right-hand corner. Pilasters containing candelabra frame the scene and are co-ordinated with the perspective of the barrel-vaulted room. The paneling of pilasters and the entablatures animate the left wall, while two windows and a pedimented door reveal the distant wall and landscape. All architecture, including the desk, is Renaissance in style.

Saint Mark is garbed in a purple robe over a blue undergarment. His hair is painted red, as is the binding of the Gospel book. Gold lines highlight both his mantle and the details of the architecture. The floor is light purple, and the architec-

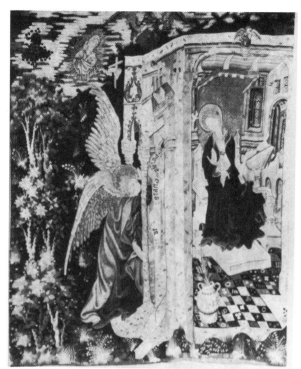

Fig. 406. "Annunciation." Tapestry from Arras, early
XVth century, 11 ft. 4 in. by 9 ft. 6 in. (The
Metropolitan Museum of Art)

Fig. 407. Jean Bourdichon. Saint Mark, from a Book
of Hours, c. 1510, 7 11/16 in. by 5 11/16 in. (Sterling
and Francine Clark Art Institute, Williamstown)

ture is accented by shades of gray, yellow, and red-orange. The treatment of the drapery reveals the articulation of Saint Mark's body. His hands are anatomically connected with arms, shoulders, and torso. Jean Bourdichon, following the precedent established by the French painter Jean Fouquet, interpreted the human form as an organic entity; his figures possess a weight and support relationship. The bulks of figures, desk, and lion are placed in the foreground of a rationally conceived space, utilizing essentially a system of one-point perspective. This rationalization of the human form as an articulated entity and the placement of forms in a Euclidean space are characteristic of the new world of the Italian Renaissance which, at this point, was in the process of eclipsing the Middle Ages.

To point up the Renaissance character of Jean Bourdichon's Saint Mark, we need only contrast this miniature with the earlier fifteenth-century Arras tapestry (fig. 406) or with the *Belles Heures* of the Duke of Berry (fig. 405). In the latter two Annunciations, voluminous drapery hides the anatomy, just as it does in the sculpture of Claus Sluter (figs. 389, 391). Systematized space is attempted in the illumination of the *Belles Heures,* but spatial ambiguities show a lack of interest in a consistent, geometrical system. The spiritual meaning of the event dominates the two earlier Annunciations, while the Renaissance miniature manifests the concern for the understanding of man in relation to his world.

In a sense, the Saint Mark by Jean Bourdichon invites comparison with the Carolingian Saint Mark (fig. 398). The unknown monk who painted the Reims Evangelist was consciously or unconsciously attempting to revive antiquity. Models in the form of Early Christian manuscripts, in which the pagan interest in physical corporeality and the illusion of space were continued, and models in the form of other earlier Carolingian manuscripts influenced by Early Christian painting were available to the Reims scribe. This interest in antiquity which characterized the Carolingian renaissance was, however, dominated by the northern spirituality with its dehumanized tendency and charged psychology, while the Renaissance miniaturist, Jean Bourdichon, a contemporary of Raphael, Leonardo da Vinci, and Michelangelo, belonged to the modern world in which the pagan past was understood and critically transformed to answer the new demands of man and the new interest in his relationship to a newly discovered universe.

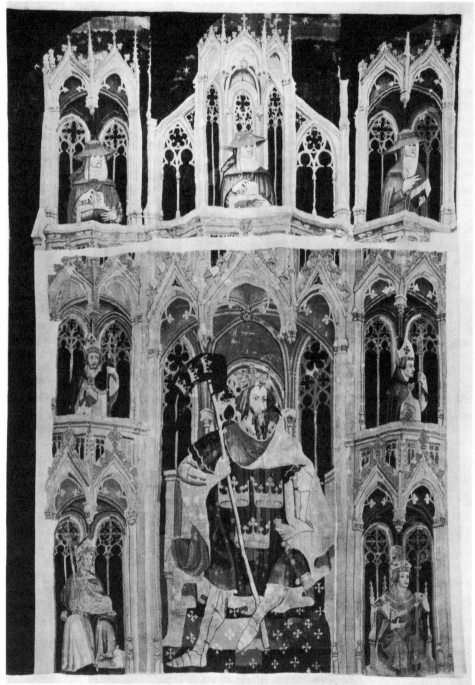

Fig. 408. Nicolas Bataille. King Arthur, tapestry, end of XIVth century, 14 ft. by 9 ft. 9 in.
(The Metropolitan Museum of Art, The Cloisters Collection)

CHAPTER 31

Tapestries

Tapestries, an art form new in the late Middle
Ages, play a practical and artistic role in the coun-
tries of northern Europe. The stone walls of cas-
tles, of the town houses, of the aristocracy, and of
some wealthy burghers were draped from floor to
ceiling with heavy tapestries to lessen the cold
and damp of winter and to enliven the dark inte-
riors with religious, historical, and secular scenes.
The wealthy dukes and princes, who gathered ar-
chitects, sculptors, manuscript illuminators, and
painters into their households to enrich their pal-
aces and to augment their collections of art, paid
great attention to the tapestry designers and
weavers in whose workshops wall hangings were
created. Since tapestries were treated as movable
furniture, transported from place to place by the
perambulating courts and often cut up and al-
tered to fit different spaces, most Medieval tapes-
tries have long since disappeared. Rooms in pal-
aces were occasionally named after a series of
tapestries. Bed hangings and coverings for furni-
ture and pillows were also tapestries, as were many
of the elaborate costumes worn by the royalty.
The well-known miniature of the month of Janu-
ary in the *Très Riches Heures du Duc de Berry* by
the Limbourg brothers depicts the Duke, sur-
rounded by his courtiers, seated at a banquet table
in front of a fireplace. In the background is an
enormous tapestry of the armor-clad knights of
France, which has been carried around the corner
of the room to cover a doorway and has been
folded back to allow use of the fireplace. The
splendor of the court of the Duke of Berry is ap-
parent in the sumptuousness of the meal and the
richness of the setting and of the costumes.

The Nine Heroes Tapestries at The Cloisters
(The Metropolitan Museum of Art, fig. 408) and
the Apocalypse Tapestries of Angers are rare ex-
amples of fourteenth-century designing and weav-
ing. Ninety-four fragments of the Heroes Tapes-
tries were purchased over a period of twenty years,
then taken apart and reassembled in a laborious
task involving "7,000 needle-woman hours." To-
day they are handsomely exhibited in a special
room in The Cloisters (see bibliography). This se-
ries consisted originally of three tapestries, 21 feet
by 16 feet, each depicting three heroes: three pa-
gan, three Hebrew, and three Christian. Five of
the Nine Heroes and most of the smaller figures
of the three tapestry panels are preserved.

Since ten of the thirteen banners depicted on
the turrets in the tapestries carry the arms of Jean,
Duke of Berry, it can be assumed that the series
was designed and woven for him. The Duke of
Berry, like his younger brother, Philip the Bold
of Burgundy, was one of history's greatest patrons
of the arts. His elaborate palace and private chapel
in Bourges were decorated by statues and stained-
glass windows, probably designed by André Beau-
neveu, while Psalters and Books of Hours were
illuminated under the Duke's patronage by Beau-
neveu and the Limbourg brothers. Because of the
relationship in style and technique between the
Heroes series and the Angers tapestries, finished in
1384, it is believed that the Heroes series was com-
pleted around 1385, having been designed by a
Fleming under the influence of André Beauneveu
and woven either in Paris or Bourges, probably by
Nicolas Bataille and his atelier.

The subject of the Nine Heroes Tapestries is

derived from a cycle of poems popularized about 1310 by the jongleur, Jacques de Longuyon. The cycle of poems was entitled "Vows of the Peacock" and was added to the older "Romance of Alexander." Porus, the hero of this popular poem, fought more bravely than did the nine great heroes of the past whom the poem enumerated: Pagan heroes Hector, Alexander, and Julius Caesar; Hebrew heroes David, Joshua, and Judas Maccabeus; Christian heroes Arthur, Charlemagne, and Godfrey de Bouillon. The nine heroes, or nine worthies, excited the imagination of patrons of the arts all through the fourteenth century; the theme was acted out in pageants, carved in large stone statues as well as on fireplaces and utensils, and woven in tapestries.

Each hero (King Arthur, fig. 408) was dressed in contemporary costume and seated precariously on an elaborate throne within a rib-vaulted niche, with windows of Rayonnant tracery in the background and trefoil arches with deep gables in the front plane. The Rayonnant architecture is similar to the architecture of such monuments as the fourteenth-century choir of Vendôme (fig. 364). Flanking and crowning each hero are projecting niches of balconies containing individual figures from all facets of fourteenth-century life. Bishops and cardinals surround King Arthur, and archers, spearmen, women playing musical instruments, and others holding animals animate the niches around Alexander the Great, Julius Caesar, Joshua, and David.

The heroes are garbed in rich costumes which completely envelop the bodies. Voluminous folds force up the disjointed poses. Even greater movement is seen in the secondary figures, especially in the variety and expressiveness of their gestures. Space is abstracted and is treated in accordance with the Medieval practice of shifting perspectives in elevation; compare Villard de Honnecourt's thirteenth-century drawing of the Laon tower (fig. 173). Silhouettes curve and undulate, and the figures fill the canopied niches. Colors are subdued. Reds and blues are the basic hues which highlight the figures and set them off from the yellow-orange of the architecture. The same blues and reds appear in the vaults of the niches and on finials and

crockets. Color is used to achieve a horizontal balance in each section of the tapestries. All the figures of the heroes are life-size and each stands or sits in front of traceried windows with dark blue-black sky. The main tonality is the golden color of the architecture. A marvelous two-dimensional pattern with a suggestion of space is achieved with a limited number of colors.

Many stylistic features relate the Nine Heroes Tapestries to other works of art commissioned by the Duke of Berry. The sweeping drapery and angular gestures are similar to those in manuscripts illuminated by André Beauneveu and in statues carved by the same artist. Further, a stained-glass window, probably designed by André Beauneveu for the chapel of the Duke's palace in Bourges, may have influenced the design of the tapestries. This stained-glass window (fig. 409), now in the crypt of the Cathedral of Bourges, shows vaulted chapels with standing figures similar in format to the Heroes Tapestries. The details of the architecture, such as the finials and crockets, are yellow outlined in red in both the tapestries and window. Since the date of the window is unknown and permission to construct the chapel was not granted by the pope until 1391, it is difficult to determine whether the windows influenced the tapestries or vice versa. This window and others in the cathedral possess an individuality which differentiates them from any other contemporary windows. André Beauneveu, the Duke's leading artist, or someone in his atelier must have designed both windows and tapestries, and the similarities between the two are typical of the pronounced relationship of the arts in this last, creative stage of Rayonnant art.

In the Heroes Tapestries, the luminous glow of the architecture, with windows blackened by the night, give the onlooker the impression that he is seeing the Heroes by torchlight inside a poetic structure. The Heroes Tapestries are the secular counterparts of the famous Apocalypse cycle in Angers, designed by Jean Bondol. It is idle but perhaps necessary to speculate whether the art of tapestry ever reaches such heights of magical quality again as in these two superb series.

As the Heroes series exemplifies the nature of

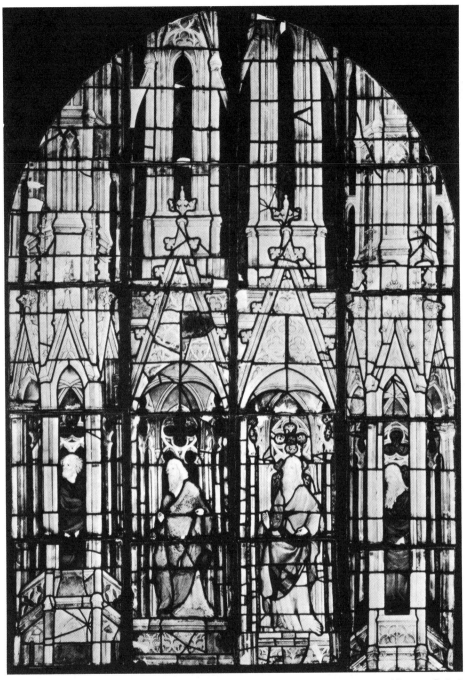

Fig 409. Stained glass window for the Duc de Berry's Saint Chapelle at Bourges, now in crypt of Bourges Cathedral

tapestry design in the late fourteenth century, the Unicorn Tapestries (fig. 410) in The Cloisters (The Metropolitan Museum of Art), over one hundred years later in date, exhibit the belated International Style in tapestry design (see bibliography). Five were commissioned to celebrate the marriage of Anne of Brittany to King Louis XII in 1499. Anne of Brittany, the widow of Charles VIII, became Queen of France for the second time in this second marriage. Two additional tapestries in the series may have been commissioned as late as 1514, when Francis I married Anne's daughter. In style, the series is related both to tapestries woven in France (in the Loire Valley) and in Flanders. However, it can be surmised that the tapestries were woven in Flanders for the King's chateau at Blois.

The subject of this series of tapestries is The Hunt of the Unicorn. It was believed that this fabulous animal defied capture by the swiftest horseman, but upon the approach of a virgin, the unicorn would lay its head on the maiden's lap. In the encyclopaedia of zoölogical and botanical subjects of the late Middle Ages, the Hunt was conceived as the allegorical drama of the Incarnation: the unicorn is Christ; the virgin, the Virgin Mary; and the huntsman, the Angel Gabriel. Another quite different level of allegorical meaning relates the Hunt of the Unicorn to the ritual of courtly love: the scenes symbolize the various phases of courtship; and the final capture of the unicorn represents the consummation of the marriage. Since these tapestries were woven as wedding gifts, the secular interpretation would appear to be the dominant one; yet both interpretations are explicitly suggested by the details in the tapestries themselves.

The first panel in the sequence of the tapestries depicts hunters, varlets, and dogs preparing for the hunt. The second panel portrays the unicorn dipping its horn into the Fountain of Eternal Life and purifying the water for other animals. The third shows the unicorn attempting to escape, while in the fourth, the unicorn gores a greyhound. The fragmentary fifth scene reveals the virgin stroking the neck of the unicorn. The vir-

gin's costume identifies her as Anne of Brittany, who plays the double allegorical role of the virgin who makes the capture possible and the Virgin of the Incarnation. The sixth (fig. 410) includes two scenes, the slaying of the unicorn and its presentation to Anne and Louis in front of the castle. The final tapestry shows the unicorn in captivity, alive but with his wounds visible. The unicorn is both symbol of the Risen Christ and of the consummation of the marriage.

In the Presentation scene (fig. 410), Anne and Louis, followed by courtiers and ladies-in-waiting, stand in front of the gate of the castle. People lean over the parapets and peer out the window of a tower. All the figures are in contemporary costume, with Anne in Breton headdress and Louis wearing red, his color, now combined with white, which was his bride's color. Ciphers and flags connect the tapestries of the two royal houses. In contrast to the fourteenth-century Heroes Tapestries (fig. 408), the unicorn series exhibits a different treatment of space. The act of killing the unicorn is above and to the left of the presentation of the unicorn. The continuous narrative, accented by the arrangement of spears, sweeps downward to focus on the royal couple. Then the space continues in a spiral in front of the castle and disappears in the upper middle zone. The front plane of the tapestry is preserved by the uniform treatment of the foliage, the mille fleurs, which serves as backdrop for the action on the left, and the trees which climb up around the castle. An extension of space is simultaneously denied and accepted; the result is a spatial ambivalence. The texture of the tightly woven wool and silk highlighted by silver and silver-gilt threads is uniform throughout the whole tapestry and partially resolves the ambivalence by reaffirming the front plane.

Figures interlocked and interwoven with each other as fluid silhouettes emphasize the elegant yet stylized gestures of the courtiers and of the king and queen. Colors are no longer reduced in numbers and intensity, as in the Heroes Tapestries, but include yellows, blues, and oranges played off against the white of the unicorn and

the blue-green and green of flowers, shrubs, and trees. The tapestry contains all the coloristic variations of Late Gothic illuminated manuscripts such as the *Belles Heures* of the Duke of Berry (fig. 405). With its continuous narrative and courtly emphasis, combined with an acute observation of the visual world (eighty-five distinct kinds of plants can be identified from among the hundred which appear in the series), the Unicorn Tapestries show the extension of the International Style into the early sixteenth century, contemporary with the High Renaissance in Italy. The hunt of the unicorn is sophisticated, courtly art. The anecdotal details, as well as the sequences of events, describe allegorically the life of the court. Each scene is a technical tour de force as well as a harmoniously balanced and delightful composition in color and form.

The art of the Unicorn Tapestries (fig. 410) and the art of the early sixteenth-century church at Brou, with its Flamboyant architecture, tombs, stained glass, and choir stalls (figs. 373–376), mark the climax and close of the late Late Middle Ages in the north as the ideals of the Italian Renaissance begin to emerge and dominate (see Jean Bourdichon, Saint Mark, fig. 407). This last flowering of the Middle Ages was the product of a new kind of individualistic patronage together with a new emphasis on the individual artist and his personal style. Indeed, as patrons, Philip the Bold of Burgundy, Jean, Duke of Berry, and later, Margaret of Austria and Kings Louis XII and Francis I of France were Renaissance individuals; yet the art which they commissioned from French, Dutch, and Flemish artists remained profoundly Medieval.

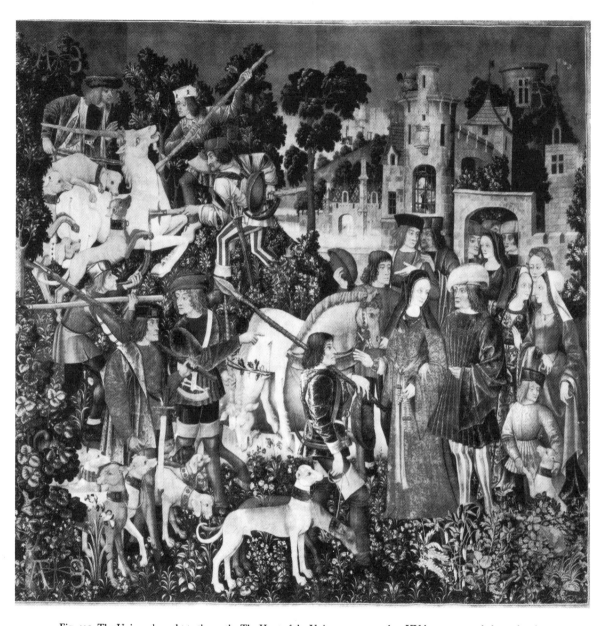

Fig. 410. The Unicorn brought to the castle. The Hunt of the Unicorn, tapestry, late XVth century, 12 ft. by 12 ft. 9 in.
(The Metropolitan Museum of Art, The Cloisters Collection)

The Treasuries of Monasteries
and Cathedrals

Art of the Treasuries of Monasteries and Cathedrals

IN RELEGATING the discussion of the art of the treasuries of monasteries and cathedrals to the last part of this study, I have not intended to imply that the objects are of less artistic merit. In Part I, the enamel of Christ in Majesty (Paris, Musée de Cluny, fig. 114) was compared with the monumental tympanum of Vézelay (fig. 111) and the frescoed mural of Berzé-la-Ville (fig. 112) and a manuscript folio (fig. 113) to point up the homogeneity of the Romanesque style in various media and in different sizes. To be sure, this small enamel is later in date (about 1175) and represents the extension into the second half of the twelfth century of the Romanesque point of view. However, the comparison was not a qualitative one. In Part III the silver-gilt statuette of Saint Stephen, 17 inches high (The Cloisters collection, fig. 317), was compared with the contemporary monumental stone statues of the Beau Dieu on the trumeaux of Chartres and Amiens cathedrals (figs. 318, 319). The statuette, probably made about 1220 in the valley of the Meuse River under the influence of French High Gothic sculpture, is a superb piece of metalwork, the equal of the stone sculptures in quality. Further, the ivory Coronation of the Virgin in the Louvre (fig. 327) possesses a subtlety of Gothic form similar to the tympana of the Coronation of the Virgin of Chartres and Moutiers-Saint-Jean (figs. 324, 326) and the miniature of the same subject in a Book of Hours (fig. 325).

The whole distinction between the major and minor arts is a nineteenth-century invention and did not exist in the Middle Ages. The goldsmith, the enameler, the illuminator, and the sculptor in stone were all equally important as artists creating objects for the Christian liturgy. As Hanns Swarzenski points out (*Monuments of Romanesque Art,* 1953, pp. 12–13):

It is therefore a mistake to see in these productions mere substitutes or reflections of lost or damaged works on a grand scale, as is often done. Just as there is no distinction to be made between "minor" and "major" arts, thus the terms "monumental" and "small" cannot be applied to these works; the monumental quality of this period is in no sense determined by size. There are frescoes and stone reliefs that have the minute subtlety and precision of miniatures, ivory carvings, and metal engravings; and there are book paintings, silver-gilt statuettes, ivories, and metal engravings which show the broad summary handling of wall paintings and stone sculptures. Of course, it is only in the true size of the original in which the artist expressed himself that the suggestive power of the whole design of these works can be fully experienced. But the point is that even so these works, no matter how tiny they may be, stand enlargement to many times their size without distortion. In fact, it is often only through such enlargements that their whole hidden artistic richness and the fullness of their imaginative world can be revealed.

In a certain sense it is the heritage of the Barbarians, the Northern tribes, that this art, at least at its beginnings, consists almost exclusively of small movable objects of precious materials. But it would be a mistake to approach merely as *objets d'art* these works executed in the more refined techniques of gold, filigree, jewels, gems, pearls, enamel and niello. Their material extravagance was not the result of the mere love of powerful ecclesiastical and secular lords for display and ostentation: *Ars auro gemmisque prior* reads the

inscription on the fragment of an enamelled shrine commissioned by Henry of Blois, Bishop of Winchester. In all young cultures gold and jewels embody and convey a magical or symbolical force, a supernatural or impersonal power. And it is due to this quality that they were used in Christian art to enshrine and emphasize the transcendental revelations of the mystery of the liturgy and of the relics. This is the reason why the Medieval craftsman and his patron found and experienced in these precious materials the appropriate medium for the artistic realization of their purpose. Both were aware that it was an offering pleasing to God, and consequently the artist gave his best to the delicate work — the *opus subtile,* as it was called. For the purer and more precious the material in which he worked, the closer he came to fulfillment of his consecrated purpose. The very preciousness of the material acquired the value of symbolic significance: crystal and ivory became attributes of the Virgin; the chalice-shaped mounts of the gems on the cover of the Codex Aureus of St. Emmeran were associated with the blood of the martyrs, and its precious stones were the Heavenly Jerusalem.

In Part V all but two of the objects discussed are in museums or libraries in the United States. Many were created outside modern France. They have been selected to illustrate the variety of media used by Medieval artists, to portray the numerous types of objects employed in the Christian ritual, and finally to summarize the whole dynamic evolution of Medieval art.

RELIQUARIES AND LITURGICAL VESSELS IN THE CLOISTERS, THE METROPOLITAN MUSEUM OF ART

The Treasury of The Cloisters in New York (The Metropolitan Museum of Art) exhibits extraordinary objects of gold, silver, silver-gilt, enamel, ivory, and leather (figs. 411–415). Some of these were used for the celebration of the Mass; others served to house relics of saints and martyrs. From Early Christian times, the fashioning of sacred, liturgical vessels in gold and silver, encrusted with jewels, had been the concern of both the clergy and royalty. All believed that objects such as bits of clothing, bone, and so forth, associated with Christ, the Virgin and Saints, and the remains of martyrs possessed miraculous powers; therefore the creation of suitable containers for relics was regarded as an art of the highest importance. A special room — the sacristy — in monasteries and cathedrals was constructed for the safekeeping of these reliquaries (see plan of Fontenay, sacristy adjacent to south transept, fig. 8).

Two statues, already discussed, are reliquary figures. The silver-gilt statuette of Saint Stephen in The Cloisters (fig. 317) once contained a relic encased in a book which the statue originally held in its hands. The majestic yet relaxed pose, the idealized head, and the exquisite play of the surfaces are the product of Mosan goldsmith work of the highest quality. Working in the valley of the Meuse in the Duchy of Lorraine, the unknown goldsmith reinterpreted French High Gothic monumental stone sculpture. The High Gothic Saint Stephen is very different from the transfixed, late ninth- and late tenth-century Sainte Foy in the Treasury of Conques (fig. 28). Sheets of gold are attached to the wooden core of the reliquary statue, while semiprecious stones, including some ancient cameos and gems, encrust the surfaces. Iconlike in pose, with starkly staring eyes, the reliquary of Sainte Foy contains the remains of this Christian martyr. In the early history of Conques miraculous cures were attributed to the presence of Sainte Foy's relics; workmen who fell from the scaffolding were cured. The presence and reputation of the relics in the shrine brought pilgrims to Conques, which is buried deep in the Massif Central of France. Many pilgrims donated jewels which were added to the statue during the late Middle Ages and subsequent centuries. Most of the pilgrims who stopped at Conques were en route to Santiago de Compostela, the burial place of Saint James Major (see Part I).

Often the shape of the reliquary is related to the nature of the relics contained therein (see bibliography). The arm reliquary in The Cloisters (fig. 411) once contained the remnants of the arm of a saint. The arm, raised in blessing, consists of an oak core to which silver plates, plaques of engraved niello with ornamental design and figures

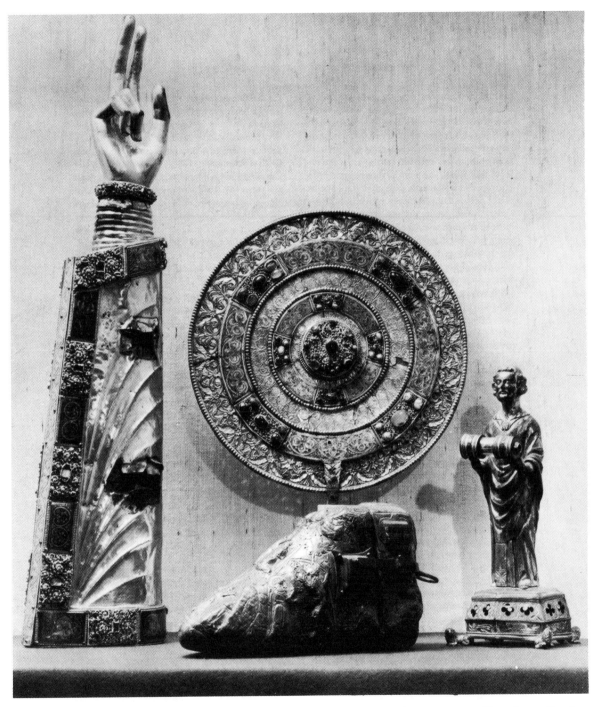

Fig. 411. Reliquaries, XIIIth to XVth centuries. Arm reliquary, Lorraine, c. 1230; Flabellum, Rhenish, c. 1200; Shoe reliquary, French, XIVth century; Standing figure, French, XIVth century (The Metropolitan Museum of Art, The Cloisters Collection)

(such as the Saint Paul directly under the sleeve), and panels of elaborate filigree work, which served as settings for semiprecious stones, have been affixed. Like the reliquary of Saint Stephen, this arm reliquary is close in style to goldsmith work of the early thirteenth century from the valley of the Meuse. The unusual shoe reliquary (fig. 411), appropriately made of leather, has episodes of the life of Saint Margaret of Antioch tooled and embossed on its surfaces. It was probably made in a French workshop in the mid-fourteenth century. A metal receptacle inside the reliquary may have once contained a piece of the bone of the right foot of Saint Margaret, who, according to a thirteenth-century account of her life, caught the Devil and "set her right foot on his neck, saying: 'Lie still, thou fiend, under the foot of a woman.' " The third reliquary (fig. 411) is a fourteenth-century French silver-gilt statuette holding a capsule, which also formerly contained a relic.

The flabellum, or liturgical fan (fig. 411), was probably made in the Rhineland about 1200. Purchased from the Soviets in the 1930's, it is one of a pair; the other one is in the Hermitage in Leningrad. Originally, the function of the flabellum was to keep flies away from the liturgical vessels during Mass. This flabellum, because of its ornateness and because the inner ring represents a cross, was designed either to stand on the high altar or to be carried in processions. Further, the central boss of filigree and jewels is hinged and implies that the flabellum was also used as a reliquary. The outer ring has floral designs in gilt-bronze, while the third ring is made of polished tin. The second and fourth rings have panels of enamels in blue against a red ground alternating with small segments of silver-gilt filigree in which jewels have been set. This sumptuous object of goldsmith work and enamel reflects the ceremonial splendor of the High Gothic ritual. All four reliquaries (fig. 411) illustrate the variety of types of objects that were designed to hold sacred relics.

Very few sets of liturgical vessels have survived from the Middle Ages. At The Cloisters (The Metropolitan Museum of Art) there is a handsome example of these rare sets: a chalice, a paten for the sacramental bread, and a pair of silver straws for the wine (figs. 412–414). These objects were made in Freiburg, in Breisgau, for the nearby Abbey of Saint Trudpert in the second quarter of the thirteenth century; they were purchased in Paris by Czar Alexander III in 1884 and were in the Hermitage in Leningrad until the 1930's. The silver paten (fig. 412) is composed of four areas of filigree set with gems on the border and a quatrefoil with figures in niello. The elegant pair of straws (fig. 413) is made of silver with silver-gilt openwork for handles. On the cup of the chalice (fig. 414) appear Christ and the Twelve Apostles set in an elaborate arcade, while on the knob are four scenes from the New Testament (the Nativity in our illustration) with Old Testament scenes on the base. This sequence from the Old Testament (Old Law) to the New Testament (New Law) represents the function of the chalice in the celebration of the Mass. The subtle silver-gilt openwork, set with garnets, sapphires, turquoises, and amethysts, is similar in all three objects and in each it contrasts with the highly polished but unadorned surfaces.

Other objects designed for the High Altar, including candlesticks, cruet, and Eucharistic Dove (fig. 415), are on display in The Cloisters (The Metropolitan Museum of Art). All four were made of copper-gilt and enamel in Limoges. During the late twelfth and thirteenth centuries, enamels were manufactured on a large scale in Limoges. The Christ in Majesty in the Musée de Cluny in Paris (fig. 114) is a superb example of this enamel work. The plaque itself is copper-gilt. The surfaces were gouged out, and enamel paste in blues, greens, and reds was set in between the ridges of copper. After heating, the enamel solidified. The pair of candlesticks is also copper with enamels on the feet and bosses. The rare altar cruet was probably one of a pair, since cruets were usually made in pairs, one for wine and one for water. This one has floral and geometric patterns in enameled bands. The Eucharistic Dove with movable wings (fig. 415) is made of enamel and copper-gilt. It was designed to hang above the altar and to function as a receptacle for the Host

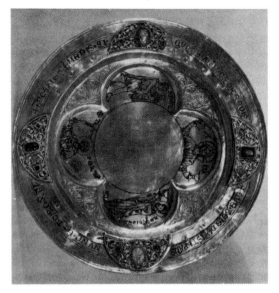

Fig. 412. Paten. Silver, parcel-gilt, niello and jewels, German, second quarter of XIIIth century (The Metropolitan Museum of Art, The Cloisters Collection)

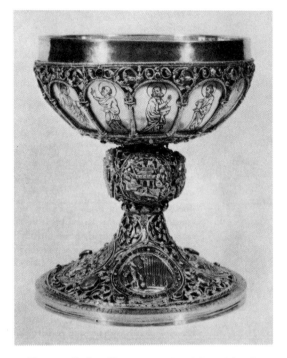

Fig. 414. Chalice. Silver, parcel-gilt, niello and jewels, German, second quarter XIIIth century (The Metropolitan Museum of Art, The Cloisters Collection)

Fig. 413. Straws. Silver-gilt, German, second quarter XIIIth century (The Metropolitan Museum of Art, The Cloisters Collection)

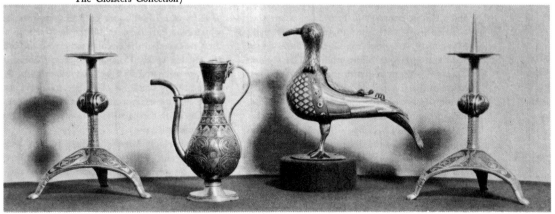

in reserve. These enamels, together with the reliquaries and liturgical vessels, all in The Cloisters, exhibit the variety of objects which formed the treasuries of monasteries and cathedrals during the Middle Ages.

PORTABLE ALTAR AND CROSSES IN THE CLEVELAND MUSEUM OF ART

The Cleveland Museum of Art has an outstanding collection of Medieval art, both in its coverage and its quality. The enamel of the Martyrdom of Saint Lawrence (fig. 117), the three mourners from the tomb of Philip the Bold (fig. 397), and the *Gotha Missal* by Jean Bondol (fig. 403), all in Cleveland, have already been discussed. The rarest and most precious objects in the Cleveland Treasury are the Gertrudis Portable Altar and Crosses (figs. 416–418). Inscriptions on the back of the crosses prove that Countess Gertrude the First of the Brunon family had them made for the old Cathedral of Saint Blasius in Brunswick, which had been constructed with the help of her patronage between 1030 and 1037 (see bibliography). The second Cross (right-hand one, fig. 416), as the inscription states, "was made to the order of the Countess Gertrude for the spiritual welfare of Count Liudolf." Since Liudolf I, her husband and Count of Brunswick, died in 1038, all three must have been made by a goldsmith in Brunswick between 1038 and 1040.

The Altar and the two Crosses, plus five other superb objects including an arm reliquary of 1175 and a Gothic Book reliquary framing a late Carolingian ivory, were purchased by the Cleveland Museum of Art from the Guelph Treasure in 1930 and 1931 (see bibliography). The Guelph Treasure is connected with the Brunswick royal house of the Guelphs and their predecessors, the Brunons. Gertrude the First, a Brunon countess, started to form the Treasure of the Brunswick Cathedral in the late 1030's. The houses of Brunon and Guelph were united by marriage in the early twelfth century. Henry the Lion, who was the son of this marriage and the greatest of the Guelph dukes, continued to collect and to commission objects for the Cathedral of Brunswick.

During the Reformation, Brunswick remained Catholic, but in 1540 the townspeople seized the cathedral and suppressed the chapter. The treasures were, however, carefully stored. In 1663 the reliquaries were inventoried for sale, but the sale was interrupted by a revolt of the town of Brunswick in 1670. The uprising was suppressed by Duke John Frederick of Hanover, who then demanded and received as indemnity the Guelph Treasure. The Treasure remained in the ducal chapel of Hanover until 1803, when it was shipped to England to escape the French invasion. By 1861 King George of Hanover had made the Treasure the core of a new Guelph Museum, but in 1866 Hanover was absorbed by Prussia and the Museum became the private property of the royal house. The final chapter of the history of the Guelph Treasure involved its transportation to Austria, back to Germany, and finally to Switzerland after World War I. It is unusual to have such unequivocal documentation of the specific patron who commissioned the objects, to have identified the cathedral for which they were destined, and to know the complete history of the Treasure from its creation to the present.

The Gertrudis Crosses (8½ in. high, fig. 416) are early eleventh-century in form. Each cross has four cloisonné enamel plaques of gold. This technique was invented in Byzantium and reinterpreted by German goldsmiths. The four plaques in the First Cross represent the symbols of the Evangelists; the four in the Second Cross consist of pairs of birds. Elegant gold filigree work, in which gems have been set, unites the four arms of the Cross around the circular pattern in the center. On the backs of the Crosses, thin plaques of gold are animated by raised inscriptions and figures in relief. The shine of the precious gold and jewels and the extraordinary subtlety of the composition mark these Crosses as masterpieces of the art of goldsmith work.

The Portable Altar (4 in. high, 10½ in. long, and 8 in. wide, figs. 416–418) has a red porphyry plaque on top with an inscription which reads: "In order to live happily in Him, Gertrude presented to Christ this stone, glistening with gold

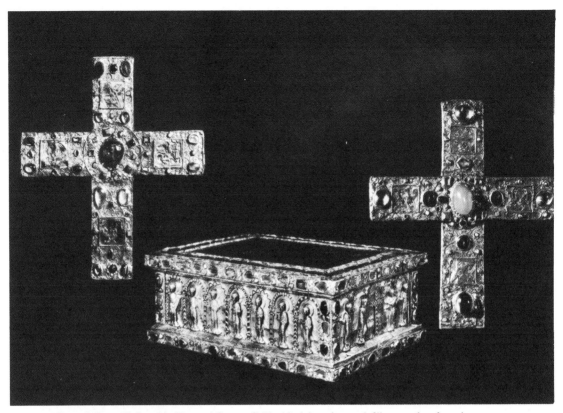

Fig. 416. Gertrudis Portable Altar and Crosses. Gold with cloisonné enamel, filigree work and precious stones, German, c. 1038–1040; Altar 4 in. high, 10 1/2 in. long, 8 in. wide; Crosses 8 1/2 in. high (The Cleveland Museum of Art)

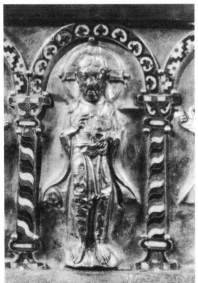

Fig. 417. Christ. Detail of Gertrudis Portable Altar, 1 15/16 in. in height (The Cleveland Museum of Art)

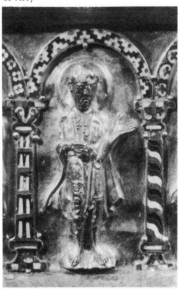

Fig. 418. Saint Peter. Detail of Gertrudis Portable Altar, 1 7/8 in. in height (The Cleveland Museum of Art)

and precious stones." The front of the Altar has six Apostles with Christ in the center under a continuous arcade of cloisonné enamel of blue and white (see Christ, fig. 417, and Saint Peter, fig. 418). The back side depicts the Virgin and the remaining six Apostles. The narrow left side has four angels with Saint Michael, while on the right side (fig. 416) a cross in enamel is adored by the Emperor, Saint Constantine, and his mother, Saint Helena, and two saints associated with the House of Brunswick.

The projecting base and cornice of the Altar are decorated by gold filigree work set with gems, similar in style and technique to the Gertrudis Crosses. The figures are embossed gold. Their relief projects beyond the enameled architecture. In spite of their tiny size (Christ, 1$\frac{15}{16}$ in., and Peter, 1$\frac{7}{8}$ in.), they stand magnification. The gold figures rest on rounded brackets. Garments reveal legs and forearms, while varying gestures, attributes, and features differentiate each figure (see Saint Peter's keys. fig. 418). Adjacent to the knees, the mantles flare outward and form animated triangular folds. The Apostles all turn their heads toward the central figure of Christ (fig. 416).

In style and technique, the Cleveland Portable Altar has many common denominators with the Golden Altar of Bâle (1002–1019), which was presented to the Cathedral of Bâle by Emperor Henry II and is now in the Musée de Cluny in Paris. The same articulation of forms and the same flaring drapery can be seen in both the large altar frontal and the small Portable Altar. The Bâle Golden Altar and the Gertrudis Portable Altar and Crosses are both the products of late tenth- and early eleventh-century monumental art of Ottonian Germany, which also produced works such as the frescoes at Reichnau, Ottonian manuscripts, and the famous bronze doors of Saint Michael's at Hildesheim (c. 1015). During this Ottonian period, before and after 1000, a new monumental style emerged from a creative synthesis of Carolingian and Byzantine forms. This Ottonian style can be called a First Romanesque style. This style, with its plastic interpretation of the human form combined with animation

through gesture and flying drapery, seems to lie behind the flowering of Romanesque sculpture and painting in France, especially in Burgundy. The figures in the capitals of the choir of Cluny III (1088–1095) exhibit many similarities to those in the Bâle altar and especially to the figures in the Gertrudis Portable Altar. Indeed, the ancestors of the scupture of Vézelay (figs. 94, 95, 106) would seem to be these Ottonian monuments. Just as the large early eleventh-century Ottonian cathedrals, with clerestory windows, seem to have influenced the design of Burgundian churches, so the sculpture and monumental painting of Germany became the point of departure for Burgundian sculpture and painting (see Berzé-la-Ville, fig. 113). The supreme quality of these Ottonian objects certainly belies the appellation of "minor" to this art of the Medieval goldsmiths.

SILVER CHASSE IN THE WALTERS ART GALLERY, BALTIMORE

Two objects from the distinguished collections of The Walters Art Gallery in Baltimore have been studied in Parts II and III: one of the two heads from the west portals of Saint-Denis (fig. 203) and a detail of the stained-glass window from Saint-Germaine-des-Prés in Paris (fig. 332). Six more objects from The Walters Art Gallery collection remain to be discussed: three Crucifixions (ivory, enamel, manuscript), a crozier, a chalice, and the end of a reliquary chasse. Since the objects were selected by the author to illustrate certain points in the text, those chosen do not always reveal the scope of the museum's holdings; for example, only one illumination from the extensive and impressive collection of manuscripts in The Walters Art Gallery is included in this study.

The end of a chasse or reliquary shrine in The Walters Art Gallery, almost 2 feet in height, contains a Triumphant Christ (fig. 419). The other end of this chasse is in a private collection in England. This relief illustrates literally Christ defeating the forces of evil as described (Psalm 91:13): "Thou shalt trample under foot the lion and the basilisk." It signifies Christ's triumph as

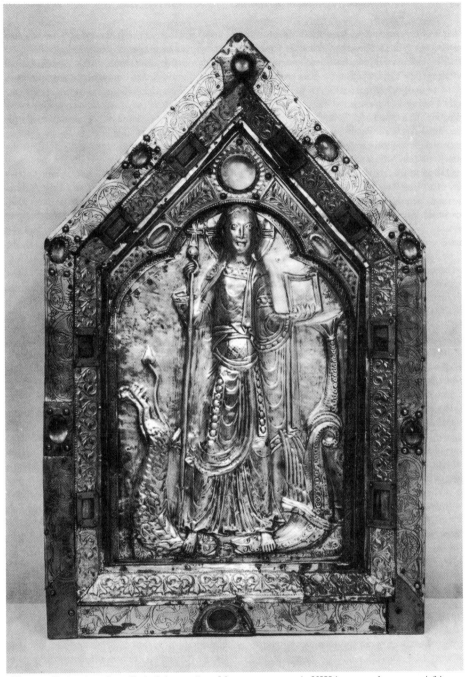

Fig. 419. Christ triumphant. End of chasse, silver, Mosan, c. 1100, set in XIIIth century frame, 23 1/16 in.
(The Walters Art Gallery, Baltimore)

priest and warrior and presages the ultimate triumph of the Church. The figure of Christ is made of silver repoussé — silver hammered or pushed out into relief. The inner floral border is of silvergilt. Originally this relief and its inner frame formed the end of a chasse which contained the relics of Saint Ode and Saint George in the Church of Amay in Belgium. In the thirteenth century the relics were transferred to another reliquary, and in the same century the outer frame was added to this relief. The Triumph of Christ is of Mosan workmanship from the valley of the Meuse River and can be dated about 1100.

Christ is depicted holding staff and book and standing on the necks of lion and basilisk (adder). Bodies and tails of the beasts curve upward and fill the voids flanking the Christ. The forms are arranged to echo the shape of a plaque like the forms of the contemporary Berzé-la-Ville fresco of a martyrdom (fig. 116). The extent of relief and the folds of the drapery give only a slight suggestion of the attenuated and disjointed anatomy. Multiple concave folds animate Christ's mantle; the undergarment flares out over His tiny feet, which are suspended in space. The dematerialized body, staring eyes, rigid pose, and animated drapery are Romanesque of high quality.

In contrast to the figures in the Gertrudis Portable Altar (figs. 416–418), this Christ Triumphant is more linear and dynamic. The figures in the Gertrudis Altar, in spite of their smaller size, are more three-dimensional. Created some seventy years earlier during the Ottonian renaissance, the Gertrudis figures combine the monumentality of the Byzantine Second Golden Age, which revived ideas from classical antiquity, with certain northern elements such as the windblown draperies, inherited from late Carolingian art. Indeed, the Christ Triumphant possesses more of the northern dynamic spirit than do the Apostles and Christ in the Gertrudis Altar. The nervous intensity of the Carolingian Reims school (see the Saint Mark from the Gospels produced at Reims in 845–882, fig. 398) seems to have reasserted itself in this Romanesque sculpture and in related painting.

The Christ Triumphant (fig. 419) possesses many similarities with Romanesque sculpture and painting. The Saint Mark of the Gospel Book, illuminated in Corbie about 1050 (fig. 211), has the same animated drapery with accented concave folds but is presented in a more disjointed, centrifugal pose. Some other examples of this rigidity of the pose can be seen in the contemporary cloister reliefs of Moissac (fig. 102); yet the more complicated drapery recalls the figures of the portals of Moissac (figs. 99–101) and Vézelay (figs. 93–95). The silver relief of Christ Triumphant has more subtle nuances of surfaces than the silver-gilt front of the shrine of Saint Hadelin of Celles, which depicts the same subject and can be dated about 1075 (see Swarzenski, pl. 98, fig. 226).

ENAMEL IN MUSEUM OF FINE ART, BOSTON

The Museum of Fine Arts, Boston, had only a small collection of Medieval art until after 1939, when Dr. Georg Swarzenski, formerly Director-General of the municipal museums of Frankfort, was appointed Fellow for Research in Sculpture and Medieval Art. During his tenure (until his death in 1957) Dr. Swarzenski recommended the purchase of many distinguished pieces of sculpture, enamel work, and manuscript pages which have greatly enriched the museum's collection in size, scope, and quality. Among the most outstanding objects are Italian marbles of the thirteenth and fourteenth centuries. Dr. Hanns Swarzenski, Curator of Decorative Arts and Sculpture since 1957, has continued the policies of his father. Of the two objects from the Boston collection included in this study, one, the large polychromed oak Virgin and Christ Child Enthroned, about 1200 (fig. 334), was discussed in Part III. The other object is a superb champlevé enamel, made about 1145, of the Song of the Three Worthies in the Fiery Furnace (fig. 420).

The Boston enamel plaque (9 in. wide by 8½ in. high) depicts the Angel of the Lord rescuing the Three Youths from the Fiery Furnace (see bibliography: Hanns Swarzenski). The Book of Daniel (Chapter 3) relates the story of the erec-

tion of the huge gold image of King Nebuchad-
nezzar, his order that all peoples worship it, and
the refusal of Ananias, Azarias, and Misael (see
inscriptions on plaque, fig. 420), who, at Daniel's
request, had been appointed by the King to rule
Babylon. Their refusal to obey King Nebuchad-
nezzar resulted in their being cast into the Fiery
Furnace, from which they were rescued miracu-
lously by the intercession of an angel. Daniel
(3:28–30) reads as follows:

> Nebuchadnezzar said, "Blessed be the God of
> Shadrach, Meshach, and Abednego [other
> names for Ananias, Azarias, and Misael] who
> had sent his angel and delivered his servants,
> who trusted in him, and set at nought the
> king's command, and yielded up their bodies
> rather than serve and worship any God except
> their own God. Therefore, I make a decree:
> Any people, nation, or language that speaks
> anything against the God of Shadrach,
> Meshach, and Abednego shall be torn limb
> from limb and their houses laid in ruins; for
> there is no other God who is able to deliver in
> this way." Then the King promoted Shadrach,
> Meshach, and Abednego in the Province of
> Babylon.

More specifically, this interpretation of the
Three Worthies plaque is derived from the Apoc-
rypha (verses 26–30) following the text of Daniel:

> But the Angel of the Lord came down into the
> furnace together with Azarias and his fellows,
> and he smote the flame of the fire out of the
> furnace, and made the midst of the furnace as
> it had been a moist whistling wind, so that the
> fire touched them not at all, neither hurt nor
> troubled them. Then the three, as out of one
> mouth, praised, and glorified, and blessed God
> in the furnace, saying: "Blessed art Thou, O
> Lord, thou God of our fathers, and to be
> praised and exalted above all forever."

On the plaque, the last sentence of the apocryphal
account appears on a scroll held by the Three
Worthies. The inscription on the border of the
plaque reads: "Neither the Fury of the King and
the Fire could harm the Youths, nor the Birth of

the Mother destroy the Seal of Her Virginity."
The inscription implies that this Old Testament
episode and others such as Daniel in the Lion's
Den and God appearing in the Burning Bush pre-
figure the Incarnation.

Because of the shape of the Boston plaque, its
slight convexity, and the five holes in its border,
Swarzenski suggests that it, together with other
Old Testament scenes such as the Fleece of Gid-
eon (a badly damaged plaque in the Lille Mu-
seum) formed a quatrefoil base for a column. The
precedent for this kind of object is a large monu-
mental cross (about 20 feet tall) which Abbot
Suger had made for the new choir of Saint-Denis
by goldsmiths from Lorraine (valley of the
Meuse). Abbot Suger, in his account of the ad-
ministration of the Abbey of Saint-Denis, de-
scribed the monumental cross in great detail:

> We applied to the perfection of so sacred an
> ornament not only these but also a great and
> expensive supply of other gems and large
> pearls. We remember, if memory serves, to
> have put in about eighty marks of refined
> gold. And barely within two years were we
> able to have completed, through several gold-
> smiths from Lorraine — at times five, at other
> times seven — the pedestal adorned by the four
> Evangelists; and the pillar upon which the
> sacred image stands, enamelled with exquisite
> workmanship, and [on it] the history of the
> Saviour, with the testimonies of the allegories
> from the Old Testament indicated, and the
> capital above looking up, with its images, to
> the Death of the Lord. Hastening to honor
> and extol even more highly the embellishment
> of so important and sacred a liturgical object,
> the mercy of our Saviour brought to us our
> Lord Pope Eugenius for the celebration of
> Holy Easter (as is the custom of the Roman
> Pontiffs when sojourning in Gaul, in honor of
> the sacred apostolate of the blessed Denis,
> which we have also experienced with his prede-
> cessors, Callixtus and Innocent); and he sol-
> emnly consecrated the aforesaid crucifix on
> that day.

The foot and pillar of the Cross of Saint-Bertin,
made about 1175, in the Museum of Saint-Omer
is a replica in miniature of Suger's Cross. It is

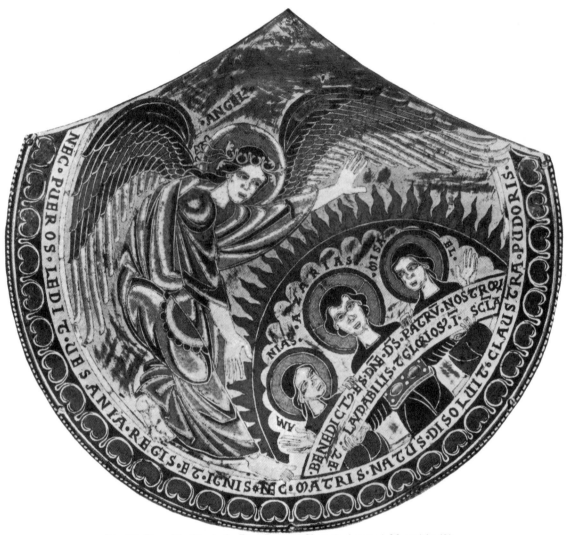

Fig. 420. Three Worthies in the Fiery Furnace. Champlevé enamel, Maastricht (?),
c. 1145, 8 1/8 in. high (Museum of Fine Arts, Boston)

tempting to suggest that the Boston plaque is a fragment of Suger's famous Cross.

The Boston plaque, a work of the craft of the goldsmith, which included the art of enameling, is made of gilded copper and enamel. Silhouette and contour lines of the figures and the ornamented border are the gilded ridges of the original surface of the copper plaque which remained after the internal areas had been gouged out to receive the enamel. The voids between the figures and surrounding the inscriptions are the gilded copper surfaces which act as a lustrous ground for the Angel and Worthies. Bright greens, yellows, and blues of two different values, rich red for the flames, and white for faces, hands, and the high lights of the drapery impart an extraordinary iridescence to the plaque. Crisp lines (ridges of copper) animate the elegant wings of the Angel and define the articulation of the forms of the Angel and the Three Youths. Shifts in value from white to dark blue and from yellow to green suggest plasticity; yet the two-dimensional surface is preserved. The Angel, with outstretched arms and wings curved to echo the concavity and convexity of the two sides of the plaque, surrounds the abstracted Fiery Furnace containing the Three Worthies. The segmental inscription held by the Youths, the circular edge of the Furnace, and the shape of the plaque itself are stabilized by the four flat halos. The movement of the Angel is played against the static frontality of the Three Worthies in a dynamic yet subtle composition.

According to Swarzenski, the style of the Boston plaque is related to a series of enamel objects associated with the famous Godefroid de Clair, of Huy, a town in the Meuse Valley. No specific objects can be attributed to Godefroid de Clair, but it is known that he continued the great Lorraine goldsmith tradition of Rainer de Huy (early twelfth century) and that the work of another goldsmith, Nicholas of Verdun, extended from the last quarter of the twelfth century into the thirteenth century. On the basis of certain stylistic details of drapery, such as the half-rosette on the Angel's thigh, the shape and epigraphy of the banner held by the Three Worthies, and other

unusual features which differ from the Godefroid de Clair style, Swarzenski suggests that the Boston plaque was made about 1145 by goldsmiths from Maastricht, on the Meuse River.

The strong classical overtones of the Angel appear to be the result of a wave of Byzantine influence which penetrated western Europe in the mid-twelfth century. We have already remarked on a wave of influence from Byzantium, via either Rome or Germany, in the early twelfth-century frescoes of Berzé-la-Ville and in a Burgundian manuscript (figs. 112, 115, 116). A new interest in organic articulation of the body can be seen in fresco and manuscript alike. In the Boston plaque this articulation is increased and made more monumental, as it is in the mid-twelfth-century Saint Augustine in a manuscript illuminated in the Abbey of Marchiennes (fig. 212). In spite of the all-over composition of the Boston plaque and its integration with the shape of the object, which remains Romanesque, one wonders whether the monumentality of the forms with their implied articulation might better be labeled Early Gothic and linked with the monumental portals of Saint-Denis and Chartres.

SUGER'S EAGLE VASE AND CHALICE

Abbot Suger was forced to import artists from outside the Île-de-France to rebuild and redecorate his Abbey of Saint-Denis. Under Suger's guidance, an architect from Normandy supervised the construction of the new narthex and façade with the first Early Gothic portals, dedicated in 1140 (figs. 124, 127, 129, 130), while a second architect, probably also from Normandy, designed the precocious ribbed-vaulted choir with its cycle of stained-glass windows, dedicated in 1144 (figs. 132–134, 136–138). It was Suger who conceived the new iconography of the jamb statues on the west portals interrelating church and state — Old Testament Prophets and Prophetesses combined with the appropriate characteristic of the kings and queens of France (figs. 126, 201, 203). Suger's *De Administratione,* or account of his administration of the abbey, gives ample evidence of his absorption in the task of making Saint-

Denis a religious symbol worthy of the French monarchy. In reading Suger, one is impressed by his own vain delight in the stained-glass windows, bronze doors, crosses, and altars of gold and enamel work. His greatest pleasure seemed to center around the costliness and glitter of precious stones.

> We hasten to adorn the Main Altar of the blessed Denis where there was only one beautiful and precious frontal panel from Charles the Bald, the third Emperor; for at this [altar] we had been offered to the monastic life. We had it all encased, putting up golden panels on either side and adding a fourth, even more precious one; so that the whole altar would appear golden all the way around. On either side, we installed there the two candlesticks of King Louis, son of Philip, of twenty marks of gold, lest they might be stolen on some occasion; we added hyacinths, emeralds, and sundry precious gems; and we gave orders carefully to look out for others to be added further. . . . But the rear panel, of marvelous workmanship and lavish sumptuousness (for the Barbarian artists were even more lavish than ours), we ennobled with chased relief work equally admirable for its form as for its material, so that certain people might be able to say: *The workmanship surpassed the material.* . . . To those who know the properties of precious stones it becomes evident, to their utter astonishment, that none is absent from the number of these (with the only exception of the carbuncle), but that they abound most copiously. Thus, when — out of my delight in the beauty of the House of God — the loveliness of the many-colored gems has called me away from external cares, and worthy meditation has induced me to reflect, transferring that which is material to that which is immaterial, on the diversity of the sacred virtues: then it seems to me that I see myself dwelling, as it were, in some strange region of the universe which neither exists entirely in the slime of the earth nor entirely in the purity of Heaven; and that, by the Grace of God, I can be transported from this inferior to that higher world in an anagogical manner.

As a result of his extensive travels — five journeys to Rome, two to Germany and the Low Countries, two recorded trips to Burgundy, and one to western France — Suger was well aware of the most advanced artistic activities in Europe. Accounts of the treasures of the Byzantine emperors brought back by the crusaders excited his desire to decorate Saint-Denis with the finest objects he could commission. Reference has already been made to the lost 20-foot cross made by goldsmiths imported from the valley of the Meuse River, whose work he undoubtedly had seen in his visit to the Low Countries in 1133. Unfortunately only a few objects commissioned by Abbot Suger still exist. Two of them — the Eagle Vase in the Louvre in Paris (fig. 421) and the Sardonyx Chalice in the National Gallery of Art in Washington (fig. 422) — will be discussed in this study.

Near the end of Suger's account of the accomplishments of his administration of Saint-Denis, he included a description of liturgical objects commissioned or restored for the service of the Table of the Lord. Concerning the Eagle Vase in the Louvre (1 ft. 5 in. in height, fig. 421), Suger wrote:

> And further we adapted for the service of the altar, with the aid of gold and silver material, a porphyry vase, made admirable by the hand of the sculptor and polisher, after it had lain idly in a chest for many years, converting it from a flagon into the shape of an eagle; and we had the following verses inscribed on this vase: "This stone deserves to be enclosed in gems and gold. It was marble, but in these settings it is more precious than marble."

Panofsky (see bibliography) offers the interesting idea that "the transformation of a Roman porphyry vase into an eagle suggests the whim of an abbot rather than the invention of a professional goldsmith." Joan Evans has discovered that Suger utilized a capital from La Charité-sur-Loire for the eagle itself (see bibliography). Suger was at La Charité in Burgundy for its consecration and probably revisited the abbey on his trips to Rome. In conclusion, Miss Evans writes: "We have thus another instance of the interdependence of the iconography of various arts in the Romanesque

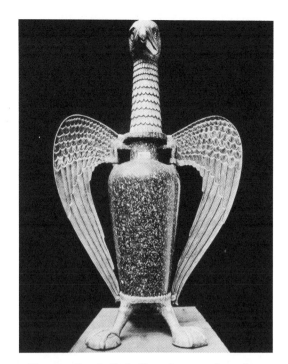

Fig. 421. Suger's Eagle Vase. Bronze and porphyry,
c. 1140 (The Louvre, Paris)

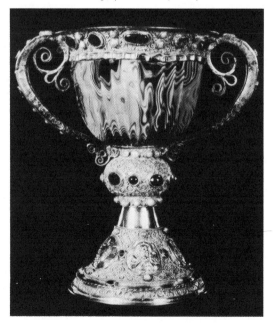

Fig. 422. Chalice of Abbot Suger. Sardonyx, gold and
jewels, mid-XIIth century, height 7 17/32 in.
(National Gallery of Art, Washington)

period, when they are dominated by the taste and fancy of such men as Suger rather than by the less eclectic tradition of craftsmen."

The silver-gilt feet, tail, wings, and head of the eagle make an impressive stand, frame, and crown for the porphyry vase which serves as the eagle's body. The wings recall those of the angel in the Boston enamel plaque (fig. 420). The animated head, covered with abstracted feathers, supported by a rigid neck, and played against the tapering vase, imparts a monumental grandeur to the Eagle Vase as a whole.

Writing about the Chalice now in the National Gallery in Washington (7$^{17}\!/_{32}$ in., fig. 422), Suger stated: "We also procured for the services at the aforesaid altar a precious chalice out of one solid sardonyx, which [word] derives from 'sardius' and 'onyx'; in which one [stone] the sard's red hue, by varying its property, so strongly contrasts with the blackness of the onyx that one property seems to be bent on trespassing upon the other." Suger's sensitivity to and delight in lustrous materials is amply revealed in this description, and one feels that he ordered a goldsmith to execute the sumptuous pedestal and the handles to intensify the qualities inherent in the sardonyx bowl itself. Framed jewels animate the lip of the cup and base. Pearls form bands separating the boss or node from base and cup. Filigree work of vines and tendrils fills the voids around the jewels. Counterparts of this ornament can be found in the jambs of the west portals of Saint-Denis, which were completed in 1140 for the consecration of the narthex. Only one of the five plaques on the base of the chalice, a bust of Christ, is original (fig. 422). In all probability the other four originally depicted the four Evangelists; they were replaced by Eucharistic symbols in the seventeenth century. Like the Eagle Vase, this Chalice is a product of Abbot Suger's taste. Political mediator, adviser to the kings of France, Regent of France, Abbot of Saint-Denis, Suger, in his desire to glorify the monarchy, rebuilt and redecorated resplendently Saint-Denis and at the same time recorded his achievements for posterity. In his actions and writings, he often seems to be more of a Renaissance

man than a Medieval abbot. Panofsky clarifies the basic differences, however:

> Yet there is a fundamental difference between the Renaissance man's thirst for fame and Suger's colossal but, in a sense, profoundly humble vanity. The great man of the Renaissance asserted his personality centripetally, so to speak: he swallowed up the world that surrounded him until his whole environment had been absorbed by his own self. Suger asserted his personality centrifugally: he projected his ego into the world that surrounded him until his whole self had been absorbed by his environment.

FOURTEENTH-CENTURY PRIVATE ALTARPIECE, THE CLOISTERS

To recapitulate, we have studied the Gertrudis Portable Altar (c. 1038–1040, figs. 416–418), the Romanesque Christ Triumphant (c. 1100, fig. 419), and three mid-twelfth-century objects from the time of Abbot Suger (figs. 420–422). Now we jump to the 1340's and to the small private altarpiece and reliquary shrine of silver-gilt and enamel in The Cloisters (The Metropolitan Museum of Art, fig. 423). This exquisite object is a piece of Rayonnant architecture with the statuettes related to the life-size fourteenth-century statue of the Virgin and Child in The Cloisters (fig. 337). The enamels were inspired by Jean Pucelle (*Hours of Jeanne d'Évreux* in The Cloisters, fig. 402). The reliquary statuette of Saint Stephen in The Cloisters (c. 1220, fig. 317), with its strong stylistic connections with the monumental sculpture of Chartres and Amiens (figs. 318, 319), illustrates the High Gothic point of view and is, in the evolution of Gothic art, halfway between the mid-twelfth-century objects and this Rayonnant altarpiece and shrine.

The altarpiece (10 in. high, fig. 423) was made in Paris by one of the 273 goldsmiths whose names are recorded (see bibliography). Paris was the center of goldsmiths' work in northern Europe during the fourteenth century. Commissions from private patrons supported large numbers of goldsmiths and miniaturists alike. The inventory

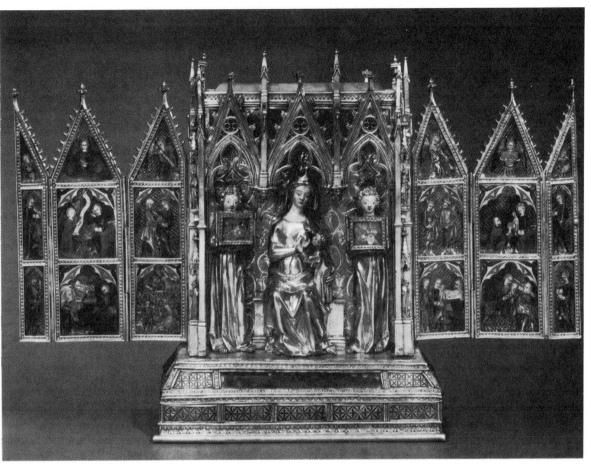

Fig. 423. Private altarpiece. Silver-gilt and enamel, French (Paris), 1340–1350, 10 in. high
(The Metropolitan Museum of Art, The Cloisters Collection)

of the possessions of Louis I of Anjou, which can be dated about 1379, list 3,600 objects of goldsmiths' work and jewelry. We have already seen the extent of patronage of the arts by two of Louis of Anjou's brothers, Jean, Duke of Berry, and Philip the Bold, Duke of Burgundy. This private altarpiece and shrine (fig. 423) was probably commissioned by and in the possession of Queen Elizabeth of Hungary. Elizabeth, daughter of King Vladislav of Poland, married Charles Robert of the Angevin line of Naples, who was made King of Hungary after the death of the last of the Árpad dynasty. Queen Elizabeth was beautiful and wealthy, with extensive income from her gold mines in Hungary. She traveled in Italy and Germany and was related by marriage to the French kings. In 1334 she founded the Convent of the Poor Clares of the Franciscan Order, and it is the inventory of this convent, dated 1782, which describes a "small altarpiece with two wings for a house chapel in the center part of which the image of the Holy Virgin is giving her breast to the Child Jesus, flanked on both sides by the figures of virgins. The whole is made of silver-gilt." This description and others, plus the research of Hungarian scholars, seem to connect this private altarpiece with Queen Elizabeth, who bequeathed it to the Convent of the Poor Clares.

Inside the opened altarpiece are silver-gilt statuettes in the round of the Virgin and Child seated on a throne and of two standing angels holding reliquaries. Places where wings of thin metal, enamel, or real feathers could be attached on the backs of the heads and shoulders of the standing figures prove that they were angels, not virgins, as the description of the inventory has indicated. The Virgin is preparing to nurse the Christ Child, who leans toward the Virgin's breast, which was originally painted with flesh tones. In contrast to the more symbolic interpretations of the thirteenth century (see the trumeau of Paris, fig. 336, and the Virgin and Child in Boston, fig. 334), this interpretation, emphasizing the human aspects of the Virgin, was especially popular in the fourteenth century. Faces and hands are painted to simulate actual flesh. Every detail of the statu-

ettes points up their poise and delicacy. The graceful curves of the angels' garments and their mirror poses (left vs. right) serve as a subtle, human frame for the central Virgin and Child. This is an exquisite, sophisticated, courtly work of art.

In style, the figures are related to other fourteenth-century objects already studied. In the simplified treatment of folds and in their pronounced convexities and concavities, the figures of the altarpiece resemble the Jean Pucelle miniatures of the *Hours of Jeanne d' Évreux* (fig. 402); they also resemble statues carved around Paris in the first half of the fourteenth century.

Vying for equal attention with the statuettes in the altarpiece are the thirty-six enameled plaques. When the altarpiece is opened (fig. 423), scenes from the Infancy of Christ are revealed: Annunciation, Visitation, Nativity, Angel Appearing to the Shepherds, Adoration of the Magi, Presentation in the Temple, Flight to Egypt, and angels in the gables. These enameled plaques are not opaque like the champlevé enamel in Boston (c. 1145, fig. 420), in which powdered glass is fused on copper. Here a new technique, called basse taille, developed in the late thirteenth century, involves fusing translucent enamel on silver or gold already engraved and chiseled in low relief. The polished metal shines through the added, translucent enamel, and variations of high lights and darks are determined by the depth of the relief and the thickness of the enamel. Some of the plaques have been restored in part, but twelve are in their original condition. The scenes are simply organized against a lozenge pattern of deep blue. Enameled arches of red, yellow, and green crowning each scene echo the trefoil arches over the statuettes. Purple, green and yellow, and yellow-orange are the predominant colors. The compositions and the figure style are so close to Jean Pucelle's miniatures (see fig. 402) that their designs must have come from his workshop (see bibliography).

The architecture of the altarpiece is straight Rayonnant in style. The trefoil arches, gables framing quatrefoils, pinnacles, crockets, and statues under canopies all reflect the characteristics of fourteenth-century architecture. Indeed, the su-

perstructure of Sainte-Chapelle (fig. 346) in spirit and form suggests the architecture of this much later altarpiece. As a totality, this private altarpiece combines Rayonnant architecture, sculpture, and painting in one object and epitomizes the extraordinary harmony of the arts in this period. It is at once a monument in spite of its size, 10 inches high. Perhaps Rayonnant with its exquisite gracefulness and sparkle is at its best when small.

CROZIERS AND CHALICES

Two croziers in ivory (figs. 424, 425) and two silver chalices (figs. 426, 427) illustrate the evolution of Medieval art from the early twelfth to the fourteenth centuries. Each pair exhibits a change in the design of the objects themselves, a different attitude toward the treatment of the human form (in the case of the croziers only), and a varying handling of ornament in its relation to the surface being decorated. Croziers are staffs of a bishop's office, and they are designed to be carried by the bishops in processions. The two croziers consist of the top curved crook of the staff. The bishop, wearing a miter, on the left edge of the Romanesque crozier (fig. 424) is carrying a crozier (the bottom half of the staff is missing). The chalices and those already studied (figs. 414, 422) held the sacramental wine during the celebration of the Mass.

The Romanesque crozier (National Museum, Florence, 5 in. high, fig. 424) was carved in ivory in the early twelfth century in northern France (Goldschmidt, Vol. IV, Plate XII, 42, *a, b, c*). The boss or node, contains angels interwoven with vines. The crook itself depicts monks under an arch assisting a bishop who holds a crozier in his left hand. Above the arches rise tiny towers. The curved sections are animated by four animals, a nude woman, a bird, and a winged dragon in the center. The figures are interwoven with vines which give off tightly rolled leaves and fill the voids. Animals bite either each other or the undulating vine. A seated bird, braced against the side of the arch, bites the neck of another bird and serves as the bracket to support the central curve of

the crozier. The dynamic interweaving of birds, animals, humans, and vines recalls Anglo-Irish art of the seventh and eighth centuries or Merovingian art on the Continent. Derived from the art of the nomadic barbarian tribes, this animal style reaches its apogee in the Irish manuscripts such as the Book of Durrow and the Book of Kells. During the Carolingian renaissance of the late eighth and ninth centuries, this style was largely replaced by a new interest in classical antiquity, directly derived either from ancient monuments or from their Early Christian counterparts. However, in the Romanesque period this indigenous northern tradition reasserted itself, as can be seen in the trumeau of Moissac (fig. 101). Both the figures and the animals in the crozier bear many points of resemblance with the large silver Triumphant Christ on the end of a reliquary (fig. 419). The structure of this crozier is architectonic. Silhouettes are preserved, and reliefs, whether figure, animal, or vine, project from the surface to the same depth. The figure — ground relationship is thereby consistent throughout. In spite of the over-all spiral movement, a mural character is sustained.

The second ivory crozier (The Walters Art Gallery, Baltimore, fig. 425) was made in Paris in the mid-fourteenth century. It is only 5³⁄₁₆ in. in height. The reverse side depicts the Virgin and Child flanked by angels, while the illustrated side shows the Crucified Christ with the Virgin Mary and John the Evangelist. Realistic leaves growing out of the crook, which is conceived as an organic branch, make the silhouette irregular. The design thus lends itself to the organic structure of ivory. The bent branch becomes a frame encircling the two scenes which dominate the composition. In the Romanesque crozier, although figures were carved on the surface, the crozier retained its architectural shape (fig. 424), whereas the surface of this Rayonnant crozier has been deeply undercut to create two pictorial scenes within a modulated frame. The surfaces are highly polished to maximize the satin sheen and the semi-transparency of the ivory. The zigzag pose of Christ on the Cross, the déhanchement of the Virgin, and the elegant curve of the John the Evangelist are

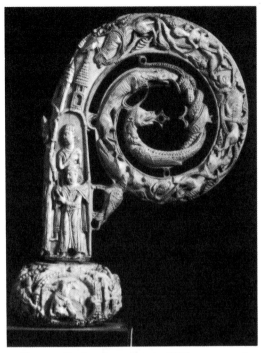

Fig. 424. Crozier. Ivory, French, XIIth century, 5 in. high (National Museum, Florence)

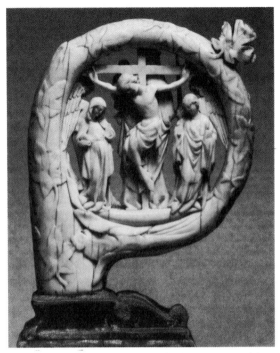

Fig. 425. Crozier. Ivory, French, XIVth century, 5 3/16 in. (The Walters Art Gallery, Baltimore)

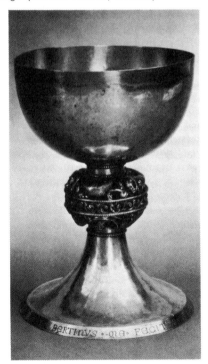

Fig. 426. Chalice. Silver, parcel-gilt, signed F. Bertinus, 1222, height 7 1/2 in. (The Metropolitan Museum of Art, The Cloisters Collection)

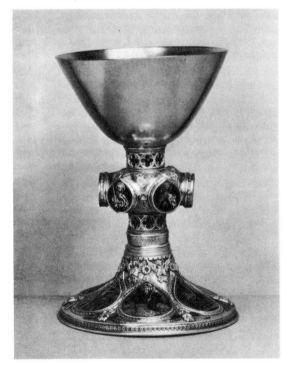

Fig. 427. Chalice. Silver-gilt with enamel medallions, German, c. 1320, height 8 1/8 in. (The Walters Art Gallery, Baltimore)

typically fourteenth-century Rayonnant, and almost exact parallels in the treatment of drapery and pose can be found in the contemporary miniatures of Jean Pucelle. The same precious quality can be seen in silver-gilt in the private altarpiece just discussed (fig. 423). The elegance of the polished surface and the movement of the swinging folds are vastly different from the transfixed figures of the Romanesque crozier (fig. 424).

Both croziers are technical achievements of a high order; yet each represents a different moment in the broad panorama of the Middle Ages. The first, with its murality reminiscent of Romanesque architecture, depicts the flattened figures combined with animals, birds, and dragons. The Rayonnant crozier, in spite of the subject of the Crucifixion, depicts graceful figures in the round in a subtly balanced composition. In contrast to the Romanesque example, this crozier is the product of a more sophisticated, personal, and specific age. The ivory of the Coronation of the Virgin in the Louvre (c. 1260, fig. 327), which was compared with Gothic portal sculpture and with a High Gothic manuscript in Part III, stands halfway between the Romanesque and the fourteenth-century croziers in date and in style. The Virgin and Child exist as three-dimensional figures which transcend their small size; they recall the monumentality of High Gothic sculpture. The fourteenth-century ivory crozier, on the other hand, seems to be a sympathetic liaison of the material, which is small by its very nature, and a refined and elegant figurine style.

Like the croziers, the two chalices exemplify an evolution of Medieval art, in this instance from 1222 to about 1320. As the inscription indicates, the first chalice (The Cloisters, The Metropolitan Museum of Art, fig. 426) was made by Brother Bertinus in 1222. Its style places its provenance in northern Europe, probably northern France. Heavy silver, hammered and polished and pierced as in the knob, has been gilded around the rim, in the interior of the cup, and on the two bands above and below the knob. The curved knob is ornamented by three borders: one narrow band of ornament separating two bands each with three

interlaced dragons. These ornamental details of animals and vines indicate the lasting power of the northern, nonhuman tradition. The rugged base and the semicircular cup seem more Early Gothic or even Romanesque than High Gothic. The massiveness of this chalice recalls the architecture of Noyon and Notre-Dame in Paris. In contrast to Suger's ornate chalice (c. 1140: fig. 421) and to the thirteenth-century German chalice (fig. 414), the Bertinus chalice is a more chaste statement. These differences may perhaps be explained by the nature of the patrons. Suger commissioned a goldsmith to make an elaborate chalice for Saint-Denis; a prince commissioned artisans to make a costly chalice, paten, and straws for an abbey; Brother Bertinus, a monk, fabricated a chalice for his own use or for that of his brothers. The apparent modernity of his chalice has great appeal.

The second chalice (The Walters Art Gallery, Baltimore, fig. 427) was made in Germany about 1320 for the church of Saint Johann in Constance. It is silver-gilt with enameled plaques around the base and knob. As a piece of architecture this chalice is Rayonnant Gothic. The elegant, pointed curve of the cup is in marked contrast to the semicircular shape of the cup of Brother Bertinus' chalice (fig. 426). The knob is separated from cup and base by two bands of quatrefoils filled with enamels. The pointed plaques on the knob contain enamels of the Apostles (James on the left and Peter on the right); these plaques and the subtle curves of the frames of the plaques on the base are fourteenth-century in character. The translucent plaques around the base, similar in technique and color to those on the private altarpiece (fig. 423), depict scenes from the Life of Christ. In our illustration, the left scene is the Crucifixion, the Resurrection is in the center, and the Annunciation is on the right. The jagged pose of the Crucified Christ and the swinging drapery of the flanking figures are not unlike the Crucifixion in the second crozier (fig. 425); yet the expressive gestures and intensely animated faces are German. Low-relief frontal angels fill the voids above and below the plaques. In shape, treatment of surface, and color this chalice is vastly different from the sim-

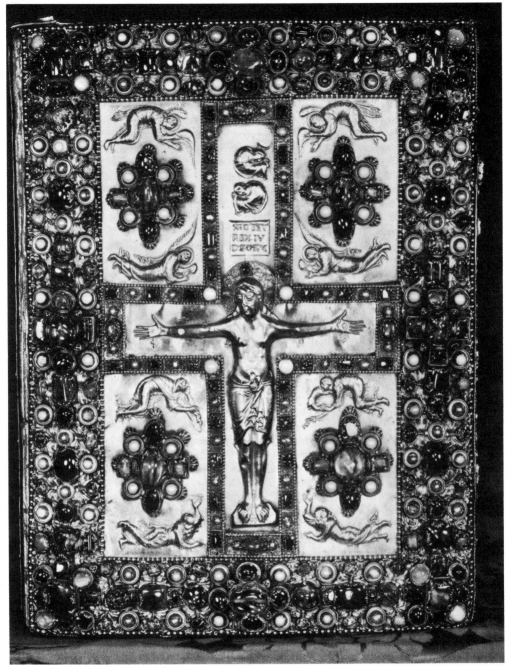

Fig. 428. "Crucifixion." Upper cover of the binding of the *Lindau Gospels,* gold and jewels, c. 870, 13 3/4 in. by 10 1/2 in. (The Pierpont Morgan Library)

pler and more monumental chalice by Brother Bertinus (fig. 426).

SERIES OF CRUCIFIXIONS IN GOLD, IVORY, TEMPERA ON PARCHMENT, AND ENAMEL

Ivory croziers and silver chalices in pairs exhibited the evolution of Medieval art from the early twelfth to the mid-fourteenth centuries. Six objects (figs. 428–433), five depicting Crucifixions and one a Deposition, reveal a variety of materials and techniques: gold, ivory, tempera on panel, paint on vellum, enamel and bronze. The objects date from the ninth to the early thirteenth centuries. All six can be seen and enjoyed in institutions in the United States: The Pierpont Morgan Library, New York, The Walters Art Gallery, Baltimore, the Cleveland Museum of Art, and The Metropolitan Museum of Art, New York.

The upper cover of the binding of the Lindau Gospels, Morgan Ms. 1 in The Pierpont Morgan Library (13¾ in. by 10½ in., fig. 428), was made of gold relief and precious stones about 870, possibly in Corbie or Reims. The wide outside border and narrow inner one framing the Crucified Christ consist of jewels raised above the surface on arcaded turrets and claw feet to allow light to penetrate beneath the stones and intensify their brilliance. This raised technique is derived from metalwork of the barbarians, but here it is used in this Christian book cover to clarify the balanced composition of the figures and the jeweled escutcheons. The classical Christ in gold with marked articulation is Carolingian, probably derived from the School of Tours. Blood from the wounds in the hands, feet, and chest are indicated, but no expression of pain crosses His face. The Carolingian goldsmith is swept up by the tide of interest in antiquity, as seen in the physical presence of the Body of Christ. Symbols of Sun and Moon above the head of Christ, the four angels in the upper panels, the mourning Virgin and John the Evangelist and two angels in the lower panels, also exhibit a decided articulation of anatomy through the flowing drapery. This groping toward a new understanding of the human form, also seen in the Carolingian miniature

of Saint Mark (fig. 398), is an important aspect of Charlemagne's desire to revive the Roman empire. The nervous, windblown draperies of the angels and Mary and John reflect the continuation of pre-Carolingian northern tradition and are similar to the draperies in manuscripts illuminated in the ninth century at Reims, such as the Ebbo Gospels and the Utrecht Psalter. This sumptuous book cover is an extraordinary synthesis of classical and northern elements brought together in an harmonious composition.

The Carolingian ivory plaque from a book cover in The Walters Art Gallery, Baltimore (6⅞ in. by 3⅜ in., fig. 429), was carved in northeastern France in the tenth century, a free copy of a ninth-century ivory. The Crucified Christ, Mary, John the Evangelist, and the two soldiers fill the upper zone; in the lower zone an angel appears to the three Maries in front of the sepulchre, above which rises a Carolingian tower. In spite of the worn outer surfaces of the ivory, the animated poses of the figures and their articulated projection in relief in front of the ground give an extraordinarily forceful and three-dimensional interpretation of the two scenes. The figures exert weight on the narrow ledges which indicate a sharply limited space. The scenes are sharply different from the illusion of space in Roman painting or the implied spatial extension of early Christian painting. Yet the desire to suggest a weight and support principle within a narrow but defined space is characteristic of the Carolingian renaissance. We have already seen the continuation of this figure style with certain modifications in the Gertrudis Portable Altar (1038–1040, figs. 416–418).

In contrast to the Lindau Gospel outer cover (fig. 428) in gold relief and the tenth-century ivory relief (fig. 429), the next Crucifixion presents an entirely different technical problem: a painting in tempera on vellum (fig. 430). This page from a sacramentary is in The Walters Art Gallery, Baltimore (Walters Ms. 28, 6, 7⅛ in. by 4⅝ in.). It was illuminated around 1150 in Arras or Marchiennes for use at Reims. The figures are strongly silhouetted against the geometric, gold background. The

Fig. 430. "Crucifixion." *Sacramentary* for use at Reims, French, mid-XIIth century, 7 1/8 in. by 4 5/8 in. (The Walters Art Gallery, Baltimore, Ms. 28, fol. 6v)

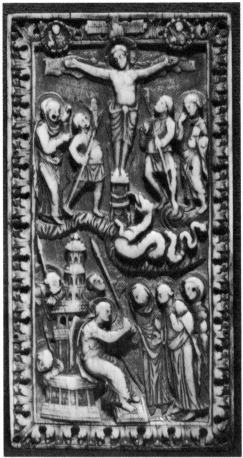

Fig. 429. "Crucifixion and Maries at the Tomb." Ivory plaque from a book cover, Northeastern France, Xth century, 6 7/8 in. by 3 3/8 in. (The Walters Art Gallery, Baltimore)

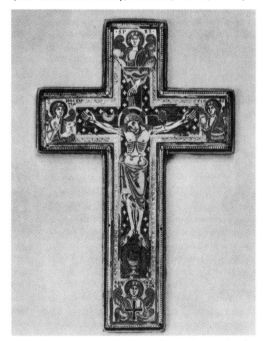

Fig. 431. "Crucifixion." Reliquary Cross, champlevé and cloisonné enamel on copper, Mosan, 1160's, 11 3/8 in. by 7 1/4 in. (The Walters Art Gallery, Baltimore)

bodies and limbs are thin and attenuated and appear suspended in a nebulous space. Enamellike colors balance and animate the composition. The light-orange flesh of Christ is accented by green lines of the ribs, while His garment is bright orange over his abdomen and the rest blue with red-orange stripes and white high lights. The Virgin has an orange undergarment around her neck and left arm and across her feet and a mantle of blue to purple with orange details. John the Evangelist's bodice is blue over a dark green undergarment. His mantle is orange. Thus oranges appear in all three figures, with purple to blue as the other hue. The attenuation of the figures and the essential dematerialization of their forms are reminiscent of Romanesque objects such as the silver Christ Triumphant of about 1100, also in The Walters Art Gallery (fig. 419). The schematic folds of the drapery and the contour lines of different colors do, however, suggest a three-dimensionality and impart a Byzantine cast to all the figures.

The fourth Crucifixion is a reliquary cross in The Walters Art Gallery, Baltimore (11⅜ in. by 7¼ in., fig. 431). It is champlevé enamel on copper and was created in the Meuse Valley in Belgium. The Crucified Christ is depicted as alive, hanging from within a Cross set against white, yellow, and red stars and the moon and sun. He is blessed by the hand of God above, and the chalice of the Eucharist is below His feet. The Cross is green; the background is deep blue. The garment of Christ consists of two shades of blue. The Cross of the halo is red. The four Virtues fill the arms of the reliquary Cross: Hope carrying a wafer and chalice at the top, Innocence with a sacrificial lamb, Faith holding a baptismal vessel, and Obedience with an opening for the relic of the True Cross. These four figures, in their poses and in the ridges of copper which delineate their forms, overlap the inner Cross with its ornamental border. Christ sags downward from the Cross. The joint of His arms and the structure of His abdomen are more forcefully and dramatically stated than in the contemporary manuscript (fig. 430). This example exhibits a quality of subtle draftsmanship combined with a sensitive use of color which compares

quite favorably in quality with the Boston plaque of the Three Worthies (fig. 420). The extensive modeling of hair in all four figures in the reliquary Cross places it as later in date than the Boston plaque, probably in the 1160's.

In the late twelfth and thirteenth centuries, Limoges, in western France, became a center of the mass production of enamels. Today the city is famous for its fine china. Many of the Limoges enamels are of mediocre quality, compared with those made in southwestern Germany and Belgium — for example, the Boston plaque (fig. 420) and the Walters reliquary Cross (fig. 431) — but a considerable number of the enamels from Limoges and the surrounding area do exhibit a sensitive harmony of precise line integrated with the sparkling colors of the vitrified enamel. The Christ in Majesty in the Musée de Cluny in Paris (c. 1175, fig. 114), which we compared with the Vézelay tympanum, the frescoes of Berzé-la-Ville, and a Cluniac manuscript in Part I (figs. 111–113), is a superb example of Limoges enamel work. In the Cleveland Museum of Art there is another distinguished Limoges enamel from the end of the twelfth or beginning of the thirteenth century (fig. 432). This large Cross (26⅞ in. by 17¹⁄₁₆ in.) consists of five enamel pieces: Christ on the Cross, and four arms (two angels above Christ, the Virgin on the left, John the Evangelist on the right, and Saint Peter at the base). The majority of the copper lines have been punched to form a series of dots which, in turn, give the lines a stippled effect. The delineation of the anatomy is more stylized and abstract than in the reliquary Cross (fig. 431). The drapery is a deep, rich blue, while the Cross against which the Christ is flattened is blue in the center, shifting to green with a yellow border. Christ's beard and hair are red. All figures float in the copper-gilt ground. The expressive, three-dimensionality of the reliquary Cross (fig. 431) and of the Boston plaque (fig. 420) is replaced by subtle linear patterns and luminous color.

The tiny Deposition in The Metropolitan Museum of Art (4¼ in. by 3⅝ in., fig. 433) is a bronze cast in two pieces depicting Joseph of Arimathea

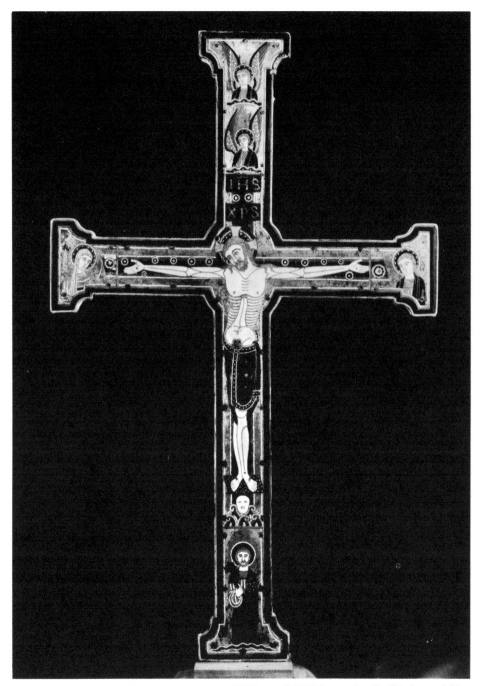

Fig. 432. "Crucifixion." Cross in enamel, Limoges, late XIIth or early XIIIth centuries, 26 7/8 in. by 17 1/16 in.
(The Cleveland Museum of Art)

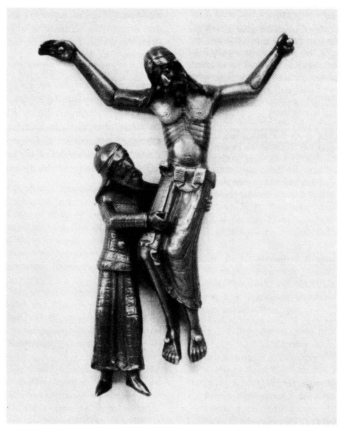

Fig. 433. "Deposition." Bronze, French or English (?),
mid-XIIth century, 4 1/4 in. by 3 5/8 in. (The
Metropolitan Museum of Art)

about to lower Christ's Body from the Cross. As described in the Gospel according to Saint Mark (15:42–47):

> And when evening had come, since it was the day of Preparation, that is, the day before the Sabbath, Joseph of Arimathea, a respected member of the council, who was also himself looking for the kingdom of God, took courage and went to see Pilate and asked for the body of Jesus. And Pilate wondered if he were already dead; and summoning the centurion, he asked him whether he was already dead. And when he learned from the centurion that he was dead, he granted the body to Joseph. And he bought a linen shroud, and taking him down, wrapped him in a linen shroud and laid him in a tomb which had been hewn out of the rock; and he rolled a stone against the door of the tomb.

In this bronze the dead Christ sags from the Cross and is embraced by Joseph. This moment in the descent from the Cross is interpreted with moving tenderness. The provenance of this object and its date can only be surmised. It was probably made in northern France or England around the middle of the twelfth century.

This bronze Deposition, like the Crucifixions in gold, ivory, tempera on vellum, and enamel, manifests the penetrating spirituality of the Middle Ages. All the objects discussed in Part V either functioned directly in the liturgy of the church or contained sacred relics of Christian martyrs; all are important examples of the extraordinary vitality and creativity of the dynamically evolving Medieval art.

Bibliography and Index

Bibliography

The following books and articles are listed in chronological order of publication within each section. With the exception of Romanesque France (Part I), a section of the bibliography is devoted to each chapter of the text.

HISTORICAL BACKGROUND: ROMANESQUE
AND GOTHIC FRANCE (Chapters 1, 8, 16, 25)

Adams, H. *Mont-Saint-Michel and Chartres.* Boston
and New York: Houghton Mifflin Company, 1913
(first published 1904).
Paperback: Doubleday Anchor Books, A166.

Haskins, C. H. *The Rise of Universities.* New York:
Henry Holt and Company, 1923.
Paperback: Great Seal Books, A Division of Cornell University Press.

Huizinga, J. *The Waning of the Middle Ages.* London: E. Arnold, 1924.
Paperback: Doubleday Anchor Books, A42.

Haskins, C. H. *The Renaissance of the Twelfth Century.* Cambridge: Harvard University Press, 1927.
Paperback: Meridian Books M49.

Evans, J. *Monastic Life at Cluny, 910–1157.* Oxford:
Oxford University Press, 1931.

Williams, W. *Saint Bernard of Clairvaux.* Manchester:
Manchester University Press, 1935.

Painter, S. *The Rise of the Feudal Monarchies.* Ithaca:
Cornell University Press, 1951.

Stephenson, C. *Mediaeval History. Europe from the
Second to the Sixteenth Century.* 3rd ed. New
York: Harper & Brothers, 1951.

Previté-Orton, C. W. *The Shorter Cambridge Medieval History.* 2 vols. Cambridge: Cambridge University Press, 1952.

Baldwin, M. *The Mediaeval Church.* Ithaca: Cornell
University Press, 1953.

Clagett, M.; Post, G.; and Reynolds, R. (editors).
*Twelfth-Century Europe and the Foundations of
Modern Society.* Proceedings of a Symposium
Sponsored by the Division of the Humanities of
the University of Wisconsin and the Wisconsin
Institute for Medieval and Renaissance Studies
(1957). Madison: University of Wisconsin Press,
1961.

Utley, F. L. (editor). *The Forward Movement of the
Fourteenth Century.* Columbus: Ohio State University Press, 1961.

Ferguson, W. K. *Europe in Transition, 1300–1520.*
Boston: Houghton Mifflin Company, 1962.

Heer, F. *The Medieval World. Europe 1100–1350.*
New York: World Publishing Company, 1962.
Paperback: Mentor Books, MQ524.

White, L., Jr. *Medieval Technology and Social
Change.* Oxford: Clarendon Press, 1962.
Paperback: Oxford Paperbacks, no. 92.

Calmette, J. *The Golden Age of Burgundy. The
Magnificent Dukes and Their Courts.* New York:
W. W. Norton & Company, 1963.

ROMANESQUE FRANCE (PART I)

(1) *General Books*

Aubert, M. *L'art français à l'époque romane. Architecture et sculpture.* 3 vols. Paris: Éditions Albert Morancé, 1929ff.

Gantner, J., and Pobé, M. *The Glory of Romanesque
Art.* New York: Vanguard Press, 1956.

Aubert, M. *L'art roman en France.* With the collaboration of Gaillard, G.; de Bouard, M., Crozet, R.;
Durliat, M.; Thibout, M.; Vallery-Radot, J.; and
Benoit, F. Paris: Flammarion, 1961.

Focillon, H. *The Art of the West in the Middle Ages.* Edited and introduced by Jean Bony. Volume One: *Romanesque Art.* New York: Phaidon Press, 1963.

(2) *French Romanesque Architecture (general)*

Viollet-le-Duc, E. *Dictionnaire raisonné de l'architecture française du XIᵉ au XVIᵉ siècle.* 10 vols. Paris, 1854–1868.

Dehio, G., and Bezold, G. von. *Die Kirchliche Baukunst des Abendlandes.* 3 vols. text, 5 vols. plates. Stuttgart, 1887–1901.

Porter, A. K. *Medieval Architecture: Its Origins and Development.* Vol. I. New York: Baker & Taylor Company, 1909.

Mortet, V. *Recueil de textes relatifs à l'histoire de l'architecture et à la condition des architectes en France au moyen-âge: XIᵉ–XIIᵉ siècles.* 2 vols. Paris, 1911–1929.

Enlart, C. *Manuel d'archéologie française.* 2nd ed. 5 vols. Paris, 1919–1932.

Baum, J. *Romanesque Architecture in France.* 2nd ed. New York: B. Westermann, 1928.

De Lasteyrie, R. *L'Architecture religieuse en France à l'époque romane.* 2nd ed., edited by Marcel Aubert. Paris: Auguste Picard, 1929.

Clapham, A. W. *Romanesque Architecture in Western Europe.* Oxford: Clarendon Press, 1936.

Plat, G. *L'art de bâtir en France, des Romans à l'an 1100, d'après les monuments anciens de la Touraine, de l'Anjou et du Vendômois.* Paris: Éditions d'Art et d'Histoire, 1939.

Conant, K. J. *Benedictine Contributions to Church Architecture.* Wimmer Lecture, 1947. Latrobe: The Archabbey Press, 1949.

Dimier, M. *Recueil de plans d'églises Cisterciennes.* 2 vols. Paris: Libraire d'Art Ancien et Moderne, 1949.

Conant, K. J. *Carolingian and Romanesque Architecture. 800 to 1200.* Baltimore: Penguin Books, 1959 (The Pelican History of Art).

Saalman, H. *Medieval Architecture: European Architecture 600–1200.* New York: George Braziller, 1962.

Dimier, M.-A., and Porcher, J. *L'art cistercien.* Zodiaque, 1962.

Aubert, M. *Cathedrales abbatiales, collegiales, prieures romans de France.* Paris: Arthand, 1965.

(3) *Pre-Romanesque Architecture* (Chapters 2, 5)

Puig i Cadafalch, J. *Le premier art roman.* Paris: Henri Laurens, 1928.

Gall, E. *Karolingische und ottonische Kirchen.* Burg bei Magdeburg, 1930.

Puig i Cadafalch, J. *La géographie et les origines du premier art roman.* Paris, 1935.

Hubert, J. *L'art pré-roman.* Paris: Les Éditions d'Art et d'Histoire, 1938.

Krautheimer, R. "The Carolingian Revival of Early Christian Architecture." *Art Bulletin,* XXIV (1942), 1–38.

Krautheimer, R. "Introduction to an Iconography of Mediaeval Architecture." *Journal of the Warburg and Courtauld Institutes,* V (1942), 1–34.

Schaefer, H. "The Origin of the Two-Tower Façade in Romanesque Architecture." *Art Bulletin,* XXVII (1945), 85–108.

Jantzen, H. *Ottonische Kunst.* München, 1947.

Focillon, H. *L'an mil.* Paris: Armand Colin, 1952.

Forsyth, G., Jr. *The Church of St. Martin at Angers. The Architectural History of the Site from the Roman Empire to the French Revolution.* 2 vols. Princeton: Princeton University Press, 1953.

Horn, W. "On the Origins of the Mediaeval Bay System." *Journal of the Society of Architectural Historians,* XVII (Summer 1958), 2–23.

Grodecki, L. *Au seuil de l'art roman; l'architecture ottonienne.* Paris: A. Colin, 1958.

Hilberry, H. "The Cathedral at Chartres in 1030." *Speculum,* XXXIV (1959), 561–572.

(4) *Romanesque Architecture of the Pilgrimage Roads* (Chapters 4, 5)

Conant, K. J. *The Early Architectural History of the Cathedral of Santiago de Compostela.* Cambridge: Harvard University Press, 1926.

Aubert, M. *L'Église Saint-Sernin de Toulouse.* Petites Monographies des Grands Édifices de la France. Paris: Henri Laurens, 1933.

Aubert, M. *L'Église de Conques.* Petites Monographies des Grands Édifices de la France. Paris: Henri Laurens, 1939.

Hersey, C. K. "The Church of Saint-Martin at Tours." *Art Bulletin,* XXV (1943), 1–39.

Lesueur, F. "Saint-Martin de Tours et les origines de l'art roman." *Bulletin monumental,* Vol. 107 (1949), 7–84.

Fau, J.-C. *Les Chapiteaux de Conques.* Toulouse: Privat, 1956.

Sheppard, C. "An Earlier Dating for the Transept of Saint-Sernin, Toulouse." *Speculum,* XXXV (1960), 584–590.

Gaillard, G., and others. *Rouergue roman.* Zodiaque, 1963.

Durliat, M. "La construction de Saint-Sernin de Toulouse au XIᵉ siècle." *Bulletin monumental,* Vol. 121 (1963), 151–170.

Scott, D. W. "A Restoration of the West Portal Relief Decoration of Saint-Sernin of Toulouse." *Art Bulletin,* XLVI (September, 1964), 271–282.

Deyres, M. "La construction de l'abbatiale Sainte-Foy de Conques." *Bulletin monumental,* CXXIII (1965), 7–23.

(5) *Burgundian Romanesque*
(Chapters 2 to 5)

Virey, P. *Paray-le-Monial et les églises du Brionnais.* Petites Monographies des Grands Édifices de la France. Paris: Henri Laurens, 1926.

Oursel, C. *L'art roman de Bourgogne.* Études d'Histoire et d'Archéologie. Dijon: Librairie L. Venot, 1928.

Conant, K. J. "Mediaeval Academy Excavations at Cluny. Drawings and Photographs of the Transept." *Speculum,* Vol. IV, no. 3, 1929, 291–302.

Evans, J. *The Romanesque Architecture of the Order of Cluny.* Cambridge: Cambridge University Press, 1938.

Conant, K. J. "The Third Church at Cluny." *Medieval Studies in Memory of A. Kingsley Porter.* Cambridge: Harvard University Press, 1939.

Sunderland, E. R. "The History and Architecture of the Church of St. Fortunatus at Charlieu in Burgundy." *Art Bulletin,* XXI (1939), 61–80.

Salet, F. "La Madeleine de Vézelay. Notes sur la façade de la nef." *Bulletin monumental,* Vol. XCIX (1940), 223–237.

Aubert, M. *L'architecture cistercienne en France.* 2 vols. Paris: Les Éditions d'Art et d'Histoire, 1943; 2nd ed., 1947.

Salet, F. *La Madeleine de Vézelay.* Étude iconographique par Jean Adhémar. Melun: Librairie d'Argences, 1948.

Oursel, C. *L'art de Bourgogne.* Grenoble: Arthand, 1953.

Conant, K. J. "Mediaeval Academy Excavations at Cluny, VIII: Final Stages of the Project." *Speculum,* Vol. XXIX (1954), 1–45.

Vallery-Radot, J. *Saint-Philibert de Tournus.* Paris: L'Inventaire Monumental, 1955.

Oursel, R., and Kres, A. M. *Les églises romanes de l'Autunois et du Brionnais; Cluny et sa région.* Mâcon: Protat, 1956.

Sunderland, E. R. "Feet and Dates at Charlieu." *Journal of the Society of Architectural Historians,* XVI, no. 2 (May 1957), 2–5.

Sunderland, E. R. "More Analogies between Charlieu and Anzy-le-Duc." *Journal of the Society of Architectural Historians,* XVI, no. 3 (1957), 16–21.

Conant, K. J. "La système modulaire de Cluny." *Bulletin de la Societé nationale des Antiquaires de France* (1957), 164–170.

Baudry, J. and others. *Bourgogne Romane.* Zodiaque, 1958.

Sunderland, E. R. "Symbolic Numbers and Romanesque Church Plans." *Journal of the Society of Architectural Historians,* XVIII (October 1959), 94–103.

Conant, K. J. "Mediaeval Academy Excavations at Cluny, IX: Systematic Dimensions in the Buildings." *Speculum,* Vol. XXXVIII (1963), 1–45.

Conant, K. J. Monograph on Cluny. To be published in Paris in 1966 or 1967.

(6) *Other Regions in France*
(Chapter 6)

Ruprich-Robert, V. *L'église Ste-Trinité et l'église St-Étienne à Caen.* Caen: Hardel, 1864.

Maillard, E. *L'église de Saint-Savin-sur-Gartempe.* Petites Monographies des Grands Édifices de la France. Paris: Henri Laurens, 1927.

Labande, L. *L'église Saint-Trophîme d'Arles.* Petites Monographies des Grands Édifices de la France. Paris: Henri Laurens, 1930.

Crozet, R. *L'art roman en Berry.* Paris: Leroux, 1932.

Lambert, E. *Caen roman et gothique.* Caen: Jouan et Bigot, 1935.

Anfray, M. *L'architecture normande, son influence dans le nord de la France aux XIᵉ et XIIᵉ siècles.* Paris: Auguste Picard, 1939.

Crozet, R. *L'art roman en Poitou.* Paris: Henri Laurens, 1948.

Vallery-Radot, J. "L'église de Saint-Guilhem-le-Désert." *Congrès archéologique de France,* 108 (1950), 156–180.

Aubert, M. "Saint-Savin-sur-Gartempe." *Congrès ar-chéologique de France*, 109 (1951), 421–436.

Defarges, B., and others. *Val de Loire roman*. Zo-diaque, 1956.

Crozet, R., and others. *Poitou roman*. Zodiaque, 1957.

Aymard, O., and others. *Touraine roman*. Zodiaque, 1957.

Craplet, B. *Auvergne roman*. Zodiaque, 1958.

Durliat, M. *Roussillon roman*. Zodiaque, 1958.

d'Herbécourt, P., and Porcher, J. *Anjou roman*. Zo-diaque, 1959.

Vallery-Radot, J. "La domaine de l'école roman en Provence." *Bulletin monumental*, 103 (1945), 5–63.

Vidal, M.; Maury, J.; and Porcher, J. *Quercy roman*. Zodiaque, 1959.

Maury, J.; Gauthier, M-M.; and Porcher, J. *Limousin roman*. Zodiaque, 1960.

Daras, C. *Angoumois roman*. Zodiaque, 1961.

FRENCH ROMANESQUE SCULPTURE

(Chapter 7)

Terret, V. *La sculpture Bourguignonné aux XIIe et XIIIe siècles, ses origines et ses sources d'inspira-tion, Cluny*. Autun, 1914.

Mâle, E. *L'art religieux du XIIe siècle en France*. Paris: Librairie Colin, 1922.

Porter, A. K. *Romanesque Sculpture of the Pilgrimage Roads*. 10 vols. Boston: Marshall Jones, 1923.

Deschamps, P. *French Sculpture of the Romanesque Period*. Pantheon Series. New York: Harcourt, Brace & Co., 1930.

Conant, K. J. "Mediaeval Academy Excavations at Cluny. The Date of the Ambulatory Capitals." *Speculum*, Vol. V, no. 1 (1930), 77–94.

Conant, K. J. "The Iconography and the Sequence of the Ambulatory Capitals of Cluny." *Speculum*, Vol. V, no. 3 (1930), 278–287.

Focillon, H. *L'art des sculpteurs romans*. Paris: Le-roux, 1931.

Schapiro, M. "The Romanesque Sculpture of Moissac" *Art Bulletin*, XIII (1931), 249–351, 464–532.

Schapiro, M. "New Documents on St.-Gilles." *Art Bul-letin*, XVII (1935), 415–431.

Rey, R. *La sculpture roman Languedocienne*. Tou-louse: Édouard Privat, 1936.

Schapiro, M. "Further Documents on St.-Gilles." *Art Bulletin*, XIX (1937), 111–112.

Horn, W. *Die Fassade von St. Gilles*. Hamburg: Paul E. Verlag, 1937.

Schapiro, M. "The Sculptures of Souillac." *Medieval Studies in Memory of A. Kingsley Porter*. Edited by Wilhelm R. W. Koehler, Vol. II (1939), 359–387.

Gischia, L., and Mazinod, L. *Frühe Kunst im West-fränkischen Reich*. Leipzig, 1939.

Mendell, E. *Romanesque Sculpture in Saintonge*. New Haven: Yale University Press, 1940.

Katzenellenbogen, A. "The Central Tympanum of Vézelay, its Encyclopedic Meaning and its Rela-tion to the First Crusade." *Art Bulletin*, XXVI (1944), 141–151.

Schapiro, M. "On the Aesthetic Attitude in Roman-esque Art." *Art and Thought, Essays in Honour of A. K. Coomaraswamy*. London, 1947, 130–150.

Freeman, M. "A Romanesque Virgin from Autun." *The Metropolitan Museum of Art, Bulletin*, Vol. VIII, Number 4 (1949), 112–116.

Evans, J. *Cluniac Art of the Romanesque Period*. Cambridge: Cambridge University Press, 1950.

Hamann, R. *Die Abteikirche von St. Gilles und ihre künstlerische Nachfolge*. 3 vols. Berlin: Academie-Verlag, 1955.

Grivot, D., and Zarnecki, G. *Gislebertus, Sculptor of Autun*. London, 1961.

Beckwith, J. *Early Medieval Art*. New York: Frederick A. Praeger, 1964.

Stoddard, W. S. *Romanesque Sculpture in Provence*. Manuscript in preparation.

FRENCH ROMANESQUE PAINTING

(Chapter 7)

Oursel, C. *La miniature du XIIe siècle à l'abbaye de Cîteaux d'après les manuscripts de la Bibliothèque de Dijon*. Dijon, 1926.

Lauer, P. *Les enluminures romanes des manuscrits de la Bibliothèque Nationale*. Paris: Éditions de la Gazette des Beaux-Arts, 1927.

Mercier, F. *Les primitifs français. La peinture Cluny-sienne en Bourgogne à l'époque romane*. Paris: Auguste Picard, 1931.

Focillon, H. *Peintures romanes des églises de France. Cent trente photographies de Pierre Devinoy*. Paris: Paul Hartmann, 1938.

Koehler, W. "Byzantine Art in the West." *Dumbarton*

Oaks Papers, no. 1 (1941), Cambridge: Harvard University Press, 63–87.

Porcher, J. *Les manuscrits à peintures en France du VII* an *XII* siècle. Catalogue of exhibition at the Bibliothèque Nationale in Paris. Paris, 1954.

Oursel, C. "La date des fresques de Berzé-la-Ville." *Bulletin monumental*, 114 (1956).

Grabar, A., and Nordenfalk, C. *Early Medieval Painting*. New York: Skira, 1957.

Grabar, A., and Nordenfalk, C. *Romanesque Painting from the Eleventh to the Thirteenth Century*. New York: Skira, 1958.

Oursel, C. *Miniatures cisterciennes (1109–1134)*. Mâcon: Protat Frères, 1960.

Deschamps, P., and Thibout, M. *La peinture murale en France au début de l'époque Gothique*. Paris: Centre National de la Recherche Scientifique, 1963.

Rubin, I. E. (editor). *Romanesque and Gothic Art. Studies in Western Art.* Acts of the Twentieth International Congress of the History of Art, Vol. 1. Princeton: Princeton University Press, 1963.

FRENCH GOTHIC ARCHITECTURE

(Parts II, III, IV)

Porter, A. K. *Medieval Architecture: Its Origins and Development*. Vol. II. Normandy and the Île-de-France. New York: Baker & Taylor Company, 1909.

Rey, R. *Les vielles églises fortifiées du Midi de la France*. Paris: Henri Laurens, 1925.

De Lasteyrie, R. *L'architecture religieuse en France à l'époque gothique*. 2 vols. Paris: Auguste Picard, 1926.

Rey, R. *L'art gothique du Midi de la France*. Paris: Henri Laurens, 1934.

Bony, J. *French Cathedrals*. Boston: Houghton Mifflin Company, 1951.

Panofsky, E. *Gothic Architecture and Scholasticism*. Wimmer Lecture, 1948. Latrobe, Pennsylvania: The Archabbey Press, 1951.
Paperback: Meridian Books, #44
Review: Bober, H., *Art Bulletin*, XXXV (1953), 310–312.

Gall, E. *Die gotische Baukunst in Frankreich und Deutschland. I. Die Vorstufen in Nordfrankreich*. Braunschweig, 1955.

von Simson, O. *The Gothic Cathedral. Origins of Gothic Architecture and the Medieval Concept of Order*. Bollingen Series XLVIII. New York: Pantheon Books, 1956.
Paperback: Harper Torchbooks, TB 2018, 1964.

Aubert, M., in collaboration with Goubet, S. *Gothic Cathedrals of France and Their Treasures*. London: Nicholas Kaye, 1959.

Branner, R. *Burgundian Gothic Architecture*. London: A. Zwemmer, 1960.

Frankl, P. *The Gothic. Literary Sources and Interpretations Through Eight Centuries*. Princeton: Princeton University Press, 1960.

Branner, R. *Gothic Architecture*. New York: George Braziller, 1961.

Jantzen, H. *High Gothic. The Classical Cathedrals of Chartres, Reims, Amiens*. New York: Pantheon Books, 1962.
Review: Barnes, C. *Journal of the Society of Architectural Historians*, Vol. 21 (December 1962), 193–194.

Frankl, P. *Gothic Architecture*. Baltimore: Penguin Books, 1962 (Pelican History of Art).
Review: Barnes, C. Jr., *Journal of the Society of Architectural Historians*, Vol. XXIV (1965), 74ff.

Focillon, H. *The Art of the West in the Middle Ages*. Edited and introduced by Jean Bony. Vol. Two: *Gothic Art*. New York: Phaidon Press, 1963.

THE ARCHITECT, STRUCTURE, AND
BUILDING TECHNIQUES

Ward, C. *Mediaeval Church Vaulting*. Princeton: Princeton University Press, 1915.

Aubert, M. *Les plus anciennes croisées d'ogives. Leur rôle dans la construction*. Paris: Auguste Picard, 1934.

Hahnloser, H. *Villard de Honnecourt*. Vienna; Schroll, 1935.

Pevsner, N. "The Term 'Architect' in the Middle Ages." *Speculum*, XVII (1942), 549–562.

Du Colombier, P. *Les chantiers des cathédrales*. Paris: A. et J. Picard, 1953.

Fitchen, J. "A Comment on the Function of the Upper Flying Buttresses in French Gothic Cathedrals." *Gazette des Beaux-Arts*, Vol. 97 (1955), 69–90.

Gimpel, J. *Les batisseurs de cathédrales*. Paris: Éditions du Seuil, 1958.
Paperback: *The Cathedral Builders*. Translated

by C. F. Barnes, Jr. New York: Grove Press, 1961.
Evergreen Profile Book, P#21.

Bowie, T. (editor) *The Sketchbook of Villard de Honnecourt.* 2nd edn., revised. New York: Wittenborn, 1959.

Fitchen, J. *The Construction of Gothic Cathedrals.* Oxford: Clarendon Press, 1961.

EARLY GOTHIC ARCHITECTURE (Part II)

SAINT-DENIS (Chapter 9)

Cartellieri, O. *Abt. Suger von Saint-Denis.* Berlin, 1898.

Crosby, S. McK. *The Abbey of Saint-Denis.* Vol. 1. New Haven: Yale University Press, 1942.

Panofsky, E. *Abbot Suger on the Art Treasures of Saint-Denis.* Princeton: Princeton University Press, 1946.

Crosby, S. McK. *L'Abbaye royale de Saint-Denis. Cent trente photographies de Pierre Devinoy.* Paris: Hartmann, 1953.

Crosby, S. McK. "Crypt and Choir Plans at Saint-Denis." *Gesta. International Center of Medieval Art,* Vol. 5 (January 1966), 4–8.

SENS AND VÉZELAY (Chapter 10)

Chartraire, L'Abbé E. *La cathédrale de Sens.* Petites Monographies des Grandes Édifices de la France. Paris: Henri Laurens, 1930.

Salet, F. *La Madeleine de Vézelay.* Melun: Librairie d'Argences, 1948.

Fourrey, R. *Sens, ville d'art et d'histoire.* Lyon: Lescuyer et Fils, 1953.

Salet, R. "La cathédrale de Sens et sa place dans l'histoire de l'architecture médiévale." *Académie des inscriptions et belles-lettres. Comptes-rendus des séances,* 1955, 182–187.

NOYON (Chapter 11)

Bony, J. "Tewkesbury et Pershore. Deux élevations à quatre étages de la fin du XIe siècle." *Bulletin monumental,* Vol. 96 (1937), 281–290.

Seymour, C., Jr. *Notre-Dame of Noyon in the Twelfth Century. A Study in the Early Development of Gothic Architecture.* New Haven: Yale University Press, 1939.

Bony, J. "La techniques normande du mur épais à l'époque romane." *Bulletin monumental,* Vol. 98 (1939), 153–188.

LAON (Chapter 12)

Lambert, E. "La cathédrale de Laon." *Gazette des Beaux-Arts,* Vol. 68 (1926), 361–384.

Broche, L. *La cathédrale de Laon.* Petites Monographies des Grands Édifices de la France. Paris: Henri Laurens, 1930.

Adenauer, H. *Die Kathedrale von Laon.* Düsseldorf, 1934.

PARIS (Chapter 13)

Aubert, M. *La cathédrale Notre-Dame de Paris.* New edition. Paris, 1950.

Temko, A. *Notre-Dame of Paris.* New York: Viking Press, 1955.

Branner, R. "Paris and the Origins of Rayonnant Gothic Architecture down to 1240." *Art Bulletin,* Vol. XLIX (March 1962), 39–51.

MANTES (Chapter 14)

Rhein, A. *Notre-Dame de Mantes.* Petites Monographies des Grands Édifices de la France. Paris: Henri Laurens, 1932.

Bony, J. "La Collégiale de Mantes." *Congrès archéologique de France* (1946), 163–220.

EARLY GOTHIC SCULPTURE AND PAINTING

(Chapter 15)

Vöge, W. *Die Anfänge des Monumentalen Stiles im Mittelalter.* Strassburg, 1894.

Aubert, M. *French Sculpture at the Beginning of the Gothic Period. 1140–1225.* New York: Harcourt, Brace & Company, 1929.

Aubert, M. *Le vitrail en France.* Paris: Larousse, 1946.

Stoddard, W. S. *The West Portals of Saint-Denis and Chartres.* Cambridge: Harvard University Press, 1952.

Sauerländer, W. "Die Marienkrönungsportalen von Senlis und Mantes." *Westdeutsches jahrbuch für kunstgeschichte,* 1958, 115–162.

Kidson, P. *Sculpture at Chartres.* London: Alec Tiranti, 1958.

Katzenellenbogen, A. *The Sculptural Programs of Chartres Cathedral.* Baltimore: The Johns Hopkins Press, 1959.
Paperback: W. W. Norton & Company, Norton N233, 1964.
Review: W. S. Stoddard, *Speculum,* XXXV (1960), 613–616.

Grodecki, L. "La première sculpture gothique. Wilhelm Vöge et l'état actuel des problèmes." *Bulletin monumental*, Vol. 117 (1959), 265–289.

Lapeyre, A. *Des façades occidentales de Saint-Denis et de Chartres aux portails de Laon*. Privately printed, 1960.

Johnson, J. R. "The Tree of Jesse Window: Laudes Regiae." *Speculum*, Vol. XXXVI (1961), 1–22.

Johnson, J. R. *The Radiance of Chartres. Studies in the Early Stained Glass of the Cathedral*. Columbia University Studies in Art History and Archaeology, no. 4. New York: Random House, 1965.

HIGH GOTHIC ARCHITECTURE

CHARTRES (Chapter 17)

Grodecki, L. "The Transept Portals of Chartres Cathedral: The Date of their Construction according to Archeological Data." *Art Bulletin*, XXXIII (1951), 156–167.

Frankl, P. "The Chronology of Chartres Cathedral." *Art Bulletin*, XXXIX (1957), 33–47.

Grodecki, L. "Chronologie de la cathédrale de Chartres." *Bulletin monumental*, Vol. 116 (1958), 91–119.

Frankl, P. "Reconsiderations on the Chronology of Chartres Cathedral." *Art Bulletin*, XLIII (1961), 51–58.

Frankl, P. "The Chronology of the Stained Glass in Chartres Cathedral." *Art Bulletin*, XLV (1963), 301–322.

Maunoury, J. *Chartres*. Paris: Les Presses Artistiques, n.d.

Grodecki, L. *Chartres*. New York: Harcourt, Brace & World, Inc., 1963.

Van der Meulen, J. "Histoire de la construction de la cathédrale de Notre-Dame de Chartres après 1194." Preliminary report. *Bulletin de la Société Archéologique d'Eure-et-Loir*, T. XXIII (1965), 81–126.

Lambert, E. "L'église abbatiale de Saint-Vincent de Laon." *Comptes-rendus des séances de l'Académie des Inscriptions et Belles-Lettres*, March–April, 1939, 124–138.

Bony, J. "The Resistance to Chartres in Early Thirteenth-Century Architecture." *Journal of the British Archaeological Association*, XX–XXI (1957–1958), 35–52.

SOISSONS (Chapter 18)

Lefèvre-Pontalis, E. "Cathédrale de Soissons." *Congrès Archéologique de France (Reims)*, LXXVIII (1911), 318–337.

Barnes, C., Jr. "The Cathedral of Chartres and the Architect of Soissons." *Journal of the Society of Architectural Historians*, Vol. XXII, no. 2 (1963), 63–74.

REIMS (Chapter 19)

Demaison, L. *La cathédrale de Reims*. Petites Monographies des Grands Édifices de la France. Paris: Henri Laurens, 1913.

Frisch, T. "The Twelve Choir Statues of the Cathedral of Reims, Their Stylistic and Chronological Relation to the Sculpture of the North Transept and of the West Façade." *Art Bulletin*, Vol. XLII (1960), 1–24.

Branner, R. "Historical Aspects of the Reconstruction of Reims Cathedral, 1210–1241." *Speculum*, Vol. XXXVI (1961), 23–37.

Branner, R. "The Labyrinth of Reims Cathedral." *Journal of the Society of Architectural Historians*, Vol. XXI (March 1962), 18–25.

Branner, R. "Villard de Honnecourt, Reims and the Origin of Gothic Architectural Drawing." *Gazette des Beaux-Arts*, Vol. 105 (1963), 129–146.

Reinhardt, H. *La cathédrale de Reims. Son histoire, son architecture, sa sculpteur, ses vitraux*. Paris: Presses Universitaires de France, 1963.
Review: Branner, R., *Art Bulletin*, XLV (1963), 375–377.

AMIENS (Chapter 20)

Durand, G. *Monographie de l'église Notre-Dame, Cathédrale d'Amiens*. Paris: Librairie A. Picard et Fils, 1901–1903.

Boivet, A. *La cathédrale d'Amiens*. Petites Monographies des Grands Édifices de la France. Paris: Henri Laurens, 1926.

Katzenellenbogen, A. "The Prophets on the West Façade of the Cathedral at Amiens." *Gazette des Beaux-Arts*, Vol. 94 (1952), 241–260.

Branner, R. *St. Louis and the Court Style in Gothic Architecture*. (Appendix A: "The Chronology of Amiens Cathedral," 138–140.) London: A. Zwemmer, Ltd., 1965.

BOURGES (Chapter 21)

Boivet, A. *La cathédrale de Bourges*. Petites Mono-

graphies des Grands Édifices de la France. Paris: Henri Laurens, n.d.

Gauchery, R., and Branner, R. "La cathédrale de Bourges aux XI⁰ et XII⁰ siècles." *Bulletin monumental*, Vol. III (1953), 105–123.

Branner, R. *La cathédrale de Bourges et sa place dans l'architecture gothique*. Bourges: Éditions Tardy, 1962.

Review: Stoddard, W., *Journal of the Society of Architectural Historians*, XXIV (May, 1965), 176–178.

Salet, F. "La cathédrale du Mans." *Congrès Archéologique de France*, 1961, 18–58.

BEAUVAIS (Chapter 22)

Leblond, V. *La cathédrale de Beauvais*. Petites Monographies des Grands Édifices de la France. Paris: Henri Laurens, 1933.

Branner, R. "Le maître de la cathédrale de Beauvais." *Art de France*, no. II (1962), 77–92.

SAINT-LEU D'ESSERENT AND RAMPILLON (Chapter 23)

Lefèvre-Pontalis, E. "St.-Leu-d'Esserent." *Congrès archéologique de France*, LXXII (1905), 121–128.

Fossard, A. *Le prieuré de St. Leu d'Esserent*. Paris, 1924.

Paquet, J-P. "La restauration de Saint-Leu d'Esserent. Problèmes de stabilité." *Les Monuments historiques de la France*, 1955, 9–19.

Carlier, A. *L'église de Rampillon*. Paris, 1930.

HIGH GOTHIC SCULPTURE AND PAINTING

(Chapter 24)

de Laborde, A. *Étude sur la Bible Moralisée Illustrée*. 5 vols. Paris, 1911–1927.

Mâle, E. *Religious Art in France, XIII Century*. New York: E. P. Dutton & Co., 1913.

Delaporte, Y., and Houvet, E. *Les vitraux de la cathédrale de Chartres*. 1 vol., 3 albums plates. Chartres, 1926.

Aubert, M. *French Cathedral Windows of the Twelfth and Thirteenth Centuries*. New York: Oxford University Press, n.d.

Vitry, P. *French Sculpture During the Reign of Saint Louis. 1226–1270*. New York: Harcourt, Brace & Company, n.d.

Grodecki, L. "A Stained Glass Atelier of the 13th century. A Study of Windows in the Cathedrals of Bourges, Chartres, and Poitiers." *Journal of the Warburg and Courtauld Institute*, XI (1948), 87–111.

Rorimer, J. "The Virgin from Strasbourg Cathedral." *The Metropolitan Museum of Art, Bulletin*, Vol. VII, no. 8 (1949), 220–227.

Aubert, M., and Beaulieu, M. *Musée National du Louvre. Description raisonée des sculptures du Moyen Age, de la Renaissance et des temps modernes. I. Moyen Age*. Paris: Éditions des Musées Nationaux, 1950.

Freeman, M. "A Saint to Treasure" [Saint Stephen in The Cloisters]. *The Metropolitan Museum of Art, Bulletin*, Vol. XIV, no. 10 (1956), 237–245.

Aubert, M.; Grodecki, L.; and others. *Le Vitrail Français*. Sous la haute direction du Musée des Arts Décoratifs de Paris. Paris: Éditions des Deux Mondes, 1958.

Aubert, M.; Grodecki, L.; Lafond, J.; and Verrier, J. *Les Vitraux de Notre-Dame et de la Sainte-Chapelle de Paris*, Vol. 1, Paris, 1959.

Katzenellenbogen, A. *The Sculptural Programs of Chartres Cathedral*. Baltimore: The Johns Hopkins Press, 1959.

Paperback: W. W. Norton & Company, Norton #233.

Swarzenski, H. "A Vièrge d'Orée." *Bulletin, Museum of Fine Arts, Boston*, Vol. LVIII (1960), 64–83.

Saint Louis à la Sainte Chapelle. Exposition organisée par la Direction Générale des Archives de France. Paris, 1960.

Verdier, P. "A Stained Glass Window from St. Germain des Prés." *Bulletin of the Walters Art Gallery*, Vol. 13 (February 1961), 2–4.

Sauerländer, W. "Art antique et sculpture autour de 1200." *Art de France*, Vol. 1, 1961, 47–56.

Lapeyre, A.; Salet, F.; Beyer, V.; Grodecki, L.; and Porcher, J. *Cathédrals. Sculptures, vitraux, objets d'art, manuscrits des XII⁰ et XIII⁰ siècles*. Catalogue of exhibition at the Louvre, Paris, 1962.

FROM RAYONNANT TO FLAMBOYANT
(PART IV)

RAYONNANT ARCHITECTURE (Chapter 26)

Masson, A. *L'église abbatiale Saint-Ouen de Rouen*. Petites Monographies des Grands Édifices de la France. Paris: Henri Laurens, 1927.

du Ranquet, H. *La cathédrale de Clermont-Ferrand*.

Petites Monographies des Grands Édifices de la France. Paris: Henri Laurens, 1928.

Mâle, E. *La cathédrale d'Albi. Cent trente et une photographies de Pierre Devinoy.* Paris: Paul Hartmann, 1940.

Lambert, E. "L'église et le couvent des Jacobins de Toulouse et l'architecture dominicaine en France." *Bulletin monumental,* CIII (1945), 141–186.

Prin, M. "La première église des frères prêcheurs de Toulouse, d'après les fouilles." *Annales du Midi,* Vol. LXVII (1955), 5–18.

Salet, F. "Saint-Urbain de Troyes." *Congrès archéologique de France,* Vol. 113 (1955), 96–122.

De Courcel, V. "La cathédrale de Troyes." *Congrès archéologique de France,* Vol. 113 (1955), 9–28.

Branner, R. "Les débuts de la cathédrale de Troyes." *Bulletin monumental,* Vol. 118 (1960), 111–122.

Bober, H. "A Reappraisal of Rayonnant Architecture." *The Forward Movement of the Fourteenth Century.* Columbus, Ohio State University Press, 1961, 9–30.

Branner, R. "Paris and the Origins of Rayonnant Architecture down to 1240." *Art Bulletin,* XLIX (1962), 39–51.

Branner, R. "Westminster Abbey and the French Court Style." *Journal of the Society of Architectural Historians,* Vol. XXIII, no. 1 (March 1964), 3–18.

Branner, R. *St. Louis and the Court Style in Gothic Architecture.* London: A. Zwemmer Ltd., 1965.

FLAMBOYANT ARCHITECTURE

(Chapter 27)

Nodet, V. *L'église de Brou.* Petites Monographies des Grands Édifices de la France. Paris: Henri Laurens, 1928.

Leblond, V. *L'église Saint-Étienne de Beauvais.* Petites Monographies des Grands Édifices de la France. Paris: Henri Laurens, 1929.

Stein, H. *L'Hôtel-Dieu de Beaune.* Petites Monographies des Grands Édifices de la France. Paris: Henri Laurens, 1933.

Plat, G. *L'église de la Trinité de Vendôme.* Petites Monographies des Grands Édifices de la France. Paris: Henri Laurens, 1934.

Verrier, J. "L'église Saint-Séverin." *Congrès archéologique de France* (1946), 136–162.

Lemoine, J.-B. *Bourg et l'église de Brou.* Paris, 1948.

LATE GOTHIC SCULPTURE

(Chapter 29)

Kleinclausz, A. *Claus Sluter et la sculpture bourguignonne au XV^e siècle.* Paris, 1905.

David, H. *Claus Sluter.* Paris: Tisué, 1951.

Bober, H. "André Beauneveu and Mehun-sur-Yèvre." *Speculum,* Vol. XXVIII, no. 4 (1953), 741–753.

Forsyth, W. H. "The Virgin and Child in French XIVth Century Sculpture. A Method of Classification." *Art Bulletin,* 1957, 171–182.

ILLUMINATED MANUSCRIPTS AND TAPESTRIES (Chapters 30, 31)

Rorimer, J. "The Unicorn Tapestries Were Made for Anne of Brittany." *The Metropolitan Museum of Art, Bulletin,* Vol. 1, no. 1 (1942), 7–20.

Miner, D. *The Walters Art Gallery. Illuminated Books of the Middle Ages and Renaissance.* An exhibition held at the Baltimore Museum of Art. Baltimore: Walters Art Gallery, 1949.

Swarzenski, H. *Early Medieval Illumination.* New York: Oxford University Press, 1951.

Panofsky, E. *Early Netherlandish Painting. Its Origins and Character.* 2 vols. Cambridge: Harvard University Press, 1953.

Francis, H. "A Fourteenth-Century Annunciation." *Bulletin of the Cleveland Museum of Art,* December 1955, 215–219.

Freeman, M. "A Book of Hours Made for the Duke of Berry." *The Metropolitan Museum of Art, Bulletin,* Vol. XV, no. 4 (1956), 93–104.

Miner, D. *The Development of Medieval Illumination as Related to the Evolution of Book Design.* Reprinted from *Catholic Life Annual,* Vol. I, 1958.

Randall, R., Jr. "Frog in the Middle." Winternitz, E. "Bagpipes for the Lord." Grancsay, S. "Medieval Armor in a Prayer Book." *The Metropolitan Museum of Art, Bulletin,* Vol. XVI, no. 10 (1958), 269–275, 276–286, 287–292.

Rorimer, J. *The Belles Heures of Jean, Duke of Berry, Prince of France.* New York: The Metropolitan Museum of Art, 1958.

Porcher, J. *Medieval French Miniatures.* New York: Harry N. Abrams, Inc., 1959.

Rorimer, J., and Freeman, M. *The Nine Heroes Tapestries at The Cloisters.* New York: The Metropolitan Museum of Art, 1960.

Wixom, W. *A Missal for a King. A First Exhibition.* [An introduction to the Gotha Missal and a catalogue to the exhibition *Gothic Art 1360–1440* held at The Cleveland Museum of Art.] Cleveland: The Cleveland Museum of Art, 1963.

Plummer, J. *Liturgical Manuscripts for the Mass and the Divine Offices.* New York: The Pierpont Morgan Library, 1964.

Haverkamp-Begemann, E.; Lawder, S.; and Talbot, C., Jr. *Drawings from the Clark Art Institute.* A catalogue raisonné of the Robert Sterling Clark Collection of European and American Drawings at the Sterling and Francine Clark Art Institute, Williamstown, 2 vols. New Haven and London: Yale University Press, 1964.

TREASURIES OF MONASTERIES AND
CATHEDRALS (PART IV)

Goldschmidt, A. *Die Elfenbeinskulpturen.* 4 vols. Berlin: Bruno Cassirer, 1914–1926.

de Ricci, S. "Un chalice du Trésor de Saint-Denis." Académie des Descriptions et Belles-Lettres, Comptes-Rendues (1923), 335–339.

Koechlin, R. *Les ivoires gothiques français.* 2 vols. Paris: Auguste Picard, 1924.

Milliken, W. "The Acquisition of Six Objects from the Guelf Treasure for the Cleveland Museum of Art." *The Bulletin of The Cleveland Museum of Art,* November 1930, 163–177.

Milliken, W. "The Gertrudis Altar and Two Crosses." *The Bulletin of The Cleveland Museum of Art,* February 1931, 23–26.

Evans, J. "Die Adlervase des Sugerius." *Pantheon,* X (July 1932), 221–223.

Swarzenski, G. *Arts of the Middle Ages 1000–1400.* [Catalogue of a loan exhibition.] Boston: Museum of Fine Arts, 1940.

Grodecki, L. *Ivoires français.* Paris: Larousse, 1947.

Rorimer, J. "A Treasury at The Cloisters." *The Metropolitan Museum of Art, Bulletin,* Vol. VI, no. 9 (1948), 237–260.

Gauthier, M. M. *Emaux limousins champlevés des XIIᵉ XIIIᵉ et XIVᵉ siècles.* Paris: G. Le Prat, 1950.

Natanson, J. *Gothic Ivories of the 13th and 14th Centuries.* London: Tiranti, 1951.

Swarzenski, H. *Monuments of Romanesque Art. The Art of Church Treasures in North-Western Europe.* Chicago: University of Chicago Press, 1953.

Leisinger, H. *Romanesque Bronzes. Church Portals in Medieval Europe.* New York: Praeger, 1957.

Stenton, F. and others. *The Bayeux Tapestry. A Comprehensive Survey.* New York: Phaidon, 1957.

Swarzenski, H. "The Song of the Three Worthies." *Museum of Fine Arts, Boston, Bulletin,* Vol. LVI, no. 303, (spring 1958), 31–49.

Harrsen, M. *Central European Manuscripts in The Pierpont Morgan Library.* New York: The Pierpont Morgan Library, 1958.

Freeman, M. "A Shrine for a Queen." *The Metropolitan Museum of Art, Bulletin,* June 1963, 327–339.

Rorimer, J. *The Metropolitan Museum of Art. The Cloisters. The Building and the Collection of Medieval Art in Fort Tryon Park.* 3rd edn., revised in collaboration with Margaret B. Freeman and the staff of the Medieval Department and The Cloisters. New York: The Metropolitan Museum of Art, 1963.

Les trésors des églises de France. Musée des Arts Décoratifs 1965, 2nd edn. Paris: Caisse Nationale des Monuments Historiques, 1965.

Index